A Lost Art Rediscovered

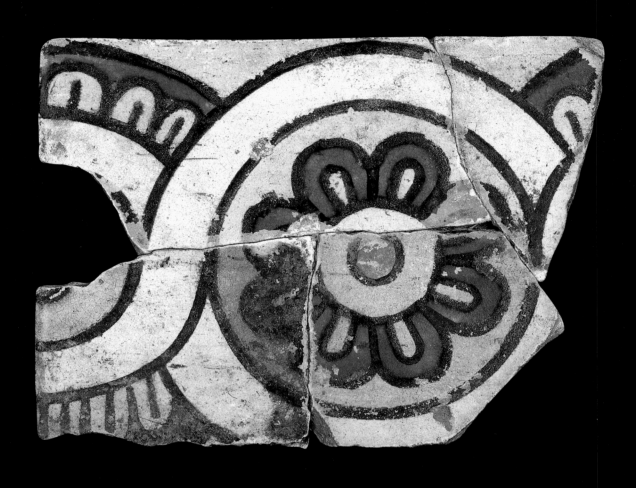

A Lost Art Rediscovered

THE ARCHITECTURAL CERAMICS OF BYZANTIUM

EDITED BY

Sharon E. J. Gerstel and
Julie A. Lauffenburger

The Walters Art Museum, Baltimore, in association with

The Pennsylvania State University Press, University Park, Pennsylvania

Support was provided by the Hagop Kevorkian Fund.

This publication was also supported by endowments established by
The Jacob and Hilda Blaustein Foundation and
The Louis and Henrietta Blaustein Foundation.

Library of Congress Cataloging-in-Publication Data

A lost art rediscovered : the architectural ceramics of Byzantium /
edited by Sharon E. J. Gerstel and Julie A. Lauffenburger.

 p. cm.
 Includes bibliographic references and index.
 ISBN 0-271-02139-X (pbk.: alk. paper)
 1. Tiles Byzantine—Turkey—Istanbul—Catalogs. 2. Decoration and
ornament, Architectural—Turkey—Istanbul—Catalogs. 3. Tiles—
Maryland—Baltimore—Catalogs. 4. Walters Art Museum (Balti-
more, Md.)—Catalogs. I. Gerstel, Sharon E. J. II. Lauffenburger,
Julie A.

NA2985.L67 2001
738.6'094961'80747526—dc21 20001032100

Contents

Preface

The Byzantine polychrome tiles at the Walters Art Museum constitute exceptional examples of one of the rarest and least-known decorative media. The collection is unparalleled in the world in terms of its breadth and scale. Purchased in 1956, the more than two thousand fragments include twenty-eight rare figural plaques. The tiles further enhanced the already world-renowned collection of Byzantine art acquired by Henry Walters and bequeathed to the city of Baltimore in 1931. The study of the Walters tiles served as the catalyst for this publication, and the tiles form the center of the scholarly discussion that follows.

For the present volume, editors Sharon Gerstel and Julie Lauffenburger have brought together all of the known examples of polychrome tiles from medieval Byzantium, both from excavated sites and from public and private collections worldwide. The study of the tiles, considered to have been used in decorative schemes from the mid-ninth to the mid-eleventh century, offers greater information about the working practices of the Byzantine craftsman and provides insights into the development of ornamental patterns in the medieval East. Set within a catalogue of all known tiles from Constantinople, the Walters tiles reflect the beauty and power of this expressive medium.

I would like to thank Julie Lauffenburger and Sharon Gerstel for initiating this project and for their time, effort, and enthusiasm for their subject. I would also like to express my gratitude to Deborah Horowitz, Editor of Curatorial Publications at the Walters, and Susan Tobin, Head Photographer, for all of their work. *A Lost Art Rediscovered: The Architectural Ceramics of Byzantium* is an eloquent expression of the Walters Art Museum's long-standing commitment to scholarly collaboration between art historians and conservators.

GARY VIKAN
Director, The Walters Art Museum

Acknowledgments

This volume is the product of the close collaboration of scholars and institutions from a number of countries.

We wish to express our heartfelt appreciation to our Turkish colleagues at the Istanbul Archaeological Museum, Dr. Halil Özek, Director, and Dr. Alpay Pasinli, former Director. We also thank the following curators, who were very welcoming: Nilüfer Atakan, Saliha Gönenç, Asuman Denker, Sahrazat Karagöz, Sevinç Pasinli, Işil Aktaş, and Tahsin Sezer. We also warmly thank Dr. Nuşin Asgari, former Director of the Istanbul Archaeological Museum, for her permission to publish photographs from her excavations at the Boukoleon Palace. We thank the director of the Hagia Sophia Museum, Mr. Ali Kiliçkaya, and the curators, Sabriye Parlak and Nilay Yılmaz Emre, who collaborated with us on the publication of tiles from the Hospital of Sampson.

We owe an enormous debt of gratitude to Dr. Jannic Durand, Head Curator of the Department of Objects of Art at the Musée du Louvre, who spent many hours with us in storerooms, galleries, and conservation labs. We thank Professor Nicole Thierry for her assistance in viewing tiles in her collection and for providing us with photographs of the material.

We thank Anastasia Drandake, Curator at the Benaki Museum in Athens, for her assistance in examining tiles in the museum's collection and for helping us to obtain photographs. Dr. Anna Ballian, also at the Benaki Museum, assisted us in providing photographs of Fāṭimid vessels included in this volume. We also thank Demetra Bakirtzi for her encouragement to study this material and her generous advice about ceramic matters.

At Dumbarton Oaks, we thank Susan Boyd, Curator of the Byzantine Collection, for her assistance in discussing the tiles and in reading portions of the text. We also thank Stephen Zwirn, Associate Curator of the Byzantine Collection, as well as Katherine Hill, Assistant to the Curator of the Byzantine Photograph and Fieldwork Archives. Joe Mills, photographer at Dumbarton Oaks, provided photographs for many of the essays in this volume.

This volume has benefited from the generous advice of a number of scholars in the field of Byzantine studies. We thank Ihor Ševčenko for examining the epigraphy of the tiles. We also thank Judith Herrin and Jean-Michel Spieser for constructive criticism throughout the process of examining this material. The contributors to this volume have all demonstrated their scholarly investment through sustained conversations and unending interest. From the beginning to the end, all of them were equal partners in this project. Above all, we thank Cecil L. Striker, whose friendship, intellectual guidance, and high standards have shaped this volume.

We thank the General Research Board of the University of Maryland for assistance in funding travel related to this project.

The excellent maps in this volume were drawn by Dr. Karen Rasmussen.

A number of staff members at the Walters Art Museum contributed to the success of this publication. We would like to thank Deborah Horowitz, Editor of Curatorial Publications, Susan Tobin, photographer, Jenny Campbell and Cynthia Pratt, photo production staff, for their tireless work. We thank the entire staff of the Objects Conservation Lab at the Walters Art Museum, especially Terry Drayman-Weisser, Director of Conservation and Technical Research. The tiles included in this volume were studied and pieced together by the many interns, fellows, and staff members. Jane Williams's initial study of the tiles formed the basis for the current scientific analysis of this material.

Finally, we thank Gary Vikan, Director, and Marianna Shreve Simpson, former Director of Curatorial Affairs, at the Walters Art Museum for their commitment to this project, one that began with numerous small fragments and, after many years, has joined together to form a wonderful assemblage of materials and scholars.

Contributors to the Volume

Authors of Chapters

Jeffrey C. Anderson, Professor of Art History,
The George Washington University

Anne Bouquillon, Researcher, Centre de Recherches et
de Restauration des Musées de France

Anthony Cutler, Research Professor of Art History,
The Pennsylvania State University

Sharon E. J. Gerstel, Associate Professor of Byzantine
Art and Archaeology, University of Maryland

Julie A. Lauffenburger, Senior Objects Conservator,
The Walters Art Museum

Cyril Mango, Bywater and Sotheby Professor Emeritus
of Byzantine and Modern Greek Language and
Literature, University of Oxford

Marlia Mundell Mango, University Lecturer in
Byzantine Archaeology and Art, University of Oxford

William Tronzo, Professor of Art History, Tulane
University

Christine Vogt, Researcher, Maison de l'Archéologie et
de L'Ethnologie R. Ginouvès, CNRS

Contributors to the Catalogue

J.D.	Joanna Demopoulos
	University of Oxford
N.Y.E.	Nilay Yılmaz Emre
	Ayasofya Müzesi
E.S.E.	Elizabeth S. Ettinghausen
	Independent scholar
Ö.G.	Özge Gençay
	University of Maryland
S.G.	Sharon Gerstel
	University of Maryland
M.H.	Monika Hirschbichler
	University of Maryland
J.L.	Julie Lauffenburger
	The Walters Art Museum

M.M.M.	Marlia Mundell Mango
	University of Oxford
M.P.	Maria Parani
	University of Oxford
S.P.	Sabriye Parlak
	Ayasofya Müzesi
B.P.	Brigitte Pitarakis
	Collège de France
R.B.R.	Rossitza B. Roussanova
	University of Maryland
L.T.	Lioba Theis
	Rheinische Friedrich-Wilhelms-Universität
C.V.	Christine Vogt
	Centre National de Recherche Scientifique

List of Abbreviations

Exhibitions

Athens 1964	*Byzantine Art, an European Art,* Zappeion Exhibition Hall, Athens, 1964	New York 1997	*The Glory of Byzantium,* The Metropolitan Museum of Art, New York, 1997
Athens 1999	*Byzantine Glazed Pottery in the Benaki Museum,* Athens, 1999	Paris 1992–93	*Byzance: L'art byzantin dans les collections publiques françaises,* Musée du Louvre, 1992–93
Athens 2000	*Mother of God: Representations of the Virgin in Byzantine Art,* Benaki Museum, Athens, 2000	Washington, D.C., 1995	*Byzantine Ceramics: Art and Science,* Dumbarton Oaks, Washington, D.C., 1995
Brussels 1982	*Splendeur de Byzance,* Musées Royaux d'Art et d'Histoire, Brussels, 1982		

Abbreviated Titles

AA	*Archäologischer Anzeiger*
ABME	*Archeion ton Byzantinon Mnemeion tes Hellados*
AMY	*Ayasofya Müzesi Yıllığı*
ArtB	*The Art Bulletin*
BSA	*The Annual of the British School at Athens*
BZ	*Byzantinische Zeitschrift*
CahArch	*Cahiers archéologiques*
CEB	*Congrès international des études byzantines: Actes*
CSHB	*Corpus scriptorum historiae byzantinae*
DACL	*Dictionnaire d'archéologie chrétienne et de liturgie*
DChAE	*Deltion tes christianikes archaiologikes hetaireias*
DOP	*Dumbarton Oaks Papers*
DOS	Dumbarton Oaks Studies
EChR	*Eastern Churches Review*
IAMY	*Istanbul Arkeoloji Müzeler Yıllığı*
IRAIK	*Izvestija Russkogo Arheologičeskogo Instituta v Konstantinopole*

IstMitt	*Istanbuler Mitteilungen*
JBAA	*Journal of the British Archaeological Association*
JÖB	*Jahrbuch der Österreichischen Byzantinistik*
JSAH	*Journal of the Society of Architectural Historians*
ODB	*Oxford Dictionary of Byzantium*
REB	*Revue des études byzantines*
RSBN	*Rivista di studi bizantini e neoellenici*
TM	*Travaux et Mémoires*
TürkArkDerg	*Türk arkeoloji dergisi*
VizVrem	*Vizantijskij vremennik*
ZRVI	*Zbornik radova Vizantološkog Instituta*

Age of Spirituality
> *Age of Spirituality: Late Antique and Early Christian Art, Third to Seventh Century,* ed. K. Weitzmann (New York, 1979)

Asgari, "İstanbul"
> N. Asgari, "İstanbul temel kazılarından haberler—1983," *Araştırma sonuçları toplantısı* 2 (1984), 45–46, figs. 12–19

Bossert, "Istanbul Excavations"

 H. T. Bossert, "Istanbul akropolünde üniversite hafriyatı," *Üniversite konferansları* 125 (Istanbul, 1939/40)

Byzance

 Byzance: L'art byzantin dans les collections publiques françaises, ed. J. Durand, exh. cat., Musée du Louvre (Paris, 1992)

Byzantine Art, an European Art

 Byzantine Art, an European Art/L'art byzantin, art européen, ninth exhibition held under the auspices of the Council of Europe, exh. cat., Zappeion Exhibition Hall (Athens, 1964)

Chatzidakis, *Hosios Loukas*

 N. Chatzidakis, *Hosios Loukas* (Athens, 1997)

Coche de la Ferté, *L'antiquité*

 É. Coche de la Ferté, *L'antiquité chrétienne* (Paris, 1958)

Coche de la Ferté, "Décors"

 É. Coche de la Ferté, "Décors en céramique byzantine au Musée du Louvre," *CahArch* 9 (1957), 187–217

Cutler, *Hand of the Master*

 A. Cutler, *Hand of the Master: Craftsmanship, Ivory, and Society in Byzantium (9th–11th Centuries)* (Princeton, 1994)

Dirimtekin, "Fouilles"

 F. Dirimtekin, "Les fouilles faites en 1946–1947 et en 1958–1960 entre Sainte-Sophie et Sainte-Irène, à Istanbul," *CahArch* 13 (1962), 161–85

Durand, "Plaques"

 J. Durand, "Plaques de céramique byzantine des collections publiques françaises," in *Materials Analysis of Byzantine Pottery,* ed. H. Maguire (Washington, D.C., 1997), 25–50

Durand and Vogt, "Plaques"

 J. Durand and C. Vogt, "Plaques de céramique décorative byzantine d'époque macédonienne," *Revue du Louvre* 4 (1992), 38–44

Ebersolt, *Catalogue*

 J. Ebersolt, *Catalogue des poteries byzantines et ana-* toliennes du Musée de Constantinople (Constantinople, 1910)

Ebersolt, *Miniature byzantine*

 J. Ebersolt, *La miniature byzantine* (Paris, 1926)

Ettinghausen, "Byzantine Tiles"

 E. Ettinghausen, "Byzantine Tiles from the Basilica in the Topkapu Sarayi and Saint John of Stoudios," *CahArch* 7 (1954), 79–88

Fıratlı, *Bizans Eserleri*

 N. Fıratlı, *Seçme Bizans Eserleri Rehberi* (Istanbul Arkeoloji Müzeleri, 1955)

Fıratlı, *Sculpture byzantine*

 N. Fıratlı et al., *La sculpture byzantine figurée au Musée archéologique d'Istanbul* (Paris, 1990)

Fıratlı, "Sébaste"

 N. Fıratlı, "Découverte d'une église byzantine à Sébaste de Phrygie," *CahArch* 19 (1969), 151–66

Frantz, "Ornament"

 M. Alison Frantz, "Byzantine Illuminated Ornament. A Study in Chronology," *ArtB* 16 (1934), 43–76

Glory of Byzantium

 The Glory of Byzantium, ed. H. Evans and W. Wixom, exh. cat., The Metropolitan Museum of Art (New York, 1997)

Grabar, *Recherches*

 A. Grabar, *Recherches sur les influences orientales dans l'art balkanique* (Paris, 1928)

Grabar, *Sculptures* I

 A. Grabar, *Sculptures byzantines de Constantinople (IVe–Xe siècle),* Bibliothèque archéologique et historique de l'Institut Français d'Archéologie d'Istanbul 17 (Paris, 1963)

Grabar, *Sculptures* II

 A. Grabar, *Sculptures byzantines du Moyen Âge,* II, *XIe–XIVe siècle,* Bibliothèque des Cahiers archéologiques 12 (Paris, 1976)

Harrison, *Saraçhane*

 R. M. Harrison et al., *Excavations at Saraçhane in Istanbul,* 1, *The Excavations, Structures, Architec-*

tural Decoration, Small Finds, Coins, Bones, and Molluscs (Princeton, 1986)

Hayes, *Saraçhane*
J. W. Hayes, *Excavations at Saraçhane in Istanbul, 2, The Pottery* (Princeton, 1992)

Janin, *Églises centres*
R. Janin, *Les églises et les monastères des grands centres byzantins* (Paris, 1975)

Jolivet-Lévy, *Les églises*
C. Jolivet-Lévy, *Les églises byzantines de Cappadoce: Le programme iconographique de l'abside et de ses abords* (Paris, 1991)

Lauffenburger and Williams, "Byzantine Tiles"
J. Lauffenburger and J. L. Williams, "Byzantine Tiles in the Walters Art Gallery and Dumbarton Oaks Collections: A Comparison of Technique," in *Materials Analysis of Byzantine Pottery,* ed. H. Maguire (Washington, D.C., 1997), 67–83

Macridy, "Monastery of Lips"
T. Macridy, "The Monastery of Lips and the Burials of the Palaeologi," *DOP* 18 (1964), 253–78

Mango, *Materials*
C. Mango, *Materials for the Study of the Mosaics of St. Sophia at Istanbul,* Dumbarton Oaks Studies 8 (Washington, D.C., 1962)

Mango, *Sources and Documents*
C. Mango, *The Art of the Byzantine Empire: 312–1453, Sources and Documents* (Englewood Cliffs, N.J., 1972)

Mango and Dagron, *Constantinople*
C. Mango and G. Dagron, eds., *Constantinople and Its Hinterland* (Papers from the Twenty-seventh Spring Symposium of Byzantine Studies, Oxford, April 1993), Society for the Promotion of Byzantine Studies 3 (Cambridge, 1995)

Mango and Hawkins, "Additional Finds"
C. Mango and E. J. W. Hawkins, "Additional Finds at Fenari Isa Camii, Istanbul," *DOP* 22 (1968), 177–84

Mango and Hawkins, "Additional Notes"
C. Mango and E. J. W. Hawkins, "Additional Notes," *DOP* 18 (1964), 299–315

Mason and Mango, "Glazed 'Tiles of Nicomedia'"
R. B. Mason and M. Mundell Mango, "Glazed 'Tiles of Nicomedia' in Bithynia, Constantinople, and Elsewhere," in *Constantinople and Its Hinterland* (Papers from the Twenty-seventh Spring Symposium of Byzantine Studies, Oxford, April 1993), Society for the Promotion of Byzantine Studies 3, ed. C. Mango and G. Dagron (Cambridge, 1995), 313–31

Mathews, *Byzantine Churches*
T. F. Mathews, *The Byzantine Churches of Istanbul: A Photographic Survey* (University Park, Pa., 1976)

Mathews, *Early Churches*
T. F. Mathews, *The Early Churches of Constantinople: Architecture and Liturgy* (University Park, Pa., 1971)

Megaw, "Byzantine Pottery"
A. H. S. Megaw, "Byzantine Pottery," in *World Ceramics,* ed. R. J. Charleston (New York, 1968), 100–106

Megaw and Jones, "Byzantine and Allied Pottery"
A. H. S. Megaw and R. E. Jones, "Byzantine and Allied Pottery: A Contribution by Chemical Analysis to Problems of Origin and Distribution," *BSA* 78 (1983), 236–63

Miatev, *Keramik*
K. Miatev, *Die Keramik von Preslav* (Sofia, 1936)

Morgan, *Byzantine Pottery*
C. Morgan, *Corinth,* XI, *The Byzantine Pottery* (Cambridge, Mass., 1942)

Müller-Wiener, *Bildlexikon*
W. Müller-Wiener, *Bildlexikon zur Topographie Istanbuls* (Tübingen, 1977)

Naumann and Belting, *Die Euphemia-Kirche*
R. Naumann and H. Belting, *Die Euphemia-Kirche am Hipppodrom zu Istanbul und ihre Fresken* (Berlin, 1966)

Oğan, "Les fouilles"
A. Oğan, "Les fouilles de Topkapi Saray," *Türk Tarih Kurumu Belleten* 4 (1940), 317–35

Omont, *Miniatures*

 H. Omont, *Miniatures des plus anciens manuscrits grecs de la Bibliothèque nationale du VIe au XIVe siècle*, 2d ed. (Paris, 1929)

Papanikola-Bakirtzi et al., *Benaki Museum*

 D. Papanikola-Bakirtzi, F. N. Mavrikiou, and C. Bakirtzis, *Byzantine Glazed Pottery in the Benaki Museum* (Athens, 1999)

Peschlow, "Byzantinische Keramik"

 U. Peschlow, "Byzantinische Keramik aus Istanbul: Ein Fundkomplex bei der Irenenkirche," *IstMitt* 27/28 (1977/1978), 363–414

Ross, *Catalogue* I

 M. Ross, *Catalogue of the Byzantine and Early Medieval Antiquities in the Dumbarton Oaks Collection*, I, Dumbarton Oaks Studies 1 (Washington, D.C., 1962)

Schmit, *Die Koimesis-Kirche*

 T. Schmit, *Die Koimesis-Kirche von Nikaia: Das Bauwerk und die Mosaiken* (Berlin and Leipzig, 1927)

Sgalitzer (Ettinghausen), "Baukeramik"

 E. Sgalitzer (Ettinghausen), "Die byzantinische Baukeramik" (unpublished *license* thesis, Istanbul University, 1941)

Splendeur de Byzance

 Splendeur de Byzance (Brussels, 1982)

Stern, *Cordoue*

 H. Stern, *Les mosaïques de la Grande Mosquée de Cordoue*, Madrider Forschungen 11 (Berlin, 1976)

Striker, *Myrelaion*

 C. L. Striker, *The Myrelaion (Bodrum Camii) in Istanbul* (Princeton, 1981)

Striker and Kuban, *Kalenderhane*

 C. L. Striker and Y. Doğan Kuban, *Kalenderhane in Istanbul: The Buildings* (Mainz, 1997)

Talbot Rice, "Byzantium and the Islamic World"

 D. Talbot Rice, "The Pottery of Byzantium and the Islamic World," in *Studies in Islamic Art and Archi-tecture in Honour of Professor K. A. C. Creswell* (Cairo, 1965), 194–236

Talbot Rice, *Glazed Pottery*

 D. Talbot Rice, *Byzantine Glazed Pottery* (Oxford, 1930)

Talbot Rice, "Polychrome Pottery"

 D. Talbot Rice, "Byzantine Polychrome Pottery: A Survey of Recent Discoveries," *CahArch* 7 (1954), 69–77

Totev, "L'atelier"

 T. Totev, "L'atelier de céramique peinte du monastère royal de Preslav," *CahArch* 35 (1987), 65–80

Totev, *Ceramic Icon*

 T. Totev, *The Ceramic Icon in Medieval Bulgaria* (Sofia, 1999)

Totev, *Preslavskata*

 T. Totev, *Preslavskata keramična ikona* (Sofia, 1988)

Treasury of San Marco

 The Treasury of San Marco, Venice, ed. D. Buckton (Milan, 1984)

Verdier, "Byzantine Tiles"

 P. Verdier, "Byzantine Tiles," *Bulletin of the Walters Art Gallery* 9.2 (November 1956), 1–2

Verdier, "Tiles of Nicomedia"

 P. Verdier, "Tiles of Nicomedia," in *Okeanos: Essays Presented to Ihor Ševčenko on His Sixtieth Birthday by His Colleagues and Students*, Harvard Ukrainian Studies, VII, ed. C. Mango and O. Pritsak (1983), 632–38

Vogt and Bouquillon, "Technologie"

 C. Vogt and A. Bouquillon, "Technologie des plaques murales décorés de Preslav et de Constantinople (IXe–XIe siècles)," *CahArch* 44 (1996), 105–16

Vogt, Bouquillon, et al., "Glazed Wall Tiles"

 C. Vogt, A. Bouquillon, M. Dubus, and G. Querré, "Glazed Wall Tiles of Constantinople: Physical and Chemical Characterization and Decorative Processes," in *Materials Analysis of Byzantine Pottery*, ed. H. Maguire (Washington, D.C., 1997), 51–65

Weitzmann, *Byzantinische Buchmalerei*
K. Weitzmann, *Die byzantinische Buchmalerei des 9. und 10. Jahrhunderts,* 2d ed. (Vienna, 1996)
Wharton Epstein, *Tokalı Kilise*
A. Wharton Epstein, *Tokalı Kilise:Tenth-Century Metropolitan Art in Byzantine Cappadocia* (Washington, D.C., 1986)
Zalesskaja, "Nouvelles découvertes"
V. N. Zalesskaja, "Nouvelles découvertes de céramique peinte byzantine du xe siècle," *CahArch* 32 (1984), 49–62

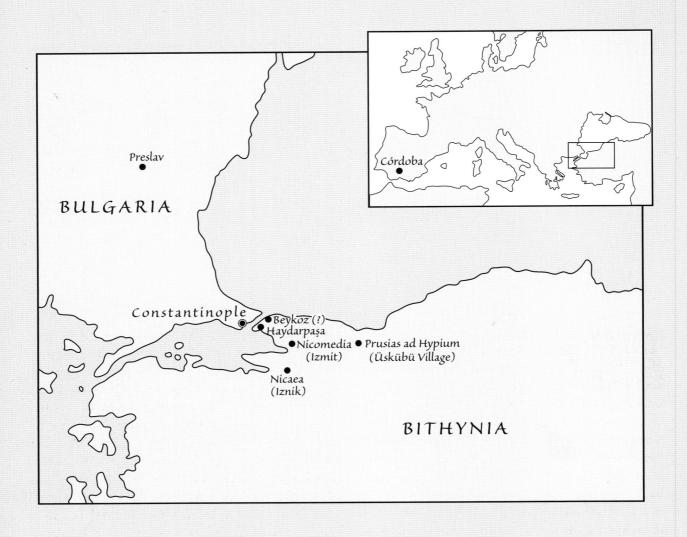

Introduction

SHARON E. J. GERSTEL

The discovery in 1907 of broken bits of ceramic revetment during investigations of the basilica of Saint John Stoudios introduced Byzantine polychrome tiles to the modern scholarly world. Nearly a century later, we can count more than fifteen churches and excavations within Constantinople's walls and across the Bosporus that have yielded related fragments. Not all of the tiles came to light in controlled excavations. Some circulated in the antiquities market; a high point in their trade corresponds to the years in which water pipes were laid in the old city. Small fragments from the areas of excavated sites also found their way into the shops of the bazaar and, from there, to private collections and museums. To these may be added substantial collections of ceramic tiles that were removed from the earth without benefit of proper excavation or attribution. We are left, then, with tiles and tile fragments of known provenance and those without context. This volume assembles, for the first time, all of the tiles that were excavated in the city and those that are attributed, through their decoration and ceramic fabric, to tile workshops in Constantinople and its surrounding region (see map).

The archaeological record for the tiles is difficult to read. Divorced from their architectural setting and badly smashed, the tiles are often found out of context. Few are the occasions in which we can securely state that tiles decorated the building in which they were found. Some excavated tiles may have formed part of dumped fill, perhaps soil that was carted around the city for purposes of construction. This phenomenon is suggested by the distribution of certain unusual patterns. For example, an identical peacock-feather type is found on a ceramic colonnette excavated in the Topkapı Sarayı Basilica and then again on small fragments revealed elsewhere in the same region of the city, at the Zeuxippos Baths and Saint Euphemia. In her essay, Marlia Mundell Mango uses excavation reports from the city to study some of Constantinople's best-known monuments in order to discuss issues of chronology and function.

As a decorative medium, polychrome tiles have been largely ignored in writings on Byzantine architecture and its adornment. Why these ceramic artifacts never received the thorough treatment accorded other media is a question worth posing. One answer may lie in their hybrid status. Although they were produced in ceramic workshops, they were never intended to grace the tables of the Byzantine palace or household. Consequently, the tiles never found a secure place within broader ceramic studies or typologies. At the same time, polychrome tiles have not been fully treated as part of the ornamental fabric of build-

ings. As borders separating marble revetment and mosaic, as accents used on church furnishings, or as framing devices, the tiles have had no role within larger discussions of decorative systems. Few of the figural tiles from Constantinople have been published. Yet, considering the paucity of surviving cycles of monumental decoration in the capital from around the year 1000, polychrome icons constitute some of the best surviving examples of metropolitan painting of the period—an accident of survival that elevates their status far beyond their position as curious ceramic artifacts. The third essay in this volume introduces all of the known polychrome icons from Constantinople and explores their subject matter and function.

Discussions about polychrome tiles have often focused on establishing the location of the workshops in which they were manufactured.[1] While tile-producing workshops have been discovered at Bulgarian sites such as Patleina,[2] Tuzlalâka,[3] and Preslav,[4] Constantinople has not yet revealed the location of its tile industry, which may, indeed, lie across the Bosporus. In their essay, Julie Lauffenburger, Christine Vogt, and Anne Bouquillon assemble scientific data in order to discuss production sequences and assess workshop characteristics.

The efflorescence of polychrome tiles in the capital begins with a small chamber in the Boukoleon Palace, which, in all likelihood, dates to the mid-ninth century, following the end of Iconoclasm. By the middle or end of the twelfth century, polychrome tiles had already fallen out of use. Their entrance into the ornamental life of the Byzantine building is easy to trace. Their proliferation marks a period of increased construction within the city; tiles adorned the richly appointed buildings erected by imperial figures and high court officials. Cyril Mango introduces the patrons associated with this building surge and discusses their motivations for endowing new constructions. In their design, both ornamental and figural tiles demonstrate affinities with other luxury works favored by the court. The sharing of design qualities across media and the aesthetic of rich color are characteristic of art created in the centuries governed by members of the Macedonian dynasty. In his essay, Jeffrey C. Ander-

son uses manuscripts to gain entrance into the world of the patron who could commission both architectural ornamentation and book illumination in the latest fashion. For these patrons, as has been proposed elsewhere for the Macedonian dynasty, much of the "new" ornamental vocabulary was borrowed from large-scale, pre-Iconoclastic buildings. Anderson's introduction to ornament creates a typology of design for the tiles and demonstrates that much of their decoration comprises the two-dimensional rendering of the lush, deeply carved patterns from Theodosian and Justinianic structures. It is more difficult to explain why polychrome tiles ceased to be employed as a decorative medium within Byzantine buildings. The essays in this volume offer several explanations, including the fragility of the medium and changes in taste. It cannot be coincidental that the greatest use of the tiles in documented monuments is roughly coterminus with the reign of the Macedonian rulers. In the decades following the fall of that dynasty, art changed, as the culture shifted from the aesthetics of the "new men" to that of the land-owning aristocracy.

For a number of reasons, the fragmentary and dispersed Constantinopolitan tiles have not been well published[5]—tiles from such important monuments as the Boukoleon Palace, the Myrelaion, the Hospital of Sampson, and the Kyriotissa church are fully presented for the first time in this volume. On the contrary, there has been a long tradition of publishing the Bulgarian material, long considered to predate the Byzantine works.[6] The tiles from Bulgaria, found in systematic excavations, are associated with both ecclesiastical structures and palaces and are distinct, in terms of fabric, from those made in Constantinople. The full publication of the Constantinopolitan tiles provides the opportunity for a more thorough understanding of the relationship between the tiles produced in both centers.

The very use of ceramic plaques as a decorative medium has led scholars to connect tiles produced in Bulgaria and Byzantium with works in the Islamic and pre-Islamic East, an area where glazed ceramics had been used as wall decoration from ancient times. Early works by

Strzygowski,[7] Filov,[8] Grabar,[9] and Talbot Rice[10] attributed the introduction of tiles into Bulgaria to Armenian and Mesopotamian artisans and sought to connect Preslav directly with the East through diplomatic missions. More recently, Mavrodinov and Vaklinov have seen the direct influence of Eastern artisans and traditions in Bulgarian ornamental patterns.[11] Constantinopolitan tiles, too, have often been associated with Mesopotamian and Islamic tiles. Although certain patterns have been seen as "orientalizing,"[12] it is difficult to pinpoint the moment of their appearance in the Byzantine ornamental vocabulary. For Miatev, for example, such patterns arrived at an early date from interaction with the Persian empire.[13] Nevertheless, the tiles have often been included in studies of East-West interaction. A discussion of a motif shared by Byzantium and the Muslim East is at the heart of the essay by William Tronzo. Anthony Cutler uses ornamental patterns on the tiles to discuss motifs shared by Byzantium and Fāṭimid Egypt.

This publication accompanies the reinstallation of the medieval collection in the Walters Art Museum and the exhibition, for the first time, of a substantial number of the collection's polychrome tiles. Initially conceived as the primary publication of the Walters material, it became apparent that the collection could only be understood when examined with other polychrome tiles of Byzantium. It is our great hope that this volume will stimulate research on this colorful and precious material and that the essays will provide new insights and directions for future study.

Notes

1. Vogt, Bouquillon, et al., "Glazed Wall Tiles," 51–65; Lauffenburger and Williams, "Byzantine Tiles," 67–83; Mason and Mango, "Glazed 'Tiles of Nicomedia,'" 313–31; Megaw and Jones, "Byzantine and Allied Pottery," 236–63.

2. J. Gospodinov, "Razkopki v Patleina," *Izvestija na Arheologičeskija institut* 4 (1914), 113–28; idem, "Keramična rabotilnitza v Patleina" (A ceramic studio in Patleina), *Izvestija na Bâlgarskoto Istoričesko druzhestvo* 14/15 (1937), 201–5; I. Akrabova-Zhandova, "Novo v Patleina sled Jordan Gospodinov," *Preslav-Sbornik* I (1968), 69–78.

3. T. Totev, "Manastirât v 'Tuzlalâka'—centâr na risuvana keramika v Preslav prez IX–X v." (The monastery of Tuzlalâka: A center of painted ceramics at Preslav in the ninth–tenth century), *Fouilles et Recherches* 7 (1982), 45–74.

4. I. Akrabova-Zhandova, "Rabotilnitza za risuvana keramika na jug ot Krâglata tzârkva" (A workshop for painted ceramics south of the Round church), *Izvestija na Arheologičeskija institut* 20 (1955), 487–510; J. Čangova, "Novi nakhodki ot Preslavska risuvana keramika," *Izvestija na Arheologičeskija institut* 33 (1972), 275–89; Totev, "L'atelier," 65–80. For a thorough analysis of the history of the Bulgarian excavations and the discovery of specific kiln sites and workshops, see Totev, *Ceramic Icon,* 46–60, with collected bibliography. For differences between tiles from Preslav and Constantinople, see Vogt and Bouquillon, "Technologie," 105–16.

5. Exceptions remain. Some of the tiles from the Topkapı Sarayı Basilica and Saint John Stoudios were published in Ettinghausen, "Byzantine Tiles." The tiles from the Lips monastery were published in *Dumbarton Oaks Papers.* Recently, J. Durand, C. Vogt, and A. Bouquillon have devoted a series of articles to the tiles from the Musée du Louvre and the Musée national de Céramique, Sèvres. See Durand and Vogt, "Plaques," 38–44; Durand, "Plaques," 25–50; Vogt, Bouquillon, et al., "Glazed Wall Tiles," 51–65. Polychrome tiles in the Benaki Museum were included in a catalogue of the Byzantine ceramics in that collection. See Papanikola-Bakirtzi et al., *Benaki Museum.*

6. The earliest Bulgarian tiles have been dated to the end of the ninth century. For an excellent review of the Bulgarian literature and the history of scholarship on those tiles, see Totev, *Ceramic Icons.*

7. J. Strzygowki, *Die Baukunst des Armenien und Europa* II (Vienna, 1918), 569.

8. B. Filov, *Starobâlgarskoto izkustvo* (Sofia, 1924), 15–16.

9. Grabar, *Recherches,* 7–55.

10. Talbot Rice, *Glazed Pottery,* 82ff.

11. N. Mavrodinov, *Starobâlgarskoto izkustvo* (Sofia, 1959), 252ff; S. Vaklinov, *Formirane na starobâlgarskata kultura, VI–XI v.* (Sofia, 1977).

12. Grabar, *Sculptures* I, 119; Talbot Rice, "Byzantium and the Islamic World," 194–236; A. Grabar, "Le succès des arts orientaux à la cour byzantine sous les Macédoniens," *Münchner Jahrbuch der bildenden Kunst* 3 (1951), 56–60.

13. Miatev, *Keramik.*

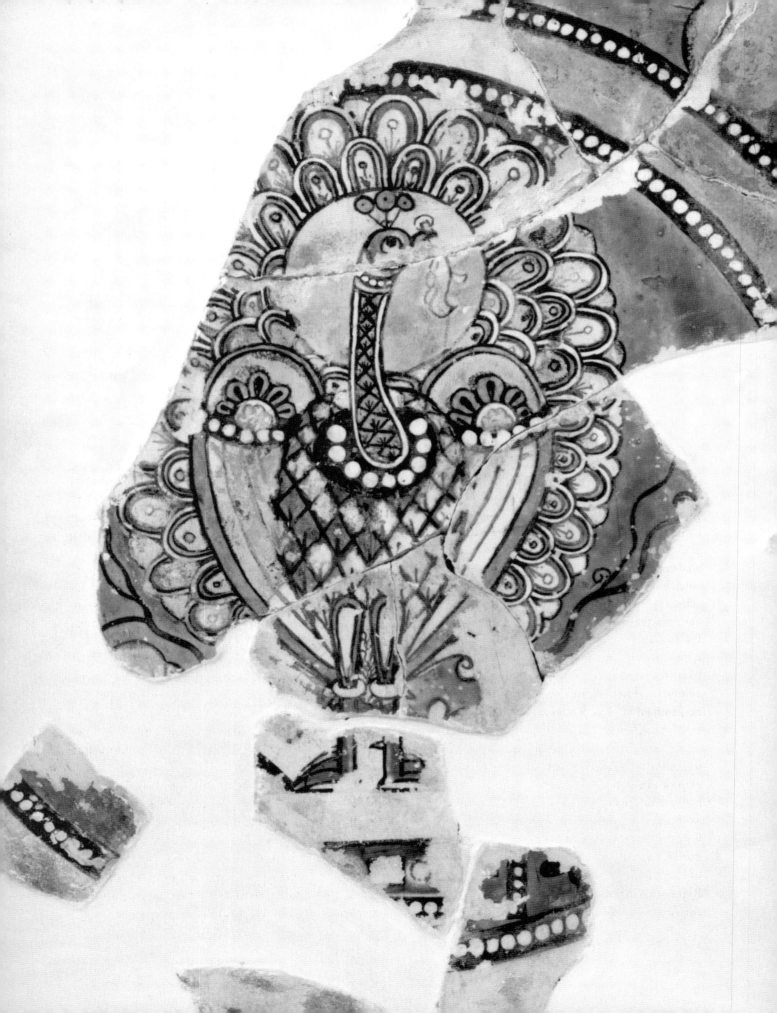

Ninth- to Eleventh-Century Constantinople: The Cultural Context

CYRIL MANGO

The Byzantine Empire did not continuously decline over the centuries: it also experienced revivals and long periods of prosperity. What was true of the empire as a whole was mirrored and magnified at Constantinople, a capital city that enjoyed disproportionate prestige and wealth as compared to the provinces it governed. Constantinople was the permanent seat of the imperial court and central administration; it absorbed the greater part of the empire's cash revenues; it dispensed all important appointments, promotions, and honors. It was also (at least from the ninth century onward) the main center of cultivation, learning, literary activity, and high-level artistic production. The period in which the Byzantine tiles studied here were made (ca. 850–1100) was one of revival.

The seventh and eighth centuries had been a time of unprecedented disasters, which permanently changed the map of the eastern Mediterranean basin. Continuously battered by the Persians, Muslims, Avars, Bulgarians, and assorted Slavs, the empire shrank to less than half of its former extent: indeed, it came close to collapsing altogether, and on two occasions serious thought was given to moving the imperial residence to either Carthage or Rome. Constantinople was now in the front line. It was attacked by the Persians and Avars in 626, blockaded by an Arab fleet from 674 to 678, besieged again by the Arabs for a full year (717–18). Two further sieges, in 742–43 and 821–22, were caused by civil wars. Nor were the calamities confined to military action. The bubonic plague, more or less endemic since 542, had its last major outbreak in 747–48, as a result of which, we are told, the city became practically deserted and settlers had to be brought in from continental Greece and the Aegean islands. A number of earthquakes, the most serious in 740, added to what reads like a catalogue of unrelieved misfortunes.

Obviously, conditions at Constantinople must have been dire, and it is hard to imagine that it could have supported a population in the range of 500,000–800,000, as one historian maintained not long ago.[1] One tenth of that figure may be nearer to the truth for the mid–eighth century. The area within the walls, never fully occupied by houses, now had a great deal of empty space given over to vegetable gardens and cemeteries. Intramural burial, still banned in the sixth century, now became normal. We are incidentally informed in the *Life* of Saint Stephen the Younger that a miraculous hailstorm in 765 damaged the "grassy fields" inside the city.[2] The water supply, partially cut off in 626, was reestablished only in 766–67, with the help of a labor force that was recruited from the provinces, since one was not available locally.

As might have been expected, almost no building occurred at Constantinople in the seventh and eighth centuries except for fortification and repair of earthquake damage. Among earlier structures, the Imperial Palace, the Hippodrome, the main colonnaded streets, and the squares, with their pompous monuments, were still there, if somewhat the worse for wear. Also still in existence were over a hundred churches, including the biggest among them—Saint Sophia, Saint Eirene (both repaired after the earthquake of 740), the Holy Apostles, and Our Lady of Blachernai. By contrast, most public buildings other than churches had gone out of use and either stood as ruins or were converted to other purposes, including the great public baths (which included the Zeuxippos Baths; see cat. XIII), the theaters, the two senate houses, and the Basilica, with its law courts and shops. In addition, the once flourishing suburbs had been systematically devastated.

Then there was Iconoclasm, whose impact has been greatly exaggerated both by medieval polemicists and modern scholars. Promoted by emperors between 730 and 780 and between 815 and 842, it met with remarkably little resistance, partly, no doubt, because Leo III and Constantine V were extremely successful and popular emperors. The official church expressed no opposition: at the Iconoclastic Council of Hiereia (754), 338 bishops, that is, the entire episcopate of the empire, signed on the dotted line. Between 730 and 780, even monks proved more compliant than has been supposed. During the second period of Iconoclasm (815–42) resistance was somewhat livelier, more on the part of the monks than bishops. Still, Iconoclasm had certain effects that interest us here. In the most immediate sense, it led to the destruction of much religious art in the churches of the capital. After 843, the images that had been obliterated were remade in mosaic or paint. So extensive an agenda must have been spread over several decades and certainly encouraged the formation of workshops and, in the case of mosaics, the mass manufacture of tesserae. In Saint Sophia, we still admire the mosaics that were put up after Iconoclasm, those in the apse and bema, the tympana, and the patriar-

chal *sekreton* above the southwest ramp. Their execution appears to have taken place between 867 and the 880s.

Iconoclasm also had certain indirect and imponderable effects. The official church came out of the struggle with a tarnished reputation, no matter how hard it later tried to build up the brave stance of its "champions." Monasticism, on the other hand, was strengthened and assumed the role of guardian of orthodoxy. At the Council of Nicaea (787), monastic leaders were for the first time admitted as full members of the church's governing body. The propaganda machine of the patriarchate and the palace went to work to demonstrate that the suppression of Iconoclasm, that "alien" heresy, ushered in a glorious rejuvenation of both church and state, the attainment of an ultimate perfection. Henceforth, everything was to be new and wrinkle free.

In fact, conditions began to get better after about 780, and the fact that the political and military position of the empire had been consolidated by iconoclastic emperors could be conveniently forgotten. Nor was revival limited to Byzantium; a similar movement with nearly the same manifestations and the same propaganda was taking place in the Carolingian West, not to mention the notable cultural activity at the 'Abbāsid court of Baghdad under Caliph Hārūn al-Rashīd (786–809) and al-Ma'mūn (813–33). It can hardly be a matter of chance that these developments occurred at the same time, but that is another story.

The Byzantine cultural revival can be studied in two domains, that of letters and that of arts and architecture, of which the former is better documented than the latter, the written word having proved more durable than stone or paint. We are not surprised to hear that at Constantinople the educational system, as it had existed from late antiquity, broke down at the beginning of the eighth century. Indeed, practically nothing of note was written there for the next sixty or seventy years. If some tradition of education was maintained in the capital, it was in the context of the civil service rather than the church. Contrary to what we might have expected, the main center of Greek culture, represented most notably by Saint John of Dam-

ascus (d. ca. 753/54), shifted to Arab-occupied Syria and Palestine, where it was gradually extinguished in the next century.

The reestablishment of culture at Constantinople meant in effect a backtracking to the status before the Dark Age, that is, to late antiquity, whose educational ideal had been that of eloquence. Whatever we may think of the literary expression of late antiquity, it was founded on certain realities: the existence of a leisured class in a great number of cities, an education apparatus that served that class, and the provision of aids to learning, that is, books. The coming of Christianity did little to alter that picture; indeed, church leaders, being themselves members of the same class and products of that system, had no urge to abolish it. The late Roman government, too, although it was under some pressure to encourage technical skills (notably knowledge of the law and notarial procedures), rewarded traditional culture as an avenue to the civil service. By the year 800, when a few "intellectuals" at Constantinople started picking up the pieces again, the social realities had completely changed: there was no leisured class or functioning system of education, provincial cities had collapsed, books were no longer available, and bishops could barely recite the Psalter. Yet an effort was made. "Correct," that is, ancient, Greek started to be taught, books were collected and copied, and a palace school was established by the middle of the ninth century. Literary composition in prose and verse increased again. Even hagiography, traditionally expressed in simple language, assumed a learned, rhetorical form. Naturally, it was a slow process that was spread over two centuries and more, and it inevitably created a mandarin culture with a very small social base centered on Constantinople. The gains achieved at the time were, however, permanent. Byzantium never slid back into another dark age.

The domain of art has received more scholarly attention than that of letters, although its significance was considerably smaller. In particular, something called rather grandly the "Macedonian Renaissance" (after the dynasty founded in 867 by Basil "the Macedonian") has been endlessly debated; but when we look for its manifestations,

we find that they are limited to about a dozen illuminated manuscripts and a group of carved ivories. With one exception, Nikander's *Theriaka* (Paris Suppl. gr. 247), the manuscripts in question are all of Christian content. The only one that can be dated with any accuracy, the Homilies of Gregory of Nazianzos in Paris (gr. 510) of ca. 880, is certainly imperial, whether it was presented to Basil I, as recently argued,[3] or presented by him. The famous Paris Psalter (gr. 139) of the second half of the tenth century is also considered imperial, probably correctly. Two others can be connected with the court, namely, the Leo Bible (Vat. Reg. gr. 1), given by one Leo Sakellarios (finance minister) to a monastery founded by his brother, and the Bible of Niketas (now divided among Turin, Florence, and Copenhagen), commissioned by an imperial chamberlain of that name. What may be deduced from these beautiful manuscripts is that they were copied from or inspired by late antique models, which were themselves illuminated manuscripts of about the sixth century. That is entirely in line with what we see in the realm of letters.

Similar observations may be made about ivory carving, which seems to date mostly from the late ninth and tenth centuries. Once again, the more classical figure style is reserved for Christian representations, especially of single, standing saints, while the series of caskets with mythological scenes are less elegant in execution. Patronage can be determined only in a few cases. Some of the ivories are certainly imperial, like the Romanos and Eudokia plaque in Paris or the triptych of Constantine (presumably Porphyrogennitos) in the Palazzo Venezia, Rome; one, rather an ugly casket also in the Palazzo Venezia, was dedicated to an emperor and empress (Basil I and Eudokia ?) by an unnamed official and his wife; a reliquary plaque, now at Cortona, was offered by a patriarchal sacristan (*skeuophylax*) to the monastery that had "nurtured him."

In other minor arts of the period there is little classical influence. In metalwork, one can cite only a silver-gilt inkpot (now in the Cathedral Treasury, Padua) decorated with distinctly inelegant mythological figures, while the much more sumptuous objects associated with Basil the

Parakoimomenos (the Limburg reliquary and a chalice and paten in Saint Mark's, Venice) show no classical influence. In glassware, a single painted bowl, also in Saint Mark's, bears some barely recognizable mythological figures, but also an ornamental band in pseudo-kufic script.

However beautiful or curious the above objects may be, they had no public exposure. An illuminated manuscript or small ivory plaque, an inkpot or a fragile glass bowl, were meant to be appreciated by a chosen few. One looks in vain for a statement of the empire's late antique roots that might have been addressed to the people at large. Coinage would have provided an obvious medium for so doing. We may remember that Charlemagne placed on his denarii his laurel-wreathed profile head in Roman style. Byzantine emperors did nothing of the kind. Nor did they think of reviving statuary in the round, although Constantinople boasted dozens of imperial statues of an earlier period whose triumphal message was not forgotten.

Preoccupation with the "Macedonian Renaissance" has deflected attention from a question that can tell us more about artistic activity at Constantinople, namely, what a high-class building of the period would have looked like. From about 780 onward, construction was resumed on a significant scale, and we can compile from narrative sources a list of new buildings. One scholar has recently calculated the number of new religious foundations erected between 750 and 1204 as about a hundred,[4] which is certainly a substantial number, although I am not sure what counts here as a foundation. We are fortunate, in any case, in possessing more or less official lists, sometimes accompanied by descriptions of buildings, financed by Theophilos (829–42), Basil I (867–86), and Constantine VII (913–59), and these can be supplemented by other sources to produce a fairly comprehensive picture.

What the texts do not tell us is the size of the buildings in question, and here we must turn to material remains at Constantinople. Unfortunately, they are neither numerous nor well preserved. The following list may not be exhaustive: a small bit of inlaid pavement of a room in the heart of the Boukoleon area of the Great Palace (cat. I.B);[5] the adjoining ruin traditionally called the House of Justinian;

the shells of two monastic churches, that of Constantine Lips (Fenari İsa Camii; cat. VI) and that of the Myrelaion (Bodrum Camii, cat. VII); the main church of Kariye Camii, assuming it dates from ca. 1070–80; probably the unidentified churches known by their Turkish names Atik Mustafa Paşa Camii (cat. VIA) and Kilise Camii (main church); the skeleton of the outer Golden Gate,[6] if I am right in attributing it to this period; the maze of substructures belonging to the monastery of Saint George of the Mangana (cat. IX);[7] the undercroft of the church of All Saints[8] and that of a church (perhaps not the main church) belonging to the monastery of Saint Mary Peribleptos.[9] I have not mentioned here the Kyriotissa church (Kalenderhane Camii; cat. V), which used to be dated on typological grounds to ca. 850 but has now been shifted in its main phase to ca. 1200, or Eski İmaret Camii, which may well be of the late eleventh century but should not, in my opinion, be identified with the monastery of Christ Pantepoptes.[10]

If we extend our search to the suburbs of Istanbul, we do not find much more. There is the symmetrically planned substructure at Küçükyalı near Maltepe, which I believe has been correctly identified as the palace of Bryas, erected by the emperor Theophilos (ca. 837), although some scholars have thought otherwise.[11] And there was—for it is no more—the pavement and some fragments of sculpture from the monastic church of Galakrenai, a foundation of the patriarch Nicholas I Mystikos (901–7, 912–25), discovered at modern Erenköy in 1943 and destroyed soon thereafter.[12]

Meager as these remains are, they tell us something about the size of the church buildings. The biggest, Saint George of the Mangana, had a nave measuring 21.50 m square; yet the contemporary account by Michael Psellos[13] gives the impression that it was scarcely smaller than Saint Sophia, while Skylitzes[14] insinuates that its construction— admittedly plans were changed several times—nearly bankrupted the imperial treasury and necessitated the imposition of new taxes. Next in size, the church of All Saints (exceptionally, not attached to a monastery), had a nave measuring 18 × 17 m; that of Constantine Lips, 13 × 10 m; that of the Myrelaion, 11 × 10 m; Atik Mustafa

Paşa Camii, 13 × 12.50 m; Kariye Camii and the Peribleptos undercroft, 10 × 10 m; Kilise Camii, 9 × 9 m. English village churches are usually larger than that.

The buildings of the period in which the polychrome wall tiles were found (none of them *in situ*) include the monastery churches of Constantine Lips, the Myrelaion, the Mangana, and John Stoudios; the public churches of the Kyriotissa, Saint Polyeuktos, the shrine of Saint Euphemia, and, possibly, the Topkapı Sarayı Basilica; the Hospital of Sampson; and the Great Palace. Tiles have also been found, out of context in the Zeuxippos Baths and on the sites of the Istanbul Archaeological Museum and the Istanbul Law Court.

The patrons of some of these buildings can be identified. Constantine Lips is known. Perhaps of Armenian descent, he conducted three diplomatic missions to Armenia and married his daughter to one Abu Ghanim, brother of the prince of Taron (west of Lake Van). He attained the rank of patrician and was captain of the Great Company (the emperor's personal bodyguard) and trusted advisor of the commander in chief of the army, Leo Phokas. He was killed fighting the Bulgarians in 917. Nothing indicates that he was a cultivated person, but he was important enough to have invited the emperor to the dedication of "his" monastery.

The Hospital of Sampson (cat. II) was refurbished in the 970s by Leo, patrician and *droungarios* of the fleet, who assumed "protection" of the establishment. This involved conversion into a church or chapel of a part of the building that was considered to have been Sampson's private house, dating back to the time before the hospital had been built.

Other relevant patrons were imperial: building in the Great Palace (cat. I.A, I.B) was carried out between 829 and 886 by Theophilos, Michael III, and Basil I. Romanos I built the Myrelaion church (cat. VII) in 920–23; Constantine IX (1042–55) built the Mangana church (cat. IX); and Isaak I Komnenos undertook the restoration of the Stoudios church (cat. X) in ca. 1057–59.

When we turn from standing monuments to texts, we can formulate a number of general observations:

1. Basil I conducted an extensive one-off campaign to restore parochial, that is, public, churches at Constantinople and its suburbs, which had either fallen into ruin or had been neglected during the Dark Age. We are given a list of about thirty such churches, including some of the biggest (Saint Sophia, the Holy Apostles, Our Lady of Chalkoprateia, the Constantinian basilica of Saint Mokios, Saint Akakios, etc.). This campaign clearly represented a major effort and expressed the slogan of "renovation." With one possible exception, no new parochial churches were built, the existing ones being doubtless deemed sufficient. Among the churches with polychrome tiles, those of the Kyriotissa and Saint Polyeuktos and the Topkapı Sarayı Basilica may have been public churches in this period, as was the shrine of Saint Euphemia.

2. Considerable attention was given to the setting up or restoration of charitable institutions (hospitals, hospices for strangers, the aged, the poor, orphans, etc.) that were now administered not by the church, as in earlier times, but by the state. Establishments of this kind are ascribed to the empress Irene, to Theophilos, Basil I, Leo VI, Romanos I, Constantine VII, Michael IV, and Constantine IX in this period. The Hospital of Sampson was refounded in the tenth century, when it may have received its tile decoration.

3. Prestige building in the Great Palace (notably under Theophilos, Michael III, and Basil I) is documented in great detail. The descriptions we have of some twenty new halls or pavilions and a dozen new chapels evoke a picture of fairly small structures decorated with the utmost sumptuousness. As the patriarch Photios put it with regard to one of the chapels in question (that of Our Lady of the Pharos), so many forms of beauty had been crammed in that the mind was unable to concentrate on any one of them.[15] All the different kinds of colored marble that are carefully enumerated were certainly lifted from earlier buildings (since they were no longer quarried), and many other items were clearly spolia, such as porphyry basins, bronze doors, and lions, columns carved with inhabited scrolls, etc. Theophilos used a whole coffered ceiling from the palace of the usurper Basiliskos (475–76). In regard to architectural planning, the

Triconch and Sigma of Theophilos went back to a late antique model. The biggest building added to the palace in this period was the five-domed New Church of Basil I (880). The room in the Boukoleon decorated with *opus sectile* work and polychrome tiles (cat. I.B) undoubtedly dates to this general period.

Apart from the Great Palace, other palaces were built either in the city for members of the imperial family (the daughters of Theophilos, the young Romanos II by his father) or in the suburbs. Among the latter, the palace of Bryas, already mentioned, is of particular interest. The story goes that the Byzantine ambassador to Baghdad, John the Synkellos (later patriarch, 837–43), was so impressed by the splendor of the Muslim capital that on his return he persuaded Theophilos to build the Palace of Bryas on the Arab model "both in form and decoration,"[16] which may have extended to decorative tiles. The extant substructure at Küçükyalı does indeed conform to an Arab palace plan, but as yet we know nothing of its decoration.

The Botaneiates complex, known from written documents of 1192 and 1203, represented aristocratic housing of the Middle Byzantine period (cat. XIV). This complex contained two churches, one of which is described as being of cross-in-square, four-column plan and having tile decoration. The date of the complex is a matter of guesswork. The Botaneiates family rose to prominence in the late tenth to eleventh centuries, but it may have purchased earlier buildings. The presence of two churches within the complex strikes me as unusual.

4. The most important aspect of architectural activity, which continued until the fourteenth century and completely transformed the face of Constantinople, was the building of "private" monasteries, of which those of Constantine Lips, the Myrelaion, and Saint George of the Mangana are typical examples (cat. VI, VII, IX). This peculiarly Byzantine practice, traceable to the period before Iconoclasm, calls for a few words of explanation. Byzantine piety and the enormous prestige enjoyed by the monastic ideal are not in question, but there was no shortage of existing monasteries both in the city and in the countryside (surely more suitable for a life of contempla-

tion), and nothing prevented a devout nobleman from joining such a community and contributing to its endowment. What inspired the likes of Constantine Lips, an active imperial official, to found monasteries of their own?

A desire for personal fame cannot be ruled out. We may cite the example of Alexios Musele, an Armenian prince married to the daughter of the emperor Theophilos when the latter had as yet no son. Alexios's hope of succeeding to the throne was dashed when a son was born to Theophilos (840); Alexios then chose to become a monk. He was offered the monastery of Chrysopolis (Üsküdar), which was imperial property, but insisted on founding one of his own because "each monastery makes immortal the name of its builder."[17] And so he did. He was eventually buried in it, as was his brother.

In addition to immortality, there were more mundane reasons. A private monastery could be declared independent of either episcopal or imperial oversight and placed under the control of the founder's heirs. Its landed endowment was in principle inalienable and, if well managed, produced a profit. Members of the founder's family were given not only a privileged place of burial and perpetual prayers for their salvation but powers of patronage over the appointment of personnel. These were important considerations in a world governed by insecurity. The higher a man climbed on the hierarchical ladder, the more likely he was to fall off it.

We can also now see why the monastic churches listed above were so small. Even if a community numbered some fifty monks or nuns (an unusually high number), they could easily be accommodated in a structure the size of the church built by Constantine Lips. The church, of course, did not stand alone. There were living quarters, a refectory, a fountain, and a garden or orchard. The whole complex was enclosed by a wall. The public was not admitted, but sometimes there was an attached hospice. The multiplication of such enclaves over the quieter parts of Constantinople, even in the vicinity of the Great Palace, radically changed the aspect of the city.

Ultimately, of course, building depends on money. A persistent myth going back to the romanticized accounts

left by the Crusaders in 1204 portrays Byzantium as fabulously wealthy and Constantinople as a veritable heap of gold, silver, and precious stones. A recent inquiry into Byzantine state finances estimates, however, that the annual cash budget in the ninth century was barely one seventh of that of the caliphate.[18] Profit from trade was negligible. Cash, collected mainly from the land tax, flowed into the imperial coffers, and most of it was spent on the army, but some was diverted along the way into the pockets of officials. The emperor had a moderate surplus, which he could choose to save or spend on buildings of modest size. Surprisingly, the church, that is, the patriarchate, was chronically poor and could not even afford in the middle of the eleventh century to celebrate daily mass in Saint Sophia.[19] A few patriarchs, like Nicholas I and Alexios Stoudites (1025–43), a notorious crook, set up their own monasteries, probably using private or diverted funds, but episcopal patronage was minimal. The maintenance and repair of churches fell to the emperor.

Imagination is required to visualize the complete effect produced by a high-class Byzantine building—be it a church or palace hall—of the ninth to eleventh centuries. None has survived with all its decoration and furnishings intact. Perhaps the nearest approximation is offered by the monastery of Hosios Loukas in Greece, which, unusually, was a newly established pilgrimage center—an expensive and relatively big structure, if not quite up to metropolitan standards. We have, of course, dozens of humbler churches that attempt to imitate in paint the impression produced by mosaic, marble revetment, inlay, and, perhaps, polychrome tiles. When we view them, we have to effect a mental transposition.

If I am right in suggesting that the artistic ideal of medieval Byzantium was one of over-elaboration, of a piling-up of expensive materials and techniques in a small space, we may have to revise a little our judgment of monumental decoration of that period, in particular with reference to what is loosely termed "classicism." It is true that Byzantine artists retained or relearned the ability to represent draped figures in a conventionally correct man-

ner. It may also be true that, as famously argued by Otto Demus, they consciously avoided naturalistic background settings so as to create the illusion of "the icon in space." Even so, it seems to me that draped figures in the antique tradition have to "breathe," and that they become, so to speak, asphyxiated when they are scaled down and drowned in gold and ornament. That is a phenomenon that we can also observe in illuminated manuscripts from the late tenth century onward. Beauty becomes synonymous with ornateness.

Notes

1. R. J. H. Jenkins in *The Cambridge Medieval History,* ed. J. M. Hussey, IV/2 (Cambridge, 1967), 79.
2. *La vie d'Étienne le Jeune par Étienne le Diacre,* ed. M.-F. Auzépy (Aldershot, 1997), 172, § 73.
3. L. Brubaker, *Vision and Meaning in Ninth-Century Byzantium: Image as Exegesis in the Homilies of Gregory of Nazianzus* (Cambridge, 1999).
4. P. Magdalino, *Constantinople médiévale* (Paris, 1996), 60.
5. Asgari, "İstanbul," 45–46, figs. 12–19. A more detailed publication of this important discovery would be desirable.
6. As I argue in "The Triumphal Way of Constantinople and the Golden Gate," *DOP* 54 (2000), 173–88.
7. R. Demangel and E. Mamboury, *Le quartier des Manganes et la Première Région de Constantinople* (Paris, 1939), 23ff.
8. W. Müller-Wiener, "Zur Lage der Allerheiligenkirche in Konstantinopel," in *Lebendige Altertumswissenschaft,* Festschrift H. Vetters (Vienna, 1985), 333–35.
9. F. Özgümüş, "Peribleptos manastırı (Sulu manastır)," *Sanat Tarihi Araştırmaları Dergisi* 14 (1997–98), 21–32.
10. As I have argued in my article "Where at Constantinople Was the Monastery of Christos Pantepoptes?" *DChAE* 20 (1998), 87–88.
11. For my reasons, see "Notes d'épigraphie et d'archéologie: Constantinople, Nicée," *TM* 12 (1994), 347–50. For the date, see W. T. Treadgold, "The Chronological Accuracy of the *Chronicle* of Symeon the Logothete," *DOP* 33 (1979), 172, 178.
12. K. Bittel and A. M. Schneider, "Fund- und Forschungsbericht Türkei," *AA* 59–60 (1944–45, publ. 1949), 78–79; I. Ševčenko, "An Early Tenth-Century Inscription from Galakrenai," *DOP* 41 (1987), 461–68.
13. *Chronographia,* ed. É. Renauld, II (Paris, 1928), 61ff.
14. *Ioannis Scylitzae Synopsis Historiarum,* ed. I. Thurn (Corpus Fontium Historiae Byzantinae 5, Series Berolinensis, 1973), 476.
15. *The Homilies of Photius Patriarch of Constantinople,* trans. C. Mango (Cambridge, Mass., 1958), 187.
16. *Theophanes Continuatus,* ed. I. Bekker (Bonn, 1838), 98–99.
17. Ibid., 109.
18. See W. T. Treadgold, *The Byzantine State Finances in the Eighth and Ninth Centuries* (New York, 1982).
19. *Ioannis Scylitzae Synopsis Historiarum,* 477.

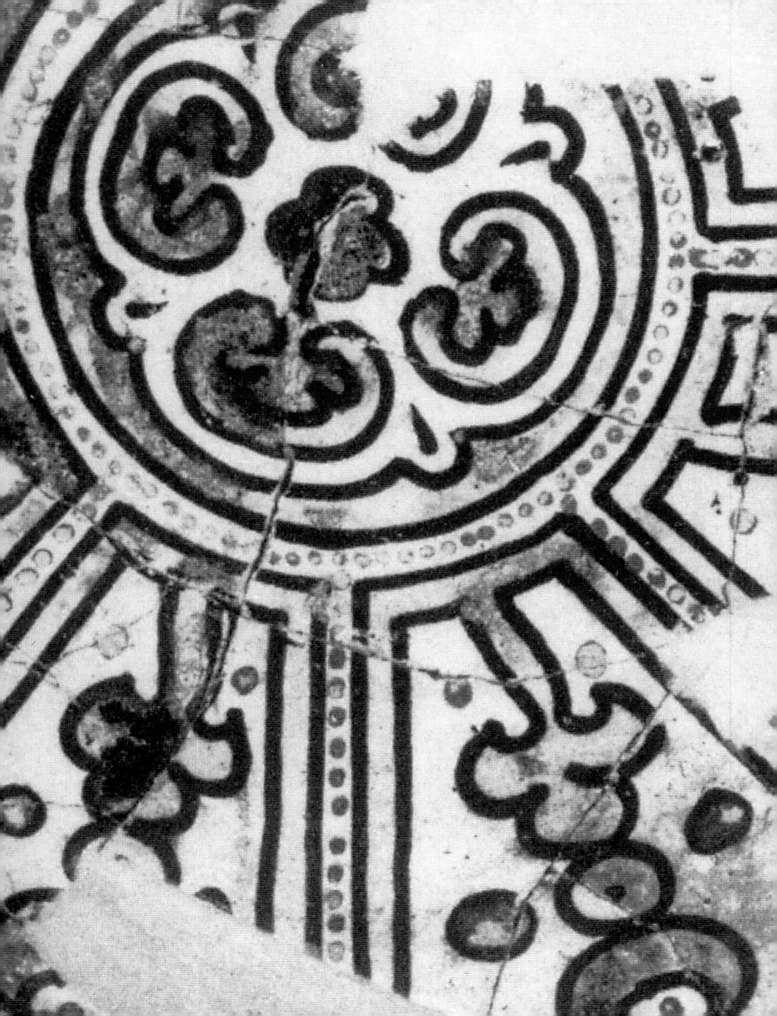

Polychrome Tiles Found at Istanbul: Typology, Chronology, and Function

MARLIA MUNDELL MANGO

 This essay focuses on polychrome wall tiles associated with particular sites within Constantinople, as distinct from tiles of other or unknown provenance. The production of Byzantine polychrome tiles falls within a period of only two centuries (possibly, it is argued here, mid-ninth to mid-eleventh), a period that saw the renovation and construction of a large number of buildings in the capital. The circumstances of the introduction of the tiles as elements of architectural decoration need to be clarified and the reasons for the eventual discontinuation of their production explained. Technically, Byzantine polychrome tiles form a fairly homogeneous group. The method of their manufacture, the chemical composition of their clay, and the style of their painting unite this large number of tiles into a single group for study. Byzantine tiles are distinct from the lusterware tiles known from ninth-century Sāmarrā (838–83) and Kairouan (862). Likewise, they stand apart from later fritware Ottoman tiles produced at Iznik (Nicaea). And they also differ in fabrication from polychrome tiles produced in Bulgaria, works that present the closest links to the Byzantine tiles in terms of decoration and function.[1] Yet, precisely how the polychrome tiles were used in Byzantium continues to be a subject of debate. The production centers of Byzantine tiles are still

to be identified. Although scientific analyses link local white clay from the vicinity of the Byzantine capital to the fabric used in specific tiles, no workshops have yet been located in the city. Furthermore, reference to "tiles of Nicomedia" in a Constantinopolitan document of ca. 1200 suggests one production center in Bithynia.

Within the extant corpus of Byzantine tiles, the polychrome tiles with documented findspots at Istanbul—occasionally in dated monuments—offer specific information that justifies their examination as a separate group. The following discussion of these tiles, based on their archaeological context, typology and decoration, chronology, and function, aims to put this one body of material into clearer perspective with regard to other groups of Byzantine polychrome tiles, including those of other, uncertain, or unknown provenance.

Findspots of Tiles at Sites in Istanbul (Tables 1, 2)

Byzantine glazed wall tiles are known from fourteen identified Constantinopolitan sites (Table 1; Maps 1–4); they were also inventoried at one other in 1192 (Botaneiates Palace church, cat. XIV). The earliest recorded discovery of tiles at Istanbul, associated with Saint John Stoudios, was made in 1907. Finds from the Atik Mustafa Paşa Camii are included

I	Great Palace
II	Hospital of Sampson
III	Istanbul Archaeological Museum
IV	Istanbul Law Court
V	Kyriotissa church (Kalenderhane Camii)
VI	Constantine Lips (Fenari Isa Camii)
VIa	Atik Mustafa Paşa Camii
VII	Myrelaion (Bodrum Camii)
VIII	Saint Euphemia
IX	Saint George of the Mangana
X	Saint John Stoudios (Imrahor Camii)
XI	Saint Polyeuktos
XII	Topkapı Sarayı Basilica
XIII	Zeuxippos Baths
XIV	Botaneiates Palace church

Table 1 Findspots of Tiles in Constantinople.

Found	Published	Site
1907–8	1954	Saint John Stoudios (cat. X)
1921–23	unpublished	Saint George of the Mangana (cat. IX)
1928	1929	Zeuxippos Baths (cat. XIII)
1930	1933	Myrelaion 1 (cat. VII)
1936–37	1947	Great Palace, central area (cat. I.A)
1937	1954	Topkapı Sarayı Basilica (cat. XII)
1930s	1964	Constantine Lips (cat. VI)
1930s	1966	Saint Euphemia (cat. VIII)
1946–47/58–60	1962	Hospital of Sampson (cat. II)
1952	1952	Istanbul Law Court (cat. IV)
1965	1981	Myrelaion 2 (cat. VII)
1968–73	1974	Istanbul Archaeological Museum (cat. III)
1960s	2001	Kyriotissa church (cat. V)
1983	1984	Great Palace, Boukoleon room (cat. I.B)
1992	unpublished	Atik Mustafa Paşa Camii (cat. VIa)
1996	unpublished	Great Palace, Boukoleon stairway (cat. I.B)

Table 2 Dates of Discovery and Publication of Constantinopolitan Sites.

in the catalogue of this volume (cat. VIa), but came to my attention too late to be included in this discussion. Chronological lists of each discovery and its publication are given in Table 2.

At some of the sites, the tiles consist of single or stray excavation finds. This is the case at Saint Polyeuktos (Map 4, site XI), the structures uncovered behind the Archaeological Museum (Map 3, site III), and at the site of the Law Court (Map 2, site IV). A larger number of tiles were found together in 4 m of earth dumped on the floor of an exedra of the Zeuxippos Baths rebuilt by Justinian (Map 2, site XIII). In the Great Palace, nearby, small numbers of tiles were found in the following locations: three tiles were reported found during excavations in what are described as tenth- and eleventh-century contexts in the vicinity of a medieval building northwest of the sixth-century peristyle court (Map 2, site I.A); a single tile was noted at the time of recent excavations in the stairway to the south of the "House of Justinian" in the Boukoleon Palace (Map 2, site I.B.2). Other, more substantial finds from the Great Palace are discussed below. A few tiles, mostly unpublished or poorly known, have also been found in association with three churches. Those from Saint George of the Mangana, dated 1042–55, remain unpublished and were reputedly few in number (Map 3, site IX).[2] The tiles found in excavations of the Virgin Kyri-

otissa, the Kalenderhane Camii, are published for the first time in this volume (Map 4, site V). The few tiles found during excavations of Saint Euphemia in the 1930s were in a private collection by the time they were briefly published in 1966 and have not been studied (Map 2, site VIII). Given the nature of the evidence, we are not able to confirm that the often few tiles found out of context were originally installed within the buildings where they were excavated. It is possible that the tile fragments were dumped, with soil, in secondary deposition. In such cases, the archaeological context is of limited value for interpreting the tiles. For, as J. Hayes points out, "The few tile fragments [at Saint Polyeuktos] do, admittedly, come mostly from rather late contexts, but given their architectural function one is inclined to discount their findspot as evidence for the period of production"[3] and, one could add, "period of use."

There are, however, monuments with more coherent tile finds, and these offer a better prospect for ascertaining their original architectural context, a topic that I take up later in this essay. Two among these are dated medieval churches. The first is the four-column monastery church built by Constantine Lips in 907 (Map 4, site VI). Various types of interior decoration, including polychrome tiles, were uncovered in the course of clearing. These included crisply carved architectural sculpture based on exotic

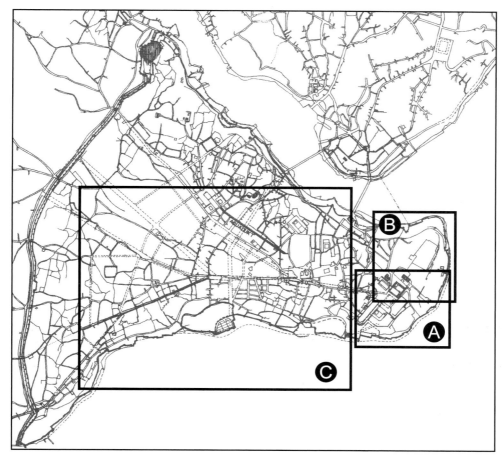

Map 1

motifs. The second church is the Myrelaion, built by Romanos I Lekapenos around 920 (Map 4, site VII). Excavations of this four-column church in the 1930s and in 1965 revealed tiles in contexts dated to the tenth century.

In addition to these two tenth-century structures, two early Byzantine churches had tiles added in the course of medieval renovations. In the fifth-century basilica of Saint John Stoudios, Russian archaeologists uncovered tiles, sculpture, and other remains in 1907–8 (Map 4, site X). In the fifth-century Topkapı Sarayı Basilica, excavated in the Saray courtyard in the 1930s (Map 3, site XII), tiles of various types were found in the area of the sanctuary and at the east end of the north and south aisles.

Two monuments of nonecclesiastical character also deserve attention within this discussion. The first is the Hospital of Sampson, a late antique foundation situated between Saint Sophia and Saint Eirene, which underwent alterations in the Middle Byzantine period (Map 3, site II). The latest published discovery of tiles from Constantinople, made in 1983, is from an elaborately decorated room of the Great Palace situated behind and to the north of the "House of Justinian," within the Boukoleon Palace (Map 2, site I.B.1).

The final set of Constantinopolitan tiles is known only from a medieval inventory. The tiles decorated a church forming part of a mansion overlooking the Golden Horn and belonging to the Botaneiates family (Map 4, site XIV); the mansion has often been identified with remains of a Byzantine building standing in the general designated area.

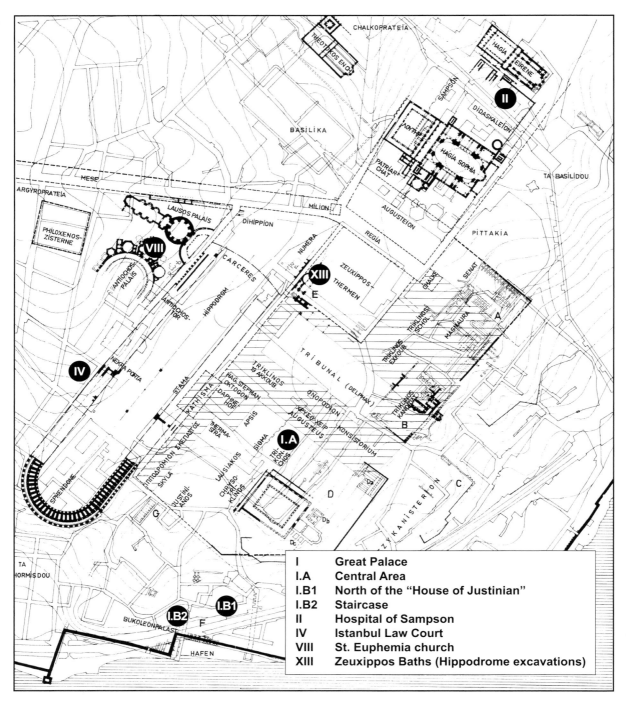

I	**Great Palace**
I.A	**Central Area**
I.B1	**North of the "House of Justinian"**
I.B2	**Staircase**
II	**Hospital of Sampson**
IV	**Istanbul Law Court**
VIII	**St. Euphemia church**
XIII	**Zeuxippos Baths (Hippodrome excavations)**

Map 2

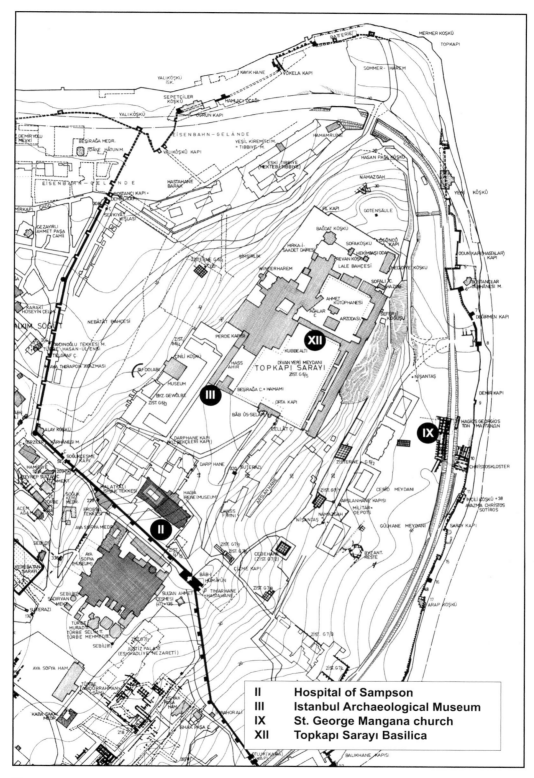

II	Hospital of Sampson
III	Istanbul Archaeological Museum
IX	St. George Mangana church
XII	Topkapı Sarayı Basilica

Map 3

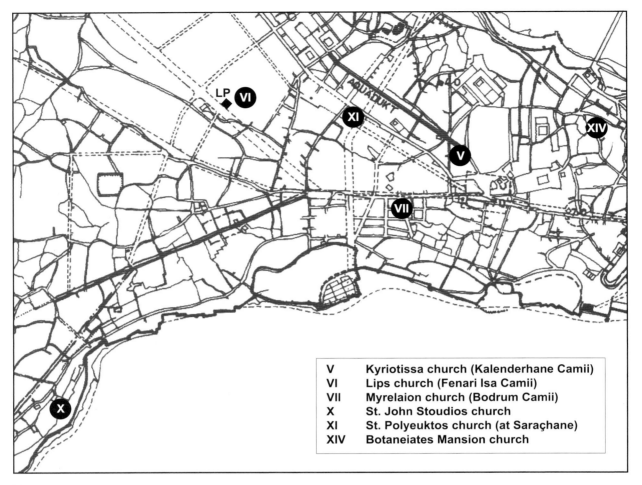

V	Kyriotissa church (Kalenderhane Camii)
VI	Lips church (Fenari Isa Camii)
VII	Myrelaion church (Bodrum Camii)
X	St. John Stoudios church
XI	St. Polyeuktos church (at Saraçhane)
XIV	Botaneiates Mansion church

Map 4

Byzantine Tiles Found Outside Istanbul

Tiles related to those uncovered at Constantinopolitan sites have been found in regions bordering the Byzantine capital. A large number of these are associated with Bithynia. In their decoration these tiles are similar or identical to those found within the walls of the city, and in some cases, analysis has demonstrated a common ceramic fabric for the two groups. They may be considered products of the same or of closely related workshops. Thanks to the well-known reference to "tiles of Nicomedia" cited above, this Bithynian city has been considered a possible center of production. The Bithynian sites with tile finds include two Asiatic suburbs of Constantinople, one at Haydarpaşa (by Kadiköy, ancient Chalcedon), where one tile (in two pieces) decorated with architectural motifs was found in 1893 (cat. XVI.1), and one at Yuşa Tepesi near Beykoz, where a tile with a standing figure was unearthed in 1924 during excavations of the church of Saint Panteleimon (cat. XVII, D.2). Nicomedia, modern Izmit, is said to be the

source of tiles in the Istanbul Archaeological Museum as well as of three figural tiles now in the State Historical Museum in Moscow (cat. F.1–F.3). Ornamental tiles apparently formed the apse cornice of the now-destroyed Koimesis church at Nicaea, modern Iznik (cat. XVIII). At Prusias ad Hypium, modern Üskübü, a single figural tile was unearthed while builders were laying the foundations of a hospital; it entered the collection of the Istanbul Archaeological Museum on 26 May 1960 (cat. XX.1). Prusias itself, as well as Bursa and Apamea in Phrygia, have all been mentioned in connection with a large group of tile fragments that have been divided between the Walters Art Museum (cat. A) and the Musée du Louvre (cat. B) since the 1950s.

Outside Bithynia, there are, in addition to the Bulgarian tiles, two other groups of tiles related to the Byzantine material. The single tile of Saint Elisabeth excavated in 1892 at Cherson (cat. XXII, F.4) could have been exported there from either Constantinople or Preslav.

The tiles at the base of the dome in front of the *mihrab* at Córdoba (cat. XXI) form a cornice for a mosaic whose decoration was completed, according to written sources, with the help of Byzantine craftsmen in 971.

In addition to the tiles associated with specific sites, there are collections of tiles without known context. Some of these, which may have a provenance in Istanbul—perhaps with some of the documented finds—are now in the Istanbul Archaeological Museum, the Benaki Museum in Athens (cat. D), the Musée national de Céramique, Sèvres (cat. C), the Thierry Collection in France (cat. H), and the Museo Internazionale delle Ceramiche at Faenza (cat. G). Of certain tiles offered for sale on the art market in Istanbul in the 1940s (cat. XV), the present whereabouts and provenance are unknown.

Typology and Decoration of Tiles Found at Istanbul (Tables 3, 4)

By shape, the tiles found at Istanbul have been classified (Table 3) as oblong and as architectural elements; others are square or rectangular plaques. The oblong tiles are subdivided into convex, concave, and flat, according to section, and as either straight or arched in plan. The plaques are likewise convex, concave, and flat and are either square or rectangular in plan. The rectangular plaques differ from the oblong tiles in being broader. By far the greatest number of tiles found at Istanbul are

oblong, coming from all but two sites. Strictly speaking, by function, the oblong tiles could also be classified as architectural, since they may have served as cornices, door frames, etc. The arched oblong tiles are all from the Topkapı Sarayı Basilica (cat. XII). Tiles formed as architectural elements, comprising predominantly colonnette shafts, bases, and capitals, are known from seven sites. The Boukoleon room tiles also included pieces that have been tentatively classified as pilasters, piers, and a ridged cornice block (with plaster support) (cat. I.B.1). One of the convex oblong tiles was also found with a plaster cornice block in the Lips church (cat. VI.3). There are very few square plaques from Istanbul, from only two sites (the Boukoleon chamber and the Topkapı Sarayı Basilica), and most of these are flat. The greatest variety of shapes is found among the tiles from the Topkapı Sarayı Basilica.

Due to the fragmentary state of many finds, it is difficult to make precise statements about the sizes of the various types of tiles. In general, most are thin, being from 0.4 to 0.7 cm in thickness, although one colonnette tile from the Kyriotissa church is 1 to 1.25 cm thick (cat. V.9). Plaques measure up to 23 cm on a side. Colonnette shafts are from 7.5 to 14 cm wide and up to 42 cm high (cat. II.18). Oblong tiles range from very narrow, flat strips, 2 to 4 cm wide (or high), to broader, mostly convex tiles, from 5 up to 18.2 cm high (or wide). The longest tiles preserved are from the Sampson Hospital, namely, six flat strips 60 to 61 cm long (cat. II.1, II.3, II.5, II.6, II.8–II.9)

Sites	I.B	II	III	IV	V	VI	VII	VIII	IX	X	XI	XII	XIII
OBLONG TILES													
Convex—Straight	•	•			•	•	•		•	•	•	•	•
Convex—Arched												•	
Concave—Straight	•						•					•	
Concave—Arched												•	•
Flat—Straight		•				•	•					•	
Flat—Arched												•	
ARCHITECTURAL FORMS													
Colonnette Shafts	•	•		•	•			•				•	•
Capitals		•										•	
Bases	•											•	•

Table 3 Shapes of Constantinopolitan Tiles by Monument.

and convex tiles 97, 94, and 87 cm long (cat. II.16, II.14, II.2).

Decorative motifs on the tiles found at Istanbul have been classified in Table 4 either as geometric or organic types. The specific types are described in the essay on ornament typology by Jeffrey Anderson.

Decorative trends among the Constantinopolitan tiles are notable. By far the greatest number of tiles, occurring at all tabulated sites, have geometric or organic designs. Merely two plaques from a single site have portraits of saints (cat. XII.1, XII.2), in contrast to the greater number on finds from elsewhere or on those of unknown provenance. Other Istanbul plaques have either crosses or overall patterns (marbling, diaper) that, in theory, could constitute a "wallpaper" type of decoration. In general, each tile surface contains only one decorative pattern. Exceptions include tiles from the Topkapı Sarayı Basilica and the Zeuxippos Baths, where two types of self-contained patterns are joined on a single tile (cat. XII.19, XIII.3, XIII.6). Tiles decorated with truncated motifs, such as half-circles, may have been joined to form a whole motif, as demonstrated in the tiles from the Hospital of Samson (cat. II.6).

The inspiration for these motifs can be traced to architecture (sculpture, mosaic, wall painting) and to manuscript illumination. The development of the decorative repertory has chronological implications and is closely linked to the architectural function of the tiles. The characterization of these various sources, without citing specific comparanda, will help to describe this development. The majority of motifs used on polychrome tiles found at Istanbul, especially those of the geometric and organic friezes (Table 4), are based on forms known from architectural sculpture. Many are based on traditional, classical motifs, such as beads (concentric circles), guilloche, bead and reel, tongue and dart, and *cymation* (the shells) (Table 4, rows 1, 4, 8, 9, 39) as well as paired acanthus leaves and vine scroll (Table 4, rows 21, 34). Others may derive from early Byzantine or late antique sculpture types, such as the guilloche (Table 4, row 4), known from two-zone capitals. Other tile motifs can be traced to

medieval architectural sculpture, as represented by the rich repertory of carving in the Lips church, itself in part inspired by the sixth-century carving of Saint Polyeuktos.[4] The tile motifs derived from carving as seen at Lips (figs. 31, 32) include large circles, lozenges (Table 4, rows 2, 3, 10), rosettes, and palmettes (Table 4, rows 24, 28).[5] Two other motifs, the imbrication pattern imitating peacock feathers and the arched motif, may also be based on details of carvings of a type known from the Lips church. The remains of at least two large peacocks in relief (over 70 cm high) recovered there may have been inspired by similar carvings in Saint Polyeuktos (see Gerstel essay, fig. 21).[6] The Lips birds have erect tail feathers covered in a flat pattern composed of triangles and imbrications and are thus related to the colonnette tiles. The peacocks' wings have large palmettes at the top, below which runs a horizontal beaded band followed by the vertical, lower feathers. This last configuration—of beaded band above a series of vertical lines—recalls that of the patterning on the arched motif as described by Elizabeth Ettinghausen in her catalogue entries on a series of tiles from the Topkapı Sarayı Basilica (cat. XII.5–XII.7).

In other cases, the source of the tile motifs appears to be painted (or mosaic) decoration. Thus, the marbling on the Boukoleon tiles (cat. I.B.5–I.B.8) could be seen to parallel the long tradition of wall painting imitating marble revetment. The jeweled band, wave crest, and diaper patterns (Table 4, rows 7, 19) are known from late antique wall and floor mosaics.[7] The step and stepped cross motifs appear as a medieval mosaic or painted border (Table 4, rows 12, 13).[8] Palmettes and foliate scrolls are common motifs in medieval painting, both monumental and miniature, as well as on metalware.[9] Finally, the kufesque motif (Table 4, row 20) is imported and, within the empire, is known principally from painted or mosaic ornament, aside from its use in decorative brickwork.[10]

Some of these motifs deriving from painted or mosaic decoration, such as marbling, jeweled band, and diaper patterns, could be considered primarily monumental, that is, a form of architectural decoration (on wall, floor, etc.) and therefore a variant of the carved architectural decora-

Sites	I.B	II	III	IV	V	VI	VII	VIII	IX	X	XI	XII	XIII
Geometric													
1 Concentric Circles		•				•							•
2 Circles with Diamonds											•		
3 Circles with Cross-in-Square												•	
4 Guilloche		•										•	
5 Guilloche with Eyelets								•					•
6 Looped Circles with Rosette (Guilloche Type)												•	
7 Jeweled Band					•	•						•	
8 Concentric Circle and Rectangle (Bead and Reel)									•				
9 Tongue and Dart	•	•			•	•	•			•		•	•
10 Lozenges		•				•						•	•
11 Pitched Squares with Crosslets													•
12 Step		•											
13 Cross (and Stepped Cross)					•	•						•	
14 Lattice						•	•				•		•
15 Boxes													•
16 Chevron												•	
17 Lozenge Braid					•								
18 Scale												•	
19 Wave Crest					•								
20 Kufesque						•							
Organic													
21 Paired Acanthus Leaves										•		•	•
22 Acanthus Circles with Rosettes												•	
23 Circle with Four-Petaled Flower		•				•	•					•	
24 Circle with Rosette				•			•					•	•
25 Circle and Pitched Square with Four-Petaled Flower and Rosette						•							
26 Circle with Floral Motif											•		
27 Circle with Disk												•	
28 Circle with Palmette													•
29 Circle with Scrolling Tendrils		•			•								
30 Acanthus Half-Circles (Arched Motif)					•							•	
31 Half-Circle with Half-Rosette												•	•
32 Lozenges with Four-Petaled Flowers						•							
33 Acanthus Volutes		•											
34 Ivy Leaf with Grape Clusters (Vine Scroll)					•		•	•				•	
35 Scrolling Tendrils			•										
36 Quatrefoil												•	
37 Simple Palmettes												•	
38 Floral Motif and Bands						•							
39 Shell					•	•	•		•			•	
40 Shell with Palmettes							•					•	
Other													
41 Peacock Feather		•		•	•			•					•
42 Marbling	•												
43 Figural												•	

Table 4 Patterns on Constantinopolitan Tiles by Monument.

tion considered above. Other tile patterns, such as those that mix geometric and organic motifs, may be seen as less architecturally inspired. They are closer in spirit to fanciful painted patterns found in manuscript illumination.[11] One could cite in particular the bold composite patterns on oblong tiles from the Sampson Hospital (cat. II.7), the Topkapı Sarayı Basilica (cat. XII.13, XII.19). These latter motifs and patterns may well have originated independently, within the tile workshops. One could note also the application of "painterly" motifs to the most architectural members, namely, colonnettes covered with featherlike imbrications (cat. II.18, II.19, IV.1, V.8, VIII.3, XII.35, XIII.12) and lozenge braids (cat. V.9). This carries on a tradition of inlaid colonnettes known already in the sixth century at Saint Polyeuktos (fig. 6).

The relation between the tile motifs and those of polychrome-ware vessels will be discussed below in connection with the chronology of the tiles. The motifs will also be considered again below with reference to the use of the tiles.

The Chronology of Tiles Found at Istanbul

The chronology of the tiles is based on their archaeological contexts, on their decorative features, and on the dating of polychrome vessels.[12] We start with the tiles themselves and their contexts for evidence of chronology.

The Ninth Century

Two buildings with Byzantine tiles may be dated to the ninth century, making them roughly contemporary with the earliest glazed tiles in the Islamic world. As mentioned in Cyril Mango's essay, the emperor Theophilos built the Palace of Bryas in imitation of an Arab palace after the return from Baghdad of his ambassador John the Synkellos in 830. Although glazed wall tiles have not been recovered archaeologically from Baghdad itself, they are extant at Sāmarrā (838–83) and at Kairouan, where they had been exported in 862. It is conceivable that glazed tiles were in use at Baghdad before Sāmarrā was founded in 838 and that they formed part of an Arab palace's decora-

tive scheme carried home to Constantinople by John in 830. Until now, the Byzantine tiles in the Lips church of 907 have been considered the earliest produced in Constantinople. Any Byzantine tiles dated to the ninth century would place their production earlier than, or at least about the same time as, those made in and near Preslav (by 900?). The question of tile manufacture during the ninth century in Byzantium is therefore crucial in establishing links with production in these other areas.

A. The Boukoleon Room

Recent tiles finds in the Boukoleon area of the Great Palace require further study before dating and, possibly, a more precise identification of the structure in which they were found. But preliminary remarks may be made concerning the character of the structure's decoration, which has a bearing on the place of the Boukoleon tiles within the chronology of those found at Istanbul. Stylistically, the Boukoleon tiles stand apart from the others and should be considered as either earlier or later in date. Other elements in the decoration, namely, the *opus sectile* pavement and two inlaid panels, support an attribution of the Boukoleon tiles to a period preceding the Lips church (907).

The pavement. From written sources, we know that *opus sectile* pavements were in fashion in the ninth century in the Imperial Palace; Basil I installed them in the Chalke and the Nea, and Theophilos laid another in the Justinianos. In his Tenth Homily, Photios describes a pavement with animals and other forms in the church of the Virgin of the Pharos.[13] The *opus sectile* pavement of the Boukoleon room comprises on one side three panels with quincunx patterns (fig. 1); their central roundels are formed from tessellated whorls swirling outward from a very small disk, not from a large marble plaque. The interlaced roundels that border the pavement contain radiating or other tessellated patterns, such as intersecting squares enclosing a star and surrounding a small central disk (fig. 2).

In its layout and execution, the pavement seems to fall between the floors of late antiquity and those of medieval Byzantium. Late antique *opus sectile* pavements, such as those at Kartmin and in Cyprus,[14] were typified by vast

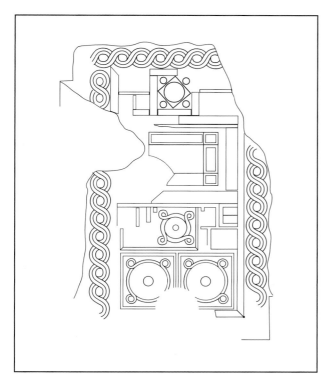

Fig. 1 Istanbul, Boukoleon Palace. Schematic drawing of pavement.

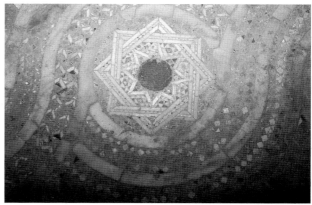

Fig. 2 Istanbul, Boukoleon Palace. *Opus sectile* pavement. Detail of border with roundels enclosing interlocking squares and eight-pointed star and quincunx pattern with tesselated whorls.

expanses of marble tessellation and whorls. Pavements with marble tessellation forming images such as fanning peacocks, eagles, and rivers were laid in the palace during the ninth century by Michael III and Basil I.[15] The medieval version of the *opus sectile* pavement, extant from the eleventh century onward, was based on an arrangement of marble disks into a quincunx pattern.[16] It is possible, therefore, that the Boukoleon pavement, containing elements associated with both late antique and medieval pavements, may represent a transitional phase of *opus sectile* work, namely, that occurring during the ninth century.

The marble panel. The stone matrix for the inlaid figure of an orant angel was found loose in the Boukoleon room (fig. 3). Inlay, or intarsia, continues an earlier tradition of *opus sectile* figural panels that were applied to walls, notably those from the house of Junius Bassus (ca. 330–50) on the Esquiline in Rome.[17] Comparable panels of champlevé carving filled with mastic or other colored materials, known mostly from the fifth and sixth centuries in the region of Antioch (fig. 4) and Cyprus, create a similar effect.[18] A series of marble inlaid iconic panels dated to the early tenth century were excavated in the Lips church. The best preserved is that of Saint Eudokia, which retains its inlay of colored marbles and glass pastes (fig. 5).

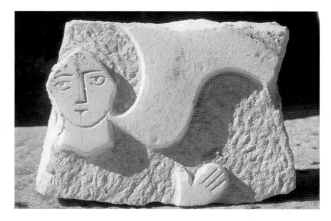

Fig. 3 Istanbul, Arkeoloji Müzeleri. Inlaid marble panel of angel from Boukoleon Palace.

The Boukoleon figural panel may represent a transitional phase between late antique and medieval forms. The face and hand of the angel are rendered in accordance with the earlier champlevé technique of Antioch and Cyprus; they are simply incised into part of the reserved level surface. The shape and features of the angel's head resemble those of the earlier examples, which also have a broad face and large eyes (fig. 4). The features are all loosely executed. By contrast, the Lips heads

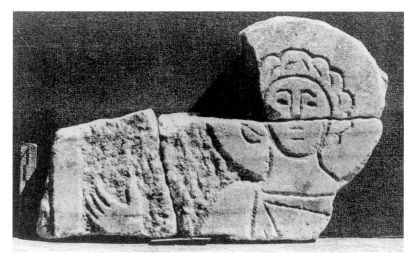

Fig. 4 Antioch-on-the-Orontes. Inlaid marble panels.

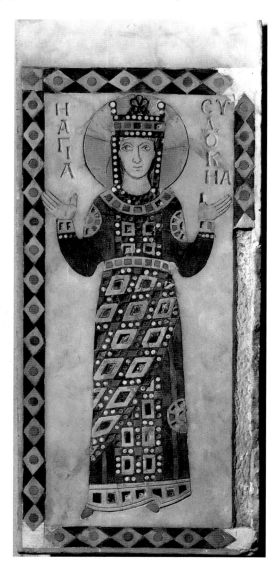

Fig. 5 Istanbul, Arkeoloji Müzeleri. Inlaid marble panel of Saint Eudokia from Constantine Lips.

(fig. 5), which are inlaid and more sculptural, are slender and have more regular and carefully drawn features.

Glass inlaid panel. Another find in the Boukoleon excavation was an arched limestone panel. Its surface is carved into four rows of circles with intervening concave triangles and diamonds; all are inlaid with deep blue glass (fig. 7). Small-scale architectural members with colored inlays are known from the sixth-century church of Saint Polyeuktos (fig. 6) and from Saint Euphemia (where they were spolia).[19] The colonnettes were cut into oblong patterns at Saint Euphemia and into more complicated hexagons, squares, diamonds, and oblongs at Saint Polyeuktos. The Saint Euphemia sculpture now lacks its inlays, but the excised shapes on the colonnettes from Saint Polyeuktos are known to have been filled with green glass, gold glass, and amethyst. Medieval versions known, for example, from the Lips church (fig. 8), from Preslav,[20] and from a second arched panel in the Boukoleon room have a different system of recesses on a smaller scale. In one room of the palace, Basil I is said to have made "walls inlaid with plaques of glass."[21] The form of the Boukoleon panel could be seen as a transitional decorative feature of this period. The bold pattern of the Boukoleon glass inlays is closer to the earlier forms represented at Saint Polyeuktos and Saint Euphemia. Significantly, it also recalls in overall effect the single or double strings of concentric circles painted onto polychrome tiles (fig. 9; cat. II.3–II.5, VI.3, VI.4, XIII.2), some of which are rendered with blue-green glaze, perhaps in imitation of the glass inlay.

The tiles. The Boukoleon glazed tiles are relatively conservative when compared with the bright colors and exotic motifs of other Constantinopolitan works. They

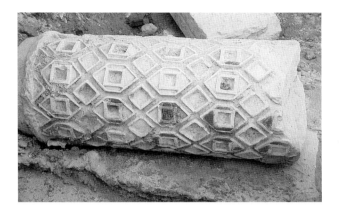

Fig. 6 Istanbul, Arkeoloji Müzeleri. Inlaid column from Saint Polyeuktos.

Fig. 7 Istanbul, Arkeoloji Müzeleri. Stone panel with blue glass inlay from the Boukoleon Palace.

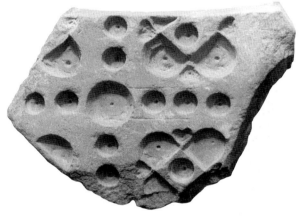

Fig. 8 Istanbul, Arkeoloji Müzeleri. Inlaid marble molding from Constantine Lips.

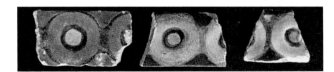

Fig. 9 Istanbul, Arkeoloji Müzeleri. Tile from Constantine Lips (cat. VI.5).

feature more classicizing architectural motifs. Here, the bands of flutes or tongue and dart are not rendered as a flat pattern (as elsewhere), but in three-dimensional form as indicated by a semicircular recess at the base of the tongue/flute (cat. I.B.1, I.B.4). The colonnettes with base, chamfered pier, raised truncated border panels, and flat panels evoking revetment slabs are all marbled. The range of colors is relatively somber: dark brown, green, and white (the natural color of the clay), with touches of blue-green (in marbling and in solid color: cat. I.B.1–I.B.5). The use of gilding is noteworthy, since the only other use of gold on tiles is on a single tile in the Boukoleon stairway nearby and in another structure of imperial patronage, the Myrelaion (cat. VII.1, VII.4).[22] The other, somber colors of the Boukoleon tiles recall the dark browns and greens of early glazed whitewares.[23] Comparable marbling is known only on a single unprovenanced colonnette tile now in the Sèvres collection (cat. C.5). The Boukoleon tiles clearly originate from a part of the Great Palace where extravagant building and decoration is recorded during the ninth and early tenth century, particularly by Theophilos, Michael III, and Basil I. Materials used then, known from written sources, include a variety of marble, mosaic, silver revetment, and impressive metalworks (fountains with zoomorphic ornament, etc.).[24] Whether some or all of this material was spolia is not important to the present discussion. That marble was unavailable for the newly discovered Boukoleon room is inconceivable.

That marble was imitated in glazed ceramics may instead be explained, in terms of taste rather than economics, as an avant-garde form of decoration newly introduced into Byzantium, probably from the East. Strictly speaking, the Boukoleon room, with its inlaid image of an angel, should be post-Iconoclastic; it could date to the period immediately following 843 and belong to a room built by Michael III (842–67) or Basil I (867–86), both of whom added to the Boukoleon Palace.[25]

B. Nicaea, Koimesis church

The tiles that apparently decorated the apse cornice of the church of the Koimesis at Nicaea, known only from a single photograph published by Theodor Schmit, may well have been contemporary with the post-Iconoclastic phase of the church's mosaic decoration in the sanctuary (cat. XVIII). The mosaic work was carried out on behalf of one Naukratios—an uncommon name[26]—who may be identified with a disciple of Theodore of Stoudios and his successor as abbot of the Stoudios monastery. Since Naukratios died in 848, the mosaics—and possibly the tile cornice below them—may date to the period 843–48. However, given the stylistic and iconographic affinity between these and the apse and *bema* mosaics of Saint Sophia, Constantinople, the Nicaea decoration may be contemporary and date to around 869. Either date would make them among the earliest Byzantine tiles known and contemporary with the proposed date for the Boukoleon tiles. However, they appear to differ in style and motifs from the latter and may more closely resemble later groups. The tiles are only partly visible in the photograph, and so the precise nature of their decoration is uncertain. They have been compared with the tiles of the dome cornice in the Córdoba *maqsura* of 971 (cat. XXI) and appear to combine features that relate both to the acanthus half-circles, known from the Kyriotissa church (cat. V.2) and the Topkapı Sarayı Basilica (cat. XII.5–XII.7), and to a version of the paired acanthus leaves that appear on tiles from the latter building, Saint John Stoudios (cat. X.3), and the Zeuxippos Baths (cat. XIII.6).

The Tenth Century

Two buildings with tile finds are firmly dated by written sources to the tenth century. Furthermore, the tile cornice at Córdoba of 971 may be attributed to Byzantine craftsmanship. Tiles from a fourth building at Constantinople may date to the same decade.

A. The Lips church

The Lips church, built in 907, offers the earliest secure dating for Byzantine polychrome tiles and is therefore a key monument in any discussion of dating and function. These tiles share the bright colors and boldly rendered motifs of other Constantinopolitan examples. Even so, the range and form of motifs is restrained, and the tiles are thinner than those from other monuments in the city. The discussion of motifs above emphasized the close links between the Lips tiles and the adjacent architectural sculpture. The use of kufesque ornament in the church is unique on polychrome tiles (cat. VI.16).[27] There is no reason to suggest, as has a recent article,[28] that the tiles represent a later phase of decoration in the Lips church.

B. The Myrelaion church

The Myrelaion church, erected in the 920s, provides a second firm date for the history of Byzantine tiles. The archaeological context differs somewhat from that of the Lips tiles. Not all the finds from the site have been published, and other decoration for the church is now lacking. Gilding is a prominent feature of the Myrelaion tiles, as on those from the Boukoleon, and may reflect imperial patronage. The ivy leaf and grape clusters motif (cat. VII.5) was already a frieze component in the Lips church, and the shell motifs here (cat. VII.2) are similar to those in the earlier church, but the tongue and dart assumes a looser form (cat. VII.1). A notable innovation is a flamboyant frieze of flaring leaves and flowers, which appears here for the first time and echoes a motif found on contemporary sculptural relief (cat. VII.3).

C. Hospital of Sampson

Cyril Mango has recently proposed that the Hospital of Sampson, founded in late antiquity and rebuilt by Justinian following the Nika Riot in 532 and again after the fire of 564, was renovated in the 970s.[29] According to U. Peschlow, the room where the tiles were found was created in two stages during post-Justinianic periods, after 740 and then later in the Middle Byzantine period.[30] The tiles were undoubtedly put into place during the second of these phases, which may well date to the 970s. The small circles of the Lips church reappear here on narrow flat strips (cat. II.3–II.5), but are also adapted to a new pattern composed of

juxtaposed half-circles (cat. II.6). The stepped cross motif of the Lips church (cat. VI.15) has here become more complicated (cat. II.11). Also added to the repertory are embellished lozenges (II.8–II.10), perhaps originally based on an angular form of bead and reel or the lozenge border of inlaid marble panels; both types of carving are found among the marble work in the Lips church.[31] The most notable innovations are the patterns that combine geometric and vegetal motifs: four-petaled flowers (cat. II.12–II.15) and circles with scrolling tendrils (cat. II.16–II.17), the scalloped edges of some roundels (cat. II.14–II.15), added also to one tongue-and-dart pattern (cat. II.2), which is otherwise comparable to that of the 920s at the Myrelaion (cat. VII.1). In sum, the tiles from the Hospital of Sampson are related to types known from the Lips and Myrelaion churches, but add the motifs described above, which derive from nonarchitectural sources. This stylistic development supports the suggested later date of the 970s for these tiles.

D. The Great Mosque, Córdoba

The tiles of the *maqsura* of al-Ḥakam II in Córdoba of 971 were thought to have been made by Byzantine craftsmen (cat. XXI), and they have been compared with those of the Koimesis church at Nicaea (cat. XVIII).[32] Related motifs are known from the Kyriotissa church (cat. V.2) and the Topkapı Sarayı Basilica (cat. XII.5–XII.7), both of uncertain date. Given the unusual—and non-Byzantine—configuration of the base of the dome, the tiles must have been made at Córdoba.[33]

The Eleventh Century

There are two dates in the eleventh century associated with polychrome tiles found at Istanbul. It should be noted that red-bodied tiles with a kufesque frieze once adorned the façade of the Panagia ton Chalkeon of 1028 in Thessalonike (fig. 33).

A. Saint George of the Mangana

Tiles were said to have been found in the area of the Mangana church, built by Constantine IX in 1042–55.[34] The

only motif identified on these tiles is that of the shell (cat. IX.1), known already in the Lips (cat. VI.8–VI.9) and Myrelaion (cat. VII.2) churches and the Topkapı Sarayı Basilica (cat. XII.4).

B. Saint John Stoudios

E. Ettinghausen has suggested that the tiles excavated in the Stoudios basilica were installed during restoration work in the church by Isaak I Komnenos in 1059 (cat. X). The Stoudios tiles are limited to three motifs. The tongue and dart (cat. X.1) has a stepped dart known only at the Boukoleon (cat. I.B.2) and the Zeuxippos Baths (cat. XIII.1). The paired acanthus leaves (cat. X.3) appear elsewhere in Istanbul only at the Topkapı Sarayı Basilica (cat. XII.15). The Stoudios concentric circle and rectangle motif (cat. X.2) is unique. None of these comparisons with mostly undated tiles helps to confirm an eleventh-century date.

Tenth or Eleventh Century

Other buildings with significant tile finds continue to elude dating and/or identification, namely, the Kyriotissa church, the Topkapı Sarayı Basilica, and the Zeuxippos Baths. All three sets of tiles share characteristics with both the tenth-century groups—the Lips, Myrelaion, and Sampson—and, in some cases, the eleventh-century and the undated tiles. Some individual motifs correspond to those of the postulated ninth-century group of tiles (Boukoleon, Nicaea).

A. Church of the Virgin Kyriotissa (Kalenderhane Camii)

The tiles excavated in the Kyriotissa church were associated with level 4 of the second phase of the north arm of the naos and were found in a twelfth-century context with pottery of an earlier period and coins dated to the ninth and tenth-eleventh centuries, but mostly to the twelfth.[35] The tiles undoubtedly belong to earlier phases of building on the site, the latest church being attributed to around 1200,[36] and their pattern can be compared with those of early monuments (Lips, Myrelaion, Sampson), namely, the

jeweled band (cat. v.1), the ivy leaf with grape clusters (cat. v.6), the circle with scrolling tendrils (cat. v.7), and the acanthus half-circles (cat. v.2), a motif that is known from the Nicaea church (cat. XVIII.1) and the undated medieval phases of the Topkapı Sarayı Basilica. The stepped cross motif (cat. v.3) seems to differ from related motifs in the Lips church and Hospital of Sampson (cat. II.11, VI.15). The frieze of shells (cat. v.4) is unique at Istanbul but corresponds to carved ornament in the Lips church.[37] Also unique in the Kyriotissa is the band of wave-crest pattern (cat. v.5) known from other media.[38]

B. Zeuxippos Baths

As with the Kyriotissa tiles, those found in the partially excavated Zeuxippos Baths apparently came from outside the immediate area in which they were found. The baths, rebuilt by Justinian I and in use until at least 713, were later converted for other and diverse functions, to serve as a prison and then as an imperial silk factory. The tiles include early motifs, such as the concentric circles (cat. XIII.2–XIII.3) known from the Lips church (cat. VI.3–VI.5) and the tongue and dart in its stepped-dart version (cat. XIII.1) known from the Boukoleon (cat. I.B.2) and the Stoudios church (cat. X.1). Other motifs reappear in the Topkapı Sarayı Basilica and Saint Euphemia, such as the guilloche with eyelets (cat. XIII.4) and the half-circles with half-rosettes (cat. XIII.8). Two Zeuxippos tiles combine two different bands of motifs on a single tile: both have a narrow lower band and a higher upper band. On one, a band of pitched squares enclosing crosslets lies below a band of concentric circles (cat. XIII.3); on the other, acanthus leaves stand above a band of lozenges (cat. XIII.6). This last combination, painted onto single (arched) tiles, reappears in the Topkapı Sarayı Basilica (cat. XII.19).

C. Topkapı Sarayı Basilica

Although the excavation of the Topkapı Sarayı Basilica is documented, the medieval phases of the building remain undated. The tiles from this site exhibit the greatest variety of both shapes and motifs. Some are well known in the tenth century, such as the ivy leaf with grape clusters motif (cat. XII.22–XII.23) and shells (cat. XII.4). The jeweled band (cat. XII.3) features in the Lips church (cat. VI.6). The arched motif, called acanthus half-circles in the catalogue (cat. XII.5–XII.7), may date to the ninth century, if the Nicaea tiles are that early. The paired acanthus leaves (cat. XII.15) occur also on Stoudios tiles (cat. X.3), which may date to the eleventh century. The looped circle with rosette (cat. XII.9) and the half-circle with half-rosette (cat. XII.30) are known only from undated Istanbul tile groups, Saint Euphemia, and Zeuxippos. Unique types emerge among the Topkapı tiles, such as the quatrefoils, the heart with five-pointed leaf (cat. XII.31), and the cross that is used both in diaper patterns (cat. XII.32) and singly on plaques (cat. XII.33–XII.34). Most striking among Istanbul tiles is the representation of figures, namely, that of the Virgin and Child and an orant figure (cat. XII.1–XII.2), as well as the sketch of a boy on the reverse side of one of the patterned tiles (XII.32).

In sum, from a core of tiles found in buildings dated to the tenth century, a chronology may be constructed both back into the ninth century and, on the basis of one or perhaps two dated groups, forward into the eleventh century. It is significant that no tiles are known from buildings securely dated to the twelfth century, such as the Pantokrator churches (1118–36). The Botaneiates inventories of 1192 and 1202 undoubtedly record tiles in an older church.

The reasons for the disappearance of the polychrome wall tiles may be explained by a number of factors. First was a shift in decorative taste by the twelfth century, leading to a reduction in architectural sculpture (both stone and ceramic). This is illustrated by a comparison at the Lips monastery, between the tenth-century north church and the thirteenth-century south church. Second was the decrease in the number of buildings given wall mosaic decoration in favor of wall painting. The decorative bands once provided by the painted tiles could now be supplied as an integral part of the general scheme of wall painting; the Odalar

Fig. 10 Istanbul, church of Saint Polyeuktos. Fragment of polychrome plate with tongue-and-dart border.

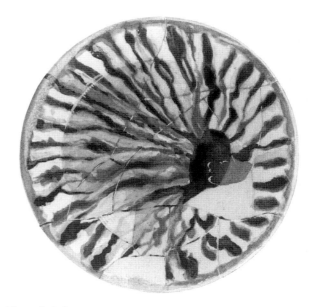

Fig. 11 Corinth. Restored polychrome plate with marbled decoration.

Camii painted cornices could belong to that trend. Both trends (less sculpture and less mosaic) could have economic causes, and while the tiles are widely viewed as cheap materials, they formed part of a costly decorative system. Finally, and probably most essentially, the polychrome tile, like polychrome ware, was the victim of another change in taste. It was replaced by the red-bodied sgraffito tile, which was less appropriate for architectural adornment in terms of technique and color, although the external frieze at Thessalonike could be cited as evidence for a continuation of red-bodied tiles (fig. 33). The known sgraffito tiles are square plaques with anecdotal secular images and were clearly put to nonecclesiastical use (fig. 26).

Polychrome Tableware

Similarities of ceramic fabric and decorative motifs demonstrate that polychrome tiles and tablewares were decorated in the same workshops.[39] The chronology of polychrome vessels may assist, therefore, in the dating of the tiles. Some of the motifs on both tiles and tablewares derive from architectural decoration and may have passed from the tiles, used for the ornamentation of buildings, to vessels. The tongue-and-dart frieze presents a case in point. The motif occurs as a narrow border on plates from Corinth imported from Constantinople and on sherds excavated at Saint Polyeuktos (fig. 10).[40] In the former case, the darts terminate in disks, as on several tiles (cat. VI.1, XVI.1). The marbling pattern on the Boukoleon tiles (cat. I.B.5–I.B.8), which imitates architectural revetment, may have inspired a related treatment of vessels, such as the so-called Green and Brown Painted Ware (fig. 11).[41]

Tiles and vessels shared other motifs as well. A small-scale version of the stepped cross motif and the heart with five-pointed leaf (cat. C.4) are combined in border friezes on plates brought to the trading center of Cherson from the Byzantine capital (fig. 12).[42] The circle with rosette (known

from a tile of unknown location; cat. XV.4) reappears on a vessel sherd (fig. 13).[43] More noteworthy perhaps are the related half-circles with half-rosettes seen on Istanbul tiles (cat. XII.30, XIII.8), forms that reappear on vessels, for example, from Saint Polyeuktos (fig. 14).[44] Ivy leaf with grape cluster motifs similar to those on a series of tiles (cat. V.6, VII.5, VIII.2, XII.22, XII.23) decorate vessels found at Corinth and Tmutarakan (figs. 15, 16).[45] More significant is the sharing of less usual motifs, such as the lozenges found on a tile from the Hospital of Sampson (cat. II.9–II.10) and on a vessel sherd from Cherson (fig. 17);[46] the circle with scrolling tendrils found on several Istanbul tiles (cat. II.16, II.17, V.7) and on vessels from Cherson and Corinth (figs. 18, 19);[47] and the circle with four-petaled flower known from the Sampson Hospital (cat. II.14, II.15) and found on a cup from Gnezdovo.[48] The acanthus half-circle motif on tiles also has echoes in vessel decoration. The small pile of three featherlike forms that appears under acanthus half-circles on tiles from several Constantinopolitan monuments and at Nicaea (cat. V.2, XII.7, XVIII) is also found on a plate with a tongue-and-dart border excavated at Corinth (Group I).[49] The motif itself (cat. V.2, XII.5–XII.7), which was discussed above

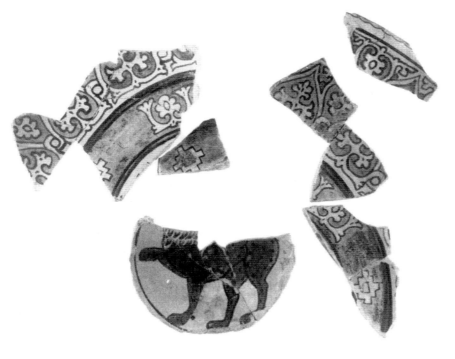

Fig. 12 Cherson. Fragmentary polychrome plate with stepped cross and heart with five-pointed leaves.

Fig. 14 Istanbul, church of Saint Polyeuktos. Fragment of a polychrome vessel with half-rosettes.

Fig. 15 Tumutarakan. Fragment of a polychrome cup with ivy leaf with grape cluster motif decoration.

Fig. 13 Fragment of a polychrome vessel bearing a rosette with a beaded center.

Fig. 16 Corinth. Fragment of a polychrome vessel.

Fig. 17 Cherson. Fragment of a polychrome vessel with lozenge.

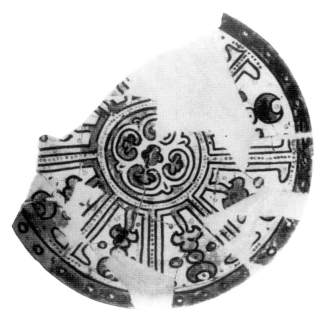

Fig. 18 Cherson. Fragmentary polychrome plate with scrolling tendrils.

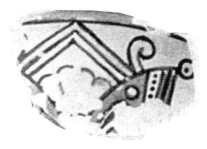

Fig. 20 Istanbul, church of Saint Polyeuktos. Fragment of a polychrome plate with acanthus half-circles.

Fig. 19 Corinth. Fragment of green and brown painted bowl with scrolling tendrils.

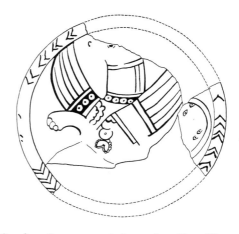

Fig. 21 Gnezdovo. Fragmentary polychrome plate with a griffin.

in relation to carved peacocks in the Lips church, is seen in a related form on a vessel sherd from Saint Polyeuktos (fig. 20).[50] A griffin with wings similar to those of the Lips peacocks decorates a plate from Gnezdovo (fig. 21).[51]

The relationship between the kufesque ornament on tablewares and that on tiles is more ambiguous. In both cases, the ornament is executed with white characters on a black ground. Four tile fragments from the Lips church (cat. VI.16) may be stylistically compared with a tile fragment from the Istanbul Archaeological Museum site that is decorated with scrolling tendrils (cat. III.1). Vessels with kufesque and related ornament are known from Corinth (Group III), Kertch, Tmutarakan, and Saint Polyeuktos[52] (fig. 22). This

imported ornament is known from architectural contexts (in brickwork), monumental decoration, and minor arts in Byzantium. Since portable objects are traded, it is reasonable to suppose that they were the means by which this motif entered the empire. The objects in question may not have been of ceramic, but of metal, glass, or textile.

Other stylistic similarities in the execution of particular images or motifs suggest a correspondence between tile and vessel workshops. Some of these similarities are highlighted elsewhere in this volume but bear repeating within this context. A polychrome bowl base found at Aksaray in Istanbul is decorated with a bust portrait of Saint Nicholas (cat. A.19) that recalls the representation

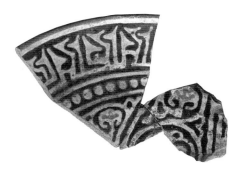

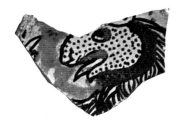

Fig. 22 Istanbul, church of Saint Polyeuktos. Fragment of a polychrome vessel with kufesque and related ornament.

Fig. 23 Istanbul. Fragment of polychrome vessel with decorated feline figure from the Kyriotissa, Istanbul.

Fig. 24 Istanbul. Fragment of polychrome vessel from Saint Polyeuktos.

of the same saint on a tile in the Walters Art Museum (cat. A.19).[53] Felines on vessels excavated at Saint Polyeuktos and the Kyriotissa church (figs. 23, 24)[54] resemble the animals that decorate a tile in the Louvre (cat. B.5).[55] A fragment of a bowl excavated at Aksaray (see page 272) bears a rosette on the interior of its base that is comparable to rosettes on another vessel from Corinth, as well as on tiles in the Walters Art Museum (cat. A.59, A.60).[56] Directly relevant to the question of the joint production of tiles and vessels is a fragmentary jug that was excavated at Saint Polyeuktos (fig. 25).[57] Constructed from four luted tiles with an added neck and handle, the shape of the vessel reveals a dependence on manufacturing techniques generally employed for concave and convex tiles.[58] Further correspondences between vessel and tile production are attested by the existence (albeit on a reduced level) of sgraffito tiles (fig. 26).[59]

The chronology of polychrome wares therefore has some bearing on the date of tiles, some of which were clearly decorated by the same hands and some of which are known to be made of the same clay. The chronology of polychrome ware has undergone several revisions since the earlier sequences established by Talbot Rice and Morgan, including a forthcoming general redating, based on ceramic sequences at the Corinth excavations, to the eleventh to twelfth centuries.[60] In the opinion of the present writer, this latter appraisal takes insufficient account of the evidence concerning tile production.

Whatever the dating of the vessels, the chronology of these two groups of polychrome ceramics may be linked but not identical. Where coincidence of architectural motifs exists, the tiles may, not surprisingly, represent a prior development. Furthermore, if the production of painted tiles was linked to the needs (dimensions, architectural configuration, etc.) of individual buildings—as is clear from the case of the Córdoba cornice—then specific ties to painted-vessel workshops may have been more occasional than systematic. For example, a common production may have concentrated more on standardized plaques for export than on the individualized strips of the type found in the Sampson Hospital. Aside from the figural plaques, which are rare among tile finds made at Istanbul, the coincidence of motifs between tiles and vessels is relatively low. The truly architectural motifs that predominate among the tiles are, with the exception of the tongue-and-dart borders mentioned above, absent from the vessels. Often the ornament (apparently) transferred from tiles to vessels is transformed in its reduction to a much smaller scale. Similarly, the rash of red dots found on one class of polychrome vessels is missing from the tiles, a fact that could have implications for dating.

Ideally, workshop production of tiles and vessels

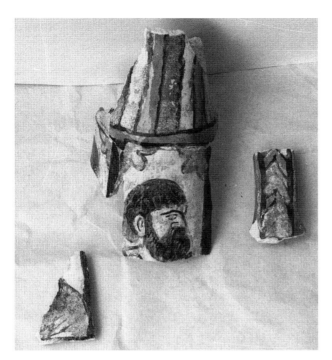

Fig. 25 Istanbul, Arkeoloji Müzeleri. Fragment of a polychrome jug with figural decoration from Saint Polyeuktos.

Fig. 26 Istanbul, Arkeoloji Müzeleri. Sgraffito tile with standing figure, found near Adana.

should be considered in terms of individual operations. If the "workshop" is seen as a building complex, then the preparation of the fabric, the formation of the tile and vessel, and the decoration of their respective surfaces may all have taken place under separate roofs, some possibly at some distance from the others. In such a large city as Constantinople, different stages of production could have taken place in different locations, and depending on the degree of coordination of these operations, Constantinople might be considered one "workshop," depending on the complexity and extent of the known evidence.

The Function of the Tiles Found at Istanbul

Relatively few polychrome tiles have been found at each site in Istanbul. It has, accordingly, been suggested that the tiles were used on a restricted basis "as borders or as frames to frescoes and mosaics."[61] Scholars have also postulated that certain tiles from Bulgaria as well as plaques in the Walters Art Museum and the Louvre were applied to the templon screen.[62] Such theories depend on the analysis of the tiles themselves and on their archaeological context. A certain amount of speculation is necessary in discussing the function of the tiles, since very few polychrome tiles have been observed anywhere still adhering to a wall surface *in situ*. An examination of the use or function of polychrome tiles in the monuments of Middle Byzantine Constantinople will again consider the evidence offered by both archaeological context and the integral design of the tiles themselves.

The buildings in which the tiles have been found varied in function and may be divided as follows: (1) secular and ecclesiastical settings within palaces and mansions: Great Palace, Saint George of the Mangana, Botaneiates, possibly the site of the Istanbul Archaeological Museum; (2) monastery churches: Lips, Myrelaion, Saint John Stoudios; (3) public churches: Kyriotissa, Saint Euphemia, Saint Polyeuktos, possibly Topkapı Sarayı Basilica; (4) a hospital: Sampson. The original contexts are unknown for the tiles found in the Zeuxippos Baths and at the Law Court site.

Before looking at this archaeological evidence, we should turn for information to the single written source regarding the use of the tiles. The inventories of the Botaneiates estate describe one of the family's two churches (cat. XIV) as having a dome on four columns (one "of white Bithynian marble"); marble revetments and sanctuary furnishings; mosaics on the upper walls, vaults, and dome; a marble pavement composed of interlace, *opus sectile*, and a border; a "carved marble icon" near the ciborium; as well as tiles. Drawn up in Latin in 1192, the document was translated into Greek in 1202 (13 October). The texts specify that the tiles covered one area toward the west and formed or revetted a high cornice of the church. The Greek version reads: "The revetment of the *gamma*-shaped spaces on the west side are of Nicomedian tiles [*dia tanstrion Nikomedeion*],[63] as is the cornice, and above that are images in gold and colored mosaic." The Latin version states: "a medio templo versus occidentem indutis testis de Nicomedia." Thus, the Botaneiates tiles were an integral part of the church's architectural decoration, at least insofar as they formed part of the upper cornice below the mosaics.

Few of the tiles of Byzantium are associated with their original architectural context. Those at Nicaea formed or revetted an apse cornice (cat. XVIII), while those at Córdoba were used for a dome cornice (cat. XXI). Among tiles found at Istanbul, two tiles from the Lips church were found still mounted on a stucco convex molding,[64] suggesting their use as part of a cornice (fig. 29), and similar evidence survives from the Boukoleon (cat. I.B.1). Other tiles imitate architectural supports; they are shaped as colonnettes or polygonal pilasters—some having integral or separate capitals and/or bases. These were found at the Boukoleon, the Hospital of Sampson, the Law Court site, the Kyriotissa, Saint Euphemia, and the Topkapı Sarayı Basilica.

Given the scattered and fragmentary nature of much of the evidence concerning function, the best results may be obtained by concentrating on the few sites that have both a range of finds and some defined archaeological context. I shall, accordingly, consider the Boukoleon room, the Lips church, the Hospital of Sampson, and the

Topkapı Sarayı Basilica. The discussion and the conclusions drawn will necessarily take account of the specific information provided by tiles from other sites.

The Boukoleon Room

The various decorative elements of the Boukoleon room have been discussed individually above in relation to dating. How these individual elements fitted together within the room is impossible to say, pending firsthand examination of the evidence. Although the term "room" has been used here for convenience, no walls have been found, but merely a self-contained expanse of paved floor (fig. 1) that measures only 7 × 5 m. The nature of this room is difficult to determine. It lies very close to the "House of Justinian" and is at the core of the Boukoleon Palace.[65] There is no observable apse, although the narrow ends are approximately oriented. Across the central field of the pavement stretches a large sunken area surrounded by raised marble borders. Within this recess is a series of rectangular and square sinkings and a long central panel that was originally inlaid.

How the various loose pieces of architectural decoration related to what is left *in situ* cannot be ascertained here. The two arched and inlaid stone panels (fig. 7) describe an arch very broad and low relative to the restricted scale of the room itself. Neither these nor the various ceramic tiles could have been freestanding, given their relative fragility. Only one tile appears complete, namely, the so-called pilaster (cat. I.B.5), which measures only 11.5 × 33.5 cm. It is hard to say whether it and a second fragmentary tile were placed vertically or horizontally. The colonettes (cat. I.B.6), with related marble surfaces, are all more narrow, being ca. 7.5–8.5 cm wide. These elements may have been combined with a string course of tiles decorated with a frieze of tongue and dart (cat. I.B.2–I.B.4). Related ornament covers a peak-shaped tile classified here as a cornice block (cat. I.B.1). The tongue and dart is arranged on either side so as to suggest the block was set vertically. The tile was probably supported by a peak-shaped block of plaster found with it.

The assorted tiles may have formed parts of a decorative frame that was attached to a wall revetted perhaps by the fragmentary plaques with marbled patterns. The tiles may have been closely integrated with the carved and inlaid stone. In addition to the arched panels mentioned above, there is part of a stone slab carved with tongue and dart or flutes (fig. 27), once possibly inlaid. The inlaid plaque with an angel, discussed above (fig. 3), may have been one of a series with standing figures, perhaps framed by some of the tile elements.

Whatever the exact configuration of these tiles and sculpted pieces, the surviving elements suggest that the decoration relied on traditional forms, such as the tongue-and-dart frieze and "marble," but was achieved in an innovative manner by the use of ceramic tile. The novelty lay not in the motifs but in the material.

The Lips Church

The Lips church preserves, in addition to the building itself, a far greater variety of decorative elements than found in the Boukoleon room. The church has extensive marble decoration, and it undoubtedly once had mosaic decoration on its vaults and upper walls. The decorative relation between the carved ornament and the tiles from the Lips church is notable and is underscored by their similar dimensions. The question to explore here is, given that they were undoubtedly contemporary, how were they used together?

The sculpture of the Lips church was examined, and a catalogue of material assembled, in a series of comprehensive articles devoted to the building in 1964 and 1968.[66] Since then, no one has attempted to carry the study forward and to reconstruct at least theoretically what is undoubtedly the best documented example of Middle Byzantine architectural decoration. Suffice it to say that such work lies well beyond the scope of the present remarks. The aforementioned articles noted that the marble architectural sculpture was very well integrated in its various parts. The three cornices were in a descending order of relief, from the dome to the apse to the upper wall

Fig. 27 Istanbul, Arkeoloji Müzeleri. Fragment of stone (?) cornice with band of flutes from Boukoleon Palace.

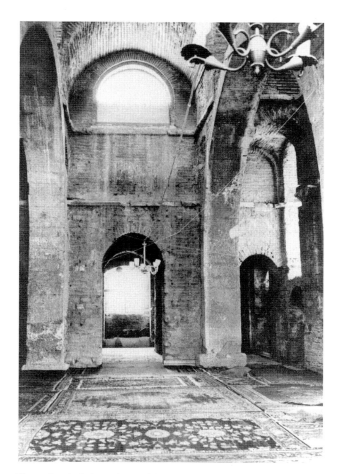

Fig. 28 Istanbul. General view of the nave of Constantine Lips.

Fig. 29 Istanbul, church of Constantine Lips. Stucco cornice with lower tile (cat. VI.3) in place and upper tile (VI.14) removed.

Fig. 30 Istanbul, church of Constantine Lips. Reconstructed view and profile of cornices shown in figs. 29 and 31.

(fig. 28).[67] The other carved surfaces of tall mullions (fig. 32), corbels, skirting, and other revetment display a wide range of ornament. Other pieces of recovered sculpture included fragments of a templon and a series of inlaid (fig. 5) and relief figural panels, some comparable to that found in the Boukoleon room. The tiles were said by Macridy to have been "found among the debris covering the floor of the churches,"[68] hence, apparently together with the inlaid panels. It was suggested that the tiles may have ornamented cornices or frames.[69]

Two tiles from the Lips church were found still mounted side by side on a stucco convex and flat molding, suggesting their use as part of a cornice (fig. 29). The stucco matrix is similar to the molding that supported one of the tiles at the Boukoleon (cat. I.B.1). But neither a stucco nor a tile molding could have functioned as a true load-bearing cornice of the types found *in situ* in the Lips church. In the case of the Botaneiates Palace, Nicaea, and Córdoba, they must have been attached to a stone cornice. However, the stone cornices at Lips all survive with abundant sculpture. The stucco molding with tiles, if serving as a cornice, must have formed an added string course, perhaps below the stone cornices, such as that of the lowest cornice (which has a 15 cm overhang)[70] placed at the top of the marble revetment in the nave, eastern chapels, and the narthex. The alternating palmettes and crosses were painted red on a blue ground (fig. 31). Judging by the Topkapı Sarayı and Zeuxippos tiles, which combine motifs (XII.19, XIII.3, XIII.6), the concentric circles should be positioned below the larger circle and pitched squares (cat. VI.14) and lozenges of the Lips molding. The stone and plaster/tile cornices combined would produce the profile illustrated in Figure 30. The circle and pitched square motif of the Lips tiles correspond in form and size to those of the north window mullions (fig. 32). Parts of a stone concave cornice found in the Odalar Camii, and formerly thought to originate in Saint Euphemia, are painted with a palmette frieze that resembles the decorative treatment of oblong tiles;[71] these provide a variant type to the carved stone cornice and the painted-tile-over-stucco cornice molding.

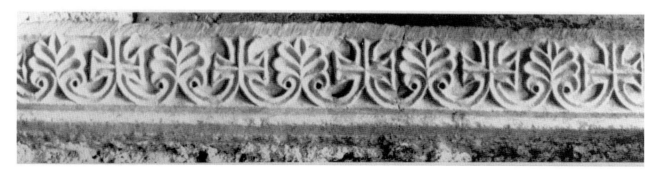

Fig. 31 Istanbul, church of Constantine Lips. Cornice above the marble revetment in the nave.

Inlaid figural panels were discovered in the Lips church "among the chunks of plaster and other debris which the Turks scraped off the walls and used to raise the level of the floor."[72] They number possibly thirteen rectangular panels (most were originally ca. 57 × 25 cm) and two medallions. The best preserved is that of Saint Eudokia (fig. 5).[73] Macridy suggested that it and the other panels may have adorned the small roof chapels, whereas Mango and Hawkins thought it more likely that they belonged to the apsed or straight walls of the eastern chapels on the lower floor. The tiles may have been used as frames in conjunction with these inlaid panels, most of which are 2.5–4 cm thick.[74] Within the church individual sheets of marble revetment were framed with marble bands carved as lozenges or bead and reel,[75] comparable in size (ca. 2 cm wide) and design to the inlaid frame of the Eudokia panel as well as the smallest type of flat glazed tile strip both in this church and elsewhere. Some of the Lips tiles, used as framing devices for marble panels, may have intentionally imitated their marble counterparts.

In sum, the evidence offered by the stucco moldings, considered together with details concerning the layout of carved ornament in the building, suggests that the tiles may have been used as a lower string course under a carved cornice (figs. 29–31), much as an intarsia band is combined with the upper cornice of the Pammakaristos parekklesion in the fourteenth century[76] and the tile band of kufesque once ornamented the façade of Panagia ton Chalkeon in Thessalonike (fig. 33). Additionally or alter-

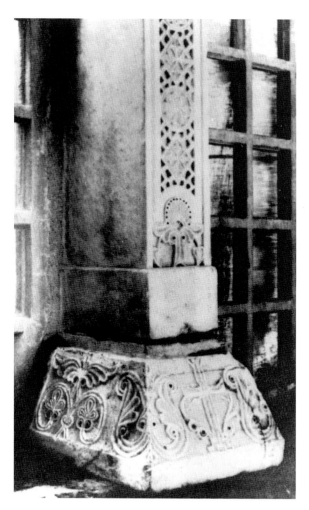

Fig. 32 Istanbul, church of Constantine Lips. Exterior face of the mullion of the north window.

natively, the tiles may have served as decorative frames for the inlaid figural panels that adorned the walls of the church. A third possibility, that they were used in combination with the marble elements of the templon, is unlikely.

The Hospital of Sampson

The tiles from the Hospital of Sampson[77] were found in a room (fig. 34) created from the eastern wing of a central peristyle court and closed off by three niches on the east side.[78] The function of the room is uncertain. It is very shallow east to west and long north to south. It does not take the conventional form of a chapel, although it is presumed to be one on the basis of the niches and the tiles. F. Dirimtekin, who excavated the room, consistently refers to it as a martyrium.[79] In fact, to the south is a cistern fronted on the west by a nymphaeum with niches and a pool in the floor. There is a cistern under the floor of the courtyard to the west of the room and another further to the east. In the room itself, "une canalisation souterraine alimentait peut-être une vasque au centre," and the northern niche in the room has a colonnette inserted into a pierced marble slab in the floor.[80] Although the walls of the room were decorated with frescoes of standing figures,[81] it may have served as a bathing room comparable to that featuring in the Pantokrator hospital, according to its *typikon*.[82]

As with the Boukoleon room and the Lips church, further work *in situ* is required to make more than tentative suggestions regarding reconstruction of the tile decoration. Three main groups of Sampson tiles survive: colonnettes, convex tiles 7–12 cm wide × 97 cm long, and narrow strips 2.5–3.6 cm wide × 60–61 cm long. Given the configuration and size (9.5 × 3.5 m) of the room, it seems certain that the tiles were attached to the walls rather than being part of a free-standing structure. Taking the most decoratively important wall, that on the east, with the niches (fig. 34), the flat wall surfaces available for the tiles are the following: the spaces (width ca. 20 cm) in the setbacks flanking the niches; the span (1.2–1.7 m) of the lintels in front of the niches; the walls (width 1.7 m)

Fig. 33 Thessalonike, Panagia ton Chalkeon. Drawing of frieze composed of redware tiles with kufesque decoration.

between the niches. A string course could have run the entire width of the room (9.5 m) above the niches. Considering the surviving tiles, one could suggest that colonnettes (max. width of capital ca. 20 cm) stood in the spaces flanking the niches and "supported" tiles covering the lintel above them, composed perhaps of a convex band (circle with scrolling tendrils, etc.) combined with a narrow flat band below (circles, lozenges, etc.). The narrow bands all survive in lengths of 60–61 cm, so that two could cover the span of at least the central niche (120 cm). Further speculation is pointless before further work *in situ*.

The Topkapı Sarayı Basilica

The architectural context and the range of tiles found in the Topkapı Sarayı Basilica, alone among the four selected monuments discussed here, allow one to contemplate the possibility of the use of tiles on a templon and in arrangements related to figural tile icons.

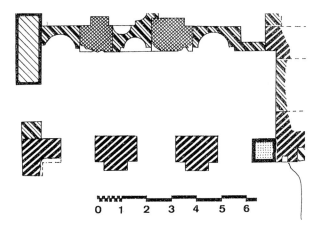

Fig. 34 Istanbul, Hospital of Sampson. Plan of room where polychrome tiles were found (north at base).

Among the tiles found at Istanbul, this group has the greatest variety of shapes and motifs. These include parts of at least five colonnettes, namely, five bases, two shafts, and one capital (cat. XII.35–XII.42). The other tiles can be divided into three significant groups: oblong tiles (convex and concave) mostly 10–12 cm high, narrow flat strips 2.4–3.6 cm wide, and figural plaques. There are several sets according to decorative patterns: looped circle with rosette (cat. XII.9), circles with four-petaled flowers or rosettes (cat. XII.10–XII.13, XII.21, XII.27–XII.29) or quatre-foils (cat. XII.25, XII.26), paired acanthus leaves (cat. XII.15), and acanthus half-circles (cat. XII.5–XII.7; slightly smaller at 6.3–7.3 cm wide). Unique among Istanbul finds are the tiles with a diaper pattern of crosses on convex oblong tiles 11 cm high (cat. XII.32).

Precise measurements of the lengths of the surviving tiles are not available, so that reconstructions must remain very general. Some of the straight oblong tiles are coordinated by motifs and dimensions with arched tiles, possibly forming a broad architectural frame. The numbers of tiles, their scale, and the horizontal configuration of the arched ones, suggest use on a larger scale than that in the other three monuments considered here. The church itself has the larger dimensions (35 × 21 m) of early Byzantine basilicas, unlike the medieval structures discussed above. The Topkapı Sarayı Basilica's apse opening of about 5.5 m could accommodate a templon of six colonnettes, using the five surviving tile bases. Tiles were, in fact, found in that vicinity, on the north side of the apse. Alternatively or additionally, the tiles could have formed engaged arched frames for painted iconic images: for example, at the eastern end of the north and south aisles (where tiles were also found), as in the carved examples in the later Kyriotissa and Chora churches.[83] The expanse of eastern wall available on the two sides is about 3 m. At least four sets of arched tiles survive. The two figural tiles (cat. XII.1, XII.2) could have featured within such arcaded frames.

Conclusion

Based on the discussion pursued in this essay, one could postulate the following development of polychrome tiles at Constantinople. The tiles were introduced into the Byzantine capital from Baghdad (or Sāmarrā) as a fashion novelty, at imperial level, at a time of building activity within the palace, perhaps as early as 830. From ninth-century Constantinople they were probably introduced to Preslav. Originally providing a witty version of marble, as seen in the Boukoleon room, they were soon adapted to bolder use in creating strong motifs in vibrant colors to supplement the decorative range offered by painted, carved architectural ornament, as seen in the Lips church. Eventually, new nonarchitectural, or "painterly," motifs were devised, as seen particularly in the Sampson Hospital and the Topkapı Sarayı Basilica. During this general process, the impact of polychrome tiles may be seen within the pottery industry. Painted motifs started to be applied to glazed whiteware vessels, but on the whole a separate repertory of motifs developed. Although there is evidence of a common production of tiles and vessels, in general it would appear that the two industries developed somewhat separately, with the tiles perhaps chronologically preceding the vessels. The mechanics of workshop practice require further consideration. The use of polychrome tiles may have ceased due to a combination of causes—a drop in the use

of architectural sculpture and wall mosaics and the increased popularity of sgraffito pottery.

This essay has focused on particular aspects of provenanced polychrome tiles found at Istanbul that may be considered as the body of material about which we are best informed in several respects. Yet the picture is far from complete, and given the current state of information, any conclusions drawn must be provisional. Future work should help to resolve certain questions. Close examination is needed of a greater number of the tiles themselves and of the sites where they were found, in particular the Boukoleon room, the Lips church, and the Hospital of Sampson. The origin and use of the unprovenanced tiles must be further pursued, and their links with the Istanbul tiles better defined. Furthermore, the enigmatic phrase "tiles of Nicomedia" should be reconsidered.

Notes

1. Vogt and Bouquillon, "Technologie," 105–16.

2. See cat. IX.

3. Hayes, *Saraçhane,* 35.

4. Mango and Hawkins, "Additional Notes," 299–315, and note 6 below.

5. For the carved version of the motifs, see Macridy, "Monastery of Lips," figs. 17–20, 42–45; Mango and Hawkins, "Additional Notes," figs. 8, 11–12, 14, 16–17, 20–22, 26–27, 33, 38; Mango and Hawkins, "Additional Finds," figs. 15, 19.

6. Macridy, "Monastery of Lips," fig. 41; Mango and Hawkins, "Additional Notes," 305; Mango and Hawkins, "Additional Finds," 179, no. 9, figs. 13–14; Harrison, *Saraçhane,* figs. 91–98. See Grabar, *Sculptures* I, 59, 107, 121; C. Mango, "Storia dell'arte," in *La civiltà bizantina dal IX all'XI secolo,* ed. A. Guillou (Bari, 1978), 261–62.

7. M. Mundell Mango, *The Sevso Treasure,* pt. 2 (in press), chap. 6C, "Decorative Motifs."

8. S. Westphalen, *Die Odalar Camii in Istanbul,* Istanbuler Mitteilungen 42 (Tübingen, 1998), 102–3, pl. 20.

9. See the essays by J. Anderson and W. Tronzo in this volume.

10. A. Cutler, "The 'Mythological' Bowl in the Treasury of San Marco at Venice," in *Near Eastern Numismatics, Iconography, and History: Studies in Honor of George C. Miles,* ed. D. K. Kouymjian (Beirut, 1974), 235–54.

11. See the essay by J. Anderson in this volume, pages 119–41.

12. Peschlow, "Byzantinische Keramik," 373; Miatev, *Keramik,* 57.

13. Mango, *Sources and Documents,* 186.

14. E. J. Hawkins and M. C. Mundell, "The Mosaics of the Monastery of Mār Samuel, Mār Simeon, and Mār Gabriel near Kartmin," *DOP* 27 (1973), fig. 48; A. H. S. Megaw, "Byzantine Architecture and Decoration in Cyprus: Metropolitan or Provincial?" *DOP* 28 (1974), fig. 5.

15. Mango, *Sources and Documents,* 186, 194, 196, 197, 205. On the development of marble *opus sectile* pavements from late antiquity through the Dark Age in the Marmara monastery churches of the eighth and ninth centuries, see U. Peschlow, "Zum byzantinischen opus sectile-Boden," *Beiträge zur Altertumskunde Kleinasiens: Festschrift für Kurt Bittel,* ed. R. M. Boehmer and H. Hauptmann (Mainz, 1983), 435–47.

16. S. Eyice, "Two Mosaic Pavements in Bithynia," *DOP* 17 (1963), 373–83.

17. R. Bianchi Bandinelli, *Rome: The Late Empire—Roman Art A.D. 200–400* (London, 1971), 96–98, figs. 83–91; G. Becatti, *Edificio con opus sectile fuori Porta Marina,* Scavi di Ostia VI (Rome, 1969), 181–215, pls. XLVI–XLVII, LII–LIII, LXXXI–LXXXIII; for similar work at Ostia, see ibid., pls. LIII–LXXIX.

18. See, recently, S. Boyd, "Champlevé Production in Early Byzantine Cyprus," in *Medieval Cyprus: Studies in Art, Architecture, and History in Memory of Doula Mouriki,* ed. N. P. Ševčenko and C. Moss (Princeton, 1999), 49–62.

19. Harrison, *Saraçhane,* 64–67, pl. 7.

20. K. Miatev, *Die Rundkirche von Preslav* (Sofia, 1932), figs. 162–63, 188.

21. Mango, *Sources and Documents,* 197.

22. A tile found out of context at Haydarpaşa also has traces of gilding (cat. XVI.1)

23. E.g., Morgan, *Byzantine Pottery,* 42–49, 53–57, 70–71, pls. IV–VII, Xa, XIX.

24. Mango, *Sources and Documents,* 160–65, 185–86, 194–99.

25. Ibid., 184–86, 194–99. On the Boukoleon Palace, see C. Mango, "The Palace of Boukoleon," *CahArch* 45 (1997), 41–50.

26. On this, the single Naukratios recorded in this period, see *Prosopographie der mittelbyzantinischen Zeit: Erste Abteilung (641–867), 3. Band: Leon (# 4271)—Placentius (# 6265),* ed. F. Winkelmann (Berlin and New York, 2000), no. 5230.

27. Red-bodied tiles decorated with a kufesque band once decorated the façade of the Panagia ton Chalkeon at Thessalonike, dated 1028. See A. Tsitouridou, *The Church of the Panagia Chalkeon* (Thessalonike, 1985), 22–24.

28. G. Sanders, "Byzantine Polychrome Pottery," in *A Mosaic of Byzantine Studies: A. H. S. Megaw Festschrift,* ed. J. Herrin and M. Mullett (in press).

29. See the essay by C. Mango in this volume, page 9.

30. U. Peschlow, *Die Irenenkirche in Istanbul* (*IstMitt* Beiheft 18) (Tübingen, 1977), 146–49, 168–71, fig. 25; his Middle Byzantine dating ("11th–12th century") is based on the recessed-brick technique of the niches, the earliest known instance of which is that of the cross-in-square Tithe Church in Kiev, completed by Byzantine builders in 996 (C. Mango, *Byzantine Architecture* [New York, 1976], 324). Its use in Constantinople as early as the 970s is therefore possible. Peschlow himself (*Irenenkirche,* 210–24) disagrees with the identification of the building south of Saint Eirene with the hospital (see cat. II).

31. Mango and Hawkins, "Additional Finds," 180, no. 22, fig. 27.

32. A. Grabar, "Notes de lecture," *CahArch* 27 (1978), 202.

33. For a discussion of this issue, see the essay by Elizabeth Ettinghausen in the catalogue, pages 239–41.

34. See cat. IX.

35. Personal communication by C. L. Striker to S. Gerstel.

36. Striker and Kuban, *Kalenderhane,* 58–71.

37. Mango and Hawkins, "Additional Notes," 309, no. 17, fig. 33.

38. Mundell Mango, *Sevso Treasure,* pt. 2, chap. 6C., "Decorative Motifs."

39. Peschlow, "Byzantinische Keramik," 57.

40. Morgan, *Byzantine Pottery,* pl. XIII; Hayes, *Saraçhane,* pl. 8.k, 8.l.

41. Morgan, *Byzantine Pottery,* nos. 404, 408; pl. XIX a, c.

42. Zalesskaja, "Nouvelles découvertes," figs. 5, 8.

43. Talbot Rice, *Glazed Pottery,* pls. VID, VIIIC.

44. Hayes, *Saraçhane,* 37, pl. 8.k.2.

45. Morgan, *Byzantine Pottery,* no. 335, pl. XVf; T. I. Makarova, *Polivnaja posuda Iz istorii keramičeskogo importa i proizvodstva drevnei Rusi,* Arheologija SSSR El-38 (Moscow, 1967), pl. III.4.

46. Zalesskaja, "Nouvelles découvertes," fig. 1.

47. Ibid., fig. 11; Morgan, *Byzantine Pottery,* no. 503, fig. 58.

48. Makarova, *Polivnaja posuda,* pl. III.1.

49. Morgan, *Byzantine Pottery,* no. 307, pl. XIII.

50. Hayes, *Saraçhane,* pl. 8h.

51. Makarova, *Polivnaja posuda,* pl. II.5.

52. Morgan, *Byzantine Pottery,* nos. 377, 379, 386, pl. XVII; Makarova, *Polivnaja posuda,* pl. XXVII.10–11; Talbot Rice, *Glazed Pottery,* pl. VI (below); Hayes, *Saraçhane,* pl. 9a.

53. See the essay by S. Gerstel in this volume, page 48.

54. Hayes, *Saraçhane,* pl. 8.k.6; Morgan, *Byzantine Pottery,* no. 376, pl. XVIID.

55. On this tile, see the essay by A. Cutler in this volume, pages 163–64.

56. Morgan, *Byzantine Pottery,* no. 364, pl. XVg.

57. Hayes, *Saraçhane,* pl. 8.g.

58. See the essay by J. Lauffenburger, C. Vogt, and A. Bouquillon in this volume, page 75.

59. See H. Cihat Soyhan, "İki Duvar Çinisi Üzerinde İnceleme," *Sanat Tarihi Yıllığı* VI (1976), 295–301.

60. Sanders, "Byzantine Polychrome Pottery" (in press).

61. Talbot Rice, *Glazed Pottery,* 15; Mango and Hawkins, "Additional Notes," 311.

62. See the essay by S. Gerstel in this volume, pages 53–57.

63. Mason and Mundell Mango, "Glazed 'Tiles of Nicomedia,'" 322–23; Mango, *Sources and Documents,* 239–40.

64. Mango and Hawkins, "Additional Notes," 311, fig. 58.

65. Mango, "Boukoleon."

66. Macridy, "Monastery of Lips"; Megaw, "The Original Form"; Mango and Hawkins, "Additional Notes"; Mango and Hawkins, "Additional Finds." See also Mango, "Storia dell'arte," 260–63, figs. 18–31.

67. Mango and Hawkins, "Additional Notes," 304.

68. Macridy, "Monastery of Lips," 276.

69. Mango and Hawkins, "Additional Notes," 311.

70. And therefore room under it in which to affix the stucco and tile cornice.

71. Westphalen, *Odalar Camii,* 142–43, nos. 4a, 4c, pl. 38.2.

72. Macridy, "Monastery of Lips," 272.

73. Ibid., 260, fig. 9.

74. Fıratlı, *Sculpture byzantine,* nos. 389–404.

75. Mango and Hawkins, "Additional Finds," 180, no. 22, fig. 27.

76. H. Belting, C. Mango, and D. Mouriki, *The Mosaics and Frescoes of St. Mary Pammakaristos (Fethiye Camii) at Istanbul,* DOS XV (Washington, D.C., 1978), figs. 94–95.

77. See note 30 above.

78. Peschlow, *Irenenkirche,* 146–49, 168–71, fig. 25.

79. Dirimtekin, "Fouilles," 162, 174–76, 181, 185.

80. Ibid., 174–75, 185, fig. 25.

81. Ibid., 162, 174, 176, 181.

82. P. Gautier, *Le typikon du Christ Sauveur Pantocrator* (Paris, 1974), 58, 62, 90–92, 110.

83. Striker and Kuban, *Kalenderhane,* pls. 20, 88–89; P. Underwood, *The Kariye Camii,* II, *The Mosaics* (New York, 1966), pl. 4.

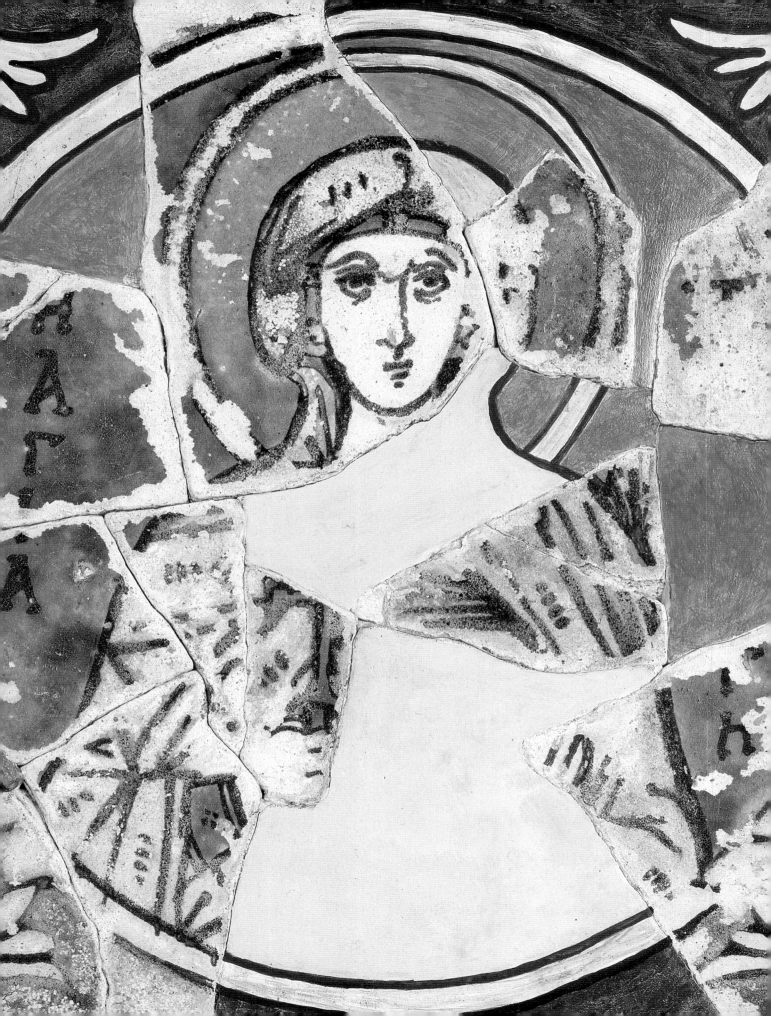

Ceramic Icons from Medieval Constantinople

SHARON E. J. GERSTEL

 Thirty-nine ceramic plaques bearing figural decoration survive from medieval Constantinople and its surroundings.[1] Of these, twenty-eight are in the collection of the Walters Art Museum.[2] What little is known of their provenance begins in recent times and is discussed elsewhere in this volume (cat. A). Here, we only need to recall that the tiles were once part of a collection of more than two thousand fragments from which the Musée du Louvre purchased several pieces in 1955, one year before the rest were acquired by the Walters.[3] It is unclear whether the lot, which comprised ornamental as well as figural tiles, was found at a single site or assembled from a number of sites by dealers in the Istanbul antiquities market. I believe that the second alternative is more likely and propose, in the following essay, a number of groupings based on style, technique, and possible function. This first attempt to reorganize the fragments is provisional and will be subject to further refinement. Before proceeding, I should briefly introduce the figural tiles associated with specific sites in or near the Byzantine capital.

Many tiles bearing ornamental patterns have been excavated in Istanbul,[4] but only four iconic tiles can be connected with known sites in the city or the surrounding region. Two tile fragments, one of the Virgin and Child, the other an orant saint, were excavated in the Topkapı Sarayı Basilica in 1937 and are now in the collection of the Istanbul Archaeological Museum (cat. XII.1, XII.2).[5] A fragment of a tile decorated with the head of a male saint, also in the Istanbul Archaeological Museum holdings, was reportedly found in the vicinity of Düzce in Bithynia (cat. XX.1; fig. 1).[6] A tile bearing the lower half of a male figure is said to be from the church of Saint Panteleimon at Yuşa Tepesi near Beykoz, on the Asian side of the Bosporus; this fourth frag-

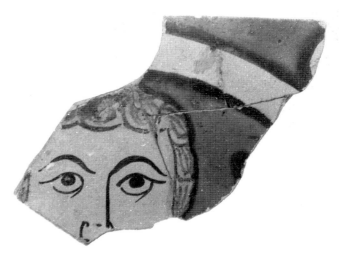

Fig. 1 Istanbul, Arkeoloji Müzeleri. Unidentified saint from Düzce (cat. XX.1).

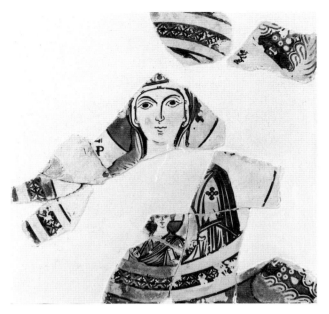

Fig. 2 Paris, Musée du Louvre. Virgin and Child (cat. B.1).

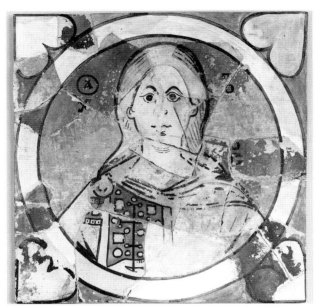

Fig. 3 Baltimore, Walters Art Museum. Saint Christopher (cat. A.2).

ment is today in the Benaki Museum, Athens (cat. D.2).[7] All the remaining figural tiles have come to us as homeless artifacts. To achieve some sense of where and when they were made and how they might have been used, we have only the information they themselves yield. The evidence consists primarily of size, subject matter, method of fabrication,[8] and styles of painting and epigraphy. On the basis of the evidence, the Walters and Louvre tiles can be organized in ways that occasionally connect them to fragments in other museums and private collections.

Group I

Four figural plaques in the Walters Art Museum and the Musée du Louvre bear a striking resemblance to the fragment found near Düzce (fig. 1). The site is mentioned as a possible findspot in the curatorial files of the Walters and Louvre, in notes added some years after the initial purchase of the tiles.[9] Stylistic affinities between the provenanced fragment, first published in 1962, and the Group I plaques, purchased in 1955/56, suggest that the tiles belong to a single assemblage and that their original findspot should be sought in the region of Düzce, most likely in the village of Üskübü, 8 km to the north.[10] That all the fragments appeared on the market or entered the museum collections within a relatively narrow space of time further suggests their derivation from a single site. As we shall see, the subject matter represented on several of

the plaques also makes a compelling case for their original installation in a church in Üskübü, known in the Byzantine period as Prusias ad Hypium. From the eighth to thirteenth century, Prusias ad Hypium was a suffragan bishopric of Claudioupolis.[11] Lead seals preserve the names of three bishops who administered the city's church between the ninth and eleventh centuries, the period in which the tiles would have been commissioned and installed.[12] The existence of these seals, most likely found in Constantinople, suggests a certain amount of epistolary activity on the part of the bishops and, consequently, an awareness of events and developments in the Byzantine capital.

The tiles in Group I are square, unusually large (29–30 cm) and thick (0.8–1.0 cm), and have slightly rounded edges. They include two saints—the partial portrait of Saint Christopher (fig. 3), two pieces of the head and inscription of Saint Panteleimon (cat. A.3)—and two representations of the Virgin holding a medallion with the Christ Child (a composition later termed the Virgin Nikopoios), one in Baltimore and the other in Paris (figs. 2, 26). Among the pieces attributable to this set is an additional small fragment from the abbreviated name of the Mother of God.[13] The group also contains several large square tiles that are decorated with peacocks, crosses, and floral and geometric motifs (cat. A.29–A.43, B.2–B.4). The plaques display a common method of fabrication; they have similarly finished edges and striations on the reverse sides that intersect at the cor-

ners. A uniformity in style, particularly in the figural representations, suggests that the Group I ceramic icons were painted by a single master.

Each figural plaque presents a half-length portrait set within a medallion having an amber or white ground. The frames of the medallions with saints are green, while those of the Virgin are more elaborately decorated, with intricate, colorful patterns reminiscent of enamel work. Heart-shaped leaves fill the corners of the plaques, except on the Louvre Virgin, where in each corner pairs of multilobed leaves flank a pearl-and-teardrop design (fig. 2). None of the saints is nimbed. The figures in this group have facial features rendered in a fairly abstract fashion. Lines descend from the corners of the eyes to emphasize the lower lids, whereas the upper lids extend horizontally toward the hairline. The eyebrows, which are painted with thick lines, are sharply arched, and the ears are small and attached low on the head. Broad strokes of paint differentiate individual strands of hair, whether straight or curled. The eyes of the Paris Virgin and Saint Christopher (fig. 3) share several distinctive features. Each pupil is centered between the eyelids, a faint crease is drawn between the upper lid and the brow, and the lids flare horizontally. On the Düzce and Christopher plaques, the pupil of the right eye appears to have a small white void at the center. On all the plaques, the noses are slightly bulbous at the tips, and the bowed shape of the lips is identical. Two curved lines articulate the upper line of the chin, and its base is defined by three curves. The painter pays close attention to fingers, especially the spatulate thumbs; he has carefully drawn nails and knuckles (figs. 2, 3).

The inscriptions on this set of plaques, although fragmentary, are characterized by calligraphic embellishments. Triangular or squared serifs ornament the letters, such as the *chi* and *sigma* in Christopher's name or the abbreviated *Theou* in the title of the Walters Virgin. The abbreviation marks on both the Walters and Louvre plaques, as well as on the fragment, are decorated with hatch marks, either diagonally over the bar or vertically at its ends.

Related to this set of figures is another icon executed in a finer hand, which may represent the efforts of a sec-

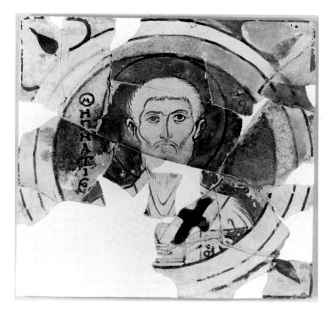

Fig. 4 Baltimore, Walters Art Museum. Saint Ignatios Theophoros (cat. A.4).

ond painter on another group of tiles from the same workshop. The plaque, which represents Saint Ignatios Theophoros, is slightly smaller in scale (25.7 × 26 cm) and has acutely beveled, not rounded, edges (fig. 4). The frontal nimbed portrait is enclosed by a copper green medallion, its frame divided into two concentric bands, with leaves filling the corners of the square plaque. The features of this episcopal saint differ slightly from those described above and are executed more subtly. Ignatios's ears are longer and are more convincingly placed. Individual strands of his hair and beard are reduced to a fringed outline. The brows are furrowed and straight. The saint's nose is long and is accented by vertical strokes that connect to the inner corner of the brows. The articulation of the eyes, however, is reminiscent of the larger plaques. The saint's upper lids also extend horizontally, creases are painted above the upper and below the lower lids, and the iris is painted solid black, with no differentiated pupils. The lettering on the Ignatios plaque also resembles the inscriptions on the Group I tiles, particularly in the manner of abbreviating the word *Hagios*.

Similarities in size, style, epigraphy, and fabrication of the Walters plaques suggest that this group of tiles was created in a single workshop by closely allied ceramicists. The fairly uniform thickness of the plaques and the appearance of intersecting striations on the reverse sides may indicate that the ceramic fabric was rolled out and finished using the same method.[14] Slight differences in

facial features, however, confirm that the tiles were decorated by two or more painters, who collaborated on the decoration and lettering.

Group II

Twelve of the ceramic icons in the Walters Art Museum constitute a second group by virtue of their size and decoration (cat. A.5–A.16). The fragmentary plaque in the Benaki Museum (cat. D.1) representing a male figure holding a closed codex may also belong to this group. Of these, only the tile representing the apostle Thomas can be completely reconstructed; it measures 16.7 cm square, is 0.6–0.7 cm thick, and has beveled edges (fig. 5). The uniform format and manufacture of all the fragments, however, show that their dimensions were the same as those of the one complete tile. Each plaque represents a half-length figure of a male saint placed within a medallion with a rich amber background and a wide green frame. Heart-shaped leaves fill the corners. Group II offers us a nearly complete set of apostles, with an additional portrait of John the Baptist. Inscriptions identify eight of the apostles as Peter, Andrew, Matthew, Luke, John the Theologian, Thomas, Simon, and Bartholomew. A ninth figure, Paul, may be identified on the basis of his portrait type. Two other figures are too fragmentary to be identified securely but are clearly also portraits of apostles, most likely James and Philip. Considering John the Baptist's turned posture and outstretched hand, we can safely assume that Christ and the Virgin were once included as part of a larger composition. To this group of portraits may be added fragments from two more Walters plaques representing archangels (cat. A.17, A.18). These tiles are the same thickness as the others and were painted in the same range of colors. Thus, Group II would have comprised at least seventeen plaques, which, when assembled, represented the composition most often found on the architrave of sanctuary screens of the tenth and eleventh centuries, the expanded Deesis. I will examine the significance of this composition in the second half of this essay.

Certain details of the facial features suggest that a sin-

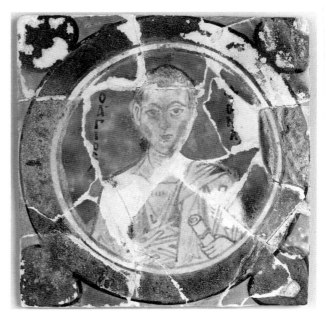

Fig. 5 Baltimore, Walters Art Museum. Saint Thomas (cat. A.5).

gle master was responsible for all of the portraits; the cheeks are picked out in patches of deep pink, and the same color is applied to the ridge of the nose and the lips. The brows meet above the nose, and the lower lid of the eyes is emphasized by the attachment of a flared line to the inner corner. Ears are carefully drawn and are slightly elongated.

Inscriptions, placed on either side of the heads, show similar letter forms and confirm that a single hand, distinct from the one that decorated the plaques from the other tile groups, was at work. The initial *omicron* is accented by a triangular breathing mark, which is counterbalanced by a triangular flourish at the end of the word *Hagios*. The *alpha* in the same word is accentuated by a thick, nearly horizontal stroke. Final *sigmas* are lunate in form, and in each instance the capital *A* is formed with a diagonal bar. The letters *theta, delta,* and *tau* are decorated with dangling triangular serifs.

The tiles in Group II are also distinguished by having Greek letters or symbols painted on their reverse sides, a feature found on tiles from Preslav, Bulgaria, but not on any other examples from Constantinople.[15] Drawn

in brush using red iron oxide pigment, the letters are placed at the center of one or both lateral edges. The letters are as follows:

Saint	Left Side of Reverse	Right Side of Reverse
Peter	N	E
Paul	O	N
John the Baptist	+ (cross)	
Bartholomew	+ (cross)	
John the Theologian	E	
Thomas	Φ	
Simon (?)	Φ	
Andrew	Φ	
Matthew	Φ	
Unidentified—Philip?	T	
Unidentified—James?		T(?)
Luke	Fragmentary letter	

The letters cannot be associated with Byzantine numbers, nor do they belong to the known apotropaic codes occasionally inscribed or painted in later churches.[16] The attribution of the group to a single master suggests that the marks on the reverse sides must have been intended for assistance in installation rather than as indicators of specific artisans. Furthermore, their addition may indicate that those installing the plaques were not involved in their initial fabrication. The evidence offered by the letters is very incomplete, and some words of caution are needed. Not all of the apostles are preserved in the Walters Art Museum, some of the tiles are fragmentary, and the figures of Christ and the Virgin are missing entirely. Nonetheless, it is clear that only a small set of letters is used on the preserved tiles and, as we shall see, that the letters help to establish some order for the series.

Group III

The third group of Walters tiles consists of only three portraits: the episcopal saint Nicholas (fig. 8), the apostle James (cat. A.21), and the female martyr Paraskeve (fig. 6).[17] All measure 16.4–16.8 cm square and have a uniform thickness of 0.6–0.7 cm. Their edges are beveled and the reverse sides are smoothed. The figures are painted in a dilute iron oxide glaze, which stands in higher relief than the more

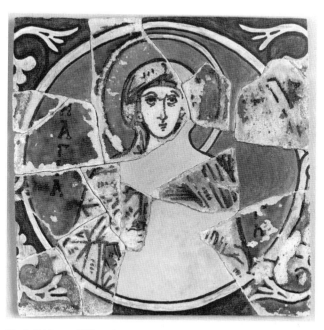

Fig. 6 Baltimore, Walters Art Museum. Saint Paraskeve (cat. A.20).

commonly used slip. The green medallions in which the half-length portraits are set are differentiated from those of Groups I and II by their distinctive white foliate frames trained into wreaths by narrow red bands. Leafy tendrils terminating in half-trefoils fill the corners of each plaque. The tendril forming the frame is knotted at either side or along the upper and lower edges of the tile. Placed next to a second plaque, the trefoils form a complete palmette, and thus provide a clue to their installation. The Paraskeve and James plaques, with lateral knots and tendrils coiling to the right and left, were intended for horizontal placement (fig. 6), whereas the Nicholas plaque, with knots at top and bottom and tendrils reaching above and below, formed part of a vertical installation (fig. 8). The continuity of the tendril design suggests that the plaques were set directly against one another, with no intervening borders or frames. That plaques were intended to be installed side by side as part of a decorative ensemble is also seen on decorative plaques from the Topkapı Sarayı Basilica (cat. XII.33)

The representation of the saints suggests that a single master worked on all three. Unlike the saints of Group I,

Fig. 7 Private Collection. Christ Pantokrator (cat. J.1).

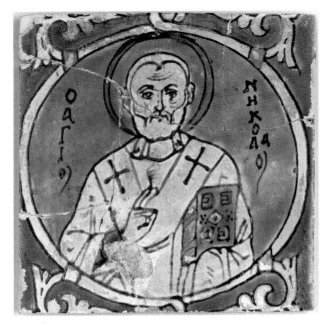

Fig. 8 Baltimore, Walters Art Museum. Saint Nicholas (cat. A.19).

which are not nimbed, these display amber haloes outlined with narrow green bands. The use of deep pink slip for highlights is another feature of this group of tiles, as is the unusually thick application of glaze, which gives these tiles a lustrous quality. Allowing for differences in sex and age, the facial features are strikingly similar. The brows, painted with thick lines, are connected by a fainter, inverted curve. The expressive eyes are creased and shadowed by blurred lines. The irises are connected to the upper lid. The nose is rendered by a single thick brush stroke on one side, and the tip is slightly flared. Whether the hands are held in a gesture of supplication or benediction, the fingers are attenuated; nails are not differentiated. The painter han-

dles the brush in a confident manner, alternating between dark and light by the pressure of the strokes. He pays careful attention to details of drapery, highlights the cloth with short parallel strokes, and renders the bent elbow in a similar fashion on all three plaques.

The epigraphy on the plaques is also consistent. The saints' names are inscribed on the right sides of the plaques, in slightly compressed form without accents. The final *sigma* in the words *Hagios* and *Nikolaos* is rendered as a curved line that descends in a dramatic flourish. The letter *alpha* on all three plaques is drawn with a diagonal bar, and on the vertical strokes of certain letters, such as the *kappa* and *nu*, the lower corner is extended horizontally, signaling where the painter lifted his brush.

A fourth tile fragment, now in a private collection in England, is a product of the same painter (cat. J.1; fig. 7). The tile is convex and smaller than the square plaques in the Walters. The central figure, Christ Pantokrator, is encircled with laterally scrolling tendrils that place the tile within a horizontal band. In the center of the plaque, set against a green background, Christ is represented in half-length. Although his head is missing, the pose, costume, and traces of long dark hair on the shoulder leave no doubts about the figure's identification. Christ raises his right hand in benediction and holds a closed codex in his left. The cover of the codex is similar in color and ornamentation to the one held by Nicholas.

Possibly related to the Group III plaques is the fragmentary base of a whiteware bowl excavated in Aksaray, in the center of Istanbul (page 252).[18] The well of the bowl is painted with a portrait of Saint Nicholas, whose facial features resemble those of the saint rendered on the Walters plaque. Even accounting for the standardization of portraits in various media, the two representations are strikingly similar. The proportions of the figures, as well as the rendering of the eyes, ears, and beard, may suggest that the same workshop produced both bowl and plaque.[19] The letter forms used on the bowl resemble those on the tile, in particular the elongated *sigma* at the end of the saint's name and sacred title.

The tiles of Group III are differentiated from those in

the other groups by their smaller size, the intense colors of their glazes, their compressed figure style, and the decorative effect created by the white foliate tendrils filling the spandrels. The provenance of this group of plaques is unknown, although they formed part of the large lot sold to the Walters. Judging by their decoration, these tiles could be the products of another workshop or of another artisan within a shop already discussed. Discovery of the stylistically related bowl within the walls of the city may be evidence that the workshop responsible for the plaques circulated its products within Constantinople, or that a consumer who purchased a bowl from this shop passed through the central district of the Byzantine capital.

Group IV

Five small plaques representing Panteleimon, Arethas, Basil, an unidentified martyr, and the Virgin and Child form a distinct group in terms of fabrication, composition, and figure style (figs. 9, 10, 24). The plaques measure approximately 17 cm square, are 0.6–0.8 cm thick, and have edges that are acutely beveled and, in most cases, double cut. Unlike the saints of Groups I–III, those of Group IV are not set within circular bands but are enclosed by the frame of the plaque, a green border with a narrow white inner strip. Only the Virgin and Child are set within a decorated arch (or canopy) supported by colonnettes—a unique composition among the tiles. The painter who worked on these plaques made wide use of aubergine-colored (manganese) glaze, especially on the vestments, and employed an amber glaze for the backgrounds. In addition, pink slip is used to highlight facial features and decorative details such as the tips of the cross held by Arethas and the ribbon binding Panteleimon's medical kit (figs. 9, 10). The fibulae worn by Arethas and the unidentified martyr (cat. A.25) are also decorated with red slip. Only one of the saints, the unidentified martyr, is nimbed. Both his representation and that of Basil are extremely fragmentary; only the upper portion of Basil's plaque can be pieced together, and only the center of the martyr's plaque survives.

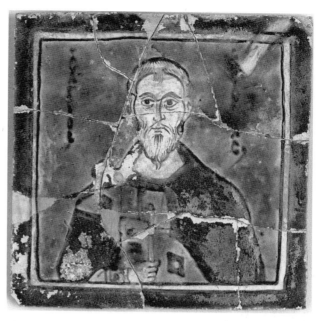

Fig. 9 Baltimore, Walters Art Museum. Saint Arethas (cat. A.22).

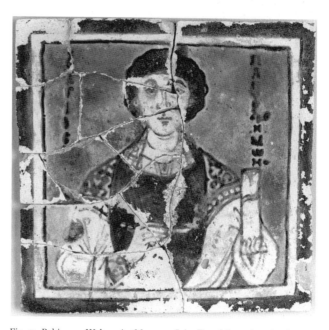

Fig. 10 Baltimore, Walters Art Museum. Saint Panteleimon (cat. A.24).

The three best-preserved tiles allow us to reconstruct the painter's method. He began with the outline of the head and upper torso. The contours of the face, whether the figure is bearded or not, are the same, with wide cheeks tapering to a narrower chin. Of all the figures, Saint Panteleimon and the youthful martyr are closest in appearance. Although their facial features are slightly blurred, one can recognize the characteristic high arched

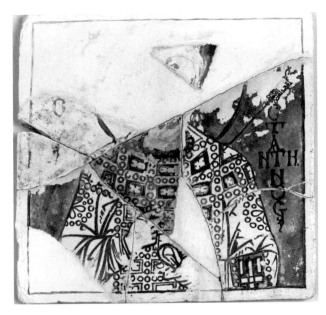

Fig. 11 Baltimore, Walters Art Museum. Saint Constantine (cat. A.27).

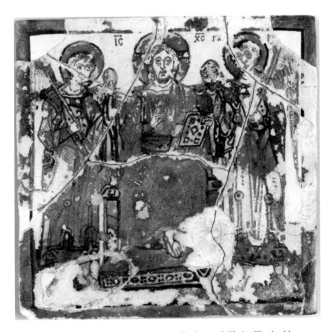

Fig. 12 Baltimore, Walters Art Museum. Enthroned Christ Flanked by Archangels (cat. A.28).

tive. There is a pronounced concern for decorative touches such as jeweled fibulae and carefully drawn and ornamented attributes.

We may assign two other plaques in the Walters Art Museum to the same group, although they lack the white inner band of the frame. The first is an unusual representation of Saint Constantine (fig. 11). The figure, framed by a green border, is set on an amber background that has the same intensity as that in the other works. Technical details support the affiliation: the tile has acutely beveled edges, and the painter employs red slip, here on the saint's hands. As in the representation of the unidentified martyr, Constantine's halo is differentiated from the amber background by a wide black band. His costume is elaborately detailed and shares the same ornamental patterns found on other portraits in the series. The continuous pearl bands on the *loros*, for example, can be seen in the beaded borders of Panteleimon's garments. The neckline of Constantine's costume is trapezoidal in shape, like those of Arethas and Panteleimon. In this portrait, particularly, the artist carefully rendered the vestments and identifying attributes: the cruciform decoration on the underside of the *loros*, the jeweled scepter-tip, the tightly held *akakia*, and the dangling *prependoulion*. What remains of Constantine's features further supports his attribution to this group. A curved line marks the connection of the chest and neck in a manner similar to that used for Panteleimon. Constantine's hair and beard, drawn of individual fine lines, closely resemble those of Arethas, and the contours of the faces are similar. There are, however, some differences in the style of this plaque, which make its attribution to this group provisional. The hands are painted in a manner much closer to that of the plaques of Group I. The thumbs are elongated, and the differentiation of the nails recalls those of Saint Christopher (fig. 3). The letter forms of the inscription, highly ornate, also differ from those on the rest of the plaques in Group IV and suggest that a second painter may have been at work or that the painter was following a more refined model.

The second tile that may belong to the group represents the Enthroned Christ Flanked by Archangels

brow, the flared tip of the nose, the soft curve of the chin, and the dimpled indentation over the upper lip. The foliate patterns that decorate their costumes are nearly identical in design, but are smudged from the slight bleeding of glaze during firing. The same pattern is employed in the spandrels of the arch above the Virgin and Child (fig. 24). Certain costume features unite the tiles into a group. The neckline of the garments, trapezoidal in shape, is distinc-

(fig. 12). The depiction of the figures in full length and reduced scale creates some differences from the more common half-length portraits. Exceptionally, the composition is set against a white background that, as in other instances, is the natural color of the tile. As with other works in Group IV, the plaque has sharply beveled edges. Red slip, moreover, is employed on the shoes of the archangels and on the clasp of the closed codex, a decorative detail similar to the colored slip ribbon binding Panteleimon's case. The archangels' wings are painted with aubergine glaze, the same treatment used on Constantine's hair and Paraskeve's mantle. Their costumes are similar to that worn by Arethas; their necklines are trapezoidal, and their *tablia* are decorated with lozenges enclosing circles in imitation of gemstones.

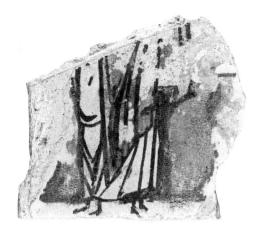

Fig. 13 Athens, Benaki Museum. Unidentified male saint (cat. D.2).

Group V

Two tiles not represented in the collection of the Walters Art Museum form another distinct group and in appearance are closer to tiles excavated in Bulgaria. Based on their individual histories, there is good reason to cluster the two tiles. In 1931, Theodore Macridy donated to the Benaki Museum a small plaque preserving the lower half of a male saint (fig. 13).[20] The fragment, which measures 5.3 cm in height, was said to be from the church of Saint Panteleimon near Beykoz. In 1924, seven years before Macridy's donation, clandestine digging had been reported within the remains of a small church at Yuşa Tepesi (near Beykoz). The Istanbul Archaeological Museum, where Macridy served as curator and assistant director, was charged with studying the site. Archaeologists identified the domed church, with three naves and a narthex, as that of Saint Panteleimon.[21] In 1931, the same year in which Macridy donated his ceramic collection to the Benaki, J. Ebersolt published a tile from the collection of Mme. Marguerite Mallon (fig. 14).[22] The tile, representing a full-length male saint, was said to be from Constantinople, but no specific site was reported. Measuring 12 cm in height, the tile is roughly twice the size of the Benaki fragment, that is, nearly the size of a complete tile,

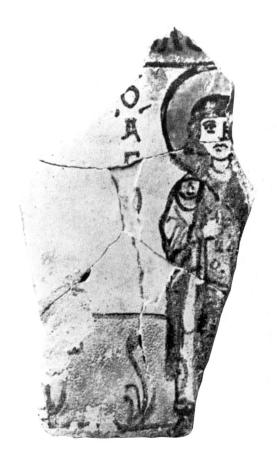

Fig. 14 Location unknown (formerly in the Mallon Collection, Paris). Unidentified male saint (cat. I.1).

and the figure proportions of the saints are the same. The Mallon tile is said to have a pink exterior and a white core. Those are traits of the Benaki tile as well; the glazes, particularly the copper green background, appear to have degraded in the same fashion.[23] Moreover, the two frag-

ments seem to have been decorated by the same hand. It is unusual to find full-length saints on Byzantine tiles, and, in both examples, the saint stands against a ground line that encloses a green field. It seems likely, given the date of their appearance in private collections and the similarity of their manufacture and decoration, that the Benaki and Mallon plaques derive from the same site. S. Eyice has proposed the ninth century as the date of the church, based on his analysis of the plan and construction technique.[24] If he is correct, the tiles associated with this structure date among the earliest found in the region of the city.

Other Plaques

A fragmentary tile with a representation of the Virgin and Child, now in the Istanbul Archaeological Museum, was excavated in the Topkapı Sarayı Basilica (cat. XII.1). Elizabeth Ettinghausen has estimated the original size to have been 18 cm square. The Virgin and Child are set within a medallion that has a white ground and a deep green frame. All that survives is a small sliver of the Christ Child's cross nimbus, most of the head and face of the Virgin, and the ligatures of her title. The delicate facial features, particularly the eyes and creased brows, resemble those of Saint Ignatios in Group I (fig. 4). Small touches of deep pink slip are used to model the nose and cheeks. In addition, the ligatures on the Topkapı plaque are in form similar to those of the Walters and Louvre Virgins. If the Topkapı Virgin is indeed related to tiles in Group I, then we can document the existence of a workshop that furnished plaques to churches on both the European and Asian sides of the Bosporus.

Three figural tiles in the State Historical Museum in Moscow are said to be from Nicomedia, although this attribution has been questioned.[25] Two are portraits of Saint George and Saint Panteleimon, and both of these are placed within medallions having green frames and heart-shaped leaves at the corners (cat. F.1, F.2). The facial features of these two saints, as well as the dimensions of the plaques, are entirely different from those of the Walters plaques. The third tile may represent Saint Michael on horseback confronting eight male figures, perhaps a scene associated with the Last Judgment (cat. F.3). The meaning of the composition is unclear, and the representation of a narrative scene is not found in any other tiles under discussion. Another tile in Moscow, representing Saint Elisabeth, is said to have been found in Cherson (cat. F.4, cat. XXII). It is unclear whether the plaque is from Constantinople.

The surviving number of figural tiles is small, and it most likely represents only a fraction of what was once produced in the tenth and eleventh century. These tiles nonetheless offer evidence about workshop practices and the uses of ceramic icons. Imperfections in both painting and glazing seem to have been acceptable in the final product. In the glaze at the upper right corner of the Arethas plaque is a wide streak created by careless handling, and the painted outline of Nicholas' fingers bled during firing.[26] Moreover, orthography proves as inexact here as in other forms of Byzantine painting. On the three tiles that represent Saint Panteleimon, for example, three different spellings appear: [ΠΑΝΤ]ΕΛΕΗΜΟΝ, [ΠΑΝ-ΤΕΛ]ΕΕΙΜΩΝ, and ΠΑΝΤΕΛΙΕΗΜΩΝ.

The similarities between the portrait on the whiteware bowl and specific tiles suggest that at least some workshops created a variety of ceramic products (see also cat. A.59, A.60).[27] Some craftsmen surely had experience painting in other media. The diversity of saints reveals a broad knowledge of sacred portraiture. Certain representations, like Constantine depicted as a solitary figure, are unusual. Some tiles may indicate a market for specific images, a point to which I will return at the end of this essay.

Considering the general absence of figural decoration on Byzantine ceramic wares in the tenth and eleventh centuries, who would have painted the figural tiles? Is it possible that painters of monumental programs turned their attention to tile decoration during the long winter months, when the damp weather curtailed their productivity? This suggestion is supported by the fact that many of the motifs and figures on the tiles can be found in Byzantine monumental decoration.

Methods of installation may also reveal the profes-

sional training of the tile painters. The decoration of at least one group, the foliate tiles of Group III, suggests that they were installed side by side, with no intervening borders or frames that might also have served to attach them to a wall. Most of the tiles are lightly scored on the reverse side, and a number have sharply beveled edges. Some preserve traces of fine white plaster, although it is impossible to identify this securely as residue from the original installation.[28] The tiles are fairly lightweight and might have been held in place by nothing more than the adhesion of a fine plaster backing;[29] if so, the striations on the reverse sides would have provided some added purchase. Although no scientific analysis has been done, we might imagine that the backing for the tiles was similar to the fine, second plaster layer to which fresco decoration was applied.[30] A section of plaster molding from the monastery of Lips, now separated from the tiles that covered it, demonstrates how, once dry, the plaster was hard and smooth (cat. VI.3).[31] The ceramic revetment could easily separate from such a surface, leaving little trace of plaster on the reverse side. We might imagine that tiles affixed using plaster would have been susceptible to damage from earthquakes.[32] Along with changes in aesthetic taste, the fragility of the tiles might account for the short life of this decorative medium in Byzantine monumental programs. Indeed, the secondary drilling of a hole in the Topkapı plaque of the Virgin and Child demonstrates how an alternative method could be used to reattach the plaque to a wall surface. In later churches in the Byzantine provinces, where ceramic plaques decorated the façade, a deep cavity was impressed into the fabric of the building and thicker cement was used as an adhesive.[33] Placed in recesses on the wall surface, these tiles were better protected, and some have survived into modern times.

In the following pages, I would like to examine how the ceramic plaques might have been used. It is clear from the wide range of sacred portraits that, in general, the tiles were meant to function as holy icons. Produced in varying sizes, the plaques may have served a variety of purposes, from components of church furnishings that

presented Orthodox history to the faithful to votive plaques that secured benefits for individual petitioners. Let us begin with a component of church decoration that was assuming a new form just as ceramic icons began to be painted in great numbers.

The Icon Screen (Group II)

Ceramic icons have long been associated with the decoration of the tall screen that separated the church nave from the sanctuary in the medieval period. Tiles from Bulgarian excavations of the Royal monastery at Preslav have been summoned as evidence that ceramic icons and ornamental bands were employed on the sanctuary barrier. By joining ceramic fragments from the Preslav excavations, T. Totev reconstructed what first appears to be a model of a sacred barrier, whose full height is only 36 cm (fig. 15).[34] The intercolumniations of the screen's colonnade are filled with diminutive icons of paired bishops rendered in frontal pose. The function of the ceramic ensemble is unknown, although it might have served as an independent shrine. While it may represent the compressed decoration of a church sanctuary, fusing the program of the interior walls with an arched barrier that stood before them, it also recalls compositions of frontal saints placed under decorative arcades in contemporary Byzantine manuscripts, as well as in other media. Evidence that ceramic tiles demarcated and adorned sacred space is found in the Byzantine capital. During the investigation of a small chapel within the Hospital of Sampson (adjacent to Saint Eirene), two ceramic columns and numerous fragments of elongated tiles were revealed at the base of three shallow niches (cat. II).[35] Whether these tiles were used to outline the niches or whether they were employed as part of a screen is unknown. However they were originally displayed, their discovery within the chapel suggests that tiles could be used to adorn the sacred east end of the church in Constantinopolitan monuments. Such a placement has also been proposed for the Topkapı Sarayı Basilica, where tile fragments were found in the eastmost sections of the church (cat. XII).

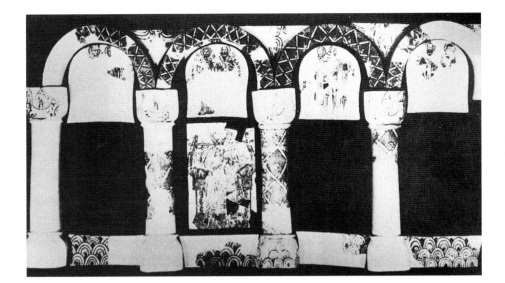

Fig. 15 Preslav, Bulgaria. Reconstruction of ceramic arches and icons.

The size, style, and subject of the tiles in Group II demonstrate that they were intended to be attached to the architrave of a sanctuary screen in imitation of compositions in more costly media, such as enamel, silver, inlaid marble, and ivory.[36] The tiles contribute important new information concerning the decoration of the templon in the tenth and eleventh century. Each of the plaques in Group II measures approximately 16.5 cm square. If the reconstruction that I propose is correct, the seventeen plaques would create a horizontal band measuring approximately 2.80 m. The width of the central sanctuary at the Myrelaion, an early-tenth-century church in which an unrelated set of polychrome tiles has been found, measures 2.70 m.[37]

The plaques of Group II, as mentioned above, comprise portraits of apostles, Saint John the Baptist, and archangels. Based on the direction in which each apostle is turned, and by comparing the order of apostles to analogous series in monumental painting and sculpture, the following order can be proposed (fig. 16):

Thomas|Simon|Matthew|[Mark]|Andrew|Paul|Angel| [Virgin]|[Christ]|John the Baptist|Angel|Peter|John the Theologian|Luke|unidentified—Philip?|unidentified— James?|Bartholomew

As mentioned above, nearly all the plaques in this group are marked with Greek letters on the reverse side. If we read the backs of the tiles from left to right, the arrangement of the letters is shown in Figure 17.

There appears to be some consistency in the arrangement of the plaques, even if the significance of the actual letters remains unclear. Those marked with the letter *tau* are placed on one side, and those with the letter *phi* are located on the other. John the Baptist, the only portrait to survive from the central Deesis, begins one side of the series with a cross on the reverse. The last tile in the same series, that representing Bartholomew, terminates with a cross on the outer side. Peter and Paul, placed adjacent to

Fig. 16 Baltimore, Walters Art Museum. Group II—obverse.

Fig. 17 Baltimore, Walters Art Museum. Group II—reverse.

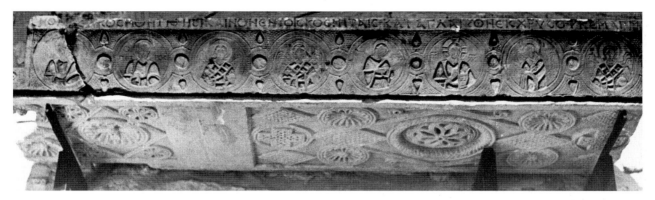

Fig. 18 Selçikler. Architrave.

the angels that flank the central Deesis, both have the letter *nu* painted toward the side of the apostles that follow.

The composition represented by the plaques in the reconstructed group is called the "expanded Deesis" by modern scholars. In the period under discussion, the composition was regularly found on the architrave of the sanctuary screen, where it represented the Church to the faithful and offered visual cues for intercessional prayers. Surviving works suggest that the scene of Deesis, either distilled to the central figures of Christ, the Virgin, and John the Baptist or expanded through the addition of angels, apostles, and saints, was the most popular subject for the architrave of the sanctuary barrier from the ninth to eleventh century.[38]

Numerous examples of marble screens carved with the expanded Deesis survive from this period, and these are close in size and in decoration to the ceramic plaques of Group II.[39] A comparable example is found in a sanctuary barrier brought to light in 1966, when Nezih Fıratlı excavated a small church in Selçikler Köyü (Sebaste) (fig. 18).[40] The carved marbles from the site include an elaborate icon screen and other liturgical furnishings. The Selçikler finds are related stylistically to other fragments from the region of ancient Phrygia, as well as an example from neighboring Lycia.[41] The Phrygian works are dated to the tenth century on the basis of inscriptions, including one on an architrave fragment in Afyon Karahisar that names the emperor Romanos I Lekapenos (919–44).[42]

The Selçikler architrave, which is incomplete, presents an expanded Deesis consisting of Christ, the Virgin, and John the Baptist flanked by four archangels and ten medallions of apostles.[43] Added to the composition is a portrait of Saint Eutychios, who may have held special importance for the church's congregation or for the screen's patron. The episcopal donor name is included in an inscription that surmounts the frieze of sacred portraits: "The bishop Eustathios, having removed the old [. . .] has wisely replaced it with a new decoration, which he beautified with gold, marble, and another brilliant and sparkling material for the [refurbishment of] the church."[44] The stone screen was painted red/ochre and then gilded.[45] The faces of the figures were left the color of the marble. The other "brilliant and sparkling material" refers to the red, green, yellow, and marine blue glass inlay used in finishing the hair and costume of each figure.

All of the figures on the frieze are rendered half-length and frontally, except for the Virgin and John the Baptist, who turn toward Christ and extend their hands in supplication. Since the name of each saint is inscribed, the sequence of portraits is secure; they read as follows:

(left) Eutychios-Thomas-Simon-Luke-Mark-Andrew-Peter
(center) Uriel-Michael-Virgin-Christ-John the Baptist-Gabriel-Raphael
(right) Paul-John the Theologian-Matthew-Bartholomew-[James?]-[Philip?]-[saint]

The order of the saints is close to the composition and the proposed reconstruction of the Walters Group II. Both sets include the Evangelists. As typical for this period, the authors of the Gospels replace several apostles, and they are placed toward the center of the series.[46] In the Walters

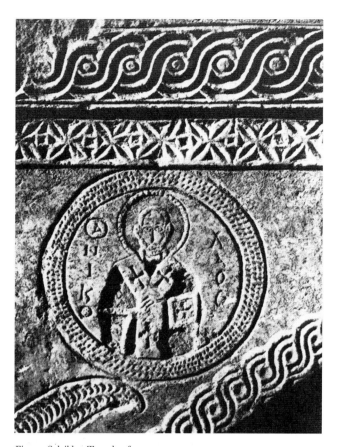

Fig. 19 Selçikler. Templon fragment.

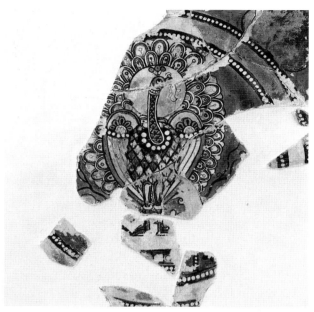

Fig. 20 Paris, Musée du Louvre. Peacock (cat. B.2).

and Selçikler sets, Andrew is located adjacent to Peter or Paul, a reflection of his status as apostolic founder of Constantinople.[47] His position indicates that the decoration of both the tiles and the carved screen visualizes the ecclesiastical ideology of the Byzantine capital.

The ceramic and marble architraves are related both in size and in their use of ornamental details. The architraves carved in western Asia Minor measure between 15 and 20 cm in height; the Walters plaques of Group II are approximately 17 cm. The red, yellow, green, and marine blue used for marble inlay are also glaze colors found on the ceramic plaques. The background of the Selçikler sculpture is painted red and is gilded. The background color of the Walters plaques is deep amber. In both media, heart-shaped leaves fill the spandrels outside the

medallions. Additional fragments from the Selçikler archivolts and templon supports are also decorated with medallions of saints. These are bordered in patterns commonly found in ornamental ceramic tiles, the looped circle and circle with four-petaled flower (fig. 19).[48]

In addition to similarities between the figural compositions, decorated marble screens and ceramic tiles share a motif that was commonly found on the lower registers of icon barriers in the Byzantine capital, the peacock. Three large plaques in Group I represent frontal peacocks with fanned tails (cat. A.29, A.30, B.2). Although different in scale, they are close in style and composition to several Constantinopolitan reliefs dated to the tenth and eleventh centuries (fig. 20).[49] The representation of peacocks on the plaques further supports the idea that icons in this medium were employed on the sanctuary barrier. The closest parallel for the ceramic representations is a carved peacock from the Lips monastery, which may have belonged to the church's tenth-century icon screen (fig. 21).[50] Ceramic plaques with ornamental patterns

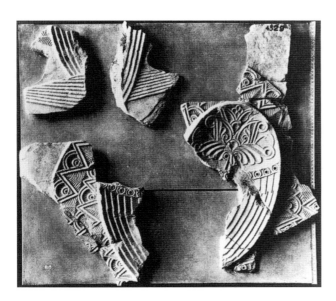

Fig. 21 Istanbul, monastery of Constantine Lips. Peacock slab.

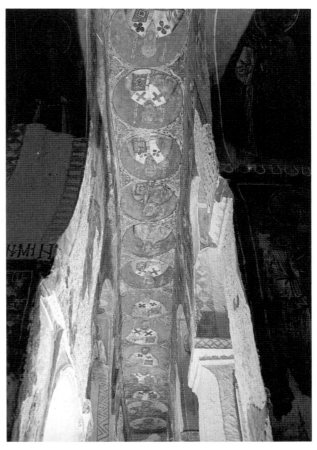

Fig. 22 Tokalı kilise. View of sanctuary corridor.

were, of course, found in the Lips monastery, as was inlaid marble, suggesting that artisans had visual access to polychrome works in both media. The size of the Group I ceramic plaques suggests that some may have been used to decorate a chancel barrier in a small chapel. With strong parallels in sculpture intended for the lowest register of the sanctuary barrier, the large peacock plaques demonstrate that ceramic tiles could be employed as an alternative medium to stone relief.

The examination of both ceramic plaques and inlaid marble architraves reveals that the media were closely linked in terms of scale, design, subject matter, color, and ornament. Ceramic plaques also imitated works in marble, both relief sculpture and larger inlaid marble icons. The interplay between the white color of the marble and the variegated tones of the inlay are mirrored in the contrast of the white fabric of the tile and the lustrous, colorful glazes. Both carved stone and painted tiles seem, in turn, to have imitated works in enamel and metal that were associated with the most lavish constructions of the period.

Votive Plaques

Other figural tiles were likely attached to the walls of churches, either to supplement a monumental program or to serve as votive plaques. Episcopal saints like Ignatios Theophoros might have been placed within the church sanctuary. A number of painted churches in Cappadocia, contemporary with the tiles, include medallions containing important bishops, and one can imagine such a use for the ceramic icons. The New Church of Tokalı kilise, dated to the middle of the tenth century, has a monumental program that has been attributed to artists from the Byzantine capital. The sanctuary corridor preserves multiple representations of prelates from Constantinople and other dioceses (fig. 22).[51] Each figure is portrayed half-

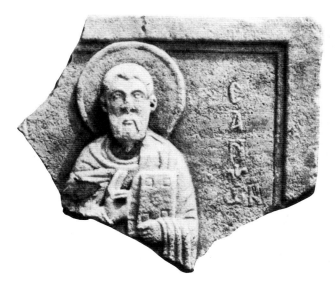

Fig. 23 Istanbul, Arkeoloji Müzeleri. Saint Sampson (inv. no. 72.59).

Fig. 24 Baltimore, Walters Art Museum. Virgin and Child (cat. A.26).

length and frontal, and the name is inscribed to the left and right of the portrait. In appearance, the portraits and their manner of installation suggest how the tiles might have been placed.

Some tiles may have served as votive panels within other parts of the church.[52] A tenth- or eleventh-century marble plaque with the representation of Saint Sampson the Xenodochos found at Edirnekapı represents the healing saint in the center of a rectangular panel, holding a codex in his left hand and raising his right hand in benediction (fig. 23).[53] The plaque measures 30 × 36 cm and is therefore of the same width as, but slightly taller than, the tiles of Group I. Healing saints find their place among the portraits on the ceramic icons, and these works may represent individual donations to churches as thanks offerings. Three plaques, for example, represent Panteleimon, the most popular physician saint in Byzantium (cat. A.3, A.24, F.2).

A number of small-scale icons used for private devotions or for votive plaques survive in such materials as metal and ivory. The plaques are similar in size, design, and subject to certain tiles in the Walters collection and suggest that ceramic icons might also have been employed in a domestic context as well as in a church.[54] A large number of ivories, often in the form of triptychs, were carved with a half-length Virgin and Child on the central panel. The composition was small in scale and intimate in meaning, intended for private prayers. As on these small

ivories, the Virgin and Child from Group IV is placed beneath an arch (fig. 24);[55] the pose and the proportions of the figures are nearly identical to those represented on the tenth-century triptychs (fig. 25).[56] The ivory plaques at the center of the triptychs measure between 12 and 15 cm in height, only slightly smaller than the ceramic plaque. Although created from different materials, the tiles present a familiar portrait of the holy mother and child. The similarity in scale and design suggests that the ceramic painters were aware of these small-scale carvings or similar ones in other media. The cost of ivory would have strictly limited ownership. Ceramic icons, with bright glaze applied to a white ground, might have substituted for the more expensive medium, providing less wealthy worshipers with a personal icon for use at home or a plaque to donate to a church.

Portraits and Patronage

As we have seen, the saints represented on Byzantine ceramic tiles range from apostles, whose portraits were most likely placed on architraves, to healing saints, whose depictions may have been intended as votive offerings. In some instances, the subject may have been chosen to satisfy a private or regional preference. Two of the Group I plaques represent the Virgin holding in front of her chest a medallion portraying her son (figs. 2, 26). In the eleventh century, the composition was often inscribed as the Virgin Nikopoios,

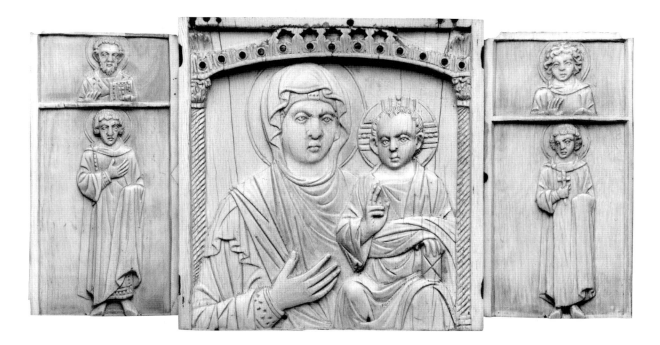

Fig. 25 Baltimore, Walters Art Museum. Virgin and Child (inv. no. 71.158).

Fig. 26 (*left*) Baltimore, Walters Art Museum. Virgin and Child (cat. A.1).

Fig. 27 (*above*) Washington, D.C., Dumbarton Oaks Collection. Lead seal of Nicholas, bishop of Prousias, eleventh century (inv. no. 55.1.4667).

but on the ceramic plaques the painter simply wrote the abbreviations for the Mother of God.[57] The image of the Virgin holding a medallion with the Christ Child was not common in Byzantine monumental decoration in the period in which the tiles were produced. The selection of this portrait type may have been dictated by regional concerns or by the wishes of specific donors. At the beginning of this chapter, I suggested that the Group I plaques, through stylistic similarities with the Düzce fragment, should be associated with Prusias ad Hypium, an episcopal seat named on the seals of three of its bishops.[58] The seal of the bishop Basil, dated to the eleventh century, has a representation of his protective saint on the obverse and a supplicatory prayer on the reverse, but those of Leo and Nicholas, dated to the ninth/tenth century and to the eleventh century respectively, were decorated with the Virgin Nikopoios type on the obverse (fig. 27). On both seals, the Virgin is labeled as Mother of God. The use of the same image on the episcopal seals and on the plaques may suggest a particular local devotion to this icon of the Virgin at Prusias ad Hypium.

The rare depiction of Saint Constantine as a solitary figure suggests that events and concerns in the Byzantine capital influenced the decoration of ceramic tiles (fig. 11). It is unusual to find Constantine represented alone; generally he is paired with his mother, Helena, with whom he shares a feast day.[59] While it is possible that Helena was represented on a separate plaque that no longer exists, another identification has been forwarded for the saint represented on the Walters tile. Constantine, who is bearded, is represented in contemporary imperial vestments. His *loros*, for example, is not draped in the traditional manner, but is a single, highly decorated panel that hangs from the shoulders.[60] Associations with the imperial saint Constantine were important for members of the Macedonian dynasty, those who reigned in the period that saw the height of ceramic-tile production.[61] The depiction of Saint Constantine as a single figure might have reflected imperial ideology of this period. In her catalogue entry in this volume, Rossitza Roussanova suggests that the Walters plaque may, in fact, represent Saint Constantine, the canonized son of the emperor Basil I. The practice of

depicting sainted members of the Macedonian dynasty is seen in other artistic media of the period.[62]

The representation of infrequently depicted figures on the ceramic tiles suggests that workshops may have produced images for private commissions. The contemporaneity of certain representations, such as that of Saint Constantine, may help to place the workshop that made these images within close range of the Byzantine capital.

Icon Frames

In addition to tiles arranged horizontally on the sanctuary screen and ones that served as individual votive panels, one set, Group III, was displayed in vertical or horizontal bands linked together by the foliate designs on their spandrels (figs. 6, 8). It is possible that these tiles, containing portraits of Saint Nicholas, the apostle James, and Saint Paraskeve, were placed in bands on the church wall. It seems unlikely, however, that we would find these three saints grouped together in one ensemble. Considering the selection of portraits and their presumed assembly, we might propose another use for these plaques, as frames for an icon. Nonfigural tiles excavated in the Byzantine capital may also have served as icon frames. Concave and arched tiles, such as those from the Topkapı Sarayı Basilica, are decorated with ornamental patterns that resemble those carved on hood moldings crowning icons on the sanctuary piers. The surviving figural tiles of Group III are intended for either vertical or horizontal installation; corner plaques would unite them in the shape of a rectangular frame. The precedent for the use of medallion portraits for frame decoration can be found on icons dated to the late tenth or early eleventh century.[63] The sacred portraits on these icons include soldiers, healers, apostles, monks, male and female martyrs, and bishops, that is, the same range of portraits—a bishop, an apostle, and a female martyr—found in the Group III tiles and more generally in the Walters collection. An example of this arrangement of figures can be seen on an eleventh-century enamel icon frame in the Dumbarton Oaks Collection, which incorporates portraits that belong to an expanded Deesis; its dec-

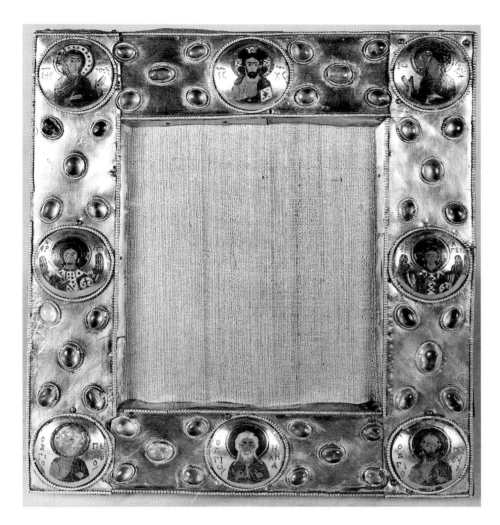

Fig. 28 Washington, D.C., Dumbarton Oaks Collection. Enamel icon frame.

oration has been related to the decoration of the architrave of the sanctuary screen, in terms of both subject and material (fig. 28).[64] The three saints in the Walters group (which presumably formed part of a larger collection now lost) are commemorated on feast days in October, November, and December, and may have formed part of a set of subjects commemorated in the first half of the Byzantine calendar.[65]

The analysis of the thirty-nine figural plaques reveals that the decoration of ceramic icons was closely allied to contemporary works in other media. In particular, the polychrome tiles seem to imitate or reflect works in marble inlay or relief. Covered with a highly reflective glaze and smooth to the touch, the carefully detailed plaques also resembled luxury works in enamel—works that were associated with the highest levels of patronage. Were the polychrome tiles a down-market substitute for those more luxurious confections? Although the figural tiles are largely without provenance, excavations have uncovered

ornamental plaques in the most prestigious monuments of the Byzantine capital.

The study of ceramic icons yields new information on workshop practices, on devotional patterns, and on church decoration. As part of the sanctuary-barrier program, they offer new insights into the demarcation of sacred, ecclesiastical space in the tenth and eleventh centuries, a period in which the decoration of the architrave served as the visual focus for intercessional prayers. As panels intended to facilitate private devotion and to secure divine assistance, the ceramic icons take their place with votive panels created in precious metals, stone, and ivory. Quickly painted and fired, tiles could easily be made to order, either for the church or for devotional use in the home. Their light weight would have made them more easily portable and an attractive alternative to parallel works in marble.

For a period of two centuries, polychrome tiles were installed in a wide variety of buildings in the Byzantine

capital and its nearest provinces. By the twelfth century, judging from archaeological evidence, ceramic icons were no longer being made or installed in Constantinopolitan churches. But in the tenth and eleventh centuries, polychrome icons formed part of the colorful images that reveted the interior walls of the capital's finest buildings. Despite their fragmentary condition, the polychrome icons provide us with a glimpse of the "brilliant and sparkling materials" for which Byzantium was known and envied.

Notes

1. This number includes tiles that were excavated or sold in Istanbul or the surrounding region. The eleven figural tiles outside the Walters Art Museum are located in the Musée du Louvre, the Istanbul Archaeological Museum, the State Historical Museum in Moscow, the Benaki Museum, a private collection, and an unknown location (last published as part of the Mallon Collection). Presumably, more tiles with figural decoration are to be found in private collections.

2. Few of the figural tiles have previously been exhibited or published. Arethas, Nicholas, and Ignatios were exhibited in Athens in 1964 for the show entitled *Byzantine Art, an European Art;* Arethas, Nicholas, Christ Enthroned, and Panteleimon were exhibited at Dumbarton Oaks in 1994–95 for a show entitled *Byzantine Ceramics: Art and Science;* Arethas and Nicholas were included in *The Glory of Byzantium* in New York, 1997. The Walters tiles have been published in Verdier, "Byzantine Tiles," 1–2 (Nicholas, Constantine, and Arethas [identified as Proklos]); idem, "Tiles of Nicomedia," figs. 1, 2 (Enthroned Christ, Apostle Simon); Lauffenburger and Williams, "Byzantine Tiles," 67–83 (Nicholas and Constantine).

3. For a tantalizing history of the two collections, see Durand, "Plaques," 25–50.

4. Mason and Mango, "Glazed 'Tiles of Nicomedia,'" 313–31, and the essay by Marlia Mango in this volume.

5. Oğan, "Les fouilles," 334, pl. lxxx; Ettinghausen, "Byzantine Tiles," 82–83, pl. xxxvi; *AMY* 6 (1965), 105–6, pl. 8. The figure of the Virgin and Child, 6170 P.T., is on exhibition in the Istanbul Archaeological Museum. The orant, represented on a concave plaque, has been published only by E. Ettinghausen and is not on display.

6. Istanbul Archaeological Museum, inv. no. 6545 P.T.; *IAMY* 10 (1962), 13.

7. Papanikola-Bakirtzi et al., *Benaki Museum,* 12.1.

8. For the chemical composition of the clay and glaze, see the essay by J. Lauffenburger, C. Vogt, and A. Bouquillon in this volume.

9. A note, dated 1968, in the curatorial files of the Walters Art Museum, records a conversation between Philippe Verdier and Miss Kutlay Çamurdan, a student at Istanbul University who had written her thesis on Byzantine tiles (I have been unable to obtain a copy of the thesis). Written in Verdier's hand, the note records: "A curator of the Archaeological Museum of Istanbul, Mr. Gamurdan [*sic*], mentioned confidentially that the Byzantine tiles of which we have a group were excavated clandestinely at the site of the ruined church of Prusias ad Hypium."

Despite this information, in 1983 Verdier wrote: "In the Istanbul museum a partly preserved head of a saint (inv. 6545) comes, as Nezih Fıratlı kindly informed me, from a church at Prusias ad Hypium, modern Üsbübü [*sic*] (Düzce), in the former province of Bithynia. From information I received some twenty years ago the tiles shared between the Louvre and the Walters Art Gallery would come from the site of Nikertai, near Apamea in Phrygia." Verdier, "Tiles of Nicomedia," 633. The archives of the Louvre also preserve a document that relates the tiles to Düzce. A marginal note on an inventory from the Department of Christian Antiquities, now in the Coptic Section of the Musée du Louvre's Department of Egyptian Antiquities, records: "M. Firatlı, conservateur du Musée archéologique d'Istanbul communique que toute cette série de céramique provient de Prusias ad Hypium, aujourd'hui Uskubé en Asie Mineure (9 juillet 1963)." See Durand, "Plaques," 29 n. 30. The 1992 catalogue for the exhibition *Byzance,* held at the Louvre, gave Üskübe (Prusias ad Hypium) as the findspot for the tiles. See *Byzance,* 388. In a conversation in 1999, Mrs. Saliha Gönenç, curator of the Byzantine Collection at the Istanbul Archaeological Museum, informed me that the Düzce tile (6545 P.T.) was found in the foundation trenches for the construction of a hospital in Üsübü Village, near Düzce.

10. For a description of Üsübü, see A. N. Rollas, *Konuralp—Üsübü Kılavuzu: Guide to Prusias-ad-Hypium* (Istanbul, 1967).

11. For episcopal registers and hagiographic texts that mention Prusias ad Hypium in the medieval period, see W. Ameling, *Die Inschriften von Prusias ad Hypium,* Inschriften griechischer Städte aus Kleinasien 27 (Bonn, 1985), 222–26.

12. E. McGeer, J. Nesbitt, and N. Oikonomides, eds., *Catalogue of Byzantine Seals at Dumbarton Oaks and in the Fogg Museum of Art* iv (Washington, D.C., 2001 [forthcoming]), nos. 9.2, 9.3 (with previous bibliography and comparanda). The seal of the bishop Leo is dated to the ninth/tenth century; the seal of the bishop Nicholas is dated to the eleventh century. I thank John Nesbitt for his assistance.

13. This fragment may belong to the Louvre plaque.

14. See the essay by Lauffenburger, Vogt, and Bouquillon in this volume, pages 76–77, for technical evidence that supports the group's integrity.

15. Letters are incised on the reverse sides of tiles found at Patleina, Bulgaria. See I. Gospodinov, "Excavations at Patleina," *Izvestija na Arheologičeskoto druzhestvo* (Bulletin of the Bulgarian Archaeological Institute) 4 (Sofia, 1914), 125; V. N. Zlatarski, "Sur l'histoire du monastère à Patlëïna près de Preslav," *Izvestija na Arheologičeskoto druzhestvo* (Bulletin of the Bulgarian Archaeological Institute) 1 (1921–22), 156; Miatev, *Keramik,* fig. 63. Zlatarski suggests that the letters were guides for installation. I thank R. Roussanova for her assistance in translating the Bulgarian material. See also Vogt and Bouquillon, "Technologie," 113.

16. See G. Babić, "Les croix à cryptogrammes peintes dans les églises serbes des xiiie et xive siècles," in *Byzance et les Slaves,* Mélanges Ivan Dujčev, ed. S. Dufrenne (Paris, 1979), 1–13.

17. The inscription begins with a *pi* and terminates in *gamma eta.* See cat. A.20 for a discussion of the spelling of the saint's name.

18. Istanbul Archaeological Museum, inv. no. 84.8 Ç.Ç. This bowl is being published by Ms. Asuman Denker, curator, Istanbul Archaeological Museum.

19. For another example of a motif that appears on both a bowl and a plaque, see cat. A.59, A.60.

20. Papanikola-Bakirtzi et al., *Benaki Museum,* 12.1.

21. E. Mamboury, "Les fouilles byzantines à Istanbul et dans sa banlieue immédiate aux xixe et xxe siècles," *Byzantion* 11 (1936), 248–49; Janin, *Églises centres,* 12–13. The church of Saint Panteleimon is mentioned in Procopios, *Buildings,* i, ix, 11–12. The architectural description of the small building as domed and having three aisles and a narthex, as well as the discovery of medieval tiles either within its walls or in close proximity to it, raises questions about the structure's early Byzantine date or phases of construction. The date of the building has also been questioned by S. Eyice. See note 24 below.

22. See J. Ebersolt, "Céramique et statuette de Constantinople," *Byzantion* 6 (1931), 559–60, pl. 22; D. Talbot Rice, "Byzantine Polychrome Pottery," *Burlington Magazine* 41 (1932), 281–82. According to Talbot Rice (282), "the Saint published by Ebersolt is executed in much thinner and washier colours than are other plaques from Constantinople or Bulgaria." Talbot Rice assigned the tile to the pre-Iconoclastic period on the basis of its decorative technique and its "strikingly Hellenistic" style. This date can no longer be sustained. In a later article, Talbot Rice noted that "quite a number [of tiles] have been found in or near Constantinople in clandestine excavations; many of these have already appeared on the market. One of the most important, in the Mallon collection, has already been noticed by Ebersolt. It bears the figure of a Saint, standing full length, with his title and name on either side of his head; unfortunately the actual name has perished. Other fragments with similar human figures upon them, also presumably from Constantinople, are in the Benaki collection at Athens, but the figures that these bear are not Saints, but would appear to be connected with the Alexander legend." Talbot Rice, "Polychrome Pottery," 74, fig. xxviii.1. Talbot Rice may have realized the connection between the Benaki and Mallon tiles.

23. This observation is based on the published photograph of the Mallon piece.

24. See S. Eyice, "Remarques sur deux anciennes églises byzantines d'Istanbul: Koça Mustafa Paşa camii et l'église du Yuşa tepesi," *IX CEB,* i (Athens, 1955), 190–95.

25. Talbot Rice, "Polychrome Pottery," 74; *Iskusstvo Vizantii v sobranijah SSSR,* ii (Moscow, 1977), nos. 476–79. Since I have had no opportunity to examine the Moscow tiles, I shall not include them in the broader discussion.

26. A discussion of the Nicholas and Arethas tiles in *The Glory of Byzantium* finds their general condition to be poor, "with no traces of plaster or mortar, as if they were faulty discards or unneeded surplus. The explosion of an impurity during firing may have caused the loss on the body of St. Nicholas, where a calcite inclusion appears as a white pebble in the clay. The glaze ran in the second saint's inscription, and it was scraped and smeared at the top of the right column." See E. Dauterman Maguire, "Tiles with Portraits of Saints," in *Glory of Byzantium,* 44. There is no reason to believe that these tiles were wasters.

27. See Peschlow, "Byzantinische Keramik" 373, 405–6, and the essay by M. Mango in this volume.

28. One fragment in the Thierry Collection is deeply scored and preserves traces of plaster (cat. H.3). It has proved difficult to determine whether the tiles were cleaned prior to sale.

29. Weight measurements for complete tiles are as follows: Thomas (Group ii), 315 g.; Nicholas (Group iii), 344 g.; Enthroned Christ Flanked by Archangels (Group iii), 329 g.; Arethas (Group iv), 390 g.; Panteleimon

(Group iv), 396 g. None of the tiles in Group i is complete enough to provide an accurate weight measurement. E. Ettinghausen informs me that Islamic tiles were attached to the walls by means of plaster.

30. On the use and composition of plaster in Byzantine monumental decoration, see D. C. Winfield, "Middle and Later Byzantine Wall Painting Methods: A Comparative Study," *DOP* 22 (1968), 64–79.

31. Mango and Hawkins, "Additional Finds," 311, figs. 47, 48.

32. For eleventh-century earthquakes in Constantinople, see V. Grumel, *Traité d'études byzantines,* i, *La chronologie* (Paris, 1958), 480.

33. For late Byzantine decorative tiles, see B. Papadopoulou and K. Tsouris, "Late Byzantine Ceramics from Arta: Some Examples," in *La ceramica nel mondo bizantino tra xi e xv secolo e i suoi rapporti con l'Italia,* ed. S. Gelichi (Florence, 1993), 254–58; S. Kissas, "Peline anaglyphe ephyalomene eikona Stavroseos apo ten Aroniada Valtou," in *Aetoloakarnania* (Acts of the First Archaeological and Historical Conference) (Agrinion, 1991), 362–65. My observations on installation were made on site.

34. Totev, "L'atelier," 65–80; idem, "Keramičnata ikona s Hristos na tron," *Preslav* 3 (1983), 72–79; idem, *Preslavkata keramična ikona* (Sofia, 1988), fig. 43; *Byzance,* 388; Durand and Vogt, "Plaques," 44. For a recent analysis of this reconstruction, see J.-M. Spieser, "Le développement du templon et les images des Douze Fêtes," in *Les images dans les sociétés médiévales: Pour une histoire comparée (Bulletin de l'Institut Historique Belge de Rome)* 69 (1999), 137–38. For the hypothetical reconstruction of an icon screen with portraits of apostles in Tuzlalâka, see V. Putzko, "Preslavkij keramičeskij epistilij," *Preslav* 4 (1993), 138–50.

35. Dirimtekin, "Fouilles," 161–85.

36. For screens decorated in silver, see the homily by Photios and the *Vita Basilii,* which describes the sanctuary screens in the church of the Virgin of the Pharos and the Nea Church. The texts do not mention figural decoration. See Mango, *Sources and Documents,* 186, 194. For screens in enamel, see the *Vita Basilii,* which describes the decoration on the sanctuary barrier of Christ the Savior. See Theophanes Continuatus, *Vita Basilii,* v, 87, 18, in *CHSB* xlviii (Bonn, 1838), 330. Translated in Mango, *Sources and Documents,* 196. For a slightly different translation, see Cutler, *Hand of the Master,* 281 n. 16. It has been generally accepted that seven enamel plaques (the Archangel Michael, Christ's Entry into Jerusalem, the Crucifixion, the Anastasis, the Ascension, the Pentecost, and the Koimesis of the Virgin), now incorporated in the Pala d'Oro, once ornamented a sanctuary screen in the Pantokrator Monastery. See A. W. Epstein, "The Middle Byzantine Sanctuary Barrier: Templon or Iconostasis?" *Journal of the British Archaeological Association* 134 (1981), 2–5, for discussion and collected bibliography. See also S. Bettini, "Venice, the *Pala d'oro,* and Constantinople," in *Treasury of San Marco,* 35–64. For a small enamel fragment of similar date and quality found in the excavations of the south church of the Pantokrator monastery and bearing a representation of Christ or an apostle, see A. H. S. Megaw, "Notes on Recent Work of the Byzantine Institute in Istanbul," *DOP* 17 (1963), 348, figs. 16, 17. K. Weitzmann reconstructed the decoration of at least one screen from ivory panels. See "Diptikh slonovoi kosti iz Ermitazha, otnosyashchiisja k krugu Imperatora Romana," *VizVrem* 32 (1971), 142–55 (repr. as "An Ivory Diptych of the Romanos Group in the Hermitage," in *Byzantine Book Illumination and Ivories* [London, 1980], no. viii); idem, "An Ivory Plaque with Two of the Forty Martyrs of Sebaste in the Glencairn Museum, Bryn Athyn, Pa.," in *Euphrosynon: Aphieroma*

ston Manole Chatzedake, II (Athens, 1992), 704–12. This assertion has been challenged by A. Cutler.

37. See Striker, *Myrelaion,* 23

38. C. Walter, "A New Look at the Byzantine Sanctuary Barrier," *REB* 51 (1993), 212.

39. A ninth-century architrave carved with the Deesis, now in the Archaeological Museum of Thebes, measures 15 cm high and preserves five medallions divided by narrow trefoils. The architrave was originally decorated with fifteen portraits and would have measured 2.20 m. See A. Orlandos, "Glypta tou Mouseiou Thebon," *ABME* 5 (1939–40), 126–28; *Byzantine Art, an European Art,* 134–35. A fragment in the Archaeological Museum at Chios (acc. no. 327) also measures 15 cm in height and is carved with medallions that enclose representations of Saint John the Theologian and Saint Isidore. See *Byzantine Art, an European Art,* 139; A. K. Orlandos, *Monuments byzantins de Chios* (Athens, 1930), pl. 7. A fragment of an architrave from a large church in Thessalonike is carved with representations of three apostles. See M. Chatzidakis, "Iconostasis Panel with Three Apostles," in *Glory of Byzantium,* 43. For a textual reference to another screen decorated with the same subject, see Michael Attaliates' *diataxis* for the monastery of Christ tou Panoiktirmonos (1078), which states that "the templon has at the center the Deesis and the *Life* of the venerable and holy Forerunner [John the Baptist]." P. Gautier, "La diataxis de Michel Attaliate," *REB* 39 (1981), 891.

40. Three fragments of the icon screen were uncovered in 1963 by antiquities traders. Fıratlı, "Sébaste," 151–66; idem, "Uşak-Selçikler Kazısı ve Çevre Araştırmaları, 1966–1970," *TürkArkDerg* 19 (1971), 109–60.

41. Many of the pieces had been collected in the yard of a secondary school at Afyon Karahisar. The related fragments with figural decoration include: (1) marble fragment, measuring 20 cm in height, representing Philip, Makarios, Luke, Panteleimon (W. H. Buckler, W. M. Calder, and W. K. C. Guthrie, *Monumenta Asiae Minoris Antiqua,* IV, *Monuments and Documents from Eastern Asia and Western Galatia* [Manchester, 1933], 13, no. 40, pl. 17); (2) white marble fragment, 19 cm high, representing Christ and John the Baptist—the fragment is inscribed ". . . mayst thou intercede with my Lord on behalf of the monk . . ." (W. H. Buckler and W. M. Calder, *Monumenta Asiae Minoris Antiqua,* VI, *Monuments and Documents from Phrygia and Caria* [Manchester, 1939], 122, no. 359, pl. 62); (3) the central section of a screen decorated with an abbreviated Deesis, which was found in the ancient agora at Smyrna and may have been carved in the region of Phrygia for export to the coastal city—the inlaid fragment has been dated to the tenth or eleventh century (A. Orlandos, "Christianika glypta tou Mouseiou Smyrnes," *ABME* 3 [1937], 128–52; Grabar, *Sculptures* II, 48–49, pl. XV); and (4) a fragment from the same group, now in a private collection in Munich—the marble fragment, 15.2 cm high, represents the healing saint Damian (M. Restle, "Bruchstück eines Templon-Epistyls," in *Rom und Byzanz: Archäologische Kostbarkeiten aus Bayern,* ed. L. Wamser and G. Zahlhaas [Munich, 1998], 22–23). The provenance of the fragment is given as Greece or the islands. For a Lycian fragment, excavated at Xanthos and decorated with three medallions containing the Deesis, see J. -P. Sodini, "Une iconostase byzantine à Xanthos," *Actes du Colloque sur la Lycie Antique,* Bibliothèque de l'institut Français d'Études Anatoliennes d'Istanbul XXVII (Paris, 1980), 119–48.

42. A fragment from Afyon Karahisar is inscribed ". . . the year 6446 in the reign of Romanos." The year falls during the reign of Romanos I

Lekapenos (919–44). See Buckler, Calder, and Guthrie, *Monumenta Asiae Minoris Antiqua,* IV, 12. For other inscriptions dated to the tenth century and a comprehensive discussion of inlaid marble beams, see Sodini, "Une iconostase byzantine," 135.

43. In his published reconstruction, Fıratlı proposed the existence of three additional medallions.

44. ['O ποι]μενάρχης Εὐστάθιος ἐμφρόνως ἔνθεν παλαιὰν ἐξάρας δυ[. . .]ν κόσμον τίθησι καινὸν ἐν τοῖς κοσμίταις καταγλαΐζων ἐκ χρυσοῦ κὲ μαρμάρον ἄλλης τε λαμπρᾶς καὶ διαυγοῦς τῆς ὕλης ναοῦ πρὸς εὐ[. . .]. Fıratlı, "Sébaste," 162.

45. Ibid., 161.

46. On the selection of apostles, see G. de Jerphanion, "Quels sont les douze apôtres dans l'iconographie chrétienne," in *La voix des monuments: Notes et études d'archéologie chrétienne* (Paris, 1930), 189–200.

47. F. Dvornik, *The Idea of Apostolicity in Byzantium and the Legend of the Apostle Andrew* (Cambridge, Mass., 1958).

48. The architrave fragment from Thebes is similarly decorated with a guilloche pattern on its underside. This pattern is found on ornamental tiles from the Hippodrome and the Topkapı Sarayı Basilica.

49. For the use of peacock feathers on Byzantine ornamental tiles, see the essay by J. Anderson in this volume, pages 119–22.

50. Fıratlı, *Sculpture byzantine,* 190–91, no. 407. Two additional peacocks are associated with the decoration of the church. See ibid., 191, nos. 408, 409; Mango and Hawkins, "Additional Finds," 179, figs. 13, 14. A peacock, associated with a sanctuary screen, was also found in the church of Saint John of Stoudios. The plaque measures 54 cm high and 66 cm wide. Fıratlı, *Sculpture byzantine,* 166–67. A third frontal peacock, a marble relief now on Mount Athos, is flanked by two heart-shaped leaves that fill the upper corners of the carved plaque. Medallions on the Walters and Louvre plaques are also framed by wide, heart-shaped leaves. The plaque, which is immured over the main gate to the Xeropotamou Monastery on Mount Athos, measures 80 × 80 cm. See Th. N. Pazaras, "Closure Panellate," in *Treasures of Mount Athos* (Thessalonike, 1997), 241–42.

51. Wharton Epstein, *Tokalı Kilise,* 27–28, 67; Jolivet-Lévy, *Les églises,* 102–8.

52. For a discussion of votive plaques in the church, see C. Walter, "The Origins of the Iconostasis," *EChR* 3 (1971), 260.

53. Istanbul Archaeological Museum, inv. no. 72.59. Fıratlı, *Sculpture byzantine,* 82, no. 141, pl. 48. For a brief biography of this saint, see *ODB* III, 1837.

54. For metal votive plaques, see S. Boyd, "Ex-Voto Therapy: A Note on a Copper Plaque with St. Hermolaos," in *Aetos: Studies in Honour of Cyril Mango,* ed. I. Ševčenko and I. Hutter (Stuttgart and Leipzig, 1998), 15–27.

55. The columns on an ivory plaque of the Virgin and Child in the Universitätsbibliothek in Leipzig are ornamented with ribbon decoration. This decoration is identical to the ribbon pattern represented on the Walters tile (fig. 24).

56. Cutler, *Hand of the Master,* 174–84.

57. On the representation of this type of Virgin, see W. Seibt, "Der Bildtypus der Theotokos Nikopoios: Zur Ikonographie der Gottesmutter-Ikone, die 1030/31 in der Balchernenkirche weideraufgefunden wurde," *Byzantina* 13 (1985), 551–64.

58. See note 12 above.

59. Among the representations in which he is depicted alone is a full-page miniature from a manuscript attributed to the first half of the eleventh century and now found in Princeton. *Illuminated Greek Manuscripts from American Collections: An Exhibition in Honor of Kurt Weitzmann,* ed. G. Vikan (Princeton, 1973), 96, no. 18, fig. 30.

60. For this aspect of imperial vestments, see P. Grierson, *Byzantine Coins* (Berkeley, 1982), 31.

61. *Vita Basilii,* III, 216. For the role of Constantine in the self-imaging of the Macedonian emperors, see C. Jolivet-Lévy, "L'image du pouvoir dans l'art byzantin à l'époque de la dynastie macédonienne (867–1056)," *Byzantion* 57 (1987), 456–70; A. Markopoulos, "Constantine the Great in Macedonian Historiography: Models and Approaches," in *New Constantines: The Rhythm of Imperial Renewal in Byzantium, 4th–13th Centuries* (papers from the Twenty-sixth Spring Symposium of Byzantine Studies, St. Andrews, March 1992), ed. P. Magdalino (Aldershot, 1994),

159–70; K. S. Schowalter, "The Absence and Presence of Emperors: Reading the Mosaic of the Southwest Vestibule, Hagia Sophia, Istanbul," *Byzantine Studies Conference Abstracts* 24 (Lexington, Ky., 1998), 24–25.

62. See cat. A.27. For other examples of this practice, see S. Gerstel, "St. Eudokia and the Imperial Household of Leo VI," *ArtB* 79 (1997), 699–707.

63. K. Weitzmann, "Fragments of an Early St. Nicholas Triptych on Mount Sinai," *DChAE,* 4 (1964–65), 12–13, fig. 9.

64. See, for example, M. C. Ross, *Catalogue of the Byzantine and Early Medieval Antiquities in the Dumbarton Oaks Collection,* II, *Jewelry, Enamels, and Art of the Migration Period* (Washington, D.C., 1965), no. 154.

65. The feast days are as follows: Nicholas (6 December), James (15 November), Paraskeve (28 October).

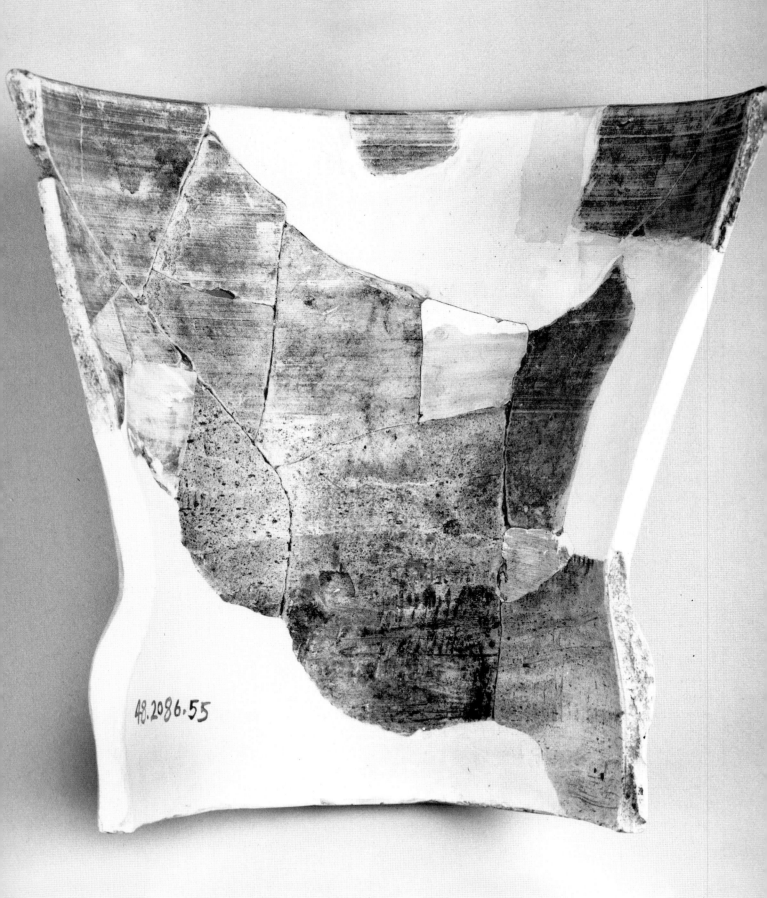
48.2086.55

Technical Insights into the Working Practices of the Byzantine Tile Maker

JULIE A. LAUFFENBURGER,
CHRISTINE VOGT, AND ANNE BOUQUILLON

 The catalogue in this volume displays the range of tiles produced for buildings in the Byzantine capital. Questions of archaeological context, subject, and ornament of the tiles, which belong to a group of ceramics defined as whitewares due to their white to buff color upon firing, are explored in other essays in this volume. This study uses the collections in the Walters Art Museum and the Musées du Louvre and Sèvres to discuss the technical aspects of the tiles, including clay-body composition, methods of manufacture, and glaze and slip application. While the tiles are not associated with a known archaeological site in Istanbul, results of previous scholarly work by the authors strongly suggest the Istanbul area as their place of origin.[1] The large number of tiles in the Walters, Louvre, and Sèvres museums provides an unprecedented opportunity for a comprehensive technical study of this rare decorative medium (fig. 1). Strong visual connections among the tiles, supported by similarities in glaze and body compositions, establish the cohesive nature of the Walters, Louvre, and Sèvres holdings, linking them to other tiles excavated in Istanbul.[2] In this essay, we have established smaller groupings within the whole, which may represent different hands or possibly developments within single or multiple regional workshops.

Little evidence has been found to identify manufacturing sites of Byzantine polychrome tiles. Chemical studies comparing tiles from Preslav, in Bulgaria, and those in the Louvre and Sèvres museums (presumed to be from Constantinople or the surrounding region)[3] clearly distinguish two different main clay sources, suggesting that separate polychrome-tile industries flourished, one in Preslav and one in Constantinople.[4] Indeed, production factories have been found at Preslav and the surrounding area.[5] Archaeological information, however, has proved of little help in pinpointing production sites in or near Constantinople. A single waster, or misfired fragment, has been found at the Topkapı Sarayı Basilica (cat. XII.9), and some wasters from white-bodied vessels have been recovered at the Kalenderhane Camii.[6]

Rolling Out

While information on specific sites may not be forthcoming from these tiles, the detailed study of the Walters, Louvre, and Sèvres tiles provides information about the manufacture of tiles and about workshop practices. Previous articles by Christine Vogt, Jannic Durand, and Anne Bouquillon have established the basic steps involved in the rolling-out and cutting of a tile. The workable ball of clay, which had a fairly

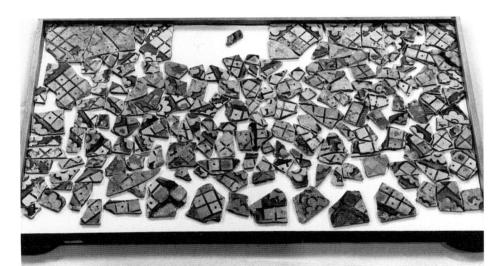

Fig. 1 One of twenty drawers of polychrome tiles in the Walters collection.

homogeneous texture, was flattened with the palm of the hand in order to create a slab of more or less regular thickness and shape (fig. 2a and b).[7] Different methods were used to prevent the damp clay from adhering to the work table. In some cases, the surface may have been coated with sand.[8] Some medium-sized sand or quartz inclusions are visible on the reverse of many of the tiles. Because the tile body also includes fair amounts of quartz added as temper, however, it is unclear whether the inclusions seen on the reverse side are the result of a separating layer of sand or are simply exposed inclusions. A second method of rolling out was to work the clay using a cloth separator,[9] a technique that left impressions on numerous fragments in the Walters but on none from the Louvre.[10] One example that is particularly well preserved shows a fairly loose, plain-weave textile consisting of nine warps and nine wefts per square centimeter (cat. A.61; fig. 3). The use of a woven textile as separator was also noted on tiles from the Sèvres museum and at Preslav.[11] This technique is still used in contemporary tile production.

The clay was thinned with a wooden roller, using guides set parallel to each other in order to maintain a fairly uniform thickness (see fig. 2c and d).[12] The Walters, Louvre, and Sèvres tiles range in thickness from 0.5 to 0.9 cm. Within a single tile the thickness may vary by 0.1 cm. The tiles are thickest at the center and often taper slightly at the edges. Depending on the original flattening of the clay by hand and the exact measure of the guides, this rolling method could easily produce such discrepancies.

Cutting

A wooden or metal template cut to the desired size and shape of the finished tile could be laid over the flattened clay and the tile shape cut with a blade.[13] Only after the tile had dried to a nearly leather-hard state, that is, dry enough to be handled, would the edge be finished with an acute (beveled) or rounded cut. A beveled edge would have permitted closer placement of finished tiles arranged in a series[14] and would have allowed for a shift in the placement angle of some of the convex and concave cornice tiles. Physical evidence for this method of installation is seen in a surviving example of two closely spaced border tiles from Constantine Lips (cat. VI.3), where the tiles are laid directly next to each other on a molded stucco core, forming an obtuse angle at their point of connection. Minor variations in tile or plaque size within an established group, such as the apostle plaques within the Walters collection (cat. A.5–A.16), indicate that the final dimensions of individual tiles may have been altered slightly in the trimming or beveling stage, and suggest that each tile was most likely cut out freehand. This group in particular has acutely beveled edges, created in some instances with a double cut of the blade. Original thickness and degree of shrinkage would also contribute to the overall finished dimensions.

The choice of a rounded or a beveled edge appears to have been a personal one, and different choices may perhaps indicate the work of different hands. While all of the small icons are finished with beveled edges, rounded edges are more common on the large square plaques, one indication that different craftsmen could perhaps have been involved in the two sets of tiles.[15] Among the large and small square plaques, both figural and ornamental, the choices between rounded and beveled edges appear to correspond to other observed differences in body and glaze composition, discussed later in this essay.

a

b

c

d

Fig. 2 Preparation of a plaque from a ball of clay.

Given the remarkable absence of warping on all of the tiles, a system for even and slow drying was apparently well established. Tiles were probably set on laths in order to allow the water content to evaporate evenly from both faces.[16] Once a tile was cut to size, the surface could be smoothed with a moistened hand or cloth[17] to obtain a homogeneous, nearly slip-covered surface.

Finishing

Once dried to a near leather hardness, the tile was turned over and worked from the reverse. It is clear from the physical evidence that most of the Walters, Louvre, and Sèvres tiles were worked in this manner prior to firing. There are indications of scraping from the back, probably to ensure the even thickness of the tiles and potentially to aid in the physical bond between the tiles and the substrate upon which they were to be placed.

Three different techniques were used to finish the reverse side of the plaques. The most common involved what appears to have been a large flat scraper, which created shallow grooves when granular temper such as quartz and iron oxide inclusions were dragged across the surface, a feature seen on the reverse of most tiles. The use of this tool resulted in a series of fine parallel striations on the reverse.

Second, a series of fine, closely spaced striations visible on the reverse of several of the large square plaques appears to result from a single pointed tool that was dragged along the tile surface. In many cases, the lines intersect at the corners of the plaque (fig. 4).[18]

Fig. 3 Textile weave impression on reverse of A.61.

Third, other tools created deep gouges and scrapes, especially evident on the Walters small figural tiles of the apostles and angels (cat. A.5–A.18). Traces of a scraping tool that produces a blunt edge followed by deep parallel scratches approximately 1–1.3 cm in width and divided into six demarcations (fig. 5) can be seen on the two Walters tiles decorated with portraits of Saint Andrew and an unknown saint, perhaps James (cat. A.12, A.15). The marks suggest a straight-edged, toothed scraper, a tool that is still commonplace among contemporary potters' equipment. Blunt-edged scrapers of differing widths and configurations were also used on the reverse of two figural plaques framed

Fig. 4 Intersecting lines defining the corners on the reverse of A.2.

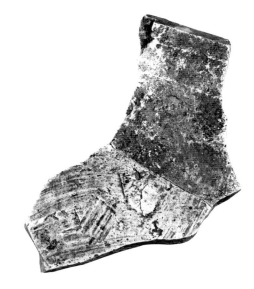

Fig. 5 Toolmarks on reverse of A.15.

Fig. 6 Toolmarks on reverse of A.25.

by square borders. A small blunted tool measuring 0.6–0.8 cm across was used on the reverse of the Saint Basil plaque (cat. A.23); recesses formed by the use of a bifurcated tool measuring 0.8 cm across were found on the plaque with an unidentified saint from the same group (cat. A.25; fig. 6). In both cases, the tool was used in a sweeping diagonal motion that extended beyond the edge of the plaque.

Two differing methods for cutting the individual tiles can be detected on the reverse sides. For many of the large square plaques, such as the Virgin and Child and Saint Christopher (cat. A.1, A.2), the existence of a distinctive series of crosshatched lines demonstrates that the dimensions of the tiles were determined before finishing the reverse. These lines intersect at each of the four corners (fig. 4). This implies that these tiles were cut and finished individually. The apostle plaques, intended to be installed as a series, have tool marks that extend beyond the edges of the individual tiles. These tiles were cut from a larger clay slab, possibly the same one (fig. 7). Unfortunately, the fragmentary state of the plaques and the absence of some of the tiles prevent us from aligning the finishing marks in order to reconstitute the production sequence.

Outlines and Sketches

Once the tiles were cut to shape, finished, and completely dry, the decorative process began. The smoothed surface of each tile was ready to receive the painted design. A bold red-brown outline was applied using a solution composed of iron oxide or hematite particles, possibly diluted with clay to form a slip.[19] In excavations at the monastery studio on the Tuzlalâka hill near Preslav, traces of a brown iron oxide "dye" were found in clay bowls used in the ceramic production process.[20] In cross section, the floating pigment particles can clearly be seen sitting beneath vitrified glaze (fig. 8).[21]

On the figural plaques, the outline of the circular

medallion was drawn first. Mechanical means of reproducing the medallions may have been employed. For the large plaques of Saint Ignatios (cat. A.4) and the Virgin and Child (cat. A.1), a compass was used to establish the circular border.[22] Depressions, which correspond to the center of the circles, are visible on both tiles. In the case of the Ignatios plaque, amber glaze extends into the depression, confirming that it was created before firing. It is likely that other circular outlines were produced in the same way, yet many of the tiles are too fragmentary to provide supporting evidence. No compass marks are found on the small figural plaques with circular borders. Given their small size and relatively thick line application, a template may have been employed to delineate the medallions. The remaining decorative patterns and figures appear to be executed freehand by a painter well acquainted with Byzantine ornament. The lines are sure and evenhanded while maintaining a certain freedom and directness.

One of the most intriguing and unique features of the tiles in the Walters collection is the presence of painted sketches on many of the reverse sides. Because they were unprotected by glaze, the sketches are often in poor condition. In many cases, the bulk of the red-brown pigment and slip has flaked away, leaving only small particles embedded in the rough tile surfaces. Twenty-two tiles have some sort of letter or sketch painted on the reverse. The same iron oxide slip used for the painted outline on the obverse of the tiles was used to create these sketches. The large number of sketches found on the Walters tiles is noteworthy; other sketches are found on tiles from the Topkapı Sarayı Basilica (cat. XII.32) and the church of Saint John Stoudios (cat. D.5) and on a tile fragment from Preslav.[23]

The significance of the letters on the reverse side of the apostle plaques has been discussed in the previous essay. Technical analysis establishes the production sequence. Splotches of green glaze over the *epsilon* marking the reverse of the portrait of Saint John the Theologian (cat. A.10; fig. 10) demonstrate that the letters were applied before firing. We may assume the same application sequence for the sketches found on the reverse. If the

Fig. 7 Toolmarks extending over the edge on reverse of A.9.

Fig. 8 Cross section of A.70, showing pigment particles (at center) floating beneath vitrified glaze. Image taken in backscatter mode on a scanning electron microscope at 330× magnification.

sketches had been painted after firing, they would have remained water soluble and fugitive and would have disappeared over the centuries.

With the exception of the letters on the apostle plaques and a small foliate design on the reverse of the Saint Nicholas plaque (cat. A.19), the sketches are found exclusively on the ornamental tiles; they include human, animal, geometric, and abstract forms. In general, sketches on the reverse bear no relationship to the designs on the obverse, either in subject or in orientation. Because of the often sig-

Fig. 9 Appearance of outline on A.54 where glaze has flaked off, leaving slip or paint behind.

Fig. 10 *Epsilon* on reverse of A.10, painted in slip and covered with glaze drip.

nificant differences between the degree of finish found on the fronts and backs of the tiles, we can confidently say that these drawings were not mistakes that would require the craftsman to turn the tile over to begin again.

In some cases, the sketches are fully realized, such as on the large plaque with a broad floral motif (cat. A.39). The reverse of the plaque shows a fairly elaborate geometric pattern that once filled the entire surface. The complete nature of the sketch is unusual among the tiles. Considering the complexity of the pattern, the painter may have availed himself of a practice effort in order to hone his skills. Four ornamental tiles have sketches of the human form: a fragment of a hand and halo (cat. A.44), a bearded saint (cat. A.46), the forehead of a male saint (cat. A.71), and a head in profile (cat. A.53). Numerous other decorative patterns have sketches on their reverse (cat. A.34, A.49, A.53, A.54, and A.55). The quality of line varies from broad to fine, suggesting that several hands were at work.

The process of applying the outline raises interesting questions about technique. Did the craftsman make use of an underdrawing painted in iron oxide slip followed by an amber or brown glaze application that traced and completely covered the original line? Or was the application of the outline a one-step process, whether executed in slip or dilute glaze? As previously mentioned, macroscopic examination shows similarities between both the painted outlines on the front of the tiles and the drawings found on the reverse. The primary difference is that the outline on the front is covered with one or more colored glazes. Firing changes the optical property of the line because it increases saturation and decreases the scattering effect of light. The result is a line of much deeper color and intensity than the original red-brown slip as applied. Examination of the cross sections of glaze and drawn line supports the theory that only a single line was drawn for the decoration, a one-step process instead of two. Sections reveal pigment particles covered directly with a single glaze; the glaze extends well beyond the confines of the line, with no intervening layer. Figure 9 shows an area of outline on the front of a tile whose glaze has flaked away to reveal the painted iron oxide slip beneath. If a two-step process was involved, we have yet to see any evidence, such as a misstep revealing the preliminary line beneath.

Careful inspection of the outlines on all of the tiles reveals two different methods of achieving the same effect. In the majority of cases on the Walters tiles and on all of the Louvre and Sèvres tiles, the outline is first drawn with a sliplike material, colored deep red-brown with iron oxide. The colored and clear glazes are then applied locally. The

applied glaze saturates the drawn lines, which when fired turn a deep brown-black color and appear vitreous. Supporting evidence for this method can be seen on the reverse of the small icon of Saint John the Theologian, discussed above, in which the Greek letter *epsilon,* drawn in iron oxide slip, has been partially covered by glaze drips from the front of the tile. Where the line was covered with glaze, it is vitreous and dark brown-black in color, whereas the unglazed areas of the slip retain the color and quality of the red-brown pigment (cat. A.10; fig.10).

A second technique is only seen on the small figural plaques of the saints James, Paraskeve, and Nicholas from the Walters collection (cat. A.19–A.21). On this set of tiles the quality of the line differs. The line has a more three-dimensional appearance and varies from opaque brown-black to completely transparent amber (cat. A.19; fig. 11). The effect is achieved by the single application of a highly colored glaze-slip mixture. When fired, the mixture resembles a highly viscous fluid that may have been extruded from a pouchlike container[24] with a focused tip, similar to today's cake-decorating implements. In either example, only a single execution of the outline has been observed.

At times we are left with other small signs of the craftsman at work. A drawing on the reverse of a flat rectangular plaque painted with concentric circles (cat. A.54) has a small thumb- or fingerprint over the sketch. This trace of the master supports the premise that the reverse was painted (and handled) prior to firing. Fingerprint impressions have also been noted on one of the large square plaques in the Louvre and on a tile in the Dumbarton Oaks Collection (cat. II.17), as well as on mold-made column bases from Preslav.[25]

Glaze Application Sequence

Once the initial red-brown outlines were sufficiently dry, colored glazes were applied in localized areas. The glazes used on the Walters, Louvre, and Sèvres tiles are of a consistent palette, which includes amber and brown colored by iron oxide, green colored by copper oxide, aubergine colored by manganese oxide, blue colored by cobalt

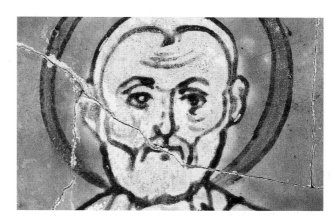

Fig. 11 Detail of drawn line on A.19.

oxide, and a clear glaze. In addition to glazes, colored slips highlight facial features and decorative details. The colors of the slip, which range from light pink to deep red, could be adjusted by adding varying proportions of differing metal oxides as colorants—here, iron and possibly manganese oxides.

While the palette used on the tiles known to be excavated in Istanbul is similar to the one described above, there are variations in the intensity and shade of the glazes, as well as in the execution of outline. These differences can best be seen by examining identical patterns from different sites or collections. When comparing the paired acanthus leaves from the Walters (cat. A.62) with a tile excavated in Saint John Stoudios (cat. X.3), the differences in execution are apparent. Based upon Julie Lauffenburger's observations of the actual tiles, both the green and amber glazes from Stoudios are brighter and more vibrant in color than the Walters examples and the line thinner and less sure in execution. The sure execution of line and the consistency of the shade and hue of the glazes unify the majority of tiles from the Walters, Louvre, and Sèvres.

Other technical aspects that unify the Walters and the Louvre tiles and distinguish them from other Constantinopolitan examples are the absence of gold leaf and the limited use of cobalt blue. The use of gold is seen on tiles from the Myrelaion and the Boukoleon, as well as on a tile found at Haydarpaşa (cat. XVI.1) and a few tiles in the

Fig. 12 Interaction zone between clear and green glaze on A.9.

Sèvres museum,[26] but is not found on any of the Walters or Louvre tiles. Among the more than two thousand tiles and fragments from these latter collections, only the plaque representing the Enthroned Christ Flanked by Archangels (cat. A.28) is decorated with cobalt blue. The virtual absence of blue glaze may indicate a scarcity of the raw material necessary to create the color and may point toward the elevated cost of a precious commodity. The deteriorated state of the cobalt on this plaque suggests an elemental incompatibility in its glaze composition. During this period, cobalt was used more liberally in other workshops within the capital. This use is demonstrated by ornamental tiles from the Sèvres museum (cat. C.6, C.7, C.13, C.14)[27] and Dumbarton Oaks Collection (cat. II.15, II.17, II.19) and others from the Topkapı Sarayı Basilica (cat. XII.11, XII.20, XII.27, XII.31, XII.36), which incorporate this glaze in their design. The restricted use of cobalt blue and gold on the Walters and Louvre tiles suggests a distinctive workshop practice and perhaps a commission or commissions based on a more limited budget.

The application of a colorless and transparent glaze was the final step before firing. Examination of the Walters and now the Louvre and Sèvres tiles indicates that clear glaze, like the colored glazes, was contained by the painted outlines. Clear was applied only to discrete areas where the white reserve of the clay body was meant to be exposed. An interaction zone between clear and colored glaze is often seen on the Walters tiles. It is evident in these cases that the clear glaze extends slightly over the others, and the mixture creates a diluted area of color (fig. 12). The thickness of the clear glaze varies dramatically among the tiles. A thick application covers the faces on the apostle plaques (cat. A.5–A.16), while the clear glaze on the figure of Nicholas (cat. A.19) is barely visible and forms only a thin skin against the unglazed tile body. This difference in glaze quality is mirrored in the varying characteristics of the outline.

Firing

Once completely dry, the tiles were fired at a fairly low temperature of about 800° C.[28] The low temperature resulted in little or no penetration of the glazes into the body, creating an insufficient glaze-body interaction zone (fig. 13). The absence of this interaction zone may have contributed to the poor bond between glaze and body and may have played a role in the instability of the glazes. The presence of the same discrete layers of glaze and ceramic body in cross sections of tiles excavated at the Hospital of Sampson (cat. II) in the Dumbarton Oaks Collection suggests a comparable firing technique and temperature within regional workshops.

Minor surface and glaze imperfections on the Walters tiles have been described in the catalogue as "acceptable manufacturing flaws." In a discussion of the Nicholas and Arethas tiles, E. Dauterman-Maguire posited that the tiles were wasters.[29] Our study indicates otherwise. The imperfections would have been visible before firing (cat. A.22). If the level of finish was not acceptable, the tiles would have been rejected before they reached this stage of production. The height and distance at which many of the tiles would have been installed, moreover, might have minimized the impact of small imperfections.

Method of Fixing Plaques to Walls

No existing archaeological record indicates the exact manner in which the tiles were installed. Close study of the

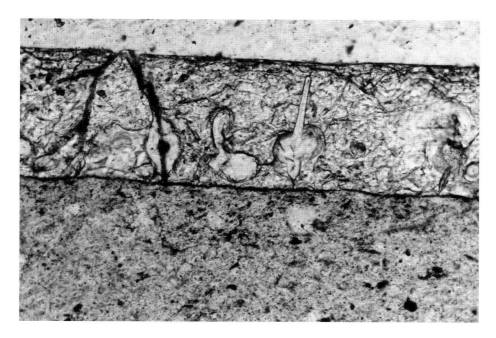

Fig. 13 Thin section from A.39, taken at 40×, showing discrete glaze layer sitting on top of fired ceramic body.

tiles, however, provides some new information. The lightly or deeply scored finishing marks on the reverse may have been intended to roughen the surface texture of the tiles in order to facilitate their adherence to a molded material such as plaster. The single preserved example of a tile still attached to a plaster support is our only true reference (cat. VI.3). Few fragments preserve traces of plaster or mounting mortar on their reverse sides. The fragment from the church of Constantine Lips reveals how a tile fragment could separate cleanly from the smooth plaster surface. Small amounts of a white plaster-like material is found on the reverse of several tiles in the Walters collection, and a plaster backing is cited on the reverse of a tile from the Boukoleon that may have been employed on a cornice (cat. I.B.1).

Moreover, the reverse sides of the tiles of the Louvre and Sèvres museums do not bear any traces of mineral mortar, either lime or plaster, which would have allowed them to be affixed to the walls or cornices. This led the authors previously to assume that another ancient adhesive, such as ichthyo-glue,[30] which is known to have been used to attach mural mosaics in Constantinople, was probably used. This fixing process could also have been

combined with a slight embedding of the tiles into the setting bed covering the stonework or brick of the building.[31]

Fabrication of Unique Forms Within the Walters, Louvre, and Sèvres Collections

Convex, concave, and half-capital profiles present more complex fabrication sequences than the flat plaques. While all three profiles are present in the Walters, Louvre, and Sèvres collections, the majority of the tiles have a convex shape; this corresponds to finds from sites in Constantinople. The convex and concave tiles were probably shaped around a wooden or plaster form,[32] but unlikely one of fired ceramic.[33] Sand or a woven fabric was used as a separator, or release.[34] Allowing the tile to dry on the form supported the shape and minimized warping.[35] Finishing marks, sometimes on both obverse and reverse surfaces, indicate that the clay was first worked as a flat slab, which was subsequently shaped and dried.

For vessel-like forms, the craftsman had to employ a pottery wheel.[36] Fragments from three half-capitals in the Walters were clearly shaped in this manner (fig. 14). The complete vessel shape was first thrown on the wheel. When

it was semidry, the bottom of the vessel was cut off, and the walls were scored vertically along the interior of opposite sides, dividing the vessel into two equal halves. After drying, the outline and glaze were applied, and the vessel was fired. Finally, the vessel was broken along the scored lines. The vertical edges of the capitals, including the glaze, show signs of fracture, supporting the theory that the vessels were cut following glazing and firing. Cutting the clay before firing would have weakened the integrity of the shape and resulted in warping. As with glass cutting, the scored line in the pottery created a point of weakness where the vessel could easily be snapped or broken.

Throw lines from the reverse of two well-preserved half-capitals at the Walters, cat. A.72 and A.73, do not match up, indicating that they were from two separate vessel shapes. It is possible that one half of the complete vessel was discarded, since it is unlikely, given the production technique, that both halves would have survived in usable form. The bases of all capital fragments were trimmed and further shaped by scraping. Forms turned on a wheel during the manufacturing process contrast with hand-built or mold-made capitals and column bases found in Constantinople and in Preslav.[37] This technical feature also reinforces the idea forwarded in other essays that workshops produced both tiles and tablewares.

Physical Evidence for Workshops: Refinements Based upon Scientific Analysis

Comprehensive study of the tiles helps to unify the Walters, Louvre, and Sèvres tiles into a cohesive group that is distinct from, yet related to, fragments excavated in Constantinople and the surrounding region. By combining visual examination with scientific analysis, we can further refine the groupings to separate out two major clusters within the collection. For this analysis, we have employed Neutron Activation Analysis (NAA)[38] and Inductively Coupled Plasma-Mass Spectrometry (ICP-AES/MS).[39] These tests, which were used to compare major, minor, and trace elements in the ceramic-body compositions, assist in the establishment of discrete ceramic groups. We

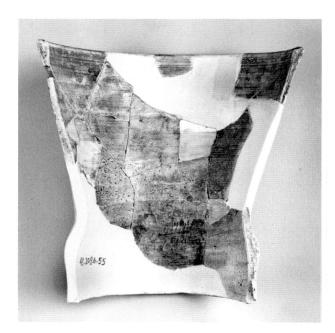

Fig. 14 Wheel and finishing marks on interior of A.72.

have also used thin-section petrography to characterize the ceramic-body type[40] and Scanning Electron Microscopy (SEM) equipped with Energy and Wave Dispersive Spectroscopy (EDS and WDS) to examine differences in glaze composition.

Icon Plaques and Their Physical Characteristics

Foremost, it is important to note two fairly unique characteristics of the Walters and Louvre tiles. First is the large number of figural plaques (only one in the Louvre), virtually nonexistent among excavated tiles within Turkish collections. While other figural plaques do exist, the majority of known examples are found among the tiles produced in Bulgaria.[41] Second is the use of large square plaques for both figural and decorative motifs. This format, seen in twenty-one examples from the Walters and Louvre, appears to be unusual among tiles produced in the Byzantine capital.

Large Square Figural and Decorative Plaques

As mentioned above, many of the large square plaques are distinguished by finishing marks on their reverse that intersect at the corners and define the final size and shape of the plaque. The large plaques share an overall thickness of 0.8–0.9 cm; the smaller plaques average 0.5–0.7 cm.

Unlike the small figural plaques, however, which are all finished with beveled edges, many of the large square plaques have rounded edges. The only large plaques to have beveled edges are those representing Saint Ignatios (cat. A.4), the Virgin and Child, peacock, acanthus leaf, and rosette (cat. B.1–B.4). The reverse side of the Ignatios tile also displays a different finish, consisting of short, staccato-like strokes without any pronounced orientation.

Small Square Plaques: The Apostle Plaques
(cat. A.5–A.16)

The apostle plaques measure 0.6–0.7 cm in thickness and have acutely beveled edges that are occasionally double-scored. This group is characterized by particularly deep scrape marks on the reverse. Small vestiges of what may have been plaster or stucco used to attach the tiles in an architectural setting remain in the recessed lines of two tiles (cat. A.5, A.6). When comparing tool marks on the reverse, two variations emerge. In the first group, deep scratches predominate. These generally originate from the lower left corner and extend in a sweeping motion diagonally and horizontally (cat. A.8, A.9, A.12, A.13; fig. 7). Tiles in the second group are finished with primarily horizontal and vertical striations using different tools, including a single point and a toothed, blunt-edged scraper measuring 1–1.3 cm wide (cat. A.5–A.7, A.10, A.11, A.14–A.16).

Small Icons Encircled by Foliate Frames
(cat. A.19–A.21)

These three tiles, measuring 0.6–0.7 cm in thickness, are distinguished by slightly beveled edges that were created with a single cut. The tiles exhibit less working from the reverse than those in the apostle group. The reverse of the Nicholas plaque is marked by long thin-toothed scrapes that run parallel (cat. A.19). The Paraskeve and James plaques both have indications of a textile pattern on their reverse (cat. A.20, A.21).

Small Icons with Squared Frames
(cat. A.22–A.28)

The tiles of this group are distinguished by sharply beveled edges, a double score along the cut edges, and an increased thickness of up to 0.8 cm. This approaches and in some cases equals the thickness of the large square plaques. Marks on the reverse of the Saint Basil plaque (cat. A.23) and on that of an unidentified saint (cat. A.25) show indications of a tool cutting into the wet clay in a sweeping motion that originates in the upper right corner and extends to the lower left (fig. 7). Although not specifically the same tool at work, the reverse of the Enthroned Christ Flanked by Archangels (cat. A.28) shows the same sweeping and cutting motion. These specific cutting actions indicate that, like many of the large square plaques, the tiles were cut from the clay matrix before they were worked on the reverse.

Finishing marks on both the Panteleimon (cat. A.24) and Arethas (cat. A.22) plaques show a pronounced diagonal motion, though in a direction opposite to that on the tiles noted above. The fabric of both tiles had a high proportion of red and black iron oxide nodules, which left shallow tapered grooves after dragging. The other tiles in this group, Saint Constantine (cat. A.27) and the Virgin and Child (cat. A.26), show neither a preferred orientation in the working of the reverse sides nor the use of a specific tool. An overriding feature of the reverse of the majority of tiles in this group is the presence of large quartz inclusions measuring 0.1–0.3 cm in width.

Petrographic Characterization

Samples were taken from six tiles in the Walters collection that corresponded to visually distinctive groupings. Ten ornamental tiles of different shape and size from the Sèvres museum were also analyzed in thin section. Microscopic examination revealed that the samples were all made from a similar class of ceramic body, composed of a soft whiteware, slightly birefringent and phylliteous matrix with some elongated air bubbles, oriented parallel to the surface of the tile, which were formed during the

rolling process,[42] and with added aggregate of varying type and proportion. Aggregate or added materials include quartz, iron oxide, and organic temper, noted only on examples from the Walters.[43] Given the large amount of added material, it is unlikely that the clay materials were levigated.[44] Sieving the initial clay would have slowly removed the coarse quartz and some of the iron nodules, leaving the potter with purer clay, but this level of preparation was not achieved. The large quantity of silica, which occurs naturally in clay deposits and may be supplemented with sand, was desirable and would provide stiffness to the structure and help reduce buckling or distortion while also reducing shrinkage during the drying phases.[45] Differences among the samples consist of variations in size and relative proportions of the added inclusions.[46] Moreover, the "marbly" aspect of the body of a few samples from Sèvres seems also to indicate that two kinds of clay were mixed and that this mixture was not sufficiently kneaded.[47]

Samples of the Walters collection were taken from cat. A.33 (whorl), cat. A.4 (Ignatios), cat. A.7 (John the Baptist), cat. A.11 (Peter), cat. A.24 (Panteleimon), and cat. A.56 (acanthus scroll). In all but one instance, the same tiles had also been analyzed by Neutron Activation Analysis (NAA), which measures the amount of minor and trace elements in the ceramic body. These samples from the Walters and Sèvres collections are characterized by a light tan to light gray color in plane polarized light and low birefringence under crossed polars. The clay is tempered primarily with quartz, of both angular and rounded morphology, in the range of 20–25 percent—crystals range from smaller, single quartz crystals to larger chunks of polycrystalline quartz—and in some cases small amounts of cristobalite. The relatively large quartz fraction may have been added as either clean sand or crushed quartz, since it is not consistent with the very small quartz grains one would expect with a fine light-colored clay; the smaller quartz grains may have come in with the clay itself. Hematite was recorded as only a minor inclusion in the sections sampled, and yet visual examination under a binocular microscope showed a variety of red to black particulate inclusions, thought to be iron oxides. Additionally, small amounts of chlorite and needle-like mullite, a product of vitrification, were noted in the sections of Saint Panteleimon (cat. A.24) and Saint Ignatios (cat. A.4).

This petrofabric is most similar to that of sherds from whiteware vessels examined and analyzed by R. B. Mason.[48] In his article, this author also sites a correlation in the raw material, especially quartz, between the petrofabric of the tile and that of the pottery associated with Iznik.[49] This composition also related most closely to samples identified as Istanbul 1, 2, and 3 by Mason.[50]

The presence of only a small amount of what appeared to be cristobalite and mullite, alteration products of quartz that fully form at 1100° C, indicates and further substantiates the relatively low firing temperature of the tiles, under 900° C, first computed by C. Kiefer more than forty years ago.[51] Because of the very minor proportion of cristobalite, a firing temperature below 900° C is proposed. At this general temperature, it is possible that hot spots occurred in a few locations within the tiles, allowing the minerals to begin to metamorphose in those isolated areas only.

Neutron Activation and ICP-AES/MS Analysis

The separation of the production of whiteware tiles in the Middle Byzantine period into two regional industries, one centered at Preslav and the other near or within Constantinople, provides a foundation upon which to base future studies of related collections. Given the general similarities in the appearance of tiles made at the two centers, and the chemical differences in glaze and body compositions, it does appear that while the technology may have been transported from place to place, raw materials were derived locally.

Forty-eight samples in the Walters collection, initially separated into groups according to differences in their physical appearances in cross section, received Neutron Activation Analysis (NAA). The tiles were loosely arranged into six groupings. For the sake of comparison, and to secure Istanbul as the place of production, some samples were also taken from tiles excavated from the Hospital of

Sampson now in the Dumbarton Oaks Collection.[52] It is interesting to note that while the divisions were made solely on the basis of clay-body type, they also corresponded to art-historical categories established through stylistic analysis. The divisions were as follows: Group I included all of the large figural plaques (cat. A.1–A.4), peacock (cat. A.30), rosette (cat. A.33), Constantine (cat. A.27), and six ornamental tiles (cat. A.48, A.54, A.61, A.63, A.70, A.72). It is described as white body with few, tiny inclusions—multiple orange, some black metallic, some quartz. Group II included all of the apostle tiles (cat. A.5–A.16). It is described as white body with few, tiny inclusions—orange, red, black metallic and some quartz (slightly higher proportions of all inclusions than in Group I). Group III included the plaques of Arethas and Panteleimon (cat. A.22, A.24). The fabric is characterized by a white body, numerous black metallic inclusions, and quartz.[53] Group IV included portraits of Saints Nicholas, Paraskeve, and James (cat. A.19–21). The fabric is characterized by a white body, few tiny red metallic inclusions, many large and small quartz inclusions, and an occasional large terracotta inclusion. Group V included only the Enthroned Christ Flanked by Archangels (cat. A.28). The tile has a pink-colored body with numerous red inclusions.

At the outset, it is important to say that because of the heterogeneous nature of clay bodies, caused by the large number and range of inclusions examined, the specific amounts of trace elements in any given drilled sample may vary considerably. This was proved when ten drillings from the same tile did not cluster well together either in dendrograms or in bivariate plots, two of the methods used to measure statistically the relationships gained in NAA analysis. This is not to say this type of analysis is meaningless for the tiles. Some tiles showed a close association using several different critical comparisons. It is these groupings that are most important to our study.

Results

Most of the tiles from the Walters collection belong to one broad compositional group. In fact, the mean concentration values of all of the tiles are not very diverse. Using two different clustering programs to create dendrograms, several groups of tiles appear to be related internally no matter how the data are compared. The slight differences between them might suggest the use of different clays or clay batches.

All of the large square plaques, both figural and decorative, with the exception of Saint Ignatios (cat. A.4), cluster together in both dendrogram plots, suggesting a single clay batch (figs. 15, 16). These results parallel the research of Sharon Gerstel, who places these icons in a distinct grouping. The Ignatios plaque falls outside the group in both plots, again confirming observations made by Gerstel, who separates the Ignatios plaque from the other large plaques.

Samples from Arethas, designated as Byzantine Tile 29 (BT29), and from Panteleimon (BT4), both stylistically related tiles, cluster together in all three dendrograms; the Saint James plaque, while stylistically different, also clusters together with these. The two remaining tiles, stylistically related to James, Nicholas (BT27, cat. A.19), and Paraskeve (BT26, cat. A.20), form a separate grouping.

Several possibilities present themselves. It is possible that all of these tiles were made in the same workshop using two different batches of clay, which, though related, were used to make two of one pattern and one of the other. The close links, which parallel those of style and execution, are intriguing and are surely more than coincidental.

Samples BT20–BT21 from the apostle plaques (cat. A.5–A.16) form a loose association that is nonetheless consistent, with each clustering technique showing a loose cluster hovering about the upper half of the chart (figs. 15, 16). The plaque representing the Enthroned Christ (cat. A.28) loosely clusters at the top third of the dendrograms and is consistently linked with sample BT24, taken from the tile representing Saint Peter (cat. A.11).

Of the ornamental tiles analyzed (BT32–BT37), samples BT33 (cat. A.63), BT34 (cat. A.72), BT35 (cat. A.54), and BT36 (cat. A.70) all cluster at the bottom of the chart together with the large icons of Saint Christopher, the Virgin, the peacock, and the rosette. Samples BT32 (cat.

```
Selected Elmnt List:  MN NA AS LA SM LU CE CO CR CS EU FE HF RB SC TA TB TH
Data Transformation:  Calculations were made using log transformed data.
Distance Meas. Used:  Squared Euclidean Distances were calculated.
Clustering Procedure: Mean within.
```

```
  BT43-.
  BT46-'-.
    BT47-'---.
       BT09-'---.
          BT02-'---.
      BT10-.           I---.
      BT11-'--------'     I
   BT22-.                 I---.
   BT23-'---.             I   I
      BT37-'-.            I   I
     BT25-.    I-.        I   I
     BT32-'---' I         I   I
         BT08-'---.       I   I
    BT14-.          I-.   I   I
    BT24-'-.        I I   I   I
      BT45-I        I I   I   I
      BT20-'-------' I    I   I
     BT03-.          I-. I    I
     BT28-'---.      I I I     I
         BT29-'-----' I I     I
   BT38-.             I-' I
   BT44-'-.           I   I
     BT21-'---.       I   I
        BT39-'-------'    I
      BT26-.              I-.
      BT27-'--------------' I
    ·BT13-.                   I-----.
     BT15-'--------------------'    I
   BT04-.                     I-.
   BT05-'---.                 I I
       BT06-'---.             I I
          BT07-'--------------------' I
                              BT17-'---------.
                                    BT16-'-------.
                                          BT19-'-------.
                                                BT18-'------------.
   BT31-.                                                          I
   BT48-'---.                                                      I
      BT30-'-----.                                                 I
         BT01-'---------.                                          I
              BT12-'--------------------------------------------'
   BT41.                                                           I
   BT42-'-.                                                        I
     BT40-'-----.                                                  I
        BT35-'-------------.                                       I
      BT33-.               I-----------------------------------------'
      BT34-'-------.       I
          BT36-'---------'
```

Fig. 15 Dendrogram; mean-within clustering procedure.

A.61) and BT37 (cat. A.48) generally fall within the upper region of the dendrograms.

Beyond purely stylistic similarities, we do see some patterns emerging. The large figural and decorative plaques, with the exception of Saint Ignatios, appear to be related more closely to each other than to the small figural plaques. Furthermore, several of the ornamental tiles sampled also have a closer association with the large figural and decorative plaques, regardless of their design. In general, the large square plaques and ornamental tiles cluster at the bottom of the dendrograms, while all of the small figural plaques cluster in the middle or the top. This point raises the possibility of two different workshops at hand. Given that the general body composition is so similar, the differences observed may also indicate different clay batches or slight shifts in composition over a short period within a single workshop.

Most of the tiles from the Louvre and Sèvres museums also belong to the same broad compositional group. Nevertheless, two subgroups may be defined, the second one constituted by a single sample, cat. C.43, which has slightly higher potassium oxide and iron oxide contents.

```
Selected Elmnt List:   MN NA AS LA SM LU CE CO CR CS EU FE HF RB SC TA TB TH
Data Transformation:   Calculations were made using log transformed data.
Distance Meas. Used:   Squared Euclidean Distances were calculated.
Clustering Procedure: Natures' groups.
```

Fig. 16 Dendrogram; natures-groups clustering procedure.

The Walters, Louvre, and Sèvres tiles thus belong to a group of whitewares, which are highly aluminous clays (about 20–25 percent aluminum oxide) characteristic of a kaolinitic clay source.[54] In fact, silica and alumina account for almost 90 percent of their overall composition.[55] The use of whiteware clays for the production of vessels by Byzantine potters is well documented for the Macedonian period[56] and suggests the ready availability of kaolin in the region. Past investigations into local clay sources have naturally turned to the neighboring province of Bithynia, a region that boasted an active tile industry in the post-Byzantine period.[57] Samples of a "white clay" taken near Ömerli Köy, however, turned out to be pure limestone, unfit for pottery production.[58] The clay sources for whitewares may, in fact, lie closer to the capital. Results from the chemical analysis of white clay taken from Anavatköy (Arnavutköy?), on the European side of the Bosporus, correspond to the chemical composition of sampled whiteware vessels from Corinth, which, in turn, are similar to fragments from Istanbul.[59]

Further testing has revealed that whiteware vessels and tiles from Constantinople could display a range of

Tiles from

	THE WALTERS						THE LOUVRE AND SÈVRES
Sample	A.70a	A.70b	A.22	A.25	A.21	A.7	B.5
Na2O	10,5	10,3	9,8	9,8	4,8	10,1	9,2
MgO	0,9	0,8	1,5	1,2	1,1	1,3	1,2
Al2O3	1,6	1,7	3,3	2,0	3,4	2,0	2
SiO2	50,4	51,8	47,3	47,3	51,4	46,2	42,4
SO3	0,2	0,1	0,3	0,7	0,9	0,9	1
Cl2O	0,7	0,8	0,4	0,8	0,4	0,5	0,9
K2O	1,2	0,9	1,4	1,2	1,1	1,2	0,9
CaO	4,6	4,0	5,5	5,0	5,5	5,3	5,6
TiO2	0,03	0,03	0,1	0,1	0,1	0,1	Nd
MnO	0,3	0,3	0,4	0,4	0,5	0,7	0,5
Fe2O3	0,4	0,4	1,0	0,7	1,0	0,7	1,1
CuO	3,7	5,1	6,1	4,2	1,4	5,1	4,8
CoO	0,01	0,02	0,01	0	0	0,02	-
PbO	26,5	24,7	26,5	27,2	24,2	26,8	30,5

Table 1 Chemical compositions of lead-alkali green glazes (in oxide %). SEM-WDS analyses (Walters) and SEM-EDS (Louvre-Sèvres) analyses (zaf correction procedure; be careful Pbo values are slightly over-estimated). Analyses calculated averages of three analyses per sample.
*Samples are identified by their catalogue number.

chemical compositions. R. B. Mason, for example, noted differences between a tile sample from Constantine Lips and a sherd from a whiteware vessel today in the Ashmolean Museum.[60] The tile contained elevated levels of calcium, 3 percent as opposed to generally less than 1 percent for the vessels, and diminished iron levels, 1 percent as opposed to 3 to 5 percent for the vessels and the clay source from Anavatköy. Based on this discrepancy, Mason and Mango posited the use of at least two different white-clay bodies, one for tiles (higher in lime) and one for vessels (higher in iron oxide).[61]

Data from the study of the Walters tiles and samples from the Dumbarton Oaks Collection derived from excavations of the Hospital of Sampson (cat. 11) parallel the lower calcium and elevated iron content of the vessels and clay sources from Anavatköy and suggest that tile-production centers made use of the same clay sources as those producing vessels.

Moreover, the body of twenty-two of the Louvre and Sèvres tiles is mainly characterized by lower calcium (less than 1 percent) and iron (less than 2 percent) contents,[62] an amount that falls between the two groups identified by Mason and Mango. Only one sample, cat. C.43, would seem to fit more closely with clay sources from Anavatköy. It is thus likely that within the Byzantine capital around A.D. 1000, in addition to the clay of Anavatköy, two other clay sources existed, one with elevated lime and diminished iron, and another with diminished lime and iron, both likely being used for both vessel and tile production. Nevertheless, we have to take into account that the tiles were produced with mixed clays, which would explain the slight chemical differences among the samples.

	TILES FROM THE WALTERS		
Sample	A.70	A.61	A.21
Na2 O	9,3	6,1	6,4
MgO	0,8	0,8	0,9
Al2O3	3,0	2,8	3,0
SiO2	44,7	34,9	37,1
SO3	0,3	0,04	0,16
Cl2O	0,5	0,2	0,2
K2O	1,6	0,8	0,8
CaO	4,5	3,3	3,5
TiO2	0,06	0,04	0
MnO	0,3	0,4	0,2
Fe2O3	11,3	12,7	9,97
CuO	Nd	0,3	0,04
CoO	0,01	0,01	0,01
PbO	27,5	37,7	39,4

Table 2 Chemical compositions of amber-colored lead-alkali glazes (in oxide %). SEM-WDS.

Glazes: Groupings Based upon the Analysis of Glaze

Systematic study reveals a difference in glaze composition that indicates a change in practice or workshop. This alteration corresponds to other noted differences between the small and large figural or ornamental plaques. Analysis of the Walters, Louvre, and Sèvres tiles shows differences in glaze composition, which reflect differences in icon size. The tiles are indeed covered either with a lead-rich glaze (PbO > 35 percent), a lead-alkaline glaze (15 percent < PbO < 35 percent), or an alkaline-rich glaze (PbO < 10 percent),[63] making use of sodium oxide as the flux.[64] The varied percentages of alkali clearly indicate an intentional mix to suit specific needs. Related tiles from Preslav, Bulgaria, are also decorated with lead-rich glazes, but these contain smaller amounts of added alkali flux.[65] It is nonetheless worth not-

Tiles from

	THE WALTERS				THE LOUVRE AND SÈVRES	
	AUB	BLUE	CLEAR	CLEAR	CLEAR	BLUE
Sample	A.24	A.28	A.70	A.28	C.14	C.14
Na2O	8,5	11,5	9,2	6,1	2,5	13,8
MgO	0,9	1,1	1,5	0,9	0,4	0,8
Al2O3	2,7	2,8	1,8	4,13*	6,4	2,4
SiO2	44,2	51,3	52,2	50,1	59,5	60,7
SO3	0,6	0,7	0,4	0,1	0,6	-
Cl2O	0,5	0,6	0,4	0,6	1,1	-
K2O	1,0	1,1	1,7	1,1	1,3	0,9
CaO	4,1	4,5	5,2	3,2	1,8	5,0
TiO2	Nd	0,06	0,03	0,1	Nd	-
MnO	2,6	0,4	0,3	0,2	Nd	0,4
Fe2O3	1,0	2,9	0,3	4,1*	0,9	3,8
CuO	0,04	0,3	0,02	0,04	Nd	0,6
CoO	Nd	0,6	0,01	Nd	Nd	0,7
PbO	34,0	22,6	26,4	29,0	24,6	8,7

Table 3 Chemical compositions of lead-alkali aubergine, cobalt blue, and clear glazes (in oxide %). SEM-WDS analyses (Walters) and SEM-EDS (Louvre-Sèvres) analyses. *Values are likely elevated because of the proximity of the sample area to a red slip layer, which would be higher naturally in aluminum and iron, respectively.

ing that the analyses of the samples from the Walters and of those from the Louvre and Sèvres have been carried out according to two different technical procedures, without any intercalibration; straight comparison of the data therefore needs to be handled with caution.

Tables 1–3 show the glaze compositions in the range defined here as lead-alkali mix, containing on average about 30 percent lead, 8–10 percent sodium, and 44–52 percent silica (with the one exception of cat. A.61). All of the small figural plaques sampled from the Walters fell into this category. In addition, several of the ornamental tiles also fell into the lower-lead and higher-alkali category.

The glazes in Tables 4–5 include those specifically high in lead, generally in the range of 50–60 percent. In all cases, the high-lead glazes belonged to the large figural and decorative plaques from both the Walters and the Louvre. A minor exception is the composition of the green glazes of this group. The lead compositions here are between 42.9 percent and 60.1 percent. Copper oxide is known to upset the stability of lead glazes, and may have in this case led to the loss in perceived lead component.[66] The composition is still higher in lead than that of the lead-alkali group and can therefore still be placed within the high-lead designation.

Tiles from

	THE WALTERS						THE LOUVRE AND SÈVRES					
Sample	A.54	A.1	A.33	B.4	B.3	B.6	SN1	C.4	C.3	C.6	C.11	B.13
Na2O	2,6	2,7	2,9	3,4	4,3	2,2	4,4	3,4	4,3	2,2	1,7	5,3
MgO	0,4	0,3	0,3	0,5	0,4	0,3	0,4	0,5	0,4	0,3	Nd	0,4
Al2O3	4,1	3,9	2,9	2,3	3,1	4,1	3,2	2,3	3,1	4,1	1,5	1,2
SiO2	25,3	23,9	25,4	22,7	25,2	22,9	22,4	22,7	25,2	22,9	23	25,4
SO3	0,2	0,2	0,04	1,1	1,1	0,8	1	1,1	1,1	0,8	1,1	0,9
Cl2O	0,1	0,2	0,2	0,4	0,9	0,2	0,4	0,4	0,9	0,2	0,4	1,1
K2O	0,5	0,5	0,5	0,3	0,3	0,3	0,2	0,3	0,3	0,3	Nd	Nd
CaO	1,8	1,5	1,7	2,3	2,1	2,1	2	2,3	2,1	2,1	0,8	1,4
TiO2	0,1	0,1	0,1					Nd	Nd	Nd		
MnO	0,16	0,01	0,2	0,1	0,1	Nd	Nd	0,1	0,1	Nd	Nd	Nd
Fe2O3	7,6	6,4	7,6	6,6	5,6	6,1	5,4	6,6	5,6	6,1	10,5	8
CuO	0,05	0,2	0,1	Nd	1,6	Nd	Nd	Nd	1,6	Nd	Nd	Nd
CoO	Nd	0,01	0,01					Nd	Nd	Nd		
PbO	56,7	59,4	58,4	60	55,6	60,8	60,6	60	55,6	60,8	61,1	56,5

Table 4 Chemical compositions of amber-brown colored high-lead glazes (in oxide %). SEM-WDS analyses (Walters) and SEM-EDS (Louvre-Sèvres) analyses.

		THE WALTERS			THE LOUVRE AND SÈVRES				
Sample	A.1	A.33	A.40	A.2	B.4	B.3	B.6	SN1	C.1
Na2O	4,7	6,0	7,3	3,2	4,7	5	4,9	5	3,9
MgO	0,6	0,6	0,7	0,4	0,5	0,4	0,4	0,6	0,4
A12O3	2,0	2,0	1,5	1,8	1,3	1,5	1,6	1,2	6,2
SiO2	38,2	36,3	38,7	38,3	24,2	27,3	30,1	31,2	36,7
SO3	0,6	0,4	0,4	0,5	1,4	1	1	1,1	Nd
C12O	1,1	1,1	0,8	1,0	0,9	1,8	1,4	1,1	Nd
K2O	0,6	0,6	0,8	0,5	0,08	0,2	0,3	0,3	0,5
CaO	3,1	3,1	2,9	2,6	2,5	2,7	2,3	2,7	2,4
TiO2	0,05	0,2	Nd	0,06	Nd	Nd	Nd	Nd	0,3
MnO	0,3	0,3	Nd	0,3	0,2	0,2	0,2	Nd	Nd
Fe2O3	0,78	0,9	0,5	0,7	0,7	0,7	0,7	0,5	1,1
CuO	5,47	5,6	3,0	4,1	3,5	5,3	4,5	2,4	2,4
CoO	Nd	0,01	Nd	0,05	Nd	Nd	Nd	Nd	
PbO	43,8	45,4	44,9	42,9	60,1	53,5	52.8	54,1	46

Table 5 Chemical compositions of green-colored high-lead glazes (in oxide %). SEM-WDS analyses (Walters) and SEM-EDS (Louvre-Sèvres) analyses.

Condition of Glazes

The glazes are in varying states of preservation. Almost without exception, the amber glaze retains nearly its original vibrancy, while all other glazes are markedly changed. All of the glaze colors exhibit pronounced crazing, identifiable as a network of cracks (fig. 9). Crazing is the result of a poor glaze-to-body fit caused by differences between the glaze and ceramic body in their rates of thermal expansion and contraction during drying and firing. The composition of the kaolinitic clay body is relatively thermally stable.[67] While the state of preservation of a glaze has many external factors, including burial environment and subsequent cleaning techniques, it is evident that the glaze composition on our tiles was more reactive, having greater thermal expansion, than the ceramic body. The resulting crazing substantially decreased the overall stability of the glaze, making it more susceptible to loss due to physical impact as well as deterioration due to penetration by foreign material, such as water and salts. Glazes high in lead are generally elastic and flow well. The addition of the sodium oxide, which has a high rate of expansion and contraction, likely contributed to the prevalent crazing.

The amber glaze is universally better preserved than are the green, clear, aubergine, and cobalt glazes; the only apparent significant difference in composition between the glaze colors is the metal oxide colorant, iron being used for the amber, which is not likely to have contributed to its stability. The relative thinness of the applied amber glaze may be the single most influential factor with respect to its stability. At nearly half the average thickness of all other glaze layers, the amber glaze appears better bonded with the ceramic body. Although the amber glaze is also crazed, the crackle pattern often does not completely permeate the glaze. It emanates from the glaze/body interface, but does not break through to the surface. This pattern contrasts with the appearance of the other more thickly applied glazes, in which a network of open cracks covers the glaze surfaces and makes them more susceptible to damage.

Postdeposition Damage

The tiles all show the effects of time. The fragmentary state of most of the tiles attests to the fragile nature of the material, a soft kaolinitic body and a glaze with an inherently poor glaze-to-body fit. Many tiles exhibit an opaque weathering crust due to the leaching of alkali components within a burial environment. In many cases, especially on the copper green glazes, the crust is opaque and obscures areas of color and outline. This is typical of archaeological glasses and glazes and is consistent with expected degradation of a lead-alkaline glaze.[68] Many tiles also show

some evidence of postdeposition exposure to heat or fire. The obverse and reverse of many fragments are darkened, and in some cases the glaze colors and texture have been changed by heat exposure. Reconstructed fragments aligned directly next to one another show different states of preservation and indicate that the exposure to heat or flame occurred following deposition (cat. A.4). Efforts at conservation have been long-term, and both the Walters and Louvre have reconstructed fragments as well as restored missing elements to help interpret the collections.

Conclusion

The collections of tiles in the Walters Art Museum and the Musées du Louvre and Sèvres have been shown to come from workshops within the region of Constantinople. This conclusion is supported by the stylistic similarities between these tiles and tiles excavated in the Byzantine capital as well as by similarities in composition between the clay bodies of the tiles and the clay sources in Istanbul. Although related to the excavated fragments presented in the catalogue of this volume, the Walters, Louvre, and Sèvres tiles remain distinct and appear to represent the rich product of a heretofore undocumented workshop or workshops.

The preceding technological and physiochemical considerations have lead to the proposal of some interesting hypotheses related to the mode of production and the location of the tile workshops. The high level of competence in forming and finishing indicates that the production of glazed tiles was a skilled craft.[69] With regard to the chemical differences in glaze compositions, it may perhaps be assumed that the lead-alkaline and alkaline glazes constituted in the Middle Ages a technological advance.[70] Moreover, the different shapes and sizes of the tiles make it obvious that they were probably produced one after the other, for just one building at a time, and in close proximity to the buildings that required such ornaments, as was the case in Bulgaria. Some small furnaces and temporary workshops, very simple in their structure, were probably built by craftsmen-potters, who were given the order and had to comply with the request for glazed tiles. Therefore, tile production, which depended on the construction, restoration, or improvement of buildings for the court or the church, was episodic. The production of glazed tiles was thus probably a part-time occupation and was the work of a limited number of itinerant craftsmen, who usually produced tablewares. This would explain the obvious technological similarities of glazed tiles and vessels.

Notes

1. For a preliminary discussion of the Walters tiles and their secure connection with the Byzantine capital, see Lauffenburger and Williams, "Byzantine Tiles," 67–83. For the Louvre and Sèvres tiles, see Durand, "Plaques," 25–50, and Vogt, Bouquillon, et al., "Glazed Wall Tiles," 51–65.
2. Within the Walters, Louvre, and Sèvres tiles there are exceptions to this group. The four large square plaques from the Louvre, cat. B.1–B.4, form the strongest connection to the Walters tiles.
3. Durand and Vogt, "Plaques," 38; Durand, "Plaques," 25–34.
4. Vogt and Bouquillon, "Technologie," 108–9.
5. I. Akrabova-Zhandova, "Un atelier de céramique peinte au sud de l'église ronde à Preslav," *Bulletin of the Archaeological Institute* 20 (1955), 487–510; idem, "Novo v Patlejna sled Jordan Gospodinov," *Preslav-Sbornik* 1 (1968), 69–78; idem, "The Glazed Pottery Workshop South of the Round Church in Preslav," *Bulletin of the Archaeological Society* 20 (1976); Miatev, *Keramik*; T. Totev, "Manastirât v Tuzlalâka—Centâr na risuvana keramika v Prelav prez ix–xv," *Fouilles et Recherches* 7 (1982), 45–74; and idem, "L'atelier," 65–80. These references are cited in Vogt and Bouquillon, "Technologie," nos. 3, 5, 7, 9, 11; Totev, *Ceramic Icon*.
6. Megaw and Jones, "Byzantine and Allied Pottery," 236.
7. Durand and Vogt, "Plaques," 42–44; Vogt, Bouquillon, et al., "Glazed Wall Tiles," fig. 13.
8. Vogt, Bouquillon, et al., "Glazed Wall Tiles," 55.
9. Durand and Vogt, "Plaques," 42.
10. See cat. A.8, A.11, A.15, A.17, A.20, A.24, A.28, A.42, A.46, A.48, A.61, A.65, A.70, B.8.
11. The use of a fine cloth for the drying of tiles was described in Totev, *Ceramic Icon*, 51, 66. "On their back side all of them bear imprints of the threads of a fine hemp cloth on which they were put during drying." See Table x for illustrations of the reverse of tiles for icons from the Round Church. Vogt and Bouquillon, "Technologie," fig. 7, illustrates the reverse of a tile from Preslav with the impression of a textile weave.
12. Durand and Vogt, "Plaques," 42; Vogt, Bouquillon, et al., "Glazed Wall Tiles," 55, fig. 13.
13. Two types of iron knives used for the cutting and cleaning of tiles were found in excavations at the monastery studio on the *Tuzlalâka* hill in Bulgaria. Totev, *Ceramic Icon*, 51.
14. Vogt and Bouquillon, "Technologie," 111.
15. The large square plaques with rounded edges include cat. A.1, A.2, A.29, A.33, A.35–A.38, A.41. Those with beveled edges, from the Louvre, include B.1, B.2, B.3, B.4.
16. Vogt, Bouquillon, et al., "Glazed Wall Tiles," 56.

17. Durand and Vogt, "Plaques," 42; Vogt and Bouquillon, "Technologie," 111.

18. Cat. A.1, A.2, A.29, A.36, A.39, A.40.

19. Vogt and Bouquillon, "Technologie," 111.

20. Totev, *Ceramic Icon,* 51.

21. Lauffenburger and Williams, "Byzantine Tiles," figs. 9, 10; Durand and Vogt, "Plaques," fig. 14; Vogt, Bouquillon, et al., "Glazed Wall Tiles," fig. 11.

22. In the eleventh to thirteenth centuries, the compass was commonly used to elaborate the painted or incised concentric patterns. See C. Vogt, "Technologie des céramiques byzantines à glaçure d'époque Comnène," *CahArch* 41 (1993), 102, figs. 2–4, 8, 11–15.

23. Totev, *Ceramic Icon,* 52.

24. Vogt and Bouquillon, "Technologie," 111.

25. Totev, "L'atelier," 78, fig. 25.

26. See Vogt, Bouquillon, et al., "Glazed Wall Tiles," 54–55.

27. Ibid., 55, table 3.

28. Coche de la Ferté, "Décors," 192.

29. *Glory of Byzantium,* 43–44.

30. Vogt and Bouquillon, "Technologie," 111–12, and nn. 57–58.

31. See also S. Gerstel's discussion of how the tiles may have been affixed to walls and other decorative surfaces, pages 52–53.

32. Vogt, Bouquillon, et al., "Glazed Wall Tiles," 55–56.

33. To our knowledge, pieces of fired ceramic molds or forms have never been recovered from excavations in Istanbul.

34. Durand and Vogt, "Plaques," 42.

35. Ron Lang, of the Maryland Institute College of Art, suggests the use of a slump mold to form convex and concave tiles. Such molds were likely made of fired ceramic or wood and would have allowed the tiles to dry in the open mold, thus minimizing shrinkage.

36. A convex tile in the Musée national de Céramique at Sèvres was thrown on a potter's wheel (cat. C.3).

37. See cat. II.18 (Hospital of Sampson), cat. XII.35–XII.42 (Topkapı Sarayı Basilica), and Totev, "L'atelier," 78, fig. 25.

38. Sarah Wisseman and Eric De Sena conducted NAA at the University of Illinois at Urbana-Champaign. A one-hundred- to two-hundred-milligram powdered sample was collected using a tungsten-carbide drill bit.

39. The Centre de Recherches Pétrographiques et Géochimiques in Nancy, France, conducted ICP-AES/MS on tile samples from the Louvre and Sèvres. A diamond drill sampled two hundred milligrams of powder in each tile.

40. Dr. Chandra Reedy of the University of Delaware conducted the examination of thin sections of the Walters tiles. Dr. Anne Bouquillon conducted the examination of the Louvre and Sèvres tiles.

41. See Totev, *Ceramic Icon.*

42. This phenomenon was previously described by C. Vogt and A. Bouquillon on samples from the Louvre and Sèvres museums. It was also observed by J. Lauffenburger on samples from the Walters and by R. B. Mason on a sample from Constantine Lips.

43. The examination of samples from the French collections did not reveal any trace of organic particles used as temper. Moreover, the addition of organic matter to kaolinitic clay is highly improbable, due to the nature of the tiles. The potters could not add sand and organic particles at the same time, because they have contradictory effects. Perhaps the physical

44. Durand and Vogt, "Plaques," 42.

45. Vogt, Bouquillon, et al., "Glazed Wall Tiles," 55.

46. Examination of tile samples from Sèvres revealed some areas of concentrated quartz measuring 800 microns in diameter and iron impurities measuring 100 microns in width and 1.3 mm in length (Vogt and Bouquillon, "Technologie," 107–8).

47. H. Crane, "Traditional Pottery Making in the Sardis Region of Western Turkey," *Muqarnas* 5 (1988), 12; Vogt, Bouquillon, et al., "Glazed Wall Tiles," 55, n. 29, and fig. 9.

48. Mason and Mango, "Glazed 'Tiles of Nicomedia,'" 326–31.

49. Ibid., 326–31.

50. Table 1 in ibid., 328, is a chart comparing one tile fragment to several clay samples in Istanbul as well as samples from various Byzantine pottery sherds.

51. Coche de la Ferté, "Décors," 189–90.

52. Lauffenburger and Willliams, "Byzantine Tiles," 67–83.

53. Lauffenburger and Willliams, "Byzantine Tiles," 69. This group is closest to the tiles excavated at the Hospital of Sampson (cat. II) now in the Dumbarton Oaks Collection. It differs, however, in the large size of the black inclusions and the higher frequency of quartz inclusions.

54. Vogt, Bouquillon, et al., "Glazed Wall Tiles," 54 (fig. 12).

55. Percentages determined by SEM-Wavelength Dispersive Analysis (WDS) by Dr. Phillip Piccoli on a JEOL 840A Electron Probe Microanalyzer (Scanning Electron Microscope with analytical capabilities) at the Center for Microanalysis, University of Maryland. Samples were coated with approximately 300 angstroms of carbon using thermal evaporation techniques prior to analysis. For WDS, an accelerating voltage of 15 kV was used. British Glass Industry Research Association (BGIRA) standard 3 (for Na, Al, Pb, and Fe), Corning Museum of Glass standard A (for Si, K, Ca, Mn and Cu, and Co metal) were used as standards. Unknowns and standards were analyzed using a sample current of 40nA, a 10 (10 um rastered beam, an accelerating voltage of 15kV, and count times up to 30 seconds. A series of three analyses were taken for each sample site, and the average of the three is reported here as data.

56. See, for example, Morgan, *Byzantine Pottery,* 64–70; Zalesskaja, "Nouvelles découvertes," 49–62.

57. Durand and Vogt , "Plaques," 43, n. 44.

58. N. Atasoy and J. Raby, *Iznik, the Pottery of Ottoman Turkey* (London, 1989), 371 n. 21; J. Raby, "A Seventeenth-Century Description of Iznik-Nicaea," *IstMitt* 26 (1976), 160, cf. 182. See also Talbot Rice, "Byzantium and the Islamic World," 197.

59. The Corinth vessels were imported from the Byzantine capital. See Megaw and Jones, "Byzantine and Allied Pottery," 236, 242–43, 247, 256–58.

60. Department of Antiquities, inv. no. 1993-13. For testing results and interpretation, see Mason and Mango, "Glazed 'Tiles of Nicomedia,'" 324, 328–31, table 1.

61. Mason and Mango, "Glazed 'Tiles of Nicomedia,'" 329, table 1.

62. Vogt, Bouquillon, et al., "Glazed Wall Tiles," 54 and table 1.

63. Vogt and Bouquillon, "Technologie," 109–10, tables 2–4; Vogt, Bouquillon, et al., "Glazed Wall Tiles," 54.

64. Vogt, Bouquillon, et al., "Glazed Wall Tiles," 54.

65. Vogt and Bouquillon, "Technologie," 107–9. The primary difference

evidence on the Walters tiles reflects impressions of organic matter on worktable surfaces.

between the tiles from Constantinople and those from Preslav lies in the differences in body type; table 1 shows clear separation between body types and notes the addition of 3 percent potassium, indicative of a greater portion of feldspars. These characteristics point to a different type of clay, specifically illite.

66. Frank and Janet Hamer, *The Potter's Dictionary of Materials and Techniques,* 4th ed. (London, 1997), 76.

67. Ibid. The thermal stability of a kaolinitic body depends on the high percentage of the stabilizer calcium oxide.

68. Bouquillon and Pouthas, "High-Lead Glazes Compositions and Alterations," 1487–90. A. Bouquillon and Ch. Pouthas, "High-Lead Glazes, Compositions, and Alterations: Example of Byzantine Tiles," in Ceramic Heritage (Proceedings of session 4 of the 5th Conference and Exhibition of the European Society, Versailles, June 22–26, 1997), ed. A. Bouquillon (Switzerland, Germany, U.K., and U.S.A.: Trans Tech Publications), 1487–90.

69. The following hypotheses about the production of the Byzantine tiles and the location of the workshops were previously presented in Durand and Vogt, "Plaques," 43–44; Vogt and Bouquillon, "Technologie," 111–13; and Vogt, Bouquillon, et al., "Glazed Wall Tiles," 56–57.

70. Vogt and Bouquillon, "Technologie," 112–13.

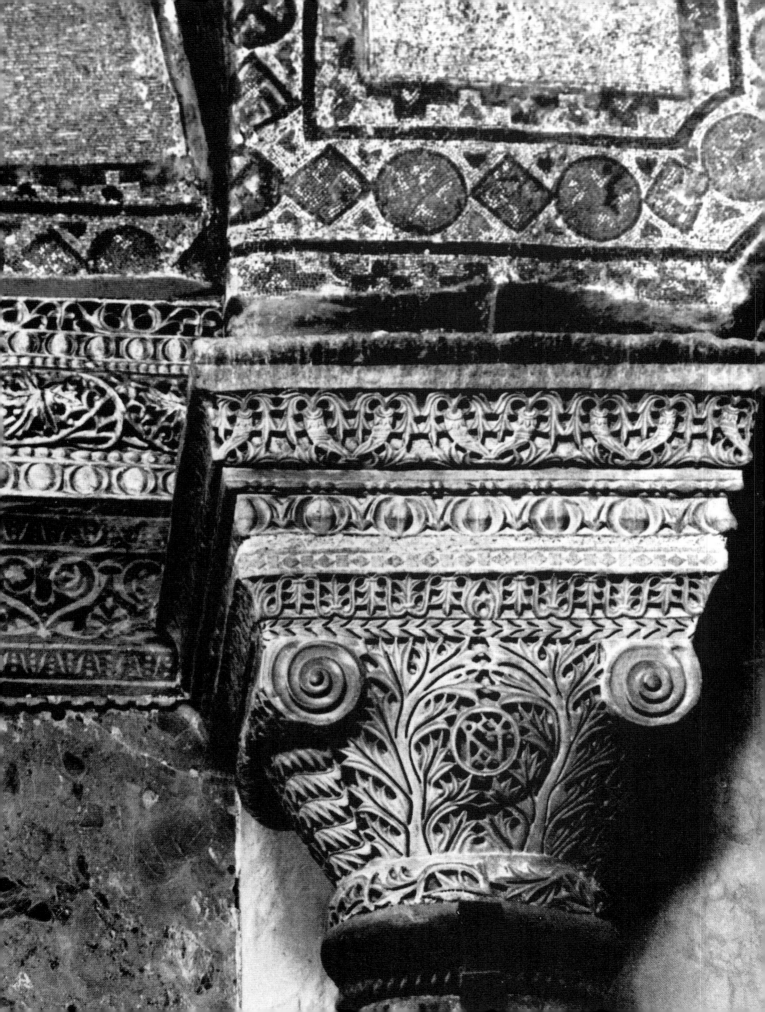

Introduction to the Ornamental Tiles

JEFFREY C. ANDERSON

 Byzantine ceramic tiles were decorated using a wide repertory of ornamental patterns, many known in antiquity and others of recent invention. With one documented exception, the Byzantine tiles have fallen free of—or have been pried, along with the revetment, from—the surfaces that they once adorned, be they the walls of churches and secular buildings or parts of monumental furnishings, like templon screens and sepulchral monuments. It is unlikely that we can reach any understanding of the principles behind the selection and treatment of the ornamental repertory without some sense of the function the tiles served. For the columns, bases, and capitals, the role as simulated architecture is relatively plain, so we will be concerned here with the ways in which the remaining, generally oblong tiles might have been used and how that use was enhanced by the choice of pattern.

The entablature from the mid-fifth-century basilica of Saint John Stoudios provides a valuable point of reference (fig. 1). The sculptors designed the entablature along conventional lines: they created a series of unornamented fasciae that step forward into the nave with each successive level. Marking divisions between the fasciae are several of the most common motifs used for this purpose in classical antiquity: beading, bead and reel, egg and dart, and,

at the topmost level, a row of leaves. The ornament separates the flat bands, yet simultaneously mediates between planes in space. The leaf pattern gives an upward push at the top of the entablature, and the leaves' outlines, when seen head-on, reflect the profile of the *cyma recta* molding on which they are carved. The most prominent element of the entablature is the garland of wound acanthus. The design serves to create a powerfully rolling sensation that propels the eye along the entablature, emphasizing its length and horizontality and, therefore, its intimate relationship with the nave space it shapes and decorates. The plasticity of the garland also hints at the load-bearing nature of a beam, for the wreath seems to bulge under the weight of the gallery. Such architectural sculpture was appropriate to a type of building and to design principles that would largely disappear from Constantinople over the course of the sixth century.

Churches crowned by domes and barrel vaults required more support and resistance to lateral forces than columns could provide. They needed strong piers that invaded the central space, compromising the basilica's distinctive axiality and relegating the columns to a role that was visually and structurally secondary. In Byzantium, strong piers and walls were built of brick and rubble that had either to be clad in marble or covered with a

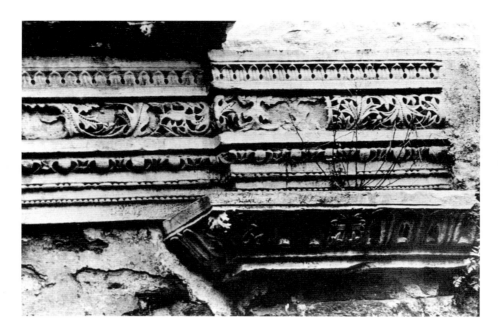

Fig. 1 Istanbul, Saint John Stoudios, entablature.

heavy layer of plaster. Decorating piers in ways that visually integrated them with adjacent or nearby walls emerged as a vital consideration among Constantinopolitan builders and those working within Byzantium's cultural orbit. A number of buildings show how the coordination of walls and load-bearing piers was carried out in the sixth century using cladding and decorative moldings. Two are found in the West. The first is the church of San Vitale, which has largely been stripped of its revetment. Investigations carried out in the 1970s used the remaining fragments and the cramp holes to reconstruct the original design.[1] As the drawings published by F. W. Deichmann show (fig. 2), the revetting was adapted to the different spaces in the building, but in the main followed a single plan of organization. A slightly projecting baseboard ran along the wall, and above it were placed marble panels reaching to the height of the doors. Two narrow fillet moldings, carved in bead and reel, framed a rich band of *opus sectile* set at the height of the door frame and its cornice. Above this continuous band was a second set of marble panels finished with a crown molding. The molding consisted of two superimposed sheets of marble and a beveled cornice (in all, slightly over a half-meter high). Above this was a band of ornament created in stucco, in imitation of carved stone. Repeated in much the same way on the piers, the design integrated walls and supports and emphasized their function by divisions that recalled, but did not imitate in form, the base and entablature of a classical order.

Cladding in veined marble and *opus sectile* was capable of a range of expression. At San Vitale, the curve of the apse above the *synthronon* was decorated with exceptional richness, presumably as a means of adding to the majesty of an area reserved for the episcopal clergy.[2] In the roughly contemporary cathedral of Euphrasius at Poreč, an even richer design was created (fig. 3).[3] The molding beneath the windows again consists of two parts: a wide flat band of decoration beneath a richly carved cap. The first consists of a line of interlocking triangles, a wide strip of decorated squares and rectangles in *opus sectile,* and a band of inlaid circle and lozenge. The cap, or projecting cornice, consists of dentils, egg and dart, and, on the beveled face, acanthus.

The two sixth-century monuments employ a system of decoration remarkably similar, probably because they were adapted from an ancient tradition. Some of the revetment in the church of Saint Demetrios at Thessalonike employs similar motifs, including a fine leaf and dart on the beveled molding.[4] By at least the sixth century, the use of revetment for important churches was well established along lines that would persist until the collapse of the empire. The evidence for continuity, though hardly abundant, is reassuringly distributed in time and place: the church of Hosios Loukas (eleventh century),[5] the Nea Moni (eleventh century),[6] the church of the Koimesis at Daphni (around 1100),[7] the Pantokrator monastery (twelfth century),[8] the Kalenderhane Camii (around 1200),[9] and the Kariye Camii (fourteenth cen-

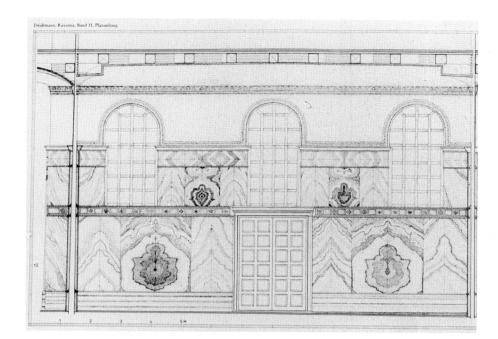

Fig. 2 Ravenna, San Vitale,
reconstruction of wall revetment.

tury).[10] In the last of these, one of the final monuments of
consequence built in the capital, the crown molding con-
sists of a pair of flat bands separated by a fillet, a third
band of eight-pointed stars executed in *opus sectile,*[11] and a
beveled cornice (twelfth century) of leaves over a line of
dentils. In none of the buildings is the revetment pre-
served in its original condition. As we experience them
today, all have been restored after losses of varying mag-
nitude. They nevertheless give an accurate sense of how
important churches were finished. With them in mind, we
can turn to the two buildings that most directly bear on
ornament found on medieval architectural tiles: the sixth-
century churches of Saint Polyeuktos and Saint Sophia.
Saint Polyeuktos is now destroyed, but fragments of revet-
ment and *opus sectile* decoration were discovered in the
excavations.[12] The importance of the building to our
understanding of sixth-century Byzantium is difficult to
overestimate, even if its impact on Byzantine art of the
Middle Ages is unclear.

Justinian's church of Saint Sophia follows the princi-
ples of decoration that have been outlined and does so
with care, richness, and variety. Saint Sophia's vast size
necessitated an elaboration in the design of the revetment.
What, for instance, could be treated at San Vitale as a sin-
gle zone from baseboard to the top of the door frame was,
even in the aisles of the cathedral, subdivided into a dado
and second level (fig. 4). At Saint Sophia the crown mold-
ing consists of two parts. The lower is a flat band deco-
rated in various *opus sectile* patterns that change

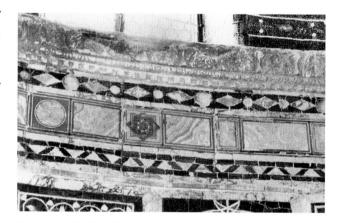

Fig. 3 Poreč, Basilica of Euphrasius, apse revetment.

throughout the church (figs. 5, 7, drawings 14, 42). The
upper part may be a strongly projecting cornice or a
mildly projecting cap molding. Together they form one of
the visually unifying features of the building. Several of the
patterns from the entablature of Saint John Stoudios reap-
pear, but under different circumstances because they dec-
orate a girdling cornice, not a load-bearing member in a
classical building. Since Byzantine cornices were mainly
or entirely decorative in nature, designers were released
from the logic of classical ornament. The fasciae for which
the ornamental repertory had been invented became dead
space and were either reduced to extremely narrow bands
or eliminated entirely. At Saint Sophia the springy vine-
scroll garland is wedged between bead and reel and egg
and dart, the latter often treated as ellipses between paren-

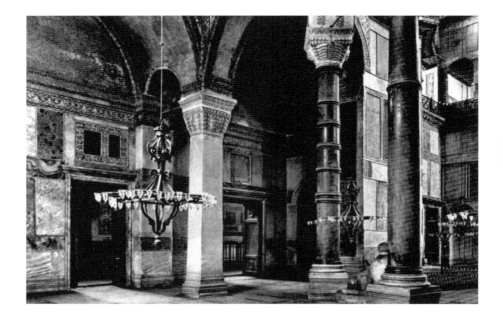

Fig. 4 Istanbul, Saint Sophia,
revetment of south aisle.

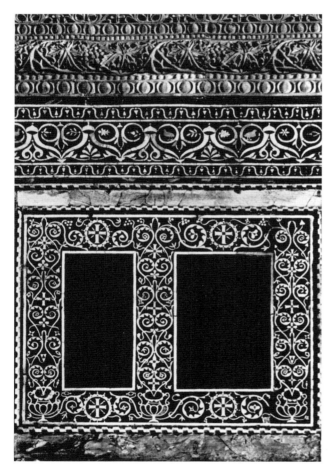

Fig. 5 Istanbul, Saint Sophia, naos revetment.

theses (fig. 5).[13] Instead of a stately progression of carefully punctuated planes (fig. 1), the artists created a rich succession of decorative forms so visually dense that the outward movement of the vine wreath fails to create any illusion of a plastic mass deformed under loading. It is simply the most prominent decorative motif and as such projects from the wall.

In the two-zone system of decoration that emerges in the sixth century, abstract patterns are splayed across the lower level to ease the transition from detailed sculpture to the vast expanse of revetment below. At Saint Sophia the *opus sectile* varies in design and is set in strong colors, including yellow and red.[14] Around the curve of the apse runs a giant circle-and-pitched-square pattern enclosed within bands of circle and lozenge (drawing 42). On one of the adjacent piers leading into the sanctuary, kantharoi alternate with crosses framed by circles. From the kantharoi spring acanthus shoots, sometimes edged in a wave pattern, that gently arc like gigantic swags (drawing 14). At gallery level, symmetrical acanthus leaves run continuously, framed by a cross-and-lozenge pattern (fig. 7). In the gallery decoration there is indication of the artists' sensitivity to the structural forms of the church. Acanthus fills the spandrels, but abruptly changes toward the piers that bear the weight and thrust of the dome and arches. The free-flowing pattern is simplified into one that seems to funnel the forces downward. In the design of the Saint Sophia crown moldings and the borders of the mosaics directly above them, we find the key to how the tiles were employed as well as the roots of the ceramicists' ornamental vocabulary.

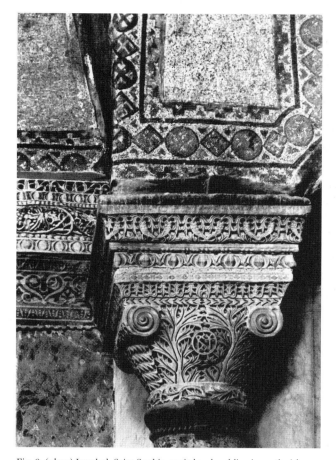

Fig. 6 (*above*) Istanbul, Saint Sophia, capital and molding in south aisle.

Fig. 7 (*below*) Istanbul, Saint Sophia, gallery-level *opus sectile*.

In the period following the return of Orthodoxy and some measure of prosperity, architectural ceramics became one method of decorating new buildings and possibly refurbishing old ones. The bright surface of strong colors that was inherent to fired ceramics could easily take the place of *opus sectile,* which requires arduous and technically demanding labor.[15] The curved profiles of many of the tiles suggest that they could have served as cornices. Cornices, which are usually set at the point of the springing of vaults, can be angled, bull-nosed, or *cyma reversa.* In many cases they were left uncut, and so appear to be plain. Robert Ousterhout has observed a layer of gesso and paint on one of the cornices of the Kariye Camii,[16] and other examples may also have been painted to create an effect much like that of ceramic tiles. In one of the patriarchal rooms at the southwest corner of Saint Sophia, a plaster cornice runs under the vault mosaic, attributed to the third quarter of the ninth century.[17] Presumably, the cornice was decorated in some manner over its main body, which curves out under a (partly preserved) molded pattern of beading. Without implying that the cornice was set with ceramic tiles, I note that one of the finds from the Lips monastery included two strips of tile still adhering to the plaster used to attach them to the walls.[18]

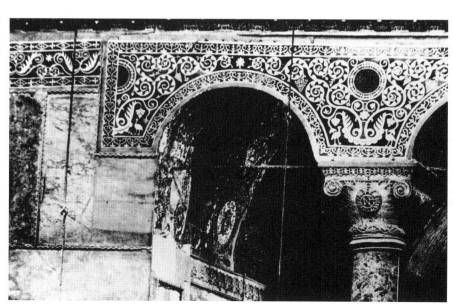

It is at this point that we should note that of the sites in which tiles were found, those that can be said to have been revetted are the Lips monastery,[19] the Myrelaion,[20] the Botaneiates Palace Church,[21] the Atik Mastafa Paşa Camii (cat. VIA), the church of the Koimesis at Nicaea,[22] and probably Saint John Stoudios. In addition to possibly having been affixed above wall revetment, ceramic tiles may have been used in other parts of the church, though presumably ones where they would not suffer chipping or scuffing. It is also unlikely that they were used as intermediary bands such as that found at San Vitale at the height of the doorframes (fig. 2), since at this level the tiles would need to support at least some of the weight of the superimposed revetment, a purpose for which ceramic tile is far too weak. Tiles might also be used to outline windows, like the bands of revetment that run over windows and doors. A number of curved tiles could have served as window frames, following *opus sectile* patterns such as that known from the church at Daphni (fig. 12).[23] One of the Fossati drawings of Saint Sophia shows an image set within a tympanum over a door framed by a pattern resembling one known on the tiles.[24] Ceramic tiles may, finally, have been used to decorate building exteriors; until recently, a section of tiles remained in place beneath the flat table cornice of the eleventh-century church of the Panagia ton Chalkeon in Thessalonike.[25] There may have been, therefore, any number of uses for ornamental tiles other than the templon screen or other monumental furnishings.

Our direct evidence for the placement of tiles is sparse. The first of the two known instances is the church of the Koimesis at Nicaea, photographed by N. K. Kluge and Arthur Kingsley Porter before its destruction (cat. XVIII). A recent investigation of the site has confirmed the revetting of the apse before the phase of eleventh-century rebuilding.[26] Above the revetment was a strip, perhaps two, of painted tiles. The second example is the Panagia ton Chalkeon, Thessalonike, where tiles decorated the south side of the church. The evidence from Nicaea and Thessalonike is supplemented by the ceramic cornices fabricated for the Great Mosque at Córdoba; they may not be of Byzantine manufacture, but, like the mosaics, reflect Byzantine practice (cat. XXI).

Analytical Index of Patterns

With the handful of monuments as our guide to the possible location of the tiles, we can turn to the design motifs and consider them within the context of Byzantine architectural ornament, carved, *opus sectile*, and mosaic. The parallels cited are kept to a minimum; they are drawn mainly from the city in which the tiles were made, but others are added when it seems advisable to suggest the diffusion of common motifs over a geographic area. Some patterns cannot be found in early Byzantine buildings, and they deserve particular attention. The primary task, though, is to give an account of the basic designs and some of the significant variations. The index is divided into two unequal divisions: oblong tiles with traditional patterns (1–62) and a group of tiles with what I take to be novel designs (63–72). Within each section the listings are alphabetical according to rubrics that follow the descriptions of ancient floor mosaics or rely on simple terms: acanthus, circle, guilloche, ivy leaf, jeweled band, lozenge, quatrefoil, shell, tongue and dart, wave crest, etc.

Oblong Tiles with Traditional Patterns (1–62)
Acanthus

Several forms of acanthus appear on the tiles: scroll, paired leaves, and a circular pattern most often represented truncated.

Drawing 1. Cat. A.56.

1. *Acanthus scroll.* One of the large rectangular plaques (13.0 × 18.2 cm, but incomplete) offers an abstract, yet conventional, version of acanthus scroll (drawing 1). The painter represented deeply ribbed stalks growing in yearly spurts, each shaped like a trumpet ending in a scalloped bell. The form is comparable to ones found in the border

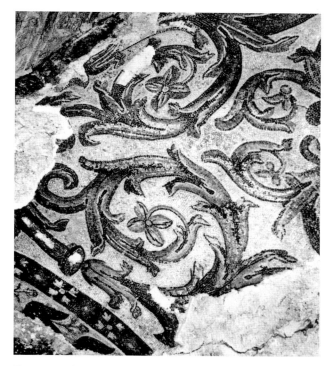

Fig. 8 Istanbul, Saint Sophia, room over the southwest ramp, vault.

of the Great Palace Mosaic, attributable to the time of Justinian,[27] and the slightly later, sixth-century decoration in the vault of the room over the southwest ramp of Saint Sophia (fig. 8).[28] Although the interspersed grapes and pomegranate[29] may seem to be out of place, they are traditional elements of acanthus scroll, found in the Great Palace Mosaic and many ancient examples.

Drawing 2. Cat. A.62.

Drawing 3. Cat. XII.15.

2. *Paired acanthus leaves.* Examples include the large reconstructed fragment from Saint John Stoudios (drawing 12) and a number of relatively well-preserved pieces. The simple, repeating design and its height of ca. 11 cm (drawings 2, 3), and in one case a generous 18.25 cm (cat. X.3), suggest that the motif sometimes served as the main pattern

in a sequence; this is confirmed by the example from the Stoudios (drawing 12) and a set of tiles used as an arch facing (cat. XII.19). The examples agree in basic design but differ in the placement of the trailing tendrils, which can be at the top, center, or bottom of the outer edge. The binding cords in one example (drawing 3) recall a motif from the church of Saint Artemios on Naxos,[30] and the set of three teardrop shapes can be found in architectural sculpture,[31] but may depend on a jewelry design.

The identification of the pattern derives from the decoration of the gallery-level *opus sectile* of Saint Sophia (fig. 7). A dense acanthus scroll, created using a soft-edged leaf,[32] fills the spandrels. Like the acanthus of the contemporary Great Palace Mosaic, that of Saint Sophia has grape clusters and flowers growing from the stalks. As the acanthus continues beyond the spandrels, the pattern changes to suit the narrow field of the band running under the cornice. A pair of leaves is presented in profile, each gracefully curving in symmetry, their scalloped edges pointing inward. The wispy stalks below reinforce the shape of the main leaves, then terminate in a spring of growth. The symmetrical pairing repeats along the length of the molding. The medieval version on the tiles is much broader and simpler in form, and in these respects it is closer to a nearly contemporary piece of inlay discovered at the Lips monastery.[33] The use of this pattern on capitals (cat. XII.37) also suggests acanthus.

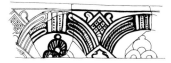

Drawing 4. Cat. XII.6.

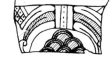

Drawing 5. Cat. XII.7.

3. *Acanthus half-circles.* The uppermost decoration of the crown molding running along the apse of the church of the Koimesis at Nicaea consists of a band of half-circles[34] much like ones on tiles found at the Topkapı Sarayı Basilica (drawings 4, 5). The half-circles are formed by bound segments, each ribbed and rounded at the tip to form a scalloped edge; the bindings are striped and dotted, like

the jeweled rings slipped around cornucopia in the *opus sectile* at Poreč.[35] The design represents an abstract version of acanthus trumpets (drawing 1), which, by the time the tile was created, may have been absorbed into decorative media well beyond architectural ornament.[36] The lunettes are filled with a variety of motifs, a triangular-scale pattern (drawing 5), a pinched scale decorated to resemble the tips of peacock feathers (drawing 4), and a single peacock feather (cat. XII.5). Filling the spandrel shape above the half-circles are darts decorated with a dotted-checkerboard pattern. Dart-and-circle motifs are found in tenth-century sculpture,[37] and dotted checkerboard is well known among tile painters (e.g., drawings 30, 41, 51); a related pattern of scored and drilled squares occurs on marble-inlay fragments found at the Lips monastery.[38] In one unusual example (cat. XII.8), the pattern has been doubled to form a repeating circle. The use of a bold half-circle design at or near the top of the molding is paralleled by the revetment of the vestibule of Saint Sophia[39] and ornament found in provincial churches.[40]

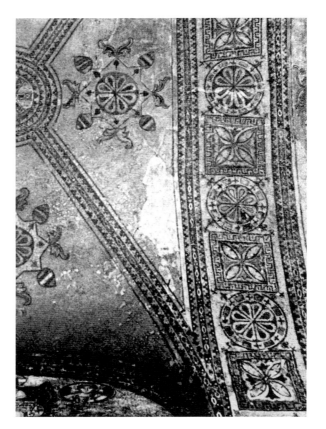

Fig. 9 Istanbul, Saint Sophia, narthex vault mosaic.

Drawing 8. Naxos, Saint Artemios, vault.

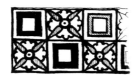

Drawing 6. Cat. A.60.

4. *Checkerboard with squares and rosettes.* Tile measuring 9.5 × 16 cm.

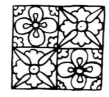

Drawing 7. Cat. A.59 (Lauffenburger).

5. *Checkerboard with four-petaled flowers and rosettes.* A second plaque measuring 9.5 cm across the one preserved dimension (drawing 7).

These related tiles were decorated with neatly drawn boxes in which the painter alternated patterns: squares and rosettes or four-petaled flowers and rosettes, all known in early Byzantine or ninth-century ornament (fig. 8, drawing 15). The scale and format of the decoration call to mind the repeating patterns found on vaults: for example, Saint Sophia, Istanbul (fig. 10), and Saint Sophia, Thessalonike (fig. 11). A close parallel occurs in one of the vault patterns of the church of Saint Artemios on Naxos, generally dated to the period of Iconoclasm (drawing 8).[41] Although possible, it seems unlikely that the tiles were used on the vaults of a church, if only because of installation difficulties.

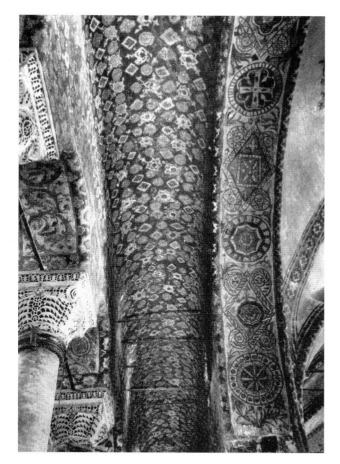

Fig. 10 Istanbul Saint Sophia, south gallery, vault mosaic.

Circle

Much of the ornamental repertory was organized using circles, whether represented alone, filled with a range of patterns, or alternating with pitched squares. It may be pointless to try to assign names to all of them, but some are sufficiently common to deserve attention, and many are variations that show how tile painters combined motifs to create novel designs. The tiles are here divided by the motif that the circle encloses; discussion begins with four narrow patterns.

Drawing 9. Cat. VI.4.

6. *Concentric circle.* A number of tiles were decorated only with concentric circles. They tend to be narrow strips, usually under 3 cm in height, that were likely created to serve as borders for other patterns (cf. cat. VI.3, XIII.3 [drawing 50], XVI) or perhaps to separate elements in a sequence.

Drawing 10. Cat. XIII.2.

7. *Dotted concentric circle.* As above but with a dot at the center.

Drawing 11. Cat. XII.14 (after Ettinghausen).

8. *Circle with cross-in-square.* Two examples of the pattern survive from the Topkapı Sarayı Basilica; they measure roughly 2.5 cm in height. This is a delicate and unusual design. The cross-in-square pattern, though known in antiquity,[42] is uncommon in the Middle Ages and does not seem to occur in buildings of the early Byzantine era.

Drawing 12. Cat. X.1–3.

9. *Concentric circle and rectangle.* Known from a single example found at Saint John Stoudios (cat. X.2), where the pattern forms the lower border in a sequence. In early Byzantine ornament, curved and rectilinear forms are often juxtaposed. Bead and reel, for instance, is transformed into circle and lozenge (fig. 3, drawing 42). Alternating circles and squares are carved on the flat abacus faces of the Saint Sophia capitals (fig. 6) as a logical alternative to bead and reel on an ovolo molding. The tile painter working for the Stoudios created rectangles that he detailed as if chamfered; the rectangles may be interpreted as illusionistic forms, perhaps to recall a jeweled border (cf. pattern 38).

In addition to circle patterns that were used as border motifs, the painters also created elaborate circle designs that, judging from their greater height, were intended to serve as the major patterns in a sequence. All can be

divided by the central motif, a four-petaled flower, rosette, or disk with circles. The four-petaled flower is common in early Byzantine art, where it alternates with lozenges or appears alone. Its one organic setting is the acanthus scroll, as in the room over the southwest ramp of Saint Sophia (fig. 8) and, in a highly abstract form, *opus sectile* panels in the church (fig. 5). Large rosettes, consisting of eight teardrop-shaped segments framed in a circle, occur as a prominent element of early Byzantine architectural decoration. Examples can be found in the Justinianic mosaics set on the inside faces of the arches in the narthex of Saint Sophia (fig. 9).[43] The tile painters elaborated the rosette by adding a circle at the center, but similar dotting occurs at Saint Polyeuktos.[44] The disk motif has no direct parallels in early Byzantine art, although a forerunner may be the circles decorated with four hearts in the mosaics of Saint Sophia (fig. 6). Possibly the earliest examples of this motif in a fully developed form are found at the end of the seventh century in the mosaics of the Dome of the Rock, Jerusalem.[45]

Drawing 13. Cat. II.14.

Drawing 14. Istanbul, Saint Sophia, *opus sectile* (Swift).

Drawing 15. Istanbul, Saint Sophia, rosette in semidome garland.

10. *Circle with four-petaled flower,* type A. In this specimen (drawing 13), which measures 8.5 cm high, the flowers are enclosed within circles enriched with half-circles pointing inward. A similar elaboration of the frame occurs in the *opus sectile* of Saint Sophia (drawing 14), where the segments are arranged on the outside of the circle, as they also are in an *opus sectile* panel found at Poreč.[46] Segments pointing inward are otherwise known in Saint Sophia, but in less elaborate form.[47] Between the circles are flower petals, one represented fully and the other two halved, to make an eight petaled-flower; the design follows almost precisely a pattern known in the ninth-century bema mosaics of Saint Sophia (ca. 867), where the petals fill the quadrants between rosettes that resemble equal-armed crosses (drawing 15).[48] As a quadrant motif it was well suited to the spandrel shape between running circles and can be found on many of the tiles (drawings 22, 29, 40, 64).

Drawing 16. Cat. II.12 (after Yılmaz).

11. *Circle with four-petaled flower,* type B. This type is known through a number of large fragments, 12 cm high. The frame is elaborated with concentric circles rather than inward-pointing scallops. The spandrel shape between the circles contains a step motif common in mosaic pavements and the Justinianic decoration of Saint Sophia (fig. 6) but augmented with a dart on the tiles.

Drawing 17. Cat. VI.17.

12. *Circle with four-petaled flower,* type C. In this large fragment, incomplete but possibly as high as the tile immediately above, the painter created an inner frame that resembles an octagon with cusped edges. The cusped octagon is prominent among the Justinianic mosaics of Saint Sophia (fig. 10) and was imitated in the early tenth century, when the area around the portrait of Alexander

was reset (ca. 912).[49] Between the large circles appear fragments of what may have been hearts placed tip-to-tip; they are a large version of the hearts represented between the circles and pitched squares in the Justinianic mosaics of Saint Sophia (fig. 6).

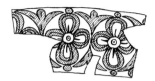

Drawing 20. Cat. XII.21.

Drawing 18. Cat. XII.10 (Ettinghausen).

13. *Circle with four-petaled flower,* type D. Several convex fragments, one roughly 7.5 cm high (cat. VII.3) and another nearly 12 cm (cat. XII.10), have an incomplete version of intersecting circles,[50] a compass pattern common in ancient floor mosaics (where it is called "quatrefoil," a misnomer here) and inscribed in squares in the sixth-century decoration of Saint Sophia (fig. 9).[51] At Poreč a similar pattern of running circles appears in *opus sectile.*[52] Between the circles on the tiles are tiny hearts, close in scale to those of the sixth-century mosaics of Saint Sophia (fig. 6). A version of this pattern in depressed circle is also attested (cf. pattern 24). Filling the segments are leaves growing inward; the prominent vein running down the center of the leaf contributes to the illusion of three-dimensionality. The detailing makes the leaves recall sharply cut sculpture, so it is worth observing that a similar leaf form appears in the tenth-century carving of the Lips monastery.[53]

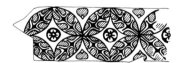

Drawing 19. Cat. A.70.

14. *Circle with four-petaled flower,* type E. Designed along the lines of type D, but with a different leaf in the ellipses. In this version as well, the leaves seem to curve outward from the field.

15. *Circle with four-petaled flower,* type F. This design falls outside the group of circle motifs because there is no enclosing circle. It is included here because the frame is so strongly implied by the flowers shown end-to-end and in profile. The specimen is an arch facing a little over 10 cm in width.

The petals are exaggerated along their length in a way that recalls flowers found in mosaic borders: at Saint Catherine's on Mount Sinai,[54] the Panagia Angeloktistos, Kiti,[55] and, closer in date to the tiles, the border to the apse mosaic at Nicaea.[56] The motif between them is different from the one discussed above (cf. pattern 10, drawing 13). It may be related to the second way in which flowers were represented when part of an acanthus pattern, which is in pure profile. Examples occur in the Saint Sophia *opus sectile* (fig. 5). The small circles or knobs that stand between the flowers also appear in the *opus sectile* of Saint Sophia.

Drawing 21. Cat. XII.28.

16. *Circle with rosette,* type A. The simplest version of circle with rosette is known from a fragment found at the Topkapı Sarayı Basilica. It consists of eight segments and a concentric-circle motif (cf. pattern 6) at the center. The proportions of the teardrop segments make the rosette resemble a flower.

Drawing 22. Cat. XII.27 (Ettinghausen).

17. *Circle with rosette,* type B. This example (drawing 22), also from the Topkapı Sarayı Basilica, measures 11 cm high and consists of bound circles with the flower motif (cf. pattern 10, drawing 13) between them. Bound circles are known from the carved ornament of Saint Sophia.[57]

Drawing 23. Cat. XII.29.

18. *Circle with rosette,* type C. A third type occurs on a tile that measures 9.5 cm high. Here the rosettes have an outer following frame and are separated by the profile flowers discussed in relation to circle with four-petaled flower, type F (drawing 20).

Drawing 24. Cat. VII.6.

19. *Circle with rosette,* type D. In this specimen, a cusped octagon is inscribed within the circle, as in one of the flower patterns (cf. pattern 12). The petals of the rosettes are elaborated with dart motifs, like ones found on tiles bearing tongue and dart (drawing 62).

Drawing 25. Cat. XII.24 (after Ettinghausen).

20. *Circle with disk,* type A. In a tile from the Topkapı Sarayı Basilica, the center design consists of seven dotted circles arranged within a disk. The articulation of the frame is the same as pattern 19 (drawing 24).

Drawing 26. Cat. A.68.

21. *Circle with disk,* type B. A small fragment in the Walters Art Museum has the inside of the enclosing circle decorated with eight inward-pointing cusps, each framing part of a flower.

Circle and pitched square: see pattern 48.

Circle with tendrils: see patterns 63, 64.

In addition to circles placed side by side, several tiles use the ancient design of looped circles. Looped-circle borders can be found in the sculpture of Saint Sophia (drawing 67), where, as in many ancient examples, the circles alternate small and large.

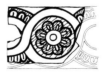

Drawing 27. Cat. A.55.

22. *Looped circle with rosette,* type A. A fragment in the Walters Art Museum may have measured around 10 cm high when complete. The large loops frame rosettes, and the small loops have been augmented on the exterior with a radial-tongue or petal motif.

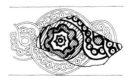

Drawing 28. Cat. XII.9.

23. *Looped circle with rosette,* type B. A specimen measuring about 10.5 cm high frames an unusual variation of the

rosette pattern. The rosette consists of a cusped octagon and dotted circle, motifs found on tiles. In particular, the treatment of the border recalls that of one of the versions of guilloche (drawing 36), to which the looped circle is obviously related. From other fragments, fleurons have been reconstructed between the large loops. Fleurons in a similar context appear in the late-ninth-century sculpture of Skripou,[58] but their design on the tile recalls that of the fleurons in Saint Sophia (fig. 9, a Justinianic pattern).

Drawing 29. Cat. XII.13.

24. *Depressed circle.* A tile from the Topkapı Sarayı Basilica was decorated with a variation of circle with four-petaled flower, type D (cf. pattern 13). The version in depressed circles is not appreciably narrower than the specimen with full circles.

Drawing 30. Cat. II.6.

25. *Half-circle.* A narrow strip (3 cm high) from the Hospital of Sampson has half-circles at the edges. The background is a dotted cross-in-square that recalls the scored and drilled inlay fragments found at the Lips monastery.[59]

Drawing 31. Cat. XII.30 (after Ettinghausen).

26. *Half-circle with half-rosette.* One of the patterns represented in half-circle contains an inner rosette articulated to resemble a petaled flower. The painter elaborated the

frame by making short strokes along a line, in a form that recalls metalwork.

Drawing 32. Cat. VI.15.

27. *Cross.* One fragment survives with a variation of the step pattern common in mosaics (fig. 6) and known on tiles (cf. pattern 57). The steps are set back-to-back, creating a cross that appears to be made of thirteen cubes set in a bilaterally symmetrical pattern. This is a rare design among the tiles, but is common in other media.

Diaper

Like lattice (patterns 39–41), diaper is essentially a variety of checkerboard set on a forty-five-degree angle and densely detailed. The tiles bearing such patterns may have served as pilasters or, in the case of curved examples, half-columns. The origin of such decoration in early Byzantine architecture is certain; pattern columns are known from several sites, including the Constantinopolitan churches of Saint Euphemia, Saint Polyeuktos, and Saint John in the Hebdomon, though in no case are the patterns quite like those on the tiles.[60] The design found on a mosaic-decorated colonnette in Saint Catherine's at Mount Sinai is more closely related to the tile patterns.[61] The relationship between the pattern and architectural members is confirmed by the use of a related lattice motif to suggest a colonnette in the bema decoration of the church of the Koimesis at Daphni (fig. 12), which is later than the tiles yet remains relevant to the issue of use. Only three of the types are illustrated here with drawings.

28. *Diaper,* type A (cat. A.63). Rows of dotted disks alternating with squares, each subdivided into nine dotted compartments.

29. *Diaper,* type B (cat. B.7). Rows of dotted disks alternating with squares; the squares subdivided into nine compartments, the center one filled and the others dotted.

30. *Diaper,* type C (cat. A.64). Rows of circles alternating with squares; the squares subdivided into alternating filled and dotted compartments.

Drawing 33. Cat. C.9.

31. *Diaper,* type D (cat. C.9). Rows of circles alternating with squares; the squares are subdivided, and those forming a cross pattern have four short dashes. See cat. C.1 for a slight variation.

32. *Diaper,* type E (cat. A.48). Similar to type D, but the large circles are augmented by four small half-circles at the outside.

Drawing 34. Cat. C.3.

33. *Diaper,* type F. Rows of squares parallel to the edge alternate with rows of squares canted forty-five degrees. All have an inner band of dotted squares, and those in alternate rows frame a filled circle. The motif, dotted squares with circles, appears in the late-seventh-century mosaics of the Dome of the Rock, Jerusalem.[62]

Drawing 35. Cat. A.49.

34. *Diaper,* type G (cat. A.49). In this example the circles have been replaced by flowers.

Guilloche

Both examples of guilloche are variations of two-strand twist. It is perhaps noteworthy that guilloche is not found in either Saint Sophia or Saint Polyeuktos. Why this is so is difficult to say, but its absence must have been intended, because guilloche is nearly ubiquitous in ancient and medieval mosaics and architectural sculpture.

35. *Simple guilloche.* A simple guilloche appears as a narrow border motif to a curved tile, approximately 10 cm high, in the Istanbul Archaeological Museum (cat. XII.24: drawing 25).

Drawing 36. Cat. XIII.4.

36. *Guilloche with eyelets.* A large tile, 11.2 cm high, is filled with an elaborate guilloche: the strands are decorated with dotted circles, and the eyelets similarly emphasized. The ornate appearance and the means by which it was achieved bear comparison with a fragment of decorative sculpture from the Boukoleon Palace.[63]

Drawing 37. Cat. B.14.

37. *Ivy leaf with grape clusters.* Examples of this motif were found at the Myrelaion (cat. VII.5), Saint Euphemia

(cat. VIII. 2), the Topkapı Sarayı Basilica (cat. XII.22), and in fill at the Kalenderhane Camii (cat. V.6). Most of the specimens are narrow (2.5 cm high) flat strips, although a narrow arch facing is also known (cat. XII.23). The tiles follow essentially the same design of alternating ivy leaves and grape clusters, and all are delicately executed.

Ivy leaf is an ancient pattern suitable to narrow bands of ornament, since the heart-shaped leaves neatly fill the space defined by the wavy stalks. Constantinopolitan mosaicists of the sixth century used a version of the pattern that combines the ivy leaves with a broad wavy ribbon that is powerfully illusionistic; the fine example of the Great Palace Mosaic was unavailable by the time the tiles were being produced, but the version in the patriarchal rooms of Saint Sophia, though of restricted access, was presumably visible.[64] The bronze doors of Saint Sophia bear a fine ivy decoration possibly closer to that on the tiles, though it lacks the grape clusters.[65] It may be germane to note the formal similarities to narrow cornice moldings in Byzantine churches, for example, the church of Constantine Lips (with grape clusters)[66] and the eleventh-century church of Christ Pantepoptes, Constantinople.[67] An arch molding with a related pattern as its basic design was uncovered in the excavations of Saint Polyeuktos; the molding possibly dates to the twelfth century.[68]

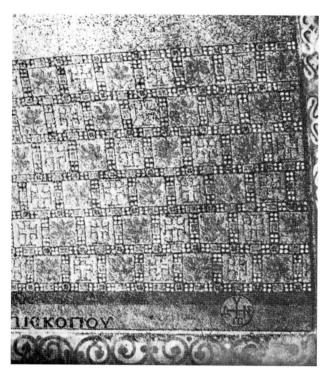

Fig. 11 Thessalonike, Saint Sophia, bema vault.

Drawing 38. Cat. XII.3.

38. Jeweled band. Jeweled bands appear as picture frames in many sixth- and seventh-century monuments, among them San Vitale, Ravenna, the Basilica of Euphrasius at Poreč (fig. 3),[69] and Saint Demetrios, Thessalonike.[70] In the late-eighth-century bema vault of Saint Sophia, Thessalonike, a dense alternating pattern of crosses and vine leaves was set in a matrix of jeweled bands (fig. 11).[71] Evidence for this decoration after the eighth century is unusual in Constantinople, found mostly in the ceramic tiles, but it is popular in Cappadocian decoration. The tiles are strips of intermediate width that measure 3.8 (cat. XII.3), 4.0 (cat. V.1), and 4.2 (cat. VI.6) cm.

Lattice

Lattice patterns consist of a prominent frame that crisscrosses the surface at an angle oblique to the edge. Lattice resembles diaper, but has a more prominent structure because the angled bars are connected throughout the pattern. The vault designs found at Saint Artemios, Naxos (drawing 8), and Saint Sophia, Thessalonike (fig. 11), are not, properly speaking, lattice, because the bars are aligned with the sides of the field. An early example of lattice occurs on one of the capitals of the church of Saint Polyeuktos,[72] and others are found in the late-ninth- or tenth-century vault mosaics set in the Saint Sophia (Istanbul) galleries[73] and, in the first half of the eleventh century, on an arch facing in the church of Hosios Loukas.[74]

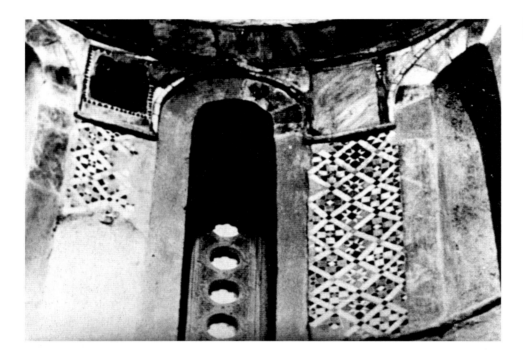

Fig. 12 Daphni, church of the Koimesis, bema revetment.

Reproduced here is the fine example from the church at Daphni (fig. 12). The few preserved examples on tiles are relatively large specimens that are either flat or convex. In addition to the three examples cited below, see the small fragment from the Lips monastery (cat. VI.13).

Drawing 39. Cat. XIII.5.

39. *Lattice,* type A. A small fragment of a flat tile with a maximum preserved height of 4.2 cm. The lattice consists of three bars marked by concentric circles at the intersection. Within one cell is a disk with dotted circles like those found on tiles with circle motifs (cf. patterns 20, 21).

Drawing 40. Cat. XI.1.

40. *Lattice,* type B. A convex tile with a maximum preserved height of 6.6 cm was uncovered in the fill at Saint Polyeuktos; it bears a very fine lattice pattern in which the cells contain delicate flowers apparently deformed to mirror the lozenge shape. At the intersections of the triple bars, the painter seems to have alternated motifs: a circle drawn in the manner of the previous tile (drawing 39) and the flower-petal motif discussed above (cf. pattern 10). This piece is now lost, known only through a poor photograph.

Drawing 41. Cat. XIII.10.

41. *Lattice,* type C. In this example (drawing 41) the bars are treated as if to suggest a beveled edge; they frame a dotted-cross-in-square pattern.

Lozenge

Lozenges form, along with circles, one of the ways in which ornamental motifs were organized to fill bands. They are closely related to pitched squares. One of the patterns in the Saint Sophia bema, for example (drawing 42), consists of a wide row of circles and pitched squares surrounded by a narrow circle-and-lozenge border. Square and lozenge motifs will be treated together in this section.

Drawing 42. Istanbul, Saint Sophia, *opus sectile* (Swift).

As a border motif found with other patterns, lozenge occurs in several forms: plain or enclosing other lozenges. An example of plain lozenge ornament occurs on one of the tiles from the Topkapı Sarayı Basilica (drawing 29).

Drawing 43. Cat. XIII.6.

Drawing 44. Istanbul, Lips monastery, frame of Eudokia Icon.

42. *Lozenge.* The edge motif to a large fragment with paired acanthus leaves (drawing 43) consists of lozenges and small half-circles along the bottom (cf. also cat. XII.19, where the same pattern is used as an arch facing). A

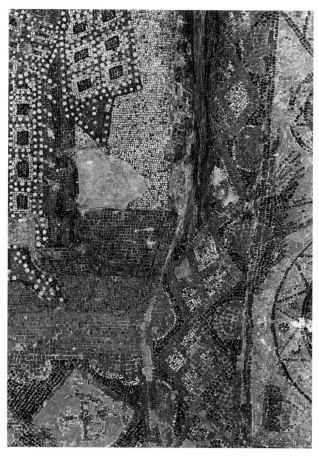

Fig. 13 Istanbul, Saint Sophia, Alexander portrait, border.

related design is found on the inlaid icon of Saint Eudokia found at the Lips monastery (drawing 44).[75]

Tiles of slightly greater height, though still under 5 cm, were found at the Hospital of Sampson. Roughly the same scale as the concentric-circle motif, they may have been used above or below other motifs, but were fashioned as single strips.

Drawing 45. Cat. II.8.

43. *Lozenge.* In this example (drawing 45) from the Hospital of Sampson (3.6 cm high) the field is filled by lozenges framing lozenges.

Drawing 46. Cat. II.9.

44. *Lozenge.* In a second specimen from the same site (3.5 cm high), the lozenge is divided into quadrants, following a pattern that first seems to appear, in the early tenth century, in the decoration around the portrait of the emperor Alexander that was set in the south gallery of Saint Sophia (fig. 13).[76] Half-quatrefoils fill the interstices, whereas in the Alexander portrait half-circles occur at the edge, as in a third tile from the Hospital of Sampson (drawing 30).

Drawing 47. Cat. VI.10.

45. *Lozenge with four-petaled flowers.* The painter of a tile (4.8 cm high) from the Lips monastery created a lozenge frame around four-petaled flowers. Delicate tendrils curve off the lozenges and support bunches of grapes.

Drawing 48. Cat. VI.14.

46. *Circle and pitched square with four-petaled flowers and rosettes.* A second specimen from the Lips monastery is, at 7.1 cm, substantially higher and may have served as a main motif in a sequence. It was found to fit on a piece of plaster molding to which a tile with concentric circles remained attached (cat. VI.3).[77]

Saint Sophia contains countless running feet of circles and pitched squares (fig. 6), as well as lozenges alternating with circles, crosses, or flowers. Lozenges enclosing flowers appear around the shallow niches of the

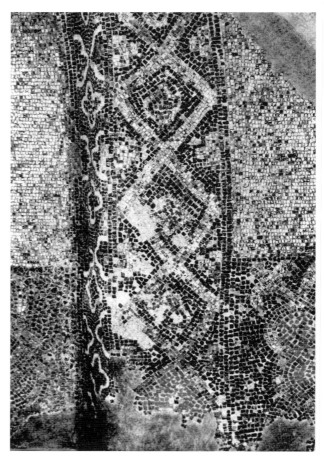

Fig. 14 Istanbul, Saint Sophia, tympanum niche border.

tympanum (fig. 14). Their decoration, executed when the church fathers were portrayed, is attributed to the time of Basil I and Photios, the late ninth century.[78] The alternating-circle-and-square design may derive from the Justinianic mosaics, but the lozenges follow the ninth-century precedent. The rosettes depicted within the circles on the tile are an elaboration of the eight-petaled flower. Here, too (as pattern 45), clusters of grapes fill the interstices.

Drawing 49. Cat. A.71.

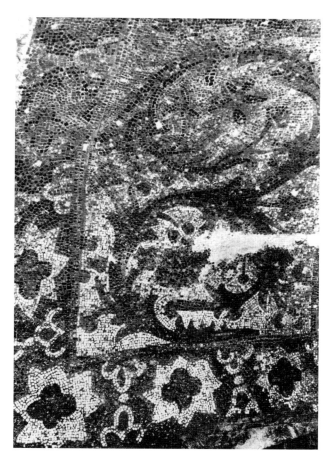

Fig. 15 Istanbul, Saint Sophia, south gallery, vault mosaic.

47. *Lozenge with profile flowers.* A large fragment (11 cm high) in the Walters Art Museum strongly recalls the work of the painter responsible for the two Lips tiles discussed above (patterns 45, 46). The pattern consists of lozenges enclosing unusual flowers; grape clusters and acanthus leaves fill the triangular interstices. The acanthus leaf represented here bears a marked resemblance to that found on a carved marble fragment reused in a wall near the southeast corner of the Hippodrome at Constantinople; the fragment, which appears to be of late-fifth- or sixth-century date, is decorated with a circle-and-lozenge pattern.[79] This is the only ceramic specimen of a simple flower seen in profile, rising from its stem. The motif is known in ancient floor mosaics and bears some

resemblance to the background flowers on an imperial silk in Bamberg that has been related to John Tzimiskes.[80]

Drawing 50. Cat. XIII.3.

48. *Pitched square with crosslets.* A fragment found in fill at the Baths of Zeuxippos and measuring only 5.6 cm high consists of a concentric-circle border and a pattern of pitched squares. The squares are filled with crosslets, a motif found in ancient floor mosaics but unattested in the early Byzantine ornament of Constantinople.[81] Another example occurs on a column base from the Topkapı Sarayı Basilica (cat. XII.39). The squares appear to be separated by circles or knobs; comparison with the mosaics of Saint Sophia (fig. 15) shows that they are associated with the trefoil or teardrop border motif.

Drawing 51. Cat. H.9.

49. *Lozenge with four-petaled flowers and checkerboard.* A fragment of a band that might be restored as lozenges with alternating patterns: four-petaled flowers and dotted checkerboard. Filling the interstices are tendril shapes similar to those found on the tiles with symmetrical acanthus leaves (e.g., drawing 3). Although composed of motifs common on the tiles, this specimen appears specifically to follow a form used in the decoration of a gallery cornice of Saint Sophia, known from one of the Fossati watercolors.[82]

Drawing 52. Cat. V.9.

50. *Lozenge braid.* A fragment (10.3 × 9.0 cm) covered with a herringbone pattern called "lozenge braid." This example

is a unique specimen decorated using a pattern known in ancient floor mosaics,[83] as well as medieval pavements set in *opus sectile,* an example of which appears at the Nea Moni.[84]

51. *Meander.* A narrow simplified meander appears as an edge motif to one of the circle-and-rosette patterns (see drawing 23). Meander was extremely common in antiquity and late antiquity. Though far less popular in the Middle Ages, meander can be found in the broad period under discussion; examples are known from the doors of Theophilos and Theodora, made in the late 830s for Saint Sophia,[85] and the mosaics of the eleventh-century church of Hosios Loukas.[86] The version here is finely drawn in a way that resembles metalwork.

Drawing 53. Cat. XII.26.

52. *Quatrefoil.* Several flat strips decorated with true quatrefoils survive: cat. XII.25 (2.6 cm high) and XII.26 (3.8 cm high). The quatrefoil pattern is discussed above in relation to lozenge motifs, but it is important to note that the curves are not pinched at their intersection. The use and proportion of the quatrefoils are much like those of the mosaic border to the portraits of the church fathers, depicted in the late ninth century, in the tympana of Saint Sophia (fig. 14). In the mosaics, the quatrefoil wraps neatly over a curved surface, but on the tile it is laid flat. The painter's imposition of a crisscross design may be his means of adapting to a flat surface a pattern he thinks of as three-dimensional.

Drawing 54. Cat. A.53.

53. *Sawtooth rows.* A sawtooth pattern appears on a large but incomplete (20.8 × 14.1 cm), plaque in the Walters

Art Museum; the motif is known in ancient floor mosaics.[87] Comparable in size and execution to the specimen with scale (drawing 55), it is possibly from the same monument or the same workshop. Both may have been applied to simulate narrow pilaster shafts. Lending support for this proposed use are the flat pieces with peacock-feather decoration (cat. A.50) that can be associated with column shafts.

Drawing 55. Cat. A.52.

54. *Scale.* A large (35.5 × ca. 15.25 cm) piece in the Walters Art Museum is covered with a scale pattern. Well known in antiquity and late antiquity, comparable areas covered in scale are otherwise unknown in medieval Byzantine ornament.

Drawing 56. Cat. VI.9 .

Drawing 57. Istanbul, Saint Polyeuktos, cornice (Harrison).

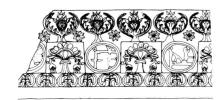

Drawing 58. Istanbul, Saint Polyeuktos, cornice (Harrison).

55. *Shell with circles.* Successor to the decorative motif known as *pelta,* after the ancient shield, the shell pattern takes its name from a cornice at Saint Polyeuktos (drawing

57) and the fact that medieval versions rarely appear empty (as do *peltae*): the shell usually serves as a frame for some decorative motif. Other cornices from the same site enclose sharply cut leaves (drawing 58), and similarly designed relief carving is known from the sixth-century work at Saint Sophia (fig. 5). The tile painters engaged by Constantine Lips, who had spolia removed from Saint Polyeuktos for reuse in his foundation, simplified the shell pattern by eliminating the ribs; to fill the resulting void, they added prominent circles of a kind common among the tile painters (drawing 56). The Lips tiles and related examples vary in size and curvature: examples include a narrow flat tile (cat. VI.9, 3.8 cm) and several larger curved tiles: cat. VI.8 (ca 7 cm, convex), VII.2 (7 cm, convex), and XII.4 (7.5 cm, concave).

Drawing 59. Cat. VII.4.

Drawing 60. Istanbul, Lips monastery, cornice (Macridy).

56. *Shell with palmettes.* A set of large fragments (9 cm high) from the Myrelaion church can be pieced together to form a unique design, a palmette enclosed in a shell border (drawing 59; cat. VII.4). The complex palmette was designed following principles apparent in the tenth-century sculpture of the Lips monastery (drawing 60): forms grow symmetrically from a pinched circle sitting on a curved base. Resembling leaves, the forms curve sharply, and those of the tile are detailed in the center in a manner that suggests knowledge of sharply grooved sculpture, such as that found in the Lips monastery.[88] The tile painter has added the segments of flower petals known in other tiles and drawn from a common motif (cf. pattern 10).

Drawing 61. Cat. II.11.

57. *Step.* The step pattern is extremely common in the ornament of Saint Sophia (fig. 6). An unusual fragment (4 cm high) from the Hospital of Sampson contains an elaborate form of step organized within interlocking triangles (drawing 61). At the base of each are two dotted squares; surrounding them on three sides are step designs, each with a circle at its base, like ones in Saint Sophia.[89] Prominently dotted motifs are common on the tiles as well as in contemporary works such as the Lips icon (drawing 44).

Tongue and Dart

Many of the specimens are badly damaged, but from those that preserve both the upper and lower edge we may note considerable variation in height: 3.6 (cat. II.1), 4 (cat. VI.1), 5.7 (cat. VII.1), 6.8 (cat. V.10), 6.9 (cat. XVI.1), 7.1 (cat. A.61), and ca. 9.6 cm (cat. XIII.1).

Drawing 62. Cat. B.6.

58. *Tongue and dart,* type A. In two of the tiles (cat. A.61, B.6) the dart has been represented as a line terminating in a dot (drawing 62).

59. *Tongue and dart,* type B (see drawing 12). Also known are examples in which the dart is treated as a line separating the tongue and terminating in a step pattern.

60. *Tongue and dart,* type C. The painter of one of the tiles elaborated the design by adding rectilinear frames (see cat. II.1).

61. *Tongue and dart,* type D. In this specimen, cat. II.2, the painter ringed the tongue motif with small half-circles, a motif used with circular frames (cf. patterns 19, 20).

Tongue and dart cornices appear in early Byzantine architectural ornament in Saint John Stoudios, Saints Sergios and Bakchos,[90] and the seventh-century building phase of the Kalenderhane Camii, where a molding of earlier date was reused.[91] At Saints Sergios and Bakchos and the Kalenderhane Camii, tongue and dart appears as an isolated motif, deeply carved on upper cornices, in the former as a *cyma reversa* and the latter a *cyma recta.* Tiles decorated with tongue and dart reflect these shapes, though simplified to a single curve; they exist in convex (cat. II.2, VII.1, XIII.1) and concave (cat. I.B.2, A.61) profiles, in addition to flat specimens (cat. II.1, VI.1). The degree of variation encountered in so simple a pattern may reflect how unusual tongue and dart was in medieval Byzantine ornament; the tiles are the principal examples, though a medieval fragment of tongue and dart was uncovered from the Boukoleon Palace,[92] and a tongue-and-dart cornice remains in place at the Nea Moni.[93] Together, the medieval sites at which this motif is found suggest that tongue and dart had a high-tone association. In the reconstructed molding from Saint John Stoudios (drawing 12), tongue and dart appears as the last of three successive patterns, a placement that agrees with the location of tongue and dart on church cornices. Decorative motifs that are flat at the base then arch upward appear to have been favored as the topmost pattern in a succession; examples include the acanthus at San Vitale[94] and leaf and dart in the Stoudios entablature (fig. 1), at Saint Demetrios, Thessalonike,[95] as well as on the Justinianic cornices reused in the medieval decoration of the Great Palace.[96] The use of tongue and dart as a final pattern is not invariable, as one tile fragment indicates (cat. XVI.1).

Drawing 63. Cat. V.5.

62. *Wave crest.* The wave-crest pattern is common in ancient mosaics but seems to lose its popularity in the early Byzantine period. It appears as an edge motif on a tile fragment found in fill at the Kalenderhane Camii (drawing 63). A comparable example is found among the mosaics of Saint Sophia, where it occurs in the early-tenth-century work undertaken when the portrait of Alexander was installed in the south gallery; this tenth-century example likely follows earlier precedents in the building.[97]

Oblong Tiles with Novel Designs (63–72)

A handful of tile patterns present forms or approaches that are noteworthy because their origin in late antique or early Byzantine ornament is less clear.

Circle with Tendrils

Drawing 64. Cat. C.7.

63. *Circle with scrolling tendrils,* type A. A fragment measuring 9.5 cm high is decorated with circles that enclose what appears to be a kind of ivy motif: sinuous vines and leaves with three lobes. In a related specimen (cat. II.16), the circles are bound, and the curve of the vine and fan-shaped segments, added where the stalks bend, relate the motif more directly to ivy leaf (cf. pattern 37). In the example illustrated here, the leaves and tendrils are drawn with regularity and precision, and the design resembles ones found in Byzantine metalwork, as is argued more fully

elsewhere.[98] The metalwork origin applies to the following tile, as well to as another in this group. In a third version of the pattern, the vines closely follow the circular frame, which is doubled (cat. v.7).

64. *Circle with tendrils,* type B. This small fragment (see cat. XIII.9) of what may have been a running-circle motif has the same three-lobed leaves, though these are perforated and grow in a cross shape from a split stalk. The draftsmanship is poor, as is the composition, which leaves much of the field empty.

Hearts

A number of tiles have hearts, rather than circles, lozenges, or squares, enclosing decorative motifs. The examples are notably concentrated in the Topkapı Sarayı Basilica. The heart shape, it seems, was unknown as a framing device in early Byzantine churches.[99] In architectural decoration from the eleventh century onward, it becomes relatively common, and the tiles may constitute some of the earliest examples used in Byzantine buildings. The form is not entirely of medieval invention; hearts are well known in the Saint Sophia mosaics, though as small accents (fig. 6), as they were also employed by the tile painters (drawing 18). The deciding factor in the growth of the heart frame is its accommodation to a leaf, rather than a flower or rosette. In a number of early Byzantine works, leaves were enclosed in sharp ellipses that resemble trained vines or stalks; examples occur among the beam carvings of Saint Catherine's at Mount Sinai[100] and carvings along the inside faces of the gallery-level arches of Saint Sophia.[101] In the latter, inserted stalks below the leaf allow the form to be read as a heart inside an ellipse, much as one of the cornice patterns at Saint Polyeuktos suggests leaves growing from stems that, along with the cornucopia from which they emerge, form a heart shape.[102] From the period during which the vocabulary of the tile painters was being formed, two examples of heart frames are known. The first is the ellipse with one end flattened that frames the

donor's inscription of the church at Skripou (873/74),[103] and the second is the pure heart shape with leaf at the Lips monastery (drawing 65). Some of the ceramic examples, unlike that at Lips, have ogival frames; for this predilection see the doors of the silver reliquary, dated 969–70, at Aachen.[104]

Drawing 65. Istanbul, Lips monastery, sculpted molding.

At Skripou and Lips, the forms are vastly simplified in contrast to the early Byzantine examples, and they have strong and simple outlines. What is unusual about the heart is its relationship to the curved ground on which it is represented: the bulk of the form rides below the center line. The heart often appears to sink and belly out, as if gathering strength to rise upward. In at least two of the examples (drawings 66, 68), the filler motifs appear only along the upper edge, to emphasize the new spatial relationship. The examples are given in order of complexity.

Drawing 66. Cat. XII.16 .

Drawing 67. Istanbul, Saint Sophia, carved frame (Antoniades).

65. *Heart with five-pointed leaves,* type A. A series of broad hearts, each enclosing a leaf with five points or lobes (drawing 66). Separating them are hearts drawn only at the upper edge. The leaves have a marked perfora-

tion that tends to a triangular form in one instance. The leaf shape and its perforation may be traced back as far as Saint Sophia, where both are common. In the looped-circle borders found at the cathedral (drawing 67), two of the prominent repeating motifs are five-pointed leaves and leaves that are split nearly down the middle.

Drawing 68. Cat. XII.17.

66. *Heart with split five-pointed leaves,* type B. In this second specimen, the leaves are split (drawing 68). The wide hearts have a double outline common to a number of the tiles and are bound. The filler motif at the top appears to be an elaborated version of the half-quatrefoil; its greater complexity reflects that of the leaf.

Drawing 69. Cat. C.4.

67. *Heart with five-pointed leaves,* type C. This fragment seems to show a double row of leaf shapes, large ones below and small delicate ones above (drawing 69). The better preserved portion along the bottom has the double outline drawn to connect the hearts after the fashion of looped circles. The painter has given the basically five-pointed leaf a complex scalloped edge and prominent perforation.

Drawing 70. Cat. XII.31.

68. *Heart with five-pointed leaves,* type D. Much like the last example, except the outline of the leaf is treated as a series of strong curves (drawing 70).

Drawing 71. Cat. B.11 .

69. *Heart with five-pointed leaves,* type E. In this specimen the hearts are notably pinched, and the filler motif elaborated downward into the space between them (drawing 71). The painter has also decoratively developed the composition. It consists of the central leaf and a second outline that mimics its shape.

70. *Heart with five-pointed leaves and flower.* Found at the Topkapı Sarayı Basilica is a notable fragment difficult to restore with any certainty (cat. XII.20). As was true of the last pattern, this one shows the painter at work creating a complicated design based on abstracted organic forms that he combines according to new principles, ones that stress linear complexity and devalue flat forms and clear symmetry. The result appears to be sure of touch and shows a high degree of creativity.

71. *Kufesque.* A few fragments from the Lips monastery were decorated with kufesque (cat. VI.16). It is a motif that appears mainly on buildings from the tenth century onward and that takes its name from an Arabic writing or epigraphical style associated with the city of Kufah, located south of Baghdad, in Iraq.[105] When compared with circle, heart, or lozenge patterns, the salient aspect of kufesque ornament is its dependence on straight lines drawn either parallel with or perpendicular to the axis of

the field. It is the only motif with this characteristic. As such, it relates to meander, which lost much of its popularity in the Middle Ages but is known on one of the tiles (cf. pattern 51). Kufesque is deconstructed meander with flourishes added at the terminals of the bars. The way in which Byzantine artists nested right-angle elements further supports the derivation from the traditional motif and helps explain why kufesque became popular: it was built on a familiar set of forms, but ones adapted to a new taste. As early as the sixth century, meander is broken down to suggest the leaves of flowering plants, this at the Panagia Kanakaria, Lythrankomi.[106] The tiles and contemporary examples of kufesque decoration show a further breakdown and reorganization of meander that is in keeping with medieval taste. The discontinuous nature of kufesque meander brings it into line with the serial ornament of individual circles, lozenges, or hearts. The growing sensibility that favored the heart shape also informed the popularity of kufesque, since it tends to be weighted toward the bottom of the field. The appearance of pseudo-kufic on the well-known glass bowl in the San Marco Treasury presumably points to the sophisticated audience for such decoration in the capital.

Drawing 72. Cat. III.1.

72. *Scrolling tendrils.* A unique fragment in the Istanbul Archaeological Museum was created using a white design on a black ground (drawing 72). There is no trace of a frame surrounding the sinuous pattern. The pattern on the tile, although related to a type of relief carving that has come to be called "champlevé," practiced in late antiquity and the Middle Ages, more closely resembles niello and some forms of enameling. A parallel for the general treatment is found in the niello patterns covering the dome of the tenth-century reliquary in Aachen.[107]

Decoration in which curving tendrils with stunted leaves appear against a solid colored background becomes popular in eleventh-century buildings; many examples appear in the handsome church of Hosios Loukas. The tile may be an early witness to this treatment as produced in the capital. Such decoration proved especially popular among eleventh- and twelfth-century frescoists, because the lack of a powerful frame allowed them to manipulate the forms to cover irregular shapes and surfaces.

Conclusion

This essay began with the Stoudios entablature (fig. 1), which is both representative and emblematic of Byzantine taste in the centuries following the establishment of Constantinople as the capital of the Roman Empire. In every respect, the carving of the entablature is conservative. The sensibility it captures agrees with that of other monuments of early Constantinople: the remains of the Theodosian Saint Sophia, Saints Sergios and Bakchos, and the mosaic-covered peristyle of the Great Palace. During the reign of Justinian, taste changed to favor more opulent decoration, which was quickly adapted to building styles different from those of antiquity. As we survey the patterns found on ceramic tiles, a large number of them can be shown to date from the era of Justinian. In fact, many occur in the church of Saint Sophia, both its Justinianic decoration and that of the Macedonian restorations and additions. A handful of patterns are otherwise known only at Saint Polyeuktos, but the state of the church in the tenth century overshadows the question of an artistic choice made by patrons and tile painters. One or two motifs, like the crosslet and the scale, do not occur in known Constantinopolitan monuments but are sufficiently common in ancient floor mosaics to remind us that we work from an imperfect record.

The tile painters do not choose indiscriminately from among the decorative motifs available in the city. They seem particularly drawn to ones that are flat. The illusionistic wavy ribbon found in both Saint Sophia and the

Great Palace Mosaic (no longer visible in the Middle Ages) is not imitated in medieval ceramics. The preference for flat patterns leads the painters to broaden, and at times coarsen, the delicate *opus sectile* designs found in the Great Church. They are not alone in their taste, as the contemporary parallels, including the wide acanthus leaf from the Lips monastery, indicate. Though they favor flat areas of color, the tile painters are not insensitive to the relationship between pattern and support surface, as the circles and lozenges painted on convex tiles indicate: the shapes are narrow at the top and swell outward with the bulge of the tile. The preference for flat patterns must largely be a function of the small scale of the tiles, which likely would have been installed above eye level. Yet even after taking into account a vantage point that demands boldness and simplicity, it is difficult to see these patterns as anything other than translations of mosaics or carved motifs, ones, in other words, that are not graphic in nature. For this reason, it is especially striking when one of the Lips painters seems suddenly to realize the potential of brush and glaze and begins to add delicate vines and grape clusters to traditional patterns (drawings 47–49). The ivy leaf that is found at a number of the sites also shows the degree of delicacy that tile painters could achieve when they exploited the possibilities of their materials and tools. It must also be said that the draftsmanship on some of the tiles is exceptionally fine freehand work. This is particularly true of the tiles with novel designs, which seem to have engaged the painters' full attention and creative gifts.

The painters of ceramic tiles value variety, and in seeking it they often mix motifs in unusual ways. Dotted circles, veined leaves, eight-petaled flowers, and others appear in a wide variety of contexts. The tongue of the tongue-and-dart pattern, for instance, is often treated as a neatly drawn circle at the tip of a line. In decorating a rosette, the painter responsible for one of the tiles recovered from the Myrelaion (drawing 24) used the dart where others painted a teardrop. The dotting of outlines or frames appears in the sixth-century mosaics of Saint

Sophia, where it was used to enclose circles (fig. 10). The tile painters employ such circles often to fill disks and, the disk's geometrical counterpart, squares (drawing 34). The capitals and bases created in ceramic show especially well how patterns often became disassociated from their traditional locations and were used to create a visually stimulating environment. In the dotted disks and squares, we encounter two of the three motifs that have their closest parallels in an Islamic monument, the Dome of the Rock. The greater significance of this unique parallel remains to be established.[108] In the end, though, the accumulation of circles, lozenges, and other forms, possibly layered in superimposed rows, recalls the architectural decoration of Saint Sophia (figs. 5, 6).

Three essays on ornament follow. The first is a comparison of tiles and manuscripts that is intended to place examples in both media into a common context, as well as to offer an interpretation of certain patterns found in books and tiles. The second and third essays take up the difficult problem of the relationship between Byzantine ceramics and the arts of the Islamic world. As is made clear in the introduction to this volume, Byzantine tiles came to light slowly and have not been, as a group, the focus of either extensive or systematic research. There may be some unspoken beliefs that quickly grew up around the first known tiles, beliefs shaped by their discovery in Turkey and the widespread use of a highly refined ceramic decoration there and in neighboring Muslim lands. Even those who accept the decorative vocabulary of the Byzantine tiles as largely traditional in nature nevertheless tend to view the adoption of ceramic ornament in Constantinople as the result of the firsthand experience of a Byzantine traveling in the Muslim East. As has been argued elsewhere,[109] the earliest Byzantine tiles may be the ones with a marble pattern. If this proves correct, then the first use was to simulate a traditional and costly building material rather well known to the Byzantines, not to recreate Umayyad or 'Abbāsid ornament in an obviously novel way. The ornamental tiles that employ motifs associated with *opus sectile* and carved decoration are one

step, if that, removed from imitation marble. How then are we to verify that what the emperor Theophilos's ambassador saw in Baghdad, in 830, led to the making of architectural ceramics in Constantinople? There are perhaps only two avenues leading to either a proof or a dismissal of the hypothesis. One is to determine the means by which brightly colored glazes entered the Byzantine craftsman's workshop. Tiles presumably began with potters, whose glazes tend to be less colorful. But are they the same substances as those used on the tiles, and if not, where did the artisans get the new glazes and knowledge of how to use them? The other is to study the patterns. Apart from kufesque, the designs used on tiles are mostly traditional, so the argument for contact with the East hinges on stylistic differences between the early and medieval Byzantine treatments of identical motifs. Are those differences the result of an appreciation of foreign craftsmanship? The authors propose answers from two perspectives.

Notes

1. F. Deichmann, *Ravenna: Hauptstadt des spätantiken Abendlandes,* II/2 (Wiesbaden, 1976), 118–34: investigations carried out by the Institut für Baugeschichte, University of Karlsruhe, reported by H. Raabe.

2. F. Deichmann, *Frühchristliche Bauten und Mosaiken von Ravenna* (Baden-Baden, 1958), pls. 258, 299. Contrast the severity of the apse decoration of the monastic church of Saint Catherine's at Mt. Sinai, built by Justinian: G. Forsyth and K. Weitzmann, *The Monastery of Saint Catherine at Mount Sinai: The Church and Fortress of Justinian* (Ann Arbor, 1973), pls. LXXXIV, LXXXVIII, LXXXIX. Toward the middle of the sixteenth century the revetment at San Vitale was moved to another part of the building, and it was only reinstated in the restoration campaign of 1900–1904 (Deichmann, *Hauptstadt des Abendlandes,* 134–35).

3. A. Terry, "The *Opus Sectile* in the Euphrasius Cathedral at Poreč," *DOP* 40 (1986), 147–64.

4. P. Asemakopoulou-Atzaka, *He technike opus sectile sten entoichia diakosmese,* Byzantina Mnemeia 4 (Thessalonike, 1980), pls. 33, 34, 45.

5. Chatzidakis, *Hosios Loukas,* fig. 8.

6. C. Bouras, *Nea Moni on Chios: History and Architecture* (Athens, 1982), 87–89.

7. Asemakopoulou-Atzaka, *He technike opus sectile,* 149, pls. 27, 71.

8. A. Megaw, "Notes on Recent Work of the Byzantine Institute in Istanbul," *DOP* 17 (1963), 340, fig. 12.

9. Striker and Kuban, *Kalenderhane,* 117–18.

10. R. Ousterhout, *The Architecture of the Kariye Camii in Istanbul,* DOS 25 (Washington, D.C., 1987), 39–46.

11. Ousterhout, *Kariye Camii,* 40. The same star pattern occurs on the floor of the Pantokrator monastery churches (Megaw, "Recent Work," fig. 5) and in the bema of the church at Daphni (fig. 12, this chapter).

12. Harrison, *Saraçhane,* 168.

13. Much of the cornice decoration was created by the Fossati, but, it seems, using molds made from original pieces in the building: E. Hawkins, "Plaster and Stucco Cornices in Haghia Sophia-Istanbul," *XII CEB,* III (Belgrade, 1964), 131–35; Mango, *Materials,* 15.

14. C. Mango and A. Ertuğ, *Hagia Sophia: A Vision for Empires* (1997), 6.

15. T. Whittemore, *The Mosaics of St. Sophia at Istanbul: Preliminary Report on the First Year's Work, 1931–1932: The Mosaics of the Narthex* (Oxford, 1933), pl. II.

16. Ousterhout, *Kariye Camii,* 46, fig. 54.

17. R. Cormack and E. Hawkins, "The Mosaics of St. Sophia at Istanbul: The Rooms Above the Southwest Vestibule and Ramp," *DOP* 31 (1977), 233–35, 246–47, figs. 22, 23.

18. Mango and Hawkins, "Additional Notes," 311, fig. 58.

19. Ibid., 306.

20. Striker, *Myrelaion,* 24.

21. M. Angold, "Inventory of the So-called Palace of Botaneiates," in *The Byzantine Aristocracy: IX–XIII Centuries,* ed. M. Angold (Oxford, 1984), 254–66; and cat. XIV.

22. Mango, *Sources and Documents,* 239.

23. See, for instance, the revetment patterns at Saint Sophia (e.g., H. Kähler, *Hagia Sophia* [New York, 1967], fig. 40) and the Kalenderhane Camii (Striker and Kuban, *Kalenderhane,* pls. 16–18, 29).

24. Mango, *Materials,* fig. 12.

25. A. Tsitouridou, *The Church of the Panagia Chalkeon* (Thessalonike, 1985), 22–24.

26. U. Peschlow, "Neue Beobachtungen zur Architektur und Ausstattung der Koimesiskirche in Iznik," *IstMitt* 22 (1972), 154.

27. G. Brett, W. Macaulay, and R. Stevenson, *The Great Palace of the Byzantine Emperors, Being a First Report on the Excavations Carried Out in Istanbul on Behalf of the Walker Trust (The University of St. Andrews), 1935–1938* (London, 1947), pls. 31, 38, 40. W. Jobst and H. Vetters, *Mosaikenforschung im Kaiserpalast von Konstantinopel,* Österreichische Akademie der Wissenschaften: Philosoph-historische Klasse, Denkschriften 228 (Vienna, 1992), 60, the pavement laid no earlier than the last quarter of the fifth century.

28. Cormack and Hawkins, "Rooms Above the Southwest Vestibule," 205–10.

29. Compare the forms of the pomegranate at Saint Polyeuktos: Harrison, *Saraçhane,* 133, fig. 156.

30. M. Chatzidakis et al., *Naxos* (Athens, 1989), 58–65, fig. 13.

31. Harrison, *Saraçhane,* fig. 147: triplet of teardrop shapes.

32. Though of possibly questionable relevance, it might nevertheless be worthwhile to note that Pliny (*NH,* 22.34) divided acanthus into spiky and broad categories.

33. Macridy, "Monastery of Lips," fig. 76.

34. See the essay by W. Tronzo in this volume, fig. 17.

35. Terry, "*Opus Sectile* at Poreč," figs. 8, 14.

36. See the necklace illustrated on fol. 438v of Paris, Bibliothèque Nationale, gr. 510: H. Omont, *Miniatures des plus anciens manuscrits grecs de la Bibliothèque Nationale du VIe au XIVe siècle,* 2d ed. (Paris, 1929), pl. LVIII;

the manuscript was made between 880 and 883.

37. Macridy, "Monastery of Lips," fig. 20; Mathews, *Byzantine Churches,* fig. 35-21.

38. Macridy, "Monastery of Lips," fig. 76.

39. Kähler, *Hagia Sophia,* fig. 30.

40. See the Cappadocian church of St. Eustathios: G. de Jerphanion, *Une nouvelle province de l'art byzantin: Les églises rupestres de Cappadoce,* I (Paris, 1925), pls. 36–38.

41. Chatzidakis et al., *Naxos,* fig. 14.

42. A. Ovadiah, *Geometric and Floral Patterns in Ancient Mosaics* (Rome, 1980), 151–52.

43. Whittemore, *Mosaics of the Narthex,* 10–11.

44. Harrison, *Saraçhane,* fig. 120.

45. S. Nuseibeh and O. Grabar, *The Dome of the Rock* (New York, 1996), figs. 100, 101.

46. Terry, "*Opus Sectile* at Poreč," fig. 19.

47. For the half-circles pointing inward: Cormack and Hawkins, "Rooms Above the Southwest Vestibule," fig. 8.

48. C. Mango and E. Hawkins, "The Apse Mosaic of St. Sophia at Istanbul: Report on Work Carried Out in 1964," *DOP* 19 (1965), 137–40.

49. P. Underwood and E. Hawkins, "The Mosaics of Hagia Sophia at Istanbul: The Portrait of the Emperor Alexander: A Report on Work Done by the Byzantine Institute in 1959–1960," *DOP* 15 (1961), 204–6, 210.

50. S. Campbell, *The Mosaics of Aphrodisias in Caria,* Subsidia mediaevalia 18 (Toronto, 1991), 43.

51. Mango, *Sources and Documents,* 239.

52. Terry, "*Opus Sectile* at Poreč," fig. 15.

53. Macridy, "Monastery of Lips," fig. 43 (right).

54. Forsyth and Weitzmann, *Saint Catherine,* pl. CXXII.B.

55. V. Lazarev, *Storia della pittura bizantina* (Turin, 1967), fig. 52.

56. See the essay by W. Tronzo in this volume, fig. 17.

57. Kähler, *Hagia Sophia,* fig. 76.

58. Grabar, *Sculptures* I, pl. XL.1-3.

59. Macridy, "Monastery of Lips," fig 76.

60. For Saint Euphemia, see Mathews, *Byzantine Churches,* fig. 12-3, and for Saint John in the Hebdomon, ibid., fig. 14-5; for Saint Polyeuktos, Harrison, *Saraçhane,* figs. 138–40.

61. See Figure 9 in the following essay.

62. Nuseibeh and Grabar, *Dome of the Rock,* pl. 119.

63. See the essay by M. Mango in this volume, fig. 1.

64. Brett, Macaulay, and Stevenson, *The Great Palace of the Byzantine Emperors,* pls. 28, 29, 31–34. Cormack and Hawkins, "Rooms Above the Southwest Vestibule," figs. 22–24.

65. E. Antoniades, *Ekphrasis tes Hagias Sophias,* I (Athens, 1907), 175, fig. 199.

66. Macridy, "Monastery of Lips," fig. 41.

67. Mathews, *Byzantine Churches,* fig. 9-24.

68. Harrison, *Saraçhane,* 156, fig. 196.

69. Deichmann, *Bauten und Mosaiken von Ravenna,* pls. 312–17.

70. R. Cormack, "The Mosaic Decoration of S. Demetrios, Thessaloniki: A Re-examination in the Light of the Drawings of W. S. George," *BSA* 64 (1969), pls. 7, 9.

71. A. Grabar, *L'iconoclasme byzantin* (Paris, 1984), 175, fig. 88.

72. Harrison, *Saraçhane,* fig. 130.

73. Mango, *Materials,* fig. 40.

74. Chatzidakis, *Hosios Loukas,* fig. 23.

75. See the essay by W. Tronzo in this volume, fig. 17.

76. Note 49 above.

77. As note 18 above.

78. C. Mango and E. Hawkins, "The Mosaics of St. Sophia at Istanbul: The Church Fathers in the North Tympanum," *DOP* 26 (1972), 37–41.

79. E. Mamboury and T. Wiegand, *Die Kaiserpaläste von Konstantinopel zwischen Hippodrom und Marmara-Meer* (Berlin, 1934), 52, pl. XCVI.

80. *Rom und Byzanz: Schatzkammerstücke aus bayerischen Sammlungen,* ed. R. Baumstark (Munich, 1998), 206–10.

81. Ovadiah, *Geometric and Floral Patterns,* 129.

82. Mango, *Materials,* fig. 44.

83. Ovadiah, *Geometric and Floral Patterns,* 99.

84. Bouras, *Nea Moni,* fig. 55.

85. Mathews, *Byzantine Churches,* fig. 31-37.

86. Chatzidakis, *Hosios Loukas,* fig. 21.

87. Ovadiah, *Geometric and Floral Patterns,* 94–96.

88. See Macridy, "Monastery of Lips," fig. 17, and Mango and Hawkins, "Additional Notes," fig. 9.

89. Mango and Ertuğ, *Hagia Sophia,* 10.

90. Mathews, *Byzantine Churches,* figs. 29-2, 29-24.

91. Striker and Kuban, *Kalenderhane,* 102.

92. See the essay by W. Tronzo in this volume, fig. 17.

93. Bouras, *Nea Moni,* 89, fig. 68.

94. Terry, "*Opus Sectile* at Poreč," fig. 28.

95. As note 4 above.

96. C. Mango, "Ancient Spolia in the Great Palace of Constantinople," in *Byzantine East, Latin West: Art-Historical Studies in Honor of Kurt Weitzmann,* ed. D. Mouriki et al. (Princeton, 1995), 647, fig. 8.

97. Underwood and Hawkins, "Portrait of the Emperor Alexander," 209, figs. 2, 19. See the decoration in the south aisle: R. Mainstone, *Hagia Sophia: Architecture, Structure, and Liturgy of Justinian's Great Church* (1988), fig. 235.

98. See the next essay in this volume.

99. But related motifs can be found in the early period, for example, Justinian's consular diptychs (*Age of Spirituality,* 51), on which something close to the ancient anthemion framed by a pair of scrolls (forming the heart) is employed. This strikes me as consciously classicizing ornament used on a kind of object irrelevant to this discussion.

100. Forsyth and Weitzmann, *Saint Catherine,* pl. LXVII.10.

101. Kähler, *Hagia Sophia,* figs. 45, 70.

102. Harrison, *Saraçhane,* figs. 114–18. The same pattern appears on one of the Saint Sophia beam casings (Antoniades, *Ekphrasis,* fig. 358), which bear a number of heart and perforated-leaf designs like those on the tiles. C. Sheppard's attempt made to date the casings ("A Radiocarbon Date for the Wooden Tie Beams in the West Gallery of Saint Sophia, Istanbul," *DOP* 19 [1965], 238) has not met with universal acceptance; the parallel with a rare design from Saint Polyeuktos should be considered as evidence in the matter of when the casings might have been carved.

103. Grabar, *Sculptures* I, 90–91, pl. XXXIX.3.

104. W. Saunders, "The Aachen Reliquary of Eustathius Maleinus, 969–70," *DOP* 36 (1982), 211–19, figs. 1,2.

105. G. Miles, "Byzantium and the Arabs: Relations in Crete and the Aegean Area," *DOP* 18 (1964), 17–32.

106. A. Megaw and E. Hawkins, *The Church of the Panagia Kanakariá at Lythrankomi in Cyprus,* DOS 14 (Washington, D.C., 1977), fig. 44.

107. As note 101 above.

108. E. Kitzinger argued that the Umayyad mosaics of the Dome of the Rock relied on Constantinopolitan art: "The Period Between Justinian and Iconoclasm," in *Berichte zum XI. Internationalen Byzantinisten-Kongress, München 1958* (Munich, 1958), IV/1, 10–11; reprinted in *The Art of Byzantium and the Medieval West: Selected Studies by Ernst Kitzinger,* ed. W. Kleinbauer (Bloomington, 1976), 166–67.

109. See the essay by W. Tronzo in this volume, fig. 17.

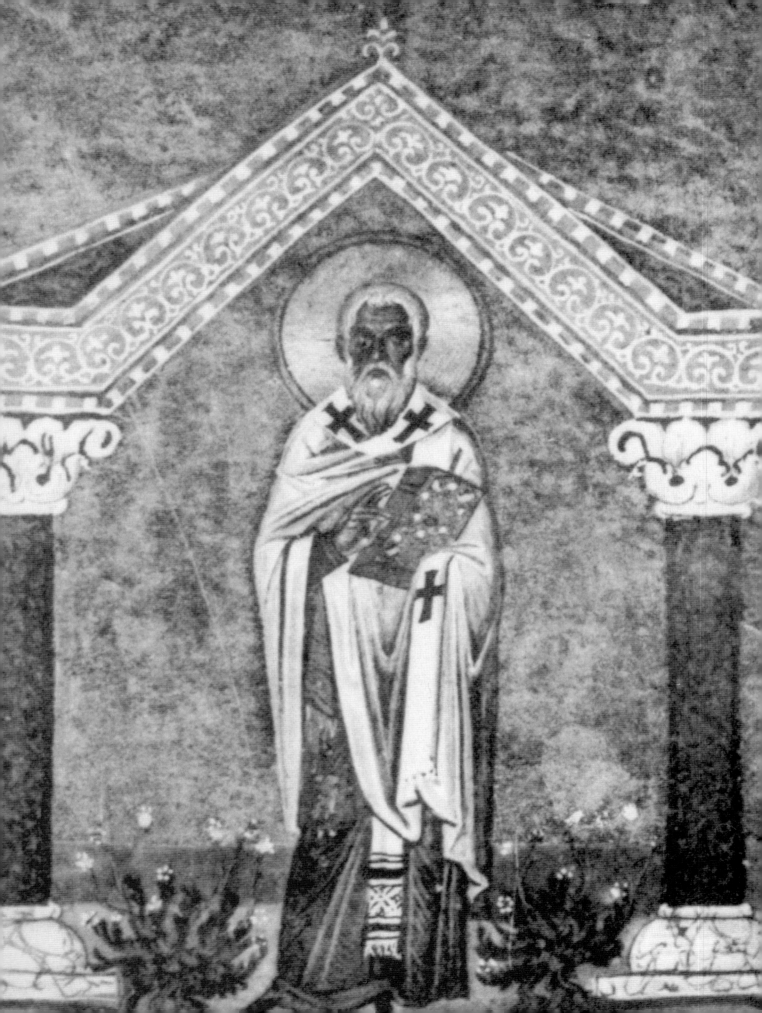

Tiles, Books, and the "Church Like a Bride Adorned with Pearls and Gold"

JEFFREY C. ANDERSON

 Byzantine ceramic tiles are mainly ornamental in nature. With a few notable exceptions, they contain nonfigural patterns that suggest their use as decorative accents in buildings, like the Great Mosque at Córdoba, in which a tile cornice remains in place.[1] Anyone seeking to analyze the patterns or set them against a wider background of Byzantine taste would turn to illuminated manuscripts, since books contain not only the largest body of ornament surviving from Constantinople but also the most varied body. Illuminators active from the sixth through the fourteenth century used ornament to shape initial letters, frame titles and miniatures, and set off lists, poems, and the Eusebian canon tables. A large number of the patterns known to illuminators were also part of the ceramicists' decorative vocabulary, and why this might have been so lies at the heart of my essay. It seems unlikely that tile makers used books as sources for their designs, because books were expensive and did not circulate beyond groups of interested readers. The alternative supposition, that illuminators took patterns from the tiles, could be argued with more conviction, but the most likely explanation may be that both sets of craftsmen drew from sources outside their respective traditions.[2] In the first part of this essay, I list and examine some patterns common to books and tiles. The second part is devoted to issues of chronology, especially to the range of centuries in which particular patterns flourished. The third offers several conclusions regarding the history of ornament in Byzantium and the ways in which tiles and manuscripts might clarify it.

Three groups of patterns help establish the common ground between the tiles and manuscripts. A small number of designs, notably the guilloche and step, are too widespread to warrant discussion, whereas a small number of others have no direct parallels in manuscripts known to me. The comparisons that follow leave little doubt that ceramic workshops operated in Constantinople or its suburbs; when and over how long a period of time are questions of chronology to which the manuscripts contribute less accurate information than archaeology, although books may provide clues to the date and function of tiles that have come to us entirely out of context.

Peacocks, decorated columns, and related designs. Peacocks figure in the fifth-century mosaics of the Rotunda of Saint George at Thessalonike. Some are represented perched on the corners of entablatures, like acroteria that have come to life (fig. 1).[3] Others spread their tails to fill monumental niches. Similarly, but in sculpture, peacocks

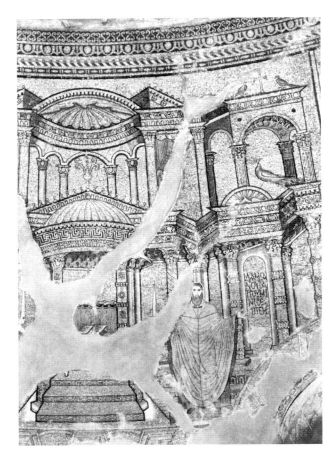

Fig. 1 Thessalonike. Rotunda of Saint George.

Fig. 3 Paris, Bibliothèque Nationale, Coislin gr. 20, fol. 5v. Canon table (detail).

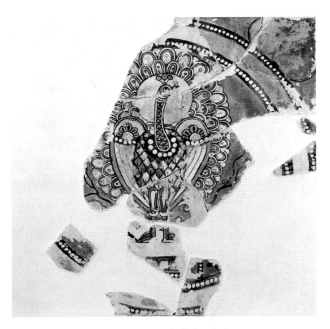

Fig. 2 Paris, Musée du Louvre. Peacock tile (cat. B.2).

with fanned tails filled the ground-level niches of the sixth-century church of Saint Polyeuktos in Istanbul.[4] During the Middle Ages, the peacock continued to be a subject represented in Byzantine buildings. Basil I (867–86) had one prominently depicted on the floor of a hall he constructed during extensive rebuilding of the Imperial Palace;[5] and fragments of a stone plaque decorated with a peacock were uncovered from the early-tenth-century church of Constantine Lips's monastery in Constantinople.[6] These birds also have parallels in a number of well-known ceramic tiles attributed generally to the time of the Lips monastery (fig. 2). In the simulated architecture of canon tables, peacocks appeared in profile or frontal view in the spandrels (fig. 3), and, having gained

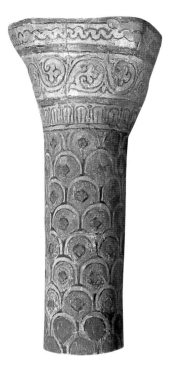

Fig. 4 Istanbul, Ayasofya Müzesi. Column with peacock feathers (cat. II.18).

currency on canons at an early date, they were used in the decoration of title frames for book chapters.[7] A substantial number of tiles only refer to peacocks through the representation of their tail feathers. Context may have determined how Byzantine beholders understood the decoration, beyond their reaction to its luxuriant richness. If seen in churches, peacock feathers may have been a sign of immanent divinity. This significance is suggested by

Byzantine writings,[8] archaeological evidence,[9] and liturgical objects.

The tips of peacock feathers appear along the border of a sixth-century liturgical fan, the Riha Flabellum.[10] With a naturalist's attention to detail, the silversmith represented the barbs of the feather growing from the central shaft, which terminates in the distinctive eye of the peacock's tail. The decorative pattern was appropriate to a liturgical object used near the eucharistic offerings because it was associated with visions of God. At the center of the fan, one of Ezekiel's Living Creatures balances on a set of flaming wheels (Ezek. 1:5–11, 10:12). By the close of the first century of our era, authors had begun to locate the eyes that the Prophet (Ezek. 1:18) placed along the wheels on the creatures' six wings (Rev. 4:8), opening the way for an association with peacocks.[11] A design based on peacock feathers covers one of the main-arcade soffits of the church of the Acheiropoietos, Thessalonike, attributed to the fifth century.[12] The feathers at the Acheiropoietos were not arranged radially, as on the flabellum, but in rows, in a scale pattern, as they also appear on ceramic columns and pilasters in the collections of the Walters Art Museum (cat. A.51), the Louvre (cat. B.15), and the Saint Sophia Museum (fig. 4).

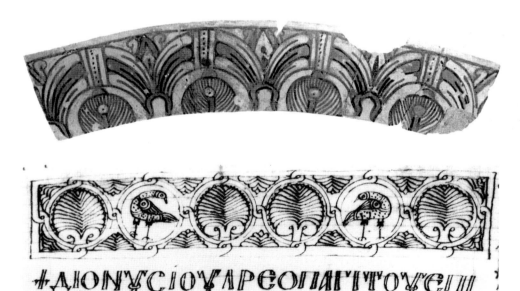

Fig. 5 Istanbul, Arkeoloji Müzerleri. Peacock-feather molding from Topkapı Sarayı Basilica (cat. XII.5).

Fig. 6 Paris, Bibliothèque Nationale, gr. 933, fol. 193. Headpiece.

Among illuminators, peacock feathers had limited appeal. The illuminator of the tenth-century Coislin Gospels[13] decorated one of the canon tables with columns bearing patterns like those on the ceramic columns (figs. 3, 4).[14] The canon-table arch was filled with peacock feathers cast in a design that created a sophisticated visual dissonance between the naturalistically represented birds in the spandrels and their abstracted feathers. An arch facing from the Topkapı Sarayı Basilica uses a similar design (fig. 5), but has feathers different from those of the Coislin Gospels. The barbs were drawn in detail, forming a pattern that matched the linear density of the framing ornament. In the middle of the tenth century, the illuminator of a copy of the writings of Dionysios the Areopagite followed a similar approach when he created a headpiece filled with alternating peacocks and densely patterned feathers (fig. 6).[15]

The peacock-feather patterns used by ceramicists and illuminators occur in much the same form in the mosaic and sculptural decoration of early Byzantine as well as contemporary buildings. The value of peacock feathers lies in the strength of their testimony. Artists were constrained from reducing them to an unrecognizable abstraction because the feathers created an atmosphere of holiness in the Byzantine church; encountering peacocks near the sanctuary barrier, some viewers may even have connected them with the cherubim surrounding God's throne, a connection reinforced by the *Cherubikon* hymn. In addition to this recognizable design, columns with abstract patterns survive.

Columns and pilasters covered in mosaic or carved with abstract ornament that was filled with colored materials are found in early Byzantine churches. Examples are found at Saint Catherine's on Mount Sinai (fig. 9) and the Constantinopolitan churches of Saint John in the Hebdomon (fig. 10), Saint Polyeuktos (fig. 11), and Saint Euphemia.[16] Survival of the decorative aesthetic established in early Byzantine times is confirmed by the discoveries made at the monastery of Constantine Lips[17] and by the canon tables in medieval manuscripts. Ceramic tiles of the Middle Ages contribute more evidence to the discussion of a form otherwise not well known after the sixth century.

Among the surviving tile fragments are patterned column bases, capitals, and curved pieces that served as shafts (fig. 7). A number of flat tiles were painted in a similar manner that suggests their possible use as pilasters (fig. 8), following a decorative technique known in the sixth century, in the ornamental responds at Justinian's Saint Sophia and the mosaic decoration of Sant'Apollinare in Classe.[18] The patterns on the tiles, whether flat or convex, run on the bias, like those of the mosaic-covered colonnette from Saint Catherine's on Mount Sinai (fig. 9) and the carved and inlaid column from the church of Saint John in the Hebdomon (fig. 10). In medieval illumination, comparable columns appear as early as the late-ninth- or early-tenth-century lectionary in the Vatican Library (fig. 14).[19] The columns, drawn with metal binding rings, were decorated with a diagonal pattern of squares and dots. Although considerably reduced in scale and detail, the pattern of the column from Saint Catherine's remains recognizable (fig. 9). A flat tile recovered from the fill at Saint Polyeuktos (fig. 21) likewise bears a pattern similar to that of the Saint Catherine's colonnette: large diagonal bars create a lattice filled with smaller designs. In this case the circles have been moved to the intersections of the bars, and the result is a denser, more varied pattern.

The makers of the two Walters tiles that we will examine more closely (figs. 7, 8) squeezed the empty space out of the colonnette design to create a checkerboard of circles and squares running on the diagonal. The individual motifs can be found in a number of medieval manuscripts, including the Leo Bible,[20] attributed to the second quarter of the tenth century. In framing a giant cross at the opening of the Bible, the illuminator used a decorated arch resting on a pair of plain marble columns (fig. 19). The pattern on the arch is composed of elements similar to those on the tiles, though arranged for a radial field. A step pattern of blue and violet half-crosses pushes in from the edges to frame brick red circles dotted in white. The circles are a motif common to both the Wal-

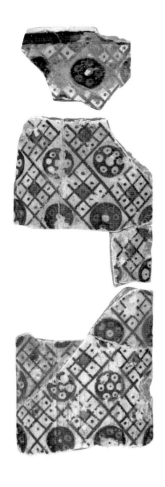

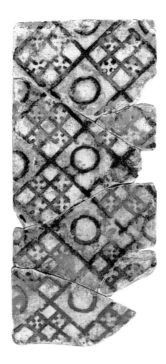

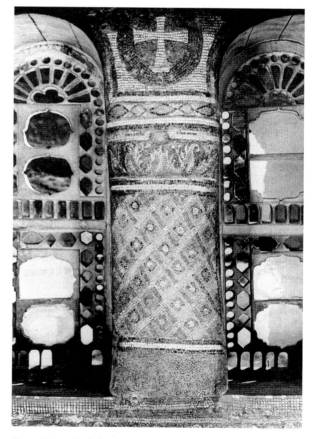

Fig. 7 (*left*) Baltimore, Walters Art Museum. Ornamental tile (cat. A.63).

Fig. 8 (*right*) Baltimore, Walters Art Museum. Ornamental tile (cat. A.45).

ters tiles and Leo Bible, works in which the decorative forms are bold and simple (figs. 7, 8, 19); contrast the fine detailing of an only slightly later headpiece (fig. 22). The dotted circles of the Leo Bible and Walters tile look like flowers,[21] but may represent the rosettes used in architectural sculpture.[22] Dotted circles otherwise appear in late-ninth- and tenth-century illumination, in headpieces as well as initials.[23] By the third quarter of the tenth century, dotted circles have become an elegant abstraction, and soon they disappear.[24]

The illuminator of the Leo Bible created a title frame, part of which helps to clarify another motif in the tiles (fig. 20). Seeking variation in the decorative program, the illuminator changed the relationship between the crosses and circles found on the arch (figs. 19, 20). Half-circles edge the motif repeating down the axis, a simple variation known from a tile excavated at the Hospital of Sampson (cat. II.6). It is the crosses in the manuscript frame that are of interest, though. At the center of each one stands a small square drawn with dashes beginning at the edge and pointing inward, the design that is found on one of the flat

Fig. 9 Mount Sinai, church of Saint Catherine. Decorated column on east wall.

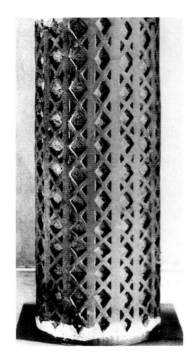

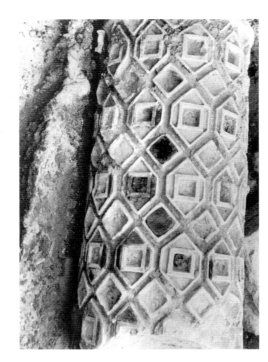

Fig. 10 (*far left*) Istanbul, Arkeoloji Müzerleri. Column from Saint John in the Hebdomon.

Fig. 11 Istanbul, Arkeoloji Müzerleri. Column from Saint Polyeuktos.

Fig. 12 Florence, Biblioteca Medicea-Laurenziana, cod. Plut. 1.56, fol. 6v. Canon table (detail).

Fig. 13 Florence, Biblioteca Medicea-Laurenziana, cod. Plut. 1.56, fol. 5v. Canon table (detail).

Fig. 14 Rome, Biblioteca Apostolica Vaticana, gr. 1522, fol. 2v. Text frame (detail).

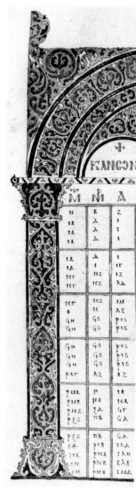

Fig. 15 (*left*) Florence, Biblioteca Medicea-Laurenziana, cod. Plut. 1.56, fol. 3v. Canon table (detail).

Fig. 16 (*right*) Messina, Biblioteca regionale universitaria, F.V. 18, fol. 2. Canon table (detail).

Fig. 17 (*left*) London, British Library, Add. MS 5112, fol. 2v. Canon table (detail).

Fig. 18 (*right*) Athens, Ethnike Bibliotheke, cod. 56, fol. 2v. Canon table (detail).

tiles proposed as a pilaster (fig. 8). Squares with dashes appear in the framing ornament of several important manuscripts made around the third quarter of the tenth century; they include a New Testament in London and the Stavronikita Gospels.[25] In the former, gold squares stand on a red background, and in the latter, they appear against a deep blue field. The dashes of both tiles and miniature frames recall jewelry mounts used to secure stones; such settings were represented in mosaics from the early Byzantine period through the Middle Ages.[26] The ceramicist likely understood the significance of the design, since a contemporary tile shows Saint Constantine wearing a *loros* covered with stones fastened to the cloth by means of pronged collets (cat. A.27). In decorating the Walters tile that is curved (fig. 7), the maker converted the dashes

into dots: an abstraction that severed the link with metalwork.

A final variation of the lattice motif found on the sixth-century colonnette returns the discussion to architectural decoration. It occurs in a headpiece found in the mid-tenth-century Paris Psalter (fig. 22).[27] The headpiece is made from angled bars with circles at the intersections; the bars run counter to the horizontal and vertical fields that surround the title (*Psalter of David*) on three sides. The underlying pattern is that of the column at Saint Catherine's (fig. 9) and the tile found at Saint Polyeuktos (fig. 21). In the manuscript, the bars are filled with S-curves, and they frame crosses composed of dots. The headpiece seems to have an architectural source: the vault of the west gallery of Saint Sophia. The vault surface was

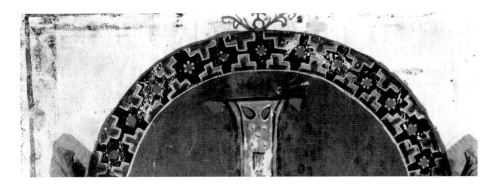

Fig. 19 Rome, Biblioteca Apostolica Vaticana, Reg. gr. 1, fol. 2. Frame (detail).

Fig. 20 Rome, Biblioteca Apostolica Vaticana, Reg. gr. 1, fol. 1v. Text frame (detail).

Fig. 21 Istanbul, location unknown. Ornamental tile from Saint Polyeuktos (cat. XI.1).

decorated in mosaics, which have disappeared from the building and are known only from drawings made by Cornelius Loos and the Fossati.[28] Judging from the drawings, the vault decoration seems to have been part of the campaigns undertaken in the church during the late ninth and tenth centuries.[29] Since the long vault was uninterrupted by ribs, the designer chose an overall pattern using a diagonal framework that created a sense of movement down the space. He conceived of the curved surface of the vault as much the same as a column. In both the headpiece and the mosaic, the patterns were sharply detailed and densely packed.

Simulated metalwork: frames and architecture. A number of medieval tiles were decorated using patterns imitating metalwork; two common types are represented by finds from the Topkapı Sarayı Basilica and Constantine Lips (figs. 23, 26). For the Topkapı tile, the connection with metalwork is confirmed by one of the miniature frames of the Paris Psalter (fig. 24).[30] With unusual care, the illuminator represented alternating square and oval stones separated by pairs of pearls, all mounted on a gold strip. The large size of the miniature (19×21 cm)[31] heightened the illusion of a picture enclosed by a band similar to the one that runs around a tenth- or eleventh-century book cover (21×29 cm) in Venice (fig. 25).[32] The maker of the Topkapı tile (fig. 23) appears to have been conscious of the metalwork origin of the ornament, since the color scheme he used, amber ground under the blue-green circles, suggests blue cabochons mounted on gold. The narrow width of the ceramic specimens (32–34 cm) strengthens the connection with metalwork bands.

Frames of simulated metalwork and the actual technique they imitate have early roots. During the fifth, sixth, and seventh centuries, metalwork patterns were popular as picture frames in monumental painting. The alternating cabochon and pearl decoration found in Saint Demetrios at Thessalonike is one prominent example.[33] In the case of the frame surrounding the fifth- or sixth-century mosaic in the apse of the church of Hosios David in Thessalonike, the metalwork connection is made

Fig. 22 Paris, Bibliothèque Nationale, gr. 139, fol. 8. Headpiece.

Fig. 23 Istanbul, Arkeoloji Müzerleri. Ornamental tile from Topkapı Sarayı Basilica (cat. XII.3).

Fig. 24 Paris, Bibliothèque Nationale, gr. 139, fol. 419v. Frame (detail).

Fig. 25 Venice, Biblioteca nazionale di San Marco, cod. Lat. Cl. 1.100. Book cover (detail).

Fig. 26 Istanbul, Arkeoloji Müzerleri. Ornamental tile from Constantine Lips (cat. VI.4).

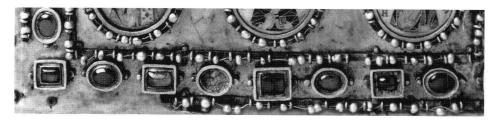

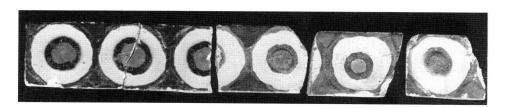

Fig. 27 Paris, Bibliothèque Nationale, gr. 115, fol. 227. Headpiece.

explicit by the decorated book covers held by figures within the composition.[34] Scribes and illuminators often adapted such patterns for the frames surrounding book titles and chapter headings, particularly in the ninth and tenth centuries.[35] Since the pattern was an inherently narrow, rectangular one, it was also suited to initial letters in the uncial style. Examples from the early ninth century exist,[36] and by the later ninth and tenth centuries such designs are relatively common.[37] In some manuscripts the initials sit on the page like pieces of jewelry.

A second, related pattern is well represented by examples in the Walters Art Museum (cat. A.54) and finds from the Lips monastery (fig. 26) and Hospital of Sampson (cat. II.3). It consists of concentric circles repeated within a narrow strip of roughly 3 cm. The design recalls that of the Topkapı simulated metalwork strips (fig. 23), in which stones are secured by wide collets,[38] but the arrangement of the circles can also suggest a pearl border. Byzantine jewelers often softened the edges of metalwork objects by using gold granulation or pearls strung on wires (figs. 28, 30),[39] sometimes fixed on gold spindles with flattened ends that formed part of the design.[40] In illumination, repeating dots were used as an edging or frame motif in the sixth century[41] and again in the ninth and tenth centuries. The late-ninth-century Paris Gregory offers a particularly clear example of the simple pearl border.[42] The designers of the tiles painted a prominent dot at the center of each circle; this variation is also known in tenth-century manuscripts, for example, the Paris Gospel book (gr. 115), in which dotted pearls outline a wide gold band, painted as if tooled in some fashion (fig. 27).[43] Dotted outlines were also favored by the illuminator of the Coislin Gospels, whose decorative vocabulary is related

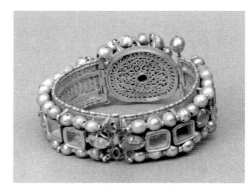

Fig. 28 New York, Metropolitan Museum of Art, acc. no. 1970.17.190. Bracelet.

to that of a number of other manuscripts of the first half of the tenth century.[44]

The narrow tiles may have served a number of functions. One is as a frame for figural images, as in one tenth-century church in which narrative scenes were framed by such ornament.[45] A second is as a border for another ornamental design; this use is confirmed by the tile from the Lips Monastery (cat. VI.3) (fig. 26) and by a miniature in the Menologium of Basil II (976–1025). Part of the architectural backdrop of the Menologium portrait consists of an architrave decorated with a vine scroll bounded top and bottom by repeating circles (fig. 32). A third use for the pattern may have been as ornament located in especially holy parts of the church, where metalwork or suitable substitutes were considered desirable. A vivid impression of richly decorated architecture is given by the fifth-century mosaics in the Rotunda at Thessalonike (fig. 1), in which figures pose against a backdrop consisting of columns and arches that are gilt or painted red and then set with gemstones and pearls.[46] The background at the

Fig. 31 Washington, D.C., Dumbarton Oaks Collection, acc. no. 40.69. Clothing pendant.

Fig. 29 (*top*) Washington, D.C., Dumbarton Oaks Collection, acc. no. 55.1.5007. Bracelet.

Fig. 30 (*bottom*) Richmond, Virginia Museum of Fine Arts, acc. no. 67.52.23. Clasp.

rotunda was an architectural fantasy, yet it may offer some sense of fixtures clad in metal or treated as if in metal. Accounts of Justinian's Saint Sophia describe the ambo as supported by gilt columns set with stones and surmounted by a ciborium that was likewise gilt and set with pearls, emeralds, and rubies.[47] The belief that columns, arches, and ciboria of sacred buildings were appropriately enhanced by metalwork, pearls, and gemstones is supported by the architecture represented in manuscripts, for instance, by the columns and ciboria in a tenth-century copy of the sermons of Gregory of Nazianzos on Mount Athos.[48] Several

of the canon tables in a Gospel book in Messina, attributed to the turn of the ninth to the tenth century, likewise create a sense of ornamental richness by representing columns and arches sheathed in gold and studded with stones (fig. 16).[49] One of the tiles with repeating circles (cat. A.54) makes extensive use of an amber glaze that creates the effect of a gold background. The tile from the Lips monastery (cat. VI.3) has a black background under the bold circles, and this background also recalls metalwork. Mounting stones on a black field is known from one of the gem-covered crosses in the sixth-century decoration of Saint Sophia, and the deep blue ground running under the mounts depicted in the Stavronikita Gospels may also refer to the practice.[50] The tiles seem to have been used in a variety of architectural contexts, including ones that defined unusually holy spaces or furnishings.

Some leaf patterns. Of the tiles that contain foliate patterns of one sort or another, two are of particular interest. The first occurs on a curved tile in the Sèvres collection and consists of five-pointed leaves set within hearts (fig. 33). The pattern, including the prominent perforations, appears among the capitals of Saint Sophia,[51] and a related design occurs in a bracelet roughly contemporary with the church (fig. 28).[52] Unlike the versions found on the capi-

Fig. 32 Rome, Biblioteca Apostolica
Vaticana, gr. 1613, p. 409.

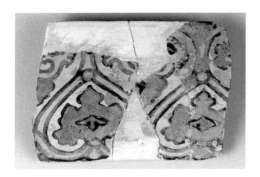

Fig. 33 Sèvres, Musée national de Céramique.
Ornamental tile (cat. C.4).

Fig. 34 Berlin, Deutsche Staatsbibliothek, cod. Phillipps 1583, fol. 2. Headpiece.

Fig. 35 Patmos, monastery of Saint John the Theologian, cod. 43 (44), fol. 305. Headpiece.

tals or in jewelry, that of the tile has leaves drawn without a hint of relief. In this regard, the tile more closely resembles headpieces found in medieval illumination. Leaves enclosed within hearts form part of a headpiece in the Berlin *Hippiatrika* (fig. 34), a veterinary-science manual associated with the patronage and collecting habits of Emperor Constantine VII (913–59).[53] The illuminator's perforated leaves have uneven edges like those created by the tile painter, but in the headpiece the heart-shaped frames are embedded in a thicket of circles and leaves and create a pattern of considerable magnificence. A simpler design that parallels that of the tile occurs in a copy of Gregory of Nazianzos's sermons made about the same time as the *Hippiatrika*.[54] The illuminator of the sermons devised a plain bar by alternating the orientation of the hearts, which, like the tile, have small circles where they touch (fig. 35). By alternating the directions of the leaves

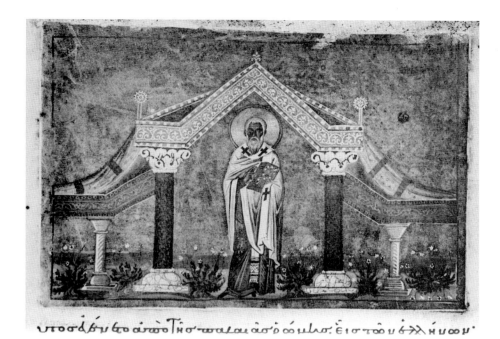

ⲩⲧⲟⲟⲇⲉⲩⲓⲟ ⲁⲣⲁⲟⲧⲏⲟ·ⲧⲟⲁⲗⲁⲓ ⲁⲟⲡⲟⲟⲩⲗⲟⲥ·ⲉⲓⲟⲧⲟⲩⲓⲭⲗⲏⲥⲟⲟⲩ·

Fig. 36 Rome, Biblioteca Apostolica Vaticana, gr. 1613, p. 377.

and hearts, the illuminator canceled the upward movement of the frame to create a stable horizontal form. An architrave represented in the menologion made for Basil II shows how the pattern might be used in a building (fig. 36).

The second leaf pattern, represented by a long fragment from the Hospital of Sampson (fig. 37), is more complex. A gold clasp, attributed to the seventh century, offers a point of departure (fig. 30).[55] The circular clasp is filled by a quartet of hearts enclosing five-lobed leaves, tooled to lend them an appearance of three-dimensionality. At first viewing, the tile seems to be a sloppy version of this pattern; but, in fact, a fundamental reorganization has taken place over the centuries. The tile design is less compact; from the main stalk, designed as an enveloping circle, meandering tendrils branch off and terminate in stunted leaves with three lobes. The illuminator of the Berlin *Hippiatrika* used the identical design (fig. 38). The delicacy of the tile is unusual among its group, all associated with a small chapel located in Constantinople between Saint Sophia and Saint Eirene.[56]

Another tile from the site of the chapel is of roughly the same size and color scheme (fig. 39), and it, too, can be compared with a headpiece in the *Hippiatrika* (fig. 40). In this instance, the tile maker's design is much simpler. The roundels enclose a ring of dotted circles that set off a cross motif, also common in manuscripts (fig. 22) and church decoration as early as the sixth century.[57] The tile pattern appears rather crude in contrast to the fine detail of the headpiece.

More parallels could be added, but enough has been gathered for a preliminary assessment. Many of the patterns common to the manuscripts and tiles appear in the fifth and sixth centuries. Are we therefore to believe that ninth- and tenth-century artists were captivated by early Byzantine ornament or that their patrons found it particularly worthy of imitation? Stated in this fashion, the conclusion is undermined by our knowledge of illumination, which, though far from perfect, is much more extensive than our

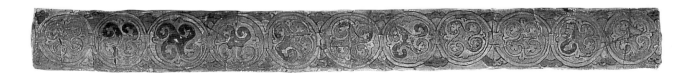

Fig. 37 Istanbul, Ayasofya Museum. Ornamental tile from Hospital of Sampson (cat. II.16).

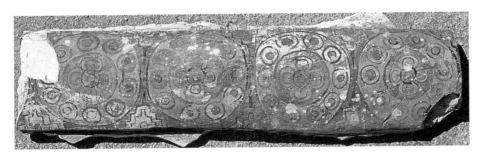

Fig. 38 Berlin, Deutsche Staatsbibliothek, cod. Phillipps 1583, fol. 66. Headpiece.

Fig. 39 Istanbul, Ayasofya Müzesi. Ornamental tile from Hospital of Sampson (cat. II.12).

Fig. 40 Berlin, Deutsche Staatsbibliothek, cod. Phillipps 1583, fol. 46. Headpiece.

knowledge of architectural ceramics. The seemingly retrospective character of tenth-century ornament is one of two issues that I wish to discuss in the second part of the essay, which begins with a brief historical introduction.

The appearance of luxury manuscripts in the fifth and sixth centuries was neither spontaneous nor isolated. It was integral to a broad realignment of taste in contemporary Byzantium. When the townspeople of Honoratiae commissioned a priceless medical text as a donation to honor Anicia Juliana, patron of Saint Polyeuktos and benefactor of their city, they had the illuminator portray her framed by gold ropes arranged like those later found in the arch soffits that are part of the Justinianic decoration of Saint Sophia.[58] The illuminator fashioned a new kind of portrait that emphasized material richness, and intertwined cables were one means to this end. Above all,

though, it was the Eusebian canon tables that invited illuminators to introduce motifs from buildings as a way of creating luxury. A few tables survive from what must have been an exceptional copy of the Gospels made in the sixth or seventh century. The leaves, now in London, were covered entirely with gold and then delicately painted.[59] The decoration on one (fig. 17) consists of three columns or pilasters and a pair of wide arches (a design feature instituted earlier).[60] Arches and supports were covered with a repeating pattern of large and small circles, enchained like ones found in the carved decoration of Saint Sophia.[61] Filling the circles are large whorls and small blossoms, both known in the same form from the sculptural details of Saint Polyeuktos.[62] The rich rinceau of the columns on folio 11v and the sharply drawn acanthus capitals likewise reflect the taste and ornamental vocabulary of Constantinopolitan architecture.[63]

The early history of metropolitan illumination must also include the canons of the Rabbula Gospels, made in 586 in Syria.[64] Though produced far from Constantinople, the Rabbula Gospels contains decorative elements not otherwise found in Syriac manuscripts. Our instinct may be to look first to the eastern periphery for the artist's sources,[65] but two factors strongly suggest that the designs found on the tables arose in Constantinople. First, many of the patterns occur in the churches of the capital and Thessalonike. Some of the decorated columns, for example, closely resemble ones from Saint John in the Hebdomon (figs. 10, 12) and Saint Polyeuktos (figs. 11, 13), as well as the painted columns represented in the background of the Rotunda of Thessalonike;[66] the rare zigzag pattern carved on capitals of Saint Polyeuktos occurs on one of the canon table columns.[67] Second, many of the motifs reappear in some of the most important Constantinopolitan books of the ninth and tenth centuries. Common designs include gems and pearls on gold (figs. 15, 16), illusionistic twisted ribbon[68] and folded ribbon,[69] sprays of three flowers on a black ground,[70] and the X-and -O pattern on red ground.[71] Together, the Rabbula Gospels and London canon tables show that the taste expressed in sixth-century churches and the formal vocabulary on which it was based were quickly absorbed by illuminators. Their ninth- and tenth-century counterparts did not necessarily gather decorative motifs directly from old buildings. The patterns may well have been present in books in the capital. But were these early Byzantine manuscripts or relatively recent ones? Has, in other words, the issue merely been shifted from the study of old buildings to the study of old books?

The level of luxury-book production in the seventh through first half of the ninth century can no longer be estimated. Although surely modest,[72] it remains unknown and beyond recovery. The book from which the London canon tables were saved was written in uncial script, which proved to be incompatible with the taste and reading habits of medieval Byzantines, who preferred cursive writing. Given how commonly available was the text of the four Gospels, there was no reason to preserve any

copy in uncial beyond, say, the eleventh century. The value of books as monuments of the past was eclipsed by the value of the raw parchment. When the text of the Gospel lectionary was reformed in the tenth century, earlier copies, even if handsomely decorated, were rendered valueless.

The salvaged portraits bound into Princeton Garrett 6[73] and the many palimpsest leaves show that old books were rarely viewed with the collector's antiquarian eye or the philologist's appreciative taste for early texts. Pictures might be saved, but the rest was recycled. Because the odds were stacked against the survival of any copy of the Gospels written in uncial, we cannot gauge the role of a nearly continuous tradition in the formation of the decorative vocabulary of ninth- and tenth-century illuminators. The one major work of the eighth or early ninth century to have survived, a copy of the Gospels set out with liturgical markings,[74] has headpieces and initials created from tight geometric patterns unlike the ornament of the London canons or Rabbula Gospels but well established in ninth- and tenth-century illumination.[75]

It is impossible to determine if the illuminators whose works have been cited as offering parallels for the tiles picked up the patterns from old books or worked from a living tradition that had been passed down in a few centers. Whichever was the case—and a continuous tradition cannot be dismissed—the presence of similar ornamental designs in the churches of the city would have acted to keep the decorative repertory current and its associations alive. They belonged to the Byzantines' everyday experience. Taste was not, of course, entirely fixed. Some patterns based on metalwork had, by the early ninth century, become so distant from their sources that they were little more than geometric abstractions. The slide into abstraction was momentarily reversed by the return of illusionistic painting.

The great majority of illusionistic miniatures—ones found in the Paris Gregory, Messina and Stavronikita Gospels, Paris Psalter, and so on—were painted on separate leaves or ones left empty by the scribe. The images did not share the page with writing, which emphasizes the surface of the parchment. Even though the miniature was

separate from the text, illuminators sought some mediation between the pictorial space and the flat border of surrounding parchment. Through his observation of contemporary metalwork, the illuminator of the Paris Psalter was able to return a design to its original significance (figs. 24, 25). By doing so, he insulated the deep space of the Crossing of the Red Sea from the empty margin by means of a pattern that gave the illusion of rising slightly off the page.[76] Such aesthetic concerns may not have been as acutely felt by the designers of the buildings decorated with tiles, since the ceramic patterns remain stuck in an abstract mode (figs. 23, 39).

The Paris Psalter frame also reveals how open was the relationship between contemporary art and an art reaching back to the early Byzantine era. In his frame for the scene of Moses on Sinai, the illuminator used a *cyma* in much the same manner as the stones and pearls on gold:[77] the wide edge of the leaf faces the miniature, and as it moves outward toward the margin, swelling and then narrowing, it gives the illusion of rising gently then pointing down to the empty parchment. The nearest forerunner for the *cyma* border occurs in the triumphal entry of Justinian II (685–95) represented in fresco in the church of Saint Demetrios at Thessalonike.[78] No good parallel occurs among the tiles or in the early churches of Constantinople, but I think it safe to suppose that something was available in the city, though of uncertain date. The way the leaf was used in tenth-century painting and sculpture makes an architectural origin possible, if not likely.[79]

The frames of the Paris Psalter are as unusual as its miniatures; both are highly illusionistic, and it is difficult to conceive of the one without the other. They belong to a style of painting recuperated by a small number of ninth- and tenth-century patrons. The frames also reveal a delight taken in *trompe l'oeil*, one of the deceptively innocent pleasures painting affords. When it came to creating frames for chapter titles, illuminators tended to seek patterns and objects that had little relief. As time passed, the insistently flat impact created by the block of writing was only one aesthetic imperative faced by tenth-century illuminators. The second was the rise of minuscule writing in

forms that were either delicately spidery or markedly circular. Particularly in the latter, the popular minuscule *bouletée*, the emphasis on repeating circles created a visual cohesion that the illuminator could hardly ignore.[80] The headpieces in the Berlin *Hippiatrika* satisfied the aesthetic demands of the page and its script (figs. 34, 38).

Related to the *Hippiatrika* is a mid-tenth-century collection of poems, some created for the Byzantine court, from the Barberini Library.[81] One of the manuscript's scribes has been credited with copying part of the Patmos Gregory (fig. 35).[82] The spare but elegant ornament of the Barberini Collection suits the text and its rounded minuscule. One of the early title frames (Saint Sophronios of Jerusalem, *Anacreontic on the Annunciation to the Virgin*) was composed of simple leaves enclosed by hearts or circles similar to ones in the Patmos Gregory (fig. 42). The treatment resembles metalwork, specifically the form and proportions of a bracelet, attributed to the seventh century, in the collection of Dumbarton Oaks (fig. 29).[83] The manuscript title has arguably been framed by what the reader would have recognized as a necklace or bracelet design. The delight taken in encountering a *trompe l'oeil* representation was, in this instance, focused on an expensive piece of jewelry: an object of significance to the reader, his sense of himself, and the value of the text.

Kurt Weitzmann called the style represented by the headpieces in the Berlin *Hippiatrika* and Barberini Collection "jigsaw," and he attributed its invention to the turn of the ninth to the tenth century.[84] The connection between the two manuscripts and the court of Constantine VII gives a rough date for two of the finest examples and places the use, if not invention, of this jewelry pattern among a Constantinopolitan elite. The forms of the two headpieces (figs. 34, 42) imitate those created by jewelers working thick sheets of gold using chisels, punches, and files. Enameling, which requires different tools and materials, led to a series of variations on jigsaw ornament. The more intricate, color-filled shapes of the canon tables in a tenth-century Gospel book in Athens imitate the technique of enameling known from a clothing pendant in the Dumbarton Oaks Collections (figs. 18, 31).[85]

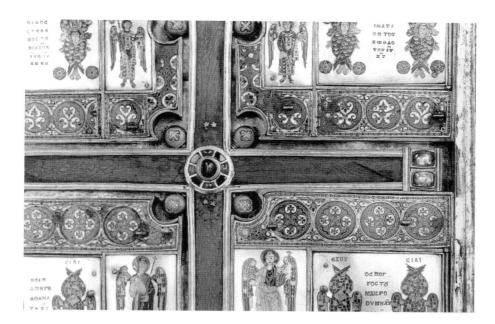

Fig. 41 Limburg, Domschatz und Diözesanmuseum. Limburg Staurothek (detail).

Several of the Berlin *Hippiatrika* headpieces also rely on enamels. The headpiece setting off the title on folio 46 (Apsurtos, *On White Spotting of the Eyes,* chap. 11) follows the style and design of one of the enamel sections of the Limburg Cross Reliquary,[86] an important commission that comes from the same milieu as the manuscript (figs. 40, 41). The relic had been encased by Constantine VII and his son, Romanos. After Constantine's death, a larger container was made at the order of Basil the Proedros, the illegitimate son of Romanos I Lekapenos (920–44) and an important figure in tenth-century politics. It is one of the patterns of Basil's addition, made in 964 or 965, that was imitated in the manuscript. Enamel was used for objects like earrings and pendants and was thus appropriate on evocative as well as aesthetic grounds for the decoration of expensive books, like the veterinary handbook in Berlin. But as the cloisonné plaques used as icon revetments[87] and the Limburg Reliquary demonstrate, enamels also served to decorate not only secular costume but also holy objects. Tiles in the Walters Art Museum, as well as ones excavated in the Hippodrome and the foundations of the Istanbul Archaeological Museum, show that ceramicists likewise adapted designs that the makers of enamels had begun to create around the middle of the tenth century (figs. 37, 38). The delicate and intricate patterns often based on leaves represent a departure in ceramic design—but one that attention to metalwork designs had, in a sense, prepared.

The significance of the unusual enamel-work patterns imitated on the tiles and in the manuscripts lies in their

Fig. 42 Patmos, monastery of Saint John the Theologian, cod. 43, fol. 1. Headpiece.

rarity. Few of the manuscripts in which they are found have explicit information regarding their patronage. What little we know points to a small aristocratic circle, consisting of men such as Emperor Constantine VII, Basil the Proedros, and the reader of court poetry. It is to the same group that we should look to find the builders of the churches decorated in ceramic tiles using imitation enamel-work patterns.

Before concluding, I would like to call attention to the disappearance of the aesthetic that seems to run from the sixth through tenth century and connects works in several media. Among the Berlin *Hippiatrika* headpieces[88] are patterns that Weitzmann called "flower petal." Ornament in the flower-petal manner appears in the work of the celebrated mid-tenth-century scribe Ephraim, notably in his copies of the Gospels: Mount Athos, Vatopedi monastery, cod. 949, dated 948,[89] and the recently attributed Stavronikita Gospels.[90] A copy of sermons by John Chrysostom made in 955 by the notary Nikephoros for Basil the Proedros, patron of the Limburg Reliquary, contains headpieces executed entirely in an early form of the flower-petal manner.[91] Though deriving from the flat and colorful style of contemporary enameling, flower-petal ornament was developed by illuminators meeting demands peculiar to their craft. Over the century following Ephraim's career, this style of decoration became the standard for not only the highest quality books but also hundreds of pedestrian manuscripts. No ceramic tiles were decorated in the flower-petal style, either because tile production ceased before the time of its widespread popularity, the mid-eleventh century and later, or because the decorative forms used principally in books were unknown to the makers of architectural ceramics. In general, though, the wide repertory of ornament that flourished with the introduction of minuscule writing dramatically shrank to a small number of motifs. An important, albeit indirect witness is the menologion commissioned by Basil II; although difficult to date precisely within the emperor's reign, the menologion is securely tied to the period around the end of the tenth and early eleventh centuries.[92] Throughout the manuscript are portraits of saints posed against architectural backgrounds. The illuminators gathered to paint the miniatures settled on a relatively uniform approach: columns were depicted as simple marble shafts, with little or no surface decoration, and entablatures were painted as if carved in a handful of motifs: the step pattern, dentils, *cyma,* and mosaic crenellation. Few of the miniatures (e.g., figs. 32, 36) contain patterns that recall those found on the ceramic tiles, and none can match the opulence of the backgrounds created for the Rotunda at Thessalonike (fig. 1). The manuscript signals the demise of an aesthetic.

The appearance, disappearance, and return of decorated manuscripts, as well as the recycling of the materials of superannuated texts, are phenomena of book production, not those of ceramics, yet the parallels seem inescapable. The low level of book production in the seventh and eighth centuries results from economic conditions that adversely affected construction and decoration, bringing them nearly to a halt. As for the reuse of parchment, there are echoes in the reuse of mosaic tesserae and carved stone columns and pilasters in the ninth and tenth centuries.[93] Differences in the material quality of the tesserae found in the Justinianic mosaics of Saint Sophia and those of medieval decorative campaigns, and the contrast between the materials used to ornament columns in the early Byzantine period and those of the Middle Ages,[94] lead one to wonder whether the fabrication of architectural ornament in ceramic might not have been a practical economy. Tiles decorated in strong colors enriched a building at, I would guess, a lower cost than carved and painted stone or mosaics using glass tesserae, assuming the materials and craftsmen trained in handling them could be found. It may be relevant that none of the early churches surveyed for their ornamental patterns seem to have been decorated with architectural ceramics.

To the best of our knowledge, the production of architectural ceramics was a short-lived phenomenon in Byzantium. As William Tronzo writes in this volume, Byzantine tiles present us with a "disjunctive phenomenon, without past or future."[95] Yet the materials, tech-

niques, and equipment required to produce tiles are those familiar to the makers of plates, bowls, and vessels: everyday objects that have a continuous history in Byzantium. Connecting the decorative patterns found on tiles with those used for tableware or more pretentious wares proves difficult,[96] but this seems to be a circumstance with a relatively straightforward explanation. Ceramicists painted the tiles destined for buildings with decorative patterns appropriate to monumental architecture, a repertory largely different from that traditionally used for tableware. One can possibly imagine a group of enterprising potters retooling their production to provide a low-cost alternative to the carved and inlaid columns and moldings sought by patrons whose aesthetic sense was largely that of the early Byzantines, though tending to prefer the flat over the sculptural; and in the flatness of the tile patterns we may find the one aspect that appealed to the medieval Byzantines, that made the tiles, in other words, something other than a cheap substitute.

Finally, in comparing the tiles with book ornament, metalwork and jewelry were cited with a notable frequency. Here, the written record offers some relevant amplification. Germanos, patriarch of Constantinople (715–30), opened his influential discussion of the church by speaking of the building as the bride of Christ.[97] Germanos's assessment, to the extent that it had a basis in experience, as well as Scripture,[98] was formed by the churches of Constantinople. In buildings like Saint Sophia and Saint Polyeuktos, the patriarch would have seen ornament that had been freed from capitals and architraves as well as from its service in framing narrative images. It had become part of the worshiper's experience in a new way. In the ground-level decoration of Saint Polyeuktos, peacocks stand within a lush enclosing grape arbor. This is decoration raised to so prominent a position in the churchgoer's experience that it invites him or her to reflect and search for meaning. In his discussion of the ornament at Saint Polyeuktos, R. M. Harrison has argued that at least some of patterns were meant to recall descriptive passages in the Old Testament.[99] Justinian's Saint Sophia presented an alternative that was, by contrast, austere. The

acanthus lacework above the main arcade and the many capitals and carved entablatures nonetheless create a powerful effect. The dense packing of solid forms recalls the bracelet in the Metropolitan Museum of Art, New York (fig. 27). They are not related to one another in any real sense; they simply evoke a similar feeling. In the tenth-century *Life of Basil*, the Nea Ekklesia was said to have been ornamented "like a bride adorned with pearls and gold, with gleaming silver."[100] Ceramic tiles, decorated with a range of patterns, from simulated jewelry to colorful abstractions, may have formed only one small part of the decoration of any building, yet their nature is such as to demonstrate why the simile of a bride so aptly characterizes the effect a church had on the Byzantine beholder. For monks and nuns, the *troparion* (short hymn) "Behold, the bridegroom comes"[101] would have served as a daily reminder of a relationship between Christ and the worshiper, gathered within the church. To the extent that illuminators drew from buildings, were inspired by contemporary trends in metalwork, and produced luxury books for the aristocratic patrons who commissioned the buildings and jewelry, their work presents a body of material that deepens our understanding of Byzantine ornament, including that of ceramic tiles.

Notes

1. Stern, *Cordoue*, 14–15, 53–55, pls. 64, 65; and discussion by E. Ettinghausen in this volume, pages 239–41.

2. Illuminators' awareness of other media, especially architecture, has been noted several times before, by C. Cecchelli in C. Cecchelli, J. Furlan, and M. Salmi, *The Rabbula Gospels* (Olten, 1959), 40–42; Grabar, *Sculptures* I, 103–22; and, most recently, A. Iacobini in L. Perria and A. Iacobini, "Il Vangelo di Dionisio," *RSBN* 31 (1994), 124–25, 138–53. I repeat some of their parallels in this essay. In the conclusion, I clarify what is meant by "craft tradition" when speaking of the tiles.

3. C. Diehl, M. Le Tourneau, and H. Saladin, *Les monuments chrétiens de Salonique* (Paris, 1918), 19–31, pls. I, II; in color, E. Kourkoutidou-Nikolaidou and A. Tourta, *Wandering in Byzantine Thessaloniki* (Athens, 1997), figs. 59, 63.

4. Harrison, *Saraçhane*, figs. A, B, 92, 95, 98, 108.

5. The *Life of Basil*, 89: Mango, *Sources and Documents*, 197. The imperial association can be made through regalia, for example, the crown decorated with a crest of peacock feathers presented to the emperor by a personification on the Gunther Silk of 971 (Diözesanmuseum Bamberg): *Rom und Byzanz: Schatzkammerstücke aus bayerischen Sammlungen*, ed. R. Baumstark (Munich, 1998), 206–10, with color illustrations.

6. Grabar, *Sculptures* I, pl. LIII; Macridy, "Monastery of Lips," fig. 41.

7. In canons they were often, as in Figure 3, in profile; see also Rome, Biblioteca Apostolica Vaticana, Pal. gr. 220, fol. 1v (C. Nordenfalk, *Die spätantiken Kanontafeln* [Gothenburg, 1938], pl. 13) and Venice, Biblioteca Nazionale di San Marco, gr. 1.8 (ibid., pl. 8). Peacocks seen head-on with their tails fanned appear in the canon-table ornament of a tenth-century copy of the Gospels in Paris, Bibliothèque Nationale, gr. 70, fol. 5 (Ebersolt, *Miniature byzantine*, pl. XL.1), and the headpiece of a twelfth-century Gospel lectionary in Venice, Biblioteca Nazionale di San Marco, gr. 548, fol. 122: I. Furlan, *Codici greci illustrati della Biblioteca Marciana*, III (Milan, 1980), fig. 4.

8. The patriarch Germanos (715–30) wrote that "the holy table is also the throne of God, on which, borne by the Cherubim, he rested in the body": *Saint Germanus of Constantinople: On the Divine Liturgy*, trans. P. Meyendorff (Crestwood, 1984), 59. For other implications of the peacock in art, see *DACL*, XIII/1, 1075–97, but the usual interpretation of the peacock, as a sign of eternal life, seems less appropriate for the works under discussion.

9. The Lips panels have been associated with the chancel screen (Grabar, *Sculptures* I, 106; Mango and Hawkins, "Additional Notes," 305), as have similarly decorated plaques from Saint John Stoudios: Fıratlı, *Sculpture byzantine*, 190–91. Tiles listed in catalogue section XII below are, for example, said to have been found toward the east end of the site.

10. Washington, Dumbarton Oaks Collections, acc. no. 36.23: Ross, *Catalogue* I, 15–17, pls. XIV, XV.

11. As representing the feathers of the creatures surrounding God, the design has parallels in the apse mosaics of Hosios David, Thessalonike (Kourkoutidou-Nikolaidou and Tourta, *Byzantine Thessaloniki*, figs. 104, 105); the angels' wings in the Panagia Angeloktistos, Kiti (detail in D. Rice, *Byzantine Art* [Harmondsworth, 1968], fig. 155); and Saint Catherine's at Mount Sinai (G. Forsyth and K. Weitzmann, *The Monastery of Saint Catherine at Mount Sinai: The Church and Fortress of Justinian* [Ann Arbor, 1973], pls. CXXXII.b, and CXXXIII.b).

12. Diehl, Le Tourneau, and Saladin, *Monuments de Salonique*, 35–37, pl. IX.1; in color in Kourkoutidou-Nikolaidou and Tourta, *Byzantine Thessaloniki*, fig. 224; see also the later church of Saint Demetrios, Thessalonike: G. and M. Soteriou, *He basilike tou hagiou Demetriou Thessalonikes* (Athens, 1952), fig. 75.

13. Paris, Bibliothèque Nationale, Coisl. gr. 20: Weitzmann, *Byzantinische Buchmalerei*, 11, relates to the Paris Psalter (Cod. Paris. gr. 139), attributable to the middle of the tenth century; see also M. Agati, *La minuscola "bouletée,"* Littera antiqua IX/1 (Vatican City, 1992), 164–65, with bibliography.

14. Where they appear as bands, unlike the binding rings (e.g., fig. 14) presumably added to columns to prevent spalling. Decorative collars appear in miniatures of the Basil Menologion, where they are depicted as a means of securing curtains: Rome, Biblioteca Apostolica Vaticana, gr. 1613, pp. 303, 332, 408: *Il menologio di Basilio II (Cod. Vaticano greco 1613)*, Codices e vaticanis selecti . . . 8 (Turin, 1907).

15. Paris, Bibliothèque Nationale, gr. 933: Agati, *Minuscola*, 252–53; the script is said to have Italianate tendencies.

16. For Saint Euphemia: Mathews, *Byzantine Churches*, fig. 12-3, and Naumann and Belting, *Die Euphemia-Kirche*, 64–67.

17. Mango and Hawkins, "Additional Notes," 303–4.

18. Represented by porphyry inlay and simulated capitals: H. Kähler, *Hagia*

Sophia (New York, 1967), figs. 30, 31. For Sant'Apollinare: F. Deichmann, *Frühchristliche Bauten und Mosaiken von Ravenna* (Baden-Baden, 1958), fig. 403.

19. Rome, Biblioteca Apostolica Vaticana, gr. 1522: Weitzmann, *Byzantinische Buchmalerei*, 6. See also one of the canons in the roughly contemporary Messina Codex (Biblioteca regionale universitaria, FV 18, fol. 9v: Perria and Iacobini, "Il Vangelo," pl. XIV,3), and Oxford, Bodleian Library, Auct. D.4.1, fol. 24v (dated 951): I. Hutter, *Corpus der byzantinischen Miniaturenhandschriften*, I (Stuttgart, 1977), 27–28, fig. 105.

20. Rome, Biblioteca Apostolica Vaticana, Reg. gr. 1: Weitzmann, *Byzantinische Buchmalerei*, 40, figs. 275–84; C. Mango, "The Date of Cod. Vat. Regin. Gr. 1 and the 'Macedonian Renaissance,'" *Acta ad archaeologiam et artium historiam pertinentia*, 4 (1969), 121–26; facsimile of the miniatures: S. Dufrenne and P. Canart, *Die Bibel des Patricius Leo. Codex Reginensis Graecus I B* (Zurich, 1988).

21. They resemble the blossoms of the heliotrope known as scorpion's-tail, at least as it was represented in the tenth-century New York Dioscorides: New York, Pierpont Morgan Library, MS 652, fol. 116v: *Pedanii Dioscurides Anazarbaei De materia medica* (Paris, 1935).

22. Compare the spandrel ornament in the background architecture of Paris, Bibliothèque Nationale, gr. 510, fol. 71v (Omont, *Miniatures*, pl. XXVII), with the rosettes at the monastery of Lips: Macridy, "Monastery of Lips," figs. 17, 18.

23. See Paris, Bibliothèque Nationale, gr. 510, fol. 149v (Ebersolt, *Miniature byzantine*, pl. XV.1), and gr. 139, fol. 7v (Omont, *Miniatures*, pl. VII); Paris, Bibliothèque Nationale, gr. 278, fol. 220 (K. Weitzmann, "The Selection of Texts for Cyclic Illustration in Byzantine Manuscripts," in *Byzantine Books and Bookmen*, Dumbarton Oaks Colloquium, 1971 [Washington, 1975], fig. 48).

24. See Vienna, Österreichische Nationalbibliothek, Theol. gr. 240, fol. 7: P. Buberl and H. Gerstinger, *Die byzantinischen Handschriften*, II, *Die Handschriften des X. bis XVIII. Jahrhunderts*, Die illuminierten Handschriften und Inkunabeln der Nationalbibliothek in Wien IV/4 (Leipzig, 1938), pl. I.2.

25. London, British Library, Add. MS 28815: Weitzmann, *Byzantinische Buchmalerei*, 20, fig. 136, reproduced in color in G. Galavaris, *He hellenike techne: Zographike byzantinon cheirographon* (Athens, 1995), fig. 40. Mount Athos, Stavronikita monastery, cod. 43: Weitzmann, *Byzantinische Buchmalerei*, 23, figs. 169–72, in color in S. Pelekanides et al., *The Treasures of Mount Athos*, IV (Athens, 1991), figs. 348, 349, 352, 352, and Galavaris, *Byzantinon cheirographon*, figs. 32–35.

26. For the sixth century, see the crosses represented in mosaic in the vault of the southwest aisle of Saint Sophia, Istanbul: C. Mango and E. Hawkins, "The Mosaics of Saint Sophia at Istanbul: The Church Fathers in the North Tympanum," *DOP* 26 (1972), fig. 51, and in color in C. Mango and A. Ertuğ, *Hagia Sophia: A Vision for Empires* (1997), 82–90. For the tenth and eleventh centuries: the garments in the portraits of Alexander (P. Underwood and E. Hawkins, "The Mosaics of Hagia Sophia at Istanbul: A Report on Work Done in 1959 and 1960: The Portrait of the Emperor Alexander," *DOP* 15 [1961], 189–215, fig. 5) and Constantine IX and Zoe in Saint Sophia (T. Whittemore, *The Mosaics of Haghia Sophia at Istanbul: Third Preliminary Report: The Imperial Portraits of the South Gallery* [Boston, 1942], color frontispiece and pls. III, IX, XIII).

27. Paris, Bibliothèque Nationale, gr. 139: Omont, *Miniatures*, 4–10, pls. I–XIVbis; A. Cutler, *The Aristocratic Psalters in Byzantium*, Bibliothèque

des Cahiers archéologiques 13 (Paris, 1984), 63–71, figs. 245–58.

28. Mango, *Materials,* 40, 41, 43, figs. 40, 46.

29. Ibid., 33–35.

30. Paris. gr. 139, fol. 419v, reproduced in color in *Byzance,* 343. See also the frame in the earlier Paris Gregory, Bibliothèque Nationale, gr. 510, fol. 149: Omont, *Miniatures,* pl. XXXIV.

31. Dimensions from Cutler, *Aristocratic Psalters,* 67.

32. Venice, Biblioteca Nazionale di San Marco, cod. lat. cl. I.100: *Treasury of San Marco,* 153.

33. Color reproductions may be found in R. Cormack, "The Mosaic Decoration of S. Demetrios, Thessaloniki: A Re-examination in Light of the Drawings of W. S. George," *BSA* 64 (1969), pls. 7, 9; Kourkoutidou-Nikolaidou and Tourta, *Byzantine Thessaloniki,* figs. 181, 183.

34. J.-M. Spieser, "Remarques complémentaires sur la mosaïque de Osios David," *Diethenes symposio Byzantine Makedonia* (Thessalonike, 1995), 295–306, on date. Kourkoutidou-Nikolaidou and Tourta, *Byzantine Thessaloniki,* figs. 104, 105, in color.

35. Title frames occur in Paris, Bibliothèque Nationale, gr. 510, fol. 239v (Ebersolt, *Miniature byzantine,* pl. XVI.3), as well as the miniature frame on fol. 149 (Omont, *Miniatures,* pl. XXXIV), and New York, General Theological Seminary, cod. DeRicci 3, fol. 26 (Weitzmann, *Byzantinische Buchmalerei,* fig. 705). See also Oxford, Bodleian Library, Canon. gr. 110, fol. 293: Hutter, *Corpus,* I, fig. 14. It is perhaps to metalwork patterns that the frame on fol. 3 of Mount Sinai, Monastery of Saint Catherine, cod. 417, refers: K. Weitzmann and G. Galavaris, *The Monastery of Saint Catherine at Mount Sinai: The Illuminated Greek Manuscripts,* I (Princeton, 1990), 28–31 (mid-tenth century), pl. I.b.

36. Patmos, Monastery of Saint John the Theologian, cod. 171, p. 226: Weitzmann, *Byzantinische Buchmalerei,* fig. 328; C. Nordenfalk, *Die spätantiken Zierbuchstaben* (Stockholm, 1970), fig. 58b; and Paris, Bibliothèque Nationale, gr. 510, fol. 44: Ebersolt, *Miniature byzantine,* pl. XVI. 2. See also Rome, Biblioteca Apostolica Vaticana, gr. 2342, fol. 170v: Agati, *Minuscola,* 96–97 (second half of the tenth century), pl. 53.

37. Paris, Bibliothèque Nationale, gr. 510, fol. 239v: Ebersolt, *Miniature byzantine,* pl. XVI.3. Examples occur in the early-tenth-century Princeton, University Library, Scheide Library, cod. M 2, fols. 27v, 35v: *Illuminated Greek Manuscripts,* fig. 3. Oxford, Bodleian Library, Barocci 206, fol. 124v: Hutter, *Corpus,* III (1982), 21–25, fig. 47.

38. For an example of such mounts, see the ring, attributed to the sixth or seventh century, in Brussels, Musées royaux d'Art et d'Histoire, inv. no. B 2800: *Splendeur de Byzance,* 199.

39. New York, Metropolitan Museum of Art, acc. no. 1970.17.190: *Age of Spirituality,* 323–24, dated to the seventh century. Richmond, Virginia Museum of Fine Arts, acc. no. 67.52.23: A. Gonosová and C. Kondoleon, *Art of Late Rome and Byzantium in the Virginia Museum of Fine Arts* (Richmond, 1994), 106–7, dated to the late sixth or early seventh century.

40. For example, the cross, attributed to the eighth or ninth century, in Tournai, Trésor de la cathédrale Notre-Dame (*Splendeur de Byzance,* 148–49). In a pair of medieval earrings in Thessalonike, Museum of Byzantine Culture, AE 2508 (*Glory of Byzantium,* 243), the flattened ends of the gold spindles form a dot in the center of the pearl.

41. Rossano, Museo Diocesano, Gospels, fol. 5 (G. Cavallo, J. Gribomont, and W. Loerke, *Codex purpureus Rossanensis* [Rome, 1987]), which has a close tenth-century parallel in the later Gospel book, Rome, Biblioteca Apostolica Vaticana, Pal. gr. 220, fol. 4: Nordenfalk, *Kanontafeln,* pl. 14a.

See also the late-ninth-century Paris, Bibliothèque Nationale, gr. 510, fol. 44: Weitzmann, *Byzantinische Buchmalerei,* fig. 14.

42. Paris, Bibliothèque Nationale, gr. 510, fol. 44: Ebersolt, *Miniature byzantine,* pl. XVI.2,4.

43. Paris, Bibliothèque Nationale, gr. 115: Weitzmann, *Byzantinische Buchmalerei,* fig. 608; C. Paschou, "Les peintures dans un Tétraévangile de la Bibliothèque nationale de Paris: Le grec 115 (xe siècle)," *CahArch* 22 (1972), figs. 1, 2; Agati, *Minuscola,* 251–52. See also the uncial lectionary in London, British Library, Harley 5787, fol. 41 (Weitzmann, *Byzantinische Buchmalerei,* fig. 289) and the frame to the Eusebian *Letter* in Mount Athos, Megiste Lavra, cod. A 61, fol. 16 (Pelekanides et al., *Treasures,* III [1979], fig. 41), which unmistakably represents metalwork.

44. London, British Library, Add. MS 11300 (Weitzmann, *Byzantinische Buchmalerei,* figs. 37–38; Agati, *Minuscola,* 64–69) and Saint Petersburg, Gosudarstvennaja Publičnaja Biblioteka im. M. E. Saltykova-Ščedrina, gr. 220 (Weitzmann, *Byzantinische Buchmalerei,* fig. 673; Agati, *Minuscola,* 79–82).

45. The Old Church of Tokalı Kilise: Wharton Epstein, *Tokalı Kilise,* pls. 16–31.

46. References note 3 above; sixth-century representations of gem-studded crosses in Saint Sophia, Istanbul (reference note 26 above), were represented with red and black backgrounds.

47. Mango, *Sources and Documents,* 88 (Paul the Silentiary, *Description of Saint Sophia,* 720–54) and 100 (*Narratio de S. Sophia,* 21). For a survey of other known instances, see M. Mango, "The Monetary Value of Silver Revetments and Objects Belonging to Churches, A.D. 300–700," in *Ecclesiastical Silver Plate in Sixth-Century Byzantium,* ed. S. Boyd and M. Mango (Washington, 1992), 123–36.

48. Mount Athos, Iviron monastery, cod. 27, fol. 413v: Pelekanides et al., *Treasures,* II (1975), fig. 45. The form to which they refer is represented in the late-ninth-century Paris Gregory, Bibliothèque Nationale, gr. 510, fol. 104: Omont, *Miniatures,* pl. XXXI.

49. Messina, Biblioteca regionale universitaria, F.V. 18, fol. 2: Perria and Iacobini, "Il Vangelo," pl. XII.

50. Reference note 26 above.

51. Capitals in the gallery arcade of Saint Sophia were decorated with what appear to be perforated leaves with five points (Kähler, *Hagia Sophia,* fig. 49; Mathews, *Byzantine Churches,* fig. 31-76), but another capital suggests that this design actually consists of two leaves seen in profile, meeting but not completely joined (Kähler, *Hagia Sophia,* fig. 76).

52. See note 39 above.

53. Berlin, Deutsche Staatsbibliothek, cod. Phillipps 1583: Weitzmann, *Byzantinische Buchmalerei,* 16–17; J. Irigoin, "Pour une étude des centres de copie byzantins, II," *Scriptorium* 13 (1959), 180–81; P. Lemerle, *Le premier humanisme byzantin* (Paris, 1971), 296; N. Wilson, *Scholars of Byzantium* (Baltimore, 1983), 143. Color reproductions in J. Kirchner, *Beschreibende Verzeichnis der Miniaturen-Handschriften der preussischen Staatsbibliothek zu Berlin,* I, *Die Phillipps-Handschriften* (Leipzig, 1926), pl. III.

54. Patmos, monastery of Saint John the Theologian, cod. 43 (cod. 44): Weitzmann, *Byzantinische Buchmalerei,* 19, relating in style to the Berlin *Hippiatrika;* Agati, *Minuscola,* 205–14.

55. See note 39 above.

56. Dirimtekin, "Fouilles," 178–81, fig. 24.

57. In the molding under the window on the west wall of Saint Catherine's:

Forsyth and Weitzmann, *Church and Fortress of Justinian*, pls. CIII, CXXIX.a.

58. Vienna, Österreichische Nationalbibliothek, Med. gr. 1, fol. 6v: O. Mazaal, *Pflanzen, Wurzeln, Säfte, Samen: Antike Heilkunst in Miniaturen des Wiener Dioskurides* (Graz). For Saint Sophia: Kähler, *Hagia Sophia*, fig. 44.

59. London, British Library, Add. MS 5111–5112: Nordenfalk, *Kanontafeln*, 127–29, fig. 12, pls. 1–4, and in color in K. Weitzmann, *Late Antique and Early Christian Book Illumination* (New York, 1977), pl. 43, and in *Byzantium: Treasures of Byzantine Art and Culture from British Collections*, ed. D. Buckton (London, 1994), 77.

60. Nordenfalk, *Kanontafeln*, 122–24, discussed the width of the arch in relationship to imperial Roman architecture. For Byzantine parallels, see the decorative arches created by revetment in the church of Saint Demetrios at Thessalonike (Soteriou, *Basilike*, pl. 2.a) and Saint Catherine's on Mount Sinai: Forsyth and Weitzmann, *Church and Fortress of Justinian*, pl. LXXXVIII.

61. Kähler, *Hagia Sophia*, figs. 40, 82.

62. Whorls (treated as flowers): Harrison, *Saraçhane*, fig. F 5c[i], pl. 151, and figs. 141, 142, 145, 146, 154, 155; and blossoms: ibid., figs. 112, 151. In Saint Sophia there is a whirled acanthus pattern: Kähler, *Hagia Sophia*, fig. 53. The small flowers on the canon table are unusual for the dot in the center of the petals; absent this detail they resemble the ivy-leaf design known in Saint Polyeuktos (Harrison, *Saraçhane*, fig. 177) and Saints Sergios and Bakchos (W. Volbach, *Frühchristliche Kunst* [Munich, 1958], pl. 188).

63. London, British Library, Add. MS 5111–5112, fol. 11v: Nordenfalk, *Kanontafeln*, pl. 4, which may be compared with the design in the late-ninth- or early-tenth-century Messina, Biblioteca regionale universitaria, FV 18, fol. 8: Perria and Iacobini, "Il Vangelo," pl. XIV,2. In discussing these leaves, E. Kitzinger, "Byzantine Art in the Period Between Justinian and Iconoclasm," reprinted in *The Art of Byzantium and the Medieval West: Selected Studies by Ernst Kitzinger*, ed. W. Kleinbauer (Bloomington, 1976), 187–88, speaks of a strong dichotomy between the naturalistic and abstract elements of the canons. In this regard they seem to represent an early example of the aesthetic expressed in the ornament of the Coislin Gospels (Fig. 3).

64. J. Leroy, *Les manuscrits syriaques à peintures conservés dans les bibliothèques d'Europe et d'Orient* (Paris, 1964), 139–97. The canons are reproduced in color in Cecchelli, Furlan, and Salmi, *Rabbula Gospels*.

65. The tendency to cite Armenian parallels for the exuberant tympana and spandrel ornament prejudges the style as eccentric, isolated on the eastern periphery of the empire: Leroy, *Manuscrits syriaques*, 190, citing Josef Strzygowski. But see Grabar, *Sculptures* I, 117.

66. Florence, Biblioteca Medicea-Laurenziana, Plut. 1.56, fol. 3v (Leroy, *Manuscrits syriaques*, pl. 22.1; Cecchelli, Furlan, and Salmi, *Rabbula Gospels*, 3b); and for the Rotunda: Kourkoutidou-Nikolaidou and Tourta, *Byzantine Thessaloniki*, fig. 58.

67. Florence, Biblioteca Medicea-Laurenziana, Plut. 1.56, fol. 10 (Leroy, *Manuscrits syriaques*, 28.2; Cecchelli, Furlan, and Salmi, *Rabbula Gospels*, 10a). Saint Polyeuktos: Harrison, *Saraçhane*, fig. 158.

68. Florence, Biblioteca Medicea-Laurenziana, Plut. 1.56, fols. 5, 8 (Leroy, *Manuscrits syriaques*, pls. 23.2, 26.2; Cecchelli, Furlan, and Salmi, *Rabbula Gospels*, 5, 8). Compare Paris, Bibliothèque Nationale, gr. 510, fol. 149v (Ebersolt, *Miniature byzantine*, pl. XV.1), and gr. 139, fol. 428v (Omont, *Miniatures*, pl. XI). In mosaics the pattern appears in Sant'-

Apollinare in Classe (see note 18 above), the border of the Great Palace Mosaic: F. Cimok, *Mosaics in Istanbul* (Istanbul, 1997), 30, 31; Thessalonika, Saint Demetrios: Kourkoutidou-Nikolaidou and Tourta, *Byzantine Thessaloniki*, figs. 181, 183; and the north wall of the alcove in the southwest ramp of Saint Sophia, Istanbul: R. Cormack and E. Hawkins, "The Mosaics of Saint Sophia at Istanbul: The Rooms Above the Southwest Vestibule and Ramp," *DOP* 31 (1977), figs. 22–25.

69. Florence, Biblioteca Medicea-Laurenziana, Plut. 1.56, fol. 5v (Leroy, *Manuscrits syriaques*, pls. 24.1, 26.2; Cecchelli, Furlan, and Salmi, *Rabbula Gospels*, 5b). Compare Paris, Bibliothèque Nationale, gr. 510, fol. 78 (Omont, *Miniatures*, pl. XXIX), and gr. 139, fol. 5v (ibid., pl. v).

70. Florence, Biblioteca Medicea-Laurenziana, Plut. 1.56, fol. 4 (Leroy, *Manuscrits syriaques*, 22.2; Cecchelli, Furlan, and Salmi, *Rabbula Gospels*, 4). Compare Oxford, Bodleian Library, Canon gr. 110, fols. 142v, 157v: Hutter, *Corpus*, I, figs. 18, 19; Paris, Bibliothèque Nationale, gr. 139, fol. 431v: Omont, *Miniatures*, pl. XII; Princeton, University Library, MS Garrett 6, fol. 54v: Galavaris, *Byzantinon cheirographon*, fig. 16; Saint Petersburg, Gosudarstvennaja Publičnaja Biblioteka im. M. E. Saltykova-Ščedrina, cod. 21, fol. 2: V. Likhačova, *Byzantine Miniature* (Moscow, 1977), pl. 5.

71. Florence, Biblioteca Medicea-Laurenziana, Plut. 1.56, fol. 8v (Leroy, *Manuscrits syriaques*, pl. 27.1; Cecchelli, Furlan, and Salmi, *Rabbula Gospels*, 8b). Compare Paris, Bibliothèque Nationale, gr. 139, fol. 6v: Omont, *Miniatures*, pl. VI. For buildings, see Istanbul, Saint Sophia, Justinianic vault crosses: note 26 above.

72. C. Mango, "The Availability of Books in the Byzantine Empire, A.D. 750–850," in *Byzantine Books and Bookmen*, 29–45, which is not concerned with the text of the Gospels.

73. *Illuminated Greek Manuscripts from American Collections*, 52–55.

74. Basel, Universitätsbibliothek, AN3.12: Nordenfalk, *Zierbuchstaben*, 189–94, figs. 52–56.

75. Also known from other manuscripts of the ninth and tenth centuries: for example, Princeton, University Library, Garrett 1 (*Illuminated Greek Manuscripts from American Collections*, 56–57), and Scheide cod. M 2 (ibid., 58–59).

76. An earlier example occurs as a frame for the scene of Ezekiel in the Valley of the Dry Bones in Paris, Bibliothèque Nationale, gr. 510, fol. 438v: Omont, *Miniatures*, pl. LVIII, in color in *Glory of Byzantium*, 85.

77. Paris, Bibliothèque Nationale, gr. 139, fol. 422v: Omont, *Miniatures*, pl. x, in color in *Glory of Byzantium*, fig. 163.

78. Soteriou, *Basilike*, 207–8, color plate following pl. 78.

79. It appears on arch facings in Princeton, University Library, Garrett 6: Weitzmann, *Byzantinische Buchmalerei*, fig. 375; Rome, Biblioteca Apostolica Vaticana, Pal. gr. 220: ibid., fig. 402—in the former edged with a dentil molding and the latter a line of pearls, as in Saint Demetrios, Thessalonike (note 78 above). The *cyma* with a row of dentils edges the canopy carved above the scene of Christ Crowning Constantine VII, on the ivory in Moscow, State Pushkin Museum of Fine Arts, acc. no. II.2.b.329: A. Goldschmidt and K. Weitzmann, *Die byzantinischen Elfenbeinskulpturen des X.–XIII. Jahrhunderts*, II (Berlin, 1934), pl. XIV (34); *Glory of Byzantium*, fig. 140.

80. See the page of text from Paris, Bibliothèque Nationale, gr. 139, reproduced by Omont, *Miniatures*, pl. XIVbis, or the many illustrated by Agati, *Minuscola*.

81. Rome, Biblioteca Apostolica Vaticana, Barb. gr. 310: T. Nissen, *Die byzantinischen Anakreonteen*, Sitzungsberichte der Bayerischen

Akademie der Wissenschaften, Philosophisch-historische Abteilung 3 (Munich, 1940); Wilson, *Scholars,* 143.

82. Agati, *Minuscola,* 202, 227.

83. Washington, Dumbarton Oaks Collections, acc. no. 55.1.5007; I wish to thank Susan Boyd for her thoughts on the bracelet.

84. Weitzmann, *Byzantinische Buchmalerei,* 18.

85. Athens, National Library, cod. 56: A. Marava-Chatzinicolaou and C. Toufexi-Paschou, *Catalogue of the Illuminated Byzantine Manuscripts of the National Library of Greece,* 1, *Manuscripts of New Testament Texts, 10th–12th Century* (Athens, 1978), 17–27. Washington, Dumbarton Oaks Collections, acc. no. 40.69: Ross, *Catalogue,* II, 103, pl. LXVIII; *Glory of Byzantium,* 212–13.

86. A. Frolow, *La relique de la Vraie Croix,* Archives de l'Orient chrétien 7 (Paris, 1961), 233–37; idem, *Les reliquaires de la Vraie Croix,* Archives de l'Orient chrétien 8 (Paris, 1965), figs. 38.a,b. C. Diehl, "De la signification du titre de 'proèdre' à Byzance," in *Mélanges offerts à M. Gustave Schlumberger,* 1 (Paris, 1924), 108–10.

87. New York, Metropolitan Museum of Art, acc. no. 17.190.644–648: *Glory of Byzantium,* 348–49.

88. Berlin, Deutsche Staatsbibliothek, Phillipps 1538, fols. 39, 55: Weitzmann, *Byzantinische Buchmalerei,* figs. 112, 113.

89. Irigoin, "Pour une étude," 181–93.

90. Mount Athos, Stavronikita monastery, cod. 43: references note 25 above; for the attribution, Perria and Iacobini, "Il Vangelo," 103–12.

91. Mount Athos, Dionysiou monastery, cod. 70: Weitzmann, *Byzantinische Buchmalerei,* 22; Pelekanides et al., *Treasures,* 1, figs. 130–38.

92. See, most recently, A. Cutler, "The Psalter of Basil II," *Arte Veneta* 30 (1976), 10–25.

93. Mango and Hawkins, "Church Fathers," 22, cite the report of Basil I's having reused mosaics from Justinian's mausoleum. A considerable amount of reused architectural material appears in Constantine Lips's church: Mango and Hawkins, "Additional Notes," 303–4.

94. Mango and Hawkins, "Church Fathers," 21–22, on the quality of the materials found in the late-ninth-century program of Saint Sophia. For columns, see Naumann and Belting, *Die Euphemia-Kirche,* 64.

95. W. Tronzo, "The Vagaries of a Motif and Other Observations on Ornament," page 152.

96. The relationship between tiles and pottery is discussed in this volume, with earlier bibliography, by M. Mango, "Polychrome Tiles Found at Istanbul: Typology, Chronology, and Function," pages 29–33. The unusual instance of a bowl decorated with an image of Saint Nicholas and resembling a tile is discussed in this volume by S. Gerstel, "Ceramic Icons from Medieval Constantinople," page 48. I wish to thank Prof. Gerstel for making available to me her slides and notes on the tiles in collections outside the United States.

97. *Germanus: On the Divine Liturgy,* trans. Meyendorff, 56–57.

98. One of Christ's metaphors for himself was "bridegroom"; see Matt. 25:1–13, Mark 2:19–20, Luke 5:34, and John 3:29.

99. R. Harrison, *A Temple for Byzantium: The Discovery and Excavation of Anicia Juliana's Palace-Church in Istanbul* (Austin, 1989), 138–39.

100. *Life of Basil,* 83: Mango, *Sources and Documents,* 194.

101. *Triodion katanyktikon* (Rome, 1878), 619.

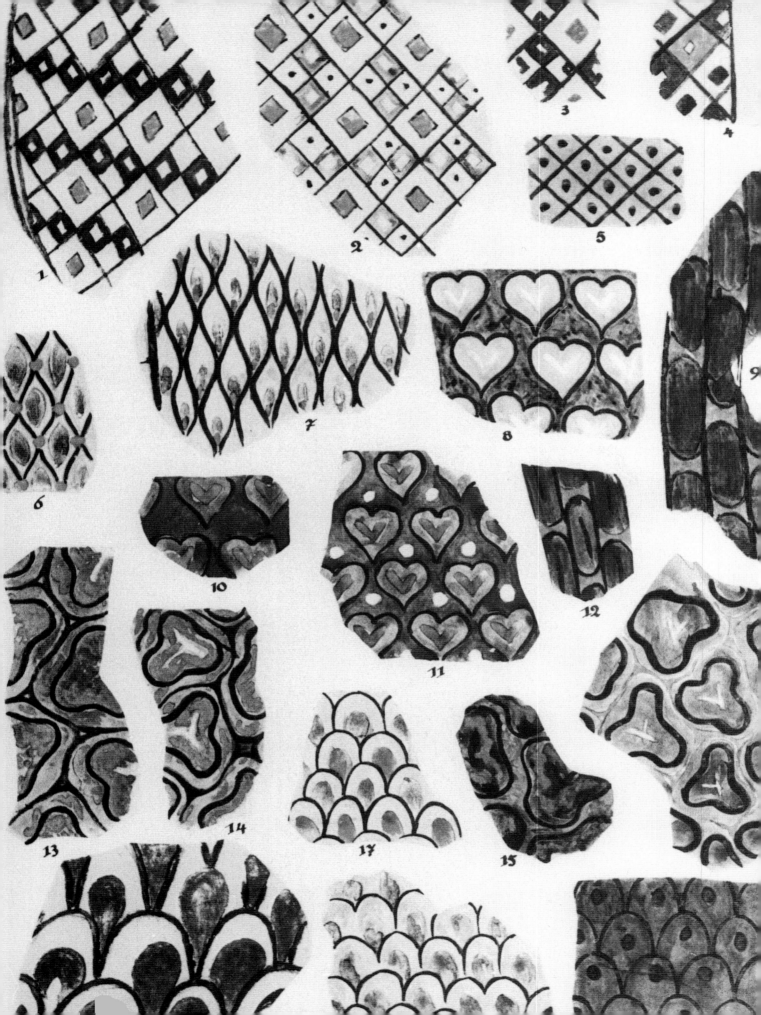

The Vagaries of a Motif and Other Observations on Ornament

WILLIAM TRONZO

 In a characteristically astute study published in the *Münchner Jahrbuch* in 1951, André Grabar assessed the relationship between Byzantine and Islamic art and architecture (including the pre-Islamic art of the Middle East) in the tenth century, discerning what he called a process of orientalization that occurred in Byzantium under the Macedonians.[1] Not only was Grabar's study one of the first attempts to synthesize disparate observations on this material with the aim of sketching the picture of a contemporary cross-cultural interchange, it was also one of the first to endeavor to redress a balance in a history of art (Byzantine) constructed largely in terms of the ebb and flow of the classical, with particular emphasis on periods of "Classical Revival" or "Renaissance." There can be no more appropriate illustration of the relevance of Grabar's analysis than the famous Byzantine glass cup of the tenth century, now in the Treasury of San Marco in Venice. The figural decoration on the outer body of the cup has often been cited as a prime example of the classicizing "Macedonian Renaissance." But it is embellished prominently on its inner rim with a kufic or pseudo-kufic inscription, which has just as often been ignored.[2] The path charted by Grabar has since been followed by others.[3]

In examining the complex, varied, and changing roles of the classical and the Islamic in Byzantine art history, however, there is an important distinction to bear in mind. Although works of classical art could serve as a point of departure or source of inspiration for Byzantine artists, they belonged to a culture that was decisively separate from the present simply by virtue of chronology and grew ever more distant from contemporary Byzantine practice. For Byzantium, beginning in the seventh century, however, Islam was a living presence in a variety of manifestations—regional, ideological, and cultural—that had the capacity to absorb as well as transmit art forms and visual ideas. One result for scholarship has been the considerable difficulty in weighing the respective roles of Byzantium and the Islamic world, particularly in the realm of textiles and the ceramic arts. The point is relevant here because of the thesis propounded by a number of scholars (including Grabar) that Byzantium derived the notion of the decorated tile from the Islamic world.[4] This is one of the central issues that I would like to address in the following essay, which takes as its focus the ornament of the smaller Walters tiles.

For the purpose of the present catalogue, the Byzantine tiles at the Walters have been divided into two groups: figural and nonfigural, or ornamental.[5] The figural group,

discussed separately by Sharon Gerstel, is composed entirely of flat plaques, square or nearly square in shape and measuring 16 to 30 cm on a side, with a bust- or full-length depiction of a saint, an angel, Christ, or the Virgin in the center (cat. A.1–A.28). The ornamental pieces, by contrast, are considerably more varied. There are several tiles of approximately the same size as the larger type of figural plaque, that is, about 29–30 cm square, embellished with whorls of geometric ornament, peacocks, rosettes, crosses, Sasanian palmettes, or a scale pattern (cat. A.29–A.43).[6] The preponderance of ornamental tiles, however, is rectangular in shape and decorated with continuous patterns—vine scroll, rosette, diaper pattern, and so on (cat. A.44–A.71). Many of these pieces are curved in section (either convex or concave) or have a sloping and cusped profile appropriate for a column. Clearly, they were originally intended to form edges or frames, including columnar shapes, just as the square plaques with figures were meant, probably for the most part, to form fields to be framed.[7] As with the figural pieces, the predominant colors on the ornamental tiles are deep amber, copper green, aubergine, black, and white (the reserved body of the clay).

It is with the smaller ornamental tiles that the following remarks are concerned, although it should be made clear at the outset that the expectations regarding a historical analysis of these, as opposed to the figural tiles, can hardly be the same. Not only did the Byzantines comment, and frequently, on the portraits of Christ, the Virgin, and the saints that they saw represented in art, but modern scholarship has often taken the figure—and particularly the holy figure—as the measure of development and meaning in Byzantine art history.[8] In other words, tradition has sanctioned the figure as an element worthy of analysis in the history of Byzantine art, for which an elaborate vocabulary and methodology have been evolved.

The same cannot be said of ornament. Apart from some brief notices, it is rare to find mention of ornament per se in the extensive writings of the Byzantines on art, although it can hardly be doubted that ornamental patterns on the walls of churches, on the pages of books, and on the objects of daily use gave the Byzantines pleasure. Making these patterns was one of the chief preoccupations of the Byzantine artist and artisan. Nor has modern scholarship created a discourse with the same depth, complexity, and interrelatedness for ornament as for the figure: the theoretical and historical issues that have been defined in the few studies that exist often seem artificial and overly speculative and are difficult to connect, one study to the other.[9]

Thus we begin with an assertion: ornament *has* a history that does not always follow that of the figure, a history within which both continuity and discontinuity play a role—the latter perhaps more interestingly. It will suffice to cite two examples: the influx, into the architectural ornament of late antiquity, of an entirely new set of designs derived from textiles, which implies for the period a new conceptualization of the building as such;[10] and the extraordinary transformation wrought by Middle Byzantine artists of Arabic script into an ornamental motif for the borders and frames of holy images and church decorations—the so-called pseudo-kufic.[11] Both of these phenomena concern the realm of ornament exclusively, and within it, disjunctive relationships, with great implications, cultural and aesthetic.

The notion of discontinuity or disjunction, of course, depends upon the perception of a norm, and in the case of the Walters tiles, the norm with regard to the ornamental patterns is revealed in a cursory glance. The patterns employed on these tiles have an overwhelmingly conventional—one might say even ordinary—Middle Byzantine character, which is one of the points of this essay (as well as Jeffrey Anderson's contribution to the present volume).[12] At the same time, however, there is evidence in the patterns themselves that would seem to support a view of the medium propounded by David Talbot Rice, André Grabar, and others as something strange, essentially a foreign import, brought into Byzantium from the Islamic world and indeed fairly recent, relative to the time in which the Walters tiles themselves were created, which is the other point to be discussed.

There are over a dozen separate ornamental patterns employed on the Walters tiles.[13] In a purely morphological

sense (following M. Alison Frantz), these patterns may be divided into essentially two groups based on the geometrical matrix from which they were derived, either rectilinear or curvilinear, that is to say, into patterns generated from a grid of right angles and straight lines or curves and arcs.[14] In the category of the former, for example, may be numbered the basketweave and diaper patterns (cat. A.44–A.49, A.63–A.64, A.72); in the latter are the vine scroll and the rosette pattern (cat. A.55–A.58). Curvilinear patterns predominate. There are several based on the serried row of circles, rendered in a range from most simple—a circle within a circle—to complex, with the circle inscribing a rosette or subdivided by arcs and embellished with lozenge-shaped sections of different colors (cat. A.54–A.55, A.65–A.66, A.68, A.71). Other patterns, however, also represent a combination of the two, curvilinear and rectilinear, such as the tongue and dart (cat. A.61) or the pattern of alternating squares and floral elements (cat. A.60).[15]

Artistic tradition provides another and perhaps more useful way of categorizing the patterns. Quite a few of the patterns employed here belong to a repertory of ornamental motifs that had their roots deep in the visual culture of the Mediterranean world. A prime witness is the vine scroll, one of the conventions of classical Greek and Roman ornamentation whose long history of development and transformation was treated in a famous study by Alois Riegl.[16] The vine scrolls depicted on the Walters tiles take several different forms, with leaves or clusters of grapes in the interstices and striated or simple stems, some of which find close analogue in a number of works of art in other media. Catalogue numbers A.56–A.58, for example, share aspects of their overall form and details with a sixth-century stucco molding in Saint Sophia, wall paintings in Cappadocia, and quite a few manuscript illuminations from the Middle and Late Byzantine periods.[17]

The latter example raises an issue treated more fully in the contribution of Jeffrey Anderson in the present volume. Apart from manuscript illumination, however, another fertile ground for comparison with the tiles is constituted by the ample remains of mosaic pavements, which were often decorated with ornamental patterns, particu-

larly in the Roman period and in late antiquity. In this context, one encounters with some frequency, for instance, the scale pattern (cat. A.52), the circle with four-petaled flowers (cat. A.70), geometric and foliate designs (cat. A.71), and the sawtooth pattern (cat. A.53).[18] All of these patterns, in turn, are also attested in other media, suggesting their availability to artists, certainly from training but, for the more complex designs, perhaps even from model books.[19] Scheller's catalogue of medieval model books contains a number of drawings of decorative motifs from late antiquity and the early Middle Ages, which could be applied, presumably, in any medium with which an artist was engaged.[20]

The aforementioned patterns, of course, do not have the same genealogy, but for the purpose of giving focus to this discussion, they serve to illustrate one point: that a significant number of patterns employed on the tiles belong to a vocabulary of ornament that was the common repertory of artists at least by late antiquity. There is no reason to doubt, furthermore, that they remained so in Byzantium up to the time the tiles themselves were created.

Against this backdrop, there is one pattern that stands out—a broad foliate volute, in this volume termed paired acanthus leaves. It occurs on the large concave tile cat. A.62, which shows the right and left sides respectively of two large looping forms whose shape may be completed with the help of tiles from Saint John Stoudios (cat. X.3) and the Topkapı Sarayı Basilica (cat. XII.15; figs. 1–3).[21] The form repeated in the main band of a Stoudios plaque—as reconstructed in between a band of stylized arches and columns and a band of "jeweled border"—is virtually identical to that on A.62, essentially U-shaped, with ends that curve in at the sides like the volutes on a proto-Ionic capital. The interior of the form is articulated with a feathery or leafy band; what look like curving tendrils extend downward on both sides. A related motif occurs on a tile from the Topkapı Sarayı Basilica (cat. XII.19; fig. 4). Here, the two looping sides of the form are not connected with one another but emerge from a rectangular shape; the feathery band and the tendrils remain.

The pattern has the feel of an elemental natural form—a floret or leaf—that has been made abstract or

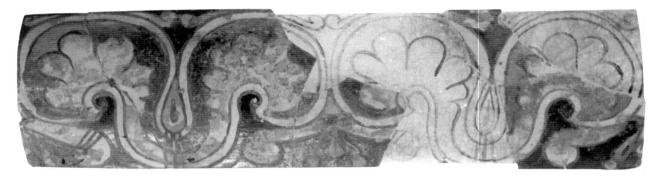

Fig. 1 Istanbul, Arkeoloji Müzeleri. Topkapı Sarayı Basilica (cat. XII.15).

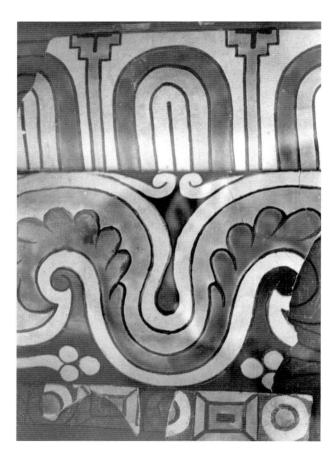

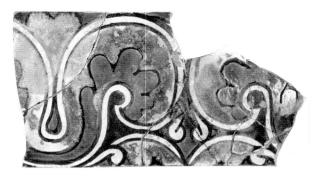

Fig. 2 (*left*) Istanbul, Arkeoloji Müzeleri. Tile from Saint John Stoudios (cat. X.1–3).

Fig. 3 (*above*) Baltimore, Walters Art Museum. Paired acanthus leaves (cat. A.62).

schematized (which is often how the development of ornament, particularly in late antiquity, is characterized). But in shape and proportions, and especially in the bulbous form of the looping sides, the pattern seems quite foreign to the classical tradition, where nothing analogous is known.[22]

The pattern finds comparison in decorations of the East. The excavations in the early part of the twentieth century that uncovered substantial remains of the city of Sāmarrā, the capital of the 'Abbāsid state in the ninth century, including wall painting and numerous objects of minor arts, brought to light many mural decorations in stucco fashioned with dadoes containing large fields of ornamental patterns.[23] The pattern found on A.62 occurs in a closely similar form in the decoration of two houses (figs. 5, 6).[24] Isolated as it is, however, the connection in and of itself could not be deemed significant were it not for two further considerations.

First, in its formal quality, the pattern finds a frame of reference in the decorations of Sāmarrā, whose ornamental motifs often have the same looping shapes and bulbous proportions (fig. 7).[25] Second, the Samarran decorations in both stucco and paint match the Walters tiles in a number of other patterns that are not quite so distinctly non-Mediterranean: the serried row of circles of cat. A.54; the scale pattern of cat. A.51; the broken diaper pattern of cat. A.44–A.49, A.63–A.64; and the rosette pattern of cat. A.55 (figs. 8, 9, 10).[26] One wonders, therefore, whether there is more to the connection between Sāmarrā and the Walters tiles than meets the eye. Three points bear on this issue.

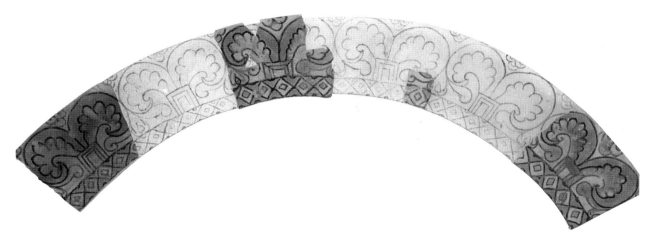

Fig. 4 Istanbul, Arkeoloji Müzeleri. Tile from Topkapı Sarayı Basilica (cat. XII.19).

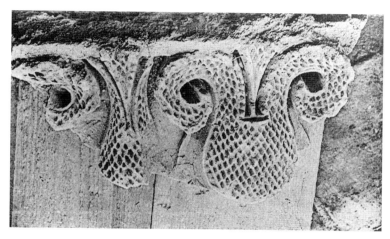

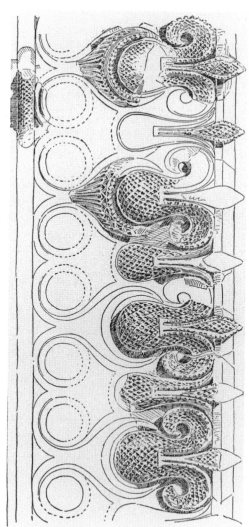

Fig. 5 (*above*) Sāmarrā. Wall decoration.

Fig. 6 (*right*) Sāmarrā. Wall decoration.

To begin with, chronology. Insofar as I have been able to determine, a study of the ornamental patterns contributes little to our picture of the chronology of the Walters tiles. Nonetheless, it does not contradict the conclusion drawn elsewhere in this volume that the Walters tiles date to the tenth or eleventh century. Marlia Mango has suggested that the Byzantines were producing tiles in Constantinople possibly even in the ninth century, although the evidence in this regard is not strong.[27] Totev and others have argued that the Bulgarian centers of tile

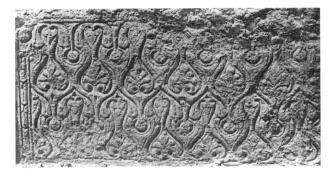

Fig. 7 Sāmarrā. Wall decoration.

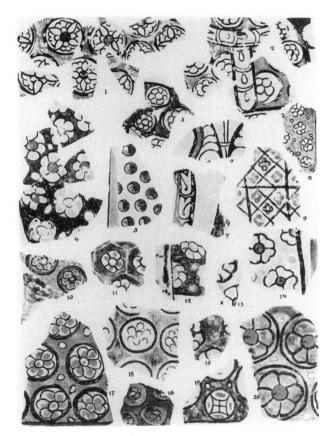

Fig. 8 Sāmarrā. Ornamental motifs.

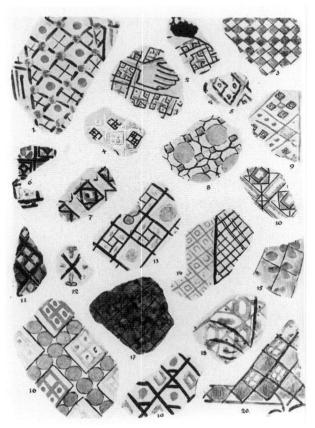

Fig. 9 Sāmarrā. Ornamental motifs.

making arose at the end of the ninth century, although here, too, the chronological evidence is not unequivocal.[28] As a city, Sāmarrā began to flourish earlier, in the first half of the ninth century, and it continued to grow and prosper essentially between the time of its founding as capital of the 'Abbāsid caliphate by the caliph al-Mu'taṣim (r. 833–42) and its abandonment for Baghdad by the caliph

al-Mu'taḍid (r. 892–902).[29] It was in this period that Sāmarrā was filled with an extraordinary new monumental architecture—great palaces and public buildings—from which all of the decorations discussed heretofore derived. Many of these decorations in the stucco medium, in particular, belong to the third of Samarran styles that Herzfeld has defined, which is often subsumed under the category of the beveled style (fig. 11).[30] The beveled style is considered one of the most distinctive visual artifacts of Samarran culture, and although its traditionalism has been stressed by some scholars, its salient quality remains its originality, which is the second point to make.[31]

Finally, there is the fact that Sāmarrā was a center of the ceramic arts, including the making of tiles (fig. 12).

Fig. 11 Sāmarrā. Wall decoration.

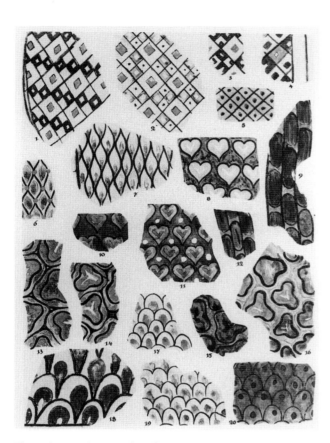

Fig. 10 Sāmarrā. Ornamental motifs.

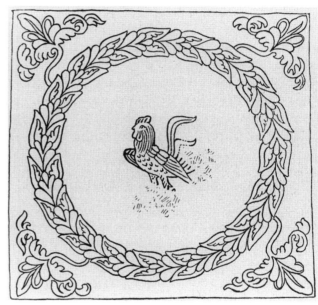

Fig. 12 Sāmarrā. Ceramic tile.

Unfortunately, none of these tiles have been found *in situ* in an architectural context, and so their original use may only be surmised.[32] Mention should also be made of the fact that these tiles were executed in the luster technique, the most elegant also being flecked with gold. The Byzantine tiles are considerably more modest in appearance, although some, for example at the Myrelaion or Boukoleon, have gold leaf. But it is interesting to observe that one of the patterns employed in the Samarran work, a vine scroll, bears a distinct similarity to the pattern depicted on cat. A.58 (figs. 13, 14).[33] Another motif shared by the Byzantine and Samarran tiles has been noted by É. Coche de la Ferté: the leaves placed in between the central medallion and corners of square plaques.[34] And it is

also relevant to note that the Samarran or Mesopotamian tradition may well have had influence elsewhere and quite early on in the Islamic world. One of these places was the Great Mosque at Kairouan, whose ninth-century *mihrab* was decorated with luster tiles, many showing motifs that have the same bulbous and looping quality as the Samarran stucco ornament (fig. 15).[35] Georges Marçais has argued that the roots and origins of this art form are to be sought in Mesopotamia in the 'Abbāsid period.[36]

Because the Byzantine tiles are materially different, above all not being executed with the luster technique, it

might be argued that they could not be related directly to any of the aforementioned cases from the Islamic world.[37] But the Byzantines never made lusterware in any format, even though they used luster models elsewhere.[38] It would certainly seem as if they were attempting to mimic, using their modest technique, the effect of a more expensive material in the extensive use of a dark amber glaze that calls to mind the precious substance of gold.[39] It might also be argued that motifs from the East, particularly ornamental motifs, were constantly being adopted by Byzantine artists, as evidenced by, for instance, the decorative program of the sixth-century church of Saint Polyeuktos in Constantinople, which is thought to have made use of the ornamental vocabulary of the distant forebears of the 'Abbāsids, the Sasanians.[40] But it is also possible that the medium itself—the decorated tile—and its distinctive ornamental motifs went hand in hand and were transmitted from 'Abbāsid Mesopotamia to Byzantium together.

In earlier analyses of Byzantine tiles related to those in the Walters collection, both Talbot Rice and Grabar have posited an Islamic source for the medium, with Mesopotamia a likely point of origin, and a similar argument has been made with regard to the tiles from Bulgaria.[41] In giving voice to this suggestion, therefore, I follow their lead, but I do so tentatively, for I recognize that my analysis (like Rice's and Grabar's) contains no proof. Nonetheless, it is important to note that such a derivation would find resonance in the documented taste and activities of important Byzantine patrons in the ninth and tenth centuries. It will suffice to cite two examples. First, in the wake of the visit in 830 of John the Synkellos to Baghdad, the 'Abbāsid capital before Sāmarrā, the emperor Theophilos (r. 829–42) was persuaded to build the Bryas Palace in the Islamic style: "Having come back to Theophilos and described to him the things [he had seen] in Syria [sic], he [John] persuaded him to build the palace of the Bryas in imitation of Arab [palaces] and in no way differing from the latter either in form or decoration."[42] One clearly wants to know what a Byzantine-built, Islamic-style edifice looked like in the ninth century, but nothing of the Bryas, beyond possibly its substructure,

Fig. 13 Baltimore, Walters Art Museum. Vine scroll with floral center (cat. A.58).

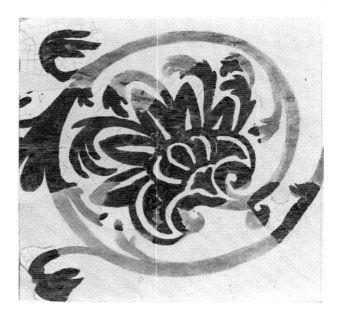

Fig. 14 Sāmarrā. Ceramic tile.

Fig. 15 Kairouan, Great Mosque.
Tiles.

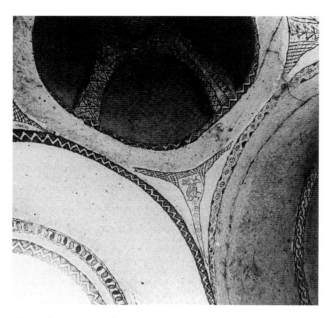

Fig. 16 Göreme, Cappadocia. Ornamental painting.

remains.[43] Second, in a letter to a friend of ca. 940, the emperor Constantine VII Porphyrogennetos praises a cup he had just received as a gift and in which he took special delight: "When I received the mountain vegetables and found these more tasty than honey in [the] honeycomb, I was thankful to the sender. I marveled at the Arabic cup, its variegated [beauty], its smoothness, its delicate work—both while eating and while going to bed."[44]

It is important to bear in mind the larger picture. The decorated tile was not an art of the early Middle Ages.[45] The first known examples of it are the very ones adduced here: from Sāmarrā, Kairouan, Preslav, and Byzantium. It then became a major art form in the Islamic world. But apparently in Byzantium (with only modest diffusion probably from Constantinople, e.g., to Bulgaria?), soon after the Walters tiles were made, it disappeared.[46] Where are its origins, therefore, to be sought: in the culture (Islam) in which it became the foundation of a tradition or in the culture (Byzantium) in which it was an ephemeral and disjunctive phenomenon without past or future but at the same time

absolutely coincident with a period of highly active and aesthetically based interest in the art of Islam?

If the Byzantines derived the art of the decorated tile from the Islamic world, they clearly, if only relatively briefly, made it their own. The presence of holy figures on the tiles is one indication of this; another is the repertory of classically based ornamental motifs (although some of these motifs would have been available to Samarran artists). But a key point is also to be derived from a consideration of the use of the tiles, for which, however, it will ultimately be necessary to go outside of Byzantium itself.

Curiously enough, even though there are only a small number of surviving fragments that retain traces of the plaster that affixed them to another surface (in the Walters, the Istanbul Archaeological Museum, and the Thierry Collection), it is reasonable to assume that the ornamental tiles were used as mural decoration.[47] The ornamental tiles of Preslav have been reconstructed as a framework around the plaques with holy images, and it is possible that some of the Walters tiles, particularly the columnar shapes, served a similar purpose.[48] The only problem is that there are no obvious fits and no holy figures on plaques with curved tops that would have accommodated the curving forms of some of the ornamental tiles. One cannot escape the impression that the Walters collection is a miscellany. Most likely, the collection did not derive from a single original ensemble but was assembled after the fact. Thus, it would be a mistake to place emphasis on recreating a context based on it alone. It is reasonable to assume that the tiles found in churches, as in the Lips monastery, were made for an ecclesiastical context. But nothing excludes the possibility that the Walters collection contains pieces that were used, not in a church, but in another kind of public building or in a domestic setting.[49] In either case, however, one might also imagine them installed similarly, as cornice or molding at important places in an edifice, much in the manner of the ornamental strips one finds in mural painting of the Middle Byzantine period (fig. 16).[50]

With regard to the architectural placement of tiles in Byzantium, there are two points of reference. One is the Botaneiates inventory of 1192/1202, for the analysis of

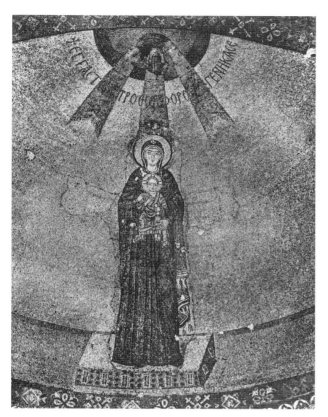

Fig. 17 Iznik (Nicaea), Koimesis church. Apse.

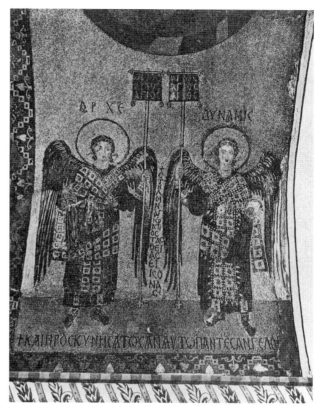

Fig. 18 Iznik (Nicaea), Koimesis church. Archangels.

which the reader is referred to the contribution of Marlia Mango to the present volume.[51] The inventory indicates that tiles revetted a cornice that formed the lower edge of a zone of mosaic decoration in a church, probably of the tenth or eleventh century. The other is the church of the Koimesis in Nicaea, which was destroyed in the early twentieth century. In a photograph published by Theodor Schmit in 1927, it has often been noted that the cornice of the apse below the mosaic of the conch appears to be decorated with ceramic tiles (fig. 17). The presumed tiles are visible only on the extreme lower right and left sides of the image. At first glance, the identification would appear to be correct. Two patterns are visible here, the upper composed of a floret framed by horn-shaped elements, and the lower, fleshy stems and leaves that resem-

ble paired acanthus leaves discussed earlier.[52] Both patterns find parallels on extant tiles discussed in the present catalogue. But on closer examination, the presumed Nicaean tiles reveal idiosyncrasies. To begin with, one might expect to see a seam at some point in between the ornamental motifs if they were indeed rendered on ceramic tiles, and the photograph shows enough of the length of the cornice to make this expectation reasonable, but in fact none is visible. As noted, the lower motif could not readily be classified as paired acanthus leaves, because of the asymmetrical element at its center. It bears some resemblance to the acanthus volute on the fragmentary capital of a colonnette formerly in the Hüghenin Collection (cat. xv.1), but even here the central element is different. The upper motif may be related to patterns described

Fig. 19 Iznik (Nicaea), Koimesis
church. Apse.

variously as an acanthus half-circle or an arched motif
with peacock feathers found on tiles from the Topkapı
Sarayı Basilica (cat. XII.5–XII.7), the Kyriotissa church (cat.
V.2), and in the Musée national de Céramique, Sèvres (cat.
C.8, C.16). In the comparanda of extant tiles, however,
the arch is always different: it never tapers, as it does in
Nicaea, to a point on either side. An additional considera-
tion also gives one pause. The cornice at Nicaea ran
around the interior of the church, and, for the most part,
to judge from the photographs in Schmit's volume, it was
covered with modern painting in the early twentieth cen-
tury. In Schmit's publication this painting is visible on the
portions of cornice underneath the mosaic bearing the
figures of archangels disposed in pairs on either side of the
barrel vault in front of the conch of the apse (fig. 18).[53]
The modern painting of the cornice is also visible to the
sides of the barrel vault in the earlier publication of the
Koimesis church by Oskar Wulff (1903) (fig. 19).[54] But in
the portion of the cornice directly beneath the mosaic of
the Virgin in the conch of the apse in the Wulff publica-
tion, there is no trace of the presumed tiles that are to be
found in the Schmit illustration of 1927. Their absence

may be due to the nature of the Wulff illustration (which is
hardly optimal as documentation) or to some other rea-
son upon which it would be useless now to speculate. In
any case, at this point the presence of Byzantine tile deco-
ration on the cornice of the Koimesis church at Nicaea
must remain an open question.

Outside of Byzantium, however, lies striking confirma-
tion of the mural hypothesis. The pertinent case is the
tenth-century *maqsura* of the Great Mosque in Córdoba,
whose central cupola, ornamented with a brilliant mosaic
decoration, contains a complex rosette-shaped cornice cov-
ered with ceramic tiles (cat. XXI; fig. 20).[55] According to the
sources, the decoration of the cupola was executed by
Byzantine craftsmen at the behest of the caliph al-Ḥakam II
and completed in 970–71; as such, it marks the earliest
instance still extant of the use of tiles as molding or frame
in an architectural context.[56] The attribution to Byzantium
has been discussed, and some scholars prefer to see it in
relationship to the mosaics, not the tiles. But as Elizabeth
Ettinghausen has observed, the practice of bringing the two
media together has no resonance in the Islamic world, ren-
dering it here either idiosyncratic and a hapax or, more

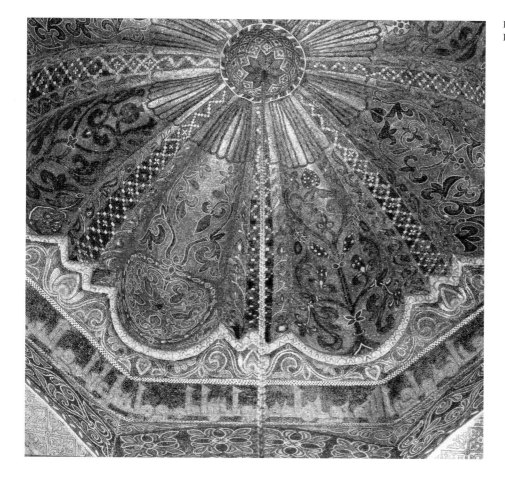

Fig. 20 Córdoba, Great Mosque. Dome over *Maqsura.*

convincingly, the intentional, natural, and indigenous synthesis of the Byzantine craftsman.[57] One wonders, in the end, whether many of the ornamental tiles did not function in Byzantium in precisely this sense: wedded to mosaic, but as a particular and very special kind of visual accent, in a larger decorative/architectural ensemble. To reserve tiles for the cornice beneath an apse mosaic, as perhaps at Nicaea, would thus have been perfectly appropriate. It is something of an irony to argue that tenth-century Byzantium in this sense is now best discerned in a once-Islamic land. But it is also an illustration of the complexity of the historical situation and the exigencies of historical evidence with which modern scholarship, beginning notably with Grabar, has had to grapple.

Notes

1. A. Grabar, "Le succès des arts orientaux à la cour byzantine sous les macédoniens," *Münchner Jahrbuch der bildenden Kunst* 2 (1951), 32–60, and esp. 56ff., with a discussion of architecture and tile decoration.

2. It is a striking fact that even though the cup has been scrutinized repeatedly by Byzantinists, the true nature of this inscription—whether kufic or pseudo-kufic—is still unknown; see, most recently, A. Cutler, "The Mythological Bowl in the Treasury of San Marco at Venice," in *Near Eastern Numismatics, Iconography, Epigraphy, and History: Studies in Honor of George C. Miles,* ed. D. K. Koumijian (Beirut, 1974), 235–54, and I. Kalavrezou-Maxeiner, "The Cup of San Marco and the 'Classical' in Byzantium," in *Studien zur mittelalterlichen Kunst 800–1250: Festschrift für Florentine Mütherich zum 70. Geburtstag,* ed. K. Bierbrauer, P. Klein, and W. Sauerlander (Munich, 1985), 167–74, both of whom discuss the inscription. It is possible that a fragmentary tile from the Lips monastery bears a kufesque design; see cat. VI.16.

3. See, for example, C. Mango, "Discontinuity with the Classical Past in Byzantium," in *Byzantium and the Classical Tradition,* University of

Birmingham Thirteenth Spring Symposium of Byzantine Studies, 1979, ed. M. Mullett and R. Scott (Birmingham, 1981), 48–57.

4. See pages 1–2.

5. My first contact with the Byzantine tiles at the Walters came in 1990, when I prepared and gave a paper on them at the Byzantine Studies Conference; see *Sixteenth BSCAbstr* (The Walters Art Gallery, 26–28 October 1990), 33–34. After languishing essentially unstudied since their brief publication at the time of their acquisition, the tiles then became the focus of scholarly attention, one of whose results is the present publication. I would like to thank Sharon Gerstel for inviting me to participate in the publication and providing every assistance toward completing the task, and Julie Lauffenburger for discussing the tiles with me.

6. M. Alison Frantz uses the term "Sasanian palmette"; see Frantz, "Ornament," 55–59. For a discussion of these plaques, see S. Gerstel's essay in this volume, pages 44–46.

7. A hypothetical reconstruction of a set of tiles in Preslav, similar in some respects to the one in the Walters, helps to visualize a possibility for the original arrangement of some of the Walters tiles; see Totev, *Preslavskata,* figs. 42, 43, and idem, *Ceramic Icon,* 61ff. (for the availability of the latter, I would like to thank Borislava Kharalampiev). On the other hand, given the differences in color and lack of fit, it is unlikely that the Walters tiles were once intended to form an ensemble. On this issue, as well as the possibility that figural plaques were used, not as fields to be framed but as the frame itself, see S. Gerstel's essay in this volume, pages 60–61.

8. See, for example, Mango, *Sources and Documents,* for a selection of Byzantine texts, and H. Belting, *Likeness and Presence: A History of the Image Before the Era of Art,* trans. E. Jephcott (Chicago, 1994), for a survey of modern scholarship on the issue.

9. Two relatively recent general studies come readily to mind, although neither is concerned with Byzantium as such: E. Gombrich, *The Sense of Order: A Study of the Psychology of Decorative Art,* 2d ed. (Oxford, 1984), and O. Grabar, *The Mediation of Ornament,* Bollingen Series XXXV (Princeton, 1992), esp. 9–46. A historical approach to the matter is taken in *Le Rôle de l'ornement dans la peinture murale du Moyen Âge: Actes du Colloque international tenu à Saint-Lizier du 1er au 4 juin 1995,* ed. J. Ottaway (Poitiers, 1997), and see especially the remarks of J.-C. Bonne, 217–20. In addition, idem, "De l'ornemental dans l'art medieval (VIIe–XIIe siècle): Le modele insulaire," in *L'image: Fonctions et usages des images dans l'Occident medieval,* ed. J. Baschet and J.-C. Schmitt (Paris, 1996), 207–40. See also D. Levi, *Antioch Mosaic Pavements,* I (Princeton, 1947), 373–489.

10. A. Gonosová, "The Role of Ornament in Late Antique Interiors with Special Reference to Intermedia Borrowing of Patterns" (Ph.D. diss., Harvard University, 1981); eadem, "The Formation and Sources of Early Byzantine Floral Semis and Floral Diaper Patterns Reexamined," *DOP* 41 (1987), 227–37. See also R. Farioli Campanati, "Sull'origine tessile di alcuni temi del repertorio musivo pavimentale del Vicino Oriente in epoca protobizantina," in *Bisanzio e l'Occidente: Arte, archeologia, storia: Studi in onore di Fernanda de' Maffei,* ed. C. Barsanti (Rome, 1996), 161–67.

11. G. Miles, "Material for a Corpus of Architectural Ornament of Islamic Derivation in Byzantine Greece," *Yearbook of the American Philosophical Society* (1959), 486–90; idem, "Classification of Islamic Elements in Byzantine Architectural Ornament in Greece," *XII CEB,* III (Belgrade, 1964), 281–87.

12. See pages 119–41.

13. See catalogue, pages 260–78. See also the discussion by Ettinghausen, "Byzantine Tiles," 79–88.

14. See the discussion by Frantz, "Ornament," 43–76. This categorization holds for the tiles from other locations discussed in the present catalogue, with one exception. Some of the tiles from the Boukoleon now in the Istanbul Archaeological Museum bear the decoration of a vein pattern in imitation of marble; see cat. 1.B.5–1.B.9.

15. See the essay by J. Anderson in the present volume, page 96.

16. A. Riegl, *Stilfragen: Grundlegungen zu einer Geschichte der Ornamentik* (Berlin, 1893).

17. For the molding in Saint Sophia, see T. Whittemore, *The Mosaics of St. Sophia at Istanbul: Preliminary Report of the First Year's Work, 1931/32* (Paris, 1933), vol. 1, pl. II (upper). A useful compendium of ornamental motifs in Byzantine manuscript illumination is to be found in Frantz, "Ornament," 43–76, and for the vine scroll, see especially pl. XIII.

18. Levi, *Antioch Mosaic Pavements,* I, 373–489.

19. The Calendar of 354 has been described as an encyclopedia of late antique ornament, and many of the patterns employed there find analogue in the Byzantine tiles, namely, the guilloche, the "jeweled border," the vine scroll, and the scale pattern; see H. Stern, *Le Calendrier de 354: Étude sur son texte et sur ses illustrations* (Paris, 1953), 321–40, pls. IV–XV.

20. See R. W. Scheller, *A Survey of Medieval Model Books* (Haarlem, 1963), 45–68, 84–87.

21. Ettinghausen, "Byzantine Tiles," pl. XXXI, fig. 1; pl. XXXII, fig. 2. See also the fragments now in the Musée national de Céramique in Sèvres and the Benaki Museum in Athens, cat. C.18 and D.3.

22. But see the fragment of a bowl from Istanbul with a similar motif; Peschlow, "Byzantinische Keramik," pl. 141.2. What appears to be a variation on the motif also occurs on twelfth-century textile from Spain; see K. Otavsky and M. Abbas Muhammad Salim, *Mittelalterliche Textilien, I, Ägypten, Persien und Mesopotamien, Spanien und Nordafrika* (=*Die Textilsammlung der Abegg-Stiftung,* 1) (Riggisberg, 1995), no.94, 171–73, fig. on p. 172. The motif has also been compared to what has been interpreted as a tile on the cornice underneath the conch of the apse in the Koimesis church in Nicaea, visible in the extreme lower right of the photograph published in 1927 in Schmit, *Die Koimesis-Kirche,* pl. XX. But this motif, as opposed to the paired acanthus leaves, is clearly asymmetrical. For a discussion of this cornice, see pages 153–54.

23. E. Herzfeld, *Der Wandschmuck der Bauten von Samarra und seine Ornamentik,* vol. 1 of *Die Ausgrabungen von Samarra* (Berlin, 1923); F. Sarre, *Die Keramik von Samarra,* vol. II of *Die Ausgrabungen von Samarra* (Berlin, 1925); E. Herzfeld, *Die Malereien von Samarra,* vol. III of *Die Ausgrabungen von Samarra* (Berlin, 1927).

24. Herzfeld, *Wandschmuck,* fig. 112b, portion to left. See also a related motif from Bab al-Amma in Djausaq; idem, fig. 28.

25. See ibid., fig. 285, pls. LVIII (bottom), LXXI (middle), LXXVI (top), LXXVII (middle), XCL.

26. Herzfeld, *Malereien,* pls. XL, XLI, XLII, XLIII.

27. See pages 22–26. Mango and Hawkins, "Additional Notes," 310–11, with regard to related material.

28. Totev, *Ceramic Icon,* 46ff.

29. E. Herzfeld, *Geschichte der Stadt Samarra,* vol. VI of *Die Ausgrabungen von Samarra* (Berlin, 1948).

30. Herzfeld, *Wandschmuck,* 4–9, 183–229.

31. R. Ettinghausen, "The 'Bevelled Style' in the Post-Samarra Period," in

Archeologia orientalia in memoriam Ernst Herzfeld, ed. G. C. Miles (Locust Valley, N.Y., 1952), 72–83; M. S. Dimand, "Studies in Islamic Ornament 1: Some Aspects of Omaiyad and Early Abbasid Ornament," *Ars Islamica* 4 (1937), 293–337; T. Allen, "The Arabesque, the Bevelled Style, and the Mirage of an Early Islamic Art," in *Five Essays on Islamic Art* (Manchester, Mich., 1988), 1–15, and esp. 11–14, on the origins of the beveled style. The ornament of Sasanian stucco work is a suggestive precedent to the ornament of 'Abbāsid Sāmarrā, without, however, explaining the distinctive style of the latter; see J. Baltrusaitis, "Sassanian Stucco, A: Ornamental," in *A Survey of Persian Art from Prehistoric Times to the Present,* 1, ed. A. Upham Pope and P. Ackerman (New York, 1981), 601–30; J. Kroger, *Sasanidischer Stuckdekor: Ein Beitrag zum Reliefdekor aus Stuck in sasanidischer und frühislamischer Zeit nach der Ausgrabungen von 1928/9 und 1931/2* (Mainz, 1982). Another fruitful line of research lies in late antique painting. Specific motifs and uses of ornament in the wall painting of the monastery of Apa Jeremiah in Saqqara find resonance in the Samarran decorations; see *Miscellanea Coptica,* Acta ad archaeologian et artium historiam pertinentia IX, ed. H. Torp, J. Rasmus Brandt, and L. Holm Monssen (1981), in particular M. Rassart-Debergh, "La décoration picturale du monastère de Saqqara," 9–124, figs. 17 (allover pattern of socle) and 18 (leaf border), pls. XXIa–b and XXIIb; P. van Moorsel and M. Hiujbers, "Repertory of the Preserved Wallpaintings from the Monastery of Apa Jeremiah at Saqqara," 125–86, pls. XXVIb, XXVIc, and XXVIIIa; and M. Rassart-Debergh, "Quelques remarques iconographiques sur la peinture chrétienne à Saqqara," 207–20, and esp. 208–9, on geometric and floral motifs.
32. Sarre, *Keramik,* 50–54.
33. Ibid., figs. 125, 126.
34. Coche de la Ferté, "Décors," 194, and also his remarks on the lion, 203.
35. Georges Marçais, *Les faïences à reflets métalliques de la grande mosquée de Kairouan* (Paris, 1928).
36. Ibid., 7–13.
37. But see the remarks of Talbot Rice, *Glazed Pottery,* 10f.
38. On luster, see the remarks in ibid., 12 and n. 1; idem, "Polychrome Pottery," 69–77, and 76, for luster.
39. Talbot Rice, *Glazed Pottery,* 11.
40. Martin Harrison, *A Temple for Byzantium: The Discovery and Excavation of Anicia Juliana's Palace-Church in Istanbul* (London, 1989), 77ff. See also Grabar, "Le succès," 32ff.

41. Talbot Rice, *Glazed Pottery,* 14–16 and 96–97, although he places no emphasis on the role of Sāmarrā. Grabar, *Sculptures* 1, 118ff. See also the remarks of Miatev, *Keramik,* 133–40, on a relationship between Preslav and Sāmarrā, and, most recently, Totev, *Ceramic Icon,* 15ff., for a review of the literature on the Bulgarian material.
42. Theophanes Continuatus, *Vita Basilii,* 98f., trans. Mango, *Sources and Documents,* 160.
43. The ruins of a Byzantine building at Kuçukyalı have traditionally been interpreted as the substructure of the Bryas Palace, but this view has recently been challenged by A. Ricci, "The Road from Baghdad to Byzantium and the Case of the Bryas Palace in Istanbul," in *Byzantium in the Ninth Century: Dead or Alive? Papers from the Thirtieth Spring Symposium of Byzantine Studies, Birmingham, March 1996,* ed. L. Brubaker (Aldershot, 1998), 131–49 (with bibliography). See the discussion by Grabar, "Le succès," 56ff., and also the contribution of C. Mango in this volume, page 8.
44. J. Darrouzès, "Épistoliers byzantins du xe siècle," *Archives de l'orient chretien,* 6 (1960), 329, as cited in Kalavrezou-Maxeiner, "The Cup of San Marco," 173.
45. But see also the remarks of Talbot Rice, *Glazed Pottery,* 13, n. 2.
46. On the priority of Constantinople over Bulgaria, see ibid., 18.
47. Ibid., 15–17; Ettinghausen, "Byzantine Tiles," 86; Coche de la Ferté, "Décors," 187 and 215; Macridy, "The Monastery of Lips," fig. 58.
48. Totev, *Ceramic Icons,* 63ff.
49. See Talbot Rice, *Glazed Pottery,* 16.
50. S. Kostof, *Caves of God* (Cambridge, Mass., 1972), pl. 24. See also M. Restle, *Die byzantinische Wandmalerei in Kleinasian,* 3 vols. (Recklinghausen, 1967).
51. See pages 34, 230.
52. See note 22 above.
53. Schmit, *Die Koimesis-Kirche,* pls. XIII, XX.
54. O. Wulff, *Die Koimesiskirche in Nicäa und ihre Mosaiken* (Strassburg, 1903), fig. 3.
55. See D. Duda, "Zur Technik des Keramiksimses in der Grossen Moschee von Cordoba," in Stern, *Cordoue,* 53ff., and the essay by E. Ettinghausen in this volume.
56. See the discussion by E. Ettinghausen, pages 239–41.
57. Ettinghausen, pages 239–41, with important observations on finds of mosaics and tiles in Istanbul.

Tiles and Tribulations: A Community of Clay Across Byzantium and Its Adversaries

ANTHONY CUTLER

 One of the ironies of history, and a phenomenon familiar to anthropologists, is the way in which societies in conflict adopt signs and technologies that are at the time held to be characteristic of an antagonist's culture and only later interpreted as evidence of the power of images and craft expertise to travel beyond political boundaries and of the thrall exerted by these alien and supposedly dangerous tokens. In the practical realm, as in the case of spurs, the use of which, it is said, the Byzantines learned from the Avars, the reasons for borrowing are not hard to discern. But where an appropriation served less immediately useful purposes, as in the pervasive medieval Greek imitations of kufic script (or, more recently, the blue jeans sported by young Russians during the Cold War), the explanation is likely to be more complicated and usually better couched in terms of internal circumstances rather than external influence. Dependence on foreign sources may explain why a fashion is initially adopted or why a tendency already under way gains reinforcement; indeed, I shall argue below for the impact of such penetrations. But even demonstrable contacts do not in themselves account for the warmth of the response that they came to enjoy or account for the widespread diffusion of foreign forms in a host region. Occam's razor suggests why, in

principle, intrinsic, rather than extrinsic, factors provide better explanations for behavior of this sort.

Among such intrinsic factors must be counted a society's history, a past that may be deliberately shunned (as present-day Germany and South Africa reject aspects of their recent pasts) or, as in Byzantium, cultivated and purposefully revived. This habit of mind, in turn, has generated the scholarly search for "sources," as if the detection of precedents can in its own right illuminate their perpetuation. Since, at least in Byzantium, no precedents existed for the practice of decorating buildings with painted and fired clay plaques, it is a salutary exercise for the art historian to investigate this fashion of the ninth, tenth, and eleventh centuries. Quite properly, the chapters and catalogue in this book have been devoted to such questions as where, when, and how the tiles were made and the functions they served. The discussions of their ornament demonstrate that their makers drew on designs that had long circulated in the empire, and also exchanged patterns with neighboring cultures. To the extent that the presence of tiles involves the deliberate decision to use them, it is left to the author of this last chapter to ask *why* the practice took hold. To discover this, it will be necessary to go over some of the material again and to look at it from a slightly different angle.

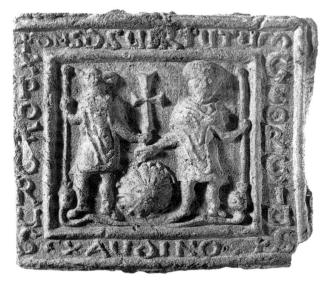

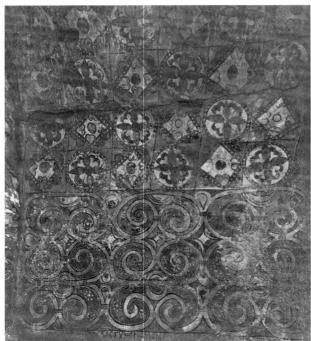

Fig. 1 (*left*) Viničko Kale. Terracotta plaque, Saints Christopher and George.

Fig. 2 (*above*) Naxos, Saint Artemios. Bema decoration.

Before undertaking this task, however, it is necessary, at least at the start, to emphasize the very novelty of the tiles studied in this volume. Strictly speaking, they had no precedents. Yet, this much said, one should remember that there is testimony from the Balkans for at least two aspects of architectural embellishment that have a bearing on our ceramic decorations. First, from a time well in advance of Byzantium's first encounter with the Arabs, there survives a body of plaques that display a variety of saintly and animal imagery prepared for insertion in masonry walls. These are best represented by the terracotta relief tiles found in 1985 at Viničko Kale, in the former Yugoslav Macedonia, some forty kilometers from the present Bulgarian border.[1] Currently assigned to the end of the sixth or seventh century, as the iconography and inscriptions of the Saints Christopher and George plaque (fig. 1) indicate, they clearly date to a period when their makers were already Christian but still not Greek-speaking. Since they are neither painted nor glazed, they cannot be considered forebears of our tiles, yet, as the archaeological evidence shows, they were embedded in a wall or walls. Although we cannot be sure that they were part of an apsed structure described as "un edifice sacré,"[2]

there is no reason to see in them anything other than votive icons.

Justifying the conceptual distinction between figurative and ornamental tiles in the present book, our second body of testimony belongs to this latter category. In this case, there is no doubt about the setting, for the decoration is still in place in the *bema* vault of the church of Saint Artemios on Naxos (fig. 2).[3] Again, this example cannot be directly fitted into the corpus of glazed tiles, for the simple reason that the surfaces in question are plaster painted with a gamut of motifs that hew more or less closely to the patterns that have been considered earlier in this volume. There can be no doubt that we have here the simulation of a tiled surface—the visible reflection, as it were, of an artifact that is no longer evident to us. In particular, I would point to the volutes over the *diakonikon,* which, enclosing sprouting buds and linked by interstitial lobes, recall a fragment of a tile once in the possession of David Talbot Rice but now lost (cat. xv.2). Even closer to one of our surviving specimens is the checkerboard with alternating floral motifs, most prominent among which are spindle-shaped leaves imposed on a succession of polylobed forms enclosed within circles.

The same design occurs on a tile in the Walters (cat. A.59; fig. 3) and is the essence of others from Preslav[4] as well as the base of a bowl excavated at Aksaray and now in the Istanbul Archaeological Museum.[5] We shall have further reason to insist on the resemblance between ceramic tiles and tableware. For now it is not so much this artisanal community that needs remarking as the fact that if painters on an island in the Cyclades saw fit to emulate a tiled vault, then adornment of this sort was probably regarded not as a cheap simulacrum of decoration in more expensive materials but as desirable in its own right. The same point is made by the use of tiles in connection with the mosaic in the vault in front of the *mihrab* at Córdoba,[6] a site where no economy measures needed to be undertaken (cat. xxi). Collectively, this evidence strengthens the argument of Sharon Gerstel for the association between ceramic decoration and the most sacred area of a holy building.[7] This was an *idée sans frontières* rather than a uniquely Orthodox phenomenon.

Recognition of the importance of Saint Artemios in this respect also carries with it chronological implications. If the church is correctly assigned to the first half of the ninth century, then it precedes or is at least contemporary with the tiles of the apsidal cornice in the Koimesis church at Nicaea (destroyed in 1922), seemingly evident in a photograph (cat. xviii), and those recently found in a room in the Boukoleon Palace (cat. i.B). These last objects are unassuming in their present state, even if one or two are gilded. They are, moreover, undated—one of the tribulations referred to in the title of this chapter—though quite possibly of the reign of Michael III or Basil I. All in all, they form a slender foundation for the notion of a body of work executed at roughly the same time as the lusterware of Sāmarrā and Kairouan.[8] Even when we began to find datable tiles (907: Lips monastery, north church), there would seem to be little reason to contest Elizabeth Ettinghausen's opinion concerning tiles from the Topkapı Sarayı Basilica and Saint John Stoudios, that the "technique and design [of] ninth-century tiles from the Islamic world would have hardly had any connection with the slightly later ones from Byzantium."[9]

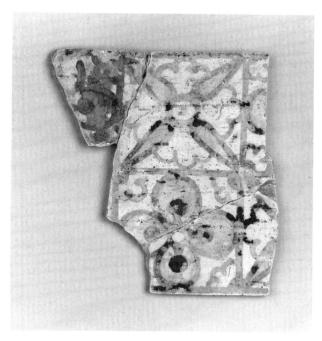

Fig. 3 Baltimore, Walters Art Museum. Tile fragments (cat. A.59).

Nonetheless, when these words were written, nearly fifty years ago, ʿAbbāsid products were vastly better known than those of Egypt, and the pioneering works of Richard Ettinghausen and Helen Philon were still unpublished. Despite the paradox that no Fāṭimid ceramic tiles survive, it is to Egypt, with which Constantinople had far closer commercial and diplomatic relations than with Baghdad,[10] that we must turn if we are to assess the impact of pots, and perhaps potters, moving across the Mediterranean in the tenth and eleventh centuries. These exchanges, as I understand them, are not so much indications of the "sources" of designs used on our tiles as evidence for a shared visual lexicon, widely apparent except where explicitly Christian subject matter was concerned. The absence of any archaeological context for most pieces in the Benaki Museum—the well-published collection on which I mainly draw—means that Philon's broad-spectrum chronologies (e.g., "10th to 12th centuries" for polychrome ware)[11] invalidate any search for "precedents," but because Fāṭimid craftsmen worked in both luster and non-

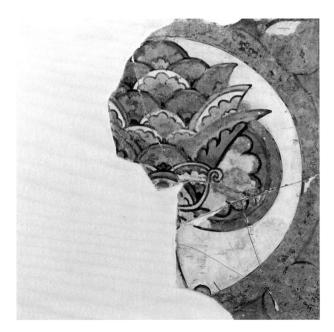

Fig. 4 Paris, Musée du Louvre. Tile fragment (cat. B.3).

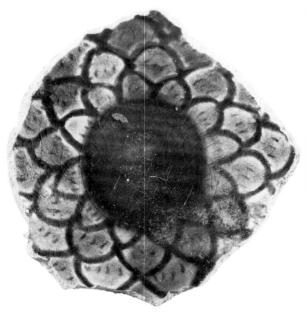

Fig. 6 Athens, Benaki Museum. Fragment of a bowl (inv. no. 476).

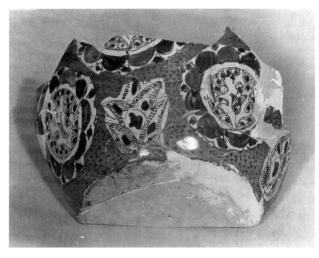

Fig. 5 Athens, Benaki Museum. Fragment of a jar (inv. no. 200).

luster, polychrome and monochrome techniques, and produced glazed relief as well as incised and carved wares, they left a repertoire broad enough for us to recognize a variety of direct Byzantine parallels. Before turning to a sample of these, one methodological principle needs to be emphasized: while the makers of our tiles did not use luster glazes,[12] the movement of designs did not necessarily go hand in glove with that of techniques. A competent painter could easily transfer a motif from one class of object to another, while a foreigner could bring his designs with him (in his head or in a sketchbook) and adapt them to local methods of manufacture.[13] Whenever a

design is complicated enough to minimize the likelihood of spontaneous, independent invention, some such connection can be hypothesized, no matter in which direction the "influence" is supposed to have traveled.

This would seem to be so in the case of the curious vegetable on one of the tiles split between the Louvre (fig. 4) and the Walters Art Museum (cat. A.43), an imbricated specimen that, were it not for its pointed leaves, might best be described as a cabbage. Why it should have decorated an iconostasis, as has recently been suggested,[14] escapes me. But its predominantly amber color, superimposed on a zone of reserved white, strengthens its formal relation to a device on a polychrome luster jar (fig. 5) that Philon assigns to a group made between the late ninth and late tenth centuries.[15] Imbrication was to become a favorite motif in late Fāṭimid art (eleventh–twelfth century), especially when, as on the interior of a vessel, incision or carving could exploit to the full the inherent plasticity of the scheme. Among a sizable number of bowls that take advantage of this potential is a fragment in Athens on which overlapping petals radiate from an undecorated

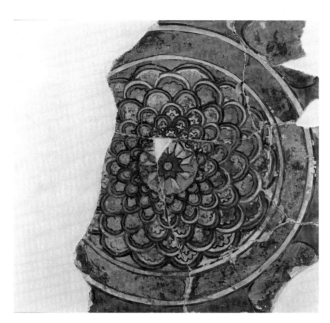

Fig. 7 Paris, Musée du Louvre. Tile (cat. B.4).

Fig. 8 Istanbul, Arkeoloji Müzeleri. Tile from Boukoleon (cat. 1.B.5).

node in which an olive-colored glaze has pooled (fig. 6).[16] The obvious Byzantine comparison is a plaque[17] said to come from the same iconostasis as the "cabbage" just discussed. Whether or not this was its original setting, the Louvre tile, reconstituted from six fragments, has not lost its bowl-like tenor (fig. 7), the ghostly echo of some three-dimensional model. To observe this resemblance is not to argue that the tile necessarily depended upon an Egyptian prototype. Rather, it serves to recall what, even by Islamicists, is sometimes forgotten: that unlike their 'Abbāsid forebears and contemporaries, Fāṭimid patrons "cast," as Philon puts it, "a covetous eye upon the Classical inheritance of the Mediterranean."[18]

This legacy is celebrated by Byzantinists whenever they use such terms as egg and dart, *cymation,* and so on, language that implies that the objects of their study consciously sought in the visual arts to evoke the glories of a Hellenic past known primarily through texts.[19] One may be permitted to doubt whether Greek artisans (and their Arab counterparts) who spent their days working with their hands had quite the same understanding of classicism as those who passed their time reading and writing. More likely, ornament that we see as Greco-Roman was just another pattern in their stock of decorative motifs. So, too, schemes that we read as derived from the veining of marble (cat. 1.B.5; fig. 8)—which might just as well be taken for a "degenerate" variety of *mashq* script as used in North Africa in the ninth and tenth centuries[20]—could have belonged to a painter's undifferentiated repertoire of designs. In short, the distinctions that we make among types of ornament were not necessarily made by those who employed them.

Still, we see what we see and cannot help but view objects in our own way rather than that of their creators. Thus, to an eye habituated to Arab forms of painting, the Louvre's frieze with animals separated by frames and identified in Greek (cat. B.5; fig. 9) inescapably recalls a manner of depicting fauna that is exhibited on the bases of a myriad of Fāṭimid ceramic vessels. The almost dancing stance of the hare in the middle of the tile finds its match in the playfully lifted paws and reversed head of a quadruped painted in gray manganese on the creamy field of a fragment in the Benaki (fig. 10),[21] while the eye of the spotted creature identified on the frieze as a lion is treated in exactly the same way on a sherd in the same museum, depicting a leopard resplendent in manganese and green against a white ground (fig. 11).[22] Whether the piece in the Louvre was the work of an Egyptian painter in the service of a Greek client or represents Byzantine familiarity with *tiraz* bands frequently adorned with sequences of framed animals,[23] the frieze appears to be connected with the Arab world, however indirectly, in terms of its content. It

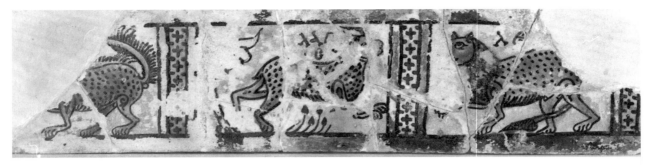

Fig. 9 Paris, Musée du Louvre. Tile, fragment of animal frieze (cat. B.5).

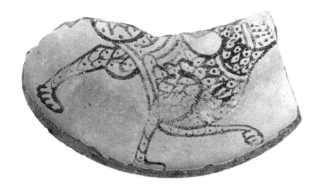

Fig. 10 Athens, Benaki Museum. Fragment of a bowl or plate with quadruped (inv. no. 464).

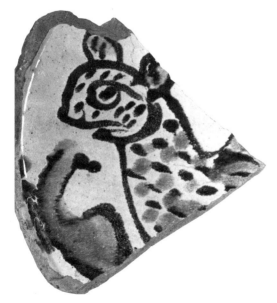

Fig. 11 Athens, Benaki Museum. Fragment of a bowl or plate with leopard (inv. no. 19778).

has not been noticed that the animals that retain their names are labeled in alphabetical order (ΛΑΓ[ο]C/ΛΕ[ων]). This could be a coincidence. It could also indicate dependence on an illustrated bestiary of a sort unknown in the Middle Byzantine world but attested from the eighth century onward in Islam.[24] In either case, the absence of the article before the names of the creatures suggests the handiwork of a non-Greek.

The presence or absence of such signs is obviously helpful if one wants to determine the ethnic or religious identity of an artist. Thus, beyond the argument advanced by both Totev[25] and Gerstel[26] that Orthodox painters produced the galleries of saints as constituent parts of ecclesiastical furniture, both the use of articles and such epigraphical flourishes as the terminal sigma of Nicholas's name[27] have considerable diagnostic value. The shape of the heads and the way in which facial features are rendered on these icons are utterly different from those drawn by Fāṭimid ceramic painters of the tenth and eleventh centuries;[28] any such participation can therefore be ruled out. Such criteria are obviously inapplicable to the largest and most impersonal category of tiles—those that are architectural either in the nature of their ornament or in the uses to which they are put.[29] Both classes show how far removed this sort of decoration is from the Greco-Roman models that are (or used to be) supposed to have preoccupied the Byzantine mind in the late ninth and tenth centuries, the period presumed for the convex embellishments preserved in Baltimore, Paris, and Sèvres (fig. 12). Tricked out with diapers, checkerboards, circles, and crosses, these represent the very antithesis of classicism as we understand it. There is reason, therefore, to suppose that, at least at the time when such schemes first reached Constantinople, they were of alien origin. Now, the latest dated monument to display this sort of design is the Great Mosque at Kairouan, where, however, rather

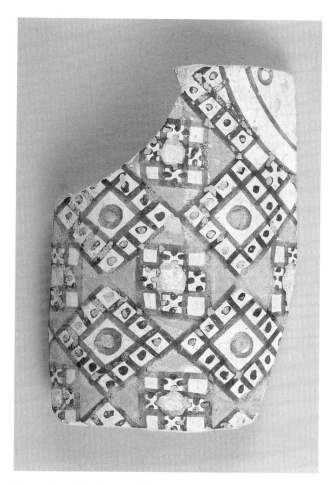

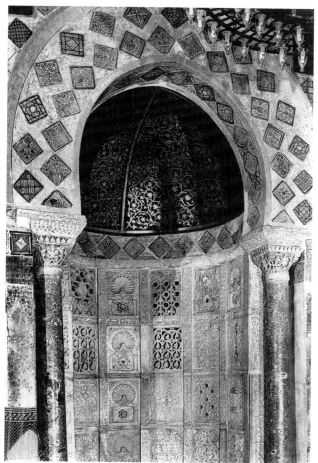

Fig. 12 Sèvres, Musée national de la Céramique. Colonnette revetment (cat. C.3).

Fig. 13 Kairouan, Great Mosque. *Mihrab.*

than being convex, lustered tiles are inserted flat against the *qibla* wall and the *mihrab* (fig. 13).

Despite this difference, the decoration at Kairouan, or rather an early-eleventh-century text that pertains to it, is of interest precisely because it speaks to the mobility of tiles, of a ceramist, and the transfer of his craft from the 'Abbāsid capital to the Great Mosque in Ifrīq'iyya.[30] A parallel and contemporary movement of matériel and artisans to Byzantium can well be imagined. On the other hand, speculation of this sort may be unnecessary. Motifs that could have been conveyed to Constantinople were certainly known to Fāṭimid painters and seem to have been employed already in the time of the Tulunid governors (A.D. 868–905, A.H. 254–92).[31] A variety of diaper patterns, some with inscribed circles or central pellets like the examples in Baltimore and the French collections, are to be found on sherds from Egypt (figs. 14, 15).[32] Despite the fact that they are lustered, these fragments, like the Byzantine pieces, display primarily amber, brown, and mustard tones.

Lest the reader who has reached this point think I believe that all the designs on the tiles, save the Christian figures, are due either to Islamic craftsmen or Islamic exemplars, there must be noted both the differences between some Greek and Arab specimens and the absence from the latter of forms that are widely diffused and therefore arguably characteristic of Byzantine paintings on glazed clay. Given that the physiology of the peacock is at once idiosyncratic and unmistakable and at the same time a favorite subject of Egyptian artists, it is worth remarking that not one of the nine versions on Fāṭimid pots in the Benaki Museum[33] bears any resemblance to either of the creatures with splendidly unfurled tails on the Walters tiles (cat. A29, A30). For this creature, then, we can assume the same independence from Islamic models as was asserted of the motif that depends upon the form of its feathers.[34] Many of the ornamental designs, too, would seem to be Byzantine "originals." To my knowledge there are no Arab counterparts for the egg and dart[35]

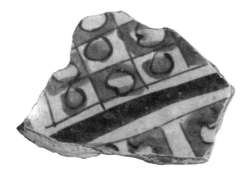

Fig. 14 Athens, Benaki Museum. Fragment of a bowl (inv. no. 19232).

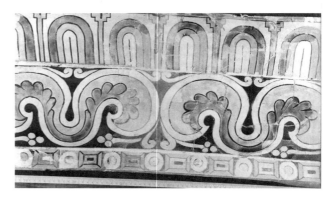

Fig. 16 Istanbul, Arkeoloji Müzeleri. Convex revetment from Saint John Stoudios (cat. x).

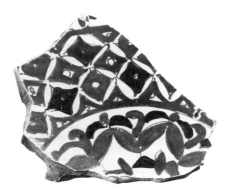

Fig. 15 Athens, Benaki Museum. Fragment of a bowl (inv. no. 21266).

or its rarer but more interesting "architectural" development in which the darts take on the form of a stepped capital, as on a fragment in the Istanbul Archaeological Museum (cat. I.B.2) and the border of a tile from the Stoudios (cat. x.1; fig. 16).[36] So, too, no analogy is apparent for the variant of the egg and dart in which the area around the "yolk" radiates toward the "shell" in a series of spiky projections.[37]

These evolutions, in sum, suggest that Arab cuttings, no matter how they traveled to Constantinopolitan workshops, sprouted forms unanticipated, or at least unparalleled, in their Islamic homelands. Even while I have stressed their foreign origins, the domestic nature of these developments requires emphasis in light of the fertility and variety of the growth that resulted from these transplants. As André Grabar argued long ago, there is no reason to suppose that these hybrids developed in artisanal isolation.[38] Rather, they appeared *pari passu* with similar manifestations in other media: the frieze of triangles set between bands of more familiar ornament on a tile from the Hippodrome excavations (fig. 17) finds more elaborate expression on the apse cornice of the Lips church.[39]

Discovery of the tiles in this and other monastic or ecclesiastical settings has led to the belief that revetment tiles were "used chiefly in churches."[40] This surmise, of course, founded in the experience of archaeologists, is a function of the sites chosen for their excavation and thus ultimately of accidents of survival. Yet, given that the findspots of the thousands of tiles and fragments in collections like the Walters are unrecorded, it would be rash to associate them automatically with a religious setting. True, the notion of the "holy tile" was deeply rooted in Byzantine thought of the tenth century, the era when the *keramidion,* the clay piece that had miraculously received the impress of Christ's face, the *mandylion,* another contact relic, arrived in Constantinople either from Emesa (Ḥims) or Hierapolis (Manbij) in Syria.[41] But the vast majority of the evidence suggests no reason why one should opt for an ecclesiastical, as against an aristocratic residential, context. Tiles that we recognize as iconic in function could have come from palace chapels[42] or been transferred to monasteries from their patron's private shrines.[43] Again, in those rare cases where we can make inferences from iconography, their apparently secular content would seem to argue for a domestic, rather than a religious, application. The animal frieze (fig. 9), for

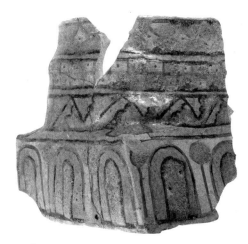

Fig. 17 Istanbul, Arkeoloji Müzeleri. Tile fragment from Zeuxippos Baths excavations (cat. XIII.11).

instance, could refer to the objects of the hunt,[44] then as now a beloved upper-class pursuit and a prime marker of social distinction.

The capacity of decoration to signal hierarchical differences has become a commonplace of modern sociological theory.[45] If analysis of this sort can be applied only with difficulty to such societies as medieval Byzantium, it is not simply because we lack the statistical basis necessary for comparison but also because too little is known about the origin of the few clients whose names can be associated with surviving artifacts; in most cases, we cannot link a specific object with any individual. The last tribulation is generally true of the tiles we have discussed. Yet in a few cases the circumstances in which they were found allows a summary description of the persons with whom these ceramics, as part of larger schemes, are associated. It is worth examining what we now know of the background of Constantine Lips, Romanos I Lekapenos, the founder of the Myrelaion, and Symeon of Bulgaria, identified as the builder of the Round Church in Preslav and the nearby Royal monastery. In the first two cases, the amount of information is—somewhat surprisingly and perhaps tellingly—little. Constantine, who by the middle of the century may have reached the important dignity of *megas hetaireiarches,*[46] the official in charge of security at the palace, belonged to a family unknown before he restored the Lips monastery in 907/8. Romanos Lekapenos, who is known to have held the same title a generation before Constantine, went on to a distinguished naval career before being crowned in 920, by which time he had acquired the Myrelaion. But he was the son of an Armenian peasant: Lekapenos *père* came to power only after he had allegedly saved the life of Basil I in battle.[47] Even Symeon, ruler of Bulgaria from 893, had, as the third son of a tsar, spent at least his first twenty years in Constantinople, studying to be a priest and remote from political contests at the court in Pliska. These patrons were, then, "new men."[48]

But it is not the psychology of the *arriviste,* setting out to make a splash with gaudily decorated churches, that best explains the nature of the art that they favored.

This sponsorship is better seen as social strategy in an age when the aristocracy was not a closed group defined by birth but an echelon "not cut off from below."[49] Vertical mobility allowed an ever-changing elite, the constitution of which was shaped by the purchase of dignities, by military or court service, and by acts of patronage that we see as expressions of taste but that were surely measured for their consonance with behavior "at the top." This is why the priority of the Boukoleon Palace, an imperial model for upper-class decoration, is so important to the history of tiles. Well-placed foreigners could hardly be immune to fashions evident all about them. Whether or not Symeon enjoyed access to the Great Palace in the early 890s,[50] ambassadors from Córdoba had such entrée in 947[51] and again in 949–50, some twenty years before the tiles were installed in the Umayyad Mosque. Although (at the end of the thirteenth century) Ibn 'Idhārī reports that a "skilled mosaicist as well as 320 quintals of mosaic cubes were offered as a gift by the king of the Rūmi,"[52] without specifically mentioning tiles, we should not assume an unmedieval division of labor or materials or, more broadly, disregard the fact that compliance with requests for both was a normal part of diplomatic protocol.[53] The participation of Greek potters or painters in the ceramic workshops of Patleina, Tuzlakâka, or Preslav is nowhere documented, but if they flourished across the extensive period generally assigned to their activity,[54] then it seems likely that domestic craftsmen worked with foreign masters—as Ibn 'Idhārī declares of Córdoba—and went on to incorporate in their own production what they had

learned. If this was the case, then at least later borrowings occurred when Bulgaria was in almost constant contention with Byzantium. Symeon marched on Constantinople in 913; after a brief cessation of hostilities, and until the end of his reign in 927, he remained a dangerous enemy and the object of tribute paid by the government of Romanos Lekapenos.

This sort of ambivalent relationship returns us to the point made at the start of the chapter: practical exchanges occur all the while the parties to such transactions engage each other in wars of words and deeds. That ideological antagonism precludes commercial and artistic relations is an anachronistic, totalizing invention of the twentieth century. The fact that Byzantium and Umayyad Andalusia were not overt foes constitutes the exception to this rule. It is of greater importance that the latter, to the slight extent that it entered the Greeks' field of view, was more likely seen as a counterweight to 'Abbāsid Baghdad.[55] But even this mightier and geographically more obvious adversary, like Fāṭimid Syria and Egypt in the tenth and eleventh centuries, continued to communicate culturally with Byzantium.[56] The tiles are small but telling signs of this community.[57]

Notes

1. *Trésors médievaux de la République de Macédoine*, exh. cat., Musée de Cluny (Paris, 1999), nos. 1–9; K. Balabanov and C. Krstevski, *Die Tonikonen von Viniča* (Munich, 1993).

2. Balabanov and Krstevski, *Tonikonen von Viniča*, 32. It is unclear to me how many objects of this sort were found. Although only nine were exhibited in Paris, the photograph of the findspot (p. 33) shows at least a dozen, while the catalogue entries for some objects (nos. 4, 5) speak of multiples: among others, eleven examples and five fragments of the archangel Michael, and nine examples and fourteen fragments of plaques with an inscribed cross. One of the Michaels and the Christopher and George in question have left traces in the mortar beds, which C. Krstevski interprets as evidence of the plaques' reuse. Their function is represented by the inscription on the piece reproduced here: +D[OMI]N(U)S D(EU)S VIRTUTUM EXAUDI NOS+ [CHRISTO]FORUS GEORGIUS.

3. A. Vasilake-Karakatsane in M. Chatzidakis, N. Drandakes, et al., *Naxos* (Athens, 1989), 58–65, figs. 9–14.

4. Talbot Rice, "Polychrome Pottery", pl. XXV.1.

5. Istanbul Archaeological Museum, inv. no. 75.408 ç.ç.

6. See the introduction by E. Ettinghausen to cat. XXI.

7. See the essay by S. Gerstel in this volume, pages 53–57.

8. See the essays by M. Mango and W. Tronzo in this volume, pages 22–26 and 150–54, respectively.

9. Ettinghausen, "Byzantine Tiles," 88, n. 3. One could expand this view to include other classes of ceramic. For example, given the endemic status of peacock-feather ornament in Constantinople (see the essay by J. Anderson in this volume, pages 119–22), there is no reason to connect its presence on 'Abbāsid pots—for example, on the ground of a stag plate in London (E. Grube, *Islamic Pottery of the Eighth to Fifteenth Centuries in the Keir Collection* [London, 1976], no. 24)—with its use on such ceramics from the Topkapı Sarayı Basilica (cat. XII.43) or the colonnettes from the chapel between Saint Sophia and Saint Eirene (cat. II.18). For the pattern's currency at Preslav, see Totev, "L'atelier," 69 and fig. 5.

10. This is expressed statistically, if somewhat baldly, in the number of embassies recorded in F. Dölger and P. Wirth, *Regesten der Kaiserurkunden des östromischen Reiches,* 3 vols. (Berlin, 1924–32; repr. Hildesheim, 1976). They list six missions to the Fāṭimids between 912 and 1081, as against two to Baghdad. Clearly, these records are incomplete, but when the number of treaties and other official communications, often mentioning gifts, is taken into account, the disparity is scarcely less marked (fifteen as against seven such documents). On cultural relations between Constantinople and Cairo in this period, see A. Cutler, "The Parallel Universes of Arab and Byzantine Art," in *L'Égypte fatimide, son art et son histoire*, ed. M. Barrucand (Paris, 1999), 635–48.

11. H. Philon, *Early Islamic Ceramics, Ninth to Late Twelfth Centuries* (London, 1980), 41. I thank Dr. Anna Ballian for providing me with photographs of the objects in the Benaki collection.

12. As W. Tronzo points out on page 149.

13. On the problem of foreign craftsmen at work in Greece, see A. Cutler, "A Christian Ewer with Islamic Imagery and the Question of Arab *Gastarbeiter* in Byzantium," in *Iconographica: Mélanges Piotr Skubiszewski* (Poitiers, 1999), 63–69.

14. *Byzance*, no. 296C (C. Vogt). The argument for its original context would seem to depend on the plaque's shape and size, similar to that of a Virgin and Child (cat. B.1). See Durand, "Plaques," 26 and fig. 3. But it is possible to conceive of several uses for both the Virgin and the "cabbage" plaques other than on a templon screen.

15. Philon, *Early Islamic Ceramics,* 77, pl. VII, A, and fig. 175.

16. Ibid., fig. 603.

17. *Byzance*, no. 296D.

18. Philon, *Early Islamic Ceramics,* 1.

19. See, for example, the essay by C. Mango in this volume, pages 6–7.

20. See the examples in Y. H. Safadi, *Islamic Calligraphy* (London, 1978), figs. 14, 15.

21. Philon, *Early Islamic Ceramics,* pl. IV, B, and fig. 118. For a similar hare on a wood panel in Cairo, see E. Pauty, *Les bois sculptés jusqu'à l'époque ayyoubide (Catalogue du Musée Arabe du Caire)* (Cairo, 1931), no. 6341/3, pl. XXXVI. An even more frolicsome, but much more schematic, hare on a fragmentary vessel in his possession, "said to have come from Constantinople," was published by Talbot Rice, *Glazed Pottery,* 114 and pl. XVC, as "probably XIVth century."

22. Philon, *Early Islamic Ceramics,* pl. IV, C, and fig. 120.

23. See, e.g., *Trésors fatimides du Caire,* exh. cat., ed. M. Barrucand (Paris, 1998), nos. 29, 191, 193.

24. See V. Meinecke-Berg, "Fatimid Painting: On Tradition and Style: The Workshop of Muslim," in *L'Égypte fatimide,* 333 n. 35, with rich bibliography.

25. *Preslavskata keramična ikona* (Sofia, 1988).

26. See pages 53–57.

27. See the essay by Gerstel in this volume, page 48.

28. Cf., e.g., Philon, *Early Islamic Ceramics,* figs. 473–76. Even more distinct from Islamic norms is the manner of rendering the body forms and their enveloping drapery. See, e.g., the now headless female saint on a tile in Moscow (cat. F.4). The fact that this piece was excavated in Cherson, as against the unproven provenance of the three other plaques in the same collection (on which, see M. Mango, page 18), has hardly been exploited in accounts of the diffusion of Byzantine tiles.

29. The important difference between the use of tiles as ornament (as at Kairouan) and their Byzantine integration into the architectural setting was grasped but not developed by Grabar, *Sculptures* I, 119.

30. K. A. C. Creswell, *Early Muslim Architecture,* II (Oxford, 1940), 314, translates the text by al-Tujibi (d. 1031), transmitted via a fifteenth-century author, as follows: "[The emīr Abū Ibrāhīm Ahmad (d. 863)] made the *mihrab.* They had imported for him these precious faïence tiles for a reception hall which he had wished to construct. . . . And he had the *mihrab* brought from 'Irāq in the form of panels of marble; he constructed this *mihrab* in the Great Mosque of Qairawan, and placed these faïence tiles on the façade of the *mihrab.* A man of Baghdad made some tiles which he added to the first. And [the emīr] gave to the *mihrab* this marvellous coating, employing marble, gold, and other fine materials."

31. For such patterns on Tulunid pots, see R. Schnyder, "Tulunidische Lüsterfayence," *Ars Orientalis* 5 (1963), 49–78.

32. Philon, *Early Islamic Ceramics,* figs. 247–48.

33. See ibid., s.v. "animals: peacocks."

34. See note 9 above.

35. Cat. B.6, C.2, VII.1. The scheme recurs on the lip of a cup at Preslav. See Totev, "L'atelier," fig. 3.

36. Ettinghausen, "Byzantine Tiles," 86 and pl. XXX.1, where this border is included in a group called "the 'orientalizing' classical type."

37. Grabar, *Sculptures* I, 119 and pl. LX, 4, now in Faenza and said to come from Constantinople (cat. G.1).

38. Grabar, *Sculptures* I, 121–22.

39. Ibid., pl. XLIV, 1, 2.

40. Hayes, *Saraçhane,* 35.

41. Depending on the tradition invoked, the acquisition of the holy tile is credited either to Nikephoros II in 966 or John Tzimiskes in 974. See N. Eliséeff in *Encyclopedia of Islam,* 2d ed., vol. 6, 379.

42. On the decoration of these, see Cutler, *Hand of the Master,* 237.

43. Cf. ibid., 235 (on the Cortona cross reliquary) and 282 n. 52.

44. A tenth-century version of the *Kynegetika* (Hunting manual) of the Pseudo-Oppian (Venice, Marc. gr. 479) contains a frieze of animals (including a lion but without a hare) with appropriate identifying labels. See Z. Kadar, *Survivals of Greek Zoological Illuminations in Byzantine Manuscripts* (Budapest, 1978), pl. 139,2.

45. See, e.g., P. Bourdieu, *Distinction: A Social Critique of the Judgement of Taste,* trans. R. Nice (Cambridge, Mass., 1984), esp. the section "Object Lessons," 76–80.

46. Mango and Hawkins, "Additional Notes," 299–301.

47. A. Kazhdan in *ODB* III, 1984; Striker, *Myrelaion,* 6–10.

48. To this group one might want to add Constantine IX, the builder of Saint George of the Mangana, whose family was little noted till after his accession. On his prodigal expenditures on this church, see the (biased) account of Psellos, *Chronographia,* ed. E. Renauld, II (Paris, 1928), 185–86.

49. A. Kazhdan and M. McCormick, "The Social Work of the Byzantine Court," in *Byzantine Court Culture from 829 to 1204,* ed. H. Maguire (Washington, D.C., 1997), 172, where they also cite the *Taktika* of Leo VI, compiled in the first decade of the tenth century: "We must evaluate the nobility of men taking into consideration their own actions and exploits, not their ancestors."

50. The *Vita Basilii* (in *Theophanes Continuatus,* ed. I. Bekker [Bonn, 1838], 392), written about 950, observes that those who are not allowed to enter the palace might, through this literary description of the Nea Ekklesia, envisage the wonders of Basil's church.

51. *De cerimoniis,* ed. J. J. Reiske, I (Bonn, 1829), 571.

52. See E. Ettinghausen, page 239. An earlier account, by al-Idrīsī (d. 1165), reports only the transfer of tesserae, not of craftsmen, to 'Abd al-Raḥmān III (d. 961). See Stern, *Cordoue,* 2.

53. A. Cutler, "Gifts and Gift-Exchange as Aspects of the Byzantine, Arab, and Related Economies," *DOP* (in press).

54. The ninth and tenth centuries, according to Totev, *Prelavskata keramična ikona* (as in note 25 above), 5.

55. There is no mention of the caliphate of Córdoba (although much on the earlier history of Spain) in the tenth-century *De administrando imperio.* An anonymous gloss in the *Commentary,* ed. R. J. H. Jenkins (London, 1962), 81 *ad* § 23–25 suggests that such a section "was never written or has been lost."

56. On 'Abbāsid connections, see A. A. Vasiliev, *Byzance et les Arabes* I (Brussels, 1935), and, above all, P. Lemerle, *Le premier humanisme byzantin* (Paris, 1971), 25–42, 150–54; for the Fāṭimid world, Cutler, "Parallel Universes."

57. I am grateful to Scott Schweigert for his invaluable assistance in the preparation of this chapter.

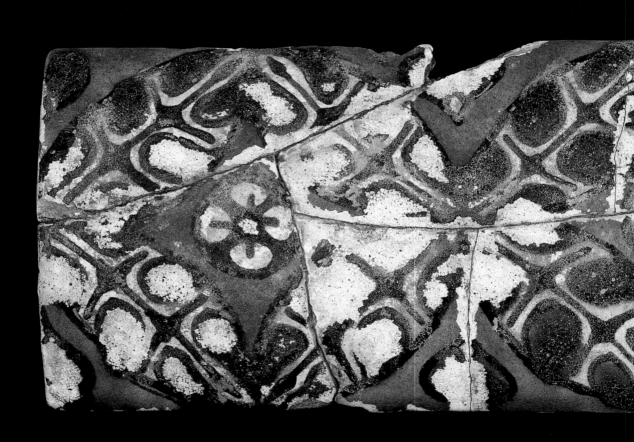

Catalogue of Tiles
from Sites in Constantinople
and in Collections

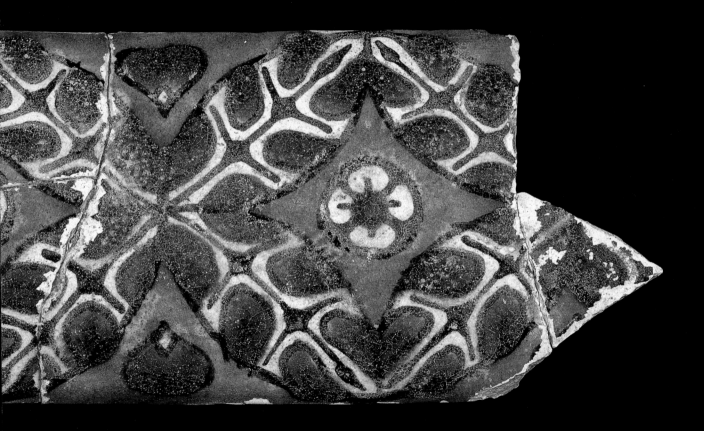

I
Great Palace

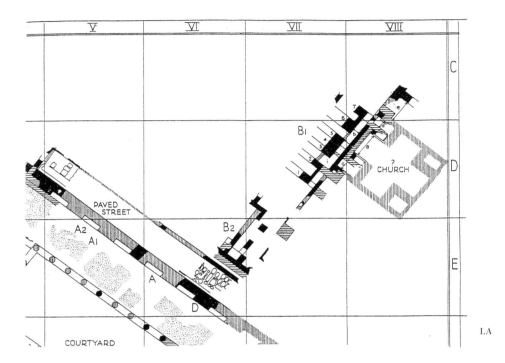

I.A

The Great, or Imperial, Palace of Constantinople, a complex of buildings situated between the Hippodrome and the Marmara, was Constantinian in origin.[1] The palace was added to and remodeled by various emperors until the twelfth century. In 976, it was reduced to a triangular area extending from the *kathisma* to the sea and came to be called the Boukoleon Palace. Alexios I Komnenos (r. 1081–1118) transferred the main imperial residence to the Blachernai, located in the northwestern corner of the city. More is known about the Great Palace from written sources, notably the *Book of Ceremonies*, than from archaeological work.

Excavations conducted in the Great Palace in 1935–38 and in 1952–54 concentrated on the central area, where a sixth-century peristyle court was uncovered. In 1983, part of the Boukoleon Palace came to light during construction work. Since then, the Boukoleon stairway has been partially excavated, and numerous parts of the Great Palace have been exposed in the course of private building operations. The last remain unpublished.

Polychrome tiles have been found in three separate locations within the palace, one in the central area and two in the Boukoleon.

I.A. Central area of the palace

In the central area of the palace, three tiles were found during the excavations of 1935–38 in what are described as tenth- and eleventh-century contexts, northeast of the peristyle court. The finds were made in "The North-West Building," Site B1, adjacent to what may have been a medieval cruciform church. One fragmentary tile (cat. I.A.1) was a stray find in Stage IV levels where ninth- and tenth-century coins were found,[2] while two other fragmentary tiles, which were not illustrated by the excavators, were found in a refuse pit dug into Stage IV levels at the northeast end of the excavated area, which also yielded a coin of Constantine X Doukas (r. 1059–67).[3]

I.B. Boukoleon Palace

In 1983, the remains of a small room (7 × 5 m) were accidentally unearthed across the railroad line behind the so-called "House of Justinian."[4] Assorted decorative material included polychrome tiles, many ornamented with a marbled pattern, a marble *opus sectile* pavement with a central raised area having inlaid stucco work, a marble champlevé carved figural pattern (M. Mango, fig. 3), arched stone

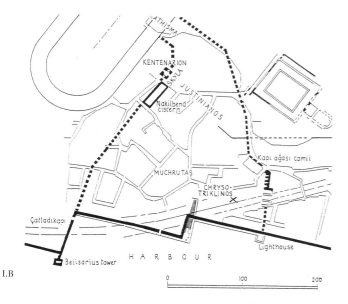

I.B

panels with glass inlay (M. Mango, fig. 7), and related work. It is suggested above, pages 22–24, that the room may date to the mid to later ninth century. In 1996, at the time of M. Tunay's excavations of the Boukoleon stairway adjacent to the House of Justinian, to the south, the present author noted a single fragmentary tile with gilding lying on the surface of earth filling the stairway. The stairway has been dated to the tenth century by C. Mango.

1 G. Brett, W. J. Macaulay, R. B. K. Stevenson, *The Great Palace of the Byzantine Emperors: Being a First Report on the Excavations Carried Out in Istanbul on Behalf of the Walter Trust (The University of St. Andrews), 1935–1938* (London, 1947); Müller-Wiener, *Bildlexikon,* 225–28, 229–37, figs. 257–61, 262a.
2 Ibid., 45–46, pl. 22.3.
3 Ibid., 47, 51.
4 Asgari, "İstanbul," 45–46, figs. 12–19; C. Mango, "The Palace of the Boukoleon," *CahArch* 45 (1997), 41–50.

MARLIA MUNDELL MANGO

I.A.1 Floral Motifs and Bands

Istanbul, Arkeoloji Müzeleri, inv. no. unknown
M.P.H. 7.8, M.P.W. 4.8 cm

FINDSPOT: Area northeast of the peristyle court.

CONDITION: Fragment of flat (?) tile; single preserved edge.

DESCRIPTION: Decorated with a banded white curvilinear frame enclosing a motif in amber and green on a black (?) background; a white tendril sprouts from the outer border of the frame.

COMPARISONS: Constantine Lips (cat. VI.18); Sèvres, Musée national de Céramique (cat. C.27).

LITERATURE: Stevenson, "Pottery," in Brett, Macaulay, Stevenson, *The Great Palace,* 45, pl. 22.3. J.D.

I.B.1 Tongue and Dart

Istanbul, Arkeoloji Müzeleri, 84.14 P.T.
H. 11.5, M.P.W. 19.0 cm

FINDSPOT: Room north of the House of Justinian.

CONDITION: Three concave nonjoining fragments of a cornice (?) reconstructed for display in the museum.

DESCRIPTION: The decoration consists of a tongue-and-dart variation. Forms are outlined and filled in deep brown, iron oxide slip. At the core of the best-preserved fragment is blue-green glaze. Although the form of this tile (two acutely concave fragments connected at their upper join to create a rectangular strip) is unique to this chamber, the tongue-and-dart motif appears in a number of buildings in Constantinople.

COMPARISONS: France, Thierry Collection (cat. H.2). J.D.

I.A.1

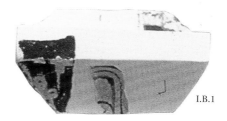

I.B.1

I.B.2 Tongue and Dart

Istanbul, Arkeoloji Müzeleri, 84.13 P.T.
H. 6.0, M.P.W. 20.5 cm
FINDSPOT: Room north of the House of Justinian.
CONDITION: Five fragments of a concave oblong tile; upper and lower edges preserved.
DESCRIPTION: The decoration consists of a tongue-and-dart variation. The concentric white tongues have a blue-green core and are set on a dark brown background. The white darts terminate in a stepped motif.
COMPARISONS: Sèvres, Musée national de Céramique (cat. C.11, C.12); France, Thierry Collection (cat. H.2). J.D.

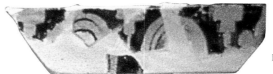

I.B.2

I.B.3 Tongue and Dart

Istanbul, Arkeoloji Müzeleri, inv. no. unknown
M.P.H. ca. 16.0, M.P.W. ca. 10.0 cm
FINDSPOT: Room north of the House of Justinian.
CONDITION: Two fragments of a slightly convex (?) tile; no preserved edges.
DESCRIPTION: The decoration consists of a tongue-and-dart variation. The white tongues have a blue-green core and are set on a dark brown background. J.D.

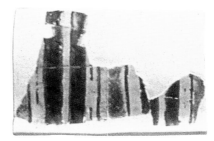

I.B.3

I.B.4 Tongue and Dart

Istanbul, Arkeoloji Müzeleri, inv. no. unknown
M.P.H. ca. 3.2 cm
FINDSPOT: Room north of the House of Justinian.
CONDITION: Two fragments of a concave oblong strip; lower edge is preserved.
DESCRIPTION: The decoration consists of a white tongue-and-dart motif against a dark brown background. The core of the tongue is blue-green and creates the impression of recessed shading. J.D.

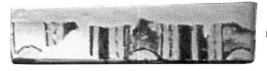

I.B.4

I.B.5 Marbling

Istanbul, Arkeoloji Müzeleri, 84.2 P.T.; inv. no. of second tile is unknown
H. 11.5, W. 33.5 cm (84.2 P.T.)
FINDSPOT: Room north of the House of Justinian.
CONDITION: Two raised oblong panels with sloping sides; one tile is completely reconstructed from numerous fragments; the other, from the end of a tile, is approximately one-quarter complete. Surface has chip losses, especially to the brown glaze.
DESCRIPTION: The central raised panel is decorated with marbling of dark amber and blue-green veins on a white-reserve background. The long, sloping sides are painted dark brown. The short sides are decorated with a white trefoil enclosing a dark brown core on a blue-green field. The shape of these tiles is unique to this site.
COMPARISONS: Although different in shape, a tile in the Thierry Collection belongs to the same group (cat. H.1).
LITERATURE: Asgari, "İstanbul," fig. 17. J.D.

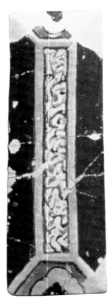

I.B.5

I.B.6

I.B.7

I.B.9

I.B.8

I.B.6 Marbling

Istanbul, Arkeoloji Müzeleri, 84.6, 84.7 P.T.; inv. nos. of two
additional tiles are unknown
H. 26.0, W. 7.5 cm (84.6 P.T.)
H. 13.5, W. 8.5 cm (84.7 P.T.)

FINDSPOT: Room north of the House of Justinian.

CONDITION: Four oblong convex tiles (colonnette shafts) of vary-
ing widths and heights; three are reconstructed from nonjoining frag-
ments.

DESCRIPTION: Decorated with marbling of amber and blue-green
veins on a white-reserve background.

COMPARISONS: Sèvres, Musée national de Céramique (cat. C.5).

LITERATURE: Asgari, "İstanbul," fig. 17. J.D.

I.B.7 Marbling

Istanbul, Arkeoloji Müzeleri, 84.10 P.T.
H. ca. 5.0, W. ca. 12.0 cm

FINDSPOT: Room north of the House of Justinian.

CONDITION: Complete semicircular ring molding from colon-
nette; upper and lower edges preserved.

DESCRIPTION: Decorated with marbling of amber and blue-green
veins on white-reserve background. The tile may have served as the
base or collar for a decorative colonnette. In diameter, appears to
match several of the convex tiles in cat. I.B.6. The shape of this tile is
unique to this site.

LITERATURE: Asgari, "İstanbul," fig. 17. J.D.

I.B.8 Marbling

Istanbul, Arkeoloji Müzeleri, inv. nos. unknown
a. M.P.H. ca. 6.4, M.P.W. ca. 9.2 cm
b. M.P.H. ca. 5.7, M.P.W. ca. 8.5 cm

FINDSPOT: Room north of the House of Justinian.

CONDITION: Two flat plaques; no preserved edges.

DESCRIPTION: Decorated with marbling of amber and blue-green
veins on white-reserve background. J.D.

I.B.9 Assembled Motifs

Istanbul, Arkeoloji Müzeleri, 84.12 P.T.
M.P.H. ca. 11.5, M.P.W. ca. 11.5 cm

FINDSPOT: Room north of the House of Justinian.

CONDITION: Flat square (?) plaque reconstructed from four non-
joining fragments for exhibition in the museum; three edges pre-
served.

DESCRIPTION: Decorated with a foliate (?) design in blue-green
and white reserve on a brown background. J.D.

II
Hospital of Sampson

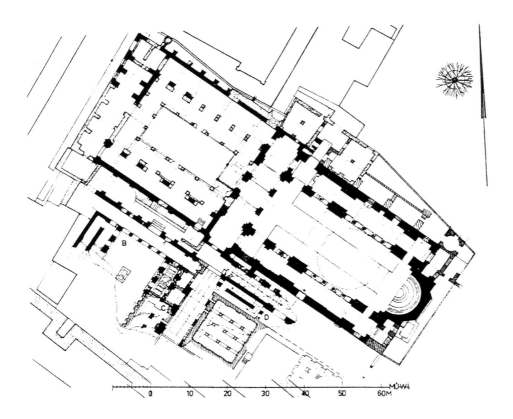

The Hospital (*Xenon*) of Sampson was a late antique foundation situated between the churches of Saint Sophia and Saint Eirene. Prokopios records its rebuilding by Justinian after the Nika Riot in 532. C. Mango suggests (see his essay in this volume, page 9) that it was refounded in the 970s by Leo, *droungarios* of the fleet.

The site identified as that of the hospital was first excavated by M. Ramazanoğlu in 1946/47 and only published after further exploration by F. Dirimtekin in 1956–60.[1] Later work by U. Peschlow in collaboration with G. and S. Sismanoğlu in 1973 provided a more focused reading of pottery found at the site (but excluding the tiles found there) and established more clearly the relationship between the excavated structures and Saint Eirene.[2] Although Müller-Wiener tentatively accepted the excavated complex as belonging to the hospital,[3] Peschlow considered its courtyard to be "the middle court (*mesiaulon*) of Saint Eirene mentioned by Theophanes as having been destroyed by fire in 564."[4] This does not preclude the possibility that the court gave access to, and was therefore part of, the hospital. The tiles were unearthed in a narrow chamber (9.5 × 3.5 m) having three niches on its east wall, remnants of figural wall painting,[5] and a pavement of marble slabs with an *opus sectile* border.[6] Dirimtekin referred to the room as a "martyrium," but water installations there and nearby may suggest another use. Many of the oblong and colonnette tiles may have framed the niches. The tiles have not previously been studied as a group.[7]

1 Dirimtekin, "Fouilles," 161–85; T. S. Miller, *The Birth of the Hospital in the Byzantine Empire* (Baltimore and London, 1985; repr. 1997).

2 U. Peschlow, *Die Irenenkirche in Istanbul* (*IstMitt* Beiheft 18) (Tübingen, 1977); Peschlow, "Byzantinische Keramik," 363–414.

3 Müller-Wiener, *Bildlexikon*, 112–14, figs. 19, 99.

4 Peschlow, *Irenenkirche*, 210–14.

5 Dirimtekin, "Fouilles," 176.

6 Ibid., 185.

7 One of the colonnettes was published in Megaw, "Byzantine Pottery," 103.

MARLIA MUNDELL MANGO

II.1

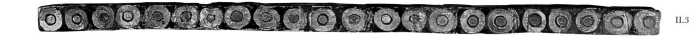
II.2

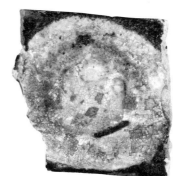
II.3

II.1 Tongue and Dart

Istanbul, Ayasofya Müzesi, 384.1
H. 3.6, M.P.W. 61.0, Th. 0.6 cm

CONDITION: Rectangular flat strip reconstructed from many fragments; upper and lower edges preserved.

DESCRIPTION: Tongue-and-dart variation; curved amber tongues are enclosed in white-reserve and amber rectilinear frames.

COMPARISONS: Hospital of Sampson (cat. II.7); Myrelaion (cat. VII.1). N.Y.E., S.P., J.D.

II.2 Tongue and Dart

Istanbul, Ayasofya Müzesi, 384.3
H. 7.0, M.P.W. 87.0, Th. 0.5 cm

CONDITION: Oblong convex tile; upper and lower edges preserved.

DESCRIPTION: Tongue-and-dart variation. Each tongue is composed of six concentric bands with black at the core, followed by amber, white reserve, blue, and white reserve. A blue band encloses a row of white-reserve half-circles, which create a scalloped effect. The narrow blue darts terminate in trefoils along the upper edge of the plaque, which is bordered by a thin band.

COMPARISONS: Istanbul, Provenance Unknown (cat. XV.9); Faenza, Museo Internazionale delle Ceramiche (cat. G.1); France, Thierry Collection (cat. H.7). N.Y.E., S.P., J.D.

II.3 Concentric Circles

Istanbul, Ayasofya Müzesi, 384.1
H. 2.7, M.P.W. 60.4, Th. 0.6 cm

CONDITION: Flat rectangular strip; upper and lower edges preserved.

DESCRIPTION: Decorated with a row of white circles enclosing blue disks on a dark brown ground.

COMPARISONS: Constantine Lips (cat. VI.3, VI.4); Istanbul, Provenance Unknown (cat. XV.9); Haydarpaşa (cat. XVI.1); Baltimore, Walters Art Museum (cat. A.54); Paris, Musée du Louvre (cat. B.12); Sèvres, Musée national de Céramique (cat. C.46).

N.Y.E., S.P., J.D.

II.4

II.4 Concentric Circles

Washington, D.C., Dumbarton Oaks Collection, 62.36.10
H. 2.5, M.P.W. 2.2, Th. 0.5 cm

CONDITION: Small fragment of a flat rectangular strip; upper and lower edges preserved. Buff-colored fabric with quartz and iron oxide inclusions. Iron oxide slip used for brown background. Clear glaze on surface runs over edges. Blue-green glaze at center of disk is opaque and crackled. Reverse side is smoothed.

DESCRIPTION: Decorated with a row of white circles enclosing blue disks on a dark brown ground.

COMPARISONS: Constantine Lips (cat. VI.3, VI.4); Istanbul, Provenance Unknown (cat. XV.9); Haydarpaşa (cat. XVI.1); Baltimore, Walters Art Museum (cat. A.54); Paris, Musée du Louvre (cat. B.12), Sèvres, Musée national de Céramique (cat. C.46). S.G.

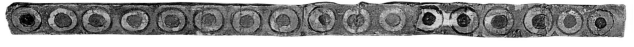
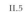

II.5

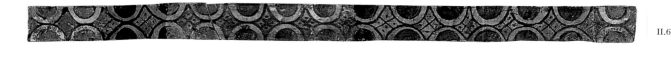

II.6

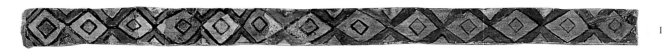

II.8

II.5 Concentric Circles

Istanbul, Ayasofya Müzesi, 384.1

H. 3.5, M.P.W. 61.3, Th. 0.6 cm

CONDITION: Flat rectangular strip; upper and lower edges preserved.

DESCRIPTION: Decorated with a row of white circles enclosing blue disks on a white-reserve ground. The circles are drawn in thick black lines. Small black triangles are painted along the edges between the circles.

COMPARISONS: Constantine Lips (cat. VI.3, VI.4); Baltimore, Walters Art Museum (cat. A.54); Paris, Musée du Louvre (cat. B.12); Sèvres, Musée national de Céramique (cat. C.46).

N.Y.E., S.P., J.D.

II.6 Lozenges

Istanbul, Ayasofya Müzesi, 384.1

H. 3.0, M.P.W. 60.6, Th. 0.6 cm

CONDITION: Flat rectangular strip; upper and lower edges preserved.

DESCRIPTION: Decoration of half-circles and lozenges runs the length of the tile. Each half-circle is formed by a dark blue disk banded in white reserve. Lozenges, originally glazed blue, fill the center of the strip between the circles. Each is divided by black diagonal lines into four compartments with a dot in the center.

COMPARISONS: Sèvres, Musée national de Céramique (cat. C.45).

N.Y.E., S.P., J.D.

II.7 Guilloche and Tongue and Dart

Istanbul, Ayasofya Müzesi, 384.10

H. 6.0, W. 4.0, Th. 0.4 cm

CONDITION: Cornice (?) fragment formed by convex tile and adjoining flat tiles.

DESCRIPTION: The design consists of three parts. The upper and lower parts are a square tongue-and-dart variation having concentric tongues of black, blue-green, black, and deep amber. The central tile is decorated with a white-banded guilloche enclosing green disks.

COMPARISONS: For tongue and dart, see Hospital of Sampson (cat. II.1); Myrelaion (cat. VII.1).

N.Y.E., S.P., J.D.

II.8 Lozenges

Istanbul, Ayasofya Müzesi, 384.1

H. 3.6, M.P.W. 61.0, Th. 0.6 cm

CONDITION: Fragment of an oblong flat strip; upper and lower edges preserved.

DESCRIPTION: Decorated with a row of amber and white-reserve concentric lozenges with blue glaze at the core. The spaces between the lozenges at the edges of the tile are filled with white-reserve triangles.

COMPARISONS: Constantine Lips (cat. VI.11); Sèvres, Musée national de Céramique (cat. C.13, C.14).

N.Y.E., S.P., J.D.

II.9 Lozenges

Istanbul, Ayasofya Müzesi, 384.1

H. 3.5, M.P.W. 61.0, Th. 0.6 cm

CONDITION: Fragment of a flat rectangular strip; upper and lower edges preserved.

DESCRIPTION: Decorated with a row of linked lozenges on a blue background. Each lozenge is divided by black diagonal lines into four smaller compartments, each with a green diamond at the center. At the upper and lower edges of the strip are repeating amber trilobed florets.

N.Y.E., S.P., J.D.

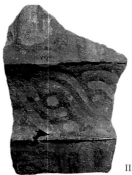

II.7

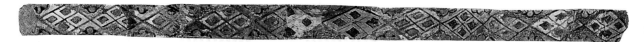

II.10 Lozenges

Washington, D.C., Dumbarton Oaks Collection, 62.36.9
H. 3.5, W. 4.9, Th. 0.6 cm

CONDITION: Single fragment of flat rectangular tile; upper and lower edges preserved. White fabric with iron oxide inclusions. Smoothed reverse. Glaze colors include copper green, amber, and clear over white fabric. Copper green glaze is opaque due to weathering crust. Glaze runs over edges.

DESCRIPTION: Decorated with a row of linked lozenges. Each lozenge is divided by black diagonal lines into four smaller compartments, each with a green diamond at the center. At the upper and lower edges of the plaque are repeating amber trilobed florets. S.G.

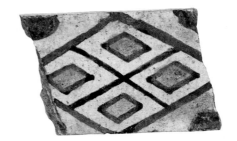

II.10

II.11 Step

Istanbul, Ayasofya Müzesi, 348.8
H. 4.0, M.P.W. 16.0, Th. 0.5 cm

CONDITION: Flat rectangular plaque reconstructed from five fragments.

DESCRIPTION: Decorated with a white zigzag line forming two rows of interpenetrating triangles. Each triangle encloses a pair of amber squares containing a smaller white square outlined in black. Along the edge of the squares are white stepped designs enclosing circular disks. The glaze within the disks has a weathering crust, and it is impossible to determine its original color. The background and outlines are black. A similar pattern of triangles and steps is found on architectural sculpture from the church of Saint Polyeuktos (Harrison, *Saraçhane*, figs. 143–58). N.Y.E., S.P., J.D.

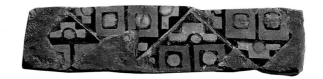

II.11

II.12 Circle with Four-Petaled Flower

Istanbul, Ayasofya Müzesi, 348.2
H. 12.0, Th. 0.5 cm

CONDITION: Two fragments of a convex oblong tile; upper and lower edges preserved.

DESCRIPTION: Decorated with a row of circular frames composed of double lines enclosing ten to twelve amber disks banded in white. Within each frame is a four-petaled flower set on a blue-green background. The center and petals of each flower are green, banded in amber and white. Amber and white stepped motifs on an amber background are placed at the upper and lower edges of the plaque, between the circular frames. N.Y.E., S.P., J.D.

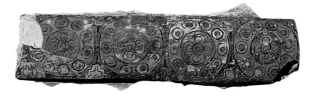

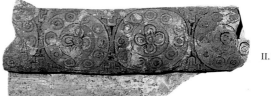

II.12

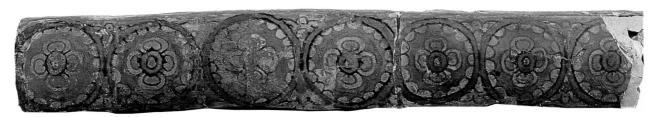

II.13

II.13 Circle with Four-Petaled Flower

Washington, D.C., Dumbarton Oaks Collection, 62.36.5
M.P.H. 4.5, Th. 0.6 cm

CONDITION: Two joining fragments of the corner of an oblong
convex tile. Edges are smoothed and squared. White fabric with iron
oxide inclusions. The fabric is depressed (Th. 0.2 cm) at the center of
the flower but painted and glazed, indicating damage before the final
firing. Glaze colors include amber, copper green, and clear. Green
glaze is opaque due to weathering crust. Glaze runs over edges.

DESCRIPTION: Repeating circular frames divided by a stepped
motif along upper (and lower?) surfaces. Frame is white reserve with
green glazed circles outlined in black. At center of frame is a four-
petaled flower with an amber disk at its center and green petals
banded in white. The flower is set on a blue-green background. Each
frame is placed on an amber background. The stepped patterns are
green, with an amber disk centered along the edge of the tile. S.G.

II.14 Circle with Four-Petaled Flower

Istanbul, Ayasofya Müzesi, 348.5
H. 9.5, W. 38.0, Th. 0.5 cm
H. 9.5, W. 56.0, Th. 0.5 cm

CONDITION: Two oblong convex tiles; three edges preserved.

DESCRIPTION: Decorated with amber roundels, each enclosing a
four-petaled flower with a green disk at the center of an amber bor-
der. The disk is surrounded by copper green petals banded in white
and set against a blue background. Along the inner border of the
roundel is a row of white linked half-circles creating a scalloped
effect. The roundels are connected by white trilobed motifs, which
enclose a teardrop-shaped field filled with green glaze.

COMPARISONS: Istanbul, Provenance Unknown (cat. XV.3);
Sèvres, Musée national de Céramique (cat. C.6).

N.Y.E., S.P., S.G.

II.15 Circle with Four-Petaled Flower

Washington, D.C., Dumbarton Oaks Collection, 62.36.1, 62.36.2,
62.36.3, 62.36.4
M.P.H. 6.8, W. 7.8, Th. 0.5 cm (62.36.1)
H. 8.5, W. 8.7, Th. 0.6 cm (62.36.2)
H. 8.5, W. 10.2, Th. 0.6 cm (62.36.3)
H. 8.5, W. 8.3, Th. 0.6 cm (62.36.4)

CONDITION: Four fragments of oblong convex tiles. White fabric
with iron oxide inclusions. The edges are squared and taper in thick-
ness. Glaze colors include cobalt blue (?), copper green, amber, and
clear. Copper green glaze is opaque due to a weathering crust.

DESCRIPTION: Decorated with amber roundels, each enclosing a
four-petaled flower with a green disk at the center of an amber bor-
der. The central disk is surrounded by copper green petals on a blue
background. Along the inner border of the roundel is a row of white
linked half-circles creating a scalloped effect. The roundels are con-
nected by a white trilobed motif that encloses a teardrop-shaped field
filled with green glaze.

COMPARISONS: Istanbul, Provenance Unknown (cat. XV.3);
Sèvres, Musée national de Céramique (cat. C.6).

EXHIBITION: Washington, D.C., 1995. S.G.

II.15

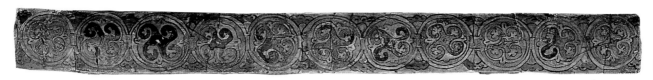

II.16 Circle with Scrolling Tendrils

Istanbul, Ayasofya Müzesi, 384.4

H. 10.0, W. 97.0, Th. 0.5 cm

CONDITION: Oblong convex tile; upper and lower edges preserved.

DESCRIPTION: Decorated with a row of white linked circles set against a green ground. The circles enclose four scrolling white tendrils set against a green background and enclosing a blue field. The spandrels between the circles are decorated with an amber lobed motif.

COMPARISONS: Kyriotissa (cat. v.7); Istanbul, Provenance Unknown (cat. xv.9); Sèvres, Musée national de Céramique (cat. C.7). N.Y.E., S.P., J.D.

II.17 Circle with Scrolling Tendrils

Washington, D.C., Dumbarton Oaks Collection, 62.36.6

M.P.H. 5.3, W. 6.8, Th. 0.6 cm

CONDITION: Fragment of an oblong convex tile; single straight edge preserved. Smooth white fabric with iron oxide inclusions. Traces of air pockets on upper and lower surfaces. Edges are squared. Traces of fingerprint impressed on reverse before firing. Glaze colors include cobalt blue, copper green, amber, and clear. Some surface chipping. Copper green is extremely worn. Thick weathering crust over blue glaze at center of floral motif.

DESCRIPTION: Decorated with a row of white linked circles set against a green ground. The circles enclose four scrolling white tendrils set against a green background and enclosing a blue field. The spandrels between the circles are decorated with an amber lobed motif.

COMPARISONS: Kyriotissa (cat. v.7); Istanbul, Provenance Unknown (cat. xv.9); Sèvres, Musée national de Céramique (cat. C.7). S.G.

II.18 Peacock Feathers and Ornamental Capital

Istanbul, Ayasofya Müzesi, 384.6, 384.7, 384.9

H. 42.0, W. 14.0 cm (384.6)

H. 31.5, W. 14.0 cm (384.7)

M.P.H. 7.0, W. 6.5 cm (384.9)

CONDITION: Two colonnettes with capitals pieced together with joining fragments; bases missing. Single fragment from same pattern. Glaze colors include cobalt blue and amber. Colonnettes are in excellent condition.

DESCRIPTION: The shaft is decorated with peacock feathers. Each blue feather, banded in white, encloses an amber diamond-shaped eye on a black stalk. The shaft is separated from the capital by a black tongue-and-dart band. The capital, framed by amber bands, is decorated with a black vine scroll with tendrils terminating in trefoils. The abacus is covered with a thick wavy line in black and is framed by amber bands.

COMPARISONS: Kyriotissa (cat. v.8). For peacock feathers with round eyes, see Istanbul Law Court (cat. iv.1); Baltimore, Walters Art Museum (cat. A.50); Paris, Musée du Louvre (cat. B.15); Sèvres, Musée national de Céramique (cat. C.28).

LITERATURE: Dirimtekin, "Fouilles," fig. 24; Megaw, "Byzantine Pottery," no. 306 (384.7).

EXHIBITION: Athens 1964, no. 612 (384.7). N.Y.E., S.P., J.D.

II.17

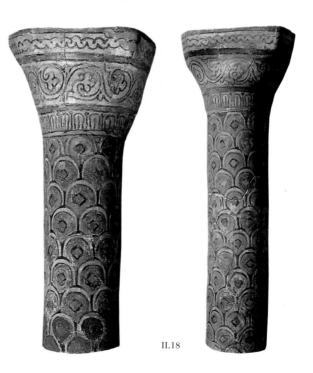

II.18

II.19 II.20

II.19 Peacock Feather

Washington, D.C., Dumbarton Oaks Collection, 62.36.7, 62.36.8
H. 6.8, W. 4.5, Th. 0.8 cm (62.36.7)
H. 5.5, W. 4.2, Th. 0.8 cm (62.36.8)

CONDITION: Small fragments from a colonnette. White fabric with iron oxide inclusions. Smoothed reverse with traces of air pockets. Edges are beveled. Glaze colors include cobalt blue, copper green, and amber. Glaze runs over edges (62.36.7).

DESCRIPTION: Decorated with peacock feathers. Alternating copper green and blue feathers banded in white reserve with amber diamonds (eyes) at center on black barb.

COMPARISONS: Hospital of Sampson (cat. II.18).

EXHIBITION: Washington, D.C., 1995. S.G.

II.20 Foliate Motif

Washington, D.C., Dumbarton Oaks Collection, 62.36.11
M.P.H. 5.0, W. 5.4, Th. 0.7 cm

CONDITION: Single fragment of a convex tile. Single straight edge preserved. White fabric with iron oxide inclusions and air pockets. Edges are squared, with smoothed finish along upper surface. Glaze colors include copper green, amber, and clear. All of the glazes are worn and are opaque due to a weathering crust.

DESCRIPTION: White-reserve foliate pattern enclosed by a white rectilinear frame on a green ground. Amber curvilinear form along broken edge.

COMPARISONS: Paris, Musée du Louvre (cat. B.11); Sèvres, Musée national de Céramique (cat. C.20). S.G.

III

Istanbul Archaeological Museum

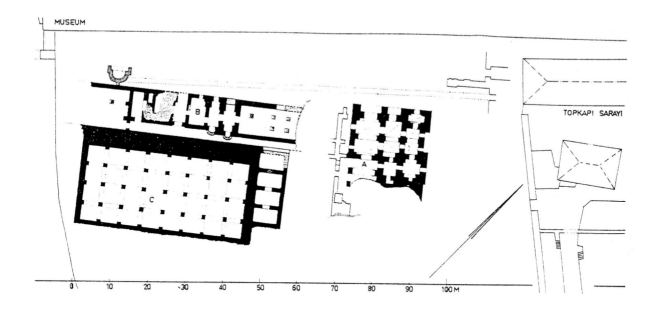

Excavations made in 1973 in the course of laying founda-tions for an annex, situated on the eastern side of the archaeological museum, exposed parts of the street that extended along the façades of Saint Sophia and Saint Eirene to the south, a late antique bath building with a cis-tern, and, to the north, the cross-vaulted substructures of an unidentified building.[1] Finds ranging in date from the fifth to the fourteenth century included a single stray tile.

1 N. Fıratlı, "Recent Archaeological Research in Turkey," *Anatolian Studies* 24 (1974), 35; Müller-Wiener, *Bildlexikon,* 48, figs. 18, 27; F. Yegül, *Baths and Bathing in Classical Antiquity* (Cambridge, Mass., 1995), 324 and n. 79, fig. 412.

MARLIA MUNDELL MANGO

III.1 Scrolling Tendrils

Istanbul, Arkeoloji Müzeleri, 89.4 P.T.
Dimensions Unknown
 CONDITION: Fragment of a convex tile; single preserved edge.
 DESCRIPTION: Decorated with a white scroll pattern on a black background. M.P.

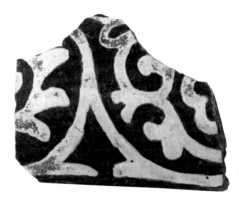

III.1

IV
Istanbul Law Court

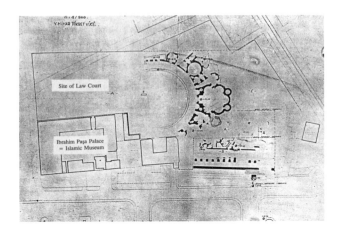

Excavations were undertaken in 1950 prior to the construction of new Law Courts behind the Ibrahim Paşa Palace, which faces the Hippodrome and today houses the Islamic Museum. The area archaeologically explored encompassed that already excavated by the German Archaeological Institute in 1942 (at the Palace of Antiochos and Saint Euphemia). Duyuran's published report of the work carried out in 1950–52 refers to Naumann's continuing activity in this area (see cat. VIII), as well as to a site to the east where part of the Hippodrome was uncovered, consisting of eight tiers of benches and part of a small bath.

The site is classified separately from that of Saint Euphemia because the two Turkish reports cited here give no indication regarding which site produced the two Byzantine wall tiles mentioned below. The ceramic finds from the "Law Court or Palace of Justice Excavations" remain unpublished aside from a brief notice by Ö. Koyunoğlu.[1] According to the excavator, R. Duyuran, "a large portion of the area [excavated] was filled up with rubble brought from other places, so that the strata and consequently Byzantine and Turkish potsherds were closely intermingled."[2] The foundations of the new Palace of Justice on the northwest side of Sultan Ahmet square were begun on 1 June 1950. Among the sherds were two fragments of polychrome tiles, one of which was illustrated.[3] Forty-six copper coins dating from the ninth to the eleventh century were found during the excavations.

1 Ö. Koyunoğlu, "Byzantine Pottery from the Palace of Justice Excavations at Istanbul," *IAMY* 5 (1952), 40–41.
2 R. Duyuran, "First Report on Excavations on the Site of the New Palace of Justice at Istanbul," *IAMY* 5 (1952), 38.
3 Koyunoğlu, "Byzantine Pottery," 41, fig. 19.

MARLIA MUNDELL MANGO

IV.1 Peacock Feather

Istanbul, Arkeoloji Müzeleri, inv. no. unknown
Dimensions Unknown
 CONDITION: Fragment of a convex tile from a colonnette shaft.
 DESCRIPTION: Decorated with banded peacock feathers. Each feather encloses a circular eye on a black barb.
 COMPARISONS: Baltimore, Walters Art Museum (cat. A.50); Paris, Musée du Louvre (cat. B.15); Sèvres, Musée national de Céramique (cat. C.28).
 LITERATURE: Koyunoğlu, "Palace of Justice," 41, fig. 19. J.D.

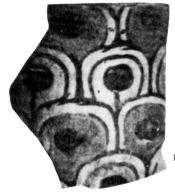

IV.1

V

Kyriotissa Church (Kalenderhane Camii)

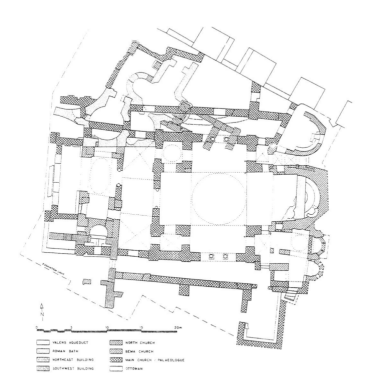

Between 1966 and 1978, Cecil L. Striker, from the University of Pennsylvania, and Y. Doğan Kuban, from the Istanbul Technical University, conducted the archaeological study of the Kalenderhane Camii.[1] The standing structure, remodeled several times, was once the *katholikon* of a monastery dedicated to the Virgin Mother of God *ta Kyriou*. This identification was confirmed with the discovery of the two frescoes of the Mother of God inscribed Kyriotissa. Careful investigation revealed at least four construction stages. The earliest building is a private Roman bath dated to ca. 400. The first church on the site, the so-called North Church, was constructed in the third quarter of the sixth century. It was demolished no later than the tenth or eleventh century, and only its apse was left standing. The Bema Church is the second church built on the site; it was damaged by fire in 1197. It is here that the earlier image of the Virgin Kyriotissa was found. After 1197, the apse of the North Church and the surviving parts of the Bema Church were incorporated into a new church, the so-called Main Church. Its dedication in the

Palaeologan period is secured by the presence of a second image of the Kyriotissa over the door to the esonarthex. During the Latin occupation of Constantinople, the Crusaders decorated an existing chapel with a fresco cycle depicting scenes from the life of Saint Francis of Assisi.

All of the tiles discovered in the Kalenderhane excavations came from contexts that were sealed by the construction of the Main Church between the fire of 1197 and the Latin conquest of 1204. In all likelihood, the tiles derive from another site and were used in the Kalenderhane as fill for the new construction. Although the archaeological contexts within the church provide a *terminus ante quem* for the fragments, they cannot further refine our dating of polychrome tiles in the area.

Letter codes included with the findspot of each tile refer to context codes used by the excavation in publications of the site.

1 Striker and Kuban, *Kalenderhane;* preliminary reports on the site were published in the following volumes of *Dumbarton Oaks Papers:* 21 (1966), 267–71; 22 (1967), 185–93; 25 (1971), 251–58; 29 (1975), 307–18.

ROSSITZA B. ROUSSANOVA

V.1 Jeweled Band

Location Unknown
H. 4.0, M.P.W. 7.6, Th. 0.4–0.5 cm
FINDSPOT: Naos, north arm, context AST.
CONDITION: Three joined fragments of a flat strip; upper and lower edges preserved.
DESCRIPTION: Decorated with a jeweled band consisting of pearls (buff-colored circles enclosing aubergine-brown disks) and gems (buff-colored rectangles enclosing smaller black rectangles or squares in an amber rectangular frame). Four pearls and part of a gem are preserved.
COMPARISONS: Constantine Lips (cat. VI.6); Topkapı Sarayı Basilica (XII.3); Sèvres, Musée national de Céramique (cat. C.29).

M.P.

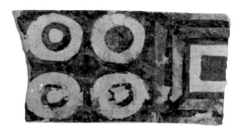

V.1

V.2 Acanthus Half-Circles

Location Unknown
H. 6.5, M.P.W. 6.1, Th. 0.5 cm
FINDSPOT: Esonarthex, north side, context BAE.
CONDITION: End fragment of a convex tile; upper and lower edges preserved.
DESCRIPTION: Amber arches enclose an imbricated pattern of three blue-green peacock feathers on a white-reserve background. The feathers are decorated with hatching. The keystone of the arches is formed by at least three vertical bands; three leaves form the arches. The spandrels between the arches are filled with amber diamond-shaped palmettes. A copper green checkerboard motif fills the triangular space created at the springing of the arch. A narrow band, once glazed green, runs along the upper edge of the tile.
COMPARISONS: Topkapı Sarayı Basilica (XII.6); Istanbul, Provenance Unknown (cat. XV.9); Nicaea, Koimesis church (cat. XVIII); Sèvres, Musée national de Céramique (cat. C.8).

M.P.

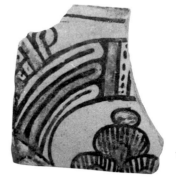

V.2

V.3 Cross

Location Unknown
Dimensions Unknown
FINDSPOT: Unknown.
CONDITION: Fragment of a flat tile; no edges preserved.
DESCRIPTION: Decorated with a banded, stepped motif enclosing a half-circle.

M.P.

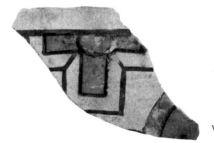

V.3

V.4 Shell Variation

Location Unknown
M.P.W. 6.4, Th. 0.35–0.5 cm
FINDSPOT: Unknown.
CONDITION: Two nonjoining fragments of convex tile; upper edge preserved.
DESCRIPTION: A narrow green band marks the upper edge of the tile. The decoration is formed by repeated black medallions, in imitation of drillwork. The medallion is encircled by an amber band that extends from the base of the medallion into flaring leaves.

M.P.

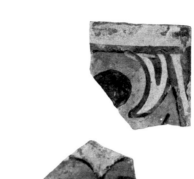

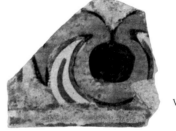

V.4

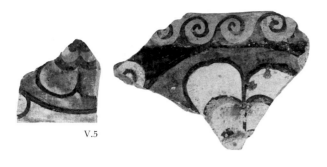

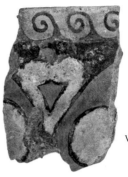

V.5　　　V.5　　　V.5

V.5　Wave Crest and Circle with Rosette

Location Unknown

M.P.H. 9.5, Th. 0.5–0.6 cm

FINDSPOT: Naos, north arm, context AST; context AJU; *Diakonikon* west room, context AOY.

CONDITION: Four nonjoining fragments of more than one convex tile. The tiles are differentiated by the direction of the spiral band. One of the fragments preserves traces of plaster.

DESCRIPTION: The fragments are decorated with a band of black wave crest along the upper edge. The main body of the plaque is filled with repeated roundels on a black ground. Each roundel encloses a six-petaled rosette set against an amber background. The colors of the petals alternate between pink/red (slip) and white reserve. Between the roundels are green heart-shaped leaves enclosing an amber core.　　M.P.

V.6　Ivy Leaf with Grape Clusters

Location Unknown

H. 2.5, M.P.W. 3.9, Th. 0.4–0.5 cm

FINDSPOT: Excavation of A1 Lime Pit, context AHU.

CONDITION: Fragments of a flat strip; upper and lower edges preserved.

DESCRIPTION: Decorated with a vine scroll with grapes glazed in deep amber; design is outlined in iron oxide slip in a white-reserve background.

COMPARISONS: Myrelaion (cat. VII.5); Saint Euphemia (cat. VIII.2); Topkapı Sarayı Basilica (cat. XII.22); Paris, Musée du Louvre (cat. B.14); Sèvres, Musée national de Céramique (cat. C.31–C.33).　　M.P.

V.7　Circle with Scrolling Tendrils

Location Unknown

H. 9.5, M.P.W. 13.9, Th. 0.5–0.7 cm

FINDSPOT: Naos, north arm, context ADV; *Diakonikon* west room, contexts AST and ASW; *Diakonikon* north aisle, context APA; bema, context ARW; B4 level, context BAX; C3 level, context AFP.

CONDITION: Seven joining fragments of an oblong convex tile with upper and lower edges preserved; six additional fragments (two joining).

DESCRIPTION: White-reserve circles linked by amber rectangular bands. Each circle encloses four white-reserve foliate tendrils that terminate in trefoils. The tendrils enclose a blue field. Foliate spandrels, colored in amber glaze, link the circles.

COMPARISONS: Hospital of Sampson (cat. II.16, II.17); Istanbul, Provenance Unknown (cat. XV.9); Sèvres, Musée national de Céramique (cat. C.7).　　M.P.

V.7

V.6

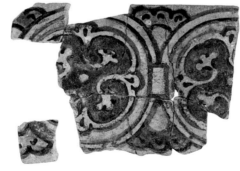

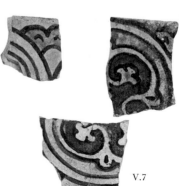

V.7

V.8 Peacock Feather

Location Unknown

M.P.H. 9.2, Th. 0.6–0.7 cm

FINDSPOT: *Diakonikon* west room, contexts AOT and AOY.

CONDITION: Four fragments of a convex tile, three joining; most likely part of a colonnette.

DESCRIPTION: Decorated with peacock feathers that alternate in color between white reserve and blue. At the center of each feather is an amber-colored diamond-shaped eye on a black shaft.

COMPARISONS: Hospital of Sampson (cat. II.18, II.19). M.P.

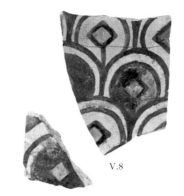

V.8

V.9 Lozenge Braid

Location Unknown

M.P.H. 10.3, M.P.W. 9.0, Th. 1.0–1.25 cm

FINDSPOT: Unknown, context BEL.

CONDITION: Two joined fragments of a colonnette shaft. Reverse side is roughened.

DESCRIPTION: Decorated with alternating blue-green and white zigzag bands. Vertical lines intersect the horizontal zigzag and create a lozenge braid. M.P.

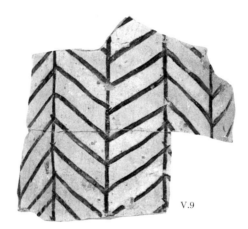

V.9

V.10 Tongue and Dart

Location Unknown

M.P.H. 6.8, Th. 0.6–0.7 cm

FINDSPOT: Naos, north arm, contexts AST and ASW.

CONDITION: Two nonjoining fragments of concave (?) tile.

DESCRIPTION: Decorated with a tongue-and-dart motif with arches of alternating brown-black and green. Central arch is white reserve.

COMPARISONS: Zeuxippos Baths (cat. XIII.11); Haydarpaşa (cat. XVI.1); Baltimore, Walters Art Museum (cat. A.61); Paris, Musée du Louvre (cat. B.6); Sèvres, Musée national de Céramique (cat. C.2, C.40). M.P.

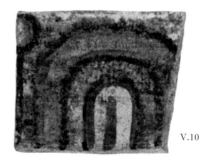

V.10

VI
Constantine Lips (Fenari İsa Camii)

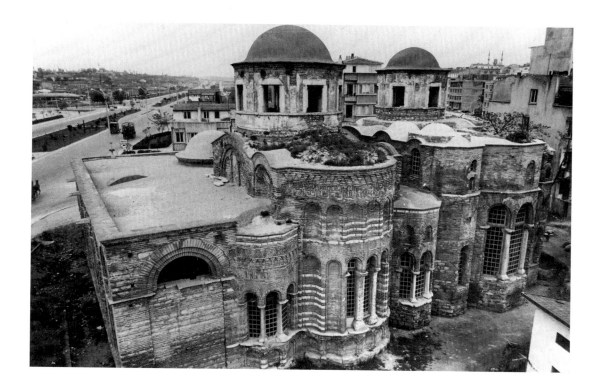

The church of the Theotokos was built in his new monastery and inaugurated in 907 by Constantine Lips, a high court official under Leo VI; a second church was added to the south in 1282 by Theodora, widow of Michael VIII. The Lips church, built on a cross-in-square plan with five domes, was lavishly decorated with wall mosaics (now gone), elaborately carved marble sculpture that included a series of inlaid figural panels, and wall tiles.

The churches were cleared and restored by T. Macridy in 1929.[1] His report was eventually published in *Dumbarton Oaks Papers* by A. H. S. Megaw, C. Mango, and E. J. W. Hawkins.[2] According to Macridy, investigation of the site revealed polychrome tiles, two mounted on stucco moldings, "among the debris covering the floor of the churches."[3] The tiles were thought to originate in the tenth-century church.[4]

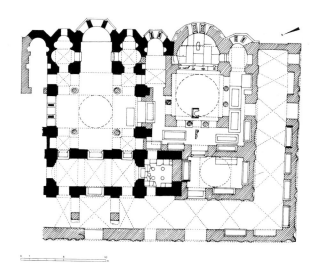

1 Macridy, "Monastery of Lips," 253–78.
2 A. H. S. Megaw, "Notes on Recent Work of the Byzantine Institute in Istanbul," *DOP* 17 (1963), 333–35; A. H. S. Megaw, "The Original Form of the Theotokos Church of Constantine Lips," *DOP* 18 (1964), 279–98; Mango and Hawkins, "Additional Notes," 299–315; Mango and Hawkins, "Additional Finds," 177–84. See also Müller-Wiener, *Bildlexikon*, 126–31, figs. 112–20.
3 Macridy, "Monastery of Lips," 276.
4 Mango and Hawkins, "Additional Notes," 311.

MARLIA MUNDELL MANGO

VI.1

VI.2

VI.1 Tongue and Dart

Istanbul, Arkeoloji Müzeleri, inv. no. unknown

H. 4.0, M.P.W. 2.6 cm

FINDSPOT: In debris covering the floor of the churches.

CONDITION: Fragment of a flat strip; upper and lower edges preserved.

DESCRIPTION: Decorated with tongue and dart. The dart terminates in a disk.

COMPARISONS: Kyriotissa (cat. V.10); Zeuxippos Baths (cat. XIII.11); Haydarpaşa (cat. XVI.1); Baltimore, Walters Art Museum (cat. A.61); Paris, Musée du Louvre (cat. B.6); Sèvres, Musée national de Céramique (cat. C.2, C.40).

LITERATURE: Mango and Hawkins, "Additional Notes," fig. 56.

M.P.

VI.2 Tongue and Dart

Istanbul, Arkeoloji Müzeleri, inv. no. unknown

M.P.H. 4.6 cm

FINDSPOT: In debris covering the floor of the churches.

CONDITION: Five fragments of convex strip, two joining; upper edge preserved on two fragments.

DESCRIPTION: Broad tongue-and-dart motif. Tongues, set against a white-reserve ground, are composed of alternating blue-green and amber bands around a central black core. Terminal point of the dart is missing. A narrow amber band runs along the upper edge of the plaque.

COMPARISONS: For variations of the tongue and dart, see Boukoleon (cat. I.B.1–I.B.4); Kyriotissa (cat. V.10); Saint John Stoudios (cat. X.1); Zeuxippos Baths (cat. XIII.1); Baltimore, Walters Art Museum (cat. A.61); Paris, Musée du Louvre (cat. B.6); Sèvres, Musée national de Céramique (cat. C.2, C.40); Athens, Benaki Museum (cat. D.4); France, Thierry Collection (cat. H.2).

LITERATURE: Mango and Hawkins, "Additional Notes," fig. 55.

M.P.

VI.3 Concentric Circles on Stucco Molding

Istanbul, Arkeoloji Müzeleri, 91.7 P.T.

H. 2.8, M.P.W. 7.8 cm (strip)

H. ca. 9.0, M.P.W. ca. 9.8 cm (molding)

FINDSPOT: In debris covering the floor of the churches.

CONDITION: Fragment of a flat strip; upper and lower edges preserved. The strip is attached to a stucco molding. The molding comprises two superimposed parts: below, a narrow flat element on which the strip is still attached, and above, a broader curved element for the attachment of a convex tile (cat. VI.14 fits exactly with the curved profile of the molding). Projecting vertical ridges in the stucco indicate joints between applied tiles.

DESCRIPTION: Preserved strip decorated with three white-reserve circles enclosing green disks. The circles, outlined in black, are placed on a black background.

COMPARISONS: Constantine Lips (cat. VI.4).

LITERATURE: Mango and Hawkins, "Additional Notes," fig. 58.

M.P.

VI.3

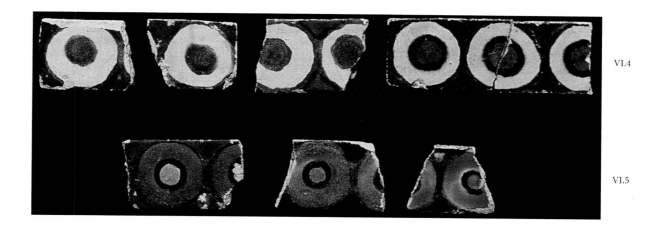

VI.4

VI.5

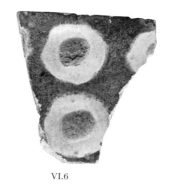

VI.6

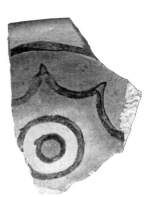

VI.7

VI.4 Concentric Circles

Istanbul, Arkeoloji Müzeleri, 91.6 P.T.

H. 2.6 cm

FINDSPOT: In debris covering the floor of the churches.

CONDITION: Fragments, some joining, of a flat strip; upper and lower edges preserved.

DESCRIPTION: Decorated with white-reserve circles enclosing green disks. The circles, outlined in black, are placed on a black background.

COMPARISONS: Hospital of Sampson (cat. II.3–II.5); Zeuxippos Baths (cat. XIII.2); Istanbul, Provenance Unknown (cat. XV.9); Baltimore, Walters Art Museum (cat. A.54); Paris, Musée du Louvre (cat. B.12); Sèvres, Musée national de Céramique (cat. C.46).

LITERATURE: Talbot Rice, "Polychrome Pottery," pl. XXV.2; Macridy, "Monastery of Lips," fig. 84; Mango and Hawkins, "Additional Notes," fig. 54.　　　M.P.

VI.5 Concentric Circles

Istanbul, Arkeoloji Müzeleri, 91.8 P.T.

H. 2.6 cm

FINDSPOT: In debris covering the floor of the churches.

CONDITION: Fragments of a flat strip; upper and lower edges preserved.

DESCRIPTION: Decorated with green circles enclosing amber disks. The circles, outlined in black, are placed on a black background.

COMPARISONS: Istanbul, Provenance Unknown (cat. XV.9); Haydarpaşa (cat. XVI.1); Sèvres, Musée national de Céramique (cat. C.47).

LITERATURE: Macridy, "Monastery of Lips," fig. 84; Mango and Hawkins, "Additional Notes," fig. 54.　　　M.P.

VI.6 Jeweled Band

Istanbul, Arkeoloji Müzeleri, inv. no. unknown

H. ca. 4.2, M.P.W. ca. 3.8 cm

FINDSPOT: In debris covering the floor of the churches.

CONDITION: Fragment of a flat (?) strip; upper and lower (?) edges preserved.

DESCRIPTION: Decorated with pairs of superimposed white-reserve circles enclosing green disks. This fragment may have formed part of a tile strip decorated with a jeweled band.

COMPARISONS: Kyriotissa (cat. V.1); Topkapı Sarayı Basilica (XII.3); Sèvres, Musée national de Céramique (cat. C.29).

LITERATURE: Mango and Hawkins, "Additional Notes," fig. 56.　　　M.P.

VI.7 Concentric Circles

Istanbul, Arkeoloji Müzeleri, inv. no. unknown

M.P.H. 4.4, M.P.W. 3.2 cm

FINDSPOT: In debris covering the floor of the churches.

CONDITION: Fragment of a flat (?) tile; no preserved edges.

DESCRIPTION: Decorated with a roundel enclosing a scalloped frame. At the center of the frame is a circle that encloses a disk.

LITERATURE: Mango and Hawkins, "Additional Notes," fig. 56.　　　M.P.

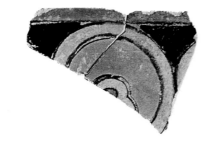

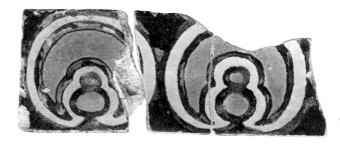

VI.9

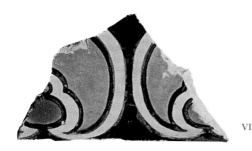

VI.8

VI.9 Shell

Istanbul, Arkeoloji Müzeleri, 91.5 P.T.

H. 3.8 cm

FINDSPOT: In debris covering the floor of the churches.

CONDITION: Fragments of a flat strip; upper and lower edges preserved.

DESCRIPTION: Decorated with a row of white-banded amber shells enclosing a copper green figure eight on a black background.

COMPARISONS: Constantine Lips (cat. VI.8).

LITERATURE: Macridy, "Monastery of Lips," fig. 84; Mango and Hawkins, "Additional Notes," fig. 50. M.P.

VI.8 Shell

Istanbul, Arkeoloji Müzeleri, 91.4 P.T.

Est. H. 7.1 cm

FINDSPOT: In debris covering the floor of the churches.

CONDITION: Fragments of a convex oblong tile; upper and lower edges preserved.

DESCRIPTION: Decorated with a row of white-banded amber shells enclosing a copper green figure eight on a black background. A narrow green band runs along the upper edge of the tile.

COMPARISONS: Myrelaion (cat. VII.2); Mangana (cat. IX.1); Topkapı Sarayı Basilica (cat. XII.4); Istanbul, Provenance Unknown (cat. XV.9); Sèvres, Musée national de Céramique (cat. C.10, C.35); Thierry Collection (cat. H.4).

LITERATURE: Talbot Rice, "Polychrome Pottery," pl. XXV.2; Macridy, "Monastery of Lips," fig. 84; Mango and Hawkins, "Additional Notes," fig. 49. M.P.

VI.10 Lozenges with Four-Petaled Flowers

Istanbul, Arkeoloji Müzeleri, 91.3 P.T.

H. 4.8 cm

FINDSPOT: In debris covering the floor of the churches.

CONDITION: Fragments of a concave tile; upper and lower edges preserved.

DESCRIPTION: Decorated with a row of banded, linked blue-green lozenges enclosing white flowers on an amber field. At the core of each flower is a blue-green disk. The white-reserve triangular spaces between the lozenges are filled with vine scrolls and grapes outlined in black.

COMPARISONS: Istanbul, Provenance Unknown (cat. XV.9).

LITERATURE: Talbot Rice, "Polychrome Pottery," pl. XXV.2; Macridy, "Monastery of Lips," fig. 84; Mango and Hawkins, "Additional Notes," fig. 48. M.P.

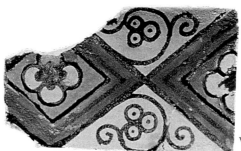

VI.10

VI.11 Lozenges

Istanbul, Arkeoloji Müzeleri, inv. no. unknown
H. 3.8 cm

FINDSPOT: In debris covering the floor of the churches.

CONDITION: Fragments of a flat tile strip; upper and lower edges preserved.

DESCRIPTION: The strip may have been decorated with a row of lozenges or pitched squares enclosing four-petaled flowers.

COMPARISONS: Lips (cat. VI.10, VI.14) Istanbul, Provenance Unknown (cat. XV.9); Sèvres, Musée national de Céramique (cat. C.13, C.14).

LITERATURE: Macridy, "Monastery of Lips," fig. 84; Mango and Hawkins, "Additional Notes," fig. 56. M.P.

VI.11

VI.12 Lozenges

Istanbul, Arkeoloji Müzeleri, inv. no. unknown
M.P.H. 2.0, M.P.W. 3.2 cm

FINDSPOT: In debris covering the floor of the churches.

CONDITION: Fragments of a flat tile strip; upper and lower edges preserved.

DESCRIPTION: Decorated with a row of linked lozenges. The triangular space between them has a dot in the middle.

COMPARISONS: Zeuxippos Baths (cat. XIII.11).

LITERATURE: Mango and Hawkins, "Additional Notes," fig. 56.
M.P.

VI.12

VI.13 Lattice

Istanbul, Arkeoloji Müzeleri, inv. no. unknown
M.P.H. 3.8, M.P.W. 3.4 cm

FINDSPOT: In debris covering the floor of the churches.

CONDITION: Extremely fragmentary; no edges preserved.

DESCRIPTION: Decorated with a white-reserve rosette with a green core. The linear components, perhaps cross arms or the bands of a lattice, are defined by amber and green bands.

COMPARISONS: Myrelaion (cat. VII.7); Saint Polyeuktos (cat. XI.1); Zeuxippos Baths (cat. XIII.5).

LITERATURE: Mango and Hawkins, "Additional Notes," fig. 56.
M.P.

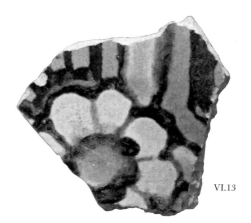

VI.13

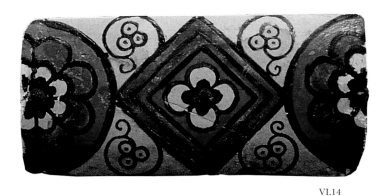

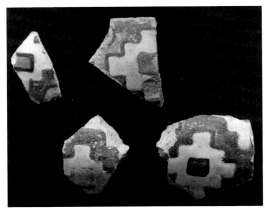

VI.14

VI.15

VI.14 Circle and Pitched Squares with Four-Petaled Flowers and Rosettes

Istanbul, Arkeoloji Müzeleri, 91.1 P.T.

H. 7.1, M.P.W. 15.2 cm

FINDSPOT: In debris covering the floor of the churches.

CONDITION: Fragment of a convex oblong tile; upper and lower edges preserved. Originally the tile was attached to the upper, curved element of the stucco molding (cat. VI.3).

DESCRIPTION: Decorated with alternating linked roundels and diamonds. The roundels enclose white and blue rosettes on an amber field. A banded blue-green diamond encloses a white four-petaled flower with a blue core on an amber field. The spaces between the roundels and diamonds are filled with vine scrolls and grapes, which sprout from the sides of the diamonds.

COMPARISONS: Istanbul, Provenance Unknown (cat. XV.9).

LITERATURE: Talbot Rice, "Polychrome Pottery," pl. XXV.2; Macridy, "Monastery of Lips," fig. 84; Mango and Hawkins, "Additional Notes," fig. 47.　　　　M.P.

VI.15 Cross

Istanbul, Arkeoloji Müzeleri, 91.10 P.T.

M.P.H. 4.2, M.P.W. 4.8 cm

FINDSPOT: In debris covering the floor of the churches.

CONDITION: Four fragments of a convex strip; one fragment preserves an edge.

DESCRIPTION: Decorated with a white cross motif enclosing an amber square. The cross is outlined in black and set against a blue background.

COMPARISONS: Sèvres, Musée national de Céramique (cat. C.34).

LITERATURE: Macridy, "Monastery of Lips," fig. 84; Mango and Hawkins, "Additional Notes," fig. 57.　　　　M.P.

VI.16 Kufesque

Istanbul, Arkeoloji Müzeleri, 91.9 P.T.

(a) H. 4.0, M.P.W. 3.2 cm

(b) H. 3.8, M.P.W. 3.2 cm

(c) H. 4.8, M.P.W. 2.6 cm

(d) H. 4.0, M.P.W. 4.0 cm

FINDSPOT: In debris covering the floor of the churches.

CONDITION: Four fragments of a convex strip; one corner and upper edges preserved.

DESCRIPTION: Decorated with white-reserve kufesque characters, including an S- and U-shaped character and a combination of vertical and horizontal straight lines on a black background.

COMPARISONS: While kufesque motifs are not found on tiles from other sites, they are found on polychrome vessels from Constantinople.

LITERATURE: Mango and Hawkins, "Additional Notes," fig. 53.

　　　　M.P.

VI.16

VI.17 Circle with Four-Petaled Flower

Istanbul, Arkeoloji Müzeleri, 91.2 P.T.
M.P.H. 6.9, M.P.W. 8.0 cm

FINDSPOT: In debris covering the floor of the churches.

CONDITION: Three fragments of an oblong convex tile; upper edges preserved.

DESCRIPTION: Decorated with an amber circle framed by a pair of blue-green vertical motifs (florets?) on a white background. The circle encloses a white-banded scalloped frame containing a white four-petaled flower with blue-green center; the flower is set against a blue-green field.

LITERATURE: Talbot Rice, "Polychrome Pottery," pl. XXV.2; Macridy, "Monastery of Lips," fig. 84; Mango and Hawkins, "Additional Notes," fig. 51. M.P.

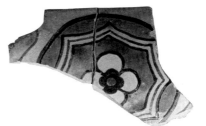

VI.17

VI.18 Floral Motifs and Bands

Istanbul, Arkeoloji Müzeleri, inv. no. unknown
M.P.H. 5.9 cm

FINDSPOT: In debris covering the floor of the churches.

CONDITION: Multiple fragments from an oblong convex tile; some edges preserved.

DESCRIPTION: The fragments are decorated with a banded polygonal frame enclosing a lobed motif, perhaps a flower.

COMPARISONS: Great Palace (cat. I.A.1); Sèvres, Musée national de Céramique (cat. C.27).

LITERATURE: Mango and Hawkins, "Additional Notes," fig. 52. M.P.

VI.18

VIa
Atik Mustafa Paşa Camii

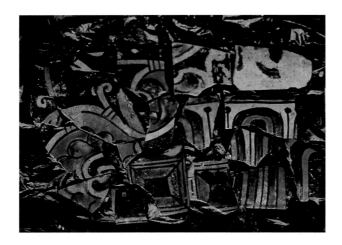

The church, which today functions as a mosque, is located in the Ayvansaray district of the city, ca. 150 m east of the Blachernai church and ca. 20 m southwest of the sea wall that borders the Golden Horn.[1] The Byzantine name of the Atik Mustafa Paşa Camii is unknown; it has been identified variously as a church dedicated to Saints Peter and Mark,[2] Saint Thekla,[3] the Anargyroi (Saints Cosmas and Damian),[4] and the Prophet Elijah at Petrion.[5] The church has traditionally been viewed by scholars as a transitional form between the domed basilica and cross-in-square type.[6] In 1992, the community responsible for the mosque undertook the renovation of the building's interior in order to correct problems resulting from water seepage. The renovation provided an opportunity to study the architectural fabric. Close examination of the masonry indicates that the corner compartments on the east and west ends of the church had upper chambers. In all likelihood, the central nave was flanked by an ambulatory that, on its upper level, connected these corner spaces. Several factors, including the plan of the church and its masonry, suggest that the Atik Mustafa Paşa Camii should be dated ca. 900.

The following discovery is reported here for the first time. Due to its position near the Golden Horn, the church was susceptible to flooding; in the early Ottoman period, the floor was raised approximately 1.5 m. In 1992, as part of the renovations, a small hole, approximately 20 × 20 cm, was dug by workmen through the Ottoman pavement in the northwest compartment of the church. Under the pavement were mosaic tesserae, fragments of *opus sectile*, marble revetment, and nineteen fragments of polychrome tiles. Apparently, these decorative components were pulled from the walls of the Byzantine church and used for fill. The tiles are convex in shape and brightly colored in amber and green-blue glaze. The fabric is white with terracotta inclusions. The outlines are executed in black on the white reserve body of the tiles. The thickness of the tiles ranges from 0.55 to 0.7 cm. Three patterns are represented among the finds: paired acanthus leaves (nine fragments), tongue and dart (seven fragments), and concentric rectangles that form part of a jeweled band (three fragments). The reconstructed height of the tongue-and-dart design is 7.8 cm. The grouping of these specific patterns within a single monument is only found elsewhere in Saint John Stoudios (cat. x); the Atik Mustafa Paşa tiles differ, however, in glaze color and in some design details. Careful investigation of the fill below the Ottoman floor will reveal, in the future, more information about these tiles and the other materials that once decorated the walls of this church.

LIOBA THEIS

1. For a thorough analysis of the building, see L. Theis, *Die Flankenräume im mittelbyzantinischen Kirchenbau: Zur Befundsicherung, Rekonstruktion und Bedeutung einer verschwundenen architektonischen Form in Konstantinopel* (Wiesbaden, 2001).
2. Patriarch Konstantios, *Konstantinias palaia te kai neotera etoi perigraphe Konstantinoupoleos* (Venice, 1824; repr. Thessalonike, 1979), 89.
3. A. M. Schneider, *Byzanz. Vorarbeiten zur Topographie und Archäologie der Stadt* (Berlin, 1936), 53.
4. B. Aran, "The Nunnery of the Anargyres and the Atik Mustafa Paşa Mosque (Notes on the Topography of Constantinople)," *JÖB* 26 (1977), 247–53.
5. T. F. Mathews and E. J. W. Hawkins, "Notes on the Atik Mustafa Paşa Camii in Istanbul and its Frescoes," *DOP* 39 (1985), 133–34.
6. N. I. Brunov, "Architektura Konstantinopolija IX–XII vv.," *VizVrem* 2/27 (1949), 153–56; Mathews and Hawkins, "Atik Mustafa Paşa Camii," 125–34.

VII
Myrelaion (Bodrum Camii)

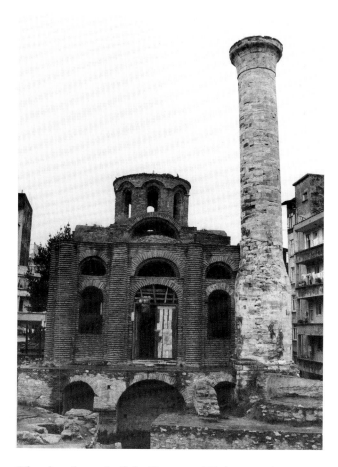

The church was built by Romanos I Lekapenos in 920–22 beside a mansion constructed on the remains of a fifth-century rotunda. The two buildings came to form part of a nunnery that he founded. Romanos and his family were buried in the church, which was built on a cross-in-square plan above a substructure that elevated the church to the height of the mansion.

The church was first investigated in 1930 by D. Talbot Rice, who excavated around its exterior and carried out a sondage on the interior of the north side of the lower level.[1] The church was extensively restored in 1964–65. Excavation and survey by C. L. Striker in 1965 clarified the structural history of the building,[2] revealing decorative elements of the church interior, which included an *opus sectile* pavement, marble wall revetment with mosaic work above, and wall tiles.[3]

Polychrome tiles were recovered during both excavations. The tiles from the Talbot Rice campaign, now on exhibition in the Istanbul Archaeological Museum, most likely came from soundings on the north side of the substructure.[4] Striker's excavations revealed allied tile fragments within the unstratified rubble fill from soundings at the base of the northeast pier of the church and in Level 3 of fill occupying the substructure. That the tiles were found mixed with architectural debris in the latter area led Striker to conclude that they belonged to the original tenth-century decoration and that they were dumped in the substructure during remodeling of the church in the Palaiologan period.[5]

1 D. Talbot Rice, "Excavations at Bodrum Camii, 1930," *Byzantion* 8 (1933), 151–76.
2 C. L. Striker, "A New Investigation of the Bodrum Camii and the Problem of the Myrelaion," *IAMY* 13–14 (1967), 210–15; idem, *Myrelaion;* J. Hayes, "The Excavated Pottery from the Bodrum Camii," in Striker, *Myrelaion,* 36. See also Müller-Wiener, *Bildlexikon,* 103–7, figs. 82–88.
3 Striker, *Myrelaion,* 24.
4 The notes from the excavation were never fully published; the short article in *Byzantion* does not reveal the findspot of the tiles.
5 Striker, *Myrelaion,* 24, 36.

MARLIA MUNDELL MANGO

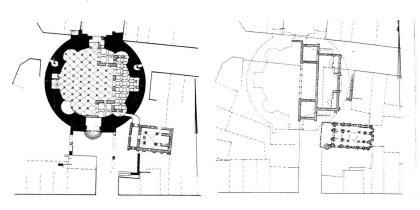

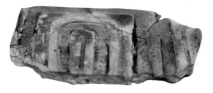

VII.1 VII.2

VII.1 Tongue and Dart

Istanbul, Arkeoloji Müzeleri, 91.36, 91.37 P.T.

H. 5.7, Th. 0.25–0.35 cm (91.36 P.T.)

 FINDSPOT: Context unknown; from the Talbot Rice excavations.

 CONDITION: Fragment from an oblong convex tile; upper edge preserved.

 DESCRIPTION: Decorated with a square tongue-and-dart variation. The design consists of concentric tongues of alternating blue-green, gold leaf, and white reserve, all outlined in black.

 COMPARISONS: Hospital of Sampson (cat. II.1, II.7). J.D.

VII.2 Shell

Istanbul, Arkeoloji Müzeleri, 91.32 P.T.

H. 7.0 cm

 FINDSPOT: Context unknown; from the Talbot Rice excavations. Two small fragments also recovered in the Striker excavations.

 CONDITION: Fragment from an oblong convex tile; upper and lower edges preserved.

 DESCRIPTION: Decorated with a row of gold double-banded crescents enclosing a blue-green figure eight. Background is black.

 COMPARISONS: Constantine Lips (cat. VI.8, VI.9); Mangana (cat. IX.1); Topkapı Sarayı Basilica (cat. XII.4); Istanbul, Provenance Unknown (cat. XV.9); Sèvres, Musée national de Céramique (cat. C.10, C.35); France, Thierry Collection (cat. H.4). J.D.

VII.3 Circle with Four-Petaled Flower

Istanbul, Arkeoloji Müzeleri, 91.34 P.T. (additional tile in private collection)

H. 7.5 cm

 FINDSPOT: Context unknown; from the Talbot Rice excavations. One small fragment also recovered in the Striker excavations.

 CONDITION: Approximately twenty fragments from an oblong convex tile; upper and lower edges preserved.

 DESCRIPTION: Elaborate leaves of quatrefoils, painted in reddish black on white reserve, link to form foliate medallions. Along the upper and lower edges, between the leaves, are heart-shaped ornaments. Between each set of leaves is a four-petaled flower set against a dark brown medallion. The medallions and leaves are placed against a gold background.

 COMPARISONS: Topkapı Sarayı Basilica (cat. XII.10–XII.13); Istanbul, Provenance Unknown (cat. XV.7, XV.9); Baltimore, Walters Art Museum (cat. A.70); Paris, Musée du Louvre (cat. B.13); Sèvres, Musée national de Céramique (cat. C.21, C.22); Athens, Benaki Museum (cat. D.7); France, Thierry Collection (cat. H.5). J.D.

VII.4 Shell with Palmette

Istanbul, Arkeoloji Müzeleri, 91.33 P.T. (additional fragment in private collection)

H. 9.6, Th. 0.55–0.6 cm

 FINDSPOT: Context unknown; from the Talbot Rice excavations.

 CONDITION: Multiple fragments from an oblong convex tile; no edges preserved. Glaze colors include turquoise blue and copper green in addition to red slip and gold leaf.

 DESCRIPTION: Repeated roundels containing lotus palmets.

 LITERATURE: Sgalitzer (Ettinghausen), "Baukeramik," pl. XV.3. E.S.E.

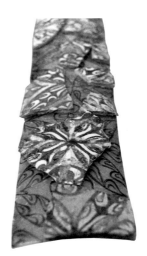

VII.3

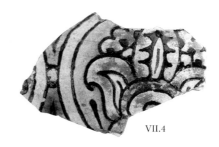

VII.4

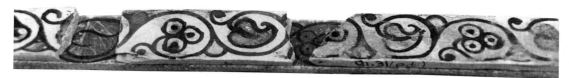

VII.5

VII.5 Ivy Leaf with Grape Clusters

Istanbul, Arkeoloji Müzeleri, 91.29, 91.30, 91.31 P.T. (variation of pattern in a private collection)
H. 2.5 cm

FINDSPOT: Context unknown; from the Talbot Rice excavations.

CONDITION: Multiple fragments from an oblong flat strip; upper and lower edges preserved.

DESCRIPTION: Decorated with a black vine scroll with amber and reddish brown leaves alternating with bunches of grapes. Background is white reserve.

COMPARISONS: Kyriotissa (cat. v.6); Saint Euphemia (cat. vIII.2); Topkapı Sarayı Basilica (cat. xII.22); Paris, Musée du Louvre (cat. B.14); Sèvres, Musée national de Céramique (cat. C.31–C.33). J.D.

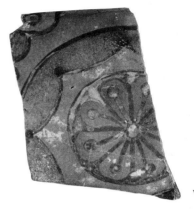

VII.6

VII.6 Circle with Rosette

Location Unknown
W. 10.7–11.0, Th. 0.45–0.5 cm

FINDSPOT: Context unknown.

CONDITION: Single fragment of a straight oblong tile. Glaze colors include amber and copper green. Traces of burning.

DESCRIPTION: At the center of a green medallion is an eight-pointed, scalloped frame enclosing a rosette on a dark medallion. The petals of the rosette, in white reserve, are each divided by a stalk terminating in a circle. Between the green medallions, along the upper and lower edges, are triple imbrications in green and amber glaze.

LITERATURE: Sgalitzer (Ettinghausen), "Baukeramik," 55, no. 20, pl. vI, 1. E.S.E.

VII.7

VII.7 Lattice

Private Collection
M.P.H. 7.5, Th. 0.6 cm

FINDSPOT: Uncertain. Possibly from Talbot Rice excavation of substructure, north side.

CONDITION: Two nonjoining fragments of slightly convex tiles with no preserved edges. Some surface losses. Fabric is white and slightly coarse. Black outline on white-reserve ground. Amber glaze is well preserved.

DESCRIPTION: On one fragment, two amber disks joined by three bands of amber flanked by blue-green. On the second fragment, an amber disk with amber and blue-green bands meeting at a right angle, with a brown-black roundel decorated with white-reserve circles in the right-hand quadrant.

COMPARISONS: Constantine Lips (cat. vI.13); Saint Polyeuktos (cat. xI.1); Zeuxippos Baths (cat. xIII.5). M.M.M.

VIII
Saint Euphemia

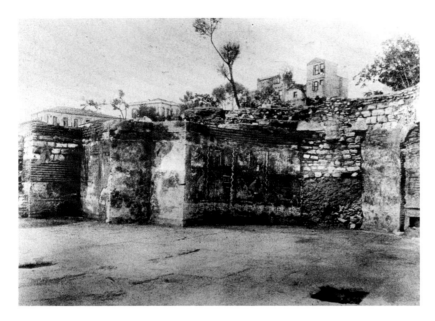

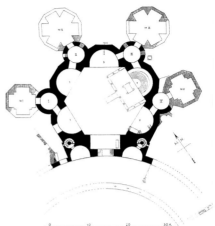

The relics of Saint Euphemia were removed from her shrine near Chalcedon in the second half of the seventh century and taken to Constantinople. During Iconoclasm, they were allegedly thrown into the sea, but were miraculously preserved and installed in a martyrium in 796.

Excavations directed by A. M. Schneider in 1942 and 1950–52 of the fifth-century Palace of Antiochos by the Hippodrome uncovered the remains of the church of Saint Euphemia; the thirteenth-century fresco cycle of the saint's martyrdom had been discovered in 1939.[1] In their 1966 publication of these excavations, R. Naumann and H. Belting dated the church to the sixth century, partly on the basis of its architectural sculpture.[2] U. Peschlow subsequently pointed out that the sculpture used as a basis for the date was, in fact, spolia.[3] Recently, C. Mango suggested, on the basis of written sources, that the church of Saint Euphemia was first installed in the palace by the Hippodrome in 796, when the relics were returned from Lemnos, and that the monogram on a polygonal base belongs to Constantine VI (r. 780–97).[4]

The specific context in which the few polychrome tiles were recovered in the church is not known, because Schneider's excavation notebooks were lost during World War II;[5] the tiles entered a private collection in Istanbul.[6] Two of the tile fragments have recently been reidentified as parts of painted stone cornices found in Odalar Camii, not Saint Euphemia.[7] The new 796 date for the conversion of the palace to a church is too early for the tiles themselves, which were probably added later.

1 K. Bittel and A. M. Schneider, "Das Martyrion des hl. Euphemia beim Hippodrom," *AA* 56 (1941), 296–315.

2 A. M. Schneider, "Grabung im Bereich des Euphemiamartyrions zu Konstantinopel," *AA* 58 (1943), 255–89; Naumann and Belting, *Die Euphemia-Kirche;* Müller-Wiener, *Bildlexikon,* 122–25, figs. 108–9.

3 U. Peschlow, "Zum Templon in Konstantinopel," in *Armos: Festschrift N. K. Moutsopoulos* (Thessalonike, 1991), 1452. See also Grabar, review of Naumann and Belting, *Die Euphemia-Kirche, CahArch* 17 (1967), 251–54.

4 C. Mango, "The Relics of St. Euphemia and the Synaxarion of Constantinople," in *Opora: Studi in onore di mgr Paul Canart per il LXX compleanno (Bollettino della Badia greca di Grottaferrata,* n.s., LIII) (1999), 79–87.

5 Naumann and Belting, *Die Euphemia-Kirche,* 10.

6 Ibid., 90, pl. 17 a–d.

7 S. Westphalen, *Die Odalar Camii in Istanbul* (Tübingen, 1999), pl. 38.2.

MARLIA MUNDELL MANGO

VIII.1 Guilloche with Eyelets

Istanbul, Private Collection
Dimensions Unknown
 Findspot: Context unknown.
 Condition: Fragment of a convex tile; no edge preserved.
 Description: Decorated with a guilloche consisting of interlacing white-reserve bands adorned with rows of green disks.
 Comparisons: Zeuxippos Baths (cat. XIII.4).
 Literature: Naumann and Belting, *Die Euphemia-Kirche*, pl. 17c.
 M.P.

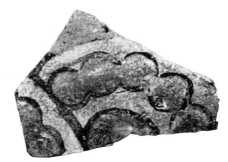

VIII.1

VIII.2 Ivy Leaf with Grape Clusters

Istanbul, Private Collection
Dimensions Unknown
 Findspot: Context unknown.
 Condition: Two fragments of a flat strip; upper and lower edges preserved.
 Description: Decorated with a vine scroll of ivy leaves and grapes.
 Comparisons: Kyriotissa (cat. V.6); Myrelaion (cat. VII.5); Topkapı Sarayı Basilica (cat. XII.22); Paris, Musée du Louvre (cat. B.14); Sèvres, Musée national de Céramique (cat. C.31–C.33).
 Literature: Naumann and Belting, *Die Euphemia-Kirche*, pl. 17b, d.
 M.P.

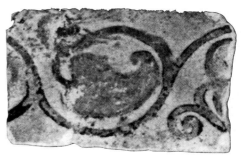

VIII.2

VIII.3 Peacock Feather

Istanbul, Private Collection
Dimensions Unknown
 Findspot: Context unknown.
 Condition: Fragment of a colonnette shaft; no edges preserved.
 Description: Decorated with peacock feathers. Each feather encloses a group of three disks on a stem, each with a dot in the middle. The barbs of the feather are articulated by incised lines.
 Comparisons: Topkapı Sarayı Basilica (cat. XII.35); Zeuxippos Baths (cat. XIII.12).
 Literature: Naumann and Belting, *Die Euphemia-Kirche*, pl. 17a.
 M.P.

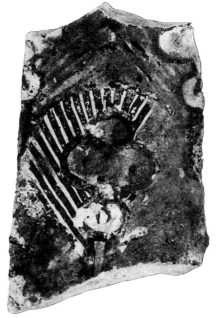

VIII.3

IX

Saint George of the Mangana

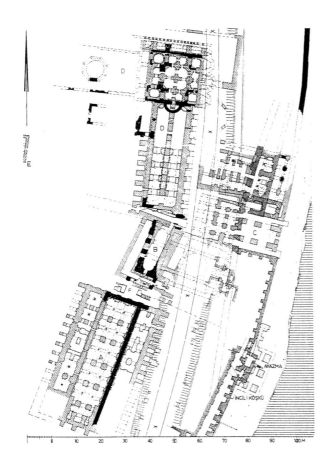

The monastic church of Saint George was built in the Constantinopolitan region of the Mangana by Constantine IX Monomachos, who was buried there in January 1055. The lavishly built church played a large role in imperial ceremony; the court visited the church each year on 23 April to celebrate the feast of the patron saint.[1] The church retained importance until the Ottoman conquest, after which it was destroyed.

Byzantine structures in the Mangana were investigated in 1921–22 by E. Mamboury and R. Demangel during occupation of the site by the French army.[2] Their brief excavations focused on the substructures of the monastery. According to their findings, the large church (32.5 × 22.5 m) was an inscribed cross-in-square with a central dome and cupolas over the four corner bays. Polychrome tiles were said to have been found in the area of the Mangana; their exact context is unknown. These were not recorded in the final report, and are mentioned only in the study of Byzantine tiles from the Topkapı Sarayı Basilica and Saint John Stoudios.[3] The only pattern recorded is the shell.

1 Pseudo-Kodinos, *Traité des offices,* ed. J. Verpeaux (Paris, 1966), 244.
2 R. Demangel and E. Mamboury, *Le quartier des Manganes et la Première Région de Constantinople* (Paris, 1939), 19–37; Müller-Wiener, *Bildlexikon,* 136–38, fig. 126.
3 Ettinghausen, "Byzantine Tiles," 79 n. 5; 84 n. 1; 85. The information was kindly given to E.S.E. by E. Mamboury.

ELIZABETH S. ETTINGHAUSEN

IX.1 Shell

Istanbul, Private Collection
Dimensions Unknown (no photo)
 DESCRIPTION: Decorated with a shell motif.
 COMPARISONS: Said to resemble tiles from Constantine Lips (cat. VI.8, VI.9); Myrelaion (cat. VII.2); Topkapı Sarayı Basilica (cat. XII.4). See also Sèvres, Musée national de Céramique (cat. C.10, C.35); France, Thierry Collection (cat. H.4).
 LITERATURE: Ettinghausen, "Byzantine Tiles," 84 n. 1, 85.

M.M.M.

X
Saint John Stoudios (Imrahor Camii)

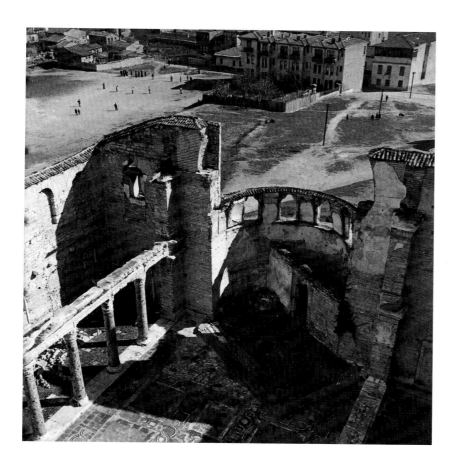

The fifth-century church of Saint John the Baptist *ton Stoudiou* was excavated in 1907–9 by B. Panchenko for the Russian Archaeological Institute in Constantinople.[1] The finds included fragments of sculpted decoration, the elaborate *opus sectile* pavement, bits of fresco, mosaic tesserae, and polychrome tiles. The tiles, supposedly found in the southern aisle of the church, were in an excellent state of preservation. They were not accessible until 1928, however, when they were reconstructed from flat and curved pieces into a single unit;[2] the fragments are currently on display in the Istanbul Archaeological Museum. Some small fragments from the site were donated to the Benaki Museum in Athens in 1931–32 (cat. D.3–D.5); the Benaki tiles, identical to those excavated by Panchenko, may have been uncovered during restoration of the church in 1928.[3]

Obviously, the tiles did not form part of the church's fifth-century program, but were added at a later date. No records explicitly state when they were installed, and there is no archaeological evidence that provides a secure date for their placement within the building. We do know, however, that Saint John Stoudios was refurbished twice. Written sources record the "rich decorations of the church given by the Emperor Isaak I Komnenos (1057–59) and his wife Aikaterina."[4] A later renovation was carried out during the reign of Andronikos II Palaiologos (1282–1328).[5] The earlier notice may refer to both the polychrome-tile decoration and the elaborate *opus sectile* pavement. The latter, according to T. Mathews, should be dated to the middle of the eleventh century.[6] The addition of the richly colored tile decoration at the same time supports the general assumption that polychrome tiles were produced and employed in important Constantinopolitan buildings, both religious and secular, in the tenth and eleventh centuries.

In all likelihood, the tiles, consisting of three joining bands of exceptional height, formed an architrave for an

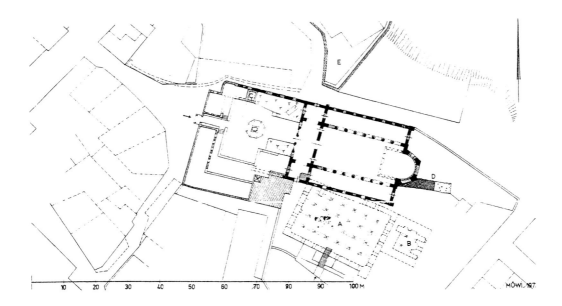

icon screen[7] or a decorative molding over a devotional image. Whatever their function, it is clear that the medieval tiles were intended to complement and reflect the basilica's original decoration. The patterns represented on the tiles fell within the framework of the fifth-century tradition, but the design was updated to suit eleventh-century taste and style. This metamorphosis is evident in all components of the ceramic frieze, but especially in the transformation of the deeply carved acanthus band of the fifth-century architrave into the undulating voluted leaf patterns on the plaques. The tile design reveals the adaptation of relief decoration for a two-dimensional rendering. Double outlines on the Stoudios tiles represent the thick cuts of a carved relief, and three-dimensional ringlets at the tips of leaves appear as dotted circles, with the dots standing for the shaded hollow of sculpted works.

1 B. Panchenko, "Hagios Ioannes Studios," *IRAIK* 14 (1909), 136–52; 15 (1911), 250–57; 16 (1912), 1–359.

2 I owe this information to the kindness of the late Dr. Arif Müfid Mansel, then Associate Director of the Museum.

3 D. Talbot Rice, "The Byzantine Pottery," in *Second Report upon the Excavations Carried Out in and near the Hippodrome of Constantinople in 1928*, by S. Casson and D. Talbot Rice (London, 1929), 33, n. 1.

4 *Ioannis Scylitzae Synopsis Historiarum*, ed. I. Thurn (Corpus Fontium Historiae Byzantinae 5, Series Berolinensis, 1973), 650.

5 The renovation was commissioned by the emperor's brother, Constantine Palaiologos Porphyrogennetos. See Nikephoros Gregoras, *Historia byzantina*, ed. L. Schopen and I. Bekker (Bonn, 1829–55), 190.

6 Mathews, *Early Churches*, 23.

7 Panchenko reports that pieces of wall mosaic were found in the crypt under the floor of the apse. It is possible that the number of tiles was sufficient for them to be used as an architrave of an icon screen or as a molding or cornice below an apse mosaic. See Panchenko, "Hagios Ioannes Studios," *IRAIK* 15 (1911), 250, 257. Megaw's caption to his figure 308 in "Byzantine Pottery" (p. 103) also suggests that the tiles were used for the architrave of an icon screen.

ELIZABETH S. ETTINGHAUSEN

X.1 Tongue and Dart

Istanbul, Arkeoloji Müzeleri, 6425a P.T.

H. 12.3–12.5, Th. 0.6–0.7 cm

CONDITION: Many fragments reconstructed as a slightly convex plaque. Perfect surface preservation with the colors and glazes intact. Fine white fabric (used in reserve). Glaze colors include bright yellow and grass green. Dark purple manganese is used for the outlines of the design.

DESCRIPTION: The design is derived from the tongue-and-dart motif, here interpreted in structural terms as arches with, between them, half columns or, more likely, pilasters with stepped capitals supporting an architrave (the narrow strip on top).[1]

COMPARISONS: Athens, Benaki Museum (cat. D.4). See also Boukoleon (cat. I.B.2); Zeuxippos Baths (cat. XIII.1). A similar pattern decorates tiles from Preslav, Bulgaria.[2]

LITERATURE: Sgalitzer (Ettinghausen), "Baukeramik," 51, no. 4, pl. XIII, 1; Ettinghausen, "Byzantine Tiles," 80, pl. XXXI, 1a.

1 I am not of the same opinion as Talbot Rice (*Glazed Pottery,* 14), who shows the fragment upside down.

2 Miatev, *Keramik,* fig. 80, h, i. E.S.E.

X.2 Concentric Circles and Rectangles

Istanbul, Arkeoloji Müzeleri, 6425c P.T.

H. 3.9, Th. 0.6 cm

CONDITION: Many flat, straight fragments reconstructed as a long narrow strip. Beautiful execution and perfect preservation. Fine white fabric (used in reserve). Glaze colors include bright yellow and grass green. Dark purple manganese is used for the background and for the outlines of the design. Very thin clear glaze over the entire surface.

DESCRIPTION: The design resembles a jeweled border with alternating concentric circles and concentric rectangles. The motif is somewhat analogous to the bead-and-reel design of a classical architrave.

LITERATURE: Sgalitzer (Ettinghausen), "Baukeramik," 48, no. 6, pl. XIII, 3; Ettinghausen, "Byzantine Tiles," 80–81, pl. XXXI, 1c; Megaw, "Byzantine Pottery," 103, fig. 308. E.S.E.

X.3 Paired Leaves[1]

Istanbul, Arkeoloji Müzeleri, 6425b P.T.

H. 18.2, Th. 0.6–0.7 cm

CONDITION: Many fragments reconstructed as a long convex plaque. The plaque has unusually large dimensions. Very fine monumental design and execution in perfect state of preservation, with original high gloss of glazes intact. Polished white fabric in reserve. Glaze colors include bright yellow and bluish grass green. Dark manganese purple glaze is used as a background color and for outlines. Very thin clear glaze over the entire surface.

DESCRIPTION: The design consists of stylized flaring leaves with seven or eight petals connected by a large loop. The volutes on the upper part are framed by a wide curved yellow background and are completely surrounded by a broad curving band as outline. Two scrolling helices are in the spandrels between the volutes. Directed downward between the leaf units are also two large confronted scrolling helices from which grape clusters on long stalks emanate.

COMPARISONS: Athens, Benaki Museum (cat. D.3). See also Topkapı Sarayı Basilica (cat. XII.15); Nicaea, Koimesis church (cat. XVIII); Baltimore, Walters Art Museum (cat. A.62); Sèvres, Musée national de Céramique (cat. C.18).

LITERATURE: Sgalitzer (Ettinghausen), "Baukeramik," 58, no. 36, pl. XIII, 2; Ettinghausen, "Byzantine Tiles," 80, pl. XXXI, 1b; Megaw, "Byzantine Pottery," 103, fig. 308, middle section.

1 Due to the representation of rounded leaves, I identify this plant as a palmette. E.S.E.

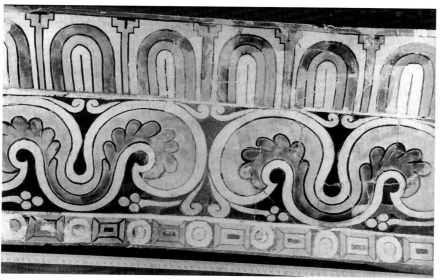

X.1

X.3

X.2

XI
Saint Polyeuktos

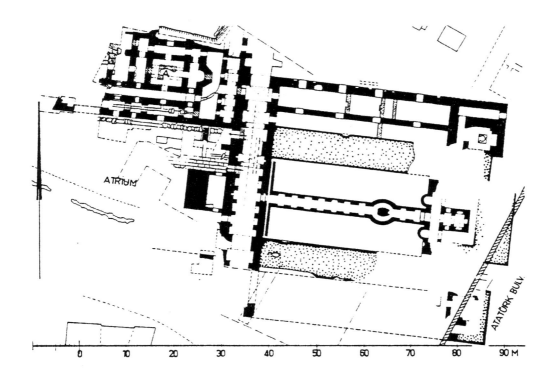

The church of Saint Polyeuktos was built in the early sixth century by Anicia Juliana beside her palace in the Constantianae quarter (modern Saraçhane) of the capital. Little is subsequently known of the church from written sources, aside from two attestations in the tenth century: it was included in an imperial itinerary of the *Book of Ceremonies,* and the text of an epigram inscribed on its walls was copied in the Palatine Anthology.

The accidental discovery in 1960 of marble blocks bearing verses of this epigram led to the excavation of the church in 1964–69 by R. M. Harrison and N. Fıratlı.[1] The excavations exposed the substructures of an enormous church and elements of its lavish decoration, including elaborately carved and inlaid sculpture. The archaeological record throws less light on the church's later history. There was evidence of possible squatter occupation in the atrium, which became a cemetery in the twelfth century. The church was in ruins by 1204, when the Pilastri Acritani and other sculptures were removed to Venice.

A total of about twenty tile fragments were found in the course of the excavations, of which three are included in the published catalogue of finds. According to J. Hayes, who studied the ceramic finds from the site, "It should be stressed that none of the tile fragments can be directly associated with the church itself; the lack of 'repeats,' the fact that most came from randomly dumped fills, and their overall rarity all point to their having adorned *other* buildings."[2]

1 Harrison, *Saraçhane;* R. M. Harrison, *A Temple for Byzantium* (London, 1989); Müller-Wiener, *Bildlexikon,* 190–92, figs. 203–6.

2 Hayes, *Saraçhane,* 35; see also 37, 228, pl. 8f, g, i, j.

MARLIA MUNDELL MANGO

XI.1 Lattice

Present Location Unknown
M.P.H. 6.6, M.P.W. 14.1 cm

FINDSPOT: Found during excavation of "later contexts"; not directly associated with the church.

CONDITION: Fragment of an oblong convex tile; single straight edge preserved.

DESCRIPTION: Decorated with a pattern of amber diamonds banded in green and enclosing green rosettes. The junctions are adorned either with an amber circle enclosing a green disk or with a black-and-white rosette.

COMPARISONS: Constantine Lips (cat. VI.13); Myrelaion (cat. VII.7); Zeuxippos Baths (cat. XIII.5).

LITERATURE: Hayes, *Saraçhane,* 228, pl. 8f. M.P.

XI.1

XI.2 Circle with Diamond

Present Location Unknown
M.P.H. 8.4, M.P.W. 9.9 cm

FINDSPOT: Found during excavation of "later contexts"; not directly associated with the church.

CONDITION: Fragment of a flat tile; single straight edge preserved.

DESCRIPTION: Decorated with a large-scale pattern in black, amber, and green with black outlines.

LITERATURE: Hayes, *Saraçhane,* 228, pl. 8i. M.P.

XI.2

XI.3 Circle with Floral Motif

Present Location Unknown
M.P.H. 5.1, M.P.W. 7.8 cm

FINDSPOT: Found during excavation of "later contexts"; not directly associated with the church.

CONDITION: Fragment of a convex tile; no straight edges preserved.

DESCRIPTION: Decorated with an amber-and-blue foliate pattern on a white-reserve ground. Part of a green leaf outside the circle, on a blue background.

LITERATURE: Hayes, *Saraçhane,* 228, pl. 8j. M.P.

XI.3

XII
Topkapı Sarayı Basilica

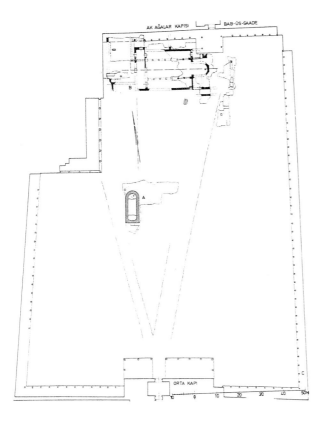

Excavations of the Topkapı Sarayı Basilica, located in the second court of the Topkapı Sarayı near the Bab-ül Saadet (Gate of Felicity), were initiated by Aziz Oğan, Director of the Istanbul Archaeological Museum, under the aegis of the Türk Tarih Kurumu (Turkish Historical Society). The excavations were carried out in September–October 1937 by Professor Helmuth T. Bossert, Chair of the Department of Near Eastern Archaeology at Istanbul University, together with his students.[1] After the conclusion of the investigations, the area was filled in again. The limited excavations revealed a small three-aisled basilica, which has been dated by scholars to the fifth century.[2] The original dedication of the church is unknown.[3] In addition to architectural components, the excavation uncovered bits of fresco decoration, tesserae from wall mosaics,[4] and numerous fragments of poly-chrome tiles.[5] The tiles were found in the northern part of the apse, at the east end of the south aisle (partly within twin graves), at the east end of the north aisle, and within

some rooms of the monastic buildings contiguous to the east end of the south aisle.[6]

The tiles from the Topkapı Sarayı Basilica include pieces curved in section, arched components, as well as several colonnettes, half-capitals, and bases. In all likeli-hood, they were added to the basilica's decoration in the tenth century and were probably intended for use on a medieval templon screen. In addition, the tiles may have served as accents on walls, as frames for individual icons or carved plaques, and possibly also as ornaments for spe-cial features, like the ciborium or sepulchral monuments. The presence of figural tiles, one pierced with a hole after its manufacture, suggests that some works may have func-tioned as portative objects. The presence of several flawed pieces may indicate that the tiles were produced nearby for use in this building.

1 The author thanks the late Professor Bossert and the authorities of the Istanbul Archaeological Museum for their generous permission to study and publish the tiles from the Topkapı Sarayı Basilica. For the excavation, see the unpublished notes in H. T. Bossert, *Topkapı Sarayı Müzesindeki Hafriyat Notları, Günün Kağıtları, Dıkte ettiren;* Bossert, "Istanbul Exca-vations," 240ff.; Oğan, "Les fouilles," 317–35; A. M. Schneider, "Grabung im Hof des Topkapı Sarayı," *AA* 54 (1939), 179–82; E. Mamboury, "Deux-ième cour du Sérail (1937)," *Byzantion* 13 (1938), 305–6; Sgalitzer (Etting-hausen), "Baukeramik"; E. Mamboury, "1937—Fouilles dans la 2e cour du Sérail," *Byzantion* 21 (1951) 426–27; Ettinghausen, "Byzantine Tiles," 79–88; Mathews, *Early Churches,* 33–39; U. Peschlow, review of Mathews, *Early Churches, JSAH* 33 (1974), 85; Müller-Wiener, *Bildlexikon,* 74–75.
2 For the mid-fifth century, see Schneider, "Grabung im Hof des Topkapı Sarayı," 181; Mathews, *Early Churches,* 35. Mamboury, "1937—Fouilles dans la 2e cour," 427, suggests the first half of the fifth century. For the sec-ond half of the fifth century, see Bossert, "Istanbul Excavations," 240ff.; Oğan, "Les fouilles," 333; Schneider, "Grabung im Hof des Topkapı Sarayı," 181.
3 Peschlow has suggested that the church was originally dedicated to Saint Paul and that it may have been built by the emperor Justin II (review of Mathews, *Early Churches,* 85). Schneider, reviewing post-Byzantine reports, suggests that it could have been a convent church and refers to trav-elers' reports of several churches in the area ("Grabung im Hof des Top-kapı Sarayı," 181).
4 Mamboury's statement ("1937—Fouilles dans la 2e cour," 427) that there were no mosaics is inaccurate.
5 Bossert, "Istanbul Excavations," 240ff.; Oğan, "Les fouilles," 334, did not consider them as significant, but devoted pls. LXXVIII–LXXXI to them; Sgal-itzer (Ettinghausen), "Baukeramik," 34–86, pls. I–XXIX; Ettinghausen, "Byzantine Tiles," 79–88.
6 Sgalitzer (Ettinghausen), "Baukeramik," 37.

ELIZABETH S. ETTINGHAUSEN

XII.1 Plaque with Virgin and Child

Istanbul, Arkeoloji Müzeleri, 6170 P.T.
M.P.H. 6.1, M.P.W. 11.0, Th. 0.9 cm

CONDITION: Single fragment of a figural tile with preserved edge at one point along upper surface. Glaze colors include aubergine, amber, and copper green. A thin, slightly yellowish glaze covers the surface. Highlights for the flesh are added in a thin wash of pink slip. Drawing and inscriptions executed in a fine black line. The hole drilled through the upper section of the tile is secondary.

DESCRIPTION: At the center of the plaque is the representation of the Virgin and Child, probably of the Hodegetria type. Both figures are depicted (most likely) in half-length on a pale golden yellow background encircled by a wide green band. To either side of the Virgin's head are the Greek abbreviations for Mother of God (MHP ΘY). Only a fraction of Christ's cross nimbus is preserved. The Virgin wears a white head cover and a dark blue-aubergine *maphorion* trimmed in amber. The cloth falls in soft folds around her face. Her head inclines toward the Child, yet her penetrating soft gaze, expressing understanding and compassion, is directed beyond the viewer. The Virgin's long nose is highlighted in pink, as are her cheeks.[1]

LITERATURE: Bossert, "Istanbul Excavations," fig. 37; Oğan, "Les fouilles," pl. LXXX, fig. 16; Sgalitzer (Ettinghausen), "Baukeramik," 43, pl. I, 1; Ettinghausen, "Byzantine Tiles," 82–83, pl. XXXVI, 1; *AMY* 6 (1965), 105–6, fig. 8.

1 Pink slip was commonly used on Byzantine figural tiles for modeling and highlights. See, for example, cat. A.4. For the use of pink highlights in Bulgarian tiles, see Miatev, *Keramik,* 16, pl. XX, nos. 3, 4. E.S.E.

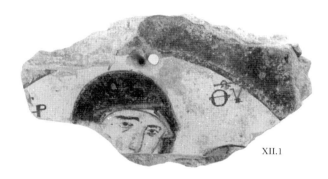

XII.1

XII.2

XII.2 Plaque with Orans Figure

Istanbul, Arkeoloji Müzeleri, inv. no. unknown
M.P.H. 2.75, M.P.W. 5.0, Th. 0.5 cm
[Reconstructed as a full-length figure, the tile would measure 11.0–12.0 × 18.0 cm]

CONDITION: Single preserved fragment, curved lengthwise. Beveled edge preserved on the left side. Finely granular and slightly pinkish fabric. Glaze colors include white, clear yellow (at lower left break), and light copper green. Pink slip is used for modeling of hand. Purple-black (iron oxide) outlines used to paint figure.

DESCRIPTION: The tile represents a single figure whose hands are raised in prayer. Only the raised right hand, the white sleeve, and a small section of the light copper green robe are preserved. Figural tiles with curved profiles are unusual; a second example, from a different workshop, survives in a private collection (cat. J.1).

LITERATURE: Sgalitzer (Ettinghausen), "Baukeramik," 50, no. a, pl. I, 2; Ettinghausen, "Byzantine Tiles" 83, pl. XXXVI, 2. E.S.E.

XII.3 Jeweled Band

Istanbul, Arkeoloji Müzeleri, 6159, 6181, 6182 P.T.
H. 3.8, Th. 0.55–0.65 cm

CONDITION: Numerous fragments reconstructed in three flat strips. White fabric. Glaze colors include amber, copper green, dark manganese (both as an area color and for outlines).

DESCRIPTION: Design is formed from four identical concentric circles, arranged two over two, alternating with three concentric rectangles.

COMPARISONS: Kyriotissa (cat. V.1); Constantine Lips (cat. VI.6); Sèvres, Musée national de Céramique (cat. C.29).

LITERATURE: Oğan, "Les fouilles," pl. LXXIX, fig. 14, left; Sgalitzer (Ettinghausen), "Baukeramik," 48, no. 9, pl. XXII, 1. E.S.E.

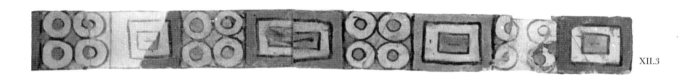

XII.3

XII.4 Shell

Istanbul, Arkeoloji Müzeleri, 6157, 6171, 6172, 6174, 6179, 6180 P.T.
H. 8.2–8.6, Th. 0.55–0.65 cm (6157, 6171, 6174, 6180 P.T.)
H. 7.5 cm (6179 P.T.)

CONDITION: Many concave fragments reconstructed as six plaques. Pale fabric in reserve. Glaze colors include amber and copper green. Design executed in black outline.

DESCRIPTION: Very stylized and somewhat altered egg-and-dart motif of a shell- or (Amazon) shieldlike shape with inscribed dotted ovals, representing the egg, and interstitial triangles in green glaze, standing for the dart motif. Narrow border strip along upper surface.

COMPARISONS: Constantine Lips (cat. VI.8, VI.9); Myrelaion (cat. VII.2); Mangana (cat. IX.1); Istanbul, Provenance Unknown (cat. XV.9); Sèvres, Musée national de Céramique (cat. C.10, C.35); France, Thierry Collection (cat. H.4).

LITERATURE: Bossert, "Istanbul Excavations," fig. 33, center; Oğan, "Les fouilles," pl. LXXIX, fig. 13, center (shown upside down); Sgalitzer (Ettinghausen), "Baukeramik," 60, no. 1, pl. XXI, 2; Ettinghausen, "Byzantine Tiles," 85, pl. XXXIV, 2.　　E.S.E.

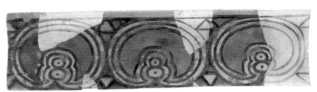

XII.4

XII.5–XII.7 Foliate Half-Circles

This design, called acanthus half-circles in other entries, represents a highly stylized and geometric version of a palmette, with curved leaf bundles growing out of various types of "trunks" or bases and joined to the neighboring bundles by keystonelike strips; there are several variants of the bases out of which the palmette volutes emerge and of the motifs above the bases and under the arches. This design, known to me only from tiles, occurs at the Topkapı Sarayı Basilica in slightly different widths. It is an architecturally conceived vegetal motif. This denatured and stylized concept of representation occurs also in several other tile patterns. The arched motif occurs as a framing border or, more likely, a molding below the apse mosaic of the Virgin and Child in the Koimesis church in Nicaea (cat. XVIII). This placement gives us a concrete indication of the use of the design.　　E.S.E.

XII.6 Foliate Half-Circles

Istanbul, Arkeoloji Müzeleri, inv. no. unknown
(a) H. 6.4, Th. 0.4–0.5 cm
(b) H. 7.3, Th. 0.4–0.5 cm

CONDITION: Single fragment of convex straight tile (a) and seven fragments of an additional tile (b). Carefully executed. Buff-colored fabric. Glaze colors include amber, green, and brick red (slip?) for small accents. Design executed in manganese purple.

DESCRIPTION: The curved leaf bundles grow out of a triangular "trunk" and are joined together by quadruple keystonelike strips (all other varieties of this design have only triple keystonelike strips), with the central ones dotted. Above the "trunks" are checkerboard designs flanked by scrolling helices. Under the arched leaves is a pile of three hatched half-circles. There is a narrow framing strip along the upper edge. The pile of hatched circular figures (under the "arches") occurs also on polychrome vessels.[1]

COMPARISONS: Kyriotissa (cat. V.2); Nicaea, Koimesis church (cat. XVIII); Sèvres, Musée national de Céramique (cat. C.8, C.16).

LITERATURE: Sgalitzer (Ettinghausen), "Baukeramik," 52, no. 7, pl. XVI, 2; Ettinghausen, "Byzantine Tiles," 81, pl. XXXIII, 1.

1 See the decoration of a vessel from Corinth in Morgan, *Byzantine Pottery*, pl. XIIIa.　　E.S.E.

XII.5 Foliate Half-Circles

Istanbul, Arkeoloji Müzeleri, 6164, 6177, 6184 P.T.
H. 6.3–6.4, Th. 0.55–0.65 cm

CONDITION: Several convex arched fragments reconstructed as three tiles. Pale pink fabric. Fine design and execution but in poor condition. Glaze colors include amber, green, and brick red (slip?). Design outlined in black.

DESCRIPTION: Under the half-circle, one large peacock feather with barbs articulated by black lines. The arch is composed of three leaves and has a triple keystone at its center. One variant of the same design has four leaves instead of the usual three. The single peacock motif occurs also in Preslav, albeit entirely by itself.[1]

LITERATURE: Oğan, "Les fouilles," pl. LXXIX, fig. 15, bottom; Sgalitzer (Ettinghausen), "Baukeramik," 59, no. 42, pl. XVII, 1; Fıratlı, *Bizans Eserleri*, fig. 39, bottom.

EXHIBITION: Athens 1964, no. 609.

1 K. Miatev, *L'église ronde de Preslav* (Sofia, 1932), 118 and pl. 200, figs. 4–7, 10.　　E.S.E.

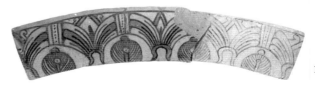

XII.5

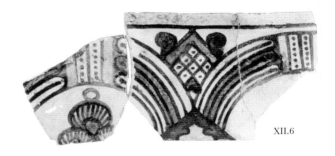

XII.6

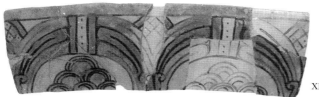

XII.7

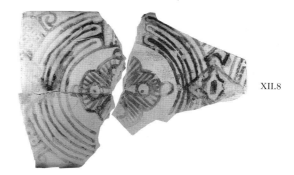

XII.8

XII.7 Foliate Half-Circles

Istanbul, Arkeoloji Müzeleri, 6155, 6173, 6178, 6183 P.T.
H. 8.6–8.8, Th. 0.6–0.7 cm

CONDITION: Several fragments reconstructed as four convex tiles. Pale pink fabric. Glaze colors include amber and green. Design outlined in black. Similar in design to 6177 P.T. (cat. XII.5), but here the palmette leaf bundles grow out of stalks framed by helices.

DESCRIPTION: Three-tiered imbrication motif under three arching leaves. A checkerboard design fills the spandrels of the arches; the small squares are alternately colored and dotted. The presence of helices at the stalks of the arched leaf bundles appears to point more clearly to the origin of this highly stylized pattern as derived from the split-palmette motif and not from an architectural design.

LITERATURE: Oğan, "Les fouilles," pl. LXXIX, fig. 15, bottom; Sgalitzer (Ettinghausen), "Baukeramik," 60, no. 43, pl. XVII, 2; Fıratlı, *Bizans Eserleri*, fig. 39, bottom. E.S.E.

XII.8 Foliate Circle with Rosette

Istanbul, Arkeoloji Müzeleri, 6017, 6026 P.T.
H. 11.6, Th. 0.65–0.7 cm

CONDITION: Seven fragments of a convex straight tile. Very fine execution and colors. White fabric. Glaze colors include light and dark amber, grass to leaf green, and carmine to brick red. The colors run together where they join. The pattern, outlined in manganese brown, is carefully drawn.

DESCRIPTION: While the components of the design are similar to those of the other examples of this type, a different configuration results from opposing two arched leaf bundles, one right side up and the other upside down to create a circular composition. The leaves, which alternate in color between amber and green, enclose a quatrefoil composed of four green-glazed peacock "eyes," each crowned by a red circle. The eyes are connected by a smaller quatrefoil, glazed amber, which assumes a cruciform shape. The leaf-bundle "arches" have "keystones" at the center formed by red exterior bands enclosing white-reserve bands decorated with a vertical row of dots. The design in the spandrels, identical to that on XII.6 (b), consists of green and white-reserve checkerboard decorations flanked by green helices. The circular leaf bundles are fastened together by a lozenge shape, related—when doubled—to the triangular form of the single "arch" of cat. XII.5.

LITERATURE: Sgalitzer (Ettinghausen), "Baukeramik," 52, no. 8, pl. XVI, 1. E.S.E.

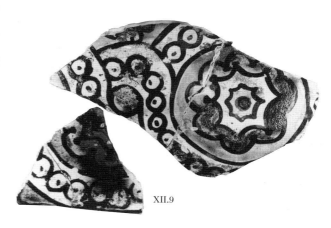

XII.9

XII.9 Looped Circle with Rosette

Istanbul, Arkeoloji Müzeleri, inv. no. unknown
H. 10.5–10.6, Th. 0.5–0.6 cm

CONDITION: Convex plaque reconstructed from eight fragments. Carefully executed fine design in bright and well-preserved colors. White fabric. Glaze colors include yellow and green; sometimes reddish brown used instead of the green. Design executed in manganese purple outline. Wherever grass green (instead of the darker leaf green) is used, the tile appears to be more carefully executed and shows purer colors. One fragment shows defects in the colors (a waster?).

DESCRIPTION: Eight-petaled, triple-layered green rosette within white-reserve loop consisting of two wide bands decorated with a row of nearly circular green-dotted ovals. The large loops alternate with small ones, the latter topped above and below by a split palmette. The background of the tile is glazed yellow.

COMPARISONS: Baltimore, Walters Art Museum (cat. A.55).

LITERATURE: Sgalitzer (Ettinghausen), "Baukeramik," 53, no. 10, pl. XX, 2; Ettinghausen, "Byzantine Tiles," 82, pl. XXXIII, 3; Talbot Rice, "Byzantium and the Islamic World," 199. E.S.E.

XII.10–XII.13 Circle with Four-Petaled Flower

Highly abstracted, confronted split palmettes within large lancet-shaped leaves. Four, positioned diagonally, result in a circular external space; within it and in the interstices are various filler motifs. When two or more plaques are aligned side by side, the continuing design, with several large-leaf motifs, can be read as focused on the flower surrounded by the leaves, or it can be seen as the juncture of four diagonally arranged leaves as the primary focus and the flower and other figures as ancillary motifs. This type of slight ambiguity and the possibility of different interpretations are encountered more often in Islamic art.

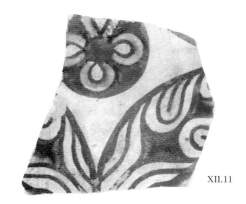

XII.10

XII.10 Circle with Four-Petaled Flower

Istanbul, Arkeoloji Müzeleri, inv. no. unknown
H. 11.8, Th. 0.45–0.55 cm

CONDITION: Two fragments of a convex straight plaque. Fine workmanship and colors. Buff-colored fabric. Glaze colors include amber, grass green, and azure blue (at the center of the rosettes). Design executed in manganese purple outline.

DESCRIPTION: Within the center of the flaring azure blue leaves, a four-petaled flower with small interstitial leaves and four heart-shaped figures (ivy leaves) in the surrounding white-reserve area. Larger green heart-shaped "leaves" decorate the interstices of the flaring leaves. The entire composition is placed on an amber background.

COMPARISONS: Myrelaion (cat. VII.3); Istanbul, Provenance Unknown (cat. XV.7); Baltimore, Walters Art Museum (cat. A.70); Paris, Musée du Louvre (cat. B.13); Sèvres, Musée national de Céramique (cat. C.21, C.22); Athens, Benaki Museum (cat. D.7); France, Thierry Collection (cat. H.5); Preslav, Round church.[1]

LITERATURE: Sgalitzer (Ettinghausen), "Baukeramik," 56, no. 25, pl. X, 1; Ettinghausen, "Byzantine Tiles," 81, pl. XXXIII, 2.

1 Miatev, *L'église ronde,* 128, fig. 221, 7; 141, fig. 244; 151, fig. 261, 3. E.S.E.

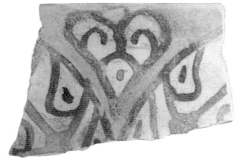

XII.11

XII.12

XII.11 Circle with Four-Petaled Flower

Istanbul, Arkeoloji Müzeleri, inv. no. unknown
Th. 0.45 cm

CONDITION: Single fragment of convex straight plaque. Buff-colored fabric. Glaze colors include amber, grass green, and azure blue. Design executed in manganese purple outline.

DESCRIPTION: Within the center of the blue-and-green lancet-shaped leaves is a four-petaled rosette in green and amber on a manganese medallion set against a white ground.

LITERATURE: Sgalitzer (Ettinghausen), "Baukeramik," 56, no. 26, pl. XI, 1. E.S.E.

XII.12 Circle with Four-Petaled Flower

Istanbul, Arkeoloji Müzeleri, inv. no. unknown
H. 10.0, Th. 0.6 cm

CONDITION: Single fragment of convex straight plaque. Buff-colored fabric. Glaze colors include amber and grass green. Design executed in blackish brown outline.

DESCRIPTION: Partially preserved lancet-shaped leaves with heart-shaped leaflet in the interstices. The leaflet is divided into decorative compartments.

COMPARISONS: Istanbul, Provenance Unknown (cat. XV.7).

LITERATURE: Sgalitzer (Ettinghausen), "Baukeramik," 56, no. 27, pl. X, 2. E.S.E.

XII.13 Depressed Circle with Four-Petaled Flower

Istanbul, Arkeoloji Müzeleri, inv. no. unknown
(a) H. 10.0, Th. 0.4–0.5 cm
(b) H. 11.0, Th. 0.4–0.5 cm

CONDITION: Three fragments of a concave arched tile; seven fragments of a second tile. Rather crude execution, thick application of colors. Glaze colors include amber and green. Design is executed in blackish brown outline.

DESCRIPTION: The fragments show the same motif as on the straight convex plaques, but with extra-long, diagonally arranged, lancet-shaped leaves; in the oval central area is a large four-petaled flower with interstitial petals. In the spandrels between the large leaves is a trefoil design. A strip at the upper border is decorated with a row of contiguous lozenges. The second tile displays the identical decoration, but its border is wider and has two rows of joined lozenges.

LITERATURE: Sgalitzer (Ettinghausen), "Baukeramik," 61, no. 5, pl. VIII, 2; 62, no. 6, pl. IX, 1. E.S.E.

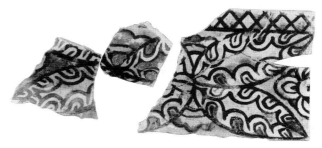

XII.13

XII.14 Circles with Cross-in-Square

Istanbul, Arkeoloji Müzeleri, inv. no. unknown
H. 2.4, Th. 0.5–0.55 cm

CONDITION: Fragments of narrow flat strips. Fine workmanship. White fabric. Glaze colors include brick red and light grass green. Purplish black is used to outline the design.

DESCRIPTION: The fragments are decorated with a row of white circles with inscribed red lozenges, some divided into quarters. The background of the tile is glazed green.

LITERATURE: Sgalitzer (Ettinghausen), "Baukeramik," 48, no. 4, pl. XXII, 6. E.S.E.

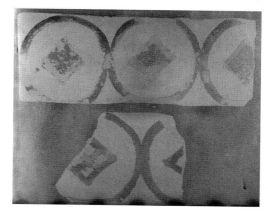

XII.14

XII.15 Paired Leaves

Istanbul, Arkeoloji Müzeleri, 6166 P.T.
H. 11.5, Th. 0.5–0.6 cm

CONDITION: Several fragments reconstructed as a concave straight tile. The tile is in poor condition. Buff-colored fabric (used within design in reserve). Glaze colors include amber and dull green. Manganese purple is used as a filler and for outlines of design.

DESCRIPTION: The design is closely related to the central motif of the cornice from Saint John Stoudios (cat. X.3). The Topkapı tile is much narrower, and its execution poorer, with less pure colors. One could perhaps call it a less refined imitation of a finer paradigm. Connected palmette volutes framed by a broad band and narrow edging; interstitial, downward-facing, three-petaled motif framed by broad helices; some ornamental hatching.

COMPARISONS: Saint John Stoudios (cat. X.3); Nicaea, Koimesis Church (cat. XVIII); Baltimore, Walters Art Museum (cat. A.62); Sèvres, Musée national de Céramique (cat. C.18); Athens, Benaki Museum (cat. D.3).

LITERATURE: Oğan, "Les fouilles," pl. LXXVIII, fig. 11, second from the top (the picture is upside down); Sgalitzer (Ettinghausen), "Baukeramik," 58, no. 35, pl. XII, 3. E.S.E.

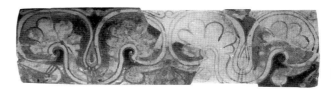

XII.15

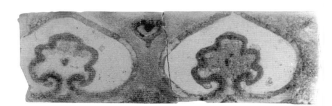

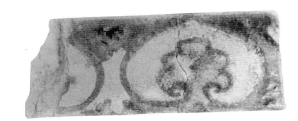

XII.16

XII.16 Hearts with Five-Pointed Leaves

Istanbul, Arkeoloji Müzeleri, inv. no. unknown
H. 2.3, Th. 0.5–0.55 cm

CONDITION: Thirteen fragments of a strip. Some fragments are unfinished or have defects to the outline or glaze. Glaze colors include amber, copper green, azure blue, and aubergine-black outlines. The well-polished white fabric is used in reserve in the design.

DESCRIPTION: Series of leaves within heart-shaped frames. There is a heart-shaped leaflet between each motif along the upper edge of the tile.

LITERATURE: Sgalitzer (Ettinghausen), "Baukeramik," 49, no. 12, pl. XI, 3.

E.S.E.

XII.17

XII.17 Hearts with Split Five-Pointed Leaves

Istanbul, Arkeoloji Müzeleri, inv. no. unknown
H. 5.0–5.1, Th. 0.45–0.5 cm

CONDITION: Five fragments of a concave straight tile. White fabric. Outlines in black. Glaze colors include amber, green, and dark turquoise.

DESCRIPTION: Within broad bands, elongated three-lobed split leaves on a turquoise blue background. In the interstices between individual units, a five-lobed floral motif glazed amber on a green ground. A narrow green strip runs along the upper border. The white-reserve bands, which follow the curved form of the leaf, are connected by square tabs that are glazed amber. Similar tabs are found on a group of figural plaques in the Walters Art Museum (cat. A.19–A.21).

LITERATURE: Sgalitzer (Ettinghausen), "Baukeramik," 57, no. 29, pl. XII, 1.

E.S.E.

XII.18

XII.18 Foliate Volutes

Istanbul, Arkeoloji Müzeleri, inv. no. unknown
Th. 0.5 cm

CONDITION: Single concave fragment of a straight tile. Fine design and execution but in a poor state of preservation. Glaze colors include amber, green, and brick red. Outlines in brownish black.

DESCRIPTION: Too fragmentary to be reconstructed, but probably a broad volute composition.

LITERATURE: Sgalitzer (Ettinghausen), "Baukeramik," 57, no. 34, pl. XIV, 2.

E.S.E.

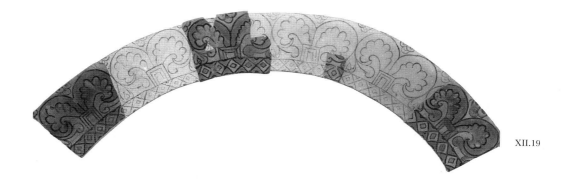

XII.19

XII.19 Paired Leaves and Concentric Lozenges

Istanbul, Arkeoloji Müzeleri, 6156 P.T.
H. 9.0, Th. 0.45–0.55 cm

CONDITION: Many fragments reconstructed as arched concave plaque; additional fragment. Fine workmanship. Design outlined in black. Glaze colors include amber and green.

DESCRIPTION: On a high rectangular base, perhaps meant as a stem but looking like a decorated flower pot, a flaring palmette framed by a broad curved band. At the upper edge of the tile, between the split volutes, are triple imbrications. In the lower interstices, between the main compositions, directed downward, a heart-shaped calyx framed by elongated scrolling helices. At lower edge of the plaque is a border strip with a row of joined concentric lozenges.

COMPARISONS: Zeuxippos Baths (cat. XIII.6); Preslav.[1]

LITERATURE: Oğan, "Les fouilles," pl. LXXIX, fig. 13, top; Sgalitzer (Ettinghausen), "Baukeramik," 62, no. 8, pl. XIV; Ettinghausen, "Byzantine Tiles," pl. XXXIV, 1; Fıratlı, *Bizans Eserleri*, fig. 39, top.

1 Miatev, *Keramik*, fig. 80k. E.S.E.

XII.20 Heart with Five-Pointed Leaves and Flower

Istanbul, Arkeoloji Müzeleri, inv. no. unknown
H. 8.0–8.5, Th. 0.5–0.55 cm

CONDITION: Two partially reconstructed convex fragments. Fine workmanship and colors, good preservation, but fragmentary. White fabric. Glaze colors include amber, grass green, and azure blue. Brick red slip used for accents. Design executed in black outline.

DESCRIPTION: Elaborate leaves descend from a curved stalk. A five-lobed flower(?) in white reserve emerges from the dividing point of the stalk. A small disk, in azure blue, counterbalances the flower at the lower division of the stalks. The background of the tile is glazed amber.

LITERATURE: Sgalitzer (Ettinghausen), "Baukeramik," 57, no. 32, pl. XII, 2. E.S.E.

XII.21 Circle with Four-Petaled Flower

Istanbul, Arkeoloji Müzeleri, 6161, 6175 P.T.
H. 10.1–10.2, Th. 0.55–0.65 cm

CONDITION: Many fragments reconstructed as two arched and concave plaques. Pinkish fabric. Glaze colors include amber and leaf green. Design executed in black outline.

DESCRIPTION: Large elongated four-petaled triple rosettes with a dotted circular medallion at each center. Each rosette is framed by curving trefoils that consist of a round central petal flanked by two pointed outer leaves. The opposed trefoils are joined at the center of the plaque by a small circle.

LITERATURE: Oğan, "Les fouilles," pl. LXXIX, fig. 14, bottom; Sgalitzer (Ettinghausen), "Baukeramik," 62, no. 7, pl. V, 1. E.S.E.

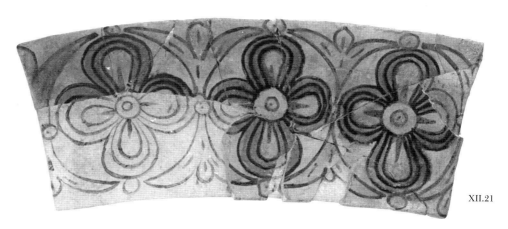

XII.20

XII.21

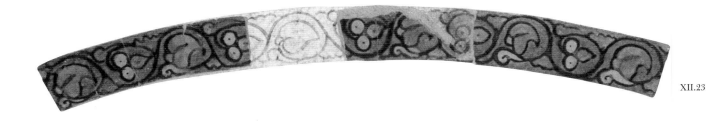

XII.23

XII.22 Ivy Leaf with Grape Clusters

Istanbul, Arkeoloji Müzeleri, inv. no. unknown
H. 2.4, Th. 0.6 cm

CONDITION: Single fragment of straight narrow strip. Slightly
pink fabric. Fine workmanship. Glaze colors include dark amber,
green, and brick red; outline in blackish brown (iron oxide).

DESCRIPTION: Design is formed from alternating grape clusters
and ivy leaves with trefoils in the interstices.

COMPARISONS: Kyriotissa (cat. V.6); Myrelaion (cat. VII.5); Saint
Euphemia (cat. VIII.2); Paris, Musée du Louvre (cat. B.14); Sèvres,
Musée national de Céramique (cat. C.31–C.33).

LITERATURE: Sgalitzer (Ettinghausen), "Baukeramik," 49, no. 13,
pl. XIX, 3. E.S.E.

XII.23 Ivy Leaf with Grape Clusters

Istanbul, Arkeoloji Müzeleri, 6162, 6165 P.T.
H. 3.6–3.8, Th. 0.65–0.7 cm

CONDITION: Several fragments reconstructed as two arched
strips. Good preservation. Buff-colored fabric. Glaze colors include
amber (as the background color) and copper green. Outline in black-
ish brown (iron oxide). The use of amber as a background color is
unusual but very effective.[1]

DESCRIPTION: The fragments are closely related in terms of
design to the flat straight strips but are slightly wider and arched, as
well as slightly more elaborate with the addition of scrolling helices.

LITERATURE: Oğan, "Les fouilles," pl. LXXVIII, fig. 11, top; Sga-
litzer (Ettinghausen), "Baukeramik," 49, no. 15, pl. XIX, 5; Etting-
hausen, "Byzantine Tiles," pl. XXXIV, 3.

EXHIBITION: Athens 1964, no. 611 (6162 P.T.).

1 The use of dark amber or light brown as a background color occurs also in
 tiles found at Patleina (here with small leaf-and-ball motifs). See Talbot
 Rice, *Glazed Pottery*, pls. IV, V. E.S.E.

XII.24 Circle with Disk and Guilloche

Istanbul, Arkeoloji Müzeleri, inv. no. unknown
H. 10, Th. 0.5 cm

CONDITION: Twelve concave fragments of oblong straight tile.
Fine execution. Glaze colors include bright amber and light green;
thin clear glaze over entire surface. Design executed in black outline.

DESCRIPTION: Decorated with repeated pattern of a rosette within
three frames, the latter consisting of an amber outer circle, an eight-
pointed starlike green roundel, and an inner circle containing a
rosette on a black ground. The framed rosette, composed of six
white-reserve circular petals around a green core, alternates with
calyces, which face in opposite directions and are joined at their ends
by a dotted circle in the middle of the tile. The framing strip has an
amber guilloche design on a green ground. The color and technique
are similar to those on tiles from Saint John Stoudios (cat. X).

LITERATURE: Sgalitzer (Ettinghausen), "Baukeramik," 61, no. 3,
pl. V, 2. E.S.E.

XII.22

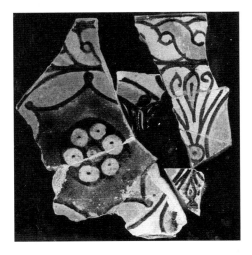

XII.24

XII.25 Quatrefoil

Istanbul, Arkeoloji Müzeleri, inv. no. unknown

H. 2.6, Th. 0.5–0.6 cm

CONDITION: Three fragments of a flat narrow strip. White fabric. Glaze colors include amber, green, and azure blue. Outlines in black. Slightly greenish tinge on the amber glaze from the green having run into it. The presence of blue may indicate a more precious and, therefore, more carefully executed piece.

DESCRIPTION: Repeated design of azure blue four-lobed motifs enclosed within amber lozenges. The background is glazed green.

LITERATURE: Sgalitzer (Ettinghausen), "Baukeramik," 49, no. 10, pl. XXI, 5. E.S.E.

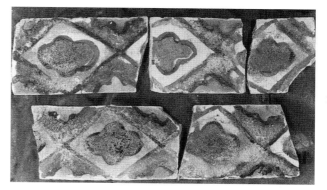

XII.25

XII.26 Quatrefoil

Istanbul, Arkeoloji Müzeleri, inv. no. unknown

H. 3.8–4.0, Th. 0.45–0.55 cm

CONDITION: Sixteen fragments of a narrow flat strip. Off-white fabric. Glaze colors include amber and dull green. Outlines in brownish black. Less fine fabric suggests restricted use.

DESCRIPTION: Design is formed by alternating amber and green four-lobed motifs within white reserve and green lozenges.

LITERATURE: Sgalitzer (Ettinghausen), "Baukeramik," 49, no. 11, pl. XXI, 4. E.S.E.

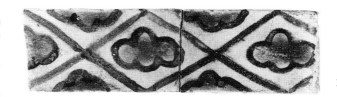

XII.26

XII.27 Circle with Rosette

Istanbul, Arkeoloji Müzeleri, inv. no. unknown

H. 11.0, Th. 0.5–0.55 cm

CONDITION: Twenty-six convex fragments, some joined to form a rectangular tile. White fabric. Fine workmanship. Glaze colors include amber, light green, and azure blue. Design is drawn in blackish brown outlines.

DESCRIPTION: Repeated pattern of eight-petaled rosettes within circular bands interconnected by a broad dotted ribbon with trefoils above and below it.

COMPARISONS: Istanbul, Provenance Unknown (cat. XV.4).

LITERATURE: Sgalitzer (Ettinghausen), "Baukeramik," 55, no. 21, pl. VI, 3; Ettinghausen, "Byzantine Tiles," 81–82, pl. XXXI, 2. E.S.E.

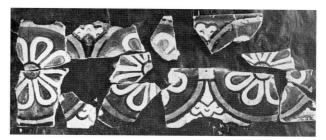

XII.27

XII.28 Circle with Rosette

Istanbul, Arkeoloji Müzeleri, inv. no. unknown

Est. H. 9.8, Th. 0.5–0.6 cm

CONDITION: Single convex fragment. Colors include buff-colored fabric in reserve, deep amber, and dull green. Design is drawn in dark manganese outlines.

DESCRIPTION: Eight-petaled rosette within a circle. The rest of the pattern cannot be reconstructed.

LITERATURE: Sgalitzer (Ettinghausen), "Baukeramik," 55, no. 19, pl. VI, 2. E.S.E.

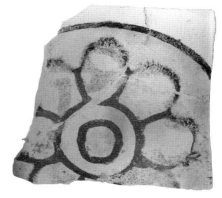

XII.28

XII.29 Circle with Rosette

Istanbul, Arkeoloji Müzeleri, inv. no. unknown

H. 9.5, Th. 0.7–0.8 cm

CONDITION: Single straight concave fragment. Very fine execution and color scheme. Thicker body than usual. Reddish fabric (similar to that on fragments associated with architectural elements). Glaze colors include light chestnut brown (amber?) and green. Design executed in black outline.

DESCRIPTION: Tile is decorated with an amber-and-green eight-petaled rosette within a circular frame alternating with green trefoil motifs. Upper border strip has a meander pattern in light brown on a black background.

LITERATURE: Sgalitzer (Ettinghausen), "Baukeramik," 61, no. 4, pl. VII, 1. E.S.E.

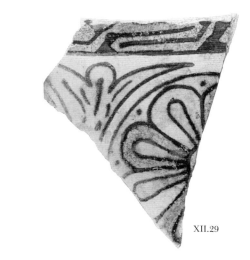

XII.29

XII.30 Half-Circle with Half-Rosette

Istanbul, Arkeoloji Müzeleri, 6158 (arched), 6163 P.T. (straight)

H. 6.3–6.5, Th. 0.55–0.66 cm

CONDITION: Eleven fragments of convex straight tile and multiple fragments of arched tiles with buff-colored fabric. Glaze colors include amber and green. Manganese purple used both as filler and as outline.

DESCRIPTION: Six- or seven-petaled half-rosettes with a thick dark vein at the center of each petal. The petals alternate in color between amber and white reserve. The rosettes are enclosed by a white-reserve band, outlined in amber, that contains a string of connected lozenges. A green heart-shaped calyx decorates the spandrels between the arched bands. A narrow framing strip at the top of the tile is glazed green. The background of the tile is painted in with manganese purple.

LITERATURE: Oğan, "Les fouilles," pl. LXXIV, figs. 13, bottom (upside down), and 15, center; Sgalitzer (Ettinghausen), "Baukeramik," 58, no. 38, pl. XIV, 4; 60, no. 44, pl. XV, 1; Fıratlı, *Bizans Eserleri*, pl. XVI, fig. 39, second from bottom. E.S.E.

XII.30

XII.31 Heart with Five-Pointed Leaf

Istanbul, Arkeoloji Müzeleri, inv. no. unknown

H. 6.5, Th. 0.4–0.45 cm

CONDITION: Single convex fragment. Fine workmanship and colors. White fabric. Glaze colors include clear bright yellow, grass green, and azure blue. Design executed in manganese purple outline.

DESCRIPTION: Decorated with an azure blue leaf with five irregularly shaped points. The green framing band, which follows the curving contour of the leaf, is held in place by an amber "knot" at the base of the plant form.

LITERATURE: Sgalitzer (Ettinghausen), "Baukeramik," 57, no. 31, pl. XI, 4. E.S.E.

XII.31

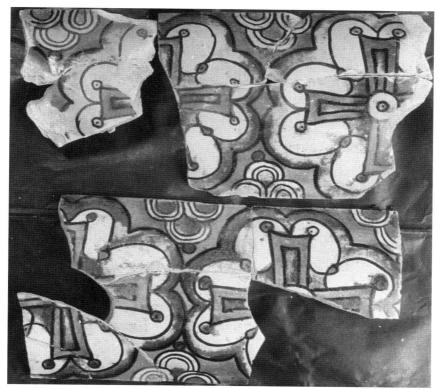

XII.32 Cross

Istanbul, Arkeoloji Müzeleri, 6176 P.T.

H. 11.1, W. 23.0, Th. 0.6 cm

CONDITION: Approximately twenty fragments of several rectangular convex tiles, some of which can be reconstructed to provide the complete design and dimensions. White fabric. Glaze colors include amber and green. The design is carefully executed in black-purple lines.

DESCRIPTION: The tile is decorated with a repeating pattern of crosses, formed of amber and green bands with a green medallion at the center. The terminal points of the slightly flaring arms are ornamented with green circular serifs in imitation of metalwork. Dotted concentric circles also adorn the lobed, green connecting links between the arms. Each cross is enclosed within a white lobed field that is outlined by a green band; at the rim of the plaque are triple imbrications—a much favored filler motif on tiles from the Topkapı Sarayı Basilica. On the reverse side of the single numbered fragment is the sketch of a figure under a transparent glaze. Executed in light purple, the figure wears a short tunic and holds an unidentifiable object in his folded arms (the tile is broken at this point). The drawing technique, with linear modeling, suggests that the painter also worked on figural representations.

LITERATURE: Sgalitzer (Ettinghausen), "Baukeramik," 53, no. 11, pl. I, 5; pl. IV, 1; Ettinghausen, "Byzantine Tiles," 82, pl. XXXV, 2.

E.S.E.

XII.32 back

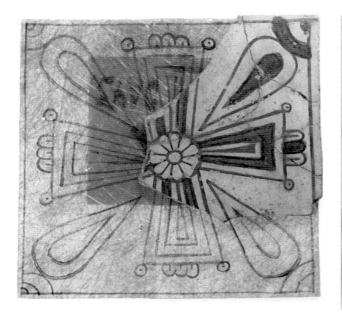 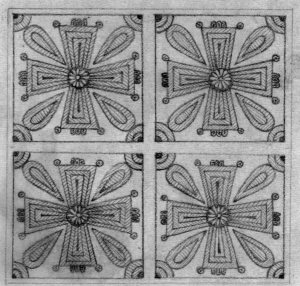

XII.33

XII.33 Cross

Istanbul, Arkeoloji Müzeleri, 6167 P.T.

H. 18.65, W. 18.65, Th. 0.65 cm (reconstructed dimensions)

CONDITION: Section of a flat plaque with a stylized foliate cross. White fabric. The execution is rather careless. Glaze colors include amber and copper green. The copper green is poorly preserved. The design is painted in thick black lines (iron oxide). A thin clear glaze covers the whole body. The tile was not very well restored and is now quite irregular.

DESCRIPTION: An eleven-petaled rosette forms the central medallion of the cross. Three small petals or loops decorate the ends of its slightly flaring arms. Each arm is subdivided into concentric segments of green and amber. Small dotted circles, in imitation of the rounded serifs that often decorate metal crosses, are added at the corners of each cross arm.[1] Large tear-shaped leaves, glazed in amber and green, are located between each arm and are attached to concentric quarter-circles in the corners of the plaque. The plaque is framed by a narrow green border. A related, smaller piece was available in the bazaar in Istanbul in the late 1930s (cat. XV.8).

Although the pattern of this tile, as of many others, could have been executed faster and in a more regular fashion with the help of a stencil showing a quarter of the symmetrical design, it was not done this way, as its very irregular execution clearly indicates. The free-hand painting of repeat designs on ceramics is practiced to this day with results ranging from very skillful to poor.

If four of the tiles were put together as two over two (see above right), the corner design of one tile, with an elongated tear-shaped leaf attached to a concentric quarter-circle, would be multiplied four times and would transform into a central medallion of concentric circles with four pointed leaves, a design reminiscent of some examples from Preslav, Bulgaria.[2] Since only one tile fragment is preserved, we cannot say whether a combination, as indicated above, was ever intended or attempted. The placement of one group of the Walters figural tiles (cat. A.20, A.21) suggests that painters did conceive of the decoration as spreading over several tiles.

COMPARISONS: Baltimore, Walters Art Museum (cat. A.31).

LITERATURE: Oğan, "Les fouilles," pl. LXXVIII, fig. 11, bottom left; Sgalitzer (Ettinghausen), "Baukeramik," 46, no. 1, pl. III, 1; Ettinghausen, "Byzantine Tiles," 82, pl. XXXV, 1b.

EXHIBITION: Athens 1964, no. 603.

1 For a selection of metal crosses displaying similar characteristics, see J. A. Cotsonis, *Byzantine Figural Processional Crosses*, ed. S. A. Boyd and H. Maguire (Washington, D.C., 1994).

2 Miatev, *L'église ronde*, pls. 200, no. 2, and 261, no. 2. E.S.E.

XII.34 Cross

Istanbul, Arkeoloji Müzeleri, 6168 P.T.

H. 20.0–20.5, W. 13.4, Th. 0.5–0.55 cm (reconstructed dimensions)

CONDITION: Incomplete tile restored in rectangular format. Single preserved edge. Whitish fabric. Elaborate design drawn in blackish brown lines. Fine execution. Glaze colors include amber and copper green. Judging from the design, the original plaque may have been square.

DESCRIPTION: Foliate cross with three petals between the slightly flared arms. Each petal terminates in a dotted circle. At the end of each arm is a small split palmette. Small dotted circles, in imitation of the rounded serifs that often decorate metal crosses, are added at the corners of each cross arm.[1] At the center of the cross is a medallion formed of an amber core and green surrounding circle. Each arm has a green core banded in amber. The combination of amber and green is reminiscent of processional crosses formed of two contrasting metals—for example, bronze and iron—such as that in the Virginia Museum of Fine Arts in Richmond, dated tenth–twelfth century.[2]

COMPARISONS: Baltimore, Walters Art Museum (cat. A.31).

LITERATURE: Oğan, "Les fouilles," pl. LXXVIII, fig. 11, bottom left; Sgalitzer (Ettinghausen), "Baukeramik," 46, no. 1, pl. III, 1; Ettinghausen, "Byzantine Tiles," 82 and pl. XXXV, 1b.

1 For a selection of metal crosses displaying similar characteristics, see Cotsonis, *Byzantine Figural Processional Crosses*.

2 A. Gonosová and C. Kondoleon, *Art of Late Rome and Byzantium in the Virginia Museum of Fine Arts* (Richmond, 1994), 286–87. E.S.E.

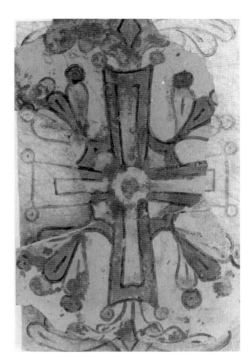

XII.34

XII.35–XII.42 Tiles for Architectural Components

The half-cylindrical tiles were apparently used as covers for attached half-columns. Ceramic bases and capitals were shaped in molds. This technique can be deduced from the uneven thickness and from the fingermarks imprinted on the reverse sides. The technique can also be seen in tiles from Preslav.[1]

1 Totev, "L'atelier," 78, fig. 25.

XII.35 Peacock Feather

Istanbul, Arkeoloji Müzeleri, inv. no. unknown

Est. H. 40.0, W. (circumference) 22.0–24.0, Th. 0.65–0.75 cm

CONDITION: Approximately five fragments and one long piece. Fairly crude execution; poorly preserved. Its size fits well with that of the ceramic bases and capitals from the Topkapı Sarayı Basilica. Colors include white fabric in reserve (for two eyes), amber, and green. Design executed in black outline.

DESCRIPTION: Decorated with stylized peacock feathers within imbrications. Radial hatching around four "eyes"—two dotted and two plain—with each unit set on a narrow wedge-shaped quill.

COMPARISONS: Saint Euphemia (cat. VIII.3); Zeuxippos Baths (cat. XIII.12).

LITERATURE: Sgalitzer (Ettinghausen), "Baukeramik," 63, no. 2, pl. XXIII, 1. E.S.E.

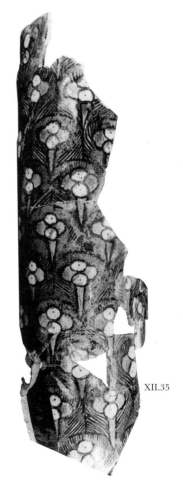

XII.35

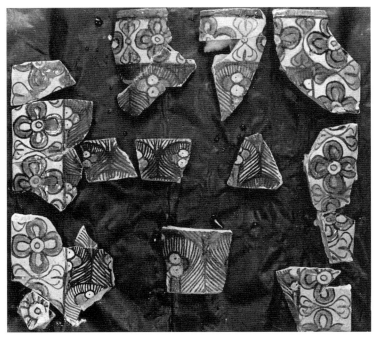

XII.36

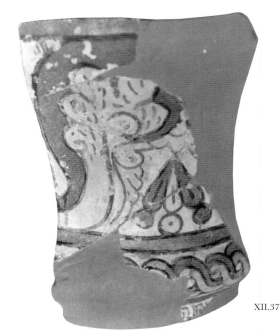

XII.37

XII.36 Peacock Feathers with Rosette Border

Istanbul, Arkeoloji Müzeleri, inv. no. unknown

Est. W. (circumference) 22.0, W. (of border design) 4.3–4.5, Th. 0.6–0.7 cm

CONDITION: Approximately fifteen fragments reconstructed to a nearly complete piece. Fine workmanship. Buff-colored fabric. Well preserved. Colors include deep amber and green. Design executed in black outline.

DESCRIPTION: Peacock feathers, identical to the half-cylindrical tile without a border, but with reduced size of the individual motifs. Border on the top and sides is partially preserved. On it, four-petaled double rosettes alternate with opposing calyces. There is a narrow border strip along the upper edge only. Judging from the purely decorative border, different from those on capitals, one could assume that this piece covered a vertical molding instead of a column with capital and base.

COMPARISONS: Topkapı Sarayı Basilica (cat. XII.35).

LITERATURE: Sgalitzer (Ettinghausen), "Baukeramik," 63, no. 4, pl. XXIII, 2; Ettinghausen, "Byzantine Tiles," 81, pl. XXXII, 1.

E.S.E.

XII.37 Leaves, Guilloche, and Tongue and Dart

Istanbul, Arkeoloji Müzeleri, 6169 P.T.

Est. H. 14.5–15.5, D. at upper edge ca. 13.5–15.0, D. at lower edge ca. 11.0–12.0, Th. 0.55–0.65 cm

CONDITION: Two-thirds complete half-capital. Careful execution with fine drawing and unusually thin outline. Pure bright colors and good color harmony, but poorly preserved. Pale pinkish cream fabric. Glaze colors include yellow and light green. Design executed in purplish black outline.

DESCRIPTION: Elaborate, scrolled leaves; in the spandrels, facing downward, a complex trefoil design from which sprout triple leaves with attached dotted circles at their tips; the latter are framed by wide-spreading helices. Narrow framing strip to both sides of the whole pattern. Below this design is a border with a double-stranded guilloche. At the bottom edge, a narrow band with tongue-and-dart motif.

LITERATURE: Oğan, "Les fouilles," pl. LXXVIII, fig. 12; Sgalitzer (Ettinghausen), "Baukeramik," 66, no. 2, pl. XXIX; Ettinghausen, "Byzantine Tiles," 81, pl. XXXII, 2.

E.S.E.

XII.38 Guilloche, Ivy Leaf, and Tongue and Dart

Istanbul, Arkeoloji Müzeleri, inv. no. unknown
Est. H. 11.0–12.0, Th. 0.6–0.7 cm

CONDITION: Two fragments of a half-base in poor condition. Glaze colors include chestnut brown and copper green. Design is executed in black outline.

DESCRIPTION: On the flat lower section, a row of tongues and circles on high stalks between narrow framing strips. On the molded part, a rinceau of grape clusters and ivy leaves with trefoils in the interstices. The upper section is decorated with a guilloche pattern. The tongue-and-dart motif, of classical derivation, occurs on tiles from many sites in the area of Constantinople.

LITERATURE: Sgalitzer (Ettinghausen), "Baukeramik," 65, no. 3, pl. XXV.

E.S.E.

XII.38

XII.39 Chevron, Triangle, and Crosslet

Istanbul, Arkeoloji Müzeleri, inv. no. unknown
Est. H. 11.0–12.0, D. at upper edge 14.5–15.5 cm, D. at lower edge 13.0–14.0, Th. 0.55–0.65 cm

CONDITION: Three fragments of a half-base. Poorly preserved; only traces of colors and glazes remain. Whitish fabric. Glaze colors include amber and green. Design executed in purplish black outline.

DESCRIPTION: On the flat bottom part of the base are angular rosettes with lozenge-shaped petals (crosslets) and core within lozenge-shaped frames; in the interstices are trefoils directed toward both edges of the plaque. On the molded part of the base are reciprocal interlocking hatched triangles, a design perhaps derived from leaf forms. The narrow half-cylindrical area on the top is decorated with a chevron motif.

COMPARISONS: For crosslets, see Zeuxippos Baths (cat. XIII.3); Sèvres, Musée national de Céramique (cat. C.15, C.30). For interlocking triangles, see Zeuxippos Baths (cat. XIII.11); Preslav, Round church.[1]

LITERATURE: Oğan, "Les fouilles," pl. LXXVIII, fig. 12; Sgalitzer (Ettinghausen), "Baukeramik," 64, no. 2, pl. XXVI; Ettinghausen, "Byzantine Tiles," 82, pl. XXIV, 4.

1 Miatev, *Keramik*, fig. 80g.

E.S.E.

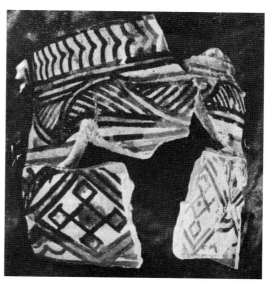

XII.39

XII.40 Triangle and Scale

Istanbul, Arkeoloji Müzeleri, inv. no. unknown
Th. 0.6 cm

CONDITION: Single fragment from the central molded section of a base. Whitish fabric. Glaze colors include amber and green. Design executed in black outline.

DESCRIPTION: Design includes two superimposed patterns: the lower one with reciprocal interlocking hatched triangles. There is a scale pattern above it. This fragment may belong to cat. XII.42, but the fragments could not be fitted together.

LITERATURE: Sgalitzer (Ettinghausen), "Baukeramik," 65, no. 6, pl. XXVII, 1. E.S.E.

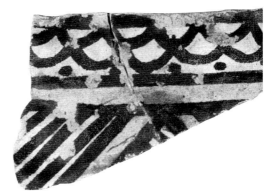

XII.40

XII.41 Foliate Pattern

Istanbul, Arkeoloji Müzeleri, inv. no. unknown
Th. 0.6–0.7 cm

CONDITION: Single fragment from the lower section of a half-base. Reddish fabric. Colors include chestnut brown and green. Design executed in blackish outline.

DESCRIPTION: Decorated with a highly stylized five-petaled palmette flanked by a trefoil motif—probably a palmette-and-lotus design.

LITERATURE: Sgalitzer (Ettinghausen), "Baukeramik," 65, no. 4, pl. XXVII, 4. E.S.E.

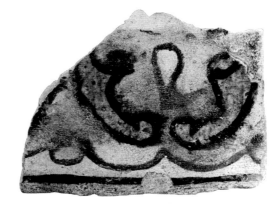

XII.41

XII.42 Foliate Pattern

Istanbul, Arkeoloji Müzeleri, inv. no. unknown
Th. 0.6–0.65 cm

CONDITION: Two fragments from the lower section of a half-base. Whitish fabric; well-polished surface. Glaze colors include amber and green. Design executed in black outline.

DESCRIPTION: Decorated with stylized palmette leaves, half of which have dotted circles at their tips, and the others, hatchings. In the interstices between the palmette motifs are three leaves with dotted circles at their tips. There is a narrow framing strip at the top.

LITERATURE: Sgalitzer (Ettinghausen), "Baukeramik," 65, no. 5, pl. XXVII, 3. E.S.E.

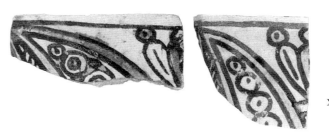

XII.42

XIII
Zeuxippos Baths

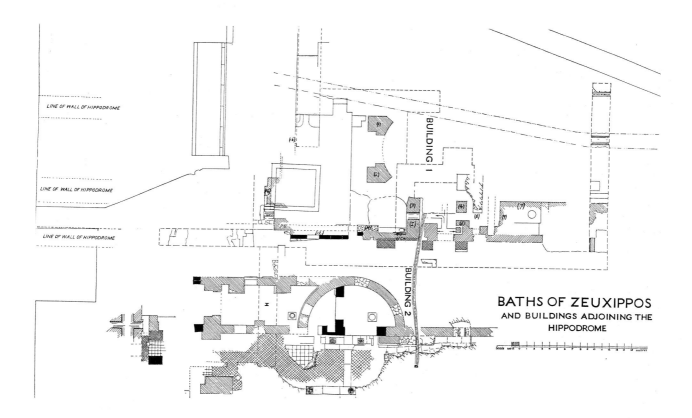

The Zeuxippos Baths, situated between the Hippodrome and the Chalke Gate of the Great Palace and opposite the Tetrastoon, may have been built by Septimius Severus in ca. 196. They were enlarged by Constantine I, becoming the most important bathing establishment in Constantinople. Justinian I rebuilt them after the Nika Riot in 532, and they remained in use at least until 713. In later centuries, the complex was converted to various other uses: a prison, the Noumera, is attested until the thirteenth century, while part of the Baths may also have housed an imperial silk workshop.[1] Excavations carried out in the Hippodrome in 1927/28 uncovered what was probably part of Justinian's Zeuxippos, which included an apse (12 m wide) of brick masonry bordering a large court (at least 43 × 24 m) paved in marble.[2] A later ashlar construction fills much of the apse.[3] A relatively coherent group of tiles was found together (but apparently out of context) in 4 m of earth, which also contained Komnenian coins dumped on the floor of the apse, perhaps during the Palaiologan period, when the area was deserted.[4] According to Talbot Rice, stratigraphical evidence for the tiles provided only a *terminus ante quem* of the twelfth century for their dating.[5]

1 C. Mango, *The Brazen House: A Study of the Vestibule of the Imperial Palace of Constantinople* (Copenhagen, 1959), 37–42.
2 S. Casson, D. Talbot Rice, and G. F. Hudson, *Preliminary Report upon the Excavations Carried Out in the Hippodrome of Constantinople in 1927* (London, 1928), 20–23, 27–28, figs. 29–32, 36; S. Casson and D. Talbot Rice, *Second Report upon the Excavations Carried Out in and near the Hippodrome of Constantinople in 1928* (London, 1929), 5–21, 32–34, figs. 3–12, 38–39; Müller-Wiener, *Bildlexikon,* 51.
3 Casson and Talbot Rice, *Second Report,* 10.
4 Ibid., 14.
5 Ibid., 34.

MARLIA MUNDELL MANGO

XIII.1 Tongue and Dart

Istanbul, Arkeoloji Müzeleri, 6020–6025 P.T.

H. ca. 9.6 cm

FINDSPOT: In earth dumped on the floor of the exedra.

CONDITION: Fragments of a convex tile; upper and lower edges preserved.

DESCRIPTION: Decorated with a tongue-and-dart motif in green and yellow on a white-reserve background. The dart terminates in a stepped pattern.

COMPARISONS: Boukoleon (cat. I.B.2); Saint John Stoudios (cat. X.1); Athens, Benaki Museum (cat. D.4).

LITERATURE: Talbot Rice, *Glazed Pottery,* pl. IX.h.

M.P., Ö.G.

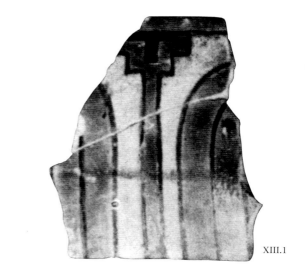

XIII.1

XIII.2 Dotted Concentric Circles

Istanbul, Arkeoloji Müzeleri, 6006–6012 P.T.

H. 2.9, Th. 0.4–0.5 cm

FINDSPOT: In earth dumped on the floor of the exedra.

CONDITION: Fragments of a flat strip; preserved upper and lower edges are beveled. Buff-colored fabric. Glaze colors include amber and clear; clear glaze is not well preserved.

DESCRIPTION: Decorated with white-reserve circles enclosing amber disks with a dot at the center. The circles are placed on a white-reserve background.

COMPARISONS: Hospital of Sampson (cat. II.3–II.5); Constantine Lips (cat. VI.3, VI.4); Baltimore, Walters Art Museum (cat. A.54); Paris, Musée du Louvre (cat. B.12); Sèvres, Musée national de Céramique (cat. C.46).

LITERATURE: Talbot Rice, *Glazed Pottery,* pl. IX.j.

M.P., Ö.G.

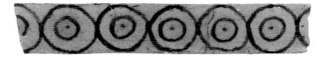

XIII.2

XIII.3 Pitched Squares with Crosslets

Istanbul, Arkeoloji Müzeleri, 6014, 6015 P.T. (in photo)

H. 5.6, W. 5.7 cm

FINDSPOT: In earth dumped on the floor of the exedra.

CONDITION: Fragments of a straight convex tile; single straight edge preserved. Buff-colored fabric. Glaze colors include amber and copper green. Iron oxide glaze used for outline and as background.

DESCRIPTION: The decorative scheme comprises two zones: a narrow band of three white-reserve circles enclosing green disks on a brown-black background and pitched squares enclosing crosslets. The diamonds are linked by small green disks. In the triangular space between the diamonds is a green half-flower enclosing an amber disk.

COMPARISONS: For crosslets, see Topkapı Sarayı Basilica (cat. XII.39); Sèvres, Musée national de Céramique (cat. C.15, C.30).

LITERATURE: Talbot Rice, *Glazed Pottery,* pl. IX.g.

M.P., Ö.G.

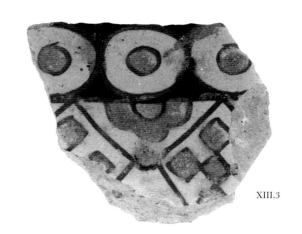

XIII.3

XIII.4 Guilloche with Eyelets

Istanbul, Arkeoloji Müzeleri, 5989–5992 P.T. (5990 P.T. in photo)
H. 11.2, W. 34.0, Th. 0.5–0.6 cm

FINDSPOT: In earth dumped on the floor of the exedra.

CONDITION: Fragments of a convex oblong tile; upper and lower edges preserved. Glaze colors restricted to green. Dilute iron oxide glaze used for outline and background.

DESCRIPTION: Decorated with a beaded guilloche of white reserve banded in green on a reddish brown background. Interlacing bands adorned with rows of white reserve and dots create small roundels that enclose a green disk with a black dot at the center.

COMPARISONS: Saint Euphemia (cat. VIII.1).

LITERATURE: Talbot Rice, *Glazed Pottery*, pl. IX.a.

EXHIBITION: Athens 1964, nos. 607 (5990 P.T.), 608 (5989 P.T.). M.P., Ö.G.

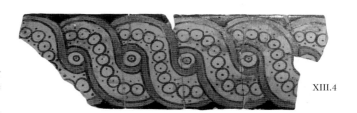

XIII.4

XIII.5 Lattice

Istanbul, Arkeoloji Müzeleri, 6018 P.T.
M.P.H. 4.2, M.P.W. 6.7, Th. 0.55 cm

FINDSPOT: In earth dumped on the floor of the exedra.

CONDITION: Fragments of a flat tile; no edges preserved. Glaze colors include amber and copper green. Black outline in dilute iron oxide glaze. Glazes are not well preserved and are crazed overall.

DESCRIPTION: Decorated with two groups of three bands crossing at right angles, perhaps the sides of a wide lozenge or the arms of a cross. The bands are formed from a green outer strip and amber core. At the junction, there is an amber medallion enclosing a green disk. In the space created between the intersecting bands is a black floral motif.

COMPARISONS: Constantine Lips (cat. VI.13); Myrelaion (cat. VII.7); Saint Polyeuktos (cat. XI.1).

LITERATURE: Sgalitzer (Ettinghausen), "Baukeramik," 55, no. 23, pl. X, 3. M.P., Ö.G.

XIII.5

XIII.6 Paired Acanthus Leaves and Concentric Lozenges

Istanbul, Arkeoloji Müzeleri, 6027 P.T.
M.P.H. 8.1, M.P.W. 7.8, Th. 0.4 cm

FINDSPOT: In earth dumped on the floor of the exedra.

CONDITION: Fragments of a concave tile; single edge preserved. Glaze colors include aubergine, amber, and green.

DESCRIPTION: There are two zones of decoration. A narrow band of four linked white-reserve lozenges encloses amber diamonds. The triangles between the lozenges are glazed green and enclose aubergine half-circles. The upper zone of the plaque is filled with paired acanthus leaves on a white-reserve ground.

COMPARISONS: Topkapı Sarayı Basilica (cat. XII.19).

LITERATURE: Talbot Rice, *Glazed Pottery*, pl. IX.k.

M.P., Ö.G.

XIII.6

XIII.7 Circle with Rosette

Istanbul, Arkeoloji Müzeleri, 6017 P.T.
M.P.H. 5.4, M.P.W. 9.7 cm

FINDSPOT: In earth dumped on the floor of the exedra.

CONDITION: Fragments of a convex (?) tile; single edge preserved. Glaze colors include amber and copper green. Glazes are crazed overall. Black outline in dilute iron oxide glaze.

DESCRIPTION: Decorated with a white-reserve circle enclosing a rosette with amber petals on a green ground. The core of the petals is in white reserve. Roundel is connected to adjacent form with lobed ornament (palmette?) on green ground. M.P., Ö.G.

XIII.7

XIII.8 Half-Circle with Half-Rosette

Istanbul, Arkeoloji Müzeleri, 5994–6005 P.T. (5995 P.T. in photo)
H. 6.12, Th. 0.6 cm

FINDSPOT: In earth dumped on the floor of the exedra.

CONDITION: Fragments of a convex oblong tile; upper and lower edges preserved. Buff-colored fabric; striations on the reverse parallel to the length of the tile.

DESCRIPTION: Decorated with a row of linked amber arched bands that enclose amber half-rosettes on a green field. The rosette petals alternate between amber and white reserve enclosing a dark core. There is a narrow green border along the upper edge of the tile. Heart-shaped palmettes fill the spandrels between the arches.

COMPARISONS: Paris, Musée du Louvre (cat. B.8).

LITERATURE: Talbot Rice, *Glazed Pottery,* pl. IX.d.

M.P., Ö.G.

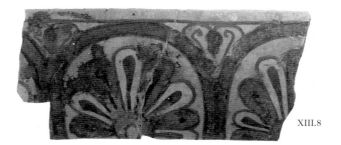

XIII.8

XIII.9 Circle with Trefoil Palmette

Istanbul, Arkeoloji Müzeleri, 6016 P.T.
H. 6.4–6.5, Th. 0.55–0.6 cm

FINDSPOT: In earth dumped on the floor of the exedra.

CONDITION: Fragments of a convex tile; upper and lower edges preserved. Glaze colors include azure blue, amber, and copper green. Glazes are not well preserved and exhibit crazing overall. Traces of burnt glaze on the reverse side.

DESCRIPTION: An amber roundel encloses a stylized white-reserve trefoil palmette. The palmette consists of a triangular stem terminating in a small lozenge with three lobed leaves stemming from the corners of the lozenge, one at the top and one at each side.

COMPARISONS: The pattern does not appear on tiles but is found on polychrome bowls excavated at Cherson. See Zalesskaja, "Nouvelles découvertes," fig. 8.

LITERATURE: Sgalitzer (Ettinghausen), "Baukeramik," 56, no. 28, pl. XI, 2. M.P., Ö.G.

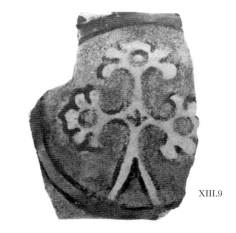

XIII.9

XIII.10 Lattice

Istanbul, Arkeoloji Müzeleri, 6013 P.T.
M.P.H. 5.4, M.P.W. 7.1 cm

FINDSPOT: In earth dumped on the floor of the exedra.

CONDITION: Fragment of a flat tile; single edge preserved. Glaze colors include amber and copper green. Glazes are crazed overall, and green is opaque due to a weathering crust. Outline in dilute iron oxide glaze.

DESCRIPTION: Decorated with a diaper pattern of green lozenges banded in amber alternating with amber-filled lozenges banded in white reserve. Amber lozenges are divided into four sections by diagonal lines, each with a black dot at the center. M.P., Ö.G.

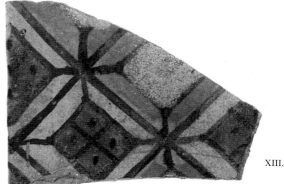

XIII.10

XIII.11 Tongue and Dart, Boxes, and Lozenges

Istanbul, Arkeoloji Müzeleri, 5993 P.T.
H. 11.4, W. (of square) 10.7, Th. 0.3–0.5 cm

FINDSPOT: In earth dumped on the floor of the exedra.

CONDITION: Colonnette base reconstructed from three fragments. Buff-colored fabric. Base is square below and convex above. It is mold-made and has wide finishing marks on the interior.

DESCRIPTION: Decorated with four superimposed zones of ornament separated from each other with horizontal amber bands. At the bottom, tongue-and-dart motif on white-reserve ground with green at the center of amber arches. Each dart terminates in a green-glazed circular medallion. Central zones composed of bands of linked green and amber triangles and two rows of linked green and white-reserve squares, each with a dot at the center. The upper zone contains green and white-reserve lozenges, each with a dot in the center.

LITERATURE: Talbot Rice, "Polychrome Pottery," pl. XXVII.1.

EXHIBITION: Athens 1964, no. 613. M.P., Ö.G.

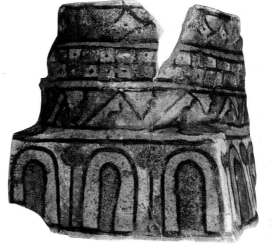

XIII.11

XIII.12 Peacock Feather

Istanbul, Arkeoloji Müzeleri, inv. no. unknown
Th. 0.9–1.0 cm

CONDITION: Single fragment with no preserved edges. Buff-colored fabric. Glaze colors include golden yellow, copper green, brick red. Outlines executed in black. The back of the fragment is rough and uneven, with marks from pressing the clay into a mold.

DESCRIPTION: Partially preserved peacock feather enclosing two disks on a stem, each with a dot in the middle. The barbs of the feather are articulated by painted lines.

COMPARISONS: Saint Euphemia (cat. VIII.3); Topkapı Sarayı Basilica (cat. XII.35).

LITERATURE: Sgalitzer (Ettinghausen), "Baukeramik," 55, no. 20, pl. VI, 1. E.S.E.

XIII.12

XIV
Botaneiates Palace Church

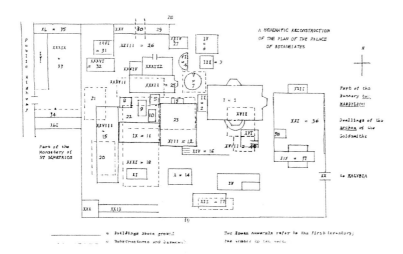

Two documents, one in Latin, the other in Greek, dated to 1192 and 1202, respectively (see texts below),[1] describe one of two churches forming part of the mansion overlooking the Golden Horn and belonging to the Botaneiates family as having been decorated with wall tiles. The church, dedicated to the Theotokos, was said to have a dome supported by four columns, and decoration consisting of marble *opus sectile* pavement and a carved marble icon, in addition to the tiles, which formed or covered the upper cornice below the mosaics and "*gamma*-shaped spaces" on the west side. A hypothetical diagram of the mansion, based on the two versions of the inventory (the Theotokos church = 1/1) was published by M. Angold. The Botaneiates mansion is usually identified with remains of a building on Cemal Nadir Sokağı.

Latin Document, May 1192:

domus . . . Votoniate que sita est in loco Caluorum que sic habet: Dei sancta ecclesia in solario unius anguli cum trulla que sustietur muris et columpnis quattuor, una bithina his autem que intra tribunal et zonam, indutis marmoribus diversorum colorum usque ad ornatum quod dicitur cosmitis, edificiis que sunt a medi templo versus occidentum, indutis testid de Nicomedia desuper predictum cosmitem et usque ad ipsam trullam est ornata musivo aureo et de coloribus cum duobus postbus, uno [A in] dasico cum pectoralibus duobus cum ostiis, cancellatis et fenestris, pavimentum auten de lapidibus viridibus circa medium trium zonarum . . . desuper autem circa medium occidentalis postis inventus est Christus marorens.[2]

Greek translation, 13 October 1202:

The particulars of the so-called Palace of Botaneiates that has been handed over to them [the Genoese], which is close to the place called Kalubia, are as follows. The holy church is domed, has a single conch and four columns, one of them being of white Bithynian marble. The face of the arch (?) (*epilôros*) and the curve (?) (*diastrophê*) of the conch (*myakion*) are reveted with marble, as are the vaults (*kamarai*). The revetment of the gamma-shaped spaces (?) (*gamatismata*) on the west side are of Nicomedian tiles (*dia transtrion Nikomedeion*), as is the cornice, and above that are images in gold and colored mosaic, as also in the dome and the four vaults, three of which have glass [windows]. The partition of the *bêma* consists of four posts (*stêmonoroi*) of green [marble] with bronze collars, two perforated closure slabs, a marble entablature, and a gilded wooden *templon*. The marble canopy (*katapetasma*) of the holy table, the latter having four straight moldings (?) (*riglia*), is [supported] on four reed-like [columns] and is enclosed by means of two railings (*systematia*) and two closure slabs (*stêtha*) as well as railing doors and [other] little doors. Above the west railing is a carved marble icon. The pavement consists of an interlace (*plokê*) of green slabs and *opus sectile* (*synkopê*) and a border of Phlegmonousian marble. To the south. . . .[3]

1 M. Angold, "Archons and Dynasts: Local Aristocracies and the Cities of the Later Byzantine Empire," appendix in *The Byzantine Aristocracy: IX–XIII Centuries*, ed. M. Angold (Oxford, 1984), 254–66; Müller-Wiener, *Bildlexikon*, 41, figs. 14 (on left), 15; Mason and Mango, "Glazed 'Tiles of Nicomedia,'" 322.

2 *Codice diplomatio della Repubblica di Genova*, ed. C. Imperiale, in *Fonti per la storia d'Italia* 89 (1942), no. 22, 68f.

3 F. Miklosich and J. Müller, eds., *Acta et diplomata graeca medii aevi*, III (Vienna, 1865), 55–57; Mango, *Sources and Documents*, 239–40.

MARLIA MUNDELL MANGO

XV
Istanbul, Provenance Unknown

The polychrome tiles in this section are reputed to derive from sites within the city. Tiles found in the city, especially in the early part of the twentieth century, often found their way into the hands of antiquities dealers. This is the case, for example, with tiles found in 1926, when water pipes were being laid in the city.

ELIZABETH S. ETTINGHAUSEN

XV.1

XV.1 Foliate Volutes, Guilloche, and Chevrons

Formerly in the Hüghenin Collection, Istanbul (formed late nineteenth/early twentieth century)
Th. 0.55–0.65 cm
CONDITION: Single fragment of colonnette capital; lower edge preserved. Glaze colors include golden yellow, copper green, blackish outline. Fabric is buff-colored. Fine execution.
DESCRIPTION: Decoration comprising three zones; the upper part is filled with large foliate volutes. The two lower bands are composed of guilloche and chevrons.
COMPARISONS: Topkapı Sarayı Basilica (cat. XII.37).
LITERATURE: Ettinghausen, "Byzantine Tiles," 84, pl. XXIV, 5.

E.S.E.

XV.2 Scrolling Vines with Leaves and Flowers

Istanbul, Exact Provenance Unknown
H. 10.3–10.8, W. 19.1–19.3, Th. 0.4 cm
CONDITION: Oblong convex tile reconstructed from numerous fragments. White fabric. Glaze colors include copper green and amber. Brick red slip (?) used for design highlights.
DESCRIPTION: Vertically arranged scrolling vines with palmette-shaped florets and heart-shaped leaflets. The interstices are filled with trefoil motifs.
LITERATURE: Sgalitzer (Ettinghausen), "Baukeramik," 59, no. 41, pl. XX, 1; Talbot Rice, *Glazed Pottery,* pl. VIII.a. E.S.E.

XV.2

XV.3 Circle with Four-Petaled Flower

Istanbul, Exact Provenance Unknown
Dimensions Unknown
CONDITION: Oblong convex tile reconstructed from numerous fragments.
DESCRIPTION: Decorated with a row of linked roundels; within each is a four-petaled flower.
COMPARISONS: Hospital of Sampson (cat. II.14, II.15); Sèvres, Musée national de Céramique (cat. C.6).
LITERATURE: Talbot Rice, *Glazed Pottery,* pl. VIII.b. S.G.

XV.3

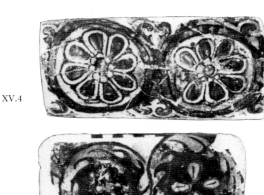

XV.6

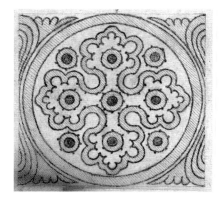

XV.4

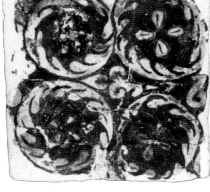

XV.5

XV.7

XV.8

XV.4 Circle with Rosette

Istanbul, Exact Provenance Unknown
Dimensions Unknown

CONDITION: Oblong convex tile reconstructed from numerous fragments.

DESCRIPTION: Repeated pattern of eight-petaled rosettes within linked roundels. Vine tendrils terminating in trefoils are found between each roundel.

COMPARISONS: Topkapı Sarayı Basilica (cat. XII.27).

LITERATURE: Talbot Rice, *Glazed Pottery,* pl. VIII, c. S.G.

XV.5 Swirling Acanthus Leaves

Istanbul, Exact Provenance Unknown
Dimensions Unknown

CONDITION: Square plaque reconstructed from numerous fragments.

DESCRIPTION: Decorated with banded roundels composed of swirling leaves. At the center of each roundel is a four-petaled flower.

COMPARISONS: The pattern resembles *opus sectile* work on the gallery level of Saint Sophia.

LITERATURE: Talbot Rice, *Glazed Pottery,* pl. VIII, d. S.G.

XV.6

See Paris, Musée du Louvre (cat. B.15).

XV.7 Circle with Four-Petaled Flower

Istanbul, Exact Provenance Unknown
Dimensions Unknown

CONDITION: Oblong convex plaque reconstructed from numerous fragments.

DESCRIPTION: Elaborate leaves of quatrefoils link to form foliate medallions. Along the upper and lower edges, between the leaves, are heart-shaped ornaments. Between each set of leaves is a four-petaled flower set against a dark medallion.

COMPARISONS: Myrelaion (cat. VII.3); Topkapı Sarayı Basilica (cat. XII.10–XII.13); Baltimore, Walters Art Museum (cat. A.70); Paris, Musée du Louvre (cat. B.13); Sèvres, Musée national de Céramique (cat. C.21, C.22); Athens, Benaki Museum (cat. D.7); France, Thierry Collection (cat. H.5).

LITERATURE: Talbot Rice, *Glazed Pottery,* pl. VIII, f. S.G.

XV.8 Cross

Istanbul, Exact Provenance Unknown (seen in the Istanbul bazaar in the late 1930s)
H. 10.2, W. 10.2, Th. 0.75 cm

CONDITION: Complete square plaque of unusual thickness. Fairly red fabric. Good preservation and fine execution in white on light grass green with light manganese outlines.

DESCRIPTION: Rosettelike cross with each arm terminating in a five-petaled shape. The whole is enclosed in a green circular band. To either side of the band are green foliate motifs that are cut in half, perhaps demonstrating that this plaque was intended to be placed in a series.

LITERATURE: Sgalitzer (Ettinghausen), "Baukeramik," 46, no. 2, pl. III, 2. E.S.E.

XV.9

The tiles assembled under this number were offered for sale in the shop of Bitar and Akawi in the Istanbul bazaar around 1944. The tiles are related to examples excavated in Constantine Lips, Zeuxippos Baths, and the Topkapı Sarayı Basilica. The publication of this collection, an assemblage created in the shop of an antiquities dealer, permits us to understand how collections of tiles from disparate sites could be sold on the art market. Two of the tiles, catalogued under xv.5 and xv.7, were published by Talbot Rice as "in private possession."[1] Another tile, decorated with a variation of the tongue-and-dart motif, is similar to the Byzantine work in Faenza (cat. G.1).

1 Talbot Rice, *Glazed Pottery,* 112.

E.S.E.

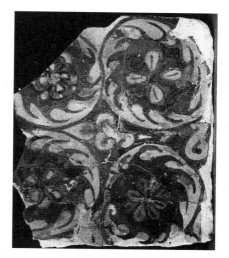

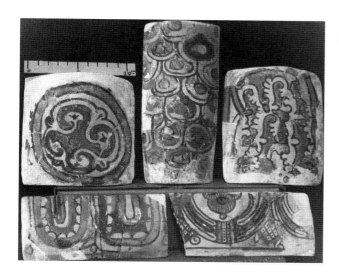

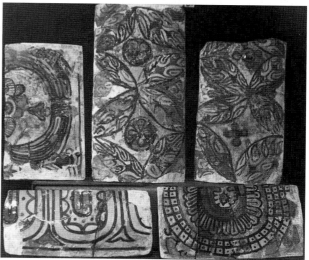

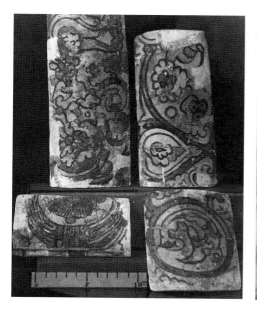

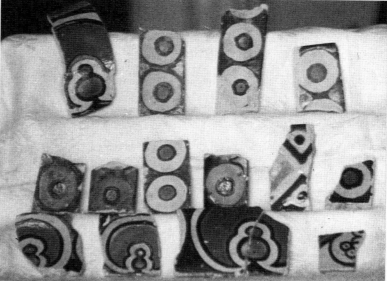

XV.10 Circle with Whirling Leaves and Rosettes

Istanbul, Exact Provenance Unknown (seen in the Istanbul bazaar in the late 1930s)

H. 8.7, W. 17.9, Th. 0.7 cm

CONDITION: Complete oblong tile. Reddish fabric. Glaze colors include amber, azure blue, leaf green. Outlines in brown.

DESCRIPTION: Four-petaled double rosettes in amber and white reserve enclosed within blue whirling leaves and surrounded by an amber band.

LITERATURE: Sgalitzer (Ettinghausen), "Baukeramik," 47, no. 4, pl. VIII, 1. E.S.E.

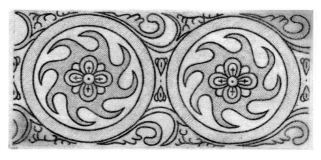

XV.10

XV.11 Peacock Feather

Private Collection

M.P.H. 21.2, W. at top 6.7, W. at base 7.0 cm

FINDSPOT: Unknown. Bought in Istanbul in 1930 together with XV.12

CONDITION: Nearly complete. Restored from eight pieces; four edges preserved. Losses to the surface, particularly along joins. Glaze colors include blue-green; outlines in black.

DESCRIPTION: Decoration composed of ten rows of peacock feathers, of which the upper five rows point upward and the lower five downward, except in the sixth row from the top, where the feather on the left hand points upward. Each blue-green feather has a rounded top banded in white reserve; the eyes are circular and gilded gold.

COMPARISONS: Istanbul Law Courts (cat. IV.1); Baltimore, Walters Art Museum (cat. A.50); Paris, Musée du Louvre (cat. B.15); Sèvres, Musée national de Céramique (cat. C. 28). J.D., M.M.M.

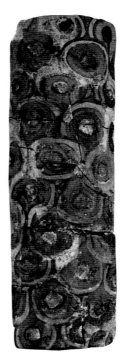

XV.11

XV.12 Chevron, Wavy Line, and Flutes

Private Collection

H. 8.0, W. 10.2 cm

FINDSPOT: Unknown. Bought in Istanbul in 1930 together with XV.11.

CONDITION: Entire base restored from two pieces. Surface losses.

DESCRIPTION: The lower section is polygonal in plan; the upper section is curved. The decoration is outlined in black on a white-reserve ground divided into four zones. At the base, a band of flutes alternating in amber and white. The central zones are decorated with an amber band followed by a thick wavy blue band. At the top is a band of chevrons pointing right and alternating in amber and white reserve.

COMPARISONS: Topkapı Sarayı Basilica (cat. XII.39); Zeuxippos Baths (cat. XIII.11). M.M.M.

XV.12

XVI
Haydarpaşa

In 1893, two polychrome tiles were found in excavations for the foundations of the railroad at Haydarpaşa. Nothing was reported about the context. The pieces, which were bought by the Istanbul Archaeological Museum in 1894, are described in Ebersolt's catalogue of the ceramic collection as sherds from a bowl decorated with engobe. To which building the fragments belong remains a mystery. Talbot Rice suggested that "there is reason to believe that they came from the ruins of some rich villa, of which there were a number in that region [on the shores of the Bosporus], rather than from those of a church."[1] There is no reason, however, that the tiles could not have been from an ecclesiastical structure.

1 Talbot Rice, *Glazed Pottery*, 16.

ELIZABETH S. ETTINGHAUSEN

XVI.1 Concentric Circles and Tongue and Dart

Istanbul, Arkeoloji Müzeleri, inv. no. unknown
H. as reconstructed 10.2, Th. 0.65–0.7 cm

CONDITION: Two fragments of an oblong convex tile. Buff-colored fabric. Glaze colors include copper green in addition to gold leaf. Brown-black outlines. The colors, except for the golf leaf, are extremely worn.

DESCRIPTION: Decorated in two zones. The upper zone has concentric circles on a dark background. The lower zone, divided by a green band, has a tongue-and-dart motif.

COMPARISONS: For concentric circles, see Hospital of Sampson (cat. II.3, II.4); Constantine Lips (cat. VI.3, VI.4); Zeuxippos Baths (cat. XIII.2, XIII.3); Baltimore, Walters Art Museum (cat. A.54); Paris, Musée du Louvre (cat. B.12); Sèvres, Musée national de Céramique (cat. C.47). For the tongue and dart, see Kyriotissa (cat. V.10); Constantine Lips (cat. VI.1); Baltimore, Walters Art Museum (cat. A.61); Paris, Musée du Louvre (cat. B.6); Sèvres, Musée national de Céramique (cat. C.2).

LITERATURE: Ebersolt, *Catalogue*, 39, nos. 151, 152. E.S.E.

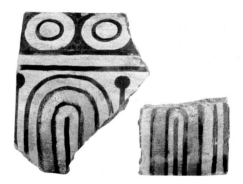

XVI.1

XVII
Beykoz

A single tile in the Benaki Museum (cat. D.2) is said to be from the church of Saint Panteleimon at Beykoz (Yuşa tepesi), on the Asian side of the Bosporus. The church was excavated by T. Macridy in 1924 after reports of clandestine digging were brought to the attention of the archaeological service. Described as a domed structure with three naves and a narthex, the dedication of the church was based on a passage in Prokopios and on the existence of a font next to the building. Macridy never published a full report of his excavations; a brief note on the work is included in Mamboury's review of early excavations in the city.[1] The church, located in a military zone, was visited much later by S. Eyice, who suggests a ninth-century date on the basis of the plan and masonry.[2] The precise findspot of the Benaki tile, if it indeed derives from this church, is unknown.

1 E. Mamboury, "Les fouilles byzantines à Istanbul et dans sa banlieue immédiate aux xixe et xxe siècles," *Byzantion* 11 (1936), 248–49; Janin, *Églises centres,* 12–13.
2 S. Eyice, "Remarques sur deux anciennes églises byzantines d'Istanbul: Koça Mustafa Paşa camii et l'église du Yuşa tepesi," in *IX CEB,* 1 (Athens, 1955), 195.

<div align="right">SHARON E. J. GERSTEL</div>

XVIII
Koimesis Church (Hyakinthos Monastery), Nicaea

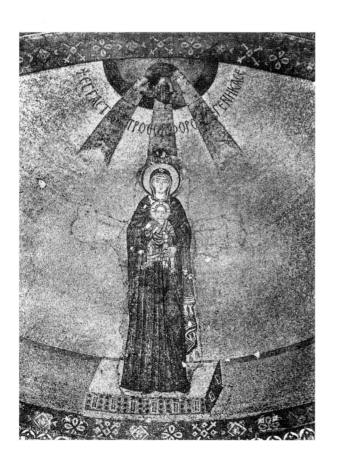

The church of the Koimesis at Nicaea has been identified as the *katholikon* of the Hyakinthos monastery. The building was destroyed in 1922; discussions of the architecture and its decoration are based on written sources, examination of the partial remains of the church, and a small set of photographs taken before the destruction.[1] Initial construction of the domed church, which included carved monograms and inscriptions referring to its founder, Hyakinthos,[2] has been dated to the end of the sixth or beginning of the seventh century.[3]

The decoration within the church is associated with distinct events and people. Carved architectural elements and portions of the mosaic program belong to the earliest phase of decoration, that linked with Hyakinthos. A second phase of decoration has been related to Iconoclasm.[4] Following the termination of the church controversy in 843, mosaics in the sanctuary, including the Virgin in the apse and archangels on the lateral walls, were restored by Naukratios, who is named in an inscription. A disciple of Theodore of Stoudios, Naukratios died in 848.[5] If he is indeed the restorer of the mosaics, then this phase of decoration would date between 843 and the year of his death.

Yet a third campaign of building, perhaps the most

extensive in the church's history, resulted from the severe earthquake that rocked Nicaea in 1065. Under Nikephoros, commander of the imperial bodyguard during the reign of Constantine X Doukas (1059–67), the narthex was redecorated with mosaics;[6] the nave was paved with a new *opus sectile* floor; and mosaic icons were applied to the pillars. The furnishings of the sanctuary were augmented to include an altar table of inlaid marble and a new templon screen for which the old columns were replaced by square piers.[7]

The tiles that apparently decorated the apse cornice of the church are known only from a single photograph published by Schmit in 1927. Another photograph, published by Wulff in 1903, does not show the ceramic cornice. Given the building history of the church, the tile cornice could date to the period of Naukratios, when the apse mosaics were restored, or to the period of Nikephoros, when, following earthquake damage, the sanctuary was refurbished.

The designs on the Nicaea tiles are composed of two patterns. The uppermost band is formed of arches that enclose triple imbrications. A lower band consists of broad leaves enclosed in bands.

COMPARISONS: (for the arched design) Kyriotissa (cat. v.2); Topkapı Sarayı Basilica (cat. xii.8); Istanbul, Provenance Unknown (cat. xv.9); Sèvres, Musée national de Céramique (cat. C.8). The foliate design is unusual. The closest comparisons are found in tiles from Saint John Stoudios (cat. x.3); Topkapı Sarayı Basilica (cat. xii.19); Baltimore, Walters Art Museum (cat. A.62); Sèvres, Musée national de Céramique (cat. C.18); Athens, Benaki Museum (cat. D.3).

1 See, most recently, C. Foss, *Nicaea: A Byzantine Capital and Its Praises* (Brookline, Mass., 1996), 97–101. Fundamental works on this church include Schmit, *Koimesis-Kirche*; O. Wulff, *Die Koimesiskirche von Nicäa und ihre Mosaiken* (Strassburg, 1903); P. Underwood, "The Evidence of Restorations in the Sanctuary of the Church of the Dormition at Nicaea," *DOP* 13 (1959), 235–44; U. Peschlow, "Neue Beobachtungen zur Architektur und Ausstattung der Koimesiskirche in Iznik," *IstMitt* 26 (1972), 145–87. For the plundering and destruction of the church, see N. H. Baynes, "Die Koimesiskirche in Nikaia," *BZ* 25 (1925), 267–69.

2 E. Wiegand, "Zur Monogrammschrift der Theotokos (Koimesis) Kirche von Nicaea," *Byzantion* 6 (1931), 411–20.

3 For the end of the sixth century, see Schmit, *Koimesis-Kirche*, 20; C. Mango, *Byzantine Architecture* (New York, 1976; repr., Milan, 1978), 90. Krautheimer gives a *terminus ante quem* of 726 for the construction. See *Early Christian and Byzantine Architecture* (New York, 1965; repr. 1981), 309. Foss (*Nicaea*, 97) has argued for its construction in the late seventh century.

4 See, for example, C. Barber, "The Koimesis Church, Nicaea: The Limits of Representation on the Eve of Iconoclasm," *JÖB* 41 (1991), 43–60.

5 See Janin, *Églises centres*, 123; E. Lipshits, "Navkratii i nikeiskii mozaiki," *ZRVI* 8 (1964), 241–46; Underwood, "Evidence of Restorations," 242.

6 C. Mango, "The Date of the Narthex Mosaics of the Church of the Dormition at Nicaea," *DOP* 13 (1959), 245–52.

7 Foss, *Nicaea*, 100–101.

MONIKA HIRSCHBICHLER

XIX
Nicomedia

See Moscow, State Historical Museum (cat. F.1, F.2, F.3).

XX
Üskübü

The village of Üskübü (Konuralp) lies 6 km north of Düzce in Bithynia. That the town thrived in the Roman and Early Christian periods is demonstrated by the wealth of archaeological material, including a large theater. The history of the site is less well documented for the medieval period, although the existence of ninth- to eleventh-century seals naming bishops of Prusias ad Hypium suggests that the town was substantial enough in size to support an episcopal seat. A guidebook to the town also notes that the Mosque of Konuralp was built "upon the site of an ancient church of which only fragments of mosaic pavement remain (*opus sectile*)."[1]

Polychrome tiles were reportedly found in the village during construction of a hospital. The finds were never reported, although they have been linked with the collections of tiles now in the Walters Art Museum and the Musée du Louvre (see cat. A, B). A single tile entered the collection of the Istanbul Archaeological Museum in 1960; its findspot was given as Düzce (cat. xx.1).

1 A. N. Rollas, *Konuralp—Üskübü—Kılavuzu: Guide to Prusias-ad-Hypium* (Istanbul, 1967), 29.

SHARON E. J. GERSTEL

XX.1 Unidentified Saint

Istanbul, Arkeoloji Müzeleri, 6545 P.T.
M.P.H. 5.5, M.P.W. 8.0 cm
 FINDSPOT: Exact context is unknown.
 CONDITION: One-quarter of a flat plaque; single upper edge preserved.
 DESCRIPTION: Head of a male saint against an amber (?) medallion encircled by thick band. A single leaf is preserved in the upper right corner. The saint is frontal and has wide eyes covered with acutely arched brows. The eyes are emphasized by thin strokes that descend at the corner. The hair is curly, and individual locks are rendered in thick strokes of paint.
 COMPARISONS: Baltimore, Walters Art Museum (A.2).
 LITERATURE: *IAMY* 10 (1962). S.G.

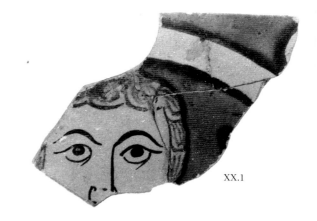

XX.1

XXI
The Great Mosque at Córdoba

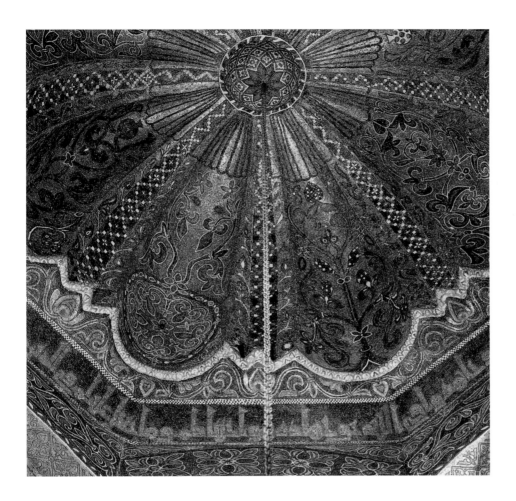

The first mosque was built in 786/87 by the Umayyad Emir 'Abd al-Raḥmān I; enlargements and additions took place foremost under Emir 'Abd al-Raḥmān II in 836 and Caliph 'Abd al-Raḥmān III around 950. A southward expansion of the mosque was completed by his son, Caliph al-Ḥakam II,[1] in 970/71, as was the installation of a new *mihrab* chamber and, in front of it, a triple-domed *maqsura;* the central dome was decorated entirely with gold and colored-glass mosaic and some white-marble tesserae. Below it, a polychrome tile strip forms a framing cornice. While Ibn 'Idhārī reports that, upon the Caliph's request, an expert craftsman with some assistants was sent by the Byzantine emperor to work on the mosaics—the team augmented by a local workforce—no record exists that would indicate the same for the tile band.[2] Indeed, there was no need for a tile maker to be summoned from

Byzantium, since indigenous pottery workshops flourished in Córdoba, as M. Jenkins has demonstrated.[3]

The cornice, composed of forty half-cylindrical plaques, is ca. 14 m in length.[4] The tiles are in a very good state of preservation; there are only minor flaked-off spots and two small later restorations where the paint appears matte due to the absence of any glaze.[5] The tiles follow the complex outline of the dome, which is actually of slightly irregular shape. The curved sections outline a rosette shape, while the pointed, angular ones circumscribe that of a star. The curved outlines are covered with three plaques of slightly different lengths (68.5 to 78 cm). The height of these tiles is reduced from about 6 to 4 cm toward the center of each lobe. The eight angular parts are framed by two glazed plaques that, in turn, flank a central angle. Together, the angular plaques form a fairly even zigzag.[6]

The cornice has a continuous design of imbrications. The pattern is applied irregularly, varying from one to three rows of scales, often of uneven size. Each encloses a small palmette directed toward the apex of the dome. The palmettes, either three- or five-lobed, are adorned in some areas with a dot at the center; occasionally, small tendrils are attached to them. The ornamentation is derived from three-dimensional architectural decoration rendered here on a two-dimensional plane. Double outlines in paint translate the thickness of the carved- or molded-relief representation. With few exceptions, the palmettes are alternately painted in yellow and manganese purple,[7] while the curved bands of the scale pattern over them are consistently green with black outlines. The selection of unusual colors such as yellow and purple to decorate the palmettes indicates that an abstract form of representation was intended. The colors of the tile cornice are metal oxides applied on the opaque white tin glaze covering the light yellow fabric.[8] As M. Jenkins has demonstrated, the tiles were executed in the "in-glaze" painting technique, the customary Hispano-Muslim method for decorating polychrome glazed pottery vessels in this period.[9] This production method differs substantially from the Byzantine technique, in which the colors are painted directly onto the dried clay surface and then selectively or completely covered with a clear glaze.[10] The intensity of the color applied on the tiles varies. In spite of the restricted palette, the uneven tonal qualities and the variations in the decoration create a feeling of greater variety than is actually the case. While D. Duda considered these irregularities in design proof of a quick and careless execution by the artisans, H. Stern attributed them to the craftsmen's inexperience in executing a large-scale ceramic program for this unusual architectural project.[11] When seen by a spectator in the usually darkened atmosphere of the domical area, the translucent and mysterious glow of the mosaic dome is framed very effectively by the bright sheen of the tiled cornice; its scale design and opaque colors can only be vaguely absorbed, like ever-changing waves. Only when observed at close range do the colors of the tiles clash with those of the mosaics. The contrast of the complex orna-

mentation of the glittering mosaic with the rather simple repeating design of the tile strip is surely intentional.

The imbrication-and-scale motif is found in both the Byzantine sphere and the Islamic world of Spain. The curved bands over each palmette leaf on the tile cornice are, in Byzantine terms, reminiscent of the stylized representation of peacock feathers. This much-used theme in the Byzantine world refers to notions of eternal life.[12] But the decoration also resonated with an Islamic viewer; according to the Qur'ān (chapters 36, 55), the palm is one of the trees found in paradise. In Byzantium, the imbrication pattern is widespread on polychrome tiles. It is found on fragments excavated at the Hospital of Sampson (cat. II.19), the church of Saint Euphemia (cat. VIII.3), and the Topkapı Sarayı Basilica (cat. XII.36). A comparable motif ornaments tiles in the Walters Art Museum (cat. A.50) and the Louvre (cat. B. 15). The design also appears on tiles excavated at the Royal monastery of Preslav, Bulgaria.[13] The patterns that adorn the Córdoba cornice, however, also mirror other well-known Hispano-Muslim works, albeit in stone relief. At Madīnat al-Zahrā', the residence of Caliph al-Ḥakam II's predecessor, 'Abd al-Raḥmān III, a molding in relief with almost identical design adorns the entrance hall to the Salón Rico ("Rich Hall"). The walls of the hall were completely covered with intricate stone decoration.[14] Furthermore, the Salón Rico itself was also decorated with imbrications over fanciful "pine cones."[15]

The great significance of the tile cornice under the mosaic dome in the Córdoba mosque stems from the fact that it is the only monument where the combination of the two media survives today. It is noteworthy that a polychrome ceramic molding was deemed important enough to be used as a framing device for a precious and significant mosaic vault in what was demonstrably one of the most outstanding houses of worship in the Islamic world. The practice of combining mosaic decoration of special importance with borders formed of polychrome tiles is well documented in Byzantine monuments of this period, and we can see this practice as the inspiration for the Córdoba molding.[16] A crucial example is the apse mosaic in the church of

the Koimesis, Nicaea, which is set apart from the lower registers of the sanctuary by a molding, apparently painted on polychrome tiles decorated with an arched palmette design (cat. XVIII). A similar motif is found on tiles excavated in ecclesiastical contexts in Constantinople, such as the Topkapı Sarayı Basilica (cat. XII.5–XII.7).[17] These patterns, to my knowledge, occur in this form exclusively on polychrome glazed tiles. In the excavations of several Constantinopolitan churches, both tesserae and tile fragments were found in or near the east end.

The presence of the tile cornice at Córdoba raises questions about its intended function. M. Gómez-Moreno believed that it constituted a technical necessity as a support for the mosaic incrustations of the dome.[18] H. Stern felt that its application served solely aesthetic aims.[19] It seems to me that even though using tiles instead of mosaic for the cornice was surely faster and more economical, the aesthetic aspect must have played a major role. I agree with M. Jenkins that the cornice creates a special accent;[20] but beyond that, it seems to me also to set apart the dome from the rest of the structure below in a manner that intentionally echoes the Byzantine decorative practices outlined above.

All indications seem to point to the manufacture of the tiles for the mosque in Córdoba on or near this site and their execution by local craftsmen who were familiar with the production of local vessels of the same colors and technique. It is likely that the collaboration of several craftsmen of slightly different inclination and inspiration, apparently given only loose guidelines for the decoration, resulted in the lively character of this narrow cornice strip. As we have seen, the design of imbrications enclosing a palmette is found in both the Byzantine and Hispano-Muslim sphere. Thus, it seems plausible to state that the

Córdoba tile cornice can be considered a successful and effective amalgam of the Byzantine and Western Islamic decorative genius.[21]

1 N. Khury, "The Meaning of the Great Mosque of Córdoba in the 10th Century," *Muqarnas* 13 (1996), 80–98. J. D. Dodds, "The Great Mosque of Córdoba," in *Al-Andalus: The Art of Islamic Spain* (New York, 1992), 11–25; H. Stern, *Les mosaïques de la Grande Mosquée de Cordoue,* Madrider Forschungen 11 (Berlin, 1976), 2.

2 See Ibn ʿIdhārī al-Marrākushī, *Kitāb al-Bayān al-Mughrib* (Leiden, 1948–50), 392.

3 See M. Jenkins, "Medieval Maghribi Ceramics: A Reappraisal of the Pottery Production of the Western Regions of the Muslim World" (Ph.D. diss., Institute of Fine Arts, New York University, 1978), 209–10. See also Stern, *Cordove,* 30. By contrast, M. Mundell Mango, in Mason and Mango, "Glazed Tiles of Nicomedia,'" 314–15, implies that Byzantine craftsmen also created the tile cornice.

4 Stern, *Cordoue,* 14.

5 D. Duda, "Zur Technik des Keramiksimses in der Grossen Moschee von Córdoba," in Stern, *Cordoue,* 53.

6 Ibid., and also Stern, *Cordoue,* 8.

7 Duda, "Zur Technik," 53.

8 Ibid., 53.

9 Jenkins, "Medieval Maghribi," 209–10.

10 See the essay by J. Lauffenburger, C. Vogt, and A. Bouquillon in this volume.

11 Stern, *Cordoue,* 14; Duda, "Zur Technik," 54.

12 On this subject, see the essay by J. Anderson in this volume.

13 Totev, "L'atelier," 68–69, figs. 4, 5; 75, figs. 15, 17.

14 B. P. Maldonado, "Memoria de la excavación de la mezquita de Medinat al-Zahra," *Excavaciones arqueológicas en España* 50 (1964), 35, fig. 17; built between 953/54 and 956/57: O. Jiménez, "Inscripciones árabes descubiertas en Madinat al-Zahra' en 1944," *Al-Andalus* 10 (1945), 154–59.

15 C. Ewert, *Spanisch-islamische Systeme sich kreuzender Bögen,* Madrider Forschungen 2 (Berlin, 1968), 53, fig. 28.

16 See also Miatev, *Keramik,* 127, for a literary description of the Great Palace that refers to decoration of mixed media.

17 The design also appears in Preslav. See Totev, "L'atelier," 69, figs. 4, 5, and related designs; Miatev, *Keramik,* 104.

18 M. Gómez-Moreno, "El Arte arabe español hasta los Almohades," *Ars Hispaniae* 3 (1951), 146, 313.

19 Stern, *Cordoue,* 9, 46.

20 Jenkins, "Medieval Maghribi," 209.

21 Stern, *Cordoue,* 7, and Kühnel before him, expressed related ideas.

ELIZABETH S. ETTINGHAUSEN

XXII
Cherson

The city of Cherson was the stronghold of Byzantium on the Crimea, especially after the *theme* of Klimata was created ca. 832 by the emperor Theophilos (829–42). Between the tenth and twelfth centuries the city became an important economic and trading center between Byzantium and the tribes living to the north. Its significance is attested by the numerous autonomous coins minted in Cherson and by the seals of Byzantine officials, *strategoi* and *kommerkiarioi,* who resided in the city. Excavations have revealed a limited number of ceramic tablewares produced and decorated in Constantinople or its vicinity.[1] The existence of polychrome wares suggests that they were imported for a small circle of users, perhaps the Byzantine officials stationed in the city. The icon of Saint Elisabeth (cat. F.4), found during excavations in the city, belongs to this group of imported polychrome wares.

1 Zalesskaja, "Nouvelles découvertes," 49–62. For the excavation of the city, see A. K. Jacobson, *Rannesrednevekovyj Chersones* (Moscow and Leningrad, 1959).

ROSSITZA B. ROUSSANOVA

A
The Walters Art Museum, Baltimore

The collection of polychrome tiles at the Walters Art Museum comprises more than two thousand fragments divided into figural and ornamental types. The tiles represent a range of shapes, decorative styles, sizes, and glazing techniques. In the 1950s, tiles matching those now in the Walters Art Museum were available for sale in the antiquities market in Istanbul's Grand Bazaar. Correspondence in the museum's curatorial files and eyewitness accounts connect the Walters tiles with Nikos Avgheris,[1] a well-known merchant who had apprenticed, along with George Zacos and Petro Hanazoglou, in the antiquities shop of Andronikos.[2] The tiles were divided between the Walters and the Musée du Louvre. The Louvre purchased a small group of ceramic fragments from Avgheris in 1955. The Walters obtained its collection in 1956.[3] A number of locations have been alleged as the original site of the Walters tiles, including Izmit (Nicomedia),[4] Nikertai,[5] Üskübü,[6] and the more immediate Asiatic suburbs of Istanbul.[7] Many of the tiles are related to ceramic artifacts from excavations and investigations in and around Byzantine monuments of Constantinople.

1 In a letter dated 11 February 1957, David Talbot Rice recalled, "I must have seen these pieces in the shop of a dealer called Avgheris at Istanbul a few years ago. I did not realize that a few pieces that Coche de la Ferté showed me in the Louvre last year came from the same collection." Professor Nicole Thierry also remembers seeing crates of tile fragments in the same shop.

2 See B. Berry, *Out of the Past: The Istanbul Grand Bazaar* (New York, n.d.), 49. According to Mrs. Jeanette Zacos, Andronikos did not use a surname. It is tempting, however, to link this figure with the donor of a group of tiles to the Benaki Museum in Athens.

3 The Walters tiles were purchased through Robert Hecht in Switzerland.

4 Letter of Philippe Verdier in the curatorial files of the Walters Art Museum.

5 Nikertai is near Apameia in Phrygia. Verdier, "Tiles of Nicomedia," 633.

6 According to a notation in the curatorial files of the Department of Egyptian Antiquities, Coptic Division, Musée du Louvre, "M. Firatli, conservateur du Musée archéologique d'Istanbul, communique que toute cette série de céramique provient de Prusias ad Hypium, aujourd'hui Uskubé en Asie Mineure (9 juillet 1965)." Reference cited in Durand, "Plaques," 9, no. 2.

7 Philippe Verdier, in an early publication of the Walters tiles, noted: "Rumor rather than fact indicates that the Walters Art Gallery tiles come from a church which was leveled to the ground somewhere on the Asia Minor shore of Turkey, not too far from Constantinople (Istanbul)," in "Byzantine Tiles," 1.

SHARON E. J. GERSTEL

A.1

A.1 The Virgin and Child
[MP] | ΘY
Baltimore, Walters Art Museum, 48.2086.11
H. 29.9, W. 29.2, Th. 0.8 cm

CONDITION: Large square plaque reconstructed from twenty fragments. Four preserved sides with slightly rounded edges. Buff-colored fabric with iron oxide and quartz inclusions. Glaze colors include aubergine, amber, copper green, and clear. Amber glaze extends over lower edge. Glazes are crazed, with major losses to copper green, clear glaze on faces, and aubergine color on the Virgin's robe. Remnants of green and aubergine glaze appear on the diamond ornament and on the halo of the Child. Red slip used to model the hand of the Virgin. The reverse is covered with fine horizontal parallel striations. Intersecting striations define the preserved upper left corner. J.L.

DESCRIPTION: Bust image of the Virgin holding a clipeus with the Christ Child in front of her chest. The Virgin is flanked by the letters MP ΘY. The superscript bar bears parallel oblique hatchings. The traditional cross-shaped pellets appear on the Virgin's shoulders, which are wrapped in a *maphorion* with dense intercrossing folds. The figural composition is enclosed in a medallion framed by a large border. The border is filled with rows of lozenges forming a checkerboard pattern. A heart-shaped leaf emerges from the right corner of the medallion. In its iconography, with the Virgin *Nikopoios,* this plaque is very similar to one in the Musée du Louvre (cat. B.1). However, in the Walters tile the artist uses a more painterly style, with less linearity and sharpness in the drapery folds. The delicate treatment of the right hand, with extremely thin and elongated fingers and neatly drawn nails, is a distinctive feature of the artist, who might also have decorated the Saint Christopher plaque (cat. A.2). The repetition of the same iconographic type of the Virgin, rarely found in monumental painting, on two plaques of the same group suggests that the donors of these pieces had a particular veneration for the image of the *Nikopoios,* the cult of which is strongly connected with the Blachernai church in Constantinople and imperial piety. B.P.

A.2 Saint Christopher

Ο Α[γιος] Χ[ρισ] | ΤΟ[φόρ]ΟΣ

Baltimore, Walters Art Museum, 48.2086.13

H. 29.5, W. 29.5, Th. 0.7 cm

CONDITION: Large square plaque reconstructed from twenty-two fragments. Four preserved sides with slightly rounded edges. Buff-colored fabric with iron oxide and quartz inclusions. The bottom left edge has a surface flaw that was created before firing. Some fragments have been affected by heat. Glaze colors include aubergine (on the fibula and chlamys), amber, copper green, and clear. Considerable loss to green glaze. The intact amber glaze is crazed with isolated flake losses. A deteriorated clear glaze can be seen on the saint's face. Figure painted in an iron oxide slip with some flake losses, leaving a pale stain. Red slip is used to highlight the chin. The reverse is covered with vertical and horizontal striations that define the corners. Samples taken for SEM and NAA analysis. J.L.

DESCRIPTION: The young martyr, Christopher, is represented in a frontal pose on an amber medallion. His portrait is encircled by a green band ornamented with a heart-shaped leaf at each corner. In his right hand, the saint holds a cross decorated with pearls at its terminal ends. The thumbnail and knuckle of the hand are differentiated by thick lines. His oval, beardless face is crowned by neatly arranged straight hair that falls over his shoulders; strands are individualized by thick brush strokes. Christopher's eyes are wide and round: the elongated line of the upper lid extends horizontally; the inner corner of his right lower lid is emphasized by a vertical crease along the nose. The high-arched brows are painted in thick black strokes. The ears are low and rounded. The chin is delineated by two arched lines below the mouth and three above the neck. As in his early-eleventh-century mosaic portrait in the *katholikon* of Hosios Loukas in Phokis (Greece), Christopher wears a chlamys with a gold, jeweled *tablion* and is not nimbed. His robe is fastened on his right shoulder by a round fibula enriched through the addition of aubergine glaze. Further decoration is provided by an ornamental band on the right sleeve. Similar facial features, especially in the formation of the eyes and the arch of the brows, are seen on a fragmentary tile from the region of Düzce (cat. xx.1). S.G.

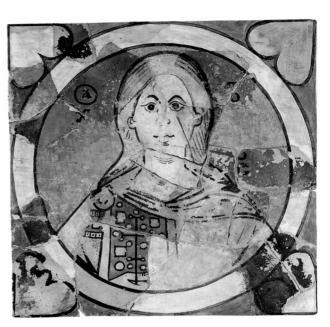

A.2

A.3 Saint Panteleimon

['Ο Ἅγιος | Παντελ]ΕΕΙΜΩΝ

Baltimore, Walters Art Museum, 48.2086.15

M.P.H. 7.7, M.P.W. 7.7, Th. 0.9 cm

CONDITION: Two nonjoining fragments from a large square plaque. No preserved edges. Buff-colored fabric with iron oxide and quartz inclusions. Glaze colors include aubergine (hair), amber, and clear. Major losses in amber and clear glazes. Design drawn in iron oxide slip. Samples taken for NAA analysis. J.L.

DESCRIPTION: Saint Panteleimon, the "all-merciful," is one of the holy *anargyroi*, physician saints who refused payment for medical treatment. His feast day is celebrated on 27 July. The youthful healing saint was originally placed on an amber ground. His wavy dark brown hair covers most of his ear. There are two types of line visible in the fragments: the quick thick lines of the unruly youthful hair and the thinner, uniform strokes that delineate Panteleimon's ear, face, and neck. The Walters portrait corresponds with contemporary representations of the healing saint in other media. The execution of the hair, for example, is consistent with the eleventh-century mosaic portrait of the saint in the *katholikon* of Hosios Loukas in Phokis (Greece).[1]

1 Chatzidakis, *Hosios Loukas*, 44–45, fig.33. M.H.

A.3

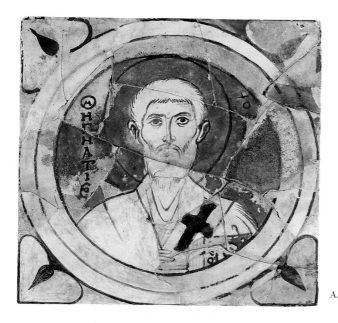

A.4

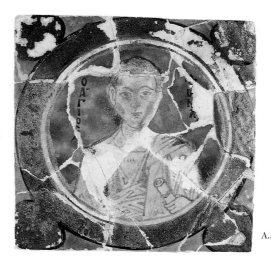

A.5

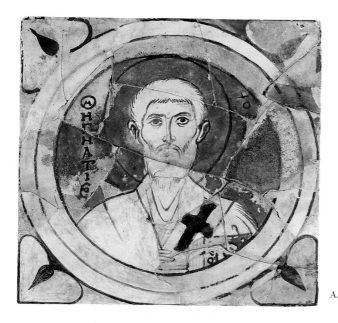

A.5 back

A.4 Saint Ignatios Theophoros

Ο Α(γιος) ΗΓΝΑΤΙΟΣ | Ο ΘΕ[ο]ΦΩΡ[ος]

Baltimore, Walters Art Museum, 48.2086.7

H. 25.7, W. 26.0, Th. 0.7 cm

CONDITION: Large square plaque reconstructed from twenty fragments. Four preserved sides; edges are acutely beveled. Buff-colored fabric with iron oxide and quartz inclusions. Uneven firing pattern evident on the reverse side; fabric is buff to pale orange. Glaze colors include amber, copper green, and clear. Much of the amber glaze is intact yet has a fine crazed pattern. Three fragments on the central right side of the plaque exhibit darkening and glaze reticulation as a result of exposure to extreme heat or fire. Fragments in direct contact with this section do not show signs of exposure to heat, indicating that the tile was burned after it was broken. Major losses to the green glaze marking the inner border and the leaves. Where the glaze remains, it is opaque due to a weathering crust. A layer of clear glaze is evident on the lower left part of Ignatios's face as well as on his left ear. Pink slip is used to model facial features. There are losses in the black iron oxide drawing of the figure; traces remain as a pale red stain. The reverse is covered with short multidirectional striations. Numerous small voids and dark pits, due to the prevalence of iron oxide, dot the surface. Samples taken for NAA analysis and thin-section petrography. J.L.

DESCRIPTION: Frontal half-length portrait of Saint Ignatios Theophoros, the third bishop of Antioch, who was martyred in Rome during the reign of the emperor Trajan (98–117). The nimbed figure is encircled by a double band; heart-shaped leaves fill the corners of the plaque. The representation, drawn in a fine, calligraphic hand, follows the artistic convention for portraits of the saint already established by this period.[1] Ignatios has white hair and a medium-length beard that terminates in a point. Individual strands of hair are marked by short, emphatic brush strokes. The saint is vested as a bishop; his *omophorion* is decorated by a thick cross. He holds a closed jewel-encrusted Gospel book in his left arm and extends the fingers of his right hand in a gesture of speech.

EXHIBITION: Athens 1964, no. 601.

1 C. Mango and E. J. W. Hawkins, "The Mosaics of St. Sophia at Istanbul: The Church Fathers in the North Tympanum," *DOP* 26 (1972), 1–41, pl. 28.

S.G.

A.5 Saint Thomas

Ο ΑΓΙΟΣ | ΘΩΜΑ[ς]

Baltimore, Walters Art Museum, 48.2086.3

H. 16.7, W. 16.7, Th. 0.6–0.7 cm

CONDITION: Small square plaque reconstructed from fifteen fragments. Four preserved sides; edges are beveled. Buff-colored fabric with iron oxide and quartz inclusions. Glaze colors include aubergine (hair), amber, copper green (opacified in areas due to a weathering crust), and clear. Glazes are crazed. The aubergine, green, and clear glazes are heavily deteriorated. The saint's white (reserve) robe is lightly tinted with a dilute green glaze. Pink slip is used to highlight facial features and the scroll. The figure is outlined in a dilute iron oxide glaze. The reverse is covered with multidirectional grooves, some deep, with voids and pockets due to dragged inclusions; there are discrete traces of glaze. The Greek letter *phi,* painted in iron oxide slip, marks the center of the left side of the reverse. J.L.

DESCRIPTION: The youthful Thomas is represented on an amber medallion encircled by a double border composed of a thin white line in reserve followed by a wider band of green. Green heart-shaped leaves decorate the corners of the plaque. The apostle has short hair and large wide eyes. Touches of red color his lips and highlight his cheeks as well as the band and interior of the scroll that he holds in his left hand. Dressed in a tunic, Thomas extends his right hand in a gesture of speech. S.G.

A.6 Saint Paul

Ο ΑΓΙΟΣ | [Παῦλο]Σ

Baltimore, Walters Art Museum, 48.2086.20

H. 16.5, W. 16.3, Th. 0.6–0.8 cm

CONDITION: Small square plaque reconstructed from five frag-
ments. Four preserved sides; edges are beveled. The tile tapers
slightly in thickness from top to bottom. Buff-colored fabric with iron
oxide and quartz inclusions. Glaze colors include aubergine, amber,
copper green, and clear. Major losses to all glazes with the exception
of amber. The glaze is crazed overall. Clear glaze is used on the inner
border of the circle and on the figure. The saint's white (reserve) robe
is lightly tinted with a dilute green glaze. Red slip highlights the orna-
ments of the book and the saint's face. Black outlines are drawn in
iron oxide slip. The reverse is finished with multidirectional deep
striations. At the center of the left side is the Greek letter *omicron;* the
letter *nu* is located on the center of the right side. Both letters are
painted in iron oxide slip. J.L.

DESCRIPTION: Although no inscription remains, the facial features
of the saint identify him as Paul. He is placed at the center of an
amber medallion encircled by a double border composed of a thin
white line in reserve followed by a wider band of green. Green heart-
shaped leaves fill the corners of the tile; the upper right corner is now
missing. The saint wears a light-colored tunic. A section of a vertical
amber band is still visible below his right shoulder. Paul carries a
codex decorated with a chevron design composed of green, amber,
and red (slip) lines. There are also some touches of red on the book's
spine. The saint can be identified by his receding hairline, thin face,
and long pointed beard. Although the face is damaged, the left eye
and tip of the nose are intact; the contours of the face and shape of
the beard conform with conventional portraits of Paul. Touches of
red slip on the lips and cheeks serve to enliven the portrait. M.H.

A.6

A.6 back

A.7 John the Baptist

[Ὁ Ἅγιος Ἰωάννης ὁ | Π]ΡΟΔΡ[ομος]

Baltimore, Walters Art Museum, 48.2086.26

H. 16.3, W. 16.3–16.5, Th. 0.7 cm

CONDITION: Small square plaque reconstructed from nine frag-
ments. Three sides are preserved; edges are beveled. Buff-colored
fabric with iron oxide and quartz inclusions. Glaze colors include
aubergine, amber, copper green, and clear. All glazes are crazed, with
major losses in the aubergine and green. Drawing in iron oxide slip.
Pink slip on cheeks. The reverse is finished with deep, primarily ver-
tical striations. A cross is painted in iron oxide slip on the reverse,
centered along the left edge. Samples taken for SEM analysis and
thin-section petrography. J.L.

DESCRIPTION: John the Baptist is placed at the center of an amber
medallion. The representation is surrounded by a double border
composed of a thin white line in reserve followed by a wider band of
green. Green heart-shaped leaves fill the corners of the tile. The saint
turns slightly to his right and raises his right hand in a preaching ges-
ture. Over his aubergine garment he wears a green mantle that is
knotted at his chest. The face has been heavily damaged. As in stan-
dard portraits of this figure, his hair and beard are unkempt. M.H.

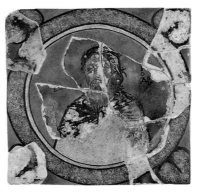

A.7

A.7 back

A.8 Saint Bartholomew

Ὁ ΑΓΙΟΣ | ΒΑΡΘΩΛΟ[μαῖος]

Baltimore, Walters Art Museum, 48.2086.29

H. 16.5, W. 16.5, Th. 0.6–0.7 cm

CONDITION: Small square plaque partially reconstructed from seven fragments. Four sides are preserved; edges are acutely beveled. Buff-colored fabric with iron oxide and quartz. Glaze colors include aubergine (hair), amber, copper green, and clear. Much of the amber glaze is intact yet crazed. Major losses in green glaze on border and in clear glaze on the robe and face. Remnants of red/pink slip beneath a clear glaze model the saint's face. Drawing in iron oxide slip. The reverse was finished with multidirectional striations. Impressions from a textile pattern are visible on the bottom corner and are covered by splashes of green glaze. The bottom half of a cross is painted in iron oxide slip on the reverse, centered along the left edge. Samples taken for NAA analysis.　　J.L.

DESCRIPTION: Saint Bartholomew is placed at the center of an amber medallion. The field is surrounded by a double border composed of a thin white line in reserve followed by a wider band of green. A single heart-shaped leaf is preserved in the lower right corner of the tile. The saint's body is missing. He has a dark trimmed beard and short hair that curls over the center of his high forehead. His left eyebrow arches acutely over his eye. Red slip provides color on the cheeks.　　M.H.

A.8

A.8 back

A.9 Saint Matthew

Ὁ Α[γιος] | ΜΑΤΘΑΙΟ[ς]

Baltimore, Walters Art Museum, 48.2086.25

H. 16.9, W. 16.6, Th. 0.6–0.7 cm

CONDITION: Small square plaque reconstructed from ten fragments. Four sides are preserved; edges are acutely beveled. Buff-colored fabric with iron oxide and quartz inclusions. The central features of Matthew's face are lost. Glaze colors include aubergine, amber, copper green, and clear. Glazes are crazed; losses to amber are restricted to break edges. Major losses to the green marking the border and to the clear on the robe and the saint's face. The green glaze is opaque in areas due to the formation of a weathering crust. A shrinkage crack due to firing passes through Matthew's name. Red slip highlights portions of his book. Drawing in iron oxide slip. The reverse is covered with multidirectional striations, especially at the bottom. Large void due to burned-out organic material. The Greek letter *phi* is painted in iron oxide slip on the reverse, centered along the left edge. Samples taken for SEM and NAA analysis.　　J.L.

DESCRIPTION: Saint Matthew is placed at the center of an amber medallion. The round field is surrounded by a double border composed of a thin white line in reserve followed by a wider band of green. Green heart-shaped leaves fill the corners of the tile. The saint raises his right hand in a gesture of benediction. In his left, he holds an amber-colored book decorated with red and green jewels. There are traces of red color on the book's spine. The saint is dressed in a light-colored tunic with an amber band over the right shoulder. The portrait employs the typical facial features associated with the saint, dark hair and beard and a high forehead.　　M.H.

A.9

A.9 back

A.10 Saint John the Theologian

[Ὁ Ἅγιος Ἰωαννης] | Ο ΘΕΟΛ[όγος]
Baltimore, Walters Art Museum, 48.2086.28
(a) M.P.H. 7.4, M.P.W. 10.0, Th. 0.7 cm
(b) M.P.H. 11.5, M.P.W. 8.0, Th. 0.7 cm

CONDITION: Small square plaque reconstructed from two groups of joined fragments. One group consists of five fragments and the other of three. Preserved edges are beveled. Buff-colored fabric with iron oxide, quartz, and terracotta inclusions. Glaze colors include aubergine, amber, copper green, and clear. The glazes are highly deteriorated and crazed. A blurring of glaze colors can be seen in several areas, including the top left ivy leaf and the inner circle at the right side, indicating that all glazes were fired at the same time and temperature. Pink slip beneath the clear glaze highlights the saint's face. Drawing in iron oxide slip. Isolated fragments, including the shoulder and the book, are darkened by heat from a fire, which created a darkened alteration layer on the amber glaze. The reverse is roughly finished with deep multidirectional striations. The Greek letter *epsilon* is painted in iron oxide slip and is centered on the reverse left side; the letter is partially covered by splashes of green and amber glaze. Samples taken for NAA analysis. J.L.

DESCRIPTION: Saint John is placed at the center of an amber medallion. The round field is surrounded by a double border composed of a thin white line in reserve followed by a wider band of green. Two green heart-shaped leaves are wholly or partially preserved in the upper corners of the tile. The right side of the saint's body and lower portions of his face are missing. John wears a light-colored garment. In his left hand, he holds an amber book decorated with jewels. The elderly saint is balding; his high forehead shows the lines of age. His brows are dark and arch acutely over his eyes. M.H.

A.10

A.10 back

A.11 Saint Peter

[Ὁ Ἅγιος] | ΠΕΤΡΟΣ
Baltimore, Walters Art Museum, 48.2086.27
(a) M.P.H. 7.6, M.P.W. 6.4, Th. 0.7 cm
(b) M.P.H. 14.9, M.P.W. 12.9, Th. 0.7 cm

CONDITION: Small square plaque reconstructed from four joined fragments and one single fragment; preserved edges are beveled. Buff-colored fabric with iron oxide and quartz inclusions. Glaze colors include aubergine (hair), amber, copper green, and clear. Glaze is crazed overall, with major losses to the green and clear. The saint's white (reserve) robe is lightly tinted with a dilute green glaze. Drawing in iron oxide slip. The reverse is finished with pronounced multidirectional striations. Impressions of a textile pattern are visible along the lower edge. Centered along the left side of the reverse is the Greek letter *nu*; the letter *epsilon* is located on the center of the right side. Both letters are painted in iron oxide slip. Samples taken for NAA analysis and thin-section petrography. J.L.

DESCRIPTION: Saint Peter is placed at the center of an amber medallion. The round field is surrounded by a double border composed of a thin white line in reserve followed by a wider band of green. One green heart-shaped leaf remains from the upper right corner of the plaque. Only the lower part of the saint's figure remains. The apostle is wearing a light-colored tunic with an amber band over the right shoulder. He carries a staff in his left hand. M.H.

A.11

A.11 back

A.12 Apostle Andrew

[Ὁ ῞Αγιος] | ΑΝΔΡΕ[ας]
Baltimore, Walters Art Museum, 48.2086.24
(a) M.P.H. 7.5, M.P.W. 7.6, Th. 0.6–0.8 cm
(b) M.P.H. 7.0, M.P.W. 16.4, Th. 0.6–0.8 cm

CONDITION: Small square plaque reconstructed from two groups. Upper right group consists of two fragments, and lower group consists of three; preserved edges are beveled. Buff-colored fabric with iron oxide and quartz inclusions. Glaze colors include amber, copper green, and clear. Significant losses to all glaze colors. Glazes are crazed; this is most evident on the dirt-encrusted clear glaze of the figure and inner circle. The saint's white (reserve) robe is lightly tinted with a dilute green glaze. Design in iron oxide slip. The reverse is finished with deep striations that fan out from the lower left-hand corner. The use of a blunt tool is visible on the reverse. The Greek letter *phi*, painted with iron oxide slip, is centered along the left edge of the reverse side. J.L.

DESCRIPTION: Saint Andrew is placed on an amber medallion. The round field is surrounded by a double border composed of a thin white line in reserve followed by a wider band of green. Only the lower part of the apostle's figure is preserved. He wears a tunic with an amber band over the right shoulder. In his left hand, he holds a cross staff, a sign of his status as apostolic founder of the Constantinopolitan Church. M.H.

A.12

A.12

A.12 back

A.13 Saint Luke

[Ὁ ῞Αγιος] | [Λου]ΚΑΣ
Baltimore, Walters Art Museum, 48.2086.21
M.P.H. 16.5, M.P.W. 10.7, Th. 0.6–0.8 cm

CONDITION: Small square plaque reconstructed from eight joined fragments; preserved edges are beveled. The tile tapers slightly in thickness from top to bottom. Buff-colored fabric with iron oxide and quartz inclusions. Glaze colors include aubergine (hair), amber, copper green, and clear. The glazes are not well preserved and are all crazed. Significant losses within the figure and border. Design is painted in iron oxide slip. The reverse is finished with multidirectional striations that fan out from the lower left corner. A fragmentary letter, illegible, is painted in iron oxide slip on the reverse and is centered along the left edge. J.L.

DESCRIPTION: The fragmentary inscription suggests the figure's identity as the apostle Luke. The saint is placed at the center of an amber medallion. The round field is surrounded by a double border composed of a thin white line in reserve followed by a wider band of green. One green heart-shaped leaf fills the lower right corner of the tile. Luke's face and upper torso are largely missing or worn; traces remain of dark hair and a beard. In his left hand, Luke holds a closed codex that is decorated with jewels, some of which show traces of green glaze. There is some red slip on the book's spine. M.H.

A.13

A.13 back

A.14 Unidentified Apostle (Simon?)

[. . .] ΣΙ [. . .] | [. . .]
Baltimore, Walters Art Museum, 48.2086.8
M.P.H. 7.8, M.P.W. 13.0, Th. 0.7 cm

CONDITION: Section of a small square plaque reconstructed from three fragments. A single side is preserved; its edge is beveled. Buff-colored fabric with iron oxide, quartz, and terracotta inclusions. Glaze colors include aubergine, amber, copper green, and clear. Glazes are crazed. Major losses are concentrated on the green border and in the clear glaze. Figure is painted in iron oxide slip. Pink slip is preserved on the face. The reverse is finished with parallel striations. The Greek letter *phi* is painted in iron oxide on the reverse, centered along the right edge. J.L.

DESCRIPTION: The frontal saint is placed on an amber ground with traces of a green and white-reserve band forming a circular frame. Only the face and upper left shoulder of the saint remain; he has a short rounded beard and dark brown hair, features generally associated with representations of the apostle Simon. Patches of pink slip highlight the cheeks and ridge of the nose. The nose is slightly flared, and the brows arch acutely over the eyes. M.H.

A.15 Unidentified Apostle (James?)

Ο ΑΓΙΟΣ | [. . .]
Baltimore, Walters Art Museum, 48.2086.23
M.P.H. 9.3, M.P.W. 7.0, Th. 0.7 cm

CONDITION: Section of a small square plaque reconstructed from two fragments. Preserved upper side; edge is beveled and double cut. Buff-colored fabric with iron oxide and quartz inclusions. Glaze colors include aubergine (hair), amber, copper green, and clear. Glazes are poorly preserved and are crazed. Aubergine, green, and clear glazes remain only as traces. Outline is drawn in iron oxide slip. The reverse shows tool marks from a blunt-edged tool. There are impressions of a textile pattern along the upper edge. J.L.

DESCRIPTION: The saint is placed at the center of an amber medallion. The round field is surrounded by a double border composed of a thin white line in reserve followed by a wider band of green. The saint wears a light-colored garment. His face is extremely damaged, but there are indications of dark hair and a long dark beard. On the basis of these features, the saint may be tentatively identified as James. M.H.

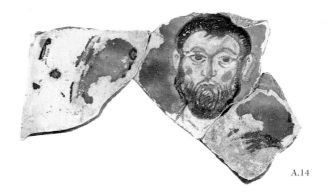

A.14

A.14 back

A.15

A.16 Unidentified Apostle (Philip?)

[΄Ο ΄Α]ΓΙΟΣ | [. . .]

Baltimore, Walters Art Museum, 48.2086.22

(a) M.P.H. 9.2, M.P.W. 9.5, Th. 0.6–0.8 cm

(b) M.P.H. 7.5, M.P.W. 12.2, Th. 0.6–0.8 cm

CONDITION: Small square plaque reconstructed from two groups of joined fragments. There are four fragments in one group (upper left) and five in the other (lower right). Preserved edges are beveled. Buff-colored fabric with iron oxide, quartz, and terracotta inclusions. Glaze colors include aubergine, amber, copper green, and clear. Glazes are crazed overall, with major losses to the green border. Drawing in iron oxide slip. The reverse is finished with multidirectional striations. The Greek letter *tau* is painted in iron oxide slip on the reverse, centered along the right edge. J.L.

DESCRIPTION: The saint is placed at the center of an amber medallion. The round field is surrounded by a double border composed of a thin white line in reserve followed by a wider band of green. Heart-shaped leaves are preserved in the upper left and lower corners. The saint raises his right hand in a gesture of speech and holds a closed codex in his covered left hand. A thin amber stripe adorns the saint's robe and can be seen to the left of his raised hand. There are traces of dark hair; there is no indication that the saint was bearded. The apostle Philip is traditionally represented without a beard; in all likelihood, this plaque was once decorated with his portrait. M.H.

A.17, A.18 Archangels

[Γαβ] | [ρ]ΙΗΛ (Angel 1)

Baltimore, Walters Art Museum, 48.2086.18

Th. 0.7–0.8, W. 16.5 cm (restored)

CONDITION: Two fragmentary square tiles consisting of many nonjoining fragments. Preserved edges are acutely beveled. Buff-colored fabric with quartz and iron oxide inclusions. Glaze colors include aubergine, amber, copper green, and clear. The amber glaze is intact yet crazed. Major losses are in aubergine glaze. Diluted green glaze is used for shading on the angels' robes and was covered by clear glaze. Red slip is used for the angels' sandals. The reverse sides are finished with multidirectional striations. On the reverse side of one plaque are marks left by a toothed blunt-edged tool (0.5 cm wide). Impressions from a textile pattern are evident on the upper left edge. A.17 consists of six joined fragments and three nonjoining fragments. A.18 consists of two groups of nonjoining fragments, five and three fragments each, and two additional fragments. J.L.

DESCRIPTION: Fragments of two archangels, most likely Michael and Gabriel. The figures are placed on an amber ground. On one fragment, the angel is in motion. His feet are turned, and he appears to be striding forward. The folds of his garment are rendered with quick, dark brush strokes. The hem is slightly agitated, and the garment flares outward. The angels' wings are aubergine, and their tips reach almost to the ground. M.H.

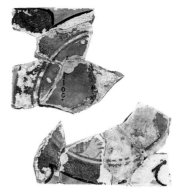

A.16

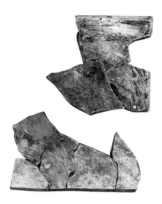

A.16 back

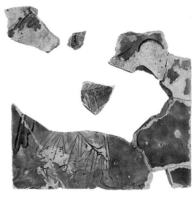

A.17

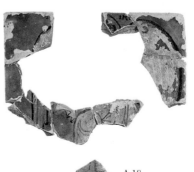

A.18

A.19 Saint Nicholas

Ο ΑΓΙΟ(ς) | ΝΗΚΟΛΑΟ(ς)

Baltimore, Walters Art Museum, 48.2086.1

H. 16.8, W. 16.4, Th. 0.6–0.7 cm

CONDITION: Small square plaque reconstructed from five fragments. Four sides are preserved; the edges are beveled. Buff-colored fabric with quartz and iron oxide inclusions. Surface is in good condition; shallow surface loss at right wrist. Glaze colors include amber, copper green, and clear. Glaze extends over edges. Overall crazing and localized loss of glaze along breaks. Figure and exposed fabric are covered by clear glaze. Red slip on book spine and ornaments as well as on decorative details of frame. Figure painted with a dilute iron oxide glaze. Reverse side smoothed, with striations that run parallel to the width of the plaque. On the reverse side are marks from a narrow-toothed scraping tool (0.2 cm wide). A simple foliate design is painted on lower part of the reverse in iron oxide slip. Samples taken for NAA analysis. J.L.

DESCRIPTION: Saint Nicholas is represented in half-length within a foliate frame. Placed on an amber background, the saint is nimbed and wears episcopal vestments, including the *omophorion* and *encheirion*. His right hand is raised in speech; his covered left hand supports an elaborately decorated Gospel book. Facial features and costume details are rendered by thick strokes; strands of hair are undifferentiated. With his wide face and short, rounded white beard, this portrait resembles contemporary representations in other media. A similar portrait of Nicholas is seen in a fresco uncovered in excavations adjacent to Saint Eirene.[1] Dated to the eleventh century by Dirimtekin, the painted portrait of the saint shows the same economy of line as that on the ceramic icon. A portrait of the saint, perhaps the product of the same workshop, decorates the well of a whiteware bowl excavated in Aksaray (at right).[2]

COMPARISONS: Private Collection (cat. J.1).

LITERATURE: Coche de la Ferté, "Décors," 214, fig. 15b; *Glory of Byzantium*, 43–44.

EXHIBITIONS: Athens 1964, no. 600; Washington, D.C., 1995; New York 1997, no. 10a.

1 Dirimtekin, "Fouilles," 176, fig. 21.
2 The bowl will be published by Mrs. Asuman Denker. S.G.

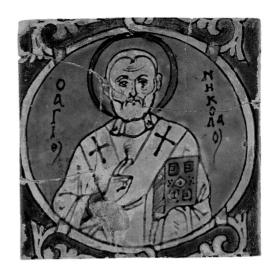

A.19

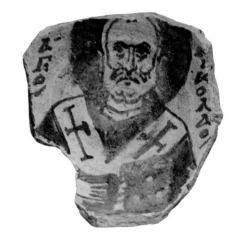

A.20 Saint Paraskeve

Η ΑΓΙΑ | Π[αρασκε]ΓΗ

Baltimore, Walters Art Museum, 48.2086.14

H. 16.6, W. 16.4, Th. 0.6 cm

CONDITION: Small square plaque reconstructed from thirteen fragments. Four preserved sides with beveled edges. Buff-colored fabric with iron oxide and quartz inclusions. Glaze colors include aubergine, amber, copper green, and clear. Much of the glaze is well preserved yet exhibits crazing. The aubergine glaze is completely worn, leaving only a pale purple stain. Clear glaze is still evident on the inner border of the foliate frame and on the figure. Red slip is visible on the polygonal shapes that secure the tendrils at the bottom edges. Figure painted with a dilute iron oxide slip. The reverse is fairly smooth. The impressions of a textile pattern are visible on the right side. Samples taken for NAA analysis. J.L.

DESCRIPTION: Although the saint's name begins with the letter *pi* and terminates with an *eta*, the penultimate letter, a *gamma*, is not consistent with the traditional spelling of Paraskeve's name.[1] The female martyr, celebrated on 26 July, is known for her active promo-

tion of Christianity. She is one of the most commonly represented female saints in Byzantine art. The half-length figure is placed at the center of an amber medallion. The round field is surrounded by a white foliate design, which extends in curling tendrils to fill the green-glazed corners of the tile. The saint's garments are aubergine. Only the right cuff and the head-covering beneath the *maphorion* are rendered in amber. The amber accents are further enhanced by four black dots arranged in a diamond pattern on the cuff and by three green squares on the headdress, which may represent gems sewn onto the fabric. A uniform dark outline defines the narrow oval head. The dark eyes, crowned by acutely arched brows, form the most prominent aspects of the saint's face. Quick lines create delicate feminine features such as the slender nose and narrow mouth. The saint holds a martyr's cross in her right hand. Her left hand, of which only a few fingers survive, is raised in a gesture of benediction. Some of the thick lines of her garment extend over the vegetal frame of the medallion and demonstrate that the painter used a quick and summary style of execution; the layering of the lines suggests that the medallion's frame was painted before the saint's portrait. The earliest preserved depiction of Paraskeve appears on folio 285r of the Paris Gregory (Bibliothèque Nationale, gr. 510), dated 879–83.[2] In the miniature, the saint wears a long brown robe with a dark *maphorion*

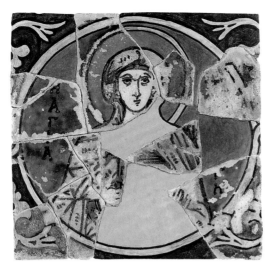

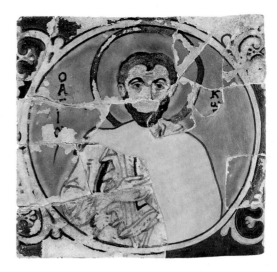

A.20

A.21

and carries the instruments of Christ's Passion, as befitting her association, through the literal translation of her name, with the Lenten celebration of Holy Friday. In monumental painting, Paraskeve is included in the early- or mid-eleventh-century decoration of Kiliçlar Kusluk (Chapel 33) in Göreme, where she is represented in half-length with her arms raised in an orant pose. In the monumental representation, her *maphorion* is deep red.[3]

1 The inscription accompanying the portrait of Paraskeve in the mid- or late-tenth-century church of Ballı kilise in Belisirma is spelled ΠΑΡΑΣΚΕΓΒΙ; the presence of the *gamma* on the tile reflects a similar misspelling or alternative spelling. Jolivet-Lévy, *Les églises,* 313. For the biography of Saint Paraskeve, see K. Onasch, "Paraskeve-Studien," *Ostkirchlichen Studien* 6 (1957), 121–41.

2 L. Brubaker, *Vision and Meaning in Ninth-Century Byzantium: Image as Exegesis in the Homilies of Gregory of Nazianzus* (Cambridge, 1999), 205, fig. 29; S. Der Nersessian, "The Illustrations of the Homilies of Gregory of Nazianzus: Paris Gr. 510: A Study of the Connections Between Text and Images," *DOP* 16 (1962), 202, pl. 3.

3 Jolivet-Lévy, *Les églises,* 145, pl. 9. M.H.

A.21 Saint James

Ο ΑΓΙΟ[ς] | ['Ιά]ΚΩΒ[ος]

Baltimore, Walters Art Museum, 48.2086.9
H. 16.7, W. 16.6, Th. 0.5–0.7 cm (restored)

CONDITION: Small square plaque reconstructed from eleven fragments. The four preserved edges are beveled. Buff-colored fabric with iron oxide inclusions. Glaze colors include aubergine (hair), amber, copper green, and clear. Glazes are crazed overall, with major losses to the aubergine and green. The amber glaze is in good condition, with isolated losses along the broken edges. Red slip is used on the scroll. The figure is painted with a dilute iron oxide slip. The reverse is fairly smooth. There are isolated hollows formed by burned-out organic materials. Samples taken for SEM and NAA analysis. J.L.

DESCRIPTION: The depicted apostle is either Saint James Major, son of Zebedee and brother of John, or Saint James Minor, son of Alphaeus. The half-length image of the apostle is placed at the center of an amber medallion. The round field is encircled by white intertwined tendrils on a green ground. The nimbed saint has a dark brown (aubergine) beard; a thick strand of wavy hair curls over the center of his furrowed brow. His face is partially preserved; features include the prominent dark brows linked by a light inverted stroke of glaze and the straight narrow nose. He wears a light-colored tunic; its bunched fabric falls in a cascade of tight folds over his right shoulder. The apostle's right hand is raised in a gesture of speech. In his left hand, he clasps a scroll, which still shows traces of red-slip coloring. The outlines and features of the figure, as well as the folds of his garment, are rendered in thick brush strokes. The apostolic garments and dark hair and beard are associated with both James Major and James Minor. In Middle Byzantine art, the two saints are usually differentiated by inscriptions. A half-length portrait of James, son of Zebedee, that is comparable in pose and attributes to the Walters plaque is found on a tenth- or eleventh-century ivory casket in Florence.[1] James, the son of Alphaeus, is represented carrying a scroll on an inlaid marble plaque from Thessalonike. The plaque, which has been identified as a fragment of a templon architrave, has been dated to the second half of the tenth century.[2] James, the dark-haired and bearded apostle, also appears on enamel plaques decorating three book covers today in the Biblioteca Marciana in Venice.[3]

1 A. Goldschmidt and K. Weitzmann, *Die byzantinischen Elfenbeinskulpturen des X.–XIII. Jahrhunderts,* I, *Kästen* (Berlin, 1930), pl. LIX, 98a.

2 *Glory of Byzantium,* 43, fig. 9.

3 *Treasury of San Marco,* 124–27, 152–55. M.H.

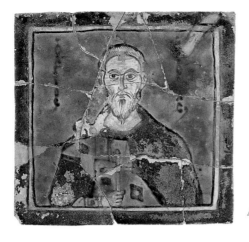

A.22

A.23

A.22 Saint Arethas

Ο ΑΓΙΟΣ | ΑΡΕΘΑΣ

Baltimore, Walters Art Museum, 48.2086.2

H. 17.2, W. 17.1, Th. 0.8 cm

CONDITION: Small square plaque reconstructed from ten fragments. The four preserved edges are acutely beveled. Buff-colored fabric with iron oxide and quartz inclusions. Glaze colors include aubergine (on right sleeve of tunic), amber, copper green, and clear. Glaze exhibits crazing overall. Losses in glaze concentrated along break edges and on green border. Uneven application of glaze in background, including above inscription; swipe across glaze on upper right corner before firing. Traces of glaze on reverse upper right corner and over edges. Pink slip used on lips, and red slip at terminal ends of cross and on his fibula. Figure is painted with a dilute iron oxide glaze. Reverse side diagonally smoothed with shallow voids due to dragged inclusions. Possible traces of plaster on left edge. On the reverse side are marks left by a narrow blunt-edged tool (0.2–0.4 cm wide). Sample taken for SEM analysis. J.L.

DESCRIPTION: Arethas is depicted in half-length on an amber background. The portrait is enclosed by a thin white-reserve and a thicker green frame. The saint, who is not nimbed, has short cropped hair with strands falling over his forehead. His beard is medium length and pointed. As is the case with the representation of Ignatios Theophoros (cat. A.4), the saint's heavy brows meet at the bridge of his nose, which is outlined by a thick and a thin stroke. The lower lids are emphasized by an elongated line beginning at the inner corner of the eye. The lips and cheeks are highlighted with pink slip. Arethas wears a chlamys and *tablion;* he holds a cross in his right hand that, as in his representation in the crypt of Hosios Loukas in Phokis (Greece), is decorated with round jewels at its terminal ends.

LITERATURE: Coche de la Ferté, "Décors," 214, fig. 15a; *Glory of Byzantium,* 43–44; I. Ševčenko, "Observations Concerning Inscriptions on Objects Described in the Catalogue 'The Glory of Byzantium,'" *Palaeoslavica* VI (1998), 243.

EXHIBITIONS: Athens 1964, no. 599; Washington, D.C., 1995; New York 1997, 10b. S.G.

A.23 Saint Basil

Ο ΑΓΙΟ[ς] | [Βα]ΣΗΛΕΙΟ[ς]

Baltimore, Walters Art Museum, 48.2086.17

M.P.H. 10.5, W. 17.2, Th. 0.6–0.7 cm

CONDITION: Small square tile reconstructed from eight fragments. Three preserved edges are acutely beveled and double cut. Buff-colored fabric with iron oxide and quartz inclusions. Glaze colors include aubergine, amber, copper green, and clear. Much of the amber glaze is intact yet crazed; losses are primarily along the break edges. Red slip is evident on the cheeks. Clear glaze can be detected on the inner border. The reverse demonstrates use of a blunted tool for finishing (approximately 0.6 cm wide). J.L.

DESCRIPTION: Basil, the fourth-century bishop of Caesarea, is represented frontally and in half-length. An important theologian and author, Basil's feast day is celebrated on 1 and 2 January. His portrait is placed against an amber background; the composition is framed by a double border of copper green and white reserve. The saint's name is inscribed on either side of his head; there is no halo. Only the right half and lower portion of the saint's face is preserved; his features are similar to those of Arethas (cat. A.22). Traces of the right eye, nose, and mouth can still be seen; features are augmented by pale pink (slip) highlights. Basil is depicted with a long thick beard. The image on the Walters icon conforms with the conventional portrait type for Basil, which was already well established by this period. A representation of the saint with a narrow face, long beard, and short dark hair is seen, for example, in a ninth-century Constantinopolitan manuscript, the Paris Gregory (Bibliothèque Nationale, gr. 510, f. 104r).[1]

1 L. Brubaker, "The Vita Icon of Saint Basil: Iconography," in *Four Icons in the Menil Collection,* ed. B. Davezac (Austin, Tex., 1992), figs. 72, 77.

R.B.R.

A.24 Saint Panteleimon

Ο ΑΓΙΟΣ | ΠΑΝΤΕΛΙΕΗΜΩΝ

Baltimore, Walters Art Museum, 48.2086.4

H. 17.0, W. 17.0–17.2, Th. 0.7 cm

CONDITION: Small square tile reconstructed from twelve fragments. Four preserved sides; edges are beveled and double cut. Buff-colored fabric with quartz and iron oxide inclusions. Glaze colors include aubergine, amber, copper green, and clear. The amber glaze is intact yet crazed. Major losses in aubergine glaze, primarily along

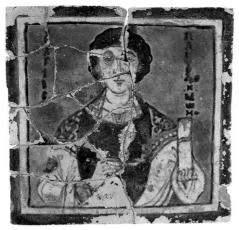

A.24

A.25

the break edges and in the lower part of the tunic, and to the green glaze at the border. Clear glaze is deteriorated on the inner border, robe, hands, and face. Red slip is used for the ornamentation of the sleeves and on the medical kit and instrument. Outline drawn in dilute iron oxide glaze. The reverse is covered with vertical striations. Some are trail marks made by the dragging of inclusions, and others are hollows from burned-out organic material. Impression of a textile pattern is visible in the upper right corner. Sample taken for SEM analysis. J.L.

DESCRIPTION: The half-length figure of Panteleimon, one of the most popular medical saints of Byzantium, is represented on a deep amber background. A double border, articulated with copper green and clear glaze, enframes the image. Panteleimon is not haloed. His head is crowned by short wavy hair painted with dark hues of aubergine glaze, which creates the illusion of a dark brown color. In accordance with conventions of Byzantine portraiture, Panteleimon is youthful and beardless. An inscription in the upper portion of the tile, above the saint's shoulders and to either side of his head, provides his identification. The saint's eyes are round and are painted with a dark brown color. The lower line of his right eye is emphasized by a horizontal crease, which parallels the lid. A thin curved line at the top of the neck accentuates the chin. In his hands, Panteleimon holds a medical kit and scalpel, the traditional attributes of his sainted profession. The saint is clad in a white tunic, which must have been cinched at the waist, as suggested by the curved fall of the cloth. His mantle, thrown over his shoulders, is glazed in deep aubergine. A wide gold collar articulates the trapezoidal neckline, and brown foliate motifs on an amber background embellish the saint's garment at his shoulders. A similar motif adorns the cuff visible on Panteleimon's right wrist. The image of Panteleimon on the Walters plaque follows an established portrait type and is comparable to other representations of the saint in different media. He is represented in a similar fashion on a cloisonné medallion incorporated into the decoration of a reliquary of the True Cross in the Treasury of San Marco, dated to the late tenth/early eleventh century.[1] In the Harbaville Triptych, where Panteleimon is carved in one of the medallions in the middle register, and in the eleventh-century mosaic decoration of the *katholikon* of Hosios Loukas in Phokis (Greece), the saint is identified not only by his inscription but also by his distinctive hairstyle, clothing, and medical instruments.[2]

1 *Treasury of San Marco,* 149.
2 *Glory of Byzantium,* 80; Chatzidakis, *Hosios Loukas,* fig. 33.

R.B.R.

A.25 Unidentified Saint

[. . .] I [. . .]IO[ς]
Baltimore, Walters Art Museum, 48.2086.17
M.P.H. 7.7, M.P.W. 13.6, Th. 0.7–0.8 cm

CONDITION: Section of a small square tile reconstructed from three fragments. Single preserved edge is acutely beveled and double cut. Buff-colored fabric with iron oxide and quartz inclusions. Glaze colors include aubergine, amber, copper green, and clear. Much of the amber and green glaze is intact yet crazed. Red slip under clear glaze is evident on the fibula. A clear glaze, deteriorated and crazed, is visible on the figure's neck. Figure painted with a dilute iron oxide glaze. The reverse shows use of a blunted tool with a single tooth (0.8 cm wide) for finishing. J.L.

DESCRIPTION: This plaque is decorated with a half-length portrait of a male saint painted on an amber background. His youthful, beardless face is partially preserved. Its right half reveals a wide, open eye and an arched brow, which blends into the thin line of the nose. The saint's dark hair curves around his small ears, which are attached low on his head. The halo, formed from the same amber glaze as the tile's background, is outlined with a thick black line. The figure is clad in a green chlamys, fastened on the right shoulder with a fibula decorated with red slip. The *tablion,* a small portion of which is still visible, must have been elaborately decorated with an aubergine-colored foliate ornament on an amber background. The pattern is similar to the foliate ornament on the costume worn by Saint Panteleimon (cat. A.24). The name of the saint is no longer preserved. Traces of three letters to the right side of his head, *IOC,* suggest a range of possibilities. The costume points to a martyr saint included in the military hierarchy, such as Prokopios, who appears among the saints carved on the Harbaville and Vatican ivory triptychs, dated to the tenth or early eleventh century.[1] In these representations, Prokopios is represented as youthful and beardless; his hair, like that of the ceramic saint, curls in waves around his ears. He, too, wears a chlamys clasped with a fibula on his right shoulder. In the ivory portraits of the saint, Prokopios holds a cross, a symbol of his martyrdom, in his right hand.

1 *Glory of Byzantium,* 132–33. R.B.R.

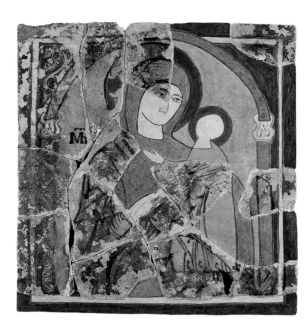

A.26

A.26 The Virgin and Child

MP | [ΘΥ]

Baltimore, Walters Art Museum, 48.2086.12

M.P.H. 18.0, W. 16.9, Th. 0.8 cm

CONDITION: Small square plaque reconstructed from fourteen fragments. Three preserved edges are beveled. Buff-colored fabric with iron oxide and quartz inclusions. An imperfection along the bottom left edge was covered with green glaze and fired. Glaze colors include aubergine, light amber, copper green, and clear. Glazes are crazed. The reticulated appearance of the glazes overall suggests that the tile was fired at an excessive temperature. The light amber glaze is intact. Major losses to the aubergine and green glazes. Figure painted in dilute iron oxide glaze with some flake losses leaving a pale stain. The reverse is smoothed with multidirectional striations. Splashes of green glaze are visible along the top edge. Isolated hollows formed by burned-out organic materials. Samples taken for SEM and NAA analysis. J.L.

DESCRIPTION: The Virgin and Child, set against an amber background, are framed by an arch set on two columns. The entire composition is enclosed by a double border of green and white reserve. The aubergine columns supporting the arch are decorated with bright amber interlaced bands. A foliate capital, with a red-slip molding, is preserved on the left side. The spandrels of the arches are decorated with a vegetal scroll painted in amber on a deep green background. At the center of the plaque, the nimbed Virgin holds her standing son on her lap and supports his body with her left hand. She points with her right hand toward Christ, revealing the tight golden cuff of her dress. The folds of the Virgin's purple *maphorion* are articulated with thick black lines. Only the lower portion of the body of the infant Christ, clad in a bright amber tunic, is preserved. This image of the Virgin and Child conforms most closely with the Eleousa type, a representation of the Virgin in which her son is seated on her lap and her cheek is pressed against his. On a Sinai icon dated to the late eleventh or twelfth century, however, a composition similar to that of the plaque identifies the Virgin embracing a standing child as the "Mother of God Blachernitissa," an indication that epithets of the Virgin did not always accompany the same type of representation.[1] In the placement of the Virgin and Child under a canopy, and in the proportions of the figures, the composition resembles a series of ivory icons carved in the tenth century.[2] These icons, unlike the plaque, represent the Virgin holding a seated Child, according to the popular Hodegetria type. Damage to the tile, specifically the absence of the complete faces of the Virgin and Child, makes exact identification of the represented type impossible.

1 A. Cutler and J.-M. Spieser, *Byzance Médiévale, 700–1204* (Paris, 1996), fig. 310.

2 Cutler, *Hand of the Master*, 174–84. R.B.R.

A.27 Saint Constantine

['Ο Ἅγιος | Κων]ΣΤΑΝΤΗΝΟΣ

Baltimore, Walters Art Museum, 48.2086.6

M.P.H. 13.5, W. 17.6–17.7, Th. 0.6–0.7 cm

CONDITION: Small square plaque reconstructed from ten fragments. Three preserved sides; edges are beveled. Buff-colored fabric with iron oxide and quartz inclusions. The thickness tapers from center to the edges. Glaze colors include aubergine, amber, and copper green. The majority of the amber glaze is intact; flake losses along the break edges and on the ornaments of Constantine's robe. The upper left fragment is in poor condition; the glaze and outline are completely destroyed. Remnants of green glaze are barely detectable on the cuff and on the border. Red slip is used to model the hands. Figure painted in iron oxide slip. The reverse is smoothed and covered with some striations. Samples taken for NAA analysis. J.L.

DESCRIPTION: The half-length figure of Saint Constantine is represented frontally on an amber background. Borders of copper green enframe the image. The saint is haloed and once wore a crown, as suggested by the partially preserved *prependoulion* hanging over his left shoulder. Pale pink slip is used to highlight the face and the hands. Traces of a light beard, executed in quick, single brush strokes can be seen along the diagonal crack. Constantine is clad in a jeweled *loros* and a *divetesion,* a long silk tunic. This particular type of *loros,* a single piece of cloth falling down from the shoulders with a longer portion pulled from behind and draped over the left arm, was worn by Byzantine emperors from the late ninth century onward.[1] On this plaque, the inner surface of the *loros* is revealed over the figure's left arm as an amber cloth with cruciform decoration. The neckline is articulated by a string of golden circles. Flower-shaped ornaments painted with amber glaze and surrounded by pearls adorn the upper portion of the *divetesion*. In his right hand, with carefully articulated fingers and nails, the saint holds a scepter with a jeweled tip. This attribute of imperial office crosses the saint's body diagonally and terminates at the upper right corner of the plaque. In his left hand, Con-

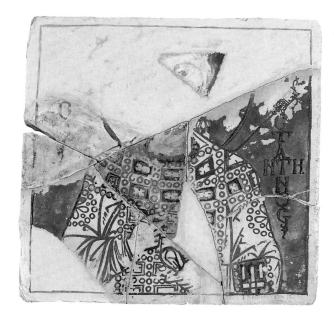

A.27

intended by the painter. An alternative candidate for the emperor represented in this portrait may be the son of Basil I, Constantine, who was crowned co-emperor in 867/68 and was made a saint after his untimely death in 879. Following his death, the emperor's son appeared to a monk, Theodore Santabarenos; at the place of his apparition, his father built a church dedicated to his son's name saint, Constantine the Great, thus linking the reputation of his family to the fame of Constantinople's founder as well as asserting the legitimacy of his son's cult through the protection of the first sainted emperor to bear that name.[6] The sainted son of Basil I, identified as the "New Constantine" in the Constantinopolitan *Synaxarion,* is celebrated on 3 September.[7] The commemoration of sainted members of the Macedonian dynasty through unusual artworks and architectural commissions has been noted by several scholars.[8] Indeed, Robin Cormack has suggested that a late-ninth-century portrait of Saint Constantine in the room over the southwest vestibule in Saint Sophia may have been associated with the son of Basil I and that it might have reflected the dynastic ambitions of the first ruler of the Macedonian family.[9]

LITERATURE: Verdier, "Byzantine Tiles," 1.

1 P. Grierson, *Byzantine Coins* (Berkeley and Los Angeles, 1982), 31.

2 Grierson, *Byzantine Coins,* 32.

3 Wharton Epstein, *Tokalı Kilise,* fig. 116.

4 S. Pelekanides and M. Chatzidakis, *Kastoria* (Athens, 1985), 29.

5 N. Teteriatnikov, "Leaf from a Gospel Book Depicting Constantine," in *Byzantium at Princeton,* ed. S. Ćurčić and A. St. Clair (Princeton, 1986), 54–56.

6 G. Majeska, "The Body of St. Theophano the Empress and the Convent of St. Constantine," *Byzantinoslavica* 38 (1977), 20–21. For links between the Macedonian dynasty and Constantine the Great, see A. Markopoulos, "Constantine the Great in Macedonian Historiography: Models and Approaches," in *New Constantines: The Rhythm of Imperial Renewal in Byzantium, 4th–13th Centuries* (papers from the Twenty-Sixth Spring Symposium of Byzantine Studies, St. Andrews, March 1992), ed. P. Magdalino (Aldershot, 1994), 159–70.

7 *Synaxarium ecclesiae Constantinopolitanae: Propylaeum ad Acta sanctorum Novembris,* ed. H. Delehaye (Brussels, 1902), col. 12, no. 6.

8 Majeska, "The Body of St. Theophano," 14–21; S. Gerstel, "St. Eudokia and the Imperial Household of Leo VI," *ArtB* 79 (1997), 699–707.

9 R. Cormack, "The Emperor at St. Sophia: Viewer and Viewed," in *Byzance et les images,* ed. J. Durand (Paris, 1994), 229–31. R.B.R.

stantine holds a cylindrical object, a consular *mappa* or, more likely, an *akakia,* a purple silk purse carried by the emperor on ceremonial occasions. The *akakia* formed a regular part of imperial costume by the eighth century.[2]

Representations of Constantine alone are uncommon in Byzantine art. Saint Constantine, the first Christian emperor (r. 324–37), is often accompanied by his sainted mother, Helena. In the art of medieval Byzantium, the pair is generally depicted flanking the True Cross. In the tenth-century decoration of the New Tokalı Kilise in Cappadocia, Constantine and Helena are represented in two separate panels on the intrados of the central arch of the church's corridor arcade.[3] Constantine is depicted holding a cross-staff in his right hand and a globe in his left. Helena is painted in an orant pose. In the late-tenth-century narthex decoration of the church of the Hagioi Anargyroi in Kastoria, Constantine and Helena are depicted next to each other, supporting the True Cross.[4] On a single leaf from a Gospel book in the Princeton Art Museum, 32-14, the standing figure of an emperor has been identified as Constantine I.[5] It has been proposed that Saint Helena may have been placed on another folio that has now been lost. The Walters icon may have been paired with a representation of Helena, now missing. The figure on the tile, however, differs from traditional portraits of Constantine the Great. Similar depictions of the jewel-tipped staff and *akakia* most often appear in tenth-century representations of the Byzantine emperor on coins. For example, on the reverse of a golden *solidus,* Romanos I Lekapenos (r. 920–44), flanked by Constantine VII and his son Christopher, is represented full length and holding a similar jeweled staff in his right hand and an *akakia* in his left. The overpowering use of amber glaze and its different hues on the Walters plaque may suggest that the inspiration for this portrait could profitably be sought in precious metal or even on gold coins.

The unusual representation on the Walters tile, where the emperor holds the attributes of contemporary office and where he is shown as a solitary figure, may indicate that a different Constantine was

A.28 Enthroned Christ Flanked by Archangels

IC|XC, ΓΑ[β]Ρ[ιήλ]

Baltimore, Walters Art Museum, 48.2086.5

H. 17.2, W. 16.9, Th. 0.6 cm

CONDITION: Small square plaque reconstructed from seven fragments. Four preserved sides; edges are beveled. Buff-colored fabric with iron oxide and quartz inclusions. A large circular surface loss on the left bottom corner may be a result of spalling caused by soluble salts. Minor imperfections along the edges are all glazed, indicating they were acceptable manufacturing flaws. Glaze colors include aubergine, amber, copper green, cobalt blue, and clear. Glazes are not in good condition, and they are all crazed. Traces of cobalt blue are still visible on the robes of the two archangels and of Christ. Aubergine glaze is evident on the wings of the archangels. Red slip is visible on the book held by Christ and on the shoes worn by the archangels, as well as on the right and left foliate ornamentation of the throne's cushion. The rectangular outer border is divided horizontally into two separate registers: the lower third in amber and the upper two-thirds in poorly preserved green glaze. Drawing in iron oxide slip. The reverse is finished with diagonal striations beginning in the upper right and terminating at the bottom left corner, where the impression of a textile pattern can be seen. Samples taken for SEM and NAA analysis. J.L.

DESCRIPTION: At the center of the plaque is the representation of the enthroned Christ flanked by two archangels. Christ is identified by the abbreviations for his name, *IC XC,* which are placed on each side of his gold cruciform halo. Gabriel, on the right, is identified by a partially preserved inscription with the two first letters of his name. The name of the archangel to the left, Michael, must have been inscribed on the upper-left corner of the tile. Christ is presented on an amber high-backed throne. He sits on a copper green cushion, which terminates in a red (slip) flower-shaped ornament. His feet rest on a raised footstool decorated with a jeweled border composed of circles and rectangles drawn in amber and once filled with copper green glaze in imitation of metalwork. Christ wears a blue tunic embellished with a golden sash and a golden vertical strip. He lifts his right hand in a gesture of benediction and reveals a golden cuff. In his left hand, he holds a decorated codex.

Christ is attended by two archangels, who are represented in mirror poses. Michael holds a scepter in his left hand, whereas Gabriel holds one in his right. Both are clad in courtly garments. Michael wears a copper green chlamys with an amber *tablion* over a cobalt blue tunic with a broad, ornate amber hem. Additional decoration is provided by three minuscule medallions. Gabriel is dressed in similar attire. He wears a green chlamys with a golden *tablion.* His tunic is cobalt blue (now damaged) with a broad wavy band on the bottom painted with amber glaze. A deep golden color is used for the folds of Gabriel's garment and for the two small medallions in which the waves of the hem naturally terminate. The wings of the angels are aubergine.

An enthroned Christ is also the subject of a polychrome ceramic icon from Preslav, dated to the late ninth/early tenth century.[1] An enthroned Christ flanked by archangels and the Virgin and John the Baptist can be seen on a Vatican ivory triptych dated to the tenth/eleventh century.[2] It is possible that the Walters icon was once arranged with single representations of Mary and John the Baptist to the left and right of Christ and his two archangels.

LITERATURE: Verdier, "Tiles of Nicomedia," fig. 1.

1 T. Totev, "Keramičnata ikona s Hristos na tron," *Preslav* 3 (1983), 72–79.
2 *Glory of Byzantium,* 132. R.B.R.

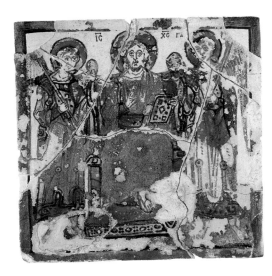

A.28

A.29 Peacock I

Baltimore, Walters Art Museum, 48.2086.30

Th. 0.6–0.7 cm

Est. W. as reconstructed 29.0 cm

CONDITION: Two nonjoining sections of a large square plaque reconstructed from twelve fragments. Head, neck, and plumage on left side are well preserved; portions of a circular band remain. Major losses to the bottom half of the plaque. Preserved edges at top and right side are rounded. Fragment with head is darkened from burning. Buff-colored fabric with iron oxide and quartz inclusions. Glaze colors include amber, copper green, and clear. Glazes crazed overall and in varying states of preservation. Brown-black outline painted in iron oxide slip exhibits loss along left side. Shallow voids due to burned-out organic temper, visible on reverse. J.L.

DESCRIPTION: The peacock, wings folded at its sides, stands at the center of an amber medallion. A wide green border surrounds the round field, and green heart-shaped leaves fill the corners of the plaque. The peacock turns its small head to its left and holds a leaf in its beak. The joint between neck and body is marked by a ring of white dots on black ground. The amber-colored body is decorated with a diamond pattern. The wings are separated into two parts by three horizontal lines with a row of white dots on black ground at the center. Above this division, dark arched strokes indicate short feathers. The wing feathers below are rendered in long inward-curving lines. The peacock's fanned tail displays a variety of colors. The feathers immediately next to the wings have an amber core on a stem, followed by concentric stripes of amber and white reserve. This arrangement changes in the outer row of feathers, where a white-reserve core is followed by amber and white-reserve stripes. To either side of the bird is a single green leaf paired with a stalk bearing three white berries. Neither the vegetal motif nor the legs of the peacock are complete. The bird and the details of its plumage are rendered with bold dark strokes that reveal no interest in visual illusionism but, rather, emphasize the decorative aspects of the subject. The decorative character of the Walters peacock recalls tenth-century Constantinopolitan reliefs of peacocks found at the churches of Saint John Stoudios and Constantine Lips.[1] The Lips peacocks display the same decorative effect and share the horizontal division of the wing and arrangement of the tail feathers.

1 Fıratlı, *Sculpture byzantine,* 166–67, 190–91, pls. 11, 101, figs. 332, 408–9.
 M.H.

A.29

A.30

A.31

A.30 Peacock II

Baltimore, Walters Art Museum, 48.2086.31
Th. 0.7 cm

CONDITION: Two nonjoining sections of a large square tile reconstructed from eleven fragments. Head and plumage partially preserved. No intact edges. Pale buff-colored fabric with iron oxide and some large quartz inclusions. Glaze colors include aubergine, amber, copper green, and clear. Brown-black outline painted in iron oxide slip. Glazes are poorly preserved; aubergine and green are crazed overall and exhibit considerable flake loss and some opaque areas due to weathering crust. Amber better preserved with some isolated loss. Clear glaze almost entirely missing; only a thin sheen remains. Evidence of working on reverse with multidirectional striations and small voids due to dragging of inclusions. J.L.

DESCRIPTION: The peacock, with fanned tail, is placed on the white-reserve ground of the tile. The central medallion is surrounded by an aubergine band followed by a broad border comprising an amber-and-white basketweave pattern. The bird's head is encircled by an amber halo. The peacock turns its small head to its left and holds a leaf in its beak. Nothing remains of the peacock's body, which was flanked by a pair of elaborately decorated wings. The left wing shows a horizontal division created by a row of white dots on an amber ground. Above, aubergine feathers are arranged in a floral pattern on the green ground of the wing. Below the dotted division extend long amber-colored and white-reserve wing feathers. Colorful tail feathers frame the peacock in three rows in an imbricated pattern. The inner feathers have an aubergine core surrounded by concentric lines of white and amber. The feathers of the next row have a green core followed by amber and white. The outermost feathers repeat the color scheme of the first row. Green trifoliate patterns inserted between the large, outer feathers conclude the arrangement. M.H.

A.31 Cross

Baltimore, Walters Art Museum, 48.2086.32
M.P.H. 13.5, M.P.W. 26.5, Th. 0.7–0.8 cm
Est. H. as reconstructed 29.5 cm

CONDITION: Section of a large square plaque reconstructed from seven joining and three additional fragments. Preserved upper edge is beveled. Buff-colored fabric with large iron oxide and quartz inclu-

sions. Glaze colors include amber, copper green, and clear. Outline painted in iron oxide slip with isolated flake loss. Glazes crazed, with opaque weathering crust obscuring areas of green; isolated losses to amber. Multidirectional striations intersect throughout reverse. Elongated voids on reverse result from burned-out organic inclusions. Shallow pockets and voids due to dragged inclusions. J.L.

DESCRIPTION: The Greek cross is placed at the center of an amber medallion. The round field is encircled by a broad green border. Heart-shaped leaves fill the plaque's corners. The cross is made up of concentric rectangles of green, white, and amber. Each color is contained by thick black lines that extend to form serifs at the outer corners of the arms. The crossing forms a perfect square that encloses a central medallion with repeating circles. The cross is among the most frequent motifs in Byzantine church decoration, where it was carved on lintels, capitals, cornices, and chancel screens.[1] In its form and decoration, the cross on the ceramic plaque also recalls metal crosses made for processional and private use.

COMPARISONS: Topkapı Sarayı Basilica (cat. XII.33, XII.34); Zeuxippos Baths (cat. XIII.5).

1 Several examples of the cross motif in sculpture survive from the church of the Dormition at Skripou, dated 873/74. Grabar, *Sculptures* I, figs. 1, 6, 7, 9, pl. XLII. Examples can also be seen in the Monastery of Constantine Lips. Mango and Hawkins, "Additional Finds," fig. 17; Macridy, "Monastery of Lips," figs. 21, 43. Several ninth- and tenth-century examples of crosses within medallions are preserved in the Istanbul Archaeological Museum. Fıratlı, *Sculpture byzantine,* pl.100, fig. 328b; pl. 101, fig. 329b. M.H.

A.32 Cross

Baltimore, Walters Art Museum, 48.2086.33
M.P.H. 7.0, M.P.W. 7.5, Th. 0.6–0.7 cm (largest fragment)

CONDITION: Three nonjoining fragments from a cross. No pre-
served edges. Light buff-colored fabric with iron oxide and quartz
inclusions. Glaze colors include amber, copper green, and clear.
Brown-black outline painted in iron oxide slip. Fragmentary and in
poor state of preservation. J.L.

DESCRIPTION: The fragment depicts part of a cross originally
placed at the center of a white-reserve medallion. Traces indicate that
the medallion was encircled by a wide green band. The extant parts
of the cross are decorated with a diamond pattern on an amber
ground. A large diamond is divided into nine smaller ones by inter-
secting diagonal lines; the small diamonds are colored in green and
white reserve to create a checkerboard pattern. Small dark dots are
placed within the white fields that surround the central diamond.
The dark outlines of the cross form a loop at the corner, in imitation
of decorative serifs on metalwork examples. M.H.

A.32

A.33 Whorl

Baltimore, Walters Art Museum, 48.2086.36
M.P.H. 29.5, Th. 0.7 cm

CONDITION: Large square plaque partially reconstructed from
fourteen fragments. Two preserved sides with rounded edges. Buff-
colored fabric with iron oxide and quartz inclusions. Glaze colors
include aubergine, amber, copper green, and clear. Glazes are crazed,
and there are major losses to the green border and all glaze colors in
the upper third of the tile. The outline is painted in iron oxide slip
and has major losses, which reveal a light brown stain underneath.
Reverse is covered with primarily horizontal striations, deep at times,
and voids from dragging of inclusions. Three deep gouges run verti-
cally along the left side. Samples taken for SEM and NAA analysis as
well as thin-section petrography. J.L.

DESCRIPTION: The central whorl is surrounded by a triple bor-
der composed of a broad green band flanked by thin white lines.
Green heart-shaped leaves on an amber ground fill the corners of the
tile. At the center of the design is a small medallion formed by con-
centric circles of amber, white reserve, and green. The medallion,
placed on a green ground, is surrounded by a row of white half-
arches, each enclosing an aubergine half-rosette. Black lines radiate
from the medallion and intersect, creating a diamond pattern that
swirls around the center counterclockwise. Individual diamonds are
glazed in amber and white, and each contains a green or aubergine
trefoil. The careful arrangement recalls the whorled design incorpo-
rated into Byzantine *opus sectile* pavements of the period in Constan-
tinople.[1]

1 Asgari, "İstanbul," 46, fig. 14. The pavement is dated to the tenth or
eleventh century. M.H.

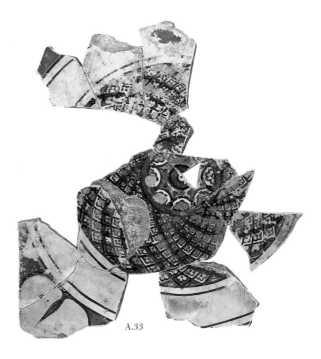

A.33

A.34 Geometric Motif

Baltimore, Walters Art Museum, 48.2086.37
Th. 0.7 cm
Est. W. as reconstructed 29.0 cm

CONDITION: Seven fragments from a large square plaque. No pre-
served edges. Buff-colored fabric with iron oxide and quartz inclu-
sions. Glaze colors include aubergine, amber, copper green, and
clear. Glazes are crazed, with major losses to the aubergine, clear, and
green. Flake loss to iron oxide slip outline. Reverse fairly smooth with
some multidirectional finishing marks. Multiple fine-lined sketches
painted in iron oxide slip on reverse. J.L.

DESCRIPTION: The geometric motif is encircled by a broad green
band flanked by narrow white-reserve lines. Only small segments of
the design remain. Rows of aubergine and white triangles alternate
with rows of green and amber triangles to create a pattern of concen-
tric circles. The careful arrangement recalls the whorled design incor-
porated into Byzantine *opus sectile* pavements of the period, for
example, in Prousa (Bursa), Bithynia, where the pattern has been
characterized as rays emanating from a central disk.[1] On the reverse
side of the ceramic tile is a series of sketches, which include a hand
extended in blessing, a foot, and a palmette.

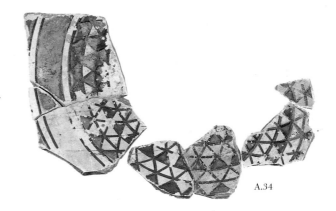
A.34

1 S. Eyice, "Two Mosaic Pavements in Bithynia," *DOP* 17 (1963), fig. 12.
 M.H.

A.35 Interlaced Squares Within Radiating Petals

Baltimore, Walters Art Museum, 48.2086.38
Th. 0.7 cm

CONDITION: Twelve nonjoining fragments of a large square
plaque. Two preserved sides have rounded edges. Buff-colored fab-
ric with iron oxide and quartz inclusions. Glaze colors include
aubergine, amber, copper green, and clear. Black outline painted in
iron oxide slip. Glaze and outlines are very deteriorated; crazing
overall, with major losses to all colors. Multidirectional striations and
pink iron staining on the reverse. Drag marks created by a toothed
scraping tool 0.7 cm wide can be seen. J.L.

DESCRIPTION: At the center of the plaque is an eight-petaled
flower framed by an eight-sided star on a green ground. The star is
formed from two intersecting squares, one amber and one white
reserve. Each corner of the star is ornamented with a loop filled with
aubergine glaze. Surrounding the star is a white-reserve band, from
which emanate elongated petals in amber and white reserve. Each of
the petals terminates in a cluster of three white circles set against a
green ground. The design is encircled by a narrow band of aubergine
followed by rows of amber and green triangles alternating with
aubergine and white ones. The tile design recalls a similar motif
incorporated into an *opus sectile* pavement excavated north of the
House of Justinian in Constantinople and dated to the tenth or
eleventh century.[1]

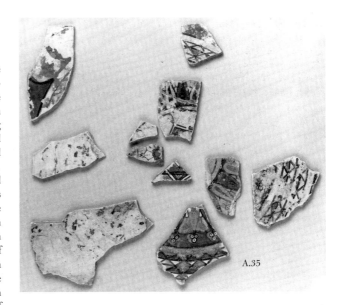
A.35

1 Asgari, "İstanbul," fig. 16. M.H.

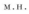

A.36 Geometric Pattern with Central Medallion

Baltimore, Walters Art Museum, 48.2086.39
M.P.H. 25.7, Th. 0.7 cm

CONDITION: Square plaque partially reconstructed from eleven joining and five nonjoining fragments. Preserved sides have rounded edges. Buff-colored fabric with iron oxide and quartz inclusions. Preserved glaze colors include amber, copper green, and clear. Glazes are very deteriorated; the amber is the best preserved. Green and clear show major losses, and areas of the green are obscured by an opaque weathering crust. Major flake losses to black outline, which reveals a dark pink stain from the iron oxide slip. Multidirectional striations appear to intersect at the corners on the reverse. Fragments along center are darkened from heat exposure. J.L.

DESCRIPTION: The geometric rosette is encircled by a border composed of two narrow white lines in reserve flanking a broad green band. Green heart-shaped leaves fill the corners of the plaque. The rosette is divided into three main parts. The inside of the central medallion is surrounded by black half-circles on a white ground and is framed by a border of white dots on a black ground. This is followed by alternating rows of amber and white triangles. The remainder of the rosette is filled with a diamond pattern. Each diamond is divided by four lines into little squares. Rows of amber diamonds alternate with rows of diamonds with aubergine centers, green squares at the corners, and black dots on the white squares in between. The design is also found on flat rectangular plaques in the Walters collection. M.H.

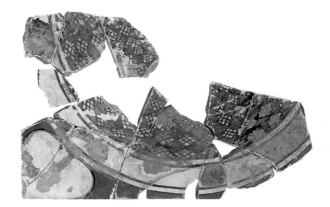

A.36

A.37 Diamond Pattern

Baltimore, Walters Art Museum, 48.2086.40
Th. 0.6 cm

CONDITION: Ten nonjoining fragments from a large square plaque; single preserved side has a rounded edge. Buff-colored fabric with iron oxide and quartz inclusions. Preserved glaze colors include amber and copper green. Outline painted in iron oxide slip. Very poor state of preservation; glazes almost completely missing; dark pink staining left from losses in outline. Reverse is fairly smooth, with some multidirectional striations. One fragment is darkened from exposure to heat. J.L.

DESCRIPTION: Fragments from the circular band subdivided into triangles that alternate in color between aubergine and green. One fragment preserves the traces of a heart-shaped leaf, which would have filled the corner of the plaque. Outside the central medallion the background is amber. M.H.

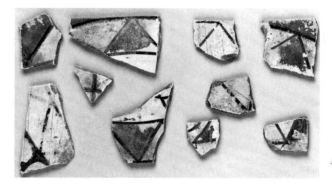

A.37

A.38 Geometric Pattern

Baltimore, Walters Art Museum, 48.2086.41
Th. 0.7 cm

CONDITION: Eight nonjoining fragments from a large square plaque. Preserved edges are rounded. Buff-colored fabric with iron oxide and quartz inclusions. Glaze colors include aubergine, amber, copper green, and possibly clear. Glazes are crazed and poorly preserved. Aubergine and green are at times obscured by an opaque weathering crust. Outline is painted in iron oxide slip and exhibits flake loss revealing pale pink staining. Reverse covered in parallel striations. J.L.

DESCRIPTION: Two sets of curved dark lines radiate in opposite directions from a central point to form a swirling diamond pattern. The design alternates between amber diamonds with a white dot in the center and light-colored (clear-glaze?) ones that are divided into smaller squares by dark lines. Dark dots are inserted into four of the small squares and create a cross shape. M.H.

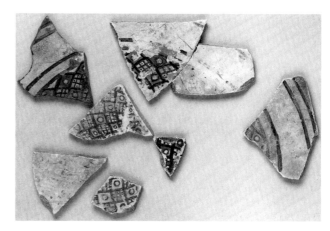

A.38

A.39 Broad Floral Motif

Baltimore, Walters Art Museum, 48.2086.43
M.P.H. 26.0, M.P.W. 17.0, Th. 0.7 cm

CONDITION: Two sections of a square plaque partially reconstructed from ten fragments. Preserved sides are beveled. Buff-colored fabric with iron oxide and quartz inclusions. Fabric varies in color through cross section from pink to buff-colored, indicating uneven or incomplete firing at center. Glaze colors include aubergine, amber, copper green, and clear. Glazes are crazed and obscured by a weathering crust. Outline painted in iron oxide slip is preserved under opaque glazes. Reverse is covered with fine striations intersecting at the corners. A complex geometric pattern is painted in iron oxide slip on the reverse of the tile. J.L.

DESCRIPTION: The fragments show the remnants of a geometric rosette. The round design is surrounded by a broad green border. Green heart-shaped leaves fill the corners of the amber-glazed tile. The center of the rosette is no longer extant. What remain are fragments of its outer band. The design is based on a series of overlapping petal-shaped forms that create a three-tiered flowerlike design. The smallest petals of the innermost tier are white and each has an aubergine half-circle at its base. Emerging from between them is a row of larger aubergine-colored petals with a green circle at the center of each. Beyond the area of overlap, toward the outer edge of the medallion, are the amber tips of the largest petals. Each one of these tips contains a green foliate shape that occupies most of its area. The negative spaces between the petals and the medallion's border form triangles. They are white except for the aubergine half-circles that are centered along the green border. The reverse side is covered with the outlines of a geometricized floral motif. The wide enclosing band is decorated with an imbricated pattern. The interior motif is a whorl with checkerboard and lozenge-shapes surrounding a central medallion, now lost. M.H.

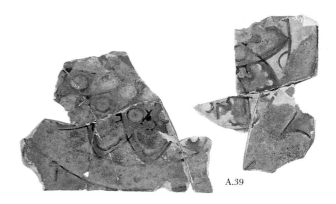

A.39

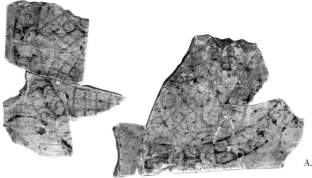

A.39 back

A.40 Acanthus

Baltimore, Walters Art Museum, 48.2086.34
Th. 0.9 cm
Est. W. as reconstructed 28.5 cm

CONDITION: Large square plaque partially reconstructed from sixteen fragments of unusual thickness. Preserved edges are beveled. Buff-colored fabric with iron oxide and quartz inclusions. Glaze colors include amber, copper green, and clear. Brown-black outline painted in iron oxide slip. Glazes crazed overall with considerable loss to green; opaque areas due to weathering crust. Localized flake loss to amber glaze and outline. Large shallow indentation with glaze on left side demonstrates acceptable manufacturing flaw. Multidirectional striations on reverse appear to intersect at corners. Use of a flat-ended scraping tool is evident on reverse. Samples taken for SEM analysis. J.L.

DESCRIPTION: The acanthus is placed at the center of an amber medallion and is surrounded by a band of green. Green heart-shaped leaves fill the corners of the tile. A single large aubergine-and-white blossom grows from a symmetrical arrangement of inward-curving elongated leaves. Their drop-shaped centers are white, and they are outlined in green. Toward the bottom of the acanthus, the leaves turn into green curled tendrils. The exact configuration of the motif can no longer be determined, due to the plaque's fragmentary state. M.H.

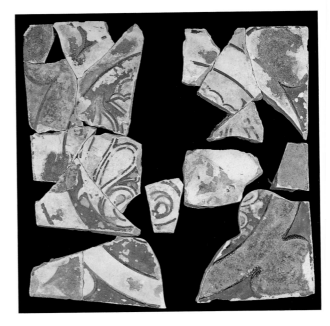

A.40

A.41 Vegetal Motif

Baltimore, Walters Art Museum, 48.2086.35
Th. 0.7 cm
Est. H. and W. as reconstructed 32.0 cm

CONDITION: Large square plaque partially reconstructed from twenty-seven fragments. Preserved sides have rounded edges. Buff-colored fabric with iron oxide and quartz inclusions. Glaze colors include amber, copper green, and clear. Tile very fragmentary; glazes poorly preserved and crazed. Clear glaze is only visible as a slight gloss in areas of white reserve. Outline painted in iron oxide slip exhibits flake loss and reveals deep red-colored stain. Reverse is finished with primarily horizontal striations with small voids due to dragging of inclusions. Break edge shows variation in body color due to incomplete firing: pink at center extending to buff color on upper and lower surfaces. Some fragments are darkened by exposure to heat. J.L.

DESCRIPTION: The vegetal motif in the amber medallion is surrounded by a border composed of a broad green band flanked by a white and a green line on the inner edge and a white line on the outer edge. The corners of the amber tile are filled by green heart-shaped leaves. A white quatrefoil occupies most of the round field at the center of the tile. At its center lies what looks like a bundle of laurel leaves. The white leaves are rendered with dark outlines and appear to grow from the bottom center of the quatrefoil. The design also includes some vine tendrils with green heart-shaped leaves and small white clusters of berries. The same types of vines grow from between the quatrefoil's leaves and curl on the amber ground along its outer edge. M.H.

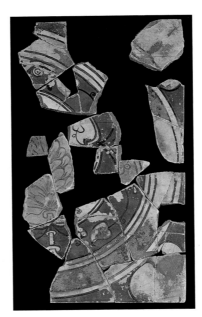

A.41

A.42 Foliate Motif

Baltimore, Walters Art Museum, 48.2086.42
Th. 0.9 cm

CONDITION: Six fragments from a large square plaque of unusual thickness. Preserved edges are beveled. Glazes include amber and copper green. Fragments are in a poor state of preservation; glaze almost entirely lost. Outline painted in iron oxide slip. Reverse covered with various finishing marks. The impression of a textile pattern is visible on the reverse side of a corner fragment. J.L.

DESCRIPTION: The fragments show parts of the outer edge of the plaque's decoration. The amber medallion is encircled by a triple border composed of two narrow white lines flanking a broad green band. The corners are occupied by elaborate foliate designs. Each corner motif is made up of two leaves curling in opposite directions in outward spirals toward the tile's edge. From their center grows a two-colored blossom. The design is flanked by a set of simplified leaves that fill the space between the medallion's border and the edge of the tile. M.H.

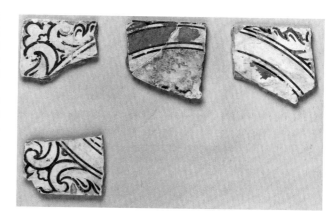

A.42

A.43 Acanthus

Baltimore, Walters Art Museum, 48.2086.44
Th. 0.7 cm

CONDITION: Five fragments from the left side of a large square plaque. No preserved edges. Buff-colored fabric with iron oxide and quartz inclusions. Preserved glaze colors include aubergine, amber, copper green, and clear. Glazes exhibit crazing, yet amber almost retains its original brilliance. Green and clear almost completely missing. Black outline painted in iron oxide slip exhibits flake loss revealing pale pink stain beneath. Reverse finished in vertical parallel lines. J.L.

DESCRIPTION: The fragmentary plaque shows remnants of leaves at the center of a white medallion. The round field is surrounded by a wide green border. These fragments join with the acanthus plaque in the Musée du Louvre (cat. B.3). The Walters plaque is composed of several petals that fan out from a single point to create a half-circle. They are placed against an amber ground. A band of green delineates the outside edge of the motif. There are also some fragments from the lower part of the palmette. Here, green vegetal shapes border fields of aubergine. Their original appearance can no longer be determined. Acanthus plants feature prominently in Byzantine architectural ornament of all periods. The wide variety of uses for this motif is seen in the sculptural decoration of the tenth-century church of Constantine Lips, where acanthus plants decorate cornices, capitals, mullions, epistyles, and other carved elements.[1] Other examples of palmettes and blossoms on ceramic plaques have been found in Patleina and Preslav, Bulgaria, where several variations of the motif decorated cornices.[2]

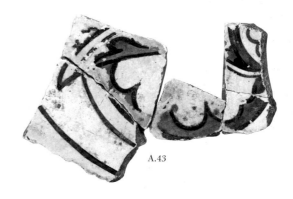

A.43

1 Mango and Hawkins, "Additional Finds," 11, 12, 15–26; Macridy, "Monastery of Lips," figs. 17–21, 42–43.
2 Coche de la Ferté, "Décors," 200–202, figs. 10a–e. M.H.

A.44 Diaper Pattern

Baltimore, Walters Art Museum, 48.2086.57 (pattern includes fifty-nine fragments)

H. 9.4, M.P.W. 17.0, Th. 0.5–0.6 cm

CONDITION: Flat rectangular plaque reconstructed from two groups of nonjoining fragments, nine and five fragments each. Preserved edge is slightly beveled. Buff-colored fabric with only minor iron oxide inclusions. Glaze colors include aubergine, amber, copper green, and clear. Amber glaze is well preserved; loss is primarily to green glaze. Where green glaze is preserved, it is partially opacified due to a weathering crust. The aubergine glaze at the center of each segmented diamond is now almost entirely gone. The clear glaze is similarly deteriorated. An impression from a textile pattern is visible on the reverse; striations parallel to the length of the tile are evident. On the reverse side of the five joining fragments is a line sketch of a right hand and two curved lines that may belong to a halo. The fragments in this pattern can be assigned to at least two, possibly three, separate tiles. J.L.

DESCRIPTION: Dark diagonal lines create a diamond pattern. Amber diamonds with green circles at their centers alternate in checkerboard fashion with diamonds that are divided into nine segments. At the center of each is an aubergine diamond from which four white squares marked with black dots radiate in cross formation. The corner segments are filled with green glaze. This pattern, which derives from metalwork and jewelry design, exists in several variations on ceramic tiles (cat. A.45–A.48, C.1, C.9). In addition to decorating flat tiles, the design is also found on convex plaques used for the revetment of colonnettes (cat. B.7, C.3). M.H.

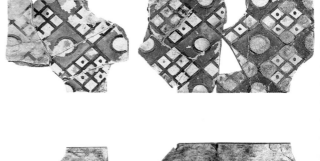

A.44

A.44 back

A.45 Diaper Pattern

Baltimore, Walters Art Museum, 48.2086.58 (pattern includes eight fragments)

H. 7.0, M.P.W. 13.2, Th. 0.6–0.7 cm

CONDITION: Flat rectangular plaque reconstructed from six fragments. Preserved edges are beveled. Buff-colored fabric with multiple iron oxide and quartz inclusions. Glazes are poorly preserved; only traces of the outline and amber glaze are visible. Multiple striations parallel to the length of the tile and some large voids are evident on the reverse. J.L.

DESCRIPTION: The plaque repeats the pattern of A.44 with one variation: the white fields of the segmented diamonds have four short lines placed perpendicular to the sides. M.H.

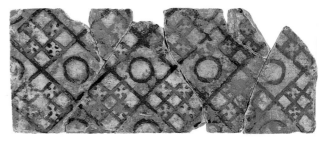

A.45

A.46 Diaper Pattern

Baltimore, Walters Art Museum, 48.2086.59 (pattern includes twenty-six fragments)

H. 17.0, M.P.W. 15.4, Th. 0.5 cm

CONDITION: Flat rectangular plaque reconstructed from six fragments. Preserved edges are slightly beveled with a single cut. Buff-colored fabric with varied inclusions, including quartz and some large terracotta fragments. Glaze colors include amber, copper green, and clear and are well preserved. Surface coloration fluctuates slightly, with patches of gray from uneven firing. Green and clear glazes are partially opacified due to weathering crust. Amber glaze extends slightly over beveled edge in some isolated instances. Brown-black outline drawn in iron oxide slip exhibits isolated flake loss. The reverse is fairly smooth, with minor nondirectional striations. Faint impressions from a textile pattern are also visible. Large voids, the results of burned-out organic temper.　　　　J.L.

DESCRIPTION: The diamond design of the plaque presents a miniature version of A.44, which it follows both in design and color. A drawing of a bearded saint appears on the reverse side of the two joined fragments.　　　　M.H.

A.47 Diaper Pattern

Baltimore, Walters Art Museum, 48.2086.60 (pattern includes twelve fragments)

H. 15.2–15.4, M.P.W. 19.0, Th. 0.7 cm

CONDITION: Flat rectangular plaque reconstructed from twelve fragments. Single beveled edge. Buff- to tan-colored fabric. Cross section shows variation in color; the center of the body is darker gray due to uneven or incomplete firing conditions. Two fragments at the center of the tile are darkened due to exposure to heat, while adjoining fragments are unaffected. Glaze colors include amber, copper green, and clear. There are multiple surface losses to both the body and the glazes. Glaze is crazed overall and poorly preserved. Black-brown outline painted in iron oxide slip. The reverse is fairly smooth and is marked by a deep incision or hollow, possibly from burned-out organic material, and multiple fine red iron oxide inclusions. Residue of what may be a plaster material used to affix the tile remains in this recess. Other markings on the reverse include fine multidirectional striations.　　　　J.L.

DESCRIPTION: The diamond-patterned plaque follows A.44 in design and color, with only some slight variation in the size of the individual diamonds.　　　　M.H.

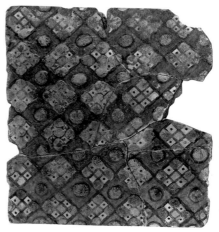

A.46

A.46 back

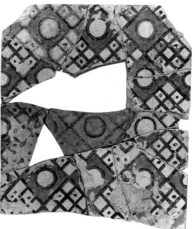

A.47

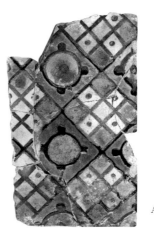
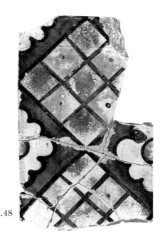

A.48 A.49

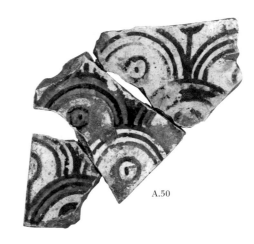

A.50

A.48 Diaper Pattern

Baltimore, Walters Art Museum, 48.2086.61 (pattern includes eleven fragments)

M.P.H. 9.3, M.P.W. 17.0, Th. 0.7 cm

CONDITION: Flat rectangular plaque reconstructed from seven fragments. Preserved side slightly beveled; edge is double cut. Buff- to white-colored fabric with multiple fine iron oxide inclusions. Preserved glaze colors include amber, copper green, and clear. Glazes are fairly well preserved and exhibit crazing overall. Glaze sits on top of a number of minor surface flaws. Green glaze is less well preserved and, in some areas, opacified due to a weathering crust. It is difficult to say what colors were used for the interior squares of the segmented diamond since the glaze is almost completely missing. In areas, glaze extends slightly over edge. The reverse is fairly smooth, with only fine striations and small voids due to the dragging of the clay body temper. Traces of textile impressions still visible in one corner. Patches of gray from direct heating are also evident. Samples taken for NAA analysis. J.L.

DESCRIPTION: The plaque's diamond pattern represents a slight variation of A.44. Four dark dots radiate from the outline of the green circle inside the amber diamond. M.H.

A.49 Diaper Pattern

Baltimore, Walters Art Museum, 48.2086.62 (pattern includes six fragments)

H. 9.3, M.P.W. 15.5, Th. 0.5–0.7 cm

CONDITION: Flat rectangular plaque reconstructed from six fragments. Preserved edge is slightly rounded. The tile is thickest at its center and tapers at the edges. Buff-colored fabric with iron oxide and quartz inclusions. Glaze colors include aubergine, amber, copper green, and clear. Glazes are crazed overall, yet amber is largely intact. Aubergine and clear are poorly preserved. Green glaze deteriorated in areas, leaving only a pale stain. The reverse is relatively smooth, with only an isolated area of shallow striations. J.L.

DESCRIPTION: The diamond design of this plaque presents a variation of the pattern described for A.44. The segmented diamonds follow the same color pattern as described above, but there are no dots. Green floral motifs are placed along the edges of the tile, between the diamonds. M.H.

A.50 Peacock Feather

Baltimore, Walters Art Museum, 48.2086.63 (pattern includes thirty-four fragments)

M.P.H. 8.0, M.P.W. 7.2, Th. 0.5 cm

CONDITION: Section of a flat rectangular plaque reconstructed from three fragments. Preserved edges are beveled. Buff- to tan-colored fabric with numerous black iron oxide inclusions. Larger terra-cotta fragments added as temper. Glaze colors include aubergine, amber, copper green, and clear; all are poorly preserved. Only one third of the area is still covered in glaze. Fine striations parallel to the length, and small voids where inclusions were dragged during the formation of the tile. J.L.

DESCRIPTION: The plaque depicts peacock feathers in an imbricated pattern. Rows of feathers with amber eyes on green ground and white and amber barbs alternate with feathers of contrasting hue. The original coloration of the second set can no longer be determined.

COMPARISONS: Istanbul Law Court (cat. IV.1); Paris, Musée du Louvre (cat. B.15); Sèvres, Musée national de Céramique (cat. C.28). Revetment plaques with a similar peacock-feather design were also discovered in Preslav.[1]

1 Totev, "L'atelier," 65–80. M.H.

A.51 Scale

Baltimore, Walters Art Museum, 48.2086.64 (pattern includes eleven fragments)
(a) M.P.H. 9.8, M.P.W. 6.0, Th. 0.6 cm
(b) M.P.H. 7.9, M.P.W. 7.2, Th. 0.6 cm

CONDITION: Flat rectangular plaque reconstructed from two contiguous groups, consisting of three fragments in the first group and two in the second. Preserved edges are beveled. Buff- to tan-colored fabric with iron oxide and quartz inclusions. Glaze colors include aubergine, amber, copper green, and clear. All glazes are crazed, and only the amber is well preserved. Outline painted in iron oxide slip. Imperfections in the formed tile are covered in glaze, indicating acceptable flaws. On the reverse are fine multidirectional striations and small voids where inclusions were dragged during the formation of the tile. Some fragments are darkened by heat. J.L.

DESCRIPTION: A simplified peacock-feather design in an imbricated pattern covers the plaque. Rows of green feathers with amber borders alternate with rows of aubergine feathers with white-reserve borders. This pattern is found in monumental decoration, for example, in the early-eleventh-century mosaics of Hosios Loukas in Phokis (Greece), where the feather pattern appears within the nave of the church.[1]

1 Chatzidakis, *Hosios Loukas*, fig. 8. M.H.

A.51

A.52

A.52 Scale

Baltimore, Walters Art Museum, 48.2086.65 (pattern includes forty-five fragments)
H. 35.2, W. 15.2–15.4, Th. 0.6–0.7 cm

CONDITION: Complete tile. Flat rectangular plaque reconstructed from six fragments. The four preserved edges are acutely beveled. Buff- to tan-colored fabric with numerous iron oxide and quartz inclusions. Glaze colors include amber, copper green, and clear. Glazes exhibit crazing overall but are largely intact. Outline, drawn in iron oxide slip, exhibits isolated flake loss. Reverse is finished with fine striations parallel to the length of the tile and hollows caused by burned-out organic material. J.L.

DESCRIPTION: The plaque is covered by a scale pattern alternating in white, copper green, and amber.

COMPARISONS: Paris, Musée du Louvre (cat. B.9). M.H.

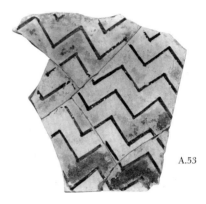

A.53

A.53 Sawtooth Rows

Baltimore, Walters Art Museum, 48.2086.66 (pattern includes fifty-nine fragments)
M.P.H. 20.8, M.P.W. 14.1, Th. 0.6–0.7 cm

CONDITION: Flat rectangular plaque reconstructed from five fragments. Fragments assigned to two different tiles; one group, consisting of twenty-one fragments, is marked by parallel wavy lines in iron oxide on the reverse. Edges are beveled. Buff- to tan-colored fabric with numerous iron oxide and quartz inclusions. Body color varies from light orange to buff due to uneven firing. Glaze colors include green and clear. Glazes are poorly preserved. Reverse is finished with striations. Samples taken for NAA analysis. J.L.

DESCRIPTION: The plaque is covered by a sawtooth design. The bands alternate between green and white reserve and are separated by black lines. Both tiles are decorated on their reverse sides, one with a wave pattern drawn freehand, the other with the sketchy outline of a female head in profile. M.H.

A.53 back

A.54

A.54 Concentric Circles

Baltimore, Walters Art Museum, 48.2086.67 (pattern includes 166 fragments)

H. 4.0, Th. 0.6 cm

CONDITION: Section of a flat rectangular border tile reconstructed from two fragments. Preserved beveled edges are double cut in places. Pale buff-colored fabric with iron oxide and quartz inclusions. Glaze colors include amber, copper green, and clear. Colors are clear and bright but exhibit fine crazing. Design painted in iron oxide slip. Isolated losses in amber, green, and outline. Glaze drips evident on reverse. Small voids on reverse due to burned-out organic temper. Striations parallel to the length of the tile on reverse, with some staining associated with iron oxide inclusions. Traces of mortar or plaster remain in one of the striations. Among the fragments, four groups emerge and are distinguished by their varying heights: 3.2, 3.6–3.7, 4.0, and 4.5–4.7 cm. The approximate preserved length of all the combined border tiles approaches 4.0 m. Drawings in red iron oxide are found on the reverse of six fragments; these bear no relationship to each other or to the patterns on the obverse. On the reverse of one fragment are several small fingerprints. Samples taken for SEM and NAA analysis. J.L.

DESCRIPTION: White-reserve circles enclosing copper green disks are aligned on an amber ground to create a continuous design. The pattern and colors imitate gem decoration on metalwork, where rows of precious stones or pearls are fastened on gold bands.

COMPARISONS: Hospital of Sampson (cat. II.3–II.5); Constantine Lips (cat. VI.3–VI.5); Zeuxippos Baths (cat. XIII.2, XIII.3); Istanbul, Provenance Unknown (cat. XV.9); Haydarpaşa (cat. XVI.1); Paris, Musée du Louvre (cat. B.12); Sèvres, Musée national de Céramique (cat. C.46). M.H.

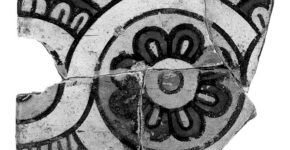

A.55

A.55 Looped Circles with Rosette

Baltimore, Walters Art Museum, 48.2086.68 (pattern includes sixty-nine fragments)

M.P.H. 8.6, M.P.W. 11.3, Th. 0.6

H. of the complete tile 9.4 cm

CONDITION: Section of a flat rectangular plaque reconstructed from four fragments. Preserved edge is squared, not beveled. Buff-colored fabric with numerous iron oxide and quartz inclusions. Glazes poorly preserved, with only traces of amber still intact. Brown-black outline painted in iron oxide slip. Striations on the reverse, which run parallel to the length of the tile, are the result of smoothing and dragging of inclusions across the surface during finishing. Large shallow voids on the reverse are the result of burned-out organic temper. Lower left fragment is darkened by post-use exposure to heat or fire. Fine drawings in iron oxide are visible on two other fragments from this pattern. Possible remains of a securing plaster are visible on the reverse of one fragment. The approximate preserved length of these plaques is 1.5 m. J.L.

DESCRIPTION: The plaque is covered by a guilloche pattern on a green ground. Broad interlacing bands form a pattern of continuous medallions with alternating designs. Green, amber, and white petals radiate from the green center of a rosette inside one of the medallions. Green petals on an amber ground radiate from the outer edge of the neighboring circle. This band, in turn, encircles a white disk on a green ground. Interlaced bands filled with rosettes appear frequently in architectural sculpture.[1]

COMPARISONS: While no exact comparison is preserved among the ceramic plaques from Constantinople, a close parallel is found on a tile from the Topkapı Sarayı Basilica (cat. XII.9).

1 Grabar, *Sculptures* I, pl. XXI, fig. 3; pl. XLIII, fig. 4. M.H.

A.56 Acanthus Scroll

Baltimore, Walters Art Museum, 48.2086.69
M.P.H. 13.0, M.P.W. 18.2, Th. 0.7 cm

CONDITION: Section of a flat plaque reconstructed from five fragments. Preserved edges are beveled. Buff-colored fabric with multiple iron oxide and quartz inclusions. Only outline painted in iron oxide slip is preserved: all other glazes are now absent. Red coloration at left edge is localized reduction of a copper green glaze. Fairly smooth reverse with some multidirectional striations. Small shallow voids and burn spots from uneven firing are evident. Traces of securing plaster are found along the left beveled edge. Samples taken for SEM analysis and thin-section petrography. J.L.

DESCRIPTION: Elongated vines are joined to create a design of connecting circles. Each circle is composed of curling leaves of varying color. Amber and green glazes are still visible on some of the leaves, but on others, the color can no longer be determined. Clusters of grapes and heart-shaped leaves alternate to fill the hollows created by the scrolling vines. The diamond-shaped intersection of the vines is filled with concentric circles. M.H.

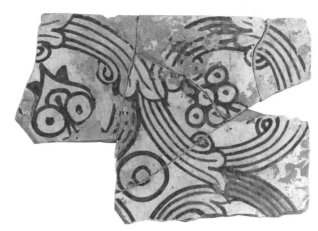

A.56

A.57 Acanthus Scroll

Baltimore, Walters Art Museum, 48.2086.70
M.P.H. 8.9, M.P.W. 18.5, Th. 0.6–0.7 cm

CONDITION: Section of a flat rectangular border plaque reconstructed from five fragments. Upper preserved edge is beveled. Buff-colored fabric with iron oxide and quartz inclusions. Very poor condition overall. Shows signs of exposure to heat. All glazes are now absent. Fabric of tile formed an open network of deep cracks due to overexposure to heat or water. Reverse is very smooth, with little evidence of working. J.L.

DESCRIPTION: The scrolling vines closely follow the pattern described for A.56. A cluster of grapes is visible at the center of one vine scroll. The motif occupying the adjoining medallion can no longer be determined. Concentric circles fill the spaces between the individual scrolls. M.H.

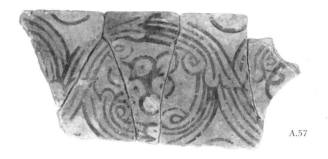

A.57

A.58 Vine Scroll with Floral Center

Baltimore, Walters Art Museum, 48.2086.71
H. 9.2–9.3, M.P.W. 11.5, Th. 0.6 cm

CONDITION: Single fragment from a flat rectangular border. Preserved edges are beveled. Buff-colored fabric with iron oxide and quartz inclusions. Glaze colors completely absent; only a pale brown stain remains from the iron oxide outline. Some fine striations parallel to the length of the tile on reverse. Small circular voids on the reverse are due to dragging of quartz inclusions. J.L.

DESCRIPTION: The interlacing vine-scroll motif presents a variant on the pattern described for cat. A.56. A daisy-shaped rosette occupies the field encircled by the scroll. M.H.

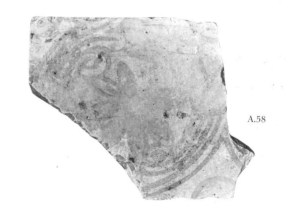

A.58

A.59 Checkerboard with Four-Petaled Flowers and Rosettes

Baltimore, Walters Art Museum, 48.2086.72 (pattern includes thirty-three fragments)

H. 9.5, Th. 0.5–0.65 cm

CONDITION: Section of a flat rectangular plaque reconstructed from three fragments. Preserved edges are slightly beveled. Thickness tapers from upper to lower edge. Buff-colored fabric with iron oxide and quartz inclusions. Glaze colors completely missing; only a pale brown stain remains from iron oxide outline. Some striations running parallel to the length of the tile on the reverse; black dotted iron stains mark obverse and reverse of the tile. When reconstructed, the fragments measure over 1 m in length.　　　　J.L.

DESCRIPTION: The plaque is divided into two rows of squares with alternating floral motifs. In one square, four amber petals form a rosette on a green ground; small trefoils fill the corners. This design alternates with a floral pattern that centers around a green circle. Four long amber petals radiate from the circle to join with the corners of their square frame. The area between the amber leaflets is occupied by white trefoil petals. A nearly identical flower, characterized by elongated, pointed amber petals alternating with white lobed petals, decorates the well of a whiteware bowl excavated in Aksaray (at right) (Istanbul, Arkeoloji Müzerleri, 75-408 Ç.Ç.). The presence of the identical motif on the tile and the bowl fragment suggests that the same painters worked on both types of ceramic wares.　　　　M.H.

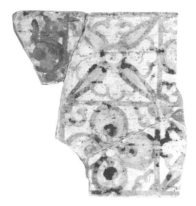

A.59

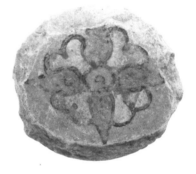

A.60 Checkerboard with Squares and Rosettes

Baltimore, Walters Art Museum, 48.2086.73 (pattern includes thirty-two fragments)

H. 9.4–9.5, M.P.W. 16.2, Th. 0.6 cm

CONDITION: Flat rectangular plaque reconstructed from four fragments. Preserved upper, lower, and left edges are slightly beveled. Buff-colored fabric with iron oxide and quartz inclusions. Glazes are poorly preserved; only a pale green stain remains where copper green glaze was painted. Outline in iron oxide slip also poorly preserved; nearly complete loss of decoration on the right side. Striations parallel to the length of the tile on the reverse. Marks left by a scraping tool 0.5 cm wide are also evident. Small shallow voids from dragging of iron oxide inclusions on the reverse. When reconstructed, the fragments measure over 1 m in length.　　　　J.L.

DESCRIPTION: Dark lines divide the plaque into two rows of decorated squares. A concentric arrangement of green and amber squares on a green ground alternates in checkerboard fashion with rosettes. The amber petals of the rosettes radiate from a green circle and join the corners of the square frame. The area between the amber leaflets is occupied by white trefoil petals. A nearly identical flower, characterized by elongated, pointed amber petals alternating with white lobed petals, decorates the well of a whiteware bowl excavated in Aksaray (Istanbul, Arkeoloji Müzerleri, 75-408 Ç.Ç.).　　　　M.H.

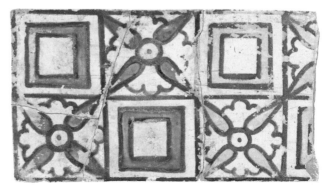

A.60

A.61 Tongue and Dart

Baltimore, Walters Art Museum, 48.2086.53 (pattern includes 118 fragments)

H. 7.1, M.P.W. 6.5, Th. 0.5–0.6 cm

CONDITION: Two fragments from a concave tile. Preserved upper and lower edges are rounded on one fragment, and squared and beveled on the other. Buff-colored fabric with iron oxide inclusions. Glaze colors include amber, copper green, and clear. Brown-black outline painted in iron oxide slip. Glazes are crazed overall but well preserved on A and in poor condition on B. Opaque weathering crust obscures much of the green glaze. Prominent scratch through glaze on A. Striations parallel to the length of the tile on the reverse. Other fragments of this pattern show impressions of a textile pattern on the reverse (page 69, fig.3). Sample taken for SEM and NAA analysis.J.L.

DESCRIPTION: The concave fragments represent a tongue-and-dart motif on white-reserve ground. A green band runs along the upper edge of the tile. The tongue is decorated with bands of green and amber that alternate with black darts to create a continuous design.

COMPARISONS: Constantine Lips (cat. VI.1, VI.2); Haydarpaşa (cat. XVI.1); Paris, Musée du Louvre (cat. B.6); Sèvres, Musée national de Céramique (cat. C.2, C.40). M.H.

A.61

A.62 Paired Acanthus Leaves

Baltimore, Walters Art Museum, 48.2086.54 (pattern includes twenty-four fragments)

H. 10.7, M.P.W. 20.3, Th. 0.6 cm

CONDITION: Section of a concave tile reconstructed from six fragments. Preserved upper and lower edges are rounded. Buff-colored fabric with iron oxide and quartz inclusions. Glaze colors include amber, copper green, and clear; glazes show a fine network of crazing yet are well preserved. Elaborate use of brown-black iron oxide slip as painted outline and background. Striations on reverse side are parallel to surface design. J.L.

DESCRIPTION: Repeated foliate pattern with broad symmetrical leaves, outlined in white and divided into a green-colored upper surface and an amber-colored wavy lower surface. A heart-shaped leaf is placed at the center of each pair of tendrils, and smaller wavy leaves spread at the base of the tile between the plants.

COMPARISONS: Saint John Stoudios (cat. X.3); Topkapı Sarayı Basilica (cat. XII.15); Sèvres, Musée national de Céramique (cat. C.18); Athens, Benaki Museum (cat. D.3). S.G.

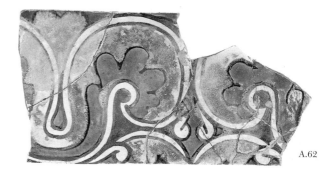

A.62

A.63 Diaper Pattern

Baltimore, Walters Art Museum, 48.2086.45 (pattern includes 189 fragments)

M.P.H. 23.9, W. 9.5, Th. 0.5, Pitch of Convex Shape 2.0 cm

CONDITION: Three sections from a convex tile. Two preserved edges are rounded. Buff-colored body with iron oxide and quartz inclusions. Parallel striations beneath the glaze and outline indicate that the tile was worked from both the obverse and reverse. Intact glaze color restricted to amber. Other fragments of this pattern confirm the use of copper green and clear glazes. Fragments are in poor condition. The surfaces are heavily abraded. Outline painted in iron oxide slip exhibits areas of flake loss. Striations parallel to the length of the tile are visible on the reverse. Shallow voids due to dragged inclusions are also evident. Other fragments with this tile pattern have drawings in iron oxide slip on the reverse. Sample taken for NAA analysis. J.L.

DESCRIPTION: Intersecting lines form squares divided into checkerboard patterns alternating with squares framing floral ornaments in medallions. The black ornaments contain white or amber petals that radiate from a white core. Black dots within the small squares of the checkerboard provide additional decoration. One fragment terminates in a dark amber border, perhaps close to the end of the plaque. Two fragments are decorated with a cross against an amber medallion.

COMPARISONS: Paris, Musée du Louvre (cat. B.7); Sèvres, Musée national de Céramique (cat. C.3, C.9). R.B.R.

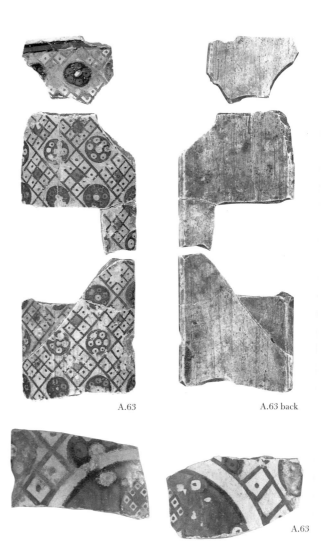

A.63 A.63 back

A.63

A.64 Diaper Pattern

Baltimore, Walters Art Museum, 48.2086.46 (pattern includes 178 fragments)

M.P.H. 10.5, W. 9.5, Th. 0.5, Pitch of Convex Shape 2.0 cm

CONDITION: Section from a convex tile reconstructed from three fragments. Two preserved edges are beveled, though others within the same group are rounded. Buff-colored body with iron oxide and quartz inclusions. Parallel striations beneath glaze indicate that the tile was worked from both the obverse and reverse. Glaze colors include aubergine, amber, and copper green. Outline painted in iron oxide slip. Diamonds intended to be white reserve may have been covered in a clear glaze, now completely deteriorated. Glazes are crazed yet intact; in some areas aubergine and copper green are opaque due to a weathering crust. Losses concentrated along break edges. Striations parallel to the length of the tile are visible on the reverse, as is a glaze drip. J.L.

DESCRIPTION: Intersecting lines form a pattern of diamonds. Diamonds enclosing circles alternate with diamonds subdivided into nine squares. The central square is painted with aubergine, and the four corners are painted with copper green. The other four squares are white reserve and have black dots at their centers. The circles are green and are set against amber squares. R.B.R.

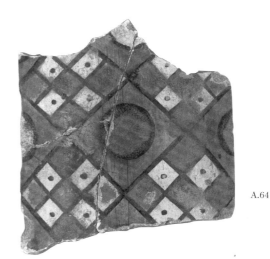

A.64

A.65 Half-Circle with Half-Rosette

Baltimore, Walters Art Museum, 48.2086.47a (pattern includes nine fragments)

H. 9.5, M.P.W. 10.8, Th. 0.5, Pitch of Convex Shape 1.8 cm

CONDITION: Section from a convex tile reconstructed from two sets of joined fragments. Three preserved edges are rounded. Buff-colored body with iron oxide and quartz inclusions. Glazes are poorly preserved; colors include amber, copper green, and clear. Outline painted in iron oxide slip exhibits flake loss. Striations parallel to the length of the tile on reverse. Impression of a textile pattern also along bottom of the reverse. J.L.

DESCRIPTION: Half-rosettes are represented on a green background under arches outlined with dark brown and subdivided into repeating boxes with black dots at their centers. Three colors are used for the petals of each rosette: black-brown in the center, white reserve, and amber. Between each petal is a trefoil.

COMPARISONS: Paris, Musée de Louvre (cat. B.8); Sèvres, Musée national de Céramique (cat. C.17). R.B.R.

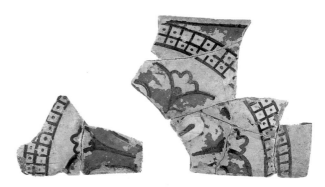

A.65

A.66 Half-Circle with Half-Rosette

Baltimore, Walters Art Museum, 48.2086.47b (pattern includes fourteen fragments)

M.P.H. 9.2, M.P.W. 9.7, Th. 0.5, Pitch of Convex Shape 1.8 cm

CONDITION: Section from a convex tile reconstructed from three fragments. Preserved edge is rounded. Buff-colored body with iron oxide and quartz inclusions; reverse of tile, at lower left, is darkened by heat. Amber and copper green glazes are poorly preserved. In some areas green glaze opaque due to weathering crust. Outline painted in iron oxide slip, which exhibits flake loss. Striations parallel to the length of the tile on both the obverse and reverse indicate that the tile was worked from both sides. J.L.

DESCRIPTION: Half-rosette formed of amber leaves with a white-reserve core. Each rosette is crowned by a white double arch subdivided into small boxes with dots at their centers. Between each arch is a heart-shaped leaf in amber on a green background.

COMPARISONS: Paris, Musée du Louvre (cat. B.8). The use of checkerboard boxes to frame or divide motifs can also be seen on whiteware ceramic vessels from the same period, for example, on a plate revealed in excavations adjacent to the church of Saint Eirene.[1]

1 Peschlow, "Byzantinische Keramik," 406, pl. 141.2. The plate has been dated to the tenth century. R.B.R.

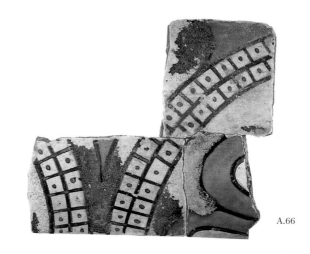

A.66

A.67 Foliate Design

Baltimore, Walters Art Museum, 48.2086.48 (pattern includes twenty-three fragments)

M.P.H 4.3, M.P.W. 7.3, Th. 0.6–0.7 cm.

CONDITION: Two fragments from a convex tile. Preserved edge is beveled. Buff-colored fabric with iron oxide and quartz inclusions. Preserved glaze colors include aubergine, amber, and copper green. Glazes are poorly preserved, with crazing overall and major losses to all colors. Outline painted in iron oxide slip exhibits major flake losses. Striations parallel to length of tile on reverse. Lower fragment darkened by heat on reverse. J.L.

DESCRIPTION: A foliate motif is inscribed within amber half-circles outlined in dark brown. In the center of each foliate pattern is painted a white or amber trilobed vegetal motif. R.B.R.

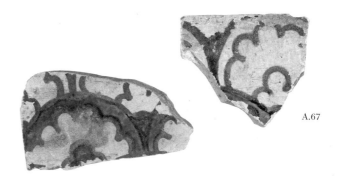

A.67

A.68 Circle with Disk

Baltimore, Walters Art Museum, 48.2086.49 (pattern includes eleven fragments)
H. 6.7, M.P.W. 14.8, Th. 0.5 cm

CONDITION: Section of a convex tile reconstructed from five fragments. Two preserved edges are rounded. Buff-colored fabric with iron oxide and quartz inclusions. Preserved glaze colors include aubergine, amber, and copper green. Outline is painted in iron oxide slip and exhibits considerable flake loss. Glazes poorly preserved, crazed overall, with major losses to green. Burial accretions on surface obscure design. Striations parallel to the length of the tile on reverse, with multiple voids due to dragging of inclusions. Quickly rendered floral sketch in iron oxide slip on reverse uses a fairly wide brush stroke (0.3 cm thick). Sketch does not relate to the design on the obverse. J.L.

DESCRIPTION: Repeated medallions on an amber background. Each contains a central floral motif painted in iron oxide slip with white-reserve petals. Surrounding this central motif is a green ground and semicircular arches enclosing lobed shapes of white, aubergine, and green, which border the medallion. On the reverse side of the tile is a split palmette with flaring leaves drawn in iron oxide slip.

R.B.R.

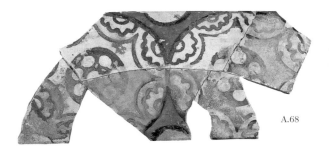

A.68

A.68 back

A.69 Circle with Palmette

Baltimore, Walters Art Museum, 48.2086.50
H. 6.7, M.P.W. 6.9, Th. 0.6, Pitch of Convex Shape 1.2 cm

CONDITION: Single preserved fragment from a convex tile. Preserved edges are rounded. Buff-colored fragment with iron oxide and quartz inclusions. Preserved glaze colors include amber and copper green. Outline is drawn in iron oxide slip and exhibits flake loss. Only colored stains remain where glazes were painted. The reverse is extremely smooth with some voids due to loss of quartz or other rounded inclusions. J.L.

DESCRIPTION: A palmette, in white reserve, is enveloped in a dark brown circle filled with green glaze. The palmette must have formed part of a continuous motif as suggested by the partially preserved circular frame visible to the left. In between the main alternating pattern on an amber background is painted a small tendril. This single fragment does not have a parallel among the decorative tiles.

COMPARISONS: While there are no tiles with the identical pattern, this design is found on polychrome bowls excavated in Cherson.[1]

1 Zalesskaja, "Nouvelles découvertes," 59. R.B.R.

A.69

A.70 Circle with Four-Petaled Flower

Baltimore, Walters Art Museum, 48.2086.51 (pattern includes one hundred fragments)

M.P.H. 30.8, W. 8.9, Th. 0.5, Pitch of Convex Shape 1.8 cm

CONDITION: Section of a convex tile reconstructed from nine fragments. Preserved edges are acutely beveled. Buff-colored body with iron oxide and quartz inclusions. Glazes include amber, copper green, and clear. Glazes are crazed overall, with major losses to all colors along the bottom third of the fragment. Black outline painted in a dilute iron oxide glaze is darker in color than most other tiles and is well preserved in the upper portions. Reverse is covered with short parallel striations and multiple voids from dragging of inclusions. A faint impression of a textile pattern is visible on the reverse, at the bottom of the tile. Sample taken for SEM and NAA analysis. J.L.

DESCRIPTION: Continuous pattern of linked four-leafed rosettes. The white-reserve leaves are outlined in black, and their fronds are colored in blue-green glaze. The corners of the leaves connect to form a pattern of repeating medallions. Each medallion encloses a four-petaled flower with a blue-green core surrounded by a black border. Between the leaves, along the upper and lower surfaces, are heart-shaped leaves in blue-green glaze. The background of the tile is glazed amber.

COMPARISONS: Myrelaion (cat. VII.3); Topkapı Sarayı Basilica (cat. XII.10–XII.13); Istanbul, Provenance Unknown (cat. XV.7, XV.9); Paris, Musée du Louvre (cat. B.13); Sèvres, Musée national de Céramique (cat. C.21, C.22); Athens, Benaki Museum (cat. D.7); France, Thierry Collection (cat. H.5). R.B.R.

A.70

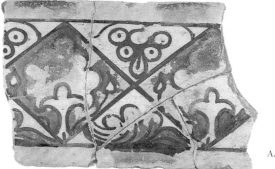

A.71

A.71 Lozenges with Profile Flowers

Baltimore, Walters Art Museum, 48.2086.52

H. 11.0, M.P.W. 16.0, Th. 0.6, Pitch of Convex Shape 1.9 cm

CONDITION: Section of a convex tile reconstructed from four fragments. Preserved upper and lower edges are beveled. Buff-colored fabric with iron oxide and quartz inclusions. Preserved glazes include amber and copper green. Glazes are crazed, and there is considerable loss to both amber and green. Outline painted in iron oxide slip; flake loss primarily along break edges. Striations parallel to the length of the tile on reverse, with shallow voids due to dragging of inclusions. A faint partial drawing of the hair and high forehead of a male saint is visible on the reverse. Drawing is executed in fine strokes only 0.1 cm in width, in contrast to the robust outline on the obverse, which is 0.3 cm in width. J.L.

DESCRIPTION: Green palmettes with white stems are enclosed within amber squares. Grapes and foliate motifs are painted on a white-reserve background in the triangles formed by the squares and the green border of the tile.

COMPARISONS: Sèvres, Musée national de Céramique (cat. B.18–B.26). R.B.R.

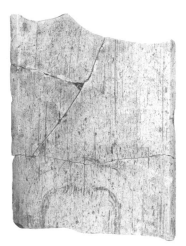

A.71 back

A.72 Capital I with Basketweave

Baltimore, Walters Art Museum, 48.2086.55
H. 20.9, D. at upper edge 21.0, D. at lower edge 15.3 (as restored),
Th. 0.7–1.0 cm

CONDITION: Nearly complete half-capital. Reconstructed from twelve contiguous fragments and three nonjoining fragments; rounded edge at the top, but flat edge at the bottom. Buff-colored fabric with iron oxide and some quartz inclusions. The majority of amber glaze is intact yet crazed overall. Losses are along the break edges. Remnants of green glaze are visible on top. Ornamentation includes a poorly preserved aubergine glaze. Glaze colors include amber, aubergine, green, and clear. On the reverse, concentric throw lines. The bottom part is finished with multidirectional striations.　J.L.

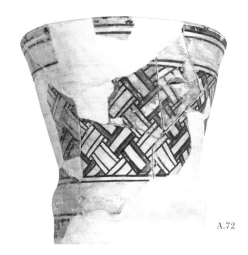

A.72

A.73 Capital II

Baltimore, Walters Art Museum, 48.2086.56
H. 20.9, D. at upper edge 22.0, D. at lower edge 17.3 (as restored),
Th. 0.7–1.0 cm

CONDITION: Half-complete capital reconstructed from twenty-four fragments. There are three contiguous groups consisting of three, five, and seven fragments. Other fragments are either solitary or in pairs; rounded edge at the top, flat edge at the bottom. Restored to original dimensions based upon the individual curvature of these fragments. Buff-colored fabric with iron oxide and some quartz inclusions. Much of the amber glaze is intact yet crazed overall. Losses are along the break edges. Remnants of green and aubergine glaze are still visible on the ornamentation. Glaze colors include amber, aubergine, green, and clear. Concentric throw lines on the reverse. The bottom part on the reverse was finished with multidirectional striations.　J.L.

A.73

A.74 Capital III (no photo)

CONDITION: The third capital consists of twenty-three nonjoining fragments from at least one additional capital.

DESCRIPTION: The polychrome half-capital is divided into three sections. The slightly bulging base is surrounded by a triple border composed of a broad green band flanked, at the bottom, by a thin line of amber and, at the top, by a line of white. Green bands with amber borders and aubergine bands with white borders are interwoven to create the basketlike pattern. A thin white line terminates the design. A broad green band followed by narrow lines of amber and white decorates the flaring top of the capital. A fragment of a ceramic half-capital with a different pattern of decoration was also found in Topkapı Sarayı Basilica (cat. XII.37). While the decoration of these fragments is different from those in the Walters Art Museum, the overall shape of the capital is similar. A variation of the basketweave pattern of the Walters capital appears on a ninth-century ceramic column from Preslav.[1]

1 Ellen C. Schwartz, "Medieval Ceramic Decoration in Bulgaria," *Byzantinoslavica* 43 (1982), fig. 7; Grabar, *Recherches,* fig. 13; J. S. Gospodinov, "Fouilles à Patléïna," *Bulletin de la Société Archéologique Bulgare* 4 (1914), pl. XXXVIII, fig. 3.　M.H.

B
Musée du Louvre, Paris

A number of hypotheses have been proposed about the provenance and origins of Byzantine glazed tiles. Jannic Durand, Head Curator of the Département des Objets d'art at the Musée du Louvre, fully discussed the history of the tiles in the Louvre and Sèvres museums in an article published in 1997.[1] According to J. Durand, a first group, consisting of eight tiles (cat. B.1–B.9) and some additional fragments (cat. B.16–B.26), derived from the same collection that was later sold to the Walters Art Museum (cat. A). The Louvre tiles were purchased in 1955 on the recommendation of E. Coche de la Ferté. The tiles were acquired from R. Hecht, who had purchased them in 1954 from the shop of Nikos Avgheris in the Istanbul bazaar. The origin of these tiles, as well as those in the Walters, remains a mystery. Numerous locations have been proposed. These include sites on the Asiatic shore of the Bosporus, Bursa, and Üskübü.[2] According to J. Durand, it is also possible that the tiles originated from Constantinople itself.[3]

Other tiles in the Louvre collection came to the museum from several donors. Three fragments of "Constantinopolitan" tiles (cat. B.10–B.12), originally in the collection of Jean Pozzi, were given to the section of Islamic Art of the Département des Antiquités orientales by Jean Soustiel in 1972.[4] Two other fragments were donated to the Département des Objets d'art by the Parisian antique dealers Agop and Mergeditch Indjoudjian in 1927 (B.13, B.14).[5] Finally, Jean Soustiel and Marie-Christine David offered to the Département des Objets d'art a ceramic colonnette ornamented with peacock feathers, a fragment that had been published by Talbot Rice (cat. B.15, xv.6).

1 Durand, "Plaques," 25–34.
2 Durand and Vogt, "Plaques," 38; Durand, "Plaques," 28–29.
3 Durand, "Plaques," 29, 34.
4 Durand, "Plaques," 32.
5 Durand, "Plaques," 33.

CHRISTINE VOGT

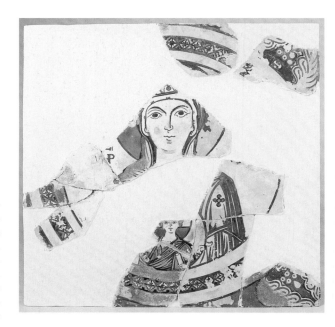

B.1

B.1 Virgin and Child

MP Θ[Y]

Paris, Musée du Louvre, Département des Objets d'art, AC 83

H. 29.5, W. 29.5, Th. 1.0 cm

CONDITION: Large square plaque reconstructed from ten fragments. Faces of the Virgin and Child are preserved. Major losses to the torso and the circular border of the medallion. Three sides are preserved and have slightly beveled edges. Buff-colored body with iron oxide and quartz inclusions. Glaze colors include amber, copper green, and clear. Pink slip used to highlight cheeks, nose, and ears of Virgin. Glazes are in a poor state of preservation and are crazed overall. Thick black-brown outline painted in iron oxide slip exhibits isolated flake loss. Reverse is relatively smooth, with some scraping marks.

DESCRIPTION: Frontal bust of the Virgin holding the Christ Child in a circular medallion in front of her chest. The figural composition is enclosed within three concentric borders. The central border is filled with a lozenge-shaped pattern enclosing intersecting crosses. The corners of the outer border are decorated with heart-shaped leaves. The Virgin is flanked by the letters MP ΘY, which are only partially preserved.[1] The *maphorion* bears cross-shaped pellets on the forehead and the shoulders. The Child makes a gesture of blessing with his right hand and holds a closed scroll in his left. He has curled hair and is wrapped in an ample *himation* with dense folds. The elongated proportions of the Virgin and highly refined treatment of the features, as well as the letter forms that flank the image, compare with ivory plaques of the tenth–eleventh centuries, such as the Hodegetria panel in Berlin similarly set in a circular medallion with a lozenge-shaped border.[2] The thick outlines of the drapery, in contrast with the fine drawing of the features, also give an impression of relief, reminiscent of ivory carvings. The circular arrangement of the composition, with a repetition of several compass-drawn circles, is particularly well suited to the iconographic type of the Virgin with the clipeus of the Child. The same iconography is repeated on a second ceramic tile of the same group, in the Walters Art Museum (cat. A.1). The origins of this iconographic type are old. On Early Christian models, however, the Christ Child is often enclosed in an oval medallion. Besides an example in the church of Panagia Drossiani in Naxos,[3] the earliest occurrences of the circular medallion with Christ Emmanuel are on a seal of the patriarch Photios (858–67 or 877–86)[4] and on an anonymous silver *miliaresion* that can be attributed to the end of the reign of Basil II.[5] This image gains popularity on seals of the eleventh century, on which it is sometimes labeled *Nikopoios*.[6] The cult of the Virgin Nikopoios was intensified after the discovery of an image of this type following the restoration work conducted by Romanos III in the sanctuary of the Blachernai church.[7] The same emperor introduced this image on his gold-coin issues.[8] Another miracle story occurring in the same church, described by Michael Psellos (1075), refers to an icon that might also be of the same type.[9] The ceramic tiles in the Louvre and the Walters Art Museum join then the earliest occurrences of this image, which is rarely represented in mon-umental arts, in contrast with its greater popularity on artifacts with a more personal use.

LITERATURE: Coche de la Ferté, "Décors," 190–94; Megaw, "Byzantine Pottery," 103; Durand and Vogt, "Plaques," 40–41; Durand, "Plaques," 26, fig. 1. Vogt, Bouquillon, et al., "Glazed Wall Tiles," 51–52, fig. 61; C. Vogt, *Les céramiques à glaçure byzantines du Musée du Louvre et du Musée national de Céramique de Sèvres* (Paris–RMN, forthcoming).

EXHIBITIONS: Athens 1964, no. 598; Brussels 1982, C.2; Paris 1992–93, no. 296A; Athens 2000, no. 39.

1 A small fragment from the inscription may be in the Walters Art Museum.

2 *Glory of Byzantium*, 469.

3 The image belongs to the first layer of decoration dated to the late sixth–first half of the seventh century, see "Panagia he Drosiane," in *Naxos*, ed. M. Chatzidakis (Athens, 1989), 24.

4 W. Seibt, "Die Darstellung der Theotokos auf byzantinischen Bleisiegeln, besonders im 11. Jahrhundert," *Studies in Byzantine Sigillography*, I, ed. N. Oikonomides (Washington, D.C., 1987), 41, fig. 6.

5 See B. Pitarakis, "A propos de l'image de la Vierge orante au Christ-Enfant (XIe–XIIe siècles): L'émergence d'un culte," *CahArch* 48 (forthcoming). For an alternative dating of this image to the year 1040, see W. Seibt, "Der Bildtypus der Theotokos Nikopoios: Zur Ikonographie des Gottesmutter-Ikone, die 1030/31 in der Blachernenkirche Wiederaufgefunden Wurde," *Byzantina* 13 (1985), 552–53.

6 Seibt, "Bildtypus," 555.

7 *Ioannis Scylitzae Synopsis Historiarum*, ed. I. Thurn (Corpus Fontium Historiae Byzantinae 5, Series Berolinensis, 1973), 384.

8 Gold tetartera in P. Grierson, *Catalogue of the Byzantine Coins in the Dumbarton Oaks Collection and in the Whittemore Collection*, III, *Leo III to Nicephorus III, 717–1081, Part 2* (Washington, D.C., 1973), 718, nos. 2.1, 2.2, pl. LVII.

9 *Logos epi to en Blachernais gegonoti thaumati*, in *Michael Psellus Orationes Hagiographicae*, ed. E. A. Fisher (Stuttgart and Leipzig, 1994), 205–6. For a discussion of this passage, see Pitarakis, "A propos de l'image."

B.P. WITH C.V.

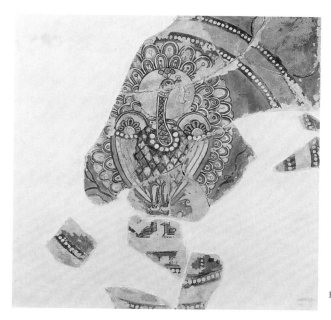

B.2

B.2 Peacock

Paris, Musée du Louvre, Département des Objets d'art, AC 84
Est. H. 29.3, est. W. 29.5, Th. 1.0 cm

CONDITION: Large square plaque reconstructed from fourteen fragments. Major losses to the left side and lower corners. The preserved edges are beveled. Buff colored body with iron oxide and quartz inclusions. Glaze colors include aubergine, amber, copper green, and clear. Glazes are crazed overall. Areas of green glaze are opaque due to the formation of a weathering crust. The brown-black outline, painted in iron oxide slip, is well preserved. The reverse is relatively smooth, with some scraping marks. The three fragments composing the feet and the platform on which the peacock stands are from another plaque;[1] striations on the reverse are not consistent with markings on the Louvre tile.

DESCRIPTION: The peacock is placed at the center of an amber medallion. The round field is encircled by a wide green band bordered by rows of white dots in imitation of pearls. Green heart-shaped leaves extend from the border to fill the amber-glazed corners of the tile. The bird stands frontally, wings tucked at its sides. The nimbed head is turned to the left, and a white leaf dangles from the beak. The base of the amber neck is encircled by a ring of white dots on black ground. The bird's body is divided into diamond-shaped amber feathers, each with a stalk at the center. The green upper joint of the wings is ornamented with a floral motif in aubergine and amber. White dots on black ground separate the upper wing from the long amber, green, and aubergine feathers below. The bird's elaborate tail is composed of rows of feathers with white-reserve cores surrounded by amber and white strips. To the left and right of the peacock's feet are traces of dark foliate tendrils. The Louvre plaque is similar in size, style, color, and manufacture to the two peacock plaques in the Walters (cat. A.29, A.30). The plaques are differentiated by the frames that encircle the central figures. For comparisons of these tiles to relief sculpture of the same period,[2] see the entries under the Walters Art Museum. The peacock plaques have also been compared to the representation of birds on silk weavings of the period from Constantinople.[3] In particular, a silk from the Reliquary of Saint Germanus in Auxerre, dated ca. 1000, is decorated with four eagles in profile. Like the reconstructed Louvre peacock, the eagles stand on beaded pedestals and display outstretched wings divided into carefully detailed abstract feathers.

COMPARISONS: The peacock-feather pattern is also commonly used in the Macedonian period, on whiteware vessels recovered at Preslav[4] and Istanbul (cat. IV.1), on glazed wall tiles from the Round Church at Preslav[5] and Topkapı Sarayı Basilica (cat. XII.35, XII.36), on convex tiles from the Louvre (cat. B.15) and Sèvres (cat. C.28), and on flat tiles from the Walters (A.50).

LITERATURE: Coche de la Ferté, "Décors," 195–98, fig. 7a; Coche de la Ferté, *L'art de Byzance* (Paris, 1981), fig. 556; Grabar, *Sculptures* I, pl. LXXa; Durand and Vogt, "Plaques," 38–39, fig. 3; C. Jolivet-Lévy, "Byzance," in *L'art du Moyen Âge,* ed. J.-P. Caillet (Paris-RMN, 1995), fig. 116; Durand, "Plaques," 26, fig. 2; Vogt, Bouquillon, et al., "Glazed Wall Tiles," 51–52, fig. 6.3; Vogt, *Céramiques à glaçure.*

EXHIBITIONS: Paris 1967, fig. 241; Brussels 1982, C.3; Paris 1992–93, 296B.

1 Durand and Vogt, "Plaques," n. 7; Durand, "Plaques," 26, n. 8.
2 Durand and Vogt, "Plaques," 38, n. 8, fig. 1.
3 Ibid., 38–39.
4 Miatev, *Keramik,* fig. 16, pls. VI.13 and VII.13–14; Totev, "L'atelier," figs. 4, 5.
5 Totev, "L'atelier," figs. 17, 19. C.V. AND M.H.

B.3

B.4

B.3 Acanthus

Paris, Musée du Louvre, Département des Objets d'art, AC 85
H. 29.8, est. W. 29.8, Th. 0.8 cm

CONDITION: Large square plaque reconstructed from eight fragments. Major loss to the left side of the plaque. May join with cat. A.43 in the Walters Art Museum, which comprises the lower left petal. The three preserved sides have beveled edges. Buff-colored body with iron oxide and quartz inclusions. Glaze colors include amber, copper green, and clear. Glazes are crazed overall, and green color is often obscured by a weathering crust. The black-brown outline painted in iron oxide slip is well preserved. The reverse is finished with multiple scratches or striations. Samples taken for ICP-AES/MS and SEM-EDS analysis.

DESCRIPTION: A broad stylized acanthus is placed at the center of a medallion framed by a green band with green heart-shaped leaves in the spandrels. The flattened leaves are divided into undulating fronds of amber, green, and white reserve. Representations of the acanthus have often been linked with art of the Near East and Islam,[1] but the abstract plant is commonly found in Byzantine enamel work,[2] architectural relief sculpture,[3] manuscripts,[4] metalwork, and other media of the period.[5]

COMPARISONS: Simplified acanthus leaves are painted on tiles from the Sèvres museum (cat. C.4).

LITERATURE: Coche de la Ferté, "Décors," 200–202, fig. 10; Durand and Vogt, "Plaques," 40–41, fig. 5; Durand, "Plaques," 26, fig. 3; Vogt, Bouquillon, et al., "Glazed Wall Tiles," 51–52, fig. 6.4; Vogt, Céramiques à glaçure.

EXHIBITIONS: Athens 1964, no. 604; Paris 1992–93, 296C.

1 Miatev, Keramik, 94–95; Coche de la Ferté, "Décors," 200; Durand and Vogt, "Plaques," 41, n. 15; Durand, "Plaques," 26–27, n. 11.

2 Durand and Vogt, "Plaques," 41, n. 16, fig. 6; Byzance, fig. 165; Glory of Byzantium, fig. 236.

3 Grabar, Sculptures I, pl. LI.2; Macridy, "Monastery of Lips," figs. 17, 29.

4 Frantz, "Ornament," pls. VII, VIII.

5 Byzance, 258, fig. 1; A. Grabar, "La soie byzantine de l'évêque Gunther à la cathédrale de Bamberg," Münchner Jahrbuch der Bildenden Kunst 7 (1956), 24–25, figs. 4, 5; A. Goldschmidt and K. Weitzmann, Die byzantinischen Elfenbeinskulpturen des X.–XIII. Jahrhunderts, II, Reliefs (Berlin, 1934), fig. 32. C.V.

B.4 Rosette

Paris, Musée du Louvre, Département des Objets d'art, AC 86
H. 29.5, est. W. 29.5, Th. 0.8 cm

CONDITION: Large square plaque reconstructed from six fragments. Major losses to one side. The three preserved sides have beveled edges. Buff-colored fabric with iron oxide and quartz inclusions. Glaze colors include amber, copper green, and clear. The glazes are crazed overall, and in many areas the green glaze is opaque due to a weathering crust. The black-brown outlines, painted in iron oxide slip, are well preserved and show only isolated flake loss. On the reverse are three deep parallel gouges. Samples taken for ICP-AES/MS and SEM-EDS analysis.

DESCRIPTION: Six rows of concentric petals surrounding a central eight-petaled core. A circular band composed of green and white reserve strips frames the rosette and terminates in large heart-shaped leaves in the corners. Each petal contains a lobed floret, enhancing the decorative aspects of the composition. The ancient rosette pattern was commonly used by the Byzantine artists. It appears, for example, on a textile fragment in Auxerre and the Bamberg silk.[1] The rosette is also represented on the mosaic pavement of the Umayyad bath at Khirbat al Mafjar.[2]

LITERATURE: Coche de la Ferté, L'antiquité, 69; Coche de la Ferté, "Décors," 198–200, fig. 8a; Durand and Vogt, "Plaques," 38–40, fig. 4; Durand, "Plaques," 26, fig. 4; Vogt, Bouquillon, et al., "Glazed Wall Tiles," 51–52, fig. 6.2; Vogt, Céramiques à glaçure.

EXHIBITION: Paris 1992–93, 296D.

1 Durand and Vogt, "Plaques," 43, 41; Byzance, 258, fig. 1.

2 R. Ettinghausen, From Byzantium to Sasanian Iran and the Islamic World: Three Modes of Artistic Influence (Leiden, 1972), pl. XVIII, fig. 61. C.V.

B.5

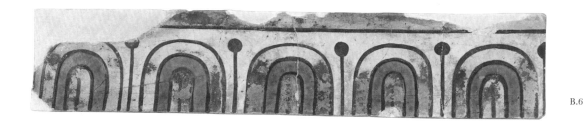

B.6

B.5 Animal Frieze

Paris, Musée du Louvre, Département des Objets d'art, AC 87
ΛΑΓ[ο]Σ (center); ΛΕ[ων] (right)
H. 7.8, W. 32.0, Th. 0.5–0.6 cm

CONDITION: Flat rectangular plaque reconstructed from thirteen fragments. Three partially preserved beveled edges. Glaze colors include amber, copper green, and an unusually thick application of clear glaze. Glazes are poorly preserved, with considerable loss along the break edges. Brown-black outline painted in iron oxide slip exhibits isolated flake loss. Striations on the reverse run parallel to the design on the obverse. Samples taken for SEM-EDS analysis.

DESCRIPTION: The plaque is divided into three compartments that contain (left to right) a boar,[1] a hare, and a lion. This is the only plaque decorated with animals on the obverse, although isolated sketches of animal claws and hooves appear on the reverse of several tiles in the Walters Art Museum (cat. A.34).[2] On the Louvre plaque, the animal portraits are divided by vertical strips that imitate designs in enamel work. Each animal is defined by a thick outline. The faces are the most detailed aspects of the portraits; the bodies, more schematic, are filled with decorative spots. The animals are labeled for the viewer, and two are placed in confronted poses. The small size of the plaque suggests that it was not used in a monumental context, such as a church or other grand structure, but that it may have served as inlay in a larger object, such as a wooden casket.[3] Portraits of animals, which originated in late antiquity[4] or in the Sasanian period,[5] constituted a popular subject for whiteware vessels in the Macedonian period;[6] this plaque presents another subject that was used on both tiles and tablewares.

LITERATURE: Coche de la Ferté, *L'antiquité,* 69; Coche de la Ferté, "Décors," 203–6; Talbot Rice, "Byzantium and the Islamic World," 207–9; Grabar, *Sculptures* I, pl. LXXb; Durand and Vogt, "Plaques," 41, fig. 10; *Byzance,* 390; Durand, "Plaques," 26, fig. 5; Vogt, Bouquillon, et al., "Glazed Wall Tiles," 51, fig. 5; Vogt, *Céramiques à glaçure.*

EXHIBITIONS: Athens 1964, 605; Brussels 1982, C.4; Paris 1992–93, 297A.

1 A similar animal is represented on a Sasanian low relief from Ctesiphon (Coche de la Ferté, "Décors," fig. 11d) and on an ivory casket illustrating hunting scenes (*Byzance,* 258–59, fig. 168).
2 See the essay by J. Lauffenburger, C. Vogt, and A. Bouquillon in this volume.
3 This idea has been suggested by S. Gerstel.
4 P. du Bourguet, *Musée national du Louvre: Catalogue des étoffes Coptes* I (Paris-RMN, 1964), 173, figs. D140–41.
5 Coche de la Ferté, "Décors," 203–6, figs. 11a, c, d.
6 Grabar, *Sculptures* I, pl. LX.2–3. C.V.

B.6 Tongue and Dart

Paris, Musée du Louvre, Département des Objets d'art, AC 88
H. 7.5, W. 36.0, Th. 0.7 cm

CONDITION: Complete concave tile reconstructed from four fragments. Edges are rounded. Buff-colored fabric with iron oxide and quartz inclusions. Glaze colors, which include amber, copper green, and clear, exhibit crazing overall and are in a poor state of preservation. Brown-black outline painted in iron oxide slip is well preserved. Reverse is finished with scrape marks parallel to the length of the tile. Samples taken for SEM-EDS analysis.

DESCRIPTION: The concave plaque represents a tongue-and-dart motif on white-reserve ground. A green band runs along the upper edge of the tile. The tongue is decorated with bands of green and amber that alternate with black darts to create a continuous design.

COMPARISONS: Constantine Lips (cat. VI.1, VI.2); Haydarpaşa (cat. XVI.1); Baltimore, Walters Art Museum (A.61); Sèvres, Musée national de Céramique (cat. C.2, C.11, C.12, C.40).

LITERATURE: Coche de la Ferté, "Décors," 209–10; Durand and Vogt, "Plaques," 41, fig. 9; Durand, "Plaques," 26, fig. 6; Vogt, Bouquillon, et al., "Glazed Wall Tiles," 51, fig. 3.2; Vogt, *Céramiques à glaçure.*

EXHIBITION: Paris 1992–93, 297F. C.V.

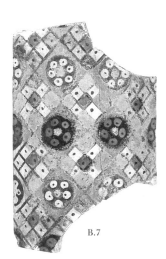

B.7

B.7 Diaper Pattern

Paris, Musée du Louvre, Département des Objets d'art, AC 89
H. 14.5, W. 9.0, Th. 0.5 cm

CONDITION: Convex plaque (colonnette) reconstructed from two fragments. Preserved edges are beveled. Buff-colored fabric with iron oxide and quartz inclusions. Glaze colors include amber, copper green, and clear. Glazes are very deteriorated, and in some areas color is obscured by an opaque weathering crust. Black-brown outline painted in iron oxide slip is well preserved beneath glazes. Striations on the reverse run parallel to the length of the tile.

DESCRIPTION: Design formed of alternating squares enclosing checkerboard patterns and floral ornaments in medallions. The central box of the checkerboard is amber in color. The four corners are green; the central boxes are white reserve and form a cruciform shape. Black dots within the white boxes provide additional decoration. The black foliate ornaments contain white or amber petals that radiate from a green core.

COMPARISONS: Baltimore, Walters Art Museum (cat. A.63); Paris, Musée du Louvre (cat. B.17).

LITERATURE: Coche de la Ferté, "Décors," 206–8; Durand, "Plaques," 26, fig. 8; Vogt, Bouquillon, et al., "Glazed Wall Tiles," 51, fig. 1.2; Vogt, *Céramiques à glaçure*.

EXHIBITION: Paris 1992–93, 297B. C.V.

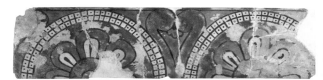

B.8

B.8 Half-Circle with Half-Rosette

Paris, Musée du Louvre, Département des Objets d'art, AC 90
H. 8.5, W. 35.0, Th. 0.5 cm

CONDITION: Nearly complete convex tile intended to cover a cornice. Reconstructed from seven fragments. Preserved edges are beveled. Buff-colored fabric with iron oxide and quartz inclusions. Glaze colors include amber, copper green, and clear. Glaze in poor state of preservation. Brown-black outline painted in iron oxide slip exhibits major loss along right edge. Finishing marks on both obverse and reverse indicate working from both sides.

DESCRIPTION: Half-rosettes, formed of amber and white petals, run along the bottom of the plaque. Each rosette is crowned by a white double arch subdivided into small boxes with dots at their centers. Between each arch are two curved tendrils, forming a heart-shaped filler in amber on a green background.

COMPARISONS: Zeuxippos Baths (cat. XIII.8). Baltimore, Walters Art Museum (cat. A.65, A.66); Sèvres, Musée national de Céramique (cat. C.17).

LITERATURE: Coche de la Ferté, "Décors," 208–9, fig. 13d; Durand and Vogt, "Plaques," 41, fig. 8; Durand, "Plaques," 26, fig. 6; Vogt, Bouquillon et al., "Glazed Wall Tiles," 51, fig. 3.1; Vogt, *Céramiques à glaçure*.

EXHIBITION: Paris 1992–93, 297D. C.V.

B.9

B.9 Scale

Paris, Musée du Louvre, Département des Objets d'art, AC 91
H. 13.5 and 7.4, W. 9.2 and 9.0, Th. 0.7 cm

CONDITION: Two nonjoining fragments from a flat rectangular plaque. Preserved edges are beveled. Buff-colored fabric with iron oxide and quartz inclusions. Glaze colors include copper green and clear and are very deteriorated. Brown-black outline painted in iron oxide slip exhibits only isolated flake loss. Intersecting striations at corners on the reverse side.

DESCRIPTION: The plaque is covered by a scale pattern alternating in white, copper green, and amber. The pattern is attested in late antiquity in mosaic pavements[1] and architectural sculpture.[2]

COMPARISONS: Baltimore, Walters Art Museum (cat. A.52).

LITERATURE: Coche de la Ferté, "Décors," 210; Durand, "Plaques," 26, fig. 9; Vogt, Bouquillon, et al., "Glazed Wall Tiles," 51, fig. 4.5; Vogt, *Céramiques à glaçure*.

EXHIBITION: Paris 1992–93, 297I.

1 L. Budde, *Antike Mosaiken in Kilikien* (1969), 45, figs. 2, 3.
2 N. Fıratlı, *Sculpture byzantine*, 150–51, pl. 96.309. C.V.

B.10 Vine Scroll

Paris, Musée du Louvre, Département des Objets d'art, MAO 449/355

M.P.H. 5.2, M.P.W. 3.3, Th. 0.6 cm

CONDITION: Single fragment from a convex tile. Single preserved edge is beveled in profile. Buff-colored body. Glaze very deteriorated, and green glaze on leaf is opacified due to weathering crust. Design painted in black-brown iron oxide slip. Samples taken for ICP-AES/MS analysis.

DESCRIPTION: The small fragment of a vine scroll preserves a round tendril and portion of a leaf in green glaze. The design is painted against a white-reserve background and is framed by a narrow black border along the upper and lower edges. This tile is unusually wide; the vine-scroll motif is generally painted on thin strips, as in examples excavated in the Myrelaion (cat. VII.5).

LITERATURE: C. Vogt, *La céramique byzantine au Musée du Louvre* (Paris, 1990), III, 16, fig. 6.3; Durand, "Plaques," 32, fig. 26; Vogt, *Céramiques à glaçure*. C.V.

B.10

B.11 Heart with Five-Pointed Leaf

Paris, Musée du Louvre, Département des Objets d'art, SN1

M.P.H. 6.8, M.P.W. 3.6, Th. 0.8 cm

CONDITION: Single preserved fragment of convex tile with lower beveled edge intact. Glaze colors include amber, copper green, and clear. Green glazes are opacified due to a weathering crust.

DESCRIPTION: Abstract leaf composed of green core and white-reserve and green surrounding bands. Adjacent to the leaf and along the upper edge of the tile is a lobed foliate motif with amber petals surrounding a green core. Along the upper edge of the tile is a narrow green border.

COMPARISONS: Hospital of Sampson (cat. II.20).

LITERATURE: Durand, "Plaques," 33, fig. 26b; Vogt, *Céramiques à glaçure*. C.V.

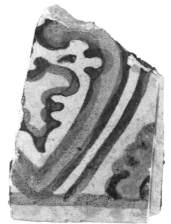

B.11

B.12 Concentric Circles

Paris, Musée du Louvre, Département des Objets d'art, SN2

H. 2.5, M.P.W. 7.7, Th. 0.45 cm

CONDITION: Two joining fragments from a flat rectangular strip. Preserved upper and lower edges are beveled. Buff-colored fabric. Design painted in black-brown iron oxide slip. Glaze colors include copper green and clear. Black filler is in a dilute iron-manganese oxide glaze (there is a drip of the same color on the reverse). Glazes are well preserved, with opaque weathering crust over the green glaze. Reverse is covered with striations parallel to the length of the tile and with glaze drips.

DESCRIPTION: Band of concentric circles composed of a green core with a white-reserve outer band. The background of the tile is black. This pattern is reminiscent of pearl strips applied to luxury objects.[1]

COMPARISONS: Constantine Lips (cat. VI.3, VI.4); Baltimore, Walters Art Museum (cat. A.54); Sèvres, Musée national de Céramique (cat. C.46).

LITERATURE: Durand, "Plaques," 33, fig. 26c; Vogt, *Céramiques à glaçure*.

B.12

1 *Glory of Byzantium*, fig. 34. C.V.

B.13 Circle with Four-Petaled Flower

Paris, Musée du Louvre, Département des Objets d'art, OA 7917
H. 7.5, M.P.W. 6.8 cm

CONDITION: Single fragment from a convex tile. Two preserved edges are slightly rounded. Buff-colored fabric with some large inclusions. Glaze colors, which are deteriorated, include amber and clear. Design painted in black-brown iron oxide slip. Reverse is fairly smooth, with traces of plaster. Samples taken for ICP-AES/MS and SEM analysis.

DESCRIPTION: The leaves of quatrefoils link to form medallions. Along the upper and lower edges, between the leaves, are heart-shaped foliate ornaments. The fronds of the leaves are painted in black; the background color is golden brown.

COMPARISONS: Myrelaion (cat. VII.3); Topkapı Sarayı Basilica (cat. XII.10–XII.13); Istanbul, Provenance Unknown (cat. XV.7, XV.9); Baltimore, Walters Art Museum (cat. A.70); Sèvres, Musée national de Céramique (cat. C.21, C.22); Athens, Benaki Museum (cat. D.7); France, Thierry Collection (cat. H.5).

LITERATURE: Vogt, *La céramique byzantine au Musée du Louvre*, III, 15, fig. 6.1; Durand, "Plaques," 33, fig. 27a; Vogt, *Céramiques à glaçure*. C.V.

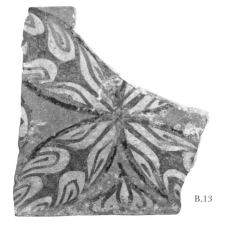

B.13

B.14 Ivy Leaf with Grape Clusters

Paris, Musée du Louvre, Département des Objets d'art, OA 7918
H. 2.6, M.P.W. 5.8, Th. 0.65 cm

CONDITION: Single fragment of a flat rectangular strip. Preserved upper and lower edges are beveled. Buff-colored fabric with small iron oxide inclusions. Glaze colors include amber and clear and are very deteriorated. Red slip decorated the interior of the foliate design. Outline painted in iron oxide slip. Reverse is fairly smooth, with some fine striations. Samples taken for ICP-AES/MS analysis.

DESCRIPTION: Vine tendrils with leaves and grapes. Grapes are glazed in yellow amber; vine is ornamented with red circles and green curved leaves.

COMPARISONS: Kyriotissa (cat. V.6); Myrelaion (cat. VII.5); Saint Euphemia (cat. VIII.2); Topkapı Sarayı Basilica (cat. XII.22); Sèvres, Musée national de Céramique (cat. C.31–C.33). Some similar fragments have been recovered from the Round church in Preslav.[1]

LITERATURE: Vogt, *La céramique byzantine au Musée du Louvre*, III, 15, fig. 6.1; Durand, "Plaques," 33, fig. 27b; Vogt, *Céramiques à glaçure*.

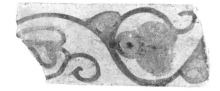

B.14

1 Miatev, *Keramik,* fig. 229. C.V.

B.15 (same as cat. XV.6) Peacock Feather

Paris, Musée du Louvre, Département des Objets d'art, OA 11789

H. 16.5, D. at upper edge 12.6, D. at lower edge 10.2 cm

CONDITION: At least five joined fragments of a colonnette. Heavily restored, possibly varnished and gilded, resulting in an overall darkened appearance. Buff-colored fabric. Glaze colors include amber, copper green, and clear. Glazes are deteriorated yet saturated by a later restoration material. Brown-black outline painted in iron oxide slip. Interior coated with plaster from later effort at consolidation.

DESCRIPTION: The plaque was published by Talbot Rice in 1965. In a footnote, he recorded that the plaque was in his possession and that he had acquired it in the bazaar at Istanbul in 1932.[1] The plaque was discovered by Jean Soustiel and Marie-Christine David for sale in a Parisian suburb and was donated recently to the Louvre.[2]

COMPARISONS: Colonnette plaques with peacock-feather decoration have been found in a number of excavations in Istanbul, including the site of the Istanbul Law Court (cat. IV.1). The closest comparison, however, is found in a tile offered for sale in the Istanbul bazaar in 1944 (cat. XV.9). See also Sèvres, Musée national de Céramique (cat. C.28). For comments on the peacock-feather motif, see cat. B.2.

LITERATURE: Talbot Rice, "Byzantium and the Islamic World," 205–6; Durand, "Plaques," 33, fig. 28; Vogt, *Céramiques à glaçure*.

1 Talbot Rice, "Byzantium and the Islamic World," 206 n. 2.
2 Durand, "Plaques," 33. C.V.

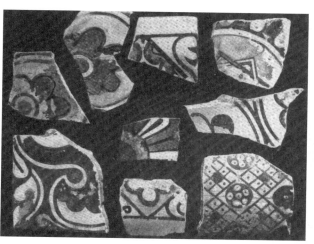

B.15

B.16, B.17 Half-Rosette and Diaper Pattern

Paris, Musée du Louvre

DESCRIPTION: Two fragments examined and scientifically tested in 1955 by Coche de la Ferté at the Institut de Céramique de Sèvres and later destroyed. Dimensions unknown.

COMPARISONS: Paris, Musée du Louvre (cat. B.7, B.8).

LITERATURE: Coche de la Ferté, "Décors," 188–92; Durand, "Plaques," 27, fig. 10; Vogt, *Céramiques à glaçure*. C.V.

B.16, B.17

B.18–B.26 Paris, Musée du Louvre

DESCRIPTION: Nine fragments published by Coche de la Ferté as part of the Louvre collection; the location of the fragments is unknown. Dimensions and condition are unknown. The fragments cluster in groups: Four (B.18–B.21) are similar to the concave tile with paired acanthus leaves in the Walters Art Museum (cat. A.62). B.22 and B.25 form part of the pattern on A.71, a convex tile with a geometric and foliate motif. B.23 may have formed part of A.35, a large square plaque in the Walters Art Museum decorated with interlaced squares within radiating petals. B.24 is similar to A.64, a convex tile with squares and circles. B.26 may have formed part of A.66, a convex tile decorated with half-rosettes.

LITERATURE: Coche de la Ferté, "Décors," 211, fig. 14b; Durand, "Plaques," 27, fig. 11; Vogt, *Céramiques à glaçure*. C.V.

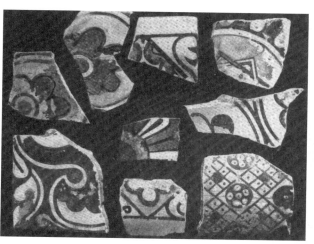

B.18–B.26

C
Musée National de Céramique, Sèvres

The tiles and fragments in the Musée national de Céramique come from the collection of Jean Pozzi; they were donated to the museum by Jean Soustiel in 1971.[1] It is quite possible that the collection derives from Istanbul, where Jean Pozzi served as a diplomat from 1907 to 1936. During the time of his posting to Istanbul, numerous tiles were found in excavations in the city.

1 Durand, "Plaques," 29–30.

CHRISTINE VOGT

C.1 Diaper Pattern with Wide Border

Sèvres, Musée national de Céramique, B1
H. 9.0, W. 13.1 cm

CONDITION: Three joining fragments of a flat rectangular plaque. Two preserved edges are beveled. Buff-colored fabric with iron oxide and quartz inclusions. Glaze colors include amber, copper green, and clear. Green and clear glazes are deteriorated and have a frosted appearance. The amber glaze is better preserved, with isolated flake loss. Red slip has been used to color small triangles within the segmented diamonds. The black-brown outline is painted in iron oxide slip and is well preserved beneath glazes. Samples taken for ICP-AES/MS and SEM analysis. On the reverse side is a label with the numbers 357/45007.

DESCRIPTION: This plaque combines a wide green border outlined in amber bands with a checkerboard pattern. The presence of the wide border, which frames the intricate and colorful pattern, suggests that the plaque formed the outer edge of a set of tiles. The internal, adjacent composition is formed by intersecting diagonals forming diamonds. The diamonds are decorated with an alternating pattern of amber circles on a green ground and boxes subdivided into compartments colored in red, green, and white reserve. The circle and box designs are further enlivened by the use of thick lines to form decorative crosses.

COMPARISONS: The pattern is similar, though not identical, to a set of flat and convex tiles in the Walters Art Museum, cat. A.44–A.48, and in the Musée national de Céramique, Sèvres (cat. C.3, C.9). A convex tile in the Walters, also decorated with a pattern of alternating diamonds, has a narrow border and must also have constituted an edge piece for a larger composition (cat. A.63).

LITERATURE: Durand, "Plaques," 30, fig. 13; Vogt, Bouquillon, et al., "Glazed Wall Tiles," 51, fig. 44; Vogt, *Céramiques à glaçure.*

C.V.

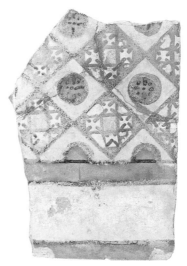

C.1

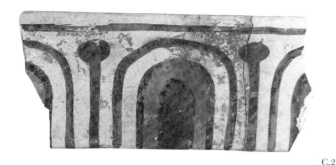

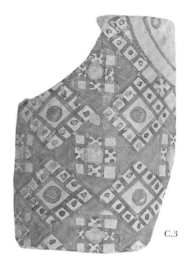

C.2

C.3

C.2 Tongue and Dart

Sèvres, Musée national de Céramique, B2

H. 6.5, M.P.W. 13.5, Th. 0.45 cm

CONDITION: Three joined fragments from a convex tile intended to cover a cornice. Preserved upper and lower edges are beveled. Buff-colored fabric with iron oxide and quartz inclusions. Glaze colors include amber, copper green, and clear. Glazes are deteriorated. Outline painted in iron oxide slip is well preserved beneath glaze. On the reverse, striations run parallel to the length of the tile. An enigmatic modern inscription, combining Greek letters and numbers, extends the length of the reverse side of the tile. On the reverse side is a label with the numbers 358/45007. Samples taken for ICP-AES/MS analysis.

DESCRIPTION: Tongue-and-dart pattern drawn in thick black lines on a white-reserve background. The tongues are formed of three arches that have a black core, an amber intermediate space, and a white reserve outer band. Green glaze is extremely worn, but would have decorated the border along the upper surface of the plaque. Where the iron oxide slip is worn, for example, on the darts, the design has a deep red color.

COMPARISONS: Constantine Lips (cat. vi.1, vi.2); Haydarpaşa (cat. xvi.1); Baltimore, Walters Art Museum (cat. A.61); Paris, Musée du Louvre (cat. B.6); Sèvres, Musée national de Céramique (cat. C.40).

LITERATURE: Durand, "Plaques," 30, figs. 14, 15; Vogt, Bouquillon, et al., "Glazed Wall Tiles," 51, fig. 2.4; Vogt, *Céramiques à glaçure*.

EXHIBITION: Paris 1992–93, 297G. C.V.

C.3 Diaper Pattern with Medallion

Sèvres, Musée national de Céramique, B3

H. 13.5, W. 9.1, Th. 0.7 cm

CONDITION: Single fragment of a narrow colonnette. Four preserved edges are beveled. Buff-colored fabric. Glaze colors include amber and clear. Glazes are heavily deteriorated and crazed overall. Amber glaze appears darkened and more worn than in other examples. Glaze at center of diamonds and squares appears red at times and may be a red slip covered in a clear glaze or a copper green glaze that turned red in a reducing environment. Brown-black outline painted in iron oxide slip or dilute glaze exhibits isolated flake loss. Parallel throw lines on reverse indicate that the fragment was thrown on a wheel.[1] Lines along the edges indicate that the tile was scored while wet, then fired, and afterward snapped. The method of fabrication is also seen in cat. A.72. Mechanical scraping marks on the reverse indicate additional hand finishing.[2] A label on the reverse is marked 356/45007. Samples taken for ICP-AES/MS analysis.

DESCRIPTION: Intersecting diagonals form a pattern of diamonds with alternating internal patterns. In one set of diamonds, each perimeter is lined by small boxes that surround an internal circle. At the center of each box is a dot. The other diamonds contain squares that are subdivided into nine compartments with decoration imitating gemstone settings on metalwork objects. At one corner of the tile is the partial outline of a medallion, which appears to contain a Greek letter. The existence of the partially preserved medallion suggests that this plaque was intended to be placed next to another of similar design. In its design, the plaque presents a unique pattern reminiscent of late antique works.[3]

LITERATURE: Durand, "Plaques," 30, figs. 14, 15; Vogt, Bouquillon, et al., "Glazed Wall Tiles," 51, fig. 1.1; Vogt, *Céramiques à glaçure*.

EXHIBITION: Paris 1992–93, 297C.

1 Vogt, Bouquillon, et al., "Glazed Wall Tiles," 55–56.

2 Ibid., fig. 15; see also the essay by J. Lauffenburger, C. Vogt, and A. Bouquillon in this volume, 69–70.

3 Coche de la Ferté, "Décors," 206, 208. C.V.

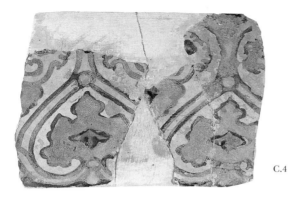

C.4

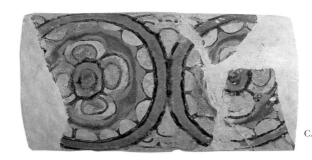

C.6

C.5

C.5 Marbling

Sèvres, Musée national de Céramique, B5
M.P.H. 10.2, W. 7.6 cm

CONDITION: Single fragment of a convex tile. Preserved edges are squared. Buff-colored fabric. Glaze colors include amber, copper green, and a thicker dark brown-black iron oxide glaze. Glaze surface is highly abraded, with losses concentrated along high spots and edges. Green glaze is obscured by an opaque weathering crust. On the reverse is the impression of a textile pattern.

DESCRIPTION: The upper surface of the tile is covered with an imitation marble-vein pattern in deep amber and blue-green on a white field. Marbling is associated with tiles found in excavations at the Boukoleon in a room north of the House of Justinian. Given the rarity of this decorative form, it is likely that this tile was found at the same site as the excavated examples.

COMPARISONS: Boukoleon (cat. I.B.6).

LITERATURE: Durand, "Plaques," 31, fig. 22; Vogt, Bouquillon, et al., "Glazed Wall Tiles," 51, fig. 1.3; Vogt, *Céramiques à glaçure*.

C.V.

C.6 Circle with Four-Petaled Flower

Sèvres, Musée national de Céramique, B6
H. 8.4, M.P.W. 15.1 cm

CONDITION: Section of a convex tile reconstructed from three fragments. Preserved edges are beveled. Buff-colored fabric. Glaze colors include cobalt blue, amber, and copper green. Green and blue glazes are very deteriorated and exhibit crazing overall. Brown-black outline painted in iron oxide slip is well preserved.

DESCRIPTION: Two circles, each enclosing a four-petaled flower. Each circle is framed by an outer amber band and an inner turquoise or green field enclosing a row of white linked half-circles. The spandrels between the circles are filled with a white trilobed motif. The core of each flower is a blue disk encircled by a band. Each petal has a green core surrounded by a white-reserve band. This decorative pattern, which perhaps originated in the Sasanian period,[1] is well known in the Macedonian period, especially on glazed tiles and whiteware vessels from the Zeuxippos Baths and the Topkapı Sarayı Basilica.[2]

COMPARISONS: Hospital of Sampson (cat. II.14, II.15); Istanbul, Provenance Unknwon (cat. XV.3).

LITERATURE: Durand, "Plaques," 30, fig. 17; Vogt, Bouquillon et al., "Glazed Wall Tiles," 51, fig. 2.3; Vogt, *Céramiques à glaçure*.

EXHIBITION: Paris 1992–93, 297E.

C.4 Hearts with Five-Pointed Leaves

Sèvres, Musée national de Céramique, B4
H. 9.5, M.P.W. 13.1, Th. 1.0 cm

CONDITION: Section from a convex tile reconstructed from four fragments. Preserved edges are beveled. Buff-colored fabric. Glaze colors include gray-blue, amber, and copper green. Glazes are very deteriorated, with major losses to color fields. Red iron oxide slip was also used to highlight areas; black-brown outline painted in iron oxide slip is well preserved.

DESCRIPTION: Repeated pattern of five-pointed flaring leaves set within heart-shaped tendrils. At the core of each leaf is a small amber trefoil. The connections between the tendrils are highlighted by small circles filled in with red slip, in a manner reminiscent of the slip articulation on the foliate frames of the Group III figural plaques from the Walters Art Museum (A.19–A.21). In its design, this tile presents a unique pattern.

LITERATURE: Durand, "Plaques," 30, fig. 16; Vogt, Bouquillon, et al., "Glazed Wall Tiles," 51, fig. 2.2; Vogt, *Céramiques à glaçure*.

C.V.

1 K. Erdman, *Die Kunst Irans zur Zeit der Sasaniden* (Berlin, 1934), fig. 58.
2 Talbot Rice, "The Byzantine Pottery," figs. 39.2, 3 and 6, 7; Ettinghausen, "Byzantine Tiles," pl. XXXI, fig. 2.

C.V.

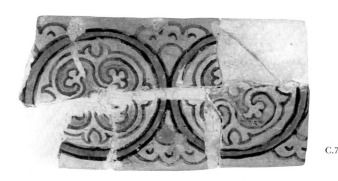

C.7

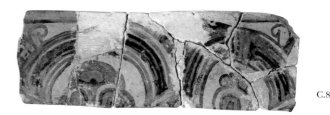

C.8

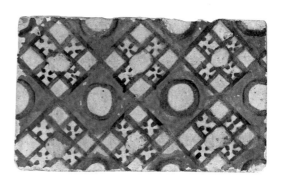

C.9

C.7 Circle with Scrolling Tendrils

Sèvres, Musée national de Céramique, B7
H. 9.4, M.P.W. 17.1 cm

CONDITION: Section of a convex tile reconstructed from six fragments. Preserved edges are beveled. Buff-colored fabric. Glaze colors include cobalt blue, amber, copper green, and clear. Glazes are deteriorated. Brown-black outline painted in iron oxide slip is loosely rendered and exhibits flake loss in numerous areas, leaving behind a faint red-brown stain.

DESCRIPTION: Buff-colored circles are linked by amber bands. Each circle encloses an ochre foliate scroll with trefoils on a dark blue field. The green glaze in the background and within the tear-shaped motifs between the circles is extremely worn. The spandrels between the circles are decorated with a lobed motif; the original glaze color is hard to detect.

COMPARISONS: Hospital of Sampson (cat. II.16, II.17); Kyriotissa (cat. V.7); Istanbul, Provenance Unknown (cat. XV.9). Whiteware vessels decorated with the identical pattern, and securely dated to the tenth century, have been found at excavations conducted from 1978 to 1980 at Cherson, a prosperous trading center on the Crimean peninsula.[1]

LITERATURE: Durand, "Plaques," 30–31, fig. 18; Vogt, Bouquillon, et al., "Glazed Wall Tiles," 51, fig. 2.1; Vogt, *Céramiques à glaçure*.

1 Zalesskaja, "Nouvelles découvertes," figs. 4, 11–14. For examples of tablewares from Constantinople decorated with similar patterns, see Talbot Rice, *Glazed Pottery*, pl. VII; idem, "Polychrome Pottery," pl. XXVII.2. C.V.

C.8 Acanthus Half-Circles

Sèvres, Musée national de Céramique, B8, B12, B57
H. 6.0, M.P.W. 16.2 cm

CONDITION: Section of a flat rectangular plaque reconstructed from eight fragments. Buff-colored fabric. Glaze colors include grayblue, amber, and clear. Glazes are heavily deteriorated, with crazing overall. Some areas are opaque due to the formation of a weathering crust. Red slip is present as a decorative element. Brown-black outline painted in iron oxide slip.

DESCRIPTION: Triple imbrications under arched leaves. At the center of each arch is a triple "keystone" motif with a central amber band flanked by green. Between each arch is a triangular spandrel divided into a cherckerboard pattern. The arches emerge, at the bottom of the tile, from a triangular element enclosing a trilobed form. There is a narrow framing strip along the upper edge of the tile.

COMPARISONS: Kyriotissa (cat. V.2); Topkapı Sarayı Basilica (cat. XII.5–XII.7); Istanbul, Provenance Unknown (cat. XV.9); Nicaea, Koimesis church (cat. XVIII).

LITERATURE: Durand, "Plaques," 31, fig. 20; Vogt, *Céramiques à glaçure*. C.V.

C.9 Diaper Pattern

Sèvres, Musée national de Céramique, B9
M.P.H. 10.7, M.P.W. 6.8, Th. 0.5 cm

CONDITION: Single complete fragment of a flat rectangular plaque. Four finished edges. Buff-colored fabric with iron oxide and quartz inclusions. Glaze colors include amber, copper green, and clear. Glazes are deteriorated and exhibit crazing overall; major losses to the green glaze. Brown-black outline painted in iron oxide slip is well preserved. Multiple striations and scratches on the reverse side. The reverse side has a label marked with the numbers 359/45007.

DESCRIPTION: Dark diagonal lines intersect to create a pattern of alternating diamonds. Amber diamonds each with a green circle at its center alternate with diamonds that are subdivided into a checkerboard pattern of nine boxes. The corners of the boxes are filled with green glaze; the white squares at the center of each side are marked by four lines perpendicular to their sides, in imitation of the fastenings for gemstones in metalwork.

COMPARISONS: Baltimore, Walters Art Museum (cat. A.45).

LITERATURE: Durand, "Plaques," 30, fig. 12; Vogt, *Céramiques à glaçure*.

EXHIBITION: Paris 1992–93, 297H. C.V.

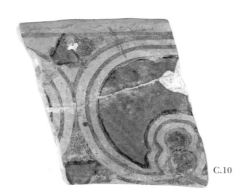

C.10

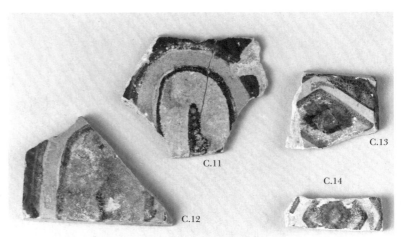

C.11

C.13

C.14

C.12

C.10 Shell

Sèvres, Musée national de Céramique, B23

H. 9.0, M.P.W. 8.2 cm

CONDITION: Two fragments from a convex tile. Preserved edges are beveled. Buff-colored fabric. Glaze colors include amber, copper green, and clear. Glazes are deteriorated and in some areas opaque due to weathering crust. Brown-black outline painted in iron oxide slip. Samples taken for ICP-AES/MS analysis.

DESCRIPTION: Repeated pattern of double-banded amber shells enclosing a green figure eight. Background is glazed green, with a narrow green strip running along the upper edge of the plaque. Amber triangles, with points oriented toward the upper and lower edges of the plaque, are placed between the shells.

COMPARISONS: Constantine Lips (cat. VI.8, VI.9); Myrelaion (cat. VII.2); Mangana (cat. IX.1); Topkapı Sarayı Basilica (cat. XII.4); Istanbul, Provenance Unknown (cat. XV.9); Sèvres, Musée national de Céramique (cat. C.35); France, Thierry Collection (cat. H.4).

LITERATURE: Durand, "Plaques," 31, fig. 19; Vogt, *Céramiques à glaçure.* C.V.

C.11–C.14 Tongue and Dart and Concentric Lozenges

Sèvres, Musée national de Céramique, B31, B56, B47, B48

CONDITION: Four fragments from rectangular plaques. Buff-colored fabric. Glazes are deteriorated. Beneath the glaze is a layer of gold leaf (C.11, C.12), and two fragments have a cobalt glaze (C.13, C.14). Brown-black outline painted in iron oxide slip. Samples taken for SEM-EDS (cat. C.11, C.12, C.14) and ICP-AES/MS (cat. C.12, C.14) analysis.

DESCRIPTION: Two of the fragments belong to an oblong tile decorated with a tongue-and-dart motif. The other two fragments form part of a band of lozenges enclosing circles. Tile fragments with gold leaf have been associated primarily with the Myrelaion and the Boukoleon, and an additional fragment, also decorated with tongue and dart, was found as Haydarpaşa.

COMPARISONS (FOR TONGUE AND DART): Boukoleon (cat. I.B.1–I.B.4); Haydarpaşa (cat. XVI.1); France, Thierry Collection (cat. H.2).

LITERATURE: Durand, "Plaques," 32, fig. 25; Vogt, Bouquillon, et al., "Glazed Wall Tiles," 55; Vogt, *Céramiques à glaçure.* C.V.

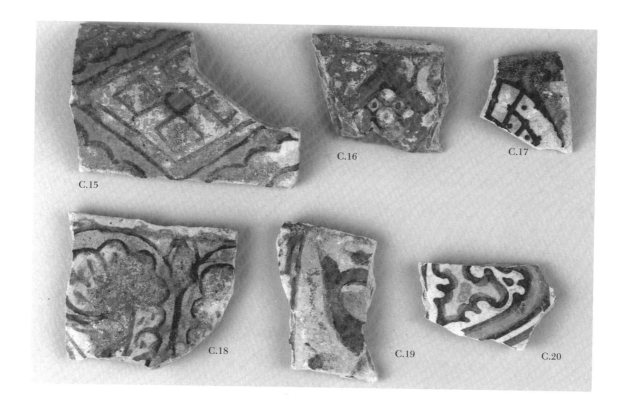

C.15 Lozenges with Crosslets

Sèvres, Musée national de Céramique, B24
M.P.H. 6.0 cm

 Condition: Samples taken for ICP-AES/MS analysis.
 Comparisons: Topkapı Sarayı Basilica (cat. xɪɪ.39); Zeuxippos Baths (cat. xɪɪɪ.3); Sèvres, Musée national de Céramique (cat. C.30).
 Literature: Durand, "Plaques," fig. 23a; Vogt, *Céramiques à glaçure.* c.v.

C.16 Acanthus Half-Circles

Sèvres, Musée national de Céramique, B28

Description: Fragment from the narrow green upper border of a tile and part of the connecting checkerboard triangle between the arches.

Comparisons: Kyriotissa (cat. v.2); Topkapı Sarayı Basilica (cat. xɪɪ.5–xɪɪ.7).

Literature: Durand, "Plaques," fig. 23b; Vogt, *Céramiques à glaçure.* c.v.

C.17 Half-Circle with Half-Rosette

Sèvres, Musée national de Céramique, B20

Comparisons: Baltimore, Walters Art Museum (cat. A.65, A.66); Paris, Musée du Louvre (cat. B.8).

Literature: Durand, "Plaques," fig. 23c; Vogt, *Céramiques à glaçure.* c.v.

C.18 Paired Acanthus Leaves

Sèvres, Musée national de Céramique, B25

 Condition: Samples taken for ICP-AES/MS analysis.
 Comparisons: Saint John Stoudios (cat. x.3); Topkapı Sarayı Basilica (cat. xɪɪ.15); Baltimore, Walters Art Museum (cat. A.62); Athens, Benaki Museum (cat. D.3).
 Literature: Durand, "Plaques," fig. 23d; Vogt, *Céramiques à glaçure.* c.v.

C.19 Unknown Pattern

Sèvres, Musée national de Céramique, B32

Description: The design does not appear to be part of the decorative repertoire of the tiles and may represent a fragment of an animal. There are no known parallels for this fragment.

Literature: Durand, "Plaques," fig. 23e; Vogt, *Céramiques à glaçure.* c.v.

C.20 Foliate Motif

Sèvres, Musée national de Céramique, B30

Comparisons: Hospital of Sampson (cat. ɪɪ.20); Paris, Musée du Louvre (cat. B.11).

Literature: Durand, "Plaques," fig. 23f; Vogt, *Céramiques à glaçure.* c.v.

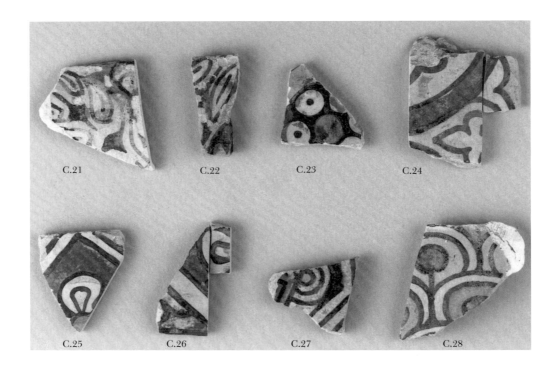

C.21 C.22 C.23 C.24

C.25 C.26 C.27 C.28

C.21, C.22 Circle with Four-Petaled Flower

Sèvres, Musée national de Céramique, B29, B49

CONDITION: Samples taken for ICP-AES/MS analysis (cat. C.21).

COMPARISONS: Myrelaion (cat. VII.3); Topkapı Sarayı Basilica (cat. XII.10–XII.13); Istanbul, Provenance Unknown (cat. XV.7, XV.9); Baltimore, Walters Art Museum (cat. A.70); Paris, Musée du Louvre (cat. B.13); Athens, Benaki Museum (cat. D.7); France, Thierry Collection (cat. H.5).

LITERATURE: Durand, "Plaques," figs. 23g, h; Vogt, *Céramiques à glaçure.* C.V.

C.23 Foliate Motif

Sèvres, Musée national de Céramique, B53

DESCRIPTION: Floral medallion from center of a larger composition. Red slip core with white dots in surrounding band.

COMPARISONS: Baltimore, Walters Art Museum (cat. A.68); Paris, Musée du Louvre (cat. B.7).

LITERATURE: Durand, "Plaques," fig. 23i; Vogt, *Céramiques à glaçure.* C.V.

C.24 Ivy Leaf with Grape Clusters

Sèvres, Musée national de Céramique, B13

DESCRIPTION: Amber vine scroll with delicate tripartite leaves.

COMPARISONS: Sèvres, Musée national de Céramique (cat. C.36, C.37).

LITERATURE: Durand, "Plaques," fig. 23j; Vogt, *Céramiques à glaçure.* C.V.

C.25, C.26 Lozenges with Four-Petaled Flowers

Sèvres, Musée national de Céramique, B18, B42

COMPARISONS: Constantine Lips (cat. VI.10).

LITERATURE: Durand, "Plaques," figs. 23k, l; Vogt, *Céramiques à glaçure.* C.V.

C.27 Floral Motifs and Bands

Sèvres, Musée national de Céramique, B50

COMPARISONS: Constantine Lips (cat. VI.18).

LITERATURE: Durand, "Plaques," fig. 23m; Vogt, *Céramiques à glaçure.* C.V.

C.28 Peacock Feather

Sèvres, Musée national de Céramique, B15

COMPARISONS: Istanbul Law Court (cat. IV.1); Istanbul, Provenance Unknown (cat. XV.9); Baltimore, Walters Art Museum (cat. A.50); Paris, Musée du Louvre (cat. B.15).

LITERATURE: Durand, "Plaques," fig. 23n; Vogt, *Céramiques à glaçure.* C.V.

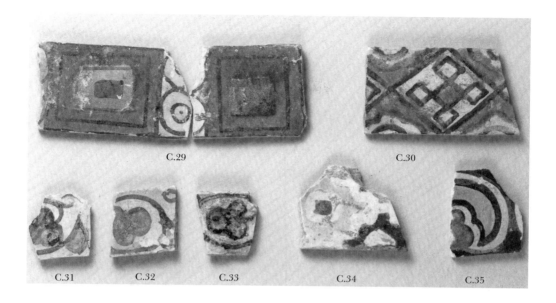

C.29

C.30

C.31 C.32 C.33 C.34 C.35

C.29 Jeweled Band

Sèvres, Musée national de Céramique, B45, B27

COMPARISONS: Kyriotissa (cat. v.1); Constantine Lips (cat. vi.6); Topkapı Sarayı Basilica (xii.3).

LITERATURE: Durand, "Plaques," fig. 24a; Vogt, *Céramiques à glaçure.* c.v.

C.30 Lozenges with Crosslets

Sèvres, Musée national de Céramique, B26

COMPARISONS: Topkapı Sarayı Basilica (cat. xii.39); Zeuxippos Baths (cat. xiii.3); Sèvres, Musée national de Céramique (cat. C.15).

LITERATURE: Durand, "Plaques," fig. 24b; Vogt, *Céramiques à glaçure.* c.v.

C.31, C.32, C.33 Ivy Leaf with Grape Clusters

Sèvres, Musée national de Céramique, B38, B43, B44

DESCRIPTION: Three fragments of the same pattern.

COMPARISONS: Kyriotissa (cat. v.6); Myrelaion (cat. vii.5); Saint Euphemia (cat. viii.2); Topkapı Sarayı Basilica (cat. xii.22); Paris, Musée du Louvre (cat. B.14).

LITERATURE: Durand, "Plaques," figs. 24c–e; Vogt, *Céramiques à glaçure.* c.v.

C.34 Cross

Sèvres, Musée national de Céramique, B54

COMPARISONS: Constantine Lips (cat. vi.15).

LITERATURE: Durand, "Plaques," fig. 24f; Vogt, *Céramiques à glaçure.* c.v.

C.35 Shell

Sèvres, Musée national de Céramique, B21

COMPARISONS: Constantine Lips (cat. vi.8, vi.9); Myrelaion (cat. vii.2); Mangana (cat. ix.1); Topkapı Sarayı Basilica (cat. xii.4); Sèvres, Musée national de Céramique (cat. C.10); France, Thierry Collection (cat. H.4).

LITERATURE: Durand, "Plaques," fig. 24g; Vogt, *Céramiques à glaçure.* c.v.

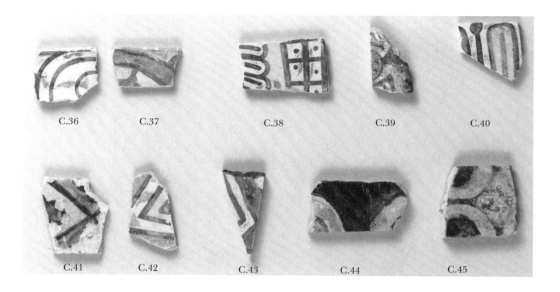

C.36　C.37　　　　C.38　　　　C.39　　　　C.40

C.41　　C.42　　　　C.43　　　　C.44　　　　C.45

C.36, C.37　Ivy Leaf with Grape Clusters

Sèvres, Musée national de Céramique, B39, B40

DESCRIPTION: Amber vine scroll with delicate tripartite leaves.

COMPARISONS: Sèvres, Musée national de Céramique (cat. C.24).

LITERATURE: Durand, "Plaques," figs. 24h–i; Vogt, *Céramiques à glaçure*.　　　　　　　　　　　　　　　　　　　C.V.

C.38　Half-Circle with Half-Rosette

Sèvres, Musée national de Céramique, B22

COMPARISONS: Topkapı Sarayı Basilica (cat. XII.30); Zeuxippos Baths (cat. XIII.8); Paris, Musée du Louvre (cat. B.8); Sèvres, Musée national de Céramique (cat. C.17).

LITERATURE: Durand, "Plaques," fig. 24j; Vogt, *Céramiques à glaçure*.　　　　　　　　　　　　　　　　　　　C.V.

C.39　Shell (?)

Sèvres, Musée national de Céramique, B55

LITERATURE: Durand, "Plaques," fig. 24k; Vogt, *Céramiques à glaçure*.　　　　　　　　　　　　　　　　　　　C.V.

C.40　Tongue and Dart

Sèvres, Musée national de Céramique, B37

COMPARISONS: Topkapı Sarayı Basilica (cat. XII.37).

LITERATURE: Durand, "Plaques," fig. 24l; Vogt, *Céramiques à glaçure*.　　　　　　　　　　　　　　　　　　　C.V.

C.41　Lozenge

Sèvres, Musée national de Céramique, B46

LITERATURE: Durand, "Plaques," fig. 24m; Vogt, *Céramiques à glaçure*.　　　　　　　　　　　　　　　　　　　C.V.

C.42　Lozenge

Sèvres, Musée national de Céramique, B41

LITERATURE: Durand, "Plaques," fig. 24n; Vogt, *Céramiques à glaçure*.　　　　　　　　　　　　　　　　　　　C.V.

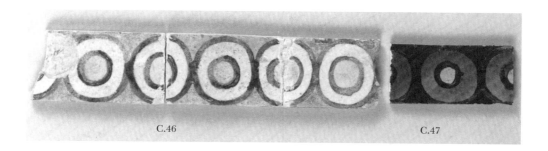

C.46

C.47

C.43 Lozenge

Sèvres, Musée national de Céramique, B52
 LITERATURE: Durand, "Plaques," fig. 24o; Vogt, *Céramiques à glaçure*. C.V.

C.44 Tongue and Dart

Sèvres, Musée national de Céramique, B17
 COMPARISONS: Sèvres, Musée national de Céramique (cat. C.11, C.12).
 LITERATURE: Durand, "Plaques," fig. 24p; Vogt, *Céramiques à glaçure*. C.V.

C.45 Half-Circles and Diamonds

Sèvres, Musée national de Céramique, B51
 COMPARISONS: Hospital of Sampson (cat. II.6).
 LITERATURE: Durand, "Plaques," fig. 24q; Vogt, *Céramiques à glaçure*. C.V.

C.46 Concentric Circles

Sèvres, Musée national de Céramique, B19
 COMPARISONS: Hospital of Sampson (cat. II.3, II.4); Constantine Lips (cat. VI.3, VI.4); Baltimore, Walters Art Museum (cat. A.54).
 LITERATURE: Durand, "Plaques," fig. 24r; Vogt, Bouquillon, et al., "Glazed Wall Tiles," fig. 4.2; Vogt, *Céramiques à glaçure*. C.V.

C.47 Concentric Circles

Sèvres, Musée national de Céramique, B10
 COMPARISONS: Sèvres, Musée national de Céramique (cat. C.46).
 LITERATURE: Durand, "Plaques," fig. 24s; Vogt, Bouquillon, et al., "Glazed Wall Tiles," fig. 4.1; Vogt, *Céramiques à glaçure*. C.V.

D
Benaki Museum, Athens

The ten polychrome tile fragments in the Benaki Museum[1] form part of a superb ceramic collection that was first assembled by the museum's founder, Antonis Benakis. The collection was expanded by Theodore Macridy, who became the Director of the Benaki Museum in 1931. Macridy had served as Curator of the Greek and Byzantine Department as well as Assistant Director of the Istanbul Archaeological Museum, and through his position in Istanbul, Macridy was intimately involved with excavations and restoration projects in the Byzantine capital and in neighboring regions. When he assumed the position of Director of the Benaki Museum, Macridy donated his extensive collection of Byzantine ceramic wares, including two frag-ments of polychrome tiles with figural decoration. In 1931–32, the Constantinopolitan antiquities dealer Andronikos Kintaoglou (or Kitaoglou) donated a collection of "Turkish" ceramics to the museum.[2] The Kintaoglou gift was, for the most part, composed of Byzantine ceramics (including eight polychrome tiles) associated with sites or excavations in Constantinople.

1 Information on the history of the collection in the Benaki Museum derives from the excellent study by D. Papanikola-Bakirtzi et al., *Benaki Museum*, 11–20. The editors would like to express their thanks to D. Papanikola-Bakirtzi for her assistance and support of this project and to A. Drandaki for permission to study the tile fragments and for providing photographs.
2 For this donation, see Papanikola-Bakirtzi et al., *Benaki Museum*, 180 n. 9.

<div align="right">SHARON E. J. GERSTEL</div>

D.1 Unidentified Saint

Athens, Benaki Museum, 13551
Gift of Theodore Macridy, 1934
W. 10.0, Th. 0.6 cm

CONDITION: Two joined fragments of a flat plaque. No finished edges preserved. White fabric with iron oxide inclusions. Small chip losses along cracks on upper surface. Iron oxide is flaked in several locations, leaving red traces along lines. Glaze colors include amber and clear. Red slip used for the book.

DESCRIPTION: Frontal torso of a male saint. Dressed in a white tunic and mantle, the saint holds a closed red-colored codex in his left hand and raises his right hand in a gesture of speech. The pages of the codex are differentiated by black parallel lines; the elaborate cover and clasp are similarly articulated by thick strokes. The identity of the figure is difficult to establish. Although scholars have suggested that the represented figure is Christ Pantokrator,[1] the Benaki saint is rendered in a scale and fashion similar to those of the Walters apostles, who also wear white robes and carry ornate Gospel books.

LITERATURE: Papanikola-Bakirtzi et al., *Benaki Museum*, 16, 19.
EXHIBITION: Athens 1999.

1 Papanikola-Bakirtzi et al., *Benaki Museum*, 19.

<div align="right">S.G.</div>

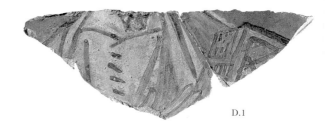

D.1

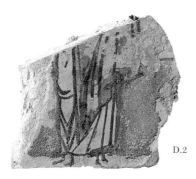

D.3

D.4

D.2

D.2 Unidentified Saint

Athens, Benaki Museum, 13552
Said to be from the monastery of Saint Panteleimon at Beykoz on the
Asian side of the Bosporus
Gift of Theodore Macridy, 1931
M.P.H. 5.3, Th. 0.7 cm

CONDITION: Single fragment of a flat tile. White fabric with iron
oxide inclusions, pink surface. Chip losses around edges. Glaze col-
ors include amber, copper green, and clear. Surface losses to the
amber glaze. Copper green glaze is opacified due to a weathering
crust. Figure and details are outlined in iron oxide slip.

DESCRIPTION: Frontal portrait of a male figure; only the lower
portion of the body is preserved. Dressed in a white tunic and amber-
colored mantle, the figure stands against a green background. The
provenance of the plaque is indicated in a letter written by Theodore
Macridy to the Swedish Ambassador to Constantinople, M. Tyler,
dated 26 September 1938: "Nous avons au Musée un fragment d'une
plaquette de revêtement en faience représentant le bas du corps d'un
personnage vêtu: il mésure 0,05 de haut sur 0,055 de large. Le per-
sonnage est de couleur rose avec des traits noirs, sur fond vert. Il
provient de l'église du monastère de Saint Pantéléimon sur la rive
Asiatique du haut-Bospore (Beikos)." In its design and fabrication,
the tile is similar to a fragment that was published as part of the Mal-
lon Collection (cat. I.1).

LITERATURE: Papanikola-Bakirtzi et al., *Benaki Museum*, 16, 19.
EXHIBITION: Athens 1999. S.G.

D.4 Tongue and Dart

Athens, Benaki Museum, 17496, 17497, 17498
From the church of Saint John Studios
Gift of Andronikos Kintaoglou, 1931–32
Maximum Dimension 8.5, Th. 0.7 cm (14796)
Maximum Dimension 5.0, Th. 0.5 cm (17497)
Maximum Dimension 5.5, Th. 0.9 cm (17498)

CONDITION: Three fragments, including corner (17498), edge
(17496), and center piece (17497), of a convex tile. Edge is squared
and slightly beveled, with traces of fine plaster along the outer sur-
face. Buff-colored fabric with iron oxide inclusions. Shallow surface
losses along breaks. Glaze colors include amber, copper green, and
clear. The lines of design painted in iron oxide.

DESCRIPTION: Segments of tongue-and-dart motif. Green border
along upper edge. The lengthened arches, set against a white-reserve
background, are rendered in copper green (outer band), yellowish
amber (central band), and white reserve (interior). The vertical dart is
stepped along the upper edge of the tile and is rendered in yellowish
amber.

COMPARISONS: Saint John Studios (cat. x.1).
LITERATURE: Papanikola-Bakirtzi et al., *Benaki Museum*, 19–20.
EXHIBITION: Athens 1999. S.G.

D.3 Paired Acanthus Leaves

Athens, Benaki Museum, 17495
From Saint John Studios
Gift of Andronikos Kintaoglou, 1931–32
Maximum Dimension, 12.0, Th. 0.6 cm

CONDITION: Section of a convex tile reconstructed from four frag-
ments. Single preserved edge is squared and slightly beveled. Buff-
colored fabric with iron oxide inclusions. Shallow surface losses
along breaks. Glaze colors include amber, copper green, and clear.
Black background painted with iron oxide.

DESCRIPTION: Fragment of a broad leaf outlined in white and
divided into a bright amber upper surface and a green wavy lower
surface.

COMPARISONS: Saint John Studios (cat. x.3).
LITERATURE: Macridy, "Monastery of Lips," 276, fig. 85;
Papanikola-Bakirtzi et al., *Benaki Museum*, 19.
EXHIBITION: Athens 1999. S.G.

D.5 Paired Acanthus Leaves

Athens, Benaki Museum, 17411, 17331
From the church of Saint John Stoudios
Gift of Andronikos Kintaoglou, 1931–32
Th. 0.4 cm

CONDITION: Fragments of thin convex tiles. Buff-colored fabric with iron oxide inclusions. Shallow surface losses along edges. Glaze colors include amber, copper green, and clear. Foliate pattern painted with iron oxide. Green glaze extremely worn; where it remains on the surface, it is opacified due to a weathering crust. Reverse sides are smoothed, and both fragments have traces of horizontal and curved lines in red paint.

DESCRIPTION: Two small fragments of a broad leaf set on a white-reserve background and divided into a bright amber upper surface and a green wavy lower surface. A second leaf, or border, decorated with amber glaze, is set off by a thick black line.

LITERATURE: Papanikola-Bakirtzi et al., *Benaki Museum*, 18–20.

EXHIBITION: Athens 1999. 　　　　　　　S.G.

D.5

D.5 back

D.5

D.6 Circle with Scrolling Tendrils

Athens, Benaki Museum, 17403
Gift of Andronikos Kintaoglou, 1931–32
Maximum Dimension 5.5, Th. 0.3 cm

CONDITION: Fragment of a convex tile with a single preserved edge. Buff-colored fabric with iron oxide inclusions. Shallow surface losses along edges. Glaze colors include copper green (in hues of bright green and blue-green), amber, and clear. Green glaze is opacified due to a weathering crust. Pattern painted with iron oxide.

DESCRIPTION: Portion of a white roundel enclosing a foliate design (in white reserve) on a blue-green background. Within the roundel, as well, is a small circle enclosing amber glaze. The roundel is set on a bright green background and is connected to an adjacent but missing roundel by an amber tendril.

LITERATURE: Papanikola-Bakirtzi et al., *Benaki Museum*, 18–20.

EXHIBITION: Athens 1999. 　　　　　　　S.G.

D.6

D.7 Circle with Four-Petaled Flower

Athens, Benaki Museum, 17525
Gift of Andronikos Kintaoglou, 1931–32
M.P.H. 6.0, Th. 0.7 cm

CONDITION: Fragment of a convex tile. Buff-colored fabric with iron oxide inclusions. Shallow surface losses along edges. Glaze colors include amber, copper green, and clear. Green glaze is heavily opacified due to weathering crust. Pattern painted with iron oxide.

DESCRIPTION: Portion of a broad leaf placed against an amber background. The petals of the flower are outlined and detailed in black and dark red (due to iron oxide wash); the edges of each petal are bordered in green glaze. Between the petals is a small heart-shaped leaf outlined in black and filled in with green glaze.

COMPARISONS: Myrelaion (cat. VII.3); Topkapı Sarayı Basilica (cat. XII.10–XII.13); Istanbul, Provenance Unknown (cat. XV.7, XV.9); Baltimore, Walters Art Museum (cat. A.70); Paris, Musée du Louvre (cat. B.13); Sèvres, Musée national de Céramique (cat. C.21, C.22); France, Thierry Collection (cat. H.5).

LITERATURE: Papanikola-Bakirtzi et al., *Benaki Museum*, 18, 20.

EXHIBITION: Athens 1999. 　　　　　　　S.G.

D.7

E

Dumbarton Oaks Collection, Washington, D.C.

The eleven tiles in the Dumbarton Oaks Collection derive from the excavations of the Hospital of Sampson (between Saint Sophia and Saint Eirene). The tiles were a gift from Ernest J. W. Hawkins, who received them from the director of the excavations. Individual tiles are discussed with other material from the site. See cat. II.4, II.10, II.13, II.15, II.17, II.19, II.20.

<div align="right">Sharon E. J. Gerstel</div>

F

State Historical Museum, Moscow

Three tiles in the collection are said to be from Nicomedia (cat. F.1–F.3). They were formerly in the collection of P. I. Sevastianov in Moscow. The plaques were given to him by Pantelejmon Sapozhnikov, an Athonite monk. They were acquired in 1924 from the Rumjantsov Museum in Moscow.

A fourth tile, F.4, was revealed in excavations in Cherson conducted by K. K. Kostjuinko-Valjuzhinich in 1892. The fragmentary plaque was added to the collection of the State Historical Museum in 1893.

<div align="right">Rossitza B. Roussanova</div>

F.1 Saint George
Ο Α(γιος) ΓΕΟΡ | ΓΙΟΣ
Moscow, State Historical Museum, 53066
H. 17.3, W. 17.2 cm

DESCRIPTION: George is represented at the center of a medallion surrounded by a thick band accented by heart-shaped leaves at the four corners of the plaque. His face is rendered in fine calligraphic lines; the painter differentiates the thumbnail and the creases of the neck. The lower lids of the eyes are emphasized and the brows elongated and darkened. The youthful saint has dark curly hair, fringed around the face. The line of his nose and lips is highlighted by red slip. George wears the costume of an aristocrat. His robe is clasped on the right shoulder. In his right hand, he holds a cross, a symbol of his martyrdom.

LITERATURE: *Moskovskij Publičnyi Rumiantsevskij Muzei Putevoditel po otdeleniju drevnostej* (Moscow, 1909), 9, no. 733; Talbot Rice, "Polychrome Pottery," 74, pl. xxx.1; *Iskusstvo Vizantii v sobranijakh SSSR* (Moscow, 1977), II, no. 477. R.B.R.

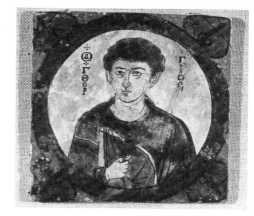

F.1

F.2 Saint Panteleimon

[ʹΟ ʺΑγιος Παντ] | ΕΛΕΗΜΟΝ
Moscow, State Historical Museum, 53066
H. 14.5, W. 14.0 cm

DESCRIPTION: The tile constitutes the upper right corner of a plaque containing the half-length portrait of Saint Panteleimon, the "all-merciful," one of the holy *anargyroi*. The portrait reflects the conventional representation of the saint as a youthful figure with short curly hair.

LITERATURE: *Moskovskij Publičnyi Rumiantsevskij Muzei Putevoditel po otdeleniju drevnostej*, 9, no. 734; Talbot Rice, "Polychrome Pottery," 74, pl. XXX.2; *Iskusstvo Vizantii v sobranijakh SSSR*, II, no. 476. R.B.R.

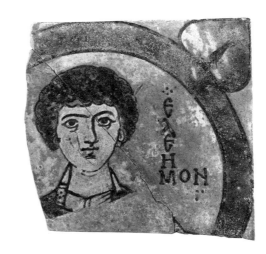

F.2

F.3 Archangel Michael (?) on Horseback

Moscow, State Historical Museum, 53066
H. 11.0, W. 15.4 cm

DESCRIPTION: The fragmentary plaque represents an archangel on horseback approaching a group of eight figures. The archangel holds a spear in his right hand; his horse rears up on its hind legs. The small figures to the right have heads but no bodies. The representation constitutes a rare example of a narrative scene on a Byzantine tile. The precise meaning of the scene, however, is enigmatic. Since the sketchy figures appear to be immersed in water, the scene may refer to the Miracle at Chonae. An alternative reading might associate the figures, perhaps burning, with a scene of the Last Judgment. This tile has been dated by the State Historical Museum to the thirteenth/fourteenth century.

LITERATURE: *Moskovskij Publičnyi Rumiantsevskij Muzei Putevoditel po otdeleniju drevnostej*, 9, no. 732; Talbot Rice, "Polychrome Pottery," 74, pl. XXIX.2; *Iskusstvo Vizantii v sobranijakh SSSR*, III, no. 1003. S.G.

F.3

F.4 Saint Elisabeth

[ʹΗ ἀγί]Α [ʹΕλισ)ΑΒΕΤ
Moscow, State Historical Museum, 28740
H. 10.0, W. 9.0 cm

DESCRIPTION: The small tile is decorated with the figure of a female saint, Elisabeth, dressed in a long dark robe and carrying a cross in her right hand. The portrait may represent the mid-fifth-century Constantinopolitan saint Elisabeth the Wonderworker, whose feast is celebrated on 24 April.[1] In scale and painting technique, the tile appears to be closer to examples from Bulgaria than to preserved figural tiles from the Byzantine capital.

LITERATURE: *Iskusstvo Vizantii v sobranijakh SSSR*, II, no. 478 (here, the figure is identified as the Virgin).

1 For the *Life* of the saint, see "Life of St. Elisabeth the Wonderworker," trans. V. Karras, in *Holy Women of Byzantium*, ed. A.-M. Talbot (Washington, D.C., 1996), 117–35. R.B.R.

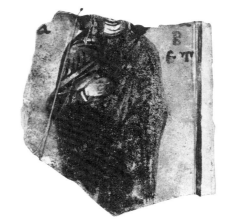

F.4

G
Museo Internazionale delle Ceramiche, Faenza

A single Byzantine tile formed part of a collection of more than 2,700 fragments of Egyptian and Islamic pottery donated to the museum in Faenza by F. R. Martin in 1937.[1]

1 We thank the museum for sending us information from the curatorial files.

SHARON E. J. GERSTEL

G.1 Tongue and Dart

Faenza, Museo Internazionale delle Ceramiche, AB839
H. 7.7, W. 15.0 cm

CONDITION: Convex tile reconstructed from numerous fragments. Upper, lower, and left edges preserved.

DESCRIPTION: Tongue-and-dart variation. Each tongue is composed of six concentric bands with black at the core. A band encloses a row of white-reserve half-circles, which create a scalloped effect. The narrow darts terminate in circles along the upper edge of the plaque, which is bordered by a thin band.

COMPARISONS: Hospital of Sampson (cat. II.2); France, Thierry Collection (cat. H.7).

LITERATURE: G. Ballardini, "Ceramiche bizantine al Museo delle Ceramiche di Faenza," *Faenza* 8 (1920), 61–84; idem, "Un particolare aspetto della ceramica policroma bizantina," *Bollettino d'arte* 25 (1931), 551–59.

S.G.

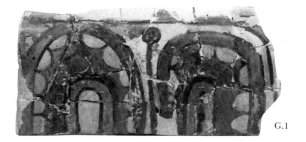

G.1

H
Thierry Collection, France

The fragments in the Thierry Collection were purchased from Jean Pozzi.

<div style="text-align: right">SHARON E. J. GERSTEL</div>

H.1 Intersecting Hexagonal Pattern

France, Thierry Collection
H. 15.0, W 10.3 cm

CONDITION: Three joining fragments of a nearly complete, acutely angled cover tile. Restored in modern times with buff-colored plaster at outer edges. Three finished, squared edges. Fabric is reddish white with traces of burning on the reverse. The reverse side is deeply scored with two rows of parallel lines that form mirrored diagonals. There are traces of white, very fine plaster within some of the lines. Glaze colors include copper green (appearing blue-green) and brown, most likely iron oxide slip. Green glaze is heavily oxidized and has formed an opaque weathering crust.

DESCRIPTION: The pattern on this sloping tile is formed by half-hexagonals. The hexagonals are formed by a common white border at the center, tallest point of the tile. The white-reserve border of each hexagonal is outlined in black and surrounds a band of copper green. This colorful band, in turn, encloses a brown field with a trilobed white floral motif at the center edge of each side of the tile.

COMPARISONS: Boukoleon (cat. 1.B.5). S.G.

H.2 Tongue and Dart

France, Thierry Collection
Dimensions Unknown

CONDITION: Single fragment of a concave tile. No finished edges preserved. Glaze colors include copper green (here seen as blue-green) and gold leaf; the deep brown background is painted with iron oxide.

DESCRIPTION: Upper portion of arch from center of concave tile. The arch is composed of two bands of gold leaf surrounding a core of blue-green glaze. The pattern is outlined by thick black lines.

COMPARISONS: Boukoleon (cat. 1.B.1, 1.B.2); Sèvres, Musée national de Céramique (cat. C.11, C.12). S.G.

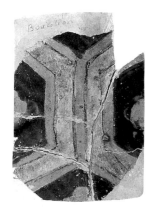

H.1

H.1 back

H.2

H.3 Tongue and Dart

France, Thierry Collection
M.P.H. 4.5, M.P.W. 7.0 cm

CONDITION: Flat tile reconstructed from two fragments. No finished edges. Reverse side is deeply scored with crosshatched lines and contains traces of plaster. Surface glaze is very worn.

DESCRIPTION: The fragmentary tile contains a single arch set against a dark brown (iron oxide?) background. The exterior segment of the arch is white, and the interior appears to have been green; the glaze is completely worn off, but the tile preserves a greenish wash. S.G.

H.3

H.3 back

H.4 Shell (no photo)

France, Thierry Collection
M.P.H. 3.8, M.P.W. 4.0, Th. 0.4 cm

CONDITION: Small fragment of a convex oblong tile. Upper edge preserved. Reverse side is smoothed. Glaze colors include amber and copper green; background painted in iron oxide.

DESCRIPTION: Portions of two crescents in amber glaze on black (iron oxide) background. There is a slight trace of green glaze at the center of the crescent. A narrow border runs along the upper edge.

COMPARISONS: Constantine Lips (cat. VI.8, VI.9); Myrelaion (cat. VII.2); Mangana (cat. IX.1); Topkapı Sarayı Basilica (cat. XII.4); Sèvres, Musée national de Céramique (cat. C.10, C.35). S.G.

H.5 Circle with Four-Petaled Flower

France, Thierry Collection
M.P.H. 3.2, M.P.W. 4.0, Th. 0.3 cm

CONDITION: Single corner fragment of convex oblong tile. Traces of fine plaster on reverse side. Glaze color is limited to amber; iron oxide used to draw the design and as the fill within the petal. Red slip used at the center of the flower. Glaze relatively well preserved.

DESCRIPTION: The two rounded elongated leaves and single small flower form part of a longer band of foliate decoration. The large leaves radiate diagonally from the edge of the plaque and, if the plaque were complete, would join with two adjacent diagonal leaves to form a circle with a flower at its center. Each leaf is outlined in black and is divided into white lobes set on a darker, reddish brown ground. A four-petaled flower is represented between the leaves at the center of the plaque. Its petals are outlined in black. At the center of the flower is a dark red disk. The entire composition is set against an amber background.

COMPARISONS: Myrelaion (cat. VII.3); Topkapı Sarayı Basilica (cat. XII.10–XII.13); Istanbul, Provenance Unknown (cat. XV.7, XV.9); Baltimore, Walters Art Museum (cat. A.70); Paris, Musée du Louvre (cat. B.13); Sèvres, Musée national de Céramique (cat. C.21, C.22); Athens, Benaki Museum (cat. D.7). S.G.

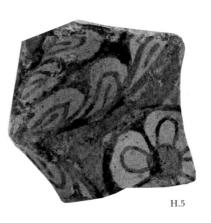

H.5

H.6 Hearts with Profile Flowers

France, Thierry Collection

Th. 0.6 cm

CONDITION: Fragment of a thick convex tile with traces of glue on all sides. Reverse is smoothed.

DESCRIPTION: A heart-shaped white border encloses a leaf with three reddish amber berries. A second floral motif is composed of white petals. s.g.

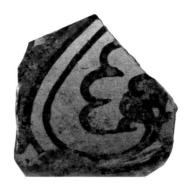

H.6

H.7 Tongue and Dart

France, Thierry Collection

H. 7.0, W. 13.2 cm

CONDITION: Section of a convex rectangular tile reconstructed from eight fragments. White fabric with iron oxide and quartz inclusions. Preserved upper and lower edges. Amber glaze and iron oxide line on surface are well preserved. Reverse side is obscured by plaster used to stabilize the tile.

DESCRIPTION: This fragment of a longer tile represents two tongues divided by a vertical strip, which terminates in two flaring ends and is filled with amber glaze. A thin band marks the upper surface of the tile. The tongues, drawn in black line, enclose a band of eight half-circles; between each of these is a small dot. The center of the tongue is decorated with amber glaze, which enframes a central post in black.

COMPARISONS: Hospital of Sampson (cat. 11.2); Faenza, Museo Internazionale delle Ceramiche (cat. G.1). s.g.

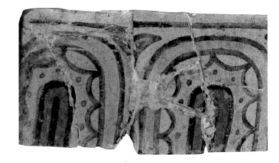

H.7

H.8, H.9 Lozenges

France, Thierry Collection

H. 6.1, M.P.W. 6.8, Th 0.4 cm

CONDITION: Two fragments of oblong tiles. Upper and lower edges are preserved and are beveled. Glaze colors include amber and copper green.

DESCRIPTION: The tiles are decorated with repeating amber-colored lozenges. The lozenges alternate between those that contain a quatrefoil and those that contain a checkerboard pattern. Green-colored foliate tendrils, outlined in black, emerge from between the lozenges and curl along the upper and lower edges of the plaque. Along the upper edge of the tile is a band of amber. One tile contains two lozenges and the foliate design between them. To the left, the lozenge contains a quatrefoil, with petals outlined in amber glaze and decorated with green glaze at their centers. The flower is set within the lozenge, on a green background. The second lozenge, filled with a checkerboard pattern, contains spaces that alternate between copper green and amber. At the center of each space is a black dot, painted with iron oxide. A second tile from the same pattern (formed of two pieces incorrectly restored) contains two additional lozenges with checkerboard patterns. S.G.

H.8

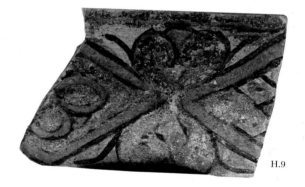

H.9

H.10 Tongue and Dart and Concentric Circles

France, Thierry Collection

Th. 0.8 cm

CONDITION: Upper section of column capital reconstructed from three fragments. In profile, the fragment is vertical at the top and bulges at the center. Chip losses along breaks. Glaze colors include amber, copper green, and clear. In places, the copper green is extremely worn and appears as a white background with a slight green wash. Iron oxide is used to paint the design and to fill in the background in several locations. The reverse side is smoothed.

DESCRIPTION: The fragment is divided into three bands of decoration and a thin green border at the very top of the capital. The upper decorative band is a narrow tongue-and-dart pattern. Each arch is doubled, with a worn outer copper green band and an inner amber band. Between each arch is a black post that terminates in a thickened circle. The central register of decoration is composed of green half-circles set on an amber background. The lowest register is filled with a beaded motif of white circles on a brown-black (iron oxide) surface. At the center of each bead is a small amber circle.

S.G.

H.10

I
Mallon Collection

A single tile was published by Jean Ebersolt in 1941 as part of the collection of Mme. Marguerite Mallon in Paris. We have been unable to locate this tile.

SHARON E. J. GERSTEL

I.1 Unidentified Male Saint

O AΓ[I]O[Σ]

Location Unknown
According to Ebersolt, the tile is from Constantinople
M.P.H 12.0 cm

CONDITION: At least five fragments of a flat plaque. White fabric fired pink at surface. Chip losses around breaks. No decoration on the reverse. Glaze colors include amber, blue, copper green, and clear (?). Copper green glaze appears to be opacified due to a weathering crust.

DESCRIPTION: The plaque is decorated with the frontal portrait of a sainted official dressed in chlamys and *tablion*. The figure's identity is unknown; his sanctity is represented by the golden nimbus outlined in deep blue surrounding his head and the inscription to his right, "the saint." Ebersolt suggests that the saint was accompanied by a second figure, now missing. Three letters of a second inscription, in blue letters on a gold band at the top of the plaque, are illegible. The saint stands against a green background, which is emphasized by a thick horizontal ground line. Two plants, painted in deep blue, are represented to the saint's right in the foreground. The saint's facial features are painted in thick brush strokes; only one side of the nose is articulated, and the heavily lidded eyes are surmounted by dark brows. The saint's white robe is decorated on the shoulder and cuff. The curves and bends of the body are emphasized by the use of line on the drapery, especially at the inner elbow and knee. A round fibula holds the chlamys on the saint's right shoulder. This outer garment is ornamented with a richly jeweled *tablion,* a sign of the saint's high rank. Although Ebersolt described the saint as holding a scroll in his right hand, it appears that he holds a cross, a sign that he likely was a martyr. In the style of the drawing and the scale of the figure, the representation is similar to that of a standing male saint on a polychrome tile in the Benaki Museum, Athens (cat. D.2).

LITERATURE: J. Ebersolt, "Céramique et Statuette de Constantinople," *Byzantion* 6 (1931), 559–60; Talbot Rice, "Polychrome Pottery," 74, pl. 28.1. S.G.

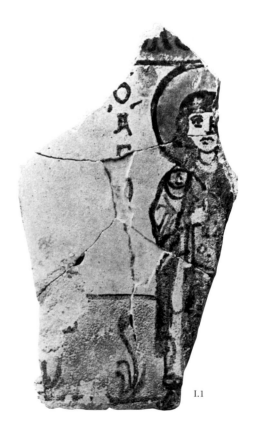

I.1

J
Private Collection

Where the findspots of the tiles in this collection are recorded, the fragments have been catalogued with the specific sites. See cat. VII.7, XV.11, XV.12.

MARLIA MUNDELL MANGO

J.1 Christ Pantokrator

M.P.H. 6.0, M.P.W. 8.3, Th. 0.4 cm

FINDSPOT: Unknown.

CONDITION: Fragment of a square (?) convex tile restored from four pieces. Lower edge preserved; left and upper half missing. Losses to surface where the four pieces are joined. Painted in black lines; only amber and darker blue glazes preserved.

DESCRIPTION: Christ Pantokrator is represented in bust form within a foliate frame. The frame is in white reserve, the background within the frame and in the lower right corner is gray-blue, and the space below the frame is pale blue. Christ, whose head is missing, has an amber halo, wears a pale chiton with green clavus and dark blue *himation,* and blesses with his right hand. In his other hand he holds an upright amber book decorated with four gems.

COMPARISONS: Baltimore, Walters Art Museum (cat. A.19).

M.M.M.

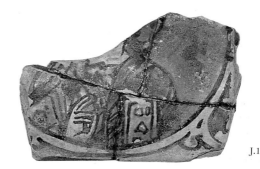

J.1

J.2 Oblong Tile with Arched Motifs

H. 6.0, W. 13.5, Th. 0.5 cm

FINDSPOT: Unknown; purchased in Athens in 1934.

CONDITION: Complete oblong convex tile.

DESCRIPTION: Brown-black outlines on white-reserve ground. Amber arches, with white border and double vertical green bands at the apex, enclose amber half-ovals with white borders from which project triangular floral motifs, amber with white borders, each with two pairs of volutes. A narrow black horizontal band runs along the upper edge of the tile.

M.M.M.

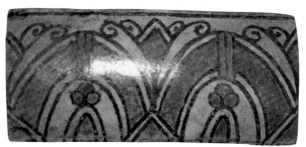

J.2

Index

niello, 113
Nika Riot, 26, 176, 225
Nikephoros, commander, 237
Nikertai, 243

Oğan, A., 208
Ömerli Köy, 81
omophorion, 245, 252
opus sectile, 23, 34, 90, 91, 92, 93, 94, 95, 96, 98, 99, 114, 196, 232
orientalization, 3, 143
orthography, 52, 252
Ousterhout, R., 93
Oxford, Ashmolean Museum, 82

Padua, Cathedral Tresaury, inkpot, 8
painters, working methods of, 45, 46, 47, 48, 49, 52, 71, 72, 114, 119, 219, 220, 240
paired acanthus leaves, 20, 26, 27, 28, 39, 73, 95, 105, 145, 153, 196, 205, 213, 215, 227, 273, 287, 293, 299, 300
paired leaves (*see* paired acanthus leaves)
Palaeologan dynasty, 185, 197, 225
Palestine, 7
palmette, 20, 47, 205, 240, 276
palmette volutes (*see* acanthus volutes)
Panchenko, B, 203
Pantelejmon Sapozhnikov, monk, 301
Paris, Bibliothèque Nationale, Cabinet des Médailles, Romanos plaque, 7
Paris, Musée du Louvre, 18, 19, 32, 33, 43, 44, 45, 52, 67, 68, 69, 72, 73, 74, 75, 76, 80, 81, 82, 83, 85, 121, 162, 163, 164, 177, 178, 181, 182, 184, 187, 188, 190, 191, 198, 201, 212, 216, 226, 228, 232, 234, 235, 238, 240, 243, 265, 268, 270, 273, 274, 275, 277, 279–87, 289, 293, 294, 295, 296, 300, 305
 Harbaville triptych, 255
Paris Gregory (*see* manuscripts, Paris, Bibliothèque Nationale, gr. 510)
Patleina, 2, 46, 62 n. 15, 167, 216, 265
patronage, 2, 7–11, 58–60, 61, 167–68
pavement, *opus sectile*, 22, 23, 34, 108, 120, 145, 172, 176, 196, 197, 203, 230, 237, 238, 260, 261, 284
peacock, 20, 23, 31, 44, 56, 57, 77, 79, 119–21, 137, 144, 165, 258–59, 281
peacock feather, 1, 20, 22, 96, 108, 121–22, 154, 181, 182, 184, 188, 201, 210, 221, 222, 229, 232, 234, 240, 268, 279, 287, 294
Persia and Persians, 3, 5
Peschlow, U., 26, 176, 200
Philon, H., 161, 162, 163
Phokis, Hosios Loukas, 11, 90, 103, 108, 113, 244, 254, 255, 269
Photios, patriarch of Constantinople, 9, 22, 63 n. 36, 106, 280
Phrygia, 18, 55

pitched square with crosslets, 28, 107, 223, 226
polychrome ware, 29–33, 161, 194, 210, 228, 240, 272, 275, 276
Poreč, Euphrasius cathedral, 90, 96, 98, 99, 103
Porter, A. K., 94
pottery wheel, 75–76, 86 n. 36
Pozzi, J., 279, 288, 304
prependoulion, 50, 256
Preslav, 3, 18, 22, 39, 46, 67, 68, 70, 71, 73, 76, 78, 82, 152, 156 n. 7, 161, 167, 168 n. 9, 205, 215, 221, 258, 265, 268, 278, 281
 Round church, 24, 85 n. 11, 167, 210, 212, 220, 223, 281, 286
 Royal monastery, 53, 167, 240
Private Collection, 48, 199, 209, 234, 309
private monasteries, 10
Prokopios, historian, 176, 236
Prokopios, saint, 255
Prusias ad Hypium, 18, 43, 44, 45, 60, 62 n. 9, 238, 243, 244, 279
psalter, 7
Psellos, Michael, 8, 280

quatrefoil, 28, 39, 94, 99, 108, 217
quincunx, 22, 23
Qu'ran, 240

al-Raḥmān I, emir, 239
al-Raḥmān II, emir, 239
al-Raḥmān III, caliph, 239, 240
Ramazanoğlu, M., 176
Ravenna, San Vitale, 90, 91, 94, 103, 110
Richmond, Virginia Museum of Fine Arts, 221
Riegl, A., 145
Riha flabellum, 121
Romanos I Lekapenos, emperor, 9, 15, 55, 135, 167, 168, 197, 257
Romanos II, emperor, 10
Romanos III, emperor, 280
Rome, 5, 23, 245
Rome, Palazzo Venezia
 casket, 7
 Constantine triptych, 7
rosette, 20, 77, 79, 98, 99, 101, 106, 111, 114, 123, 144, 145, 146, 215, 220, 222, 282
Roussanova, R., 60
Russian Archaeological Institute, Istanbul, 15, 203

Salón Rico, 240
Samarra, 13, 22, 39, 146, 148–50, 152, 161
Sampson the Xenodochos, saint, 58
sanctuary decoration, 15, 26, 34, 39, 53, 57, 237
sanctuary screen (*see* templon)
sand, 68, 75, 78
Saqqara, Apa Jeremiah monastery, 157 n. 31
Sasanians, 150, 283, 290
Sasanian palmette, 144

sawtooth, 108, 145, 269
scale, 96, 108, 113, 121, 144, 145, 146, 224, 240, 269, 284
Scheller, R., 145
Schmit, T., 26, 153, 154, 237
Schneider, A. M., 200
scrolling tendrils, 31, 113, 183, 231
sculptural relief, 20, 26, 31, 36, 56, 57, 61, 119, 281, 282
seals, 44, 60, 238, 242, 280
Sebaste (*see* Selçikler Köyü)
secondary deposition, 1, 14, 185, 206
Selçikler Köyü, 55, 56
sepulchral monuments, 89, 208
Sevastianov, P. I., 301
Sèvres, Musée national de Céramique, 19, 25, 67, 68, 69, 72, 73, 74, 75, 76, 77, 78, 80, 81, 82, 83, 85, 129, 154, 164, 173, 174, 175, 177, 178, 180, 181, 184, 187, 188, 190, 191, 192, 193, 194, 195, 198, 201, 202, 205, 209, 210, 212, 213, 216, 223, 226, 231, 232, 234, 235, 237, 268, 270, 273, 274, 275, 277, 279, 281, 282, 283, 285, 286, 287, 288–97, 300, 304, 305
sgraffito, 29, 32, 40
shell, 20, 26, 27, 28, 94, 109, 186, 192, 198, 202, 210, 292, 295, 296, 305
 with circles, 108
 with palmette, 109, 198
sieving, 78
silver revetment, 25, 54
Sismanoğlu, G. and S., 176
sketches (*see* tiles)
Skripou, Dormition church, 101, 111, 259 n. 1
Skylitzes, John, 8
Slavs, 5
Soustiel, J., 279, 287, 288
spolia, 24, 25, 109, 200
statuary, 8
step, 20, 109, 119, 179
Stephen the Younger, *Life* of, 5
stepped cross, 20, 27, 28, 29, 101, 194
stepped dart, 27, 28
Stern, H., 240, 241
Striker, C. L., 185, 197, 198
Strzygowksi, J., 3
stucco, 34, 36, 37, 68, 90, 145, 146, 148, 149, 172, 189, 190, 194
swirling acanthus leaves, 232
Symeon of Bulgaria, 167, 168
Syria, 7

tablion, 51, 244, 254, 255, 258, 308
Talbot Rice, D., 3, 32, 144, 150, 160, 197, 198, 199, 225, 233, 235, 243 n. 1, 279, 287
templon screen, 33, 36, 38, 39, 46, 53–57, 60, 61, 63 n. 36, 64 n. 39, 89, 122, 162, 163, 204, 208, 237, 259

Sources for the Illustrations

Figures

M. Agati, *La minuscola "bouletée,"* Littera antiqua 9, 2 (Vatican City, 1992): 121 fig. 6.

P. Asemakopoulou-Atzaka, *He technike opus sectile sten entoichia diakosmese,* Byzantine Mnemeia 4 (Thessalonike, 1980): 104.

Nuşin Asgari: 2; 3; 163 fig. 8; 173 cat. I.B.1; 174; 175.

T. Aydoğmuş: 121 fig. 4; 131 fig. 37; 132 fig. 39; 177 cat. II.1–II.3; 178; 179 cat. II.11, II.12; 180 cat. II.14; 181 cat. II.16, II.18.

Benaki Museum, Athens; photo K. Manoles: 51 fig. 13; 162 figs. 5, 6; 164, figs. 10, 11; 166 figs. 14, 15; 300; photo M. Skiadareses: 298; 299.

G. Brett, W. J. Macaulay, R. B. K. Stevenson, *The Great Palace of the Byzantine Emperors* (London, 1947): 173 cat I.A.1.

C. Cecchelli, J. Furlan, M. Salmi, *The Rabbula Gospels* (Olten, 1959): 124 figs. 12, 13; 125 fig. 15.

M. Chatzidakis et al., *Naxos* (Athens, 1989): 160 fig. 2.

R. Cormack, "The Arts During the Age of Iconoclasm," *Iconoclasm,* ed. A. Bryer and J. Herrin (Birmingham, 1977): 103.

R. Cormack and E. J. W. Hawkins, "The Mosaics of Saint Sophia at Istanbul: The Rooms Above the Southwest Vestibule and Ramp," *DOP* 31 (1977): 95.

F. W. Deichmann, *Ravenna: Hauptstadt des spätantiken Abendlandes,* II/2 (Wiesbaden, 1976): 91 fig. 2.

C. Diehl, M. le Tourneau and H. Saladin, *Les monuments chrétiens de Salonique* (Paris, 1918): 120 fig. 1.

S. Dufrenne and P. Canart, *Die Bibel des Patricius Leo. Codex Reginensis Graecus 1 B* (Zurich, 1988): 126 figs. 19, 20.

Dumbarton Oaks, Washington, D.C.: 25 fig. 9; 57; 59 fig. 26; 61; 124 fig. 10; 127 fig. 26; 129 figs. 29, 31; 177 cat. II.4; 179 cat. II.10; 180 cat. II.13, II.15; 181 cat. II.17; 182; 189; 190–95; 197; 200; 203.

J. Durand, *Byzantine Art* (Paris, 1999): 135 fig. 41.

J. Ebersolt, "Céramique et statuette de Constantinople," *Byzantion* 6 (1931): 51 fig. 14; 308.

E. S. Ettinghausen: 166 fig. 16; 198 cat. VII.4; 199 cat. VII.6–VII.7; 205; 209 cat. XII.1, XII.2; 210 cat. XII.3; 211 cat. XII.8, XII.9; 212; 213 cat. XII.13, XII.14; 214; 215 cat. XII.20; 216 cat. XII.22, XII.24; 217; 218; 219; 221 cat. XII.35; 222 cat. XII.36; 223; 224; 229; 231 cat. XV.1; 235.

Fıratlı, *Sculpture byzantine:* 58 fig. 23.

Fıratlı, "Sébaste": 56 fig. 19.

G. Forsyth and K. Weitzmann, *The Monastery of Saint Catherine at Mount Sinai: The Church and Fortress of Justinian* (Ann Arbor, 1973): 123 fig. 9.

S. E. J. Gerstel: 25 fig. 7; 35 fig. 27; 146 fig. 2; 183; 198 cat. VII.1–VII.3; 199 cat. VII.5; 252.

Glory of Byzantium: 127 figs. 22, 25.

A. Gonosová and C. Kondoleon, *Art of Late Rome and Byzantium* (Richmond, 1994): 129 fig. 30.

A. Grabar, *Les manuscrits grecs enluminés de provenance italienne (IXe–XIe siècles),* Bibliothèque des Cahiers archéologiques 8 (Paris, 1972): 120 fig. 3.

R. M. Harrison: 25 fig. 6, 124 fig. 11.

Hayes, *Saraçhane:* 29 fig. 10; 30 fig. 14; 31 fig. 20; 32 fig. 22; 32 fig. 24; 33 fig. 25; 126 fig. 21; 207.

E. Herzfeld, *Die Malereien von Samarra* (Berlin, 1927): 142; 148 figs. 8, 9; 149 fig. 10.

E. Herzfeld, *Die Wandschmuck der Bauten von Samarra und seine Ornamentik* (Berlin, 1923): 147 figs. 5, 6; 148 fig. 7; 149 fig. 11.

Hirmer Verlag: 24 fig. 5.

A. Iacobini and L. Perria, "Il vangelo di Dionisio," *RSBN* 31 (1994): 125 fig. 16.

Istanbul Arkeoloji Müzeleri: 43; 121 fig. 5; 127 fig. 23; 146 fig. 1; 147 fig. 4; 167 fig. 17; 209 cat. XII.3; 210 cat. XII.4, XII.5; 211 cat. XII.7; 213 cat. XII.15; 215 cat. XII.19, XII.21; 216 cat. XII.23; 220 cat. XII.33; 221 cat. XII.34; 222 cat. XII.37; 226–28; 238; 272.

H. Kähler, *Hagia Sophia* (New York, 1967): 88; 92 figs. 4, 5; 93 fig. 6.

S. Kostof, *Caves of God: Cappadocia and Its Churches* (New York, 1992): 152.

Ö. Koyunoğlu, "Byzantine Pottery from the Palace of Justice Excavations at Istanbul," *IAMY* 5 (1952): 184.

J. Lauffenburger: 68; 69 fig. 3; 70; 71; 72; 73; 74.

R. Mainstone, *Hagia Sophia: Architecture, Structure, and Liturgy of Justinian's Great Church* (London-Budapest, 1988): 93 fig. 7.

T. A. Makarova, *Polivnaja posuda iz istorii keramičeskogo importa i proizvodstva drevnei Rusi. Arheologija SSSR El-38* (Moscow, 1967): 30 fig. 15; 31 fig. 21.

G. Marçais, *Les faïences à reflets métalliques de la grande Mosquée de Kairouan* (Paris, 1928): 151.

Mathews, *Byzantine Churches:* 35 fig. 28; 90.

C. Mango: 36 fig. 29; 234; 309 cat. J.2.

Mango and Hawkins, "Additional Notes": 37.

C. Mango and E. J. W. Hawkins, "The Mosaics of St. Sophia at Istanbul: The Church Fathers in the North Tympanum," *DOP* 26 (1972): 97; 106.

M. Mundell Mango: 48 fig. 7; 309 cat. J.1.

B. Martínez Caviró, *Cerámica Hispanomusulmana: Anadalusí y Mudéjar* (Madrid, 1991): 155; 239.

Il menologio di Basilio II (Cod. Vaticano greco 1613), Codices e vaticanis selecti . . . 8 (Turin, 1907): 118; 130 fig. 32; 131 fig. 36.

The Metropolitan Museum of Art, Gift of J. Pierpont Morgan, 1917 (17.190.1670–1671): 128 fig. 28.

Morgan, *Byzantine Pottery,* 29 fig. 11; 30 fig. 16; 31 fig. 19.

Courtesy of the Museo Internazionale delle Ceramiche, Faenza: 303.

Naumann and Belting, *Die Euphemia-Kirche:* 201.

C. Nordenfalk, *Die spätantiken Kanontafeln* (Gothenburg, 1938): 125 fig. 17.

Omont, *Miniatures:* 127 fig. 24.

A. Papadopoulo, *L'Islam et l'art musulman* (Paris, 1976): 165 fig. 13.

U. Peschlow, *Die Irenenkirche in Istanbul* (Tübingen, 1977): 39.

C. Reedy: 75.

© Photo RMN; photo D. Arnaudet: 163, fig. 7; photo M. Beck-Coppola: 4; 56 fig. 20; 120 fig. 2; 130 fig. 33; 158; 162 fig. 1; 164 fig. 9; 165 fig. 12; 280–97.

F. Sarre, *Die Keramik von Samarra* (Berlin, 1925): 149; 150 fig. 14.

Schmit, *Die Koimesis-Kirche:* 153; 236.

H. Chihat Soyhan, "İki duvar Çinisi Üzerinde İnceleme," *Sanat Tarihi Yıllıgı* 6 (1976): 33 fig. 26.

Courtesy of the State Historical Museum, Moscow: 301–2.

R. Stillwell, *Antioch-on-the-Orontes,* III, *The Excavations of 1937–1939* (Princeton, 1941): 24 fig. 4.

C. L. Striker: 32 fig. 23; 186–88.

Striker and Kuban, *Kalenderhane:* 185.

Talbot Rice, *Glazed Pottery:* 30, fig. 13; 231–32.

A. Terry, "The *Opus Sectile* in the Euphrasius Cathedral at Poreč," *DOP* 40 (1986): 91 fig. 3.

N. Teteriatnikov: 55.

L. Theis: 196.

N. Thierry: 304–7.

Totev, *Preslavskata:* 54.

Trésors médiévaux de la République de Macédoine (Paris, 1999) 169 fig. 1.

A. Tsitouridou, *The Church of the Panagia Chalkeon* (Thessalonike, 1985): 38.

P. Underwood and E. J. W. Hawkins, "The Mosaics of Hagia Sophia at Istanbul: The Portrait of Emperor Alexander: A Report on Work Done by the Byzantine Institute in 1959–1960," *DOP* 15 (1961): 105; 107.

Unknown: 233.

Walters Art Museum, Baltimore; photo S. Tobin: 42; 44; 45; 46; 47; 48 fig. 8; 49; 50; 58 fig. 24; 59 figs. 25, 26; 66; 123 figs. 7, 8; 146 fig. 3; 150 fig. 13; 161; 170–71; 243–78.

Weitzmann, *Byzantinische Buchmalerei:* 124 fig. 14; 125 fig. 18; 128 fig. 27; 130 figs. 34, 35; 132

figs. 38, 40; 135 fig. 42.

T. Whittemore, *The Mosaics of St. Sophia at Istanbul: Preliminary Report on the First Year's Work, 19311932: The Mosaics of the Narthex* (Oxford, 1933): 96.

O. Wulff, *Die Koimesiskirche in Nicäa und ihre Mosaiken* (Strassburg, 1903): 154.

Zalesskaya, "Nouvelles découvertes": 12; 30 fig. 12; 30 fig. 17; 31 fig 18.

Maps and Drawings

J. C. Anderson: 94; 95; 96 drawings 6, 8; 97; 98; 99 drawings 19, 20, 21; 100; 101; 102; 103; 104; 105; 106; 107; 108 drawings 53–55; 109 drawings 59, 61, 62; 110; 111 drawings 65, 66; 112; 113.

M. Angold, ed., *The Byzantine Aristocracy: IX–XIII Centuries* (Oxford, 1984): 230.

E. Antoniades, *Ekphrasis tes Hagias Sophias*, I (Athens, 1907): 111 drawing 67.

G. Brett, W. J. Macaulay, R. B. K. Stevenson, *The Great Palace of the Byzantine Emperors* (London, 1947): 172.

R. Duyuran, "First Report on Excavations on the Site of the New Palace of Justice at Istanbul," *IAMY* 5 (1952): 184.

E. S. Ettinghausen: 99 drawings 18, 22; 220 cat. XII.33; 223; 232 cat. XV.8; 234.

Harrison, *Saraçhane*: 108 drawings 57, 58.

J. Lauffenburger: 96 drawing 7.

Macridy, "Monastery of Lips": 109 drawing 60.

C. Mango, *Byzantine Architecture* (New York, 1976): 189.

C. Mango, "The Palace of the Boukoleon," *CahArch* 45 (1997): 173.

Müller-Wiener, *Bildlexikon*: 176; 183; 202; 204; 206; 208; 225.

Naumann and Belting, *Die Euphemia-Kirche*: 200.

K. Rasmussen: xviii; 15; 16; 17; 18; 23 fig. 1.

Striker, *Myrelaion*: 197.

E. Swift, *Hagia Sophia* (New York, 1940): 98 drawing 14; 105 drawing 42.

Vogt, Bouquillon, et al., "Glazed Wall Tiles": 69 fig. 2.

A. A. Wilkins: 36 fig. 30.